KU-481-846

RENAISSANCE
SIENA
ART FOR A CITY

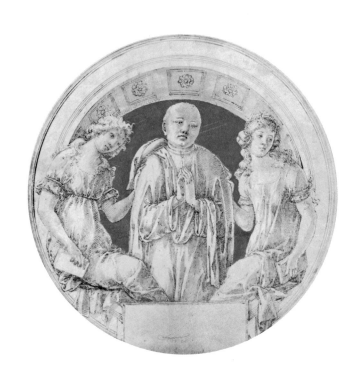

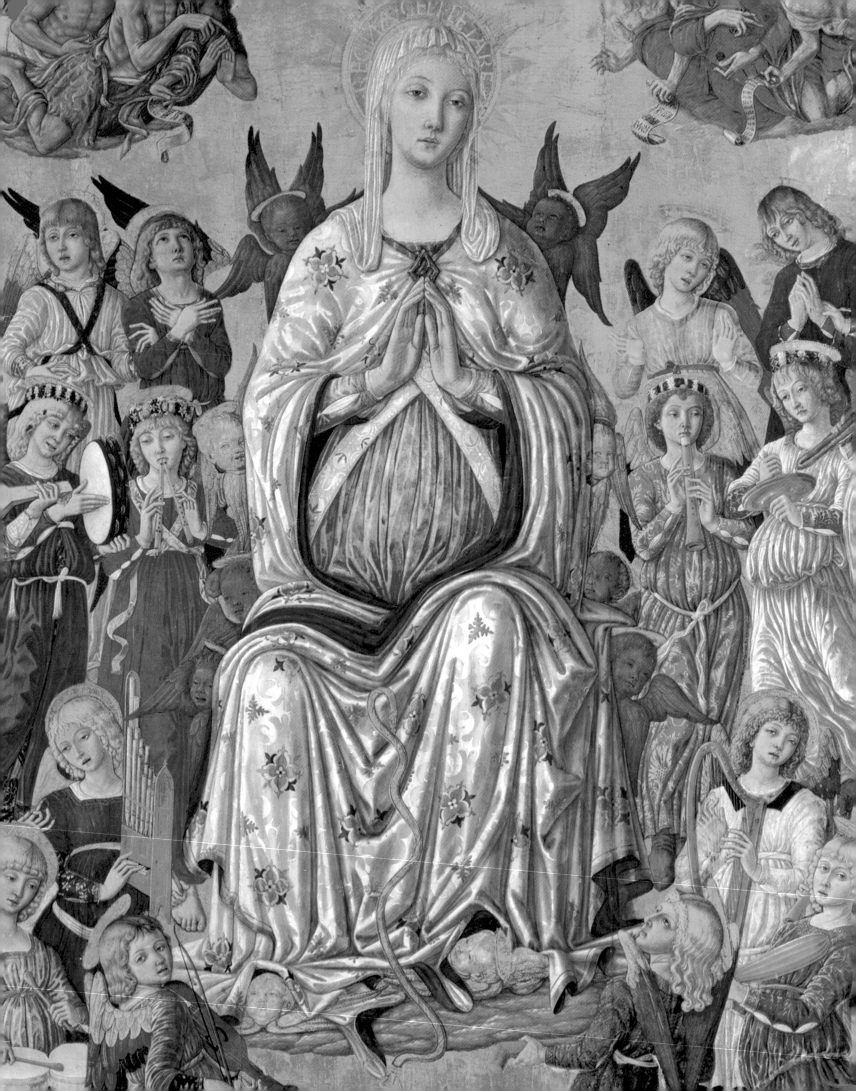

RENAISSANCE
SIENA

ART FOR A CITY

LUKE SYSON

ALESSANDRO ANGELINI, PHILIPPA JACKSON,
FABRIZIO NEVOLA, CAROL PLAZZOTTA

with contributions from

HUGO CHAPMAN, SIMONA DI NEPI,
GABRIELE FATTORINI, XAVIER F. SALOMON
AND JENNIFER SLIWKA

National Gallery Company, London
DISTRIBUTED BY YALE UNIVERSITY PRESS

For Lorne Campbell and Dillian Gordon,
with gratitude and affection.

Published to accompany the exhibition

RENAISSANCE
SIENA
ART FOR A CITY

Held at the National Gallery, London
24 October 2007 – 13 January 2008

Exhibition sponsored by Banca Monte dei Paschi di Siena

Illustrations in this catalogue have been
obtained with the generous support of
The Lila Acheson Wallace – Reader's Digest
Publications subsidy.

Copyright © National Gallery Company Limited, 2007

All rights reserved. No part of this publication may
be transmitted in any form or by any means, electronic
or mechanical, including photocopy, recording, or
any storage or retrieval system, without the prior
permission in writing from the publisher.

The Authors have asserted their rights under the
Copyright, Designs and Patents Act, 1988, to be
identified as Authors of this work.

First published in Great Britain in 2007 by
National Gallery Company Limited
St Vincent House
30 Orange Street
London WC2H 7HH
www.nationalgallery.co.uk

ISBN 978 1 85709 367 4 paperback 525492
ISBN 978 1 85709 392 6 hardback 525493

British Library Cataloguing-in-Publication Data
A catalogue record is available from the British Library
Library of Congress Control Number: 2007925384

Project Editor Claire Young
Editor Paul Holberton
Editorial Assistance Kate Bell, Jan Green,
 Davida Saunders, Tom Windross
Design Philip Lewis
Picture Research Maria Ranauro
Production Jane Hyne and Penny Le Tissier
Printed and bound in Italy by
Arti Grafiche Amilcare Pizzi, S.p.A

Catalogue contributors:
HC Hugo Chapman
SDN Simona Di Nepi
GF Gabriele Fattorini
PJ Philippa Jackson
CP Carol Plazzotta
XS Xavier F. Salomon
JS Jennifer Sliwka
LS Luke Syson

All measurements give height before width

Front cover/jacket: Francesco di Giorgio Martini,
The Virgin Mary protects Siena from Earthquakes, 1467–8
Detail of cat. 3

Frontispiece, fig. 1: Detail of cat. 43
Page 2, fig. 2: Detail of cat. 17
Page 8, fig. 3: Detail of cat. 37
Page 10, fig. 4: Detail of cat. 12
Page 75, fig. 40: Detail of cat. 50
Page 78–9: Detail of cat. 93
Page 105: Detail of cat. 9

CONTENTS

SPONSOR'S FOREWORD

Siena has been the focus for historical research on an international level for some time. After the great Italian cities of Florence, Rome and Venice, which have naturally always been of interest to scholars, this small but major city is now receiving the same attention as others that we are used to considering more prominent.

The reason for this interest lies largely in its treasures of art, architecture and urban planning, but there are other elements contributing to this new attention. One of these is the city's abundant evidence of a glorious past, combined with the complexity of fully understanding its impact on the present. These images from the past speak directly to us now, giving them a modern function that is sometimes unsettling because Siena's continuity with its past is so palpable. Late Republican Siena intrigues us because of its modernity.

While there can be little question that the fourteenth century was the golden age of Siena, and correspondingly of Sienese art, the next century was also nonetheless a period rich in history and inventiveness; a time when artists measured themselves against the Renaissance style born in Florence while drawing on their own immense heritage. Then, in the sixteenth century, the city was capable of producing great artists of the calibre of Domenico Beccafumi.

An exhibition devoted to the last century of the Republic of Siena, held in London, the international city par excellence, and in one of the most important and renowned cultural institutions in the world, the National Gallery, offers the opportunity make a part of Sienese history that may be less familiar to a global audience better known. Banca Monte dei Paschi began its work in this very period. With its birth, a tradition of cultural initiatives began that has been uninterrupted ever since, starting with the fresco commissioned in 1481 by the administrators of the Monte Pio from Benvenuto di Giovanni, one of the Sienese artists this exhibition features.

In its 500-year history, Monte dei Paschi has continually commissioned works from Siena's leading artists, and in more recent times has supplemented its original core collection with a larger group of paintings and sculptures, creating a museum devoted to the Sienese school. Our corporate head-quarters in Siena houses works by many of the artists included in this exhibition, among them the exceptional masters Francesco di Giorgio and Domenico Beccafumi.

The bank's significant involvement with the historical period explored in the exhibition has led us to support *Renaissance Siena: Art for a City*. We are sure this exhibition will remain a point of reference for the study of Sienese art on a level with the famous show organised in London by the Burlington Fine Arts Club more than a century ago in 1904, *Pictures of the School of Siena*, or the exhibition held in New York in 1988–9 on *Painting in Renaissance Siena: 1420–1500*. It is also important for us to highlight that Monte dei Paschi di Siena was able to lend to this exhibition *The Virgin and Child with Saints Jerome and Bernardino and Four Angels* by Sano di Pietro, part of the bank's outstanding Chigi Saracini collection.

On this occasion, finally, we cannot forget the debt Sienese art history owes to two great English-speaking art historians who contributed enormously to the status Sienese art now enjoys: Bernard Berenson and John Pope-Hennessy. It is our hope that in the future, with the efforts and commitment of scholars and exhibitions such as this one organised by the National Gallery, interest in Siena and its glorious, fascinating history will spread ever more widely.

BANCA MONTE DEI PASCHI DI SIENA

DIRECTOR'S FOREWORD

Since the early nineteenth century, the British affection for Siena has always included the exquisite painting of the Trecento. However, attitudes to Sienese painting and sculpture made in the decades on either side of 1500, have shifted considerably. Once passionately admired, works from this period were horribly neglected for most of the last century. This, I hope, is the moment to rediscover them.

'Siena has captivated my heart,' declared the painter Edward Burne-Jones in 1873, and he would ritually quote John Ruskin's inflammatory declaration, 'Siena is worth fifty times Florence.' In 1872 Ruskin, still thinking numerically, wrote to Charles Eliot Norton: 'It is curious that the first drawing I ever made of Italian art should have been from Duccio ... twenty times more interesting than Cimabue.' The art of Siena appealed to these Medievalists; it was there that they found a pure, spiritual 'Christian art', already prized by pioneering collectors like Lord Lindsay, whose *Saints Lucy and Agatha* by Matteo di Giovanni, bought as early as 1842, is in this exhibition (cat. 21). The painters, collectors and critics of this generation made little stylistic distinction between the art of the early Trecento and the pictures of the century following. Ruskin himself owned a *Madonna* by Neroccio de' Landi, purchased for him in Siena in 1860 by Charles Fairfax Murray, a painter, dealer and benefactor central to the Pre-Raphaelite movement.

The National Gallery had already spotted the trend. The first picture by a Quattrocento Sienese master, Matteo di Giovanni, was acquired in 1854. This initiated the arrival of other Sienese works into the collection in the following decades, thanks not least to the enthusiasm of Fairfax Murray through whose good offices Matteo's great *Assumption of the Virgin* was acquired in 1884. Our greatest nineteenth-century director, Sir Charles Eastlake, visited Siena on his picture-hunting Italian tours of mid-1850s. It may have been then that he bought Sano di Pietro's *Virgin and Child with Saints* (Lowe Art Museum, Coral Gables) for his own collection.

By the start of the twentieth century, Sienese painting was not only loved for its perceived spirituality, but had become the focus of scholarly attention from connoisseurs. In 1904, Robert Langton Douglas summed up what had become the conventional view of Sienese painters: 'Disdaining for the most part feats of modelling, they sought to express religious emotion by subtle effects of graceful line, bright, pure colour, and an exquisitely scrupulous technique.' These words are to be found in the introduction to the catalogue of the exhibition of Sienese Trecento and Quattrocento painting (and 'minor arts') organised by the Burlington Fine Arts Club, until now the last London show to be devoted to Siena. The 1904 exhibition was a success, but also curiously marks the beginning of the subsequent decline in interest. The Medievalism of nineteenth-century taste, particularly marked in the Sienese acquisitions made by British collectors, caused their critical downfall. The innovative features of Sienese art were fatally downplayed, and comparisons with a 'progressive' Renaissance Florence now reflected badly on Quattrocento Siena. The reviews of the 1904 show were lukewarm, partly because Langton Douglas was unpopular with the artistic establishment after his feud with Bernard Berenson, the admired American art historian. Berenson himself was dedicated to the Sienese Renaissance; it is not surprising that many of pictures lent to the 1904 exhibition have since crossed the Atlantic.

Since then (with the notable exception of John Pope-Hennessy), the appreciation of later Sienese painting and sculpture has been rarer in Britain. Ironically, just as twentieth-century art was no longer purely naturalistic, these qualities came to be most revered in Italian Renaissance painting and sculpture. I believe that this exhibition will herald a new appreciation of that special combination of Medieval spirituality and Renaissance rationalism that makes Sienese art of this time so remarkable.

I am delighted to acknowledge the munificent support of our sponsors, the Banca Monte dei Paschi di Siena – no sponsor could be more appropriate. I thank The Getty Foundation and The Harvard University Center for Italian Renaissance Studies at Villa I Tatti for supporting the research for this exhibition. We acknowledge the assistance of the Government Indemnity Scheme, which is provided by DCMS and administered by MLA. I am immensely grateful to the many museums and individuals who have lent their precious works. Their incredible generosity allows us to present such a rich and varied display. I am indebted to them all, but must thank in particular the people and institutions of Siena for allowing their treasures to travel, some leaving Italy for the very first time.

MARTIN WYLD
ACTING DIRECTOR, THE NATIONAL
GALLERY, LONDON

ACKNOWLEDGEMENTS

The research for this project would not have been possible without grants from The Getty Foundation and The Harvard University Center for Italian Renaissance Studies at Villa I Tatti, which enabled me to work in Italy for six months in 2006 as Craig Hugh Smyth Visiting Fellow. In addition, the Lila Acheson – Wallace Reader's Digest Publications Subsidy at Villa I Tatti made an invaluable contribution towards the costs of the catalogue's illustrations. Jonathan and Ute Kagan and Mitchell Levine have generously covered the costs of bringing Neroccio de' Landi's sculpture, *Saint Catherine of Siena*, to London.

I would like to thank all those colleagues in Siena whose collaboration has made this exhibition possible. Lucia Fornari Schianchi, Anna Maria Guiducci and Carla Zarrilli, in particular, have been constantly supportive from the outset. My esteemed co-authors, Alessandro Angelini, Hugo Chapman, Gabriele Fattorini, Philippa Jackson, Fabrizio Nevola and Carol Plazzotta, have all made working on this exhibition and catalogue a particular pleasure. My time at Villa I Tatti was enriched by the companionship and endless patience of Joseph Connors and his extraordinary colleagues; I am most grateful to Michael Rocke, Fiorella Superbi Gioffredi, Eve Borsook, Andrea Laini, Alexa Mason, Giovanni Pagliarulo, Angela Dressen, Nelda Ferace, Alessandro Focosi, Gennaro Giustino and many others. Fellows and visiting professors at I Tatti during this period were also tremendous, and though naming names is invidious, I would like to single out Alison Frazier, John Gagné, Julian Gardner, Christa Gardner von Teuffel, Sara Galletti, Marco Gentile, Nerida Newbigin, Louis Waldman and Stefanie Walker.

At the National Gallery, I have been touched by the commitment which colleagues in all the many departments involved have brought to the project. I particularly thank Simona Di Nepi and Jennifer Sliwka.

My fellow authors and I are very grateful to a vast community of experts for their generous provision of ideas and information in a great range of fields, for reading drafts, for assisting with loans and access to works of art, for allowing us to try out our theories and for their hospitality and friendship: Karl Abeyasekera, Cristina Acidini, Marta Ajmar, Cecilia Alessi, Denise Allen, Philip Attwood, László Baán, Alessandro Bagnoli, Roberto Bartalini, Andrea Bayer, David Beevers, Luciano Bellosi, Roberto Bellucci, Samuel Bibby, Monica Bietti, Laura Bonelli, Xanthe Brooke, David Alan Brown, Moreno Bucci, Duncan Bull, Marilena Caciorgna, Francesco Caglioti, Marietta Cambareri, Stephen Campbell, Pasquale Cappelli, Donatella Capresi, Doris Carl, Alessandro Cecchi, David Chambers, Gioachino Chiarini, Giuseppe Chironi, Carol Christensen, Keith Christiansen, Nicola Christie, Mauro Civai, Georgia Clarke, Frank Dabell, Andrea De Marchi, Andrea G. De Marchi, June de Phillips, Andria Derstine, Andrea Di Lorenzo, Jonathan Doria Pamphilj, James Draper, Rhoda Eitel-Porter, Caroline Elam, Sjarel Ex, Everett Fahy, Marzia Faietti, Miguel Falomir, Larry Feinberg, Lorenzo Fondelli, Antonia Ida Fontana, Burton Fredericksen, Cecilia Frosinini, Dominique Fuchs, Vittoria Garibaldi, Adelheit Gealt, Charlotte Gere, Eric Gordon, Luigi Grassi, Antony Griffiths, Roberto Guerrini, Morten Steen Hansen, Andreas Henning, Tom Henry, Gretchen Hirschauer, Jeannie Hobhouse, Sabine Hofmann, Charles Hope, Charlotte Hubbard, Frederick Ilchman, Machtelt Israëls, Tom and Paula Jackson, Laurence Kanter, Daniela Lamberini, Karen Lamberti, Friso Lammertse, Mark Leonard, Fabio Lensini, Reino Liefkes, Kristen Lippincott, Wolfgang Loseries, Cynthia Luk, Elizabeth McGrath, Federica Manoli, Peta Motture, John Murdoch, Mauro Mussolin, Jonathan Nelson, Larry Nichols, Christina Neilson, Charles Noble, Gianna Nunziati, Maureen O'Brien, Milena Pagni, Pia Palladino, Ludwin Paardekooper, Nicholas Penny, Graham Pollard, Guido Rebecchini, Charles Robertson, Patricia Rubin, Francis Russell, Paul Ryan, Dora Sallay, Bernardina Sani, Heinrich Schulze-Altcappenberg, David Scrase, Karen Serres, George Shackelford, Guillermo Solana, Amie Somerset, Paul Spencer-Longhurst, Tracy Sisson, Joaneath Spicer, David Steel, Andreas Stolzenburg, Frances Stonor Saunders, Carl Strehlke, Beatrice Paolozzi Strozzi, Yvonne Szafran, Angelo Tartuferi, Vilmos Tátrai, Jacqueline Thalmann, Dora Thornton, Simon Thurley, Enrico Toti, Patrizia Turrini, Serena Urry, Maria Grazia Vaccari, Claire Van Cleave, Axel Vecsy, Rebecca Wallace, Giles Waterfield, Stefan Weppelmann, Catherine Whistler, Patricia Whitesides, Paul Williamson, Christopher Woodroofe, Moritz Woelk, Helmut and Alice Wohl, Alison Wright and Annalisa Zanni.

Finally, I must thank my wonderful family: Lucy, Nick, Lydia, Antonia, Martin, Phoebe, Adam, Rufus and Solomon. I hope it is appropriate here to remember my father, John Syson and grandfather, Jack Gaster who were respectively responsible for introducing me to the worlds of art and politics.

LS

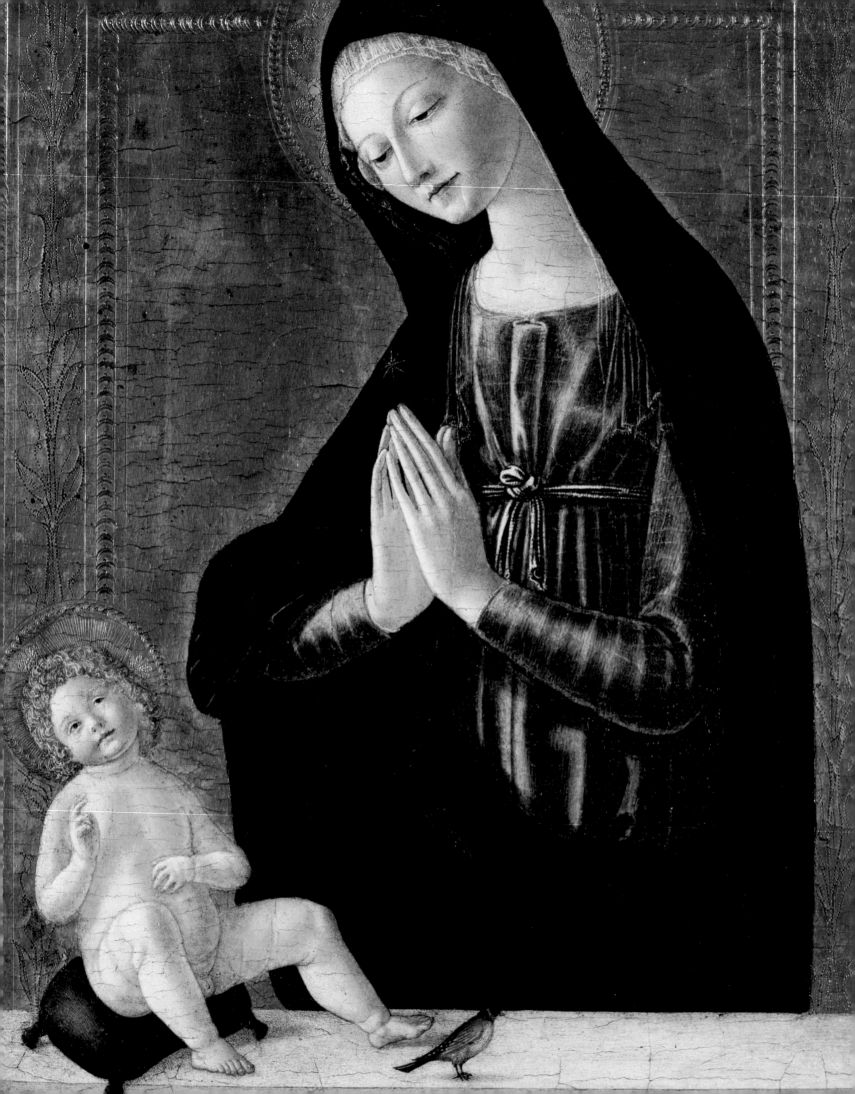

RENAISSANCE SIENA: ART FOR A CITY

LUKE SYSON

Ancient Siena, called city of the life-giving Virgin
Light, honour and lustre of all Italy:
Yours is the precious gift of innate liberty,
And yours is continuing and unceasing peace.
You excel by your zeal for virtue; glory and renown
Make you illustrious; you are above all others in talent.
You have great abundance in grain and wine,
Nor do you lack splendour and a plenitude of riches.
How shall I be silent about your beautiful women, famous throughout the world?
Who can count the number of your airy towers?
Live a long, happy life, and may all things be favourable for you!
I pray that you be happy, venerable city of the life-giving Virgin.[1]

Fig. 4
Detail of cat. 12

This ceremonial motet was perhaps first performed during the traditional celebrations for the feast of the Assumption of the Virgin on 15 August 1484. Its few lines provide an almost comprehensive litany of Sienese civic pride, starting with abstract ideals – peace, liberty and zeal for virtue – and linking them with more tangible features of the city. The dedication of the city to the Virgin Mary, worshipped as the safeguard of the republic and its political independence, is stated at the beginning and end, bracketing the rest as if under her protective cloak. Siena's politics and religion were indivisible; liberty was seen to result directly from piety. The city's wealth, splendour and antiquity, the loveliness of its women and its architectural beauty are all stressed. These were all recurrent themes in the image Siena wished to project of itself – to its own citizens and to the rest of Italy. The motet also signals a special satisfaction in the talent – *ingenium* – of its people. 'Men of skill always increase the honour of republics', a group of Sienese citizens

declared in 1531.[2] These strands were nowhere better united than in the art of the city: its architecture, but also its paintings and sculptures, drawings, manuscripts and ceramics all proclaimed the identity of Siena by their imagery, their often expensive materials, their craft and style and, increasingly, by the innate talents of their makers, serving a 'civic muse'.

In many ways, investigating these various strands is like trying to navigate Siena's complicated medieval city-plan – organic and not always logical, simultaneously divided into its constituent parts and tightly interconnected. This is not a history that can be told by sticking rigidly to a time-line, though chronology is often important, or by creating neat divisions between the various cultural forces that shaped the city's artistic output. Different streets, like different themes, can suddenly intersect, crossing, merging or opening out, while others run in parallel. Siena was (and to some extent remains) a hilly maze of a city encircled by strong defensive walls, but it

also controlled large territories in southern Tuscany. Important roads ran through its centre, leading to Rome and out to the other city-states that surrounded and sometimes menaced it. Siena could often be startlingly inward-looking, insisting on its own particular history and tradition, and sometimes paralysed by internal division. It could not, however, be wholly unaware of its place within the larger Italy, not least because its power and influence were rather less than those of Florence or Naples, Venice or Milan. The mercantile and banking interests of many Sienese citizens could be served only by establishing contacts and operational bases in other cities. Its scholars taught in universities throughout the peninsula. The religious orders had networks of their own. Even its artists moved around more than is often supposed. During the several periods of internecine struggle in Siena members of the losing side could often find themselves exiled in another city. Moreover, the victorious factions were usually dependent on the external support of another state. Indeed, Siena was regularly exploited as the political tool and victim of wider, pan-Italian power struggles. Alfonso V of Aragon, King of Naples, is said to have declared that the Sienese were 'like the inhabitants of the middle floor of a shaky house, tormented by the piss of their upstairs neighbours and smoked out by the people below'.[3]

Historians and art historians have concentrated principally on the period regarded as Siena's Golden Age, the late thirteenth century and the first half of the fourteenth. These were the years of 'Good Government' before the Black Death, when Siena's economic power was the equal of any in Europe, and when Duccio di Buoninsegna, Simone Martini and the brothers Pietro and Ambrogio Lorenzetti were among the most sought-after painters in Italy. This was also the time when many of the ingredients of the civic ideology of Siena were established and enshrined. Thus the culture and indeed the art of late Duecento and early Trecento Siena remained key points of reference there in the two centuries following.[4] The later Quattrocento and especially the early Cinquecento are less studied. These decades around 1500 were scarred by substantial political upheaval, when devotion to a glorious past was both tested and, at certain moments of crisis, strengthened. On the one hand, political uncertainties might be effectively countered by the certainty of tradition. On the other, new political beginnings could be marked by the rejection, usually partial rather than complete, of collective memory.

This survey starts around 1458, the time of the coronation of the Sienese pope Pius II Piccolomini, just after one of Siena's main factions had unsuccessfully attempted to take control of the city's government. It closes in about 1530, with the arrival in Siena of the Spanish troops of the Habsburg emperor Charles V, when the state was reconverted into something close to an imperial fief, marking the beginning of the end of the independent republic. The years between had been tumultuous. From 1497 to 1512 Pandolfo Petrucci – the Magnificent – had established himself as the city's leading citizen and effective ruler. His triumph had come after another period of fierce infighting. Pandolfo has often been understood as a kind of tyrant (therefore neglected by historians, since tyranny is generally less attractive to the democratic twentieth century than the functioning of a republic) and his time in power can be seen as representing a break with the past, just as Pius's pontificate had been. These changes are reflected in their artistic commissions and in those of their closest allies. But Pandolfo's role was actually not clearly defined and, even if he entertained lordly ambitions, his impact was felt within the context of a republican structure and dogma. His success in fact derived from the sophistication of his political balancing acts – both on the domestic front and in his foreign policy. Pius, too, had wielded political influence in Siena only by working with its government. With their deaths, tradition might reassert itself and, during their lifetimes, it might even be seen as oppositional, linked with the preservation of a *status quo* and ebbing and flowing according to circumstance. It is clear, for example, that after the collapse in 1525 of the regime established by Pandolfo and continued by his successors, the briefly revivified republic once again looked back to an ever more mythic republican past.

Against this background, certain key themes emerge. In particular, the exhibition asks how the unifying motifs adumbrated in the ceremonial motet functioned in a city that was riven for long periods by an ingrained, institutionalised factionalism, in which regime change was endemic. It becomes apparent that the city was fused to some extent by a common civic ideology and by the religion that underpinned it. This credo was quite deliberately extended into the territories controlled by Siena, the *contado*. City unity was promoted by the religious orders, especially the Franciscans

Fig. 5
Francesco di Giorgio Martini (1439–1501)
The Coronation of the Virgin, 1472–4
Tempera on panel, 337 × 200 cm
(with original frame)
Pinacoteca Nazionale, Siena (440)

and Dominicans; dominant factors were the call for penitence by the movements for Christian reform, and the dissemination of this message among the laity through membership of confraternities. The art produced to encourage lay piety had a calculated uniformity that expressed the desire for a communality of belief. However, for all the rhetoric of unity, factionalism was rife, and might be thrown into relief particularly by political crisis. The art produced for families and individuals, including some religious art, allowed for ingeniously varied approaches that could reflect their own distinct loyalties and beliefs. A single Sienese citizen might wish, and was perfectly able, to proclaim a range of distinct but overlapping identities. The same man might be at once the pious member of a confraternity, a political animal working for himself, his faction or the state, a good family man, a merchant, banker or scholar. Which aspect of his 'personality' he chose to bring to the fore at any one time could also change in line with shifts in the political and religious landscape. And these multiple identities were declared not least through the different kinds of art he owned and commissioned.

The art of Siena is particularly suited to an analysis of the effects that political and religious values, their continuity and instability, may have had on artistic styles – of the way the links between art, politics and religion were played out. Given the many factors in play, the structures of an exhibition and its catalogue – intrinsically the sum of their parts – provide perhaps the best method for comprehending this tangled mesh of topics. The desire is to present a cumulative picture instead of a (misleadingly

disentangled) linear argument; this is deliberately a mosaic, an album of snapshots, rather than a sequential narrative. Detailed accounts of the separate exhibits encourage the recognition of a whole range of connective threads, and the exhibition is so organised that visitors may follow certain main routes through a period of time while simultaneously encountering images and information that permit alternative associations.

This kind of scrutiny is especially rewarding when the works concerned are as brilliant as those by Francesco di Giorgio (fig. 5) or Domenico Beccafumi, as delicately beautiful as Neroccio de' Landi's, and as emotionally vigorous as Matteo di Giovanni's. But the variations within the œuvre of each artist demonstrate that a Sienese painter or sculptor, as well as his clients, might adopt a chameleon persona. Artists also worked within communities. Some were seemingly immured within the world of religion. A few were directly involved in the city's politics. The greatest of all Quattrocento artists in Siena, Francesco di Giorgio, had strong ties to one of the factions, returning to the city after periods working elsewhere at those times when his party was in the ascendant, serving in government positions and as the city's representative abroad. The career of the painter Benvenuto di Giovanni, by contrast, is said to have been plunged into crisis because he was a supporter of another faction, on the losing side.[5] Most painters and sculptors, however, were employed by a wide range of patrons, both corporate and individual. As well as working alone, they also might pool their resources, financial and artistic, forming companies

or joining up to undertake particular projects. Consequently, their stylistic decisions were determined not just by personal whim or capacity; instead they had to consider the nature of each commission, the precise intentions and allegiances of their patrons, and the messages the work of art was intended to convey. Painters and sculptors might therefore feel the need to adapt and even alter their styles to suit particular projects. Flexibility was crucial, and helps to explain the special success in Siena of artists like Vecchietta and his pupil Francesco di Giorgio, who could perform with equal ease as sculptors in bronze, wood and marble, as painters of panels, frescoes and manuscript illuminations and, in Francesco di Giorgio's case, as an architect and engineer.

These possibilities mean that, in assessing the œuvres of different painters and sculptors, it is not feasible to use only models of individual stylistic development. Certainly, an artist might modify his approach to particular aspects of his style and technique – his modelling of flesh, his ideal of female beauty, his concept of landscape or architecture – but these changes cannot always be straightforwardly explained as matters of personal taste. The difficulties with such an approach are exemplified above all by the myriad shifts of emphasis within the career of Francesco di Giorgio, the precise authorship and dating of whose works have long proved tricky. With only one exception, therefore, this exhibition is not divided into collections of works by the artists included. Even in the last section, devoted to Domenico Beccafumi, the selection is designed to show how he was called upon to paint pictures of a kind that were central to the Sienese tradition, and that he was

stylistically indebted as much to earlier masters as to his Florentine and Roman contemporaries.

Thus much of this catalogue is concerned with the stylistic choices of both artists and patrons working in conjunction. This was a period when many commissions were realised using an entirely 'Renaissance' vocabulary – art that looked to ancient Rome and modern Florence, full of references to the Antique, concerned with the rational description of things seen and experienced. It is certainly true that Siena enjoyed a Renaissance.[6] But at the same time, even into the sixteenth century, Sienese art could remain 'Gothic'. This is a word that is not easily applied to figurative painting or sculpture (as opposed to architecture or metalwork), but it has become a useful shorthand for an irrational, highly imaginative, spiritual and visionary art. Even when taking account of fashionable Renaissance trends, Sienese painters and sculptors still produced works that might be delightfully ethereal, sometimes containing expressive distortions of the real.[7] Such works are characterised by extraordinary spaces, by the continued use of sinuous, meandering line and of gilding, the gold worked with an almost infinite variety – all qualities associated with the Middle Ages. The art of Siena has therefore sometimes been treated as odd or eccentric, more often as backward-looking and *retardataire*.[8] Its art was certainly different from that of Florence (or for that matter anywhere else in Italy). This difference, since it was founded in part upon a devotion to the medieval values of Simone Martini rather than those of the Florentine Renaissance pioneer, Giotto, has resulted in critical

Renaissance Siena: Art for a City

distrust, embarrassment and neglect. The degree to which Sienese painting and sculpture have been treated as peripheral is evident in many general surveys of Renaissance art, full of information on Florence or Venice but including just a few scattered paragraphs devoted to Siena.[9] Adherence to tradition has been viewed as symptomatic of a city in decline. Since the myth of decline is persistent, it is important to state at the outset that, while it is true that political unrest may at times have played a part in the visual celebration of a famous past, Siena was not in social or economic freefall – far from it. While not as rich as neighbouring Florence, Siena actually benefited from a gradual economic upturn in this period.[10]

We are only just beginning to escape these attitudes, so entrenched through much of the twentieth century. Scholars have begun to realise that there was not one but several Italian Renaissances, even within a single city. In Siena, by the combination of the worldly and the otherworldly, the image of the city could be made both real and ideal, a city of men and the Virgin.[11]

1 D'Accone 1997, pp. 243–4, 246.

2 'Li Homini virtuosi esser quegli che acrescano sempre honore e fama alle republiche', Borghesi and Banchi 1898, p. 453; Hook 1979, p. 106.

3 M. Ascheri, 'Siena nel Quattrocento: una riconsiderazione' in Christiansen, Kanter and Strehlke 1989 (Italian edition), p. xxxviii.

4 In Italian, centuries are calculated by their hundreds: the Duecento is the thirteenth century, the Trecento the fourteenth and so on. See Beccadelli (Panormita) 1538, p. 113.

5 Information (source unknown) from Romagnoli Ante 1835, folio 153, 160, cited in Bandera 1999, p. 8.

6 The period is brilliantly explored from this point of view by G. Agosti, 'Su Siena nell' Italia artistica del secondo Quattrocento (desiderata scherzi cartoline)' in Bellosi 1993, pp. 488–509.

7 That an artist like Sandro Botticelli did the same in Florence should not be forgotten, though the 'oddnesses' of Botticelli's late painting are likewise explained by Vasari and many critics after him as resulting from doddering decline.

8 See, for example, the popular historian Ferdinand Schevill, writing in fine fettle at the beginning of the twentieth century on Sano di Pietro, Matteo di Giovanni and Neroccio de' Landi: 'These fifteenth-century masters, shut off from the fresh currents of thought and taking their pleasure in endlessly refining upon the old methods and the old sentiments, had necessarily to pay for their self-satisfaction with the loss of virility. They constitute an Indian summer, shedding a faint fragrance which, if sweet, suggests decay and a near end. All these belated mediaevalists, and more particularly Matteo di Giovanni and Neroccio, were endowed with great natural gifts and did not adopt their conservative creed purely from pride or ignorance. They knew perfectly well what was going on in Florence … going so far as to import occasionally a trait of one or other

Florentine into their work; but from every excursion beyond the circle of their town they returned with spontaneous resolution to the tradition of their predecessors … their attitude is the proof of a confirmed provincialism. Duccio and his followers, marching onward with the breath of the morning upon them, carried Siena into the van of Tuscan civilisation; Sano, Neroccio, and Matteo were content to have her sit remote among her hills, spinning reminiscences like an ancient pensioner.' Schevill 1909, pp. 329–30.

9 This situation is not helped by art historians' continued reliance on the writings of the sixteenth-century painter and pioneer of art history, Giorgio Vasari, based, of course, in Florence. For Vasari 'Gothic' was a dirty word. Two editions of his *Lives of the Painters, Sculptors and Architects* were published on either side of Florence's conquest of Siena in 1555 to create the Grand Duchy of Tuscany, at a time, therefore, when Florentine and Tuscan art were to be perceived as synonymous. Sienese artists did not fit easily into his progressive paradigm, running from Giotto to Masaccio to Michelangelo. He included brief lives of Vecchietta and Francesco di Giorgio, who could be seen as satisfying Florentine precepts for artists by their mastery of *disegno*. He approved of the leading sixteenth-century artists, Domenico Beccafumi and the painter turned architect Baldassare Peruzzi, emphasising their modernity. He treated Sodoma with distaste. There are no other lives of the Sienese painters who flourished in this period, a neglect that has caused an artist like the talented Pietro Orioli to have been almost completely forgotten until very recently.

10 Hicks 1986, pp. 9–42.

11 I borrow the phrase from C. Alessi, '"… Per onore, prosperità e accrescimento de la città e de' cittadini di Siena …". Siena della pittura: città reale o ideale' in Santi and Strinati 2005, pp. 30–45.

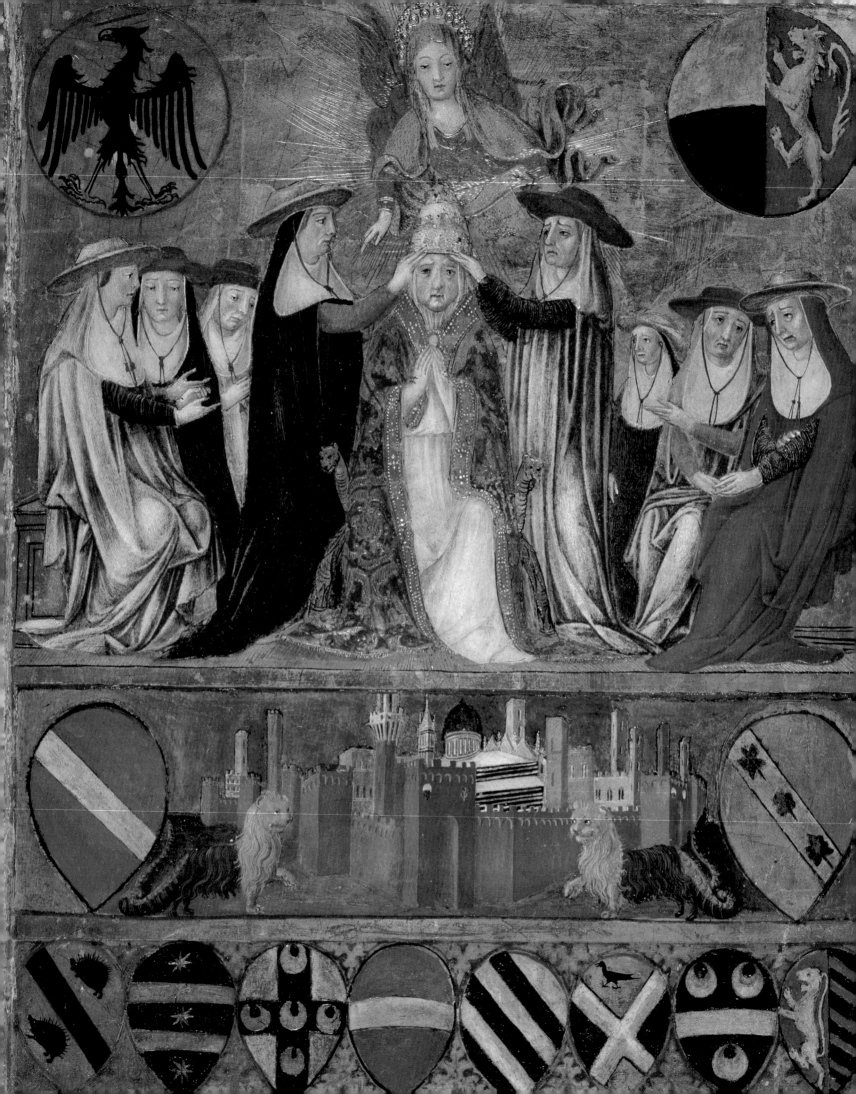

CIVIC IDENTITY AND PRIVATE PATRONS IN RENAISSANCE SIENA

FABRIZIO NEVOLA

One of the most magnificent of Siena's unique Biccherna panels (book covers commissioned annually by the tax office), shows the papal coronation of Pius II Piccolomini (cat. 2).[1] More exactly, instead of portraying the ceremony that took place in Rome on 3 September 1458, the panel shows a parallel event that took place in Siena on the same day: in an elaborate theatrical display, the papal coronation was acted out on the city's central square, in front of the Palazzo Pubblico on the piazza del Campo, using a crane to lower the Virgin Mary to place the papal tiara on to the head of a priest standing in for the pope. The artist recorded for posterity this equivalent of a modern live relay broadcast, encoding the papal coronation with details that were significantly Sienese.

Thirty-seven years later, in January 1495, an ambassador from the Holy Roman Emperor Maximilian I, arriving in Siena, noted with surprise that the city and outlying territories (the *contado*) were decorated with the coats of arms of Charles VIII, King of France. Siena, after all, was traditionally Ghibelline (allied with the Holy Roman Empire). The Sienese chronicler Allegretto Allegretti reports that the city's rulers responded rather casually that 'it was our custom on the visit of some lord to do them honour, and affix their arms about the city, usually of the sort that can be put up and taken down again, like those of the king of France'.[2] Presumably, the suggestion was that the arms of the French crown would soon be taken down and new ones honouring the Emperor would go up in their place.

This minor incident, like the recreation of the papal coronation, reveals much about the Sienese stance towards the outside world, and the confidence with which government authorities used visual symbols to alter the urban environment.[3] The city offered a façade to visitors that was carefully controlled by legislative measures, architectural interventions and artistic commissions that combined to present an ideal vision of the polity, much as it had been expressed in the mid-fourteenth century by Ambrogio Lorenzetti on the walls of the Sala della Pace in the Palazzo Pubblico. As the chronicler noted, on ceremonial occasions when particular viewers were expected – kings, emperors or popes – temporary corrections could be made to that urban image which would bind host and visitor together, much as the processional route would connect the crowds of spectators to the cavalcades of visiting potentates. Coats of arms and other ephemeral decorations were drawn or painted on wooden boards, or even on paper, and would be affixed on buildings along processional routes, while other more elaborate displays such as triumphal arches would create explicit connections between Siena and the guest of the occasion.

In 1460, when Siena had been host to a long stay by Pope Pius II Piccolomini and fifteen of his cardinals, the papal arms had been affixed throughout the city centre, and marble plaques displaying those arms can still be seen in numerous locations.[4] At this time the use of triumphal arches (in his memoirs the pope was keen to make the link to antique precedent) along a processional route appears to have been limited to arches made of vegetation (laurel, oak and other plants). Three decades later, when Charles VIII visited Siena on 2 December 1494, three more elaborate arches had been erected

Fig. 6
Detail of cat. 2

along the route to the Archbishop's palace, where he would stay.[5] The Venetian diarist and diplomat Marin Sanudo was present and recorded that an arch was erected in front of the northern entrance to the city at Porta Camollia, bearing the inscription *Sena Vetus Civitas Virginis*, which evoked the Virgin Mary's age-old protection of Siena.[6] Another arch was adorned with the suckling she-wolf that bound Siena to the foundation legend of Rome – the ultimate destination of most travellers through Siena; the third paid respect to Charles as a new Christian king, likening him to his namesake Charlemagne.[7] A final twist was added by a chorus outside the king's residence, which sang of Siena's alleged foundation by 'Senoni' Gauls, one of the more peculiar legends of the city developed during the fifteenth century, which conveniently, for this occasion, suggested a shared heritage with the visitors.[8] The French king was thus presented with a synthetic narrative that revealed Siena's high-placed celestial patron, impeccable classical heritage and even a tradition within which to set diplomatic connections with France.

Siena's dedication to the Virgin Mary had originated in its citizens' vow on the eve of their victory against the Florentine army at Montaperti on 4 September 1260, and its adoption of the she-wolf was justified by its legendary founding by Senius and Ascius, sons to Remus and nephews to Romulus.[9] Images of the Virgin Mary adorned the city gates, announcing the city's divine protection and binding relationship with the Virgin. At the Porta Camollia, for example, Simone Martini had started an image of the Assumption that seems immediately to have acquired a status that warranted its wide-

spread imitation in commissions inside the city walls and throughout the *contado*.[10] Matteo di Giovanni also turned to Simone's prototype when formulating his 1474 *Assumption* now in the National Gallery (cat. 17).[11] She-wolves, too, adorned the major city gates, and, as sculptures displayed upon classicising columns, could be found, like the street-side shrines to the Virgin, along the main route that wound through the city. These recognisable images combined with civic heraldry to project a coherent urban identity on to the public stage of streets and open spaces.

Until the late fifteenth century, this identity was inextricably linked with the republican government of the city and state – the Comune – whose proud residence was at the heart of the civic showcase, the piazza del Campo (fig. 7). The narrow alleys that give access to this remarkably theatrical space – shell-like in plan, enclosed by high brick façades – increase to this day its visual impact. The Campo slopes and converges towards the elegant Palazzo Pubblico, filling the low ground of the arena, which, like a classical *scaenae frons*, is encrusted with decorative detail, all of it conveying information: she-wolves thrust forward from the highest points of the tower, the Torre del Mangia, while the local patron saint Ansanus stands above the entrance doorway flanked again by nursing wolves, coats of arms (the black and white *balzana*) of the Comune are framed in the Gothic arches of portals and windows, while the Virgin Mary has pride of place in the chapel that consecrates the entire piazza as a devotional space, the Cappella di Piazza. This notion was metaphorically extended in the iconographic type of the Madonna

of Mercy, whose protective cloak covering the community evokes an inevitable parallel with the enclosing form of the Campo.[12] The Campo was an ideal setting for ceremonial events, from the sermon cycles delivered by Saint Bernardino in 1425 and 1427 to the banquet arranged for the Emperor Frederick III and Princess Eleanora of Portugal in February 1452.[13]

State banquets were indeed extremely theatrical affairs, to judge from Allegretto's report of the visit of the Duke of Milan's daughter Ippolita Maria Sforza on 29 June 1467, when she came through Siena with a cavalcade of around 1000 people and 150 mules carrying her dowry and possessions on the way to her wedding in Naples to Alfonso, Duke of Calabria.[14] A stage was set up in front of the Palazzo Pubblico and 'all the pretty and well-born girls in Siena' were invited to a ball, at which a theatrical display (*apparato*) had also been arranged, involving a golden she-wolf from which there came out a troop of dancing girls (a *moresca*) who sang a song about not wanting to be nuns, presumably to enjoin the pleasures of marriage to Ippolita. Allegretto's concluding remarks, which are corroborated by the financial accounts, suggest that the whole proceedings were inordinately costly and wasteful, 'and there was more thrown away than was actually eaten'.[15] Just six years later, another banquet was held when a wedding procession wound its way in the opposite direction, that of Eleonora of Aragon, daughter of King Ferrante of Naples, towards her groom Duke Ercole d'Este in Ferrara.[16] On this occasion, which commanded a cavalcade estimated at 1500 people, the banquet was held in front of Palazzo Pecci, near the Cathedral, and the

Fig. 7
Piazza del Campo, Siena

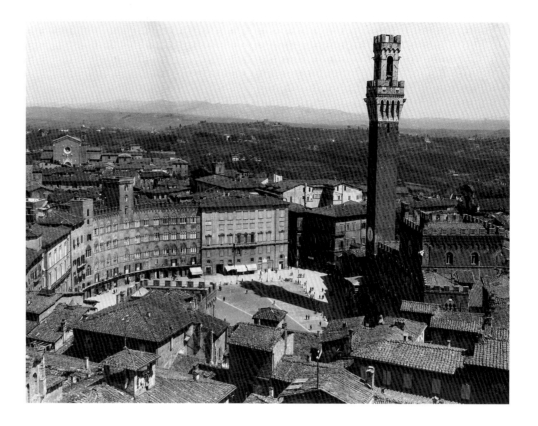

main feature of the display was a fountain running with wine and water from the mouths of a lion and a she-wolf. Following the banquet, a ball was held in the open loggia of the Mercanzia, on the most central crossroad in the city.

Religious events staged on the piazza del Campo were no less theatrical. Domenico Beccafumi's painting of Saint Bernardino preaching (cat. 96) refers back to an eye-witness view of the event by Sano di Pietro (fig. 8), in which ephemeral improvements to the permanent architecture can be observed in the dais erected for the civic officials in front of the palace and the wooden pulpit for the saint. Sano's image also documents now-lost details such as the Porta del Sale, an ostentatious coal-scuttle on the front of the palace that advertised the city's salt monopoly, as the valuable commodity was stored in the cellar beneath the palace.

Not only the Campo but also the Baptistery square and the piazza del Duomo, bounded to the north by the Cathedral and to the south by the Hospital of Santa Maria della Scala, the state hospital, were civic sites where visual information was directed

towards the creation of a clearly legible and unified identity. By the fifteenth century, Siena's *imago civitatis* (cat. 1–3), which bound the foundation narrative to the physical monumentality of the principal public buildings and the inclusive force of the city's protective ring of high brick walls, was well established. Thus, following the dramatic return to power in Siena of the *Noveschi* on 22 July 1487 – the feast day of Saint Mary Magdalene – devotion to the Magdalen increased, and her image came to be represented in a number of public commissions reflecting the new government's influence and control of major civic institutions.[17]

Devotion to saints, however, depending on their nature and role, was a reflection not only of the city as a whole but also, in all their variety, of the diverse communities of which the urban polity was made up: saints served almost as banners around which particular groups gathered, not always for pious purposes alone.[18] At one level, the division of the city into subsets connected to specific saints can be seen as an extension of the central core of Siena's patron saints who joined the Virgin Mary

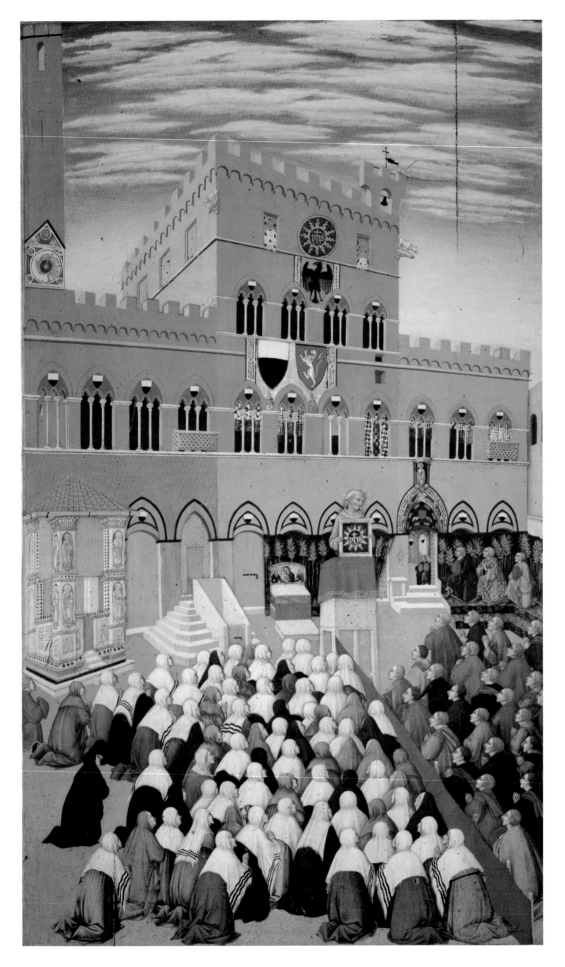

Fig. 8
Sano di Pietro (1405–1481)
Saint Bernardino preaching on the Campo, 1448
Tempera on panel
163 × 102 cm
Museo dell'Opera del Duomo, Siena (3506)

as the privileged intercessors, visible in the foreground of Duccio's *Maestà* (fig. 29, p. 58) – Ansanus, Savinus, Crescentius and Victor. This is particularly the case for the two major new Sienese saints of the fifteenth century, the Franciscan preacher Bernardino Albizzeschi and the tertiary Dominican Caterina Benincasa (Catherine). While Bernardino was canonised shortly after his death in 1444, Catherine was canonised in 1461 by Pope Pius II and immediately raised to the status of a civic patron by the Sienese authorities, who thus also ensured a balance between the Dominican and Franciscan orders.[19]

Interestingly, Catherine came from one of the city's most working-class neighbourhoods, the low-lying valley of Fontebranda, which was the heart of the leather tanning and wool industries as well as the city abattoir. Its residents were active proponents of the construction of a church dedicated to her, even before the canonisation had gone through, and appealed to the central government for subsidies for the Oratorio di Santa Caterina, which was, from its inception, a focus of local pride as well as city-wide devotion.[20] The site for the shrine, which was established in and around Catherine's own house – sanctifying the place as well as the person – was bought by the city government, while the building was largely paid for by the Fontebranda community but constructed by the *Opera del Duomo*, the Cathedral office of works. The simple church was one of the earliest religious buildings in Siena to be given a markedly *all'antica* look (a style based on Antique models): the façade is framed by classicising fluted pilasters and the portal supports an elaborately decorated frieze

and pediment. On this the arms of the partnership that had funded the construction were displayed, the Comune and the parish, which was already identified by the emblem of an *oca* (goose).[21]

Individual parishes frequently promoted such architectural projects of local interest, for which they sought additional government support. Petitions for funding appealed to general civic pride and might offer, as a return on the investment, display of Comune symbols. For example, the residents of the southern district of Abbadia Nuova di Sotto pledged to erect a gilded she-wolf adjacent to a public fountain constructed in 1466.[22] Again, in 1512, the 'district and people – both great and small – of [the street of] Vallerozzi' petitioned the city government for wax donations to be made to the church of San Rocco; the church had been under construction since May 1511, when 'for the glory and honour above all of the very glorious Saint Roch, then for all your Republic, with your help and with many devout people they set about building a church in his honour in Vallerozzi'.[23] Neither a district nor a parish, the new church of San Rocco in Vallerozzi was built and paid for by the residents of a street, who also used the church for the activities of the recently formed *contrada della lupa* (district of the she-wolf).[24] Again, civic endorsement was probably secured for this local project in return for the display of the black and white colours of the Comune and the emblem of the wolf. It would seem that the construction of a church, dedicated to a saint that did not have a wide following in Siena at the time, was also a bid to seek formal validation of local identity, which was thus able to break off from the parish of

San Pietro Ovile di Sopra, of which it had previously formed a part.[25]

A similar strategy was employed by the residents of the district of Salicotto, southeast of the piazza del Campo, who built a new church dedicated to James the Great and Christopher, titular saints of the anniversary on 25 July of Siena's 1526 victory over the Florentine army outside Porta Camollia. Here again, an event of city-wide significance provided the opportunity for a local resident group to affirm their own identity, fusing this with the devotional needs of the entire city; indeed the high altar was dedicated to the Immaculate Virgin Mary, whose miraculous intercession had ensured Siena's victory.[26] The Comune celebrated this same victory by rededicating the city to the Virgin Mary at the Cappella del Voto in the Cathedral, renewing a vow that had its origins in the ceremony that had preceded the victory of Montaperti in 1260; this is illustrated in Beccafumi's small panel from Chatsworth (cat. 94). This rededication ceremony – often involving the granting of the keys of the city gates to the Virgin – was repeated at critical moments in Siena's history and shows that the Commune relied on the practical support of the city's celestial queen.[27] Indeed, Beccafumi's image elaborates on a ritual event that is illustrated in chronicles as well as in the scene carefully observed in Pietro Orioli's *biccherna* cover of 1483 (see fig. 79, p. 304), which records two separate rededication ceremonies of March and August 1483.[28]

While the civic pantheon could be disassembled and used to represent the interests of particular constituents of the urban community, and topographically these divine intercessors were distributed in

21

churches and shrines throughout the city, so too the Renaissance city was further differentiated into devotional groups or confraternities that identified with particular saints. It is not easy to define in general terms the composition of such groups; they might be exclusively male or completely female, they might have very local memberships or draw their members from across the whole city, they might be associated with particular professions or political factions. Almost all, however, met regularly in architectural spaces of varying scale and grandeur.[29]

When the new oratory of San Sebastiano agli Umiliati was completed in 1514, a statute for its members was drawn up which succinctly explains the way in which its members viewed their devotional duties, in a standardised sequence of subsets that resembles the arrangement of Russian dolls: 'In the name of the most omnipotent God and of his glorious mother the holy Virgin Mary, and of the principal apostles Saints Peter and Paul, and of all the celestial court of paradise, and in particular of our patrons Saints Ansanus, Victor, Crescentius and Savinus, and of Saint Bernardino and Saint Catherine of Siena and of our own advocates and patrons, who are Saints Sebastian, Sigismund and Roch, who grant us favours and the spirit to do all those things that are good for our souls ….'[30] The rollcall unravels through the city's principal protectoress, Roman saints (of Catholic orthodoxy), the local pantheon and recent home-grown saints to close in on the specific intercessors of the confraternity group. A similar declension of religious affiliation is illustrated by Vecchietta's remarkable Arliquiera reliquary cupboard from the Hospital of Santa Maria della Scala – the doors depicting the saints whose intercessionary powers it contained – and characterised the dedication of religious spaces throughout the city.

Among Siena's many confraternities, that devoted to Saint Jerome is particularly interesting. Its brothers were especially devout, associating themselves with their patron in his aspect of penitent hermit rather than scholar. Further devotional allegiances, to Saints Francis and Bernardino of Siena, were added in the 1440s.[31] Abandoning their original meeting-place near Porta Camollia, the confraternity were able to secure prestigious rooms in the lower levels of the immense Hospital of Santa Maria della Scala from 1430. Interestingly, a number of painters and other artisans were brothers in the confraternity and there are instances during the fifteenth century of the involvement of artist brothers in improvements to their headquarters.[32] Surviving documents report the proceedings of the confraternity meetings, and reveal that on 23 July 1491 the painter Pietro Orioli argued in favour of permanent improvements to their oratory, which he said would be more effective and less expensive than the temporary decorations prepared annually for the feast of Saint Bernardino.[33] Orioli, who was particularly skilled in the production of illusionistic perspectival spaces in fresco and other media, appears to have co-ordinated a number of artisans in the creation of a fictive starry vault as well as gilded water stoups and other details; he was paid for the work in May 1496 but died – probably of the plague – in August 1497.[34] This first phase of renovations was followed in 1499 by a commission awarded to Girolamo di Benvenuto – the son of another brother in the confraternity, the painter Benvenuto di Giovanni – who executed a cycle of *grisaille* frescoes representing thirteen standing Old Testament Prophets framed by sophisticated *all'antica* pilasters.[35]

These two phases of renovation reveal the architectural complexity of the confraternity meeting-place, which was not limited to a chapel or oratory but appears to have been articulated in a succession of rooms, many of which were painted in fresco and furnished with altars, sculptures, furniture and liturgical objects kept in cupboards.[36] The spaces of the confraternity beneath the Hospital were accessed directly from the street, from a small square named chiasso di San Girolamo, and consisted, probably on two levels, of two rooms, two dormitories, a chapel, an oratory and a second chapel dedicated to Saint Bernardino.

In Siena, confraternity meeting-places tended to be less conspicuous than the buildings associated with most other religious groups, as their primarily devotional function and closed membership did not require projection of a public image, except in ritual events outside the headquarters such as processions in honour of a patron saint or the funeral *cortège* of one of their members.[37] The same cannot be said of private family chapels, which, as in most other cities in Italy, increased in monumentality and splendour during the Renaissance. An outstanding – though quite unusual – example is the small oratory of Santa Maria della Neve, on the city's central street, built for the Bishop of Pienza, Giovanni Cinughi in 1470 (fig. 9). This free-standing structure, with an elegant façade framed by classicising

Fig. 9
Façade of the Oratory of Santa Maria
della Neve in Siena

pilasters supporting an *all'antica* frieze and the Cinughi coat of arms, all in marble and grey *pietra serena*, enclosed a small family chapel with a single altar, adorned with Matteo di Giovanni's *Madonna of the Snows*, signed and dated 1477.[38] While the scale and design of the oratory resembled that of the locally sponsored projects for Santa Caterina in Fontebranda and San Rocco in Vallerozzi, discussed above, it in fact functioned in much the same way as a family chapel within a church, though rather more conspicuous for being isolated.

A growing demand for private chapels certainly accounts in part for the new building or enlargement of numerous churches. The major churches of all the religious orders were expanded during the period, although devastation by fire in the sixteenth and seventeenth centuries, and subsequent Baroque refurbishment, have altered most beyond recognition.[39] Thus, for example, the chapel of the Bichi family at Sant'Agostino was only rediscovered in 1977 following the removal of structures that had been introduced after a fire in 1747, covering frescoes by Francesco di Giorgio (fig. 49–50, p. 153) and Luca Signorelli.[40] Similarly, at San Francesco, it has only recently been realised that the chapel behind the high altar, belonging to the Piccolomini family, housed an elaborate classicising monument commissioned from Antonio Federighi by Pope Pius II as a tomb for his parents (see fig. 15–16, p. 33); surviving fragments of the marble monument were walled into the convent cloister after a destructive fire in 1655.[41]

At the church of San Domenico, a somewhat clearer picture of the patronage rights of the chapels emerges. Many of them were assigned in the second part of the fifteenth century, following expansion of the church around the transept.[42] In 1471, the prominent Sienese banker Ambrogio di Nanni Spannocchi secured rights over the monumental choir and '*cappella grande*' of the church for the huge sum of 700 florins, paid to the convent chapter (fig. 23, p. 48).[43] To this sum Spannocchi had to add the cost of refurbishing the chapel, which received new intarsia choir stalls in wood and

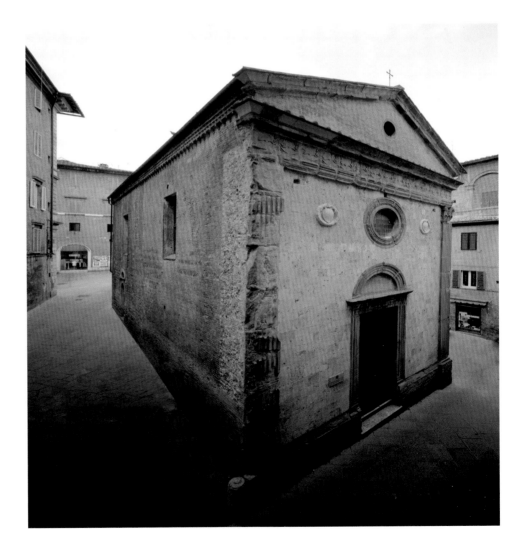

a marble tabernacle and water stoop produced by the Florentine sculptor Benedetto da Maiano and his workshop.[44] Benedetto's shop also produced for him a magnificent *all'antica* window in stone, arranged in two orders of arches framed by elegant fluted pilasters.[45] In fact, in taking over the high altar chapel, Spannocchi negotiated a swap with the Dominican chapter, which had previously ceded a side chapel to him for 100 florins; this chapel was

taken by the Placidi family, who commissioned both an altarpiece and a tomb slab.[46] The Placidi tomb survives in the last chapel of the north transept, the original site of Matteo di Giovanni's altarpiece, painted for the family in 1476 (see cat. 33–7).[47] Documents show that during the 1470s altarpieces were commissioned for their chapels by the Borghesi, Placidi and Benzi families, as well as by the 'German nation' in Siena and others (see fig. 53, p. 162). While many of these altarpieces have remained at San Domenico they are no longer to be found in their original positions; for example, the altarpiece the Borghesi family commissioned from Benvenuto di Giovanni (see cat. 32), which now shares a chapel with Matteo's Saint Barbara altarpiece, produced for the resident community of Germans – who were largely active in the textile industry – was originally to be found in the Borghesi's chapel at the end of the south transept.[48]

The difficulties in reconstructing the relationship between patrons, altars and works of art at San Domenico make it hard to draw conclusions regarding the network of families associated with the church. As in better-studied cases, such as the church of Santa Maria Novella in Florence, it is clear that chapel patrons came from all over the city, while the example of Ambrogio Spannocchi reveals the competition between wealthy patrons to secure the most prominent and central chapels.[49] That ties of alliance – political, social or professional – might be manifest in patronage choices at specific churches seems to emerge more clearly in the case of the Observant Dominican church of Santo Spirito ai Pispini, rebuilt from 1499.[50] Here, following

the decisive involvement of Pandolfo Petrucci, who assumed patronage rights over the crossing and choir, patronage of the side chapels appears to have fallen in a number of cases to close associates of his new regime.

While the collective functions of individuals' devotional patronage of chapels within Siena's churches may sometimes have recreated alliances and groupings that operated in the secular sphere, domestic buildings expressed much more clearly their patron's public standing.[51] Ambrogio Spannocchi was the owner of one of the most magnificent palaces built in Siena during the 1470s, the Palazzo Spannocchi (fig. 10), erected in a central location on the city's main street, the Strada Romana (1473–6).[52] The palace was connected visually to the chapel at San Domenico along the via della Sapienza, and was designed by Giuliano da Maiano, brother of Benedetto. The Maiano bothers had worked extensively in Naples – for the king, his son-in-law Antonio Piccolomini d'Aragona, Duke of Amalfi, and for various bankers – and it is probably there that they were contacted by Spannocchi for the Siena project. In fact, Ambrogio had been active for most of his career outside Siena, as a banker to the popes in Rome and the royal court of Naples, and his palace was consciously constructed in his home town as an expression of his immense fortune and cosmopolitan connections.

With the exception of one chronicler, who caustically criticised the employment of Florentine rather than Sienese builders, early comments and descriptions of Spannocchi's palace were directed to non-Sienese audiences. Another Sienese banker,

in reporting the building to a Florentine colleague, noted especially its great cost, while in 1475 Cardinal Giacomo Ammannati Piccolomini wrote to his friend Cardinal Francesco Gonzaga comparing it to a royal palace.[53] Spannocchi shared with Ammannati the honour of having been adopted into the Piccolomini family by Pius II, and had no qualms about scattering coats of arms over the façade and interior of the building so as to convey to as large an audience as possible the social mobility that had resulted from his financial acumen. Cardinal Ammannati, loyal to Siena even after the death of his papal patron, had been a houseguest in Ambrogio's palace in the summer of 1473. His extensive correspondence gives a sense of the way art and artists were brokered by satisfied patrons; through Spannocchi, Ammannati appears to have secured the services of Giuliano da Maiano for work on a house outside Siena at Monsindoli, which was decorated inside by Lorenzo da Viterbo with 'certi fregi (certain friezes)' as well as a painting of a Virgin and Child.[54] In his turn, Spannocchi is also known to have commended to Lorenzo de' Medici in Florence the work of a prodigious clockmaker called Dionisio da Viterbo, whose mechanical marvels included automata of the Magi presenting gifts to Christ, a God the Father with opening eyes and knights fighting a joust.[55] It was the combination of mechanical marvels, such as Spannocchi surely also owned, with other luxurious furnishings that led Ammannati to say of the palace that 'its interior is richly appointed and so spacious that it is in no way different from a royal palace'.[56] Indeed, the remarkable frieze of busts that crowns the palace was evidently intended to imply

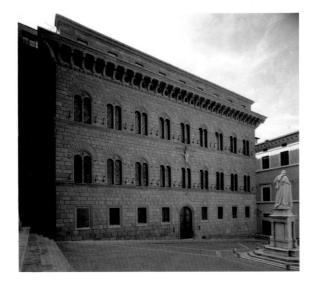

Fig. 10
The present façade of the Palazzo Spannocchi, Siena

Fig. 11
The façade of the Palazzo Piccolomini with Piccolomini Loggia seen behind, Siena

layers of ancestry and perhaps even imperial lineage for the Sienese banker, whose portrait is seemingly the only contemporary face among a host of laurel-crowned Roman emperors.[57]

A similarly ostentatious display of imperial splendour was made in January 1494, in the enormously lavish entry Giovanna Mellini (a Roman merchant's daughter) to Siena on the occasion of her marriage to Ambrogio Spannocchi's son Giulio.[58] Parading through the city from the southern gate, in the company of a number of Roman patricians and twelve knights with golden spurs, Giovanna met Giulio at the central Croce del Travaglio, travelling with him the last stretch of the route to the Palazzo Spannocchi, where a magnificent triumphal arch 'such as those made by the ancient Romans' had been erected, proudly displaying the arms of the couple. There followed a sumptuous reception: the palace was decked out in silks, silverware to the value of 60,000 *scudi* was used at the banquet, and hare, pheasant, peacock and other delicacies were served to wedding guests including such dignitaries as the Duke of Saxony and Jacopo Appiano, Lord of Piombino, as well as the Sienese élite.[59] Though evidently not set in a cold winter cityscape, it is this grand ceremony that appears to be evoked in the *spalliera* panel showing *The Magnanimity of Alexander* (fig. 12) – there is a direct reference through the inclusion of Spannocchi-Piccolomini arms – and in the three panels by the Master of Griselda (cat. 62–4).[60]

Such unbridled luxury, which suggested a splendour more appropriate to monarchs or princes, had also impressed Pius II

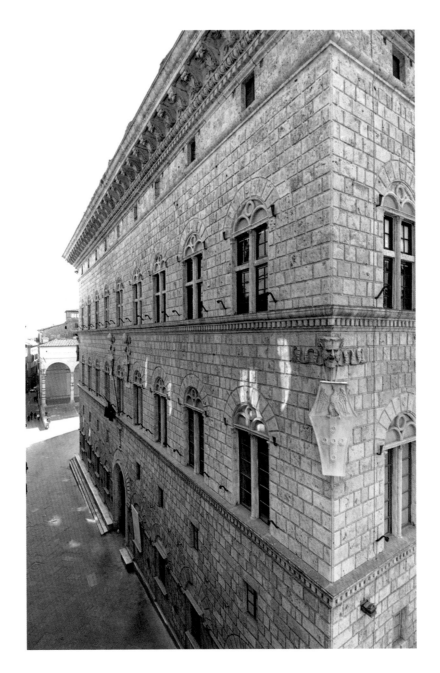

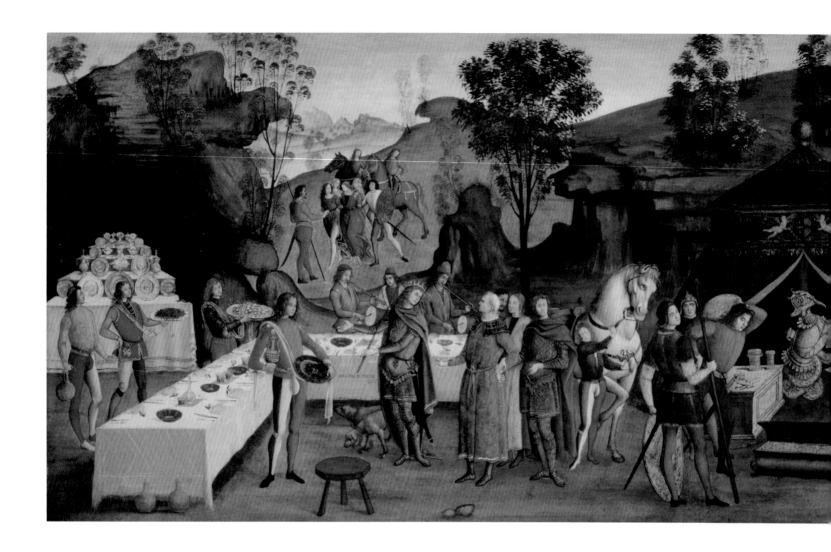

Piccolomini when some thirty years earlier, in April 1459, he had visited Cosimo de' Medici's palace in Florence, finding this, too, a residence suited to a king.[61] Piccolomini was in his own right one of Siena's most significant architectural patrons, channelling his dynastic ambitions through magnificent projects that he promoted and to a large extent funded for his sisters and nephews, over and above his direct patronage of his monument of Pienza, thirty miles south of the city.[62] Near Siena's Cathedral, he had sponsored a grand new palace, modelled closely on the Medici residence he had so much admired, for his sister Caterina; the use of such a model for the domicile of the least influential of his siblings might even seem to be a parody of the Florentine exemplar.[63] Far more ambitious was the project

developed around the piazza Piccolomini, just south of the Campo, where the building of a monumental family complex (fig. 11), including a palace and a loggia, accompanied the partial renovation of the local church of San Martino, affirming in no uncertain terms the newly acquired status of the family in the city. The simple three-bay *all'antica* arcade of the Carrara marble loggia projected the papal emblems on to the adjacent piazza and Banchi di Sotto, while an elaborate marble bench was marked with the arms of the pope's nephews, the residents of the nearby palace.[64] The massive Palazzo Piccolomini, which was begun only in 1469 after a slow and complex acquisition campaign, was of an unprecedented scale for the period, and its size and expense no doubt impeded its completion, which

dragged into the early sixteenth century. Like a number of other Sienese palaces, the Piccolomini palace was designed with two *piani nobili*, probably because two of the pope's nephews would inhabit the building, though in the end it was split vertically between them, with the younger Iacomo taking the more imposing marble-revetted portion and his brother Andrea the side facing the Campo. The design of the Strada Romana façade recalled Pius II's family palace at Pienza, while the Campo façade conformed rather to the architectural models dominant at the beginning of the sixteenth century, exemplified by the palace of Pandolfo Petrucci.

Andrea and Iacomo, whose brother Francesco was briefly elected Pope Pius III in 1503, inherited their uncle's properties at

Fig. 12
Workshop of Domenico
Ghirlandaio (1449–1494)
(Bastiano Mainardi and
Davide Ghirlandaio?)
*The History of Alexander
the Great*, about 1493–4
Tempera on panel
76 × 229.5 cm
Victoria and Albert Museum,
London (E.373–2006)
Displayed at Longleat House,
Wiltshire

his birthplace, now renamed Pienza, and shared the onus of completing a number of major religious projects in Siena. In their wills, they both allocated funds to completing the family chapel – originally the burial chapel of their grandparents, Pius II's mother and father – at San Francesco, while they also financed completion of the lavishly decorated library in the Cathedral that had been begun by their brother.[65] Their extensive land holdings outside Siena did not prevent Andrea and Iacomo from becoming actively involved in local affairs of the city, sometimes even in what might appear to be rather minor capacities. Thus, for example, in 1480–1 Andrea served as *gonfaloniere* ('standard-bearer') for his district, keeping a minutely detailed account of expenditures paid to gatekeepers,

banner-bearers and other local officials whom he oversaw.[66] Here the ancient bonds of clan allegiance overlapped with local administrative work, in a manner that resembles the social structures that operated within confraternity groupings. It does not emerge that either brother had connections with any one of the city's confraternities, possibly because the many honours and duties acquired through their papal uncle that bound them to altar privileges in Rome, Siena and other parts of Italy curtailed their ability to participate. Iacomo endowed a chapel in their local church of San Martino, while the brothers together underwrote the maintenance of the Piccolomini loggia, perhaps the most prominent monument of their status in the city. It was here, when Andrea died in September 1505, that the

Piccolomini gathered in the company of representatives of Siena's religious and political hierarchies to honour him:[67] his body, after lying in state in San Martino, was brought to the loggia and there Andrea was remembered in an oration before the funeral *cortège* formed, passing by the family palace and on to burial in the chapel of Sant'Andrea he had endowed in the church of San Francesco.[68] Family, parish, political and religious networks were all represented in the ritual ceremonial and final procession of this citizen, interlocking the different strands of one individual's life in the city.

NOTES

Civic Identity and Private Patrons
in Renaissance Siena

1 See L. Cavazzini in Bellosi 1993, pp. 114–15, cat. 2; a more extensive treatment of this theatrical event see F. Nevola, 'Ritual Geography: Housing the Papal Court of Pius II Piccolomini in Siena (1459–60)' in Jackson and Nevola 2006, pp. 65–88.

2 Allegretti 1733, col. 838 (entry dated 24 Jan 1495).

3 Issues of this sort are examined in greater detail in Nevola 2007.

4 On the entry to Siena of Pius II, see Jackson and Nevola 2006, pp. 65–88.

5 Described by Sanudo 1873, pp. 144–6; Mitchell 1979, pp. 135–8. The theme of entries to Siena is examined in diverse essays contained in Jackson and Nevola 2006.

6 Sanudo 1873, p. 144. This inscription first appears on Siena's coinage from 1279 and therefore relates to the city's independence.

7 Inscriptions: on the second arch, 'Venisti tandem, rex Christianissime, cui nostrae ultro patent januae'; on the third two statues, Charlemagne with the inscription 'Italiae, ecclesiaeque romanae liberator, christianaeque fidei ampliator sanctissimus' and Charles VIII with the inscription 'Carolus octavus Francorum rex, ad idem divino missus numine' (Sanudo 1873, pp. 144–5).

8 Sanudo 1873, p. 146; Cristofani 1979, p. 117.

9 The bibliography on both these essential strands of the city's urban mythology is vast. See, for the Virgin Mary, Norman 1999; for the she-wolf, M. Caciorgna and R. Guerrini, 'Imago Urbis. La lupa e l'immagine di Roma nell'arte e nella cultura senese come identità storica e morale' in Santi and Strinati 2005, pp. 99–118.

10 Specifically, the fresco was painted on the Antiportico di Camollia, a first line of northern defence set outside the perimeter of the city walls. For the fresco and its influence see Fattorini 2006; on the role of image of the Virgin Mary on Siena's gates see also M. Israëls 'Al cospetto della città. Sodoma a Porta Pispini e la tradizione pittorica delle porte urbiche di Siena' in Mazzoni and Nevola forthcoming; Gardner 1987, pp. 199–213.

11 See Fattorini 2006, n. 8 with bibliography and identification of other paintings directly derived from Simone's image.

12 Hook 1979, pp. 72–3, proposes this evocative connection although there is no direct textual or iconographic link between the Madonna of Mercy and the specific form of the piazza del Campo.

13 For Frederick III, see Nevola 2003, pp. 581–606.

14 Allegretti 1733, col. 772. See also Welch 1995, pp. 123–36.

15 Allegretti 1733, col. 772, 'Per arti della detta Duchessa fù ordinato un bellissimo Apparato e Ballo, ai piei del Palazzo dei Signori, e furono invitate quante giovani da bene, e fanciulle aveva Siena, le quali andarono molto bene ornate di veste e Gioie; e Giovani da danzare [...] 24000 fiorini, che e stata piú la roba che si è gittata, che è appena quella che si è mangiata, ovvero che i Commissari hanno anche loro menate le mani', indicating that Allegretto assumed that funds had actually been embezzled. Accounts of the visit survive in Archivio di Stato di Siena (hereafter 'ASS'), Concistoro 2482, fol. 1 'In questo libro appaia per iscritto tutta la ragione e spesa facta per honorare la illustre Madona Ippolita figlia dello illustrissimo ducha di Milano e allo illustre sichondo genito della Maestà del Re di Napoli, scritta e compilata per noi Bartolo di Iacomo Lotti, Francesco d'Andrea del Marecta assente la buona memeoria di Tommaso Ruffaldi e questo per deliberazione del consiglio del popolo.'

16 Allegretti 1733, col. 776; Allegretto's memory of the event was marred by the fact that his wife lost a silver dagger, 'E la mia perdé, o le fú tolto, un bel coltello fornito in argento, che mi costoro il paio lire 18'. The feast is also mentioned in Hook 1979, p. 108.

17 On Noveschi devotion to the Magdalen see now P. Jackson, 'The Cult of the Magdalen: Politics and Patronage under the Petrucci' in Mazzoni and Nevola forthcoming.

18 While the cult of saints in Italy's urban culture has been widely studied (e.g. Vauchez 1977), what follows attempts to consider these in relation to the artistic consequences of the discussion of the concept of community outlined

in various essays by E. Muir, and in particular, Muir 2002. Some interesting work has been done on the architectural and urban fragmentation of space in relation to communities, for example see Nussdorfer 1997, pp. 161–86.

19 The desire to balance the two orders can also be seen reflected in the urban rituals associated with their feast days, both of which were marked by elaborate processions throughout the city; see F. Nevola, 'Cerimoniali per santi e feste a Siena a metà Quattrocento. Documenti dallo Statuto di Siena, 39' in Ascheri 2001, pp. 171–84.

20 See Steinz-Kecks 1990, pp. 1–28; also Riedl and Seidel 1992, II, 1.2, pp. 57–304.

21 For documentary use of the 'oca' symbol for the neighbourhood as early as 1506, see Catoni and Leoncini 1993, pp. 23 and 70–4.

22 ASS, Consiglio Generale, 232, fol. 8 and Concistoro, 2125, fol. 66 (4 December 1466) and fol. 73 (14 July 1467; also in Pertici 1995, 103).

23 ASS Balìa 253, fol. 353 (19 June 1509), 'per gloria et honore prima del gloriosissimo Sancto Rocho et poi per tucta la Republica vostra con loro adiuto e con tucte le catholiche persone si sono messi ad edificare uno tempio ad laude del decto Sancto in Vallerozzi.'

24 On the role, from the start, as a contrada church, see Cecchini 1995, p. 98; the contrada was not yet formed in 1506, but appears separate from 'Bruco' in a 1546 account of contrada festivals, see Catoni and Leoncini 1993, pp. 61–3.

25 Nardi 1966–8, pp. 40–2, has stressed the administrative function of the parish from the early 1200s. That Vallerozzi was part of this district is clear from the Lira, e.g. ASS, Lira 145, fol. 110, 115, 168, 172.

26 See M. Mussolin, 'The Rise of the New Civic Ritual of the Immaculate Conception of the Virgin in Sixteenth Century Siena' in Jackson and Nevola 2006, pp. 117–39; Turrini 2003, pp. 28–39; Cecchini 1995, pp. 166–73.

27 This is a theme developed by a number of scholars, and is an important strand in Norman 1999. On the specific use of the rededication ceremony for the symbolic resolution of internal conflict, see C. Shaw, 'Peace-making Rituals in

Fifteenth-Century Siena' in Jackson and Nevola 2006, pp. 89–103.

28 See C. Shaw in Jackson and Nevola 2006, pp. 99–103; see also Kawsky 1995, pp. 122–38.

29 Analysis of the behaviour of these groups remains most effective in Weissman 1982. Confraternities in Siena have received rather scant attention, and are summarily listed in Turrini 1996–7 and 2002–3.

30 ASS, Patrimonio Resti 1626 fol. 1r: (18 June 1514): Compagnia di S Sebastiano, 'Al nome sia dello onipotente iddio e della sua gloriosa madre santa Vergine Maria e de' principali apostoli sto Pietro et santo Paulo e di tutta la corte cielestiale del paradiso et spezialmente de' nostri advocati S.to Ansano, Vettorio, Crescenzio et Savino e di Santo Bernardino e Santa Caterina da Siena et d' nostri avochati e patroni, cioè S.to Sebastiano, S.to Gismondo et Santo Roccho e' qual ci dieno favore e lo animo che noi facciamo tutte quelle cose che sieno salute dell'anime nostre et – so la cagione de nostri corpi alloro laude e di tutti quelli che entreranno nella nostra compagnia di Santo Sebastiano a l'umiliati.'

31 Christiansen 1991, pp. 451–2. See also Alessi 2003, pp. 29–32 for the dedication and location of the confraternity.

32 The connection of many artists to the confraternity has long been noted, although this would seem to be coincidental and indeed examination of the membership lists indicates that there was no continuity in this phenomenon; see, for listing of members, ASS, Patrimonio Resti 906: Libro di documenti e memorie (1428–1756), fol. 19–21 and Biblioteca Comunale di Siena (hereafter BCS), E III-bis.2, Libro secondo di deliberazioni che comincio dall'anno 1456 fino all'anno 1552 della compagnia di San Girolamo e San Francesco, fol. 6–30.

33 BCS, E III-bis.2, fol. 112v (23 July 1491): 'Pietro di Francesco degli Oriuoli, uno dei nostri fratelli si levo ditto [...] consegliava farsi dipigniare quelle volte grande di sopra e quello ex° alle spese dei frati'; document noted, but only partially discussed in Angelini 1982, p. 41.

34 ASS, Patrimonio Resti 913: Entrata e uscita (1493–1504), fol. 29v [1497] provides full financial accounts for the work done and artisans involved.

35 It is this cycle, that was only recently rediscovered under layers of plaster, that is published in Alessi 2003.

36 A useful indicator for the confraternity can be found from a series of inventories (1499–1504) contained in ASS, Patrimonio Resti 907.

37 The importance attached to burial is indicated by the many painted panels (capezzali) that survive from confraternities, and were used to adorn the ends of coffins in funeral processions; such themes are taken up in the detailed study of Siena's 'Misericordia', for which see Ascheri and Turrini 2004.

38 The altarpiece has been discussed most recently by Israëls 2003, pp. 134–5; for the chapel see Nevola 2000, pp. 41–2.

39 Such enlargements have been considered by Mussolin 1999, pp. 115–55.

40 See most recently now, with revision to the dating of the works, T. Henry in 'magister Lucas de Cortona, famosissimus pictor in tota Italia … fecisse etiam multas pulcherrimas picturas in diversis civitatibus et presertim Senis' in Mazzoni and Nevola (forthcoming).

41 M. Mussolin, in Martini 2006, pp. 61–3, and discussions with the author and Cecilia Alessi who are about to publish these findings in a more extensive form.

42 The phases of expansion are reviewed by Carl 1990, pp. 46–55; see also treatment in Riedl and Seidel 1992, II, 1.2. It would seem that chapel patronage was assigned as the chapels were completed, from the west side, moving towards the centre. A series of plans offer hypotheses for the altar patronage in 1450, 1575 and 1748, in Riedl and Seidel 1992, II, 1.2, pp. 734–5.

43 The contract is reproduced in Riedl and Seidel 1992, II, 1.2, pp. 906–7 (doc. 141, from ASS, Notarile Anticosimiano 652), dated 16 July 1471 (also Carl 1990, pp. 66–8). See also ASS, Spannocchi A1, fol. 10 (16 July 1471).

44 Riedl and Seidel 1992, II, 1.2, pp. 624–8; also Carl 1990, pp. 3–12.

45 Quinterio 1996, p. 123. The Placidi were successful bankers and were later to be closely associated with the Petrucci family; see Shaw 2001, p. 17.

46 Riedl and Seidel 1992, II, 1.2, pp. 906–7 (doc. 141). Further discussion of tomb slabs and monuments is to be found in Colucci 2003, although the Placidi monument is surprisingly absent from the catalogue. It is notable that in the post-fire reorganisation of the church of San Domenico the Placidi altarpiece and tomb slab are in different chapels.

47 M. Seidel in Riedl and Seidel 1992, II, 1.2, 619–22; also Trimpi 1983. The present position of the altarpiece, in the first chapel of the south transept, is a result of modern reordering.

48 Riedl and Seidel 1992, II, 1.2, section on 'San Domenico' assembles the documentation and maps the present-day location of each object in the church; the original distribution of ius patronatus and therefore of the paintings in their respective chapels is plotted in plans in Riedl and Seidel 1992, II, 1.2, pp. 734–5. Seidel, 'The Social Status of Patronage and its Impact on Pictorial Language in Fifteenth Century Siena' in Borsook and Superbi Gioffredi 1994, p. 120.

49 Spannocchi's case resembles the Tornabuoni's successful competition with the Sassetti for the patronage of the Cappella Maggiore at Santa Maria Novella. As for the provenance of the patrons at San Domenico, family residences range from the nearby Spannocchi (for which see below), to the more distant Placidi (in the district of Pantaneto, south of the Campo) and Accarigi (near the Duomo), as evinced from ASS, Lira tax surveys.

50 Mussolin 1997, particularly pp. 78–122 for chapel patronage and M. Mussolin, 'The Rebuilding of the Church of Santo Spirito in the Late Fifteenth Century' in Jenkens 2005, pp. 83–110.

51 The question of how private palace architecture operated within the public space of the city is a central issue examined in Nevola 2007.

52 History of the palace is most recently outlined in Nevola 2005, with earlier bibliography; on Naples connections see Quinterio 1989, pp. 204–10. Ambrogio's biography is assembled in Morandi 1978.

53 Cited in Nevola 2005, pp. 139, 141–2.

54 Ammannati Piccolomini 1997 edn, pp. 681, 1742–3 (17 Aug 1473) for a letter to Lorenzo de' Medici on these matters, 'di certi fregi, i quali havemo facti fare chostì da uno maestro Lorenzo da Viterbo, il quale ne ha havuto buona parte di pagamento da noi per il bancho v.ro.'

55 Milanesi 1854–6, II, pp. 360–1 (14 June 1477); Dionisio da Viterbo later also worked for the Venetian state.

56 Ammannati Piccolomini 1997 edn, p. 1989, 'interior ornatus, et amplitudo a Regia nil alienum'.

57 See Carl 1999.

58 It was in fact a double wedding, on 19 January 1494 as reported by Allegretti 1733, col. 840; see also ASS, Spannocchi A12, fol. 22 and 44. Giulio di Ambrogio married Giovanna Mellini while his brother Antonio married Alessandra di Neri Placidi.

59 ASS, Spannocchi A12, fol. 22 and 44 where many details are reported: 'Venne in Siena da Roma la sposa di Giulio d'Ambrogio Sapnnocchi figliola di uno mercante romano de' Mellini, la quale venne a marito [. . .] entrò da Porta San Marco e venne per Siena per la Strada, esci ala Porta Nuova e schavalcho al Palazzetto di Maria Marianna donna fu di Giovanni Tolomei a' piei Santa Chiara [. . .]' and the arch at Palazzo Spannocchi 'come usavano anticamente li romani a loro cittadini quando tornavano con la vittoria in Roma con quattro uomini famosi armati con l'arme in mano sopra detto archo.' See also Ugurgieri Azzolini 1649, II, pp. 323–4.

60 On these panels see now L. Syson in Santi and Strinati 2005, pp. 199–205.

61 Piccolomini 1984 edn, I, pp. 352–3 (Book II, ch. 28), 'aedificavit in urbe palacium rege dignum'.

62 For brevity, from a large bibliography on Pienza, see with extensive references F. Nevola, 'L'architettura tra Siena e Pienza: architettura civile' in Angelini 2005, pp. 183–215.

63 The palace is discussed by F. Nevola 'L'architettura tra Siena e Pienza: architettura civile' in Angelini 2005, pp. 199–204; see also Jenkens 2001, pp. 77–91.

64 The loggia is discussed By F. Nevola in Angelini 2005, pp. 205–7; see also Fiore 2003, pp. 129–42 and Jenkens 1997.

65 The wills survive for Andrea in ASS, Consorteria Piccolomini 17: Contratti di Andrea di Nanni Piccolomini (1464–1519), fol. 87 ff. (28 Jan 1507) and for Iacomo in ASS, Consorteria Piccolomini, 1: Bolle, diplomi, concessioni (1167–1898), inserto n° 5: 'Copia del codicillo' (18 Dec 1507). Comments below are based on information contained in these documents.

66 ASS, Concistoro 2378 provides full accounts for Andrea's term in office as gonfaloniere for San Martino: 'In questo quadernetto ovvero libretto io Andrea di Misser Nanni Piccolomini terro scripto per testamento tucto lordine et modo dello offitio del gonfaloniere quale é nella persona mia cominciato a di primo di luglio 1480.'

67 Jenkens 1997, p. 203; see now also for a useful comparison of Andrea's funeral ritual with that of Pandolfo Petrucci, P. Jackson, 'Pomp or Piety? The Funeral of Pandolfo Petrucci' in Jackson and Nevola 2006, pp. 104–16.

68 ASS, Consorteria Piccolomini 17: Contratti di Andrea di Nanni Piccolomini (1464–1519), fol. 87 (28 January 1507) for Andrea's will, which specified his wish to be buried 'in Ecclesia St. Francisci de Senis in tumulo seu sepultura sive cappelle S.ti Andree'.

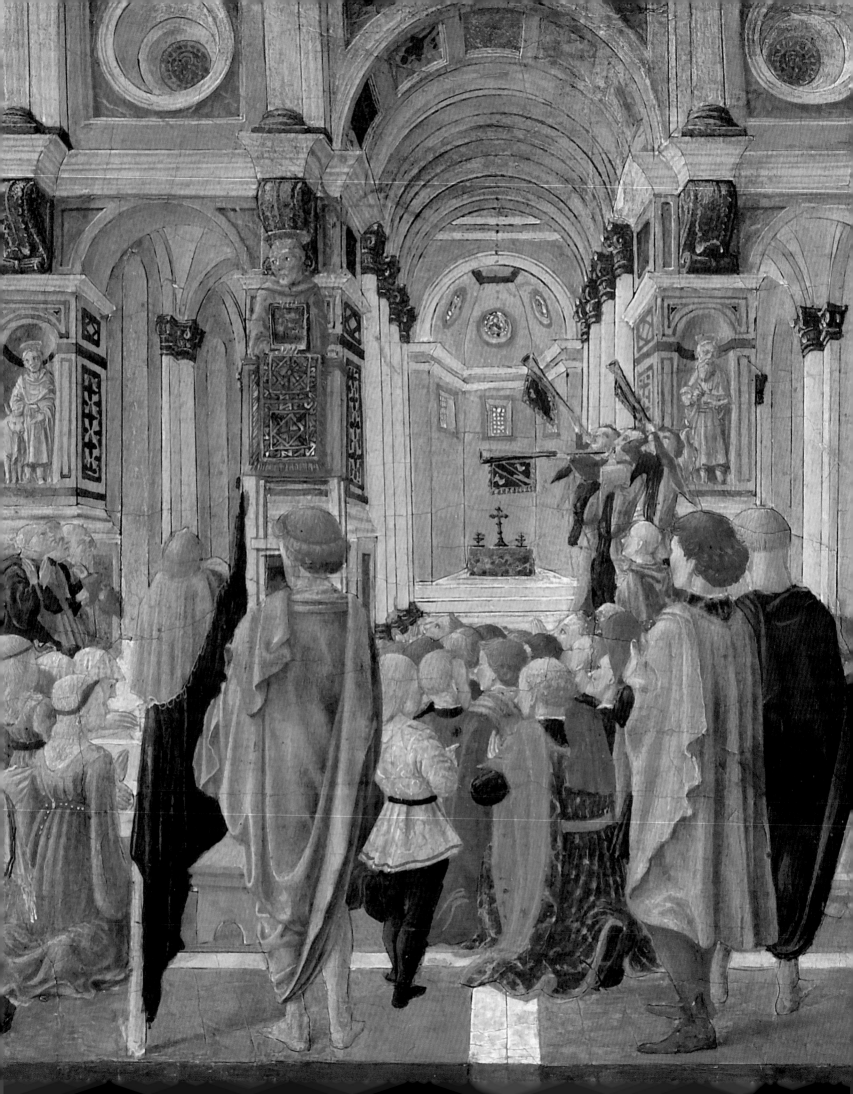

RENAISSANCE ART IN SIENA: PATRONS, ARTISTS AND WORKSHOPS

ALESSANDRO ANGELINI

A profound change in Sienese art occurred at the end of the 1450s, one which led to the gradual transformation of its visual vocabulary into a style that can truly be called 'Renaissance'. This shift was initiated by a small group of cultivated patrons, who pursued their aims with such determination and purpose that they succeeded in influencing to a rare degree the outlook of an entire city. By the end of the Quattrocento, Siena had fully embraced this great cultural transformation.[1] The foremost figure in this oligarchy of taste was Aeneas Silvius Piccolomini, one of the most active and decisive, educated and intelligent men to achieve political power in fifteenth-century Italy. The insight and firm hand that characterised his reign as Pope Pius II, from his election in 1458 to his death in 1464, had a significant impact upon the visual arts, of which he was a keen promoter.[2] This was not a man to separate art from politics or religion, viewing them all as complementary and mutually reinforcing. In particular, he recognised that certain tenets underlying his papal authority – the continuity between imperial and modern Rome, the common myths binding Rome's origins to those of Siena, his native city – needed to be expressed by the appropriate forms of architecture, painting and sculpture.[3] The style, the whole visual language, that was required to create (or recreate) this new, predominantly urban 'decorum' was inspired by Aeneas Silvius's long-standing humanist respect for antiquity. In practice, this meant that the artists he used for his projects should be capable of measuring themselves, if only tacitly, with the high ideals set out by Leon Battista Alberti in his celebrated treatises. Aeneas

Silvius's respect for Alberti's theory and practice is attested to by his reference to the famous Florentine in his autobiographical *Commentarii*, but above all in the material patronage of his pontificate.[4] By selecting Bernardo Rossellino as his architect, summoning him to Siena to plan the transformation of the town centre of Corsignano (subsequently renamed Pienza), he chose a disciple of Alberti, and as such a man who could best realise a humanist vision.[5] It is important to emphasise the degree to which the rebuilding of Pienza, and indeed the redevelopment of Siena itself during Pius II's pontificate, altered the artistic aspirations of more aware patrons, retraining, even jolting, their 'eye'.[6] The citizens of Siena saw rising simultaneously amongst them the Piccolomini Loggia beside the church of San Martino, the palace of Caterina Piccolomini, the church of Santa Maria della Neve, and other such Renaissance projects; before Pius's pontificate there had been almost no hint of discontent with the city's 'Gothic' tradition.[7] These buildings were constructed with semicircular apertures like classical triumphal arches instead of pointed ogees, with architraves in marble or travertine instead of elegant patterns of Gothic brick. Naturally enough, the style of the sculpture, in the round or in low relief, that constituted the 'ornament' of these buildings also had to look properly antique, just as Alberti was currently proposing in his treatise *De statua* (*On statuary*).

The sculptor who principally stood for the 'new wave' in Sienese art in the time of Pius II was Antonio Federighi, a personal friend and favourite of the pope.[8] Trained from boyhood in the workshop of Jacopo della Quercia, Federighi did not abandon the

Fig. 13
Detail of cat. 8

Fig. 14
Antonio Federighi (1420–1483)
Holy-water stoup, right hand pillar
about 1465
Marble
Cathedral, Siena (6010)

Fig. 15
Antonio Federighi (1420–1483)
Bust of Silvio Piccolomini, 1460
Marble
Church of San Francesco, Siena

Fig. 16
Antonio Federighi (1420–1483)
Bust of Vittoria Forteguerri, 1460
Marble
Church of San Francesco, Siena

Both shown here during restoration.

prevailing late Gothic style until the early 1450s, when he became *capomaestro* of Orvieto Cathedral. Before that, however, he had seen the work of Bernardo Rossellino – church furniture and civic decoration in marble – which offered new models inspired by classical forms. Federighi now developed Rosellino's new vocabulary in a highly original way, his holy-water stoups in the Cathedrals of Orvieto (1456) and Siena (about 1465) imitating the form of a Roman candelabrum over which humans and animals clamber among garlands of foliage (fig. 14).[9] Pius II put him in charge of two projects close to his heart, the loggia for the use of his family and household (see fig. 11, p. 25) and the tomb in which were to rest the mortal remains of his parents. The tomb, in the choir of San Francesco, was destroyed in the fire that gutted the church in 1655, but the marble fragments that have survived give some flavour of the ambition and novelty of its classical form.[10] The busts of Silvio Piccolomini and Vittoria Forteguerri were placed on the vista inside two shell niches (fig. 15, 16), resembling the front of a sarcophagus, and there was a

frieze of vases or amphorae, arms and trophies of the kind seen in several Roman imperial monuments.[11] Federighi's zestful vocabulary of antique motifs – *putti* playing instruments while riding dolphins, Atlas figures groaning dramatically or plunged in despair – reanimated and transformed the ornamental repertoire of the stones of Siena. Candelabra and friezes *all'antica* displaced the Gothic tendrils that had formerly proliferated on portals and sills. The solid corpulence of figures like Hercules exiled the more slender, insubstantial figures that had until then populated the surfaces of the city's architecture.

The architectural forms introduced into the decoration of ecclesiastical furnishings by Rossellino at Pienza, in the altar of the Sacrament in the Cathedral, for example, were taken over for the frames and cornices of the altarpieces commissioned by Pius II.[12] It has often been pointed out that these altarpieces in Pienza were the first with such classicising frames to appear on Sienese territory, though some time after the Florentine examples which they imitated.[13] The paintings these frames

contained were entrusted by Pius II – more interested perhaps in the architectural, decorative whole than in the figurative details – to Sienese masters of different generations and formations. As well as the older – and older-fashioned – Giovanni di Paolo and Sano di Pietro, working in the 'Gothic' tradition, he chose Vecchietta and Matteo di Giovanni, whose styles were better attuned to the settings, designed by Rossellino, of their works.

Indeed the pontificate of Pius II was a particularly rich and inspiring period for Vecchietta, as he assimilated the lessons of Donatello's sculptures in Siena and his description of surfaces and spaces through the fall of light (*'pittura di luce'*), a style evolved in Florence.[14] Vecchietta demonstrated a new coherence in his handling of perspective, not just in his *Assumption* for the Cathedral in Pienza but to an even greater degree in his altarpiece, again commissioned by Pius II, for San Nicola in Spedaletto, notably in the lunette of *The Annunciation* above the *sacra conversazione* of the main panel (fig. 17).[15] In this period of Vecchietta's career we see bright colours,

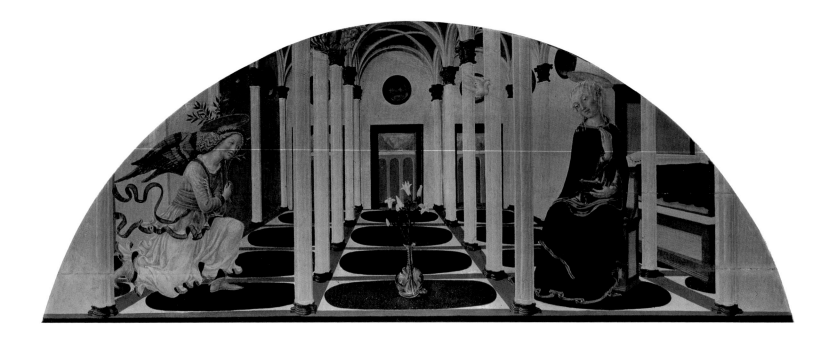

clear and precise lighting, and a charting of space in mathematical terms that fully correspond to the 'variety' of Domenico Veneziano in Florence. It was hardly by chance that in exactly these years his workshop was frequented by a series of talented disciples; indeed almost all the leading artists of the second half of the fifteenth century in Siena started out under his tutelage.

The élite circle of patrons encouraged by the example of Pius II included the rich merchant Cristoforo Felici, who from his appointment in 1457 to his death in 1463 was *Operaio* of the Opera Metropolitana di Siena, that is, rector of the Cathedral Office of Works, responsible for its programme of decoration. Felici exerted himself to bring to Siena the greatest sculptor of the age, Donatello, in whose hands he intended to place the creation of the bronze doors for the façade (see cat. 25).[16] Even though these doors were never completed, Donatello did indeed come to Siena in his old age and worked there for several years, making a profound impact on Sienese art for more than a generation. His bronze *Saint John the Baptist*, made for a site that remains unidentified, demonstrates an impressive drama

and realism. Sienese artists like Vecchietta and Francesco di Giorgio, both of them sculptors as well as painters, were profoundly struck by what one might almost term the aggression of this work, and adapted their more elegant and refined style in response to it.[17] The *Virgin and Child with Angels* that Donatello executed very probably for the framing pediment of the altar of the Madonna delle Grazie in the Cathedral was another point of reference for Sienese artists, who imitated the startling idea of seating the Virgin on the wings of the accompanying cherubim (fig. 26, p. 52).[18] It is now widely accepted that Donatello designed – though certainly did not carve, leaving the execution to his assistants, among them the undistinguished Urbano da Cortona – the wall tomb which Felici built for himself in San Francesco,[19] since the bold effect of *stiacciato* or shallow relief, and the accommodation into the design of the oblique viewpoint from which it would be seen, are entirely consistent with Donatello; even the architectural elements recall his celebrated works in Padua and Florence. Tombs were indeed a major vehicle of the classicising innovation then taking place in Siena,[20] and one of the most notable was that

of Mariano Sozzini, a jurist and humanist in the circle of Pius II, who was buried in San Domenico in 1467. Of this there survives only the bronze *gisant* (now in the Bargello in Florence), traditionally attributed to Vecchietta but more recently to Francesco di Giorgio. The way the surface is worked to break up and diffuse the light as it falls upon it is strongly indebted to the example of Donatello.[21]

WORKSHOPS AND COLLABORATIONS

For this new style to flourish required not just enlightened patrons but the transmission of motifs, designs and techniques from artist to artist. In the Siena of the second half of the Quattrocento, the organisation of artists' workshops was highly developed, and perhaps more complex than hitherto. The typical structure, established by long tradition, was that of master and pupils working together in a common space. The leading workshop of this kind around 1460 was that of Vecchietta, by then a mature and celebrated master, well versed in several techniques. As from the workshop of Andrea del Verrocchio in Florence, so from

Fig. 17
Lorenzo di Pietro, known as Vecchietta (1410–1480)
The Annunciation, lunette, 1460–2
Tempera on panel
Museo Diocesano, Pienza (60)

Vecchietta's in Siena there emerged both paintings and sculptures in bronze or marble. Publicising his versatility, Vecchietta signed himself as a sculptor on his paintings and as a painter on his sculptures. However, examining his bronze sculpture closely, for example the marvellous ciborium that now stands on the high altar of Siena Cathedral, one sees that his great talent found its fullest expression in the working of metal, as if this were an enormous piece of goldsmith's work (fig. 39, p. 70).[22] Like Ghiberti earlier in Florence or Verrocchio later, Vecchietta, having mastered the complexities of gold-smithing and metalworking, was able with comparative ease to excel in other arts, however different. He passed on a similar versatility to his most gifted apprentice, Francesco di Giorgio, who excelled him, combining extraordinary draughtsmanship with prodigious architectural imagination.

Stylistic evidence, but also documentary proof, confirms that Benvenuto di Giovanni was trained in Vecchietta's shop, working beside him from the 1450s onwards on frescoes of the life and miracles of Saint Anthony of Padua in the chapel dedicated to him in the Siena Baptistery.[23] The cycle demonstrates the brightly lit, spacious scenes of Vecchietta's painting, even if it has a rather more modern style, and several touches that seem almost Netherlandish.[24] Francesco di Giorgio, too, absorbed all the characteristics of Vecchietta's painting, but imparted to them a greater energy and animation, with an especially marked interest in dramatic perspectival space and in classicising ornament.[25] Consider for example the *incipit* page of the *De animalibus* of Albertus Magnus illuminated by Francesco di Giorgio for Alessandro Sermoneta, a

doctor and lecturer at universities in Siena and elsewhere, probably in the early 1460s (cat. 39).[26] Perhaps at the instigation of his learned patron, Francesco adorned the borders of the page with a broad frieze *all'antica*, containing three roundels representing episodes from the legend of Hercules (with the Hydra, the Lion and Nessus the Centaur). The subject was clearly inspired by the famous works of the Florentine Antonio Pollaiuolo, the Hercules series that he had painted about 1460 for the Medici. The taut bodies, their wiry energy, also reflect Pollaiuolo's style, while they and the vases in the richly decorated frieze indicate the classicising influence of Federighi.

Matteo di Giovanni had probably also been employed in Vecchietta's shop only a few years earlier, and the younger Neroccio would join him there around 1465, followed by Andrea di Niccolò.[27] There can be no doubt that the stylistic disparities in Vecchietta's painting and sculpture are attributable in large part to the variety and different levels of talent possessed by his assistants or collaborators: one might cite in particular the twenty-four small figures of the Cathedral ciborium, or the *Assumption* for Pienza Cathedral, of 1462, in which there are passages that appear close to what will become the style of Neroccio.[28] This does not mean, however, that we can or should detach or de-attribute particular elements within Vecchietta's œuvre: overly subtle, probably largely subjective distinctions between the hands responsible for predella scenes or *cassoni* produced by his workshop would be anachronistic. In certain cases nonetheless, it is possible to detect the specific qualities of a pupil

working alongside the master with some degree of objectivity. Take the three panels of Franciscan saints now held respectively in the Walker Art Gallery in Liverpool (*Saint Bernardino preaching*; cat. 8), the Alte Pinakothek in Munich (*Saint Anthony of Padua's Miracle of the Mule*) and the Pinacoteca in the Vatican (*Saint Louis of Toulouse*).[29] It is arguable that these and other small panels formerly belonged to the predella of an altarpiece in San Francesco, which, as we have seen, was destroyed by fire in 1655. Although the project was almost certainly commissioned from Vecchietta, these panels were clearly produced by Francesco di Giorgio, Benvenuto di Giovanni and Vecchietta himself, working separately. Once these pupils had reached such a level of autonomy, the next step would be their departure and setting up on their own.

Later we find Benvenuto himself at the head of a workshop, apparently well organised along traditional lines (fig. 18). His leading pupil was his own son Girolamo di Benvenuto, with whom, at least latterly, he ran a kind of family firm. Interestingly, Girolamo briefly worked independently before returning at the end of the century to collaborate in the family shop on generally rather large altarpieces and on frescoes that were signed by his father.[30] This long period of activity in a secondary role may be explained by the difficulties he encountered entering the market in his own right and procuring commissions on his own behalf. It was only in the first years of the sixteenth century that Girolamo assumed the leading role, introducing effects borrowed from Netherlandish art into his landscapes and a new monumentality – or more exactly

Fig. 18
Benvenuto di Giovanni (1436–about 1509)
Stories from the Life of Saint Anthony of Padua,
about 1460
Fresco, Baptistery of San Giovanni, Siena

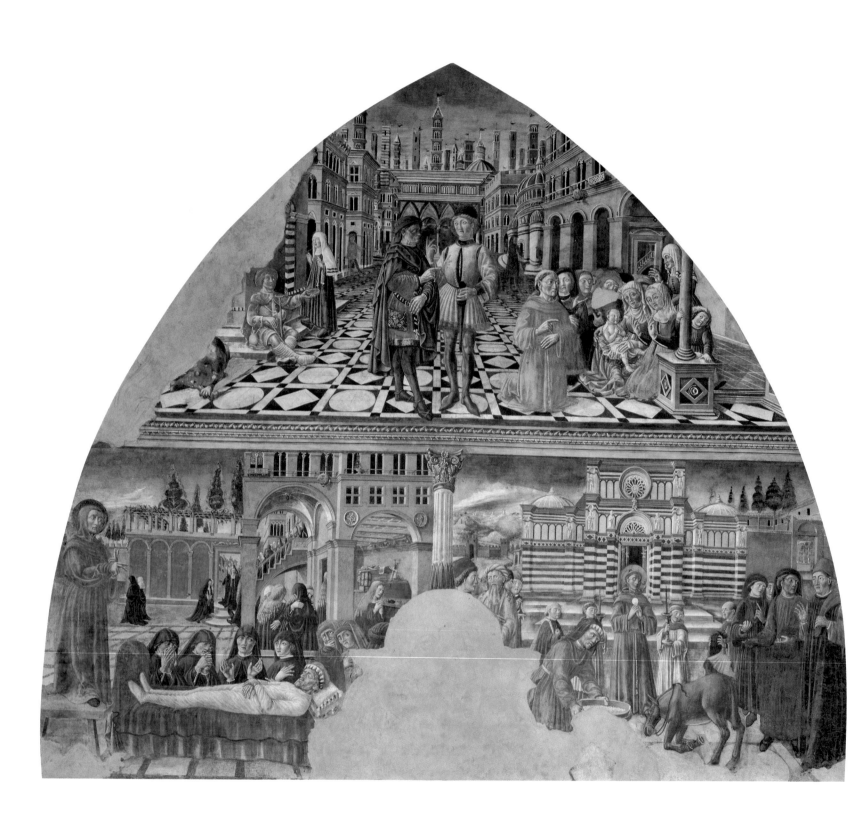

a kind of swollenness – into his figures in competition with the next generation of painters. Before his son became a permanent fixture, two other painters had served apprenticeships in Benvenuto di Giovanni's workshop, Bernardino Fungai, who is documented with Benvenuto in 1482, and Pietro di Domenico. In two of his early works, a fresco of the *Pietà* in the Sala Marcacci in the Hospital of Santa Maria della Scala (1487) and an *Assumption of the Virgin* now in the Museo d'Arte Sacra at Buonconvento (about 1493), Pietro clearly shows the imprint of his master's style.[31]

A second workshop of considerable importance was that of Matteo di Giovanni, particularly active from the early 1470s.[32] Towards the end of that decade, when it was at its busiest, Matteo took on two pupils who would enjoy successful careers of their own, Guidoccio Cozzarelli and Pietro Orioli. Cozzarelli evinced little independent invention, but regurgitated scrupulously, almost undeviatingly, what he had learnt in his master's studio.[33] Orioli, by contrast, was only briefly faithful to his master's style, and soon ranged further afield, influenced in particular by Francesco di Giorgio and probably travelling with him to Urbino, after which time he became engaged more than any other Sienese artist with the complexities of perspective. Matteo di Giovanni is even thought to have attracted to his studio a painter from Lucca, Michele Ciampanti, previously known as the 'Stratonice Master'.

While these workshops were run by a single master, to whom his pupils or the other members of the shop remained subordinate, we also find from the middle of the century, if not earlier, two or more artists usually of independent formation but of similar age coming together to work as equal partners or associates. In Florence, among the earliest and most celebrated of these partnerships was that of Donatello and Michelozzo at the end of 1420s; but it is likely that still earlier in the decade Masolino and Masaccio had teamed up in similar fashion. In the course of time these ventures came to resemble merchants' joint-stock companies – one of the best known, again in Florence, was that of the Corso degli Adimari, run by Jacopo and Giuliano d'Arrigo, known as Pesello.[34] Though they continued to run their workshops and to produce works independently, such artists shared their costs and profits, enabling them to weather the vagaries of the market. It is far from clear, however, how or whether these artists worked together on particular projects. In Siena, for example, Matteo di Giovanni formed a 'company' in 1453 with a certain Nanni di Pietro, about whom very little is known; his role has aroused considerable speculation, especially regarding an altarpiece at San Pietro a Ovile with an *Annunciation* copying Simone Martini's (Uffizi, Florence) at its centre, painted by Matteo di Giovanni on his arrival in Siena from his native Borgo San Sepolcro.[35] There are elements in the polyptych not fully in accord with the mature style of the artist, and it has been suggested that Nanni di Pietro might have been responsible for these. But to suppose that the two partners worked together on the same retable may be to misunderstand the economic basis of these associations. Certainly the main point of a '*societas in arte pictoria*' was to permit painters to pool their resources, while each generally continued to carry out his own work. Although other scholars have argued differently, I believe the San Pietro a Ovile polyptych to be the work of Matteo di Giovanni alone, still close in style at this point to his master Vecchietta and also affected by the emotional tenor of the work of Pietro di Giovanni Ambrosi. Only subsequently did he arrive at a mature style from which he would deviate little during the rest of his career.

The best-known company formed in Siena in the second half of the fifteenth century was that of Francesco di Giorgio and Neroccio de' Landi, which foundered in 1475. Although Neroccio was probably a few years younger than Francesco, they were of the same generation and both had spent time in Vecchietta's shop.[36] It seems probable that Francesco di Giorgio was led to form the company in response to an ever-increasing demand across different artistic media, hoping to find in Neroccio an associate to whom he could delegate a substantial proportion of the great number of paintings that came their way, while he concentrated on architecture, engineering projects and sculpture. Francesco certainly did not work alone on the paintings he undertook, especially after 1470, in as much as a good number of paintings from his workshop do not appear to be autograph, at least in execution. There is a considerable variation in quality in this output, and indeed in some cases a disparity between the design of the figures and their final realisation:[37] his bold and vigorous drawing can be detected in infra-red reflectography in certain paintings (mostly works for private devotion) which on their surface, in the paint, exhibit a more tender and dreamy style, influenced by the elegant delicacy of

Neroccio, suggesting that they were finished by someone else.[38] Francesco may therefore have delegated much of the painting in these works, though critics are not agreed whether they have any consistency of style, suggesting either the regular intervention of a single assistant, or that were brought to completion *ad hoc* by a variety of hands.[39] The presence of a single constant companion, now christened the '*fiduciario*' or right-hand man of Francesco, has been suggested but remains unconfirmed.[40] It may be noted, however, that Francesco delegated not only works of small format and fronts of *cassoni* or wedding chests, but also large-scale commissions, such as *The Coronation of the Virgin* delivered to the church of Monte Oliveto Maggiore between 1472 and 1474 (fig. 5, p. 13), and, I would argue, compositions on which Francesco had clearly expended considerable effort such as the *Annunciation* in the same gallery (cat. 23). In the autograph works of his early maturity Francesco shows himself by contrast a painter fully aware of volume and spatial perspective and capable of the kind of dynamism that we find in his spectacular bronze reliefs. One of these – autograph at least in the main figures – is the *Nativity* of about 1475 in the Pinacoteca Nazionale in Siena (fig. 19), which, we would conclude, is one of the few painted works that Francesco di Giorgio executed himself in his mature years. The handling is thick and oily, conveying volume and mass in bodies and drapery, but touches like the glitter of the metals and of the haloes recall youthful works like the *Saint Bernardino preaching* (cat. 8).

One faithful assistant of Francesco's who is documented was Giacomo Cozzarelli,

whose known work is mostly in bronze, though he is described in an Urbino document of 1483 as ready to '*depegnare*' (paint).[41] In Cozzarelli, Francesco found a sculptor of real ability willing to suppress his own artistic personality so as to realise the projects of his greater master. Extraordinary sculptures like the two bronze *Angels* on the high altar of Siena Cathedral, or the polychrome terracotta figures of the *Pietà* of the Basilica of San Bernardino all'Osservanza (fig. 32, p. 63), are the fruit of a very close, indeed seamless, collaboration between the two artists.[42] Only after the death of Francesco di Giorgio in 1501 did Cozzarelli acquire a greater autonomy, carving the wooden statue of *Saint Vincent Ferrer* in Santo Spirito in Siena and modelling in terracotta the *Saint Sigismund* in the church of the Carmine. These are highly expressive works, in which he adapts the lessons of Francesco di Giorgio to the latest trends, influenced by Leonardo da Vinci and the classicism of Andrea Sansovino.[43]

As well as his long-standing collaborators, thoughout his career Francesco di Giorgio gathered around him more or less occasional assistants, whom he employed in his workshop as circumstances demanded. At the end of the century, he was apparently joined by another painter, who was responsible for the energetic, decisive execution of both the great *Nativity* of San Domenico in Siena and the exquisite panel of *The Virgin and Child and Two Saints* in the Pinacoteca.[44] This artist may possibly be identifiable as Ludovico Scotti, a mysterious figure whose involvement with the Tancredi Altarpiece in San Domenico is documented until his death in 1498.[45] The best example of the way in which Francesco di Giorgio drew other

artists to work beside him is the case of the Bichi Chapel in Sant'Agostino, which his workshop decorated in about 1490. Here he used his trusted assistants, at least in part, to transfer his cartoons to the walls for the monochrome frescoes of *The Nativity* and *The Birth of the Virgin* (fig. 49–50). But he was also joined by the most talented Sienese painter of the new generation, Pietro Orioli, who painted the elaborate architectural perspectives and views into the countryside,[46] and by the Cortona-born Luca Signorelli, with whom Francesco had already been in contact, as we know from documents, in 1484. Signorelli frescoed the vault and the lunettes of two *Sibyls* in the chapel and painted the lateral panels and predella of the altarpiece, for which Francesco himself carved the wooden statue of *Saint Christopher* (now in the Louvre, Paris, see p. 244).[47]

This teaming together of artists who were already established but lacked previous experience of working together, sometimes indeed from different cities, is a phenomenon that has been little studied. It became more widespread from the last decade of the fifteenth century onwards, driven by the need to see through large-scale projects – especially fresco programmes to decorate a series of rooms – in a very short time, determined by events such as a marriage. A splendid example is the decoration carried out jointly in 1493–4 by Pintoricchio and Piermatteo d'Amelia for Pope Alexander VI in the five great rooms of the Borgia Apartments in the Vatican.[48] It is likely, in my opinion, that Piermatteo, a functionary of the Curia, provided the cartoons for the troupe that worked here, consisting of a number of Sienese painters, such as

Fig. 19
Francesco di Giorgio Martini (1439–1501)
Nativity with Saints Bernardino and
Thomas of Aquinas, about 1475
Oil and tempera on panel, 203 × 198.5 cm
(with original frame)
Pinacoteca Nazionale, Siena (437)

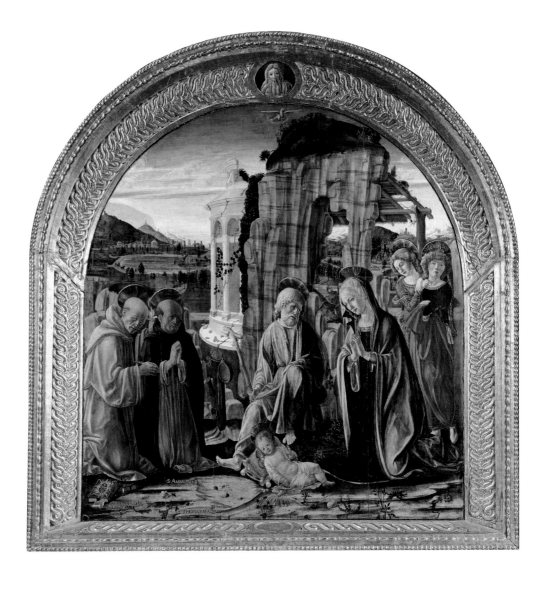

Bernardino Fungai, Girolamo di Benvenuto and Mariotto di Andrea da Volterra, beside others who came from Perugia or Bologna.[49] A similarly populous workshop undertook, during these same years, the execution of a series of paintings representing classical heroes and heroines possibly for the Piccolomini in Siena (cat. 65–72), involving Neroccio de' Landi, Matteo di Giovanni, Francesco di Giorgio and Pietro Orioli, and finished by the so-called Master of the Story of Griselda, a painter of compelling verve whom I have recently argued might be identified as Pietro di Andrea da Volterra.[50] Obviously the greater the number of hands the more rapidly the job could be completed, while the Griselda Master, with an elegant and sophisticated, 'international' style, would perhaps have seemed the best candidate

to bring such a project to completion and endow it with visual unity. He takes his name from the *spalliera* paintings representing the story of Griselda in the National Gallery (cat. 62–4), which were painted for the marriages of Antonio and Giulio Spannocchi, bankers to Pope Alexander VI.[51] Evidently these painter-contractors were happy to move up and down between Rome and Siena, following up recommendations made by the influential patrons who had employed them, and the fact that Pintoricchio, who was particularly active in this role, should employ in about 1500 two more young painters from Siena – Giacomo Pacchiarotti and Girolamo di Giovanni del Pacchia – for the decoration of the Basso della Rovere Chapel in Santa Maria del Popolo in Rome suggests that he valued the experience of

painters from Siena in this kind of work. Perhaps it is even possible that this Perugian artist settled in Siena in 1502 precisely because there he could count on recruiting sufficient numbers of painters well versed in the communal execution of ambitious mural projects.[52]

ON THE EVE OF THE HIGH RENAISSANCE

Among the artists whom Pintoricchio brought into his team for the decoration of the Piccolomini Library in Siena Cathedral in the first decade of the sixteenth century were Baldassarre Peruzzi and the young Raphael. The involvement of Raphael may have been comparatively brief, though of great significance, because it was Raphael

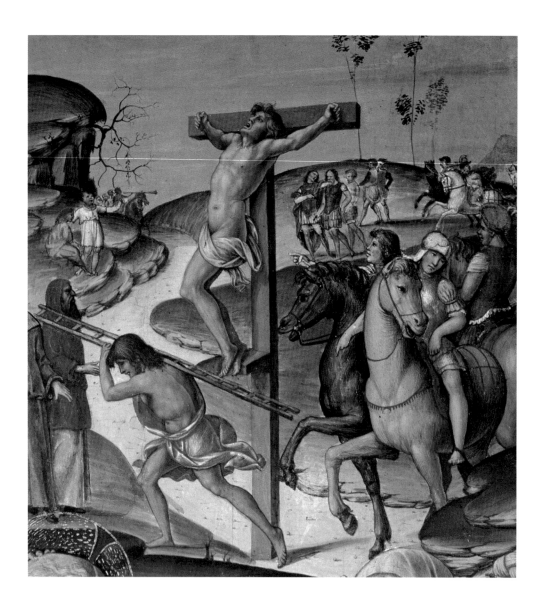

Fig. 20
Francesco di Giorgio Martini (1439–1501) and
Baldassare Peruzzi (1481–1536)
The Spoliation of Christ (detail showing the
Crucifixion of the Thieves), from 1501
Pinacoteca Nazionale, Siena (428).

who designed the initial episodes in the *Life* of Pope Pius II, those on the right wall (see cat. 76), but for Peruzzi the experience of working with Pintoricchio was formative.[53] Associated in his early years with Francesco di Giorgio, practising both architecture and painting, Peruzzi seems to have had a hand in *The Spoliation of Christ* (fig. 20), one of the last paintings to leave Francesco's studio before his death.[54] Working with Pintoricchio from as early as 1502–3, Peruzzi quickly assimilated and developed the handling of illusionistic architecture for which he was to make his name in Rome shortly afterwards. As Vasari suggests, Peruzzi was then responsible for the conception and planning of the frescoes of *The Life of the Virgin* in the apse of Sant' Onofrio al Gianicolo in Rome in 1504–5:

this would be the first project of which he was in overall charge, himself employing, in the fashion of Pintoricchio, a team of junior artists (including Jacopo Ripanda and Giovanni Pinura).[55] Extremely busy as an architect, he was also an outstanding painter of *all'antica* illusionistic decoration, both on façades and in interiors. Much later, Sebastano Serlio, his admirer and follower, recorded that, as '*l'ordinatore, come padrone di tutti coloro che nela fabricha si adoperano*' (the co-ordinator – as if the patron – of all those who worked on site) he guided them with the greatest '*giudizio*' (judgement).[56] Peruzzi's greatest achievement in this role, integrally combining architecture and its decoration, was the villa he constructed for the Sienese banker Agostino Chigi at La Lungara (the present Villa Farnese),

employing a team of painters of the calibre of Raphael, Sebastiano del Piombo and Sodoma. Peruzzi was working at a moment when an artist's powers of '*invenzione*' and of '*giudizio*' counted above all else; these were revealed in his designs, which it was then the task of others to realise on the walls themselves. Though this was probably not a fifteenth-century attitude, Peruzzi's own fulfilment of these criteria was based directly on his experience in the collaborative workshop of Francesco di Giorgio. It is quite clear that Francesco, especially in his later career, was often too busy on other kinds of designing projects to be able himself to wield a brush.

Renaissance Art in Siena: Patrons, Artists and Workshops

1 C.B. Strehlke in Christiansen, Kanter and Strehlke 1988, pp. 55–8; R. Bartalini in Bellosi 1993, pp. 92–5; Angelini 2005, pp. 28–40.

2 Prodi 1982, pp. 33–8; Pellegrini 2003, pp. 129–42.

3 Olitsky Rubinstein 1957, pp. 170–82; Angelini 2005, pp. 28–40.

4 See Piccolomini (1984 edn) p. 2233. For the ideas shared by Alberti and Pius II see Collareta 1982 and M. Collareta in Alberti 1998 edn, pp. 49–50; Caglioti 1995, pp. 126–31; R. Bartalini in Bellosi 1993, pp. 97–8; Angelini 2005, pp. 28–34; G. Fattorini in Martini 2006, pp. 46–57.

5 Olitsky Rubinstein 1957, pp. 66–85; Carli 1993; Mack 1987, pp. 34–7; R. Bartalini in Bellosi 1993, pp. 92–4; Pieper 2000, pp. 247–51; M. Mussolin in Angelini 2005, pp. 215–46.

6 For the idea of the period 'eye' see Baxandall 1978, pp. 41–99.

7 On the development of Siena in the time of Pius II see the overview given recently in Nevola 2005, pp. 183–213.

8 For Antonio Federighi see Richter 2002, and for his sculpture Angelini 2005, pp. 105–49.

9 Richter 2002, pp. 56–68; Angelini 2005, pp. 116–41.

10 G. Gentilini in Gentilini and Sisi 1989, pp. 73–5.

11 Angelini 2005, pp. 132–4; M. Mussolin in Martini 2006, pp. 61–3.

12 For the introduction of altarpieces framed all'antica in Siena see L. Paardekooper in Gasparotto and Magnani 2002, pp. 19–39; in Italy more generally Humfrey 1987, pp. 539–41; Van Os 1987; Van Os 1990; in Pienza in particular L. Martini in Angelini 2005, pp. 256–67.

13 A. De Marchi in Dalli Regoli and Ciardi 2002, pp. 199–222.

14 K. Christiansen pp. 15–18 and C.B. Strehlke pp. 258–9, in Christiansen, Kanter and Strehlke 1988. For the renewal of Vecchietta's painting practice around 1460 see especially Bellosi 1993, pp. 47–50; R. Bartalini in Bellosi 1993, pp. 92–4.

15 Paardekooper 1996, pp. 149–86.

16 On Cristoforo Felici see Moscadelli 1996, pp. 63–5; for his relations with Donatello see Caglioti 2000, pp. 34–56.

17 For the influence of Donatello on Sienese sculptors see A. Bagnoli in Bellosi 1993, pp. 162–9; G. Fattorini in Angelini 2005, pp. 45–81.

18 On the original location of Donatello's tondo see now M. Butzek in Angelini 2005, pp. 45–81.

19 A. Angelini in Cioni and Fausti 1991, pp. 264–72; A. Bagnoli in Bellosi 1993, pp. 166–9; Caglioti 2000, p. 50; Colucci 2003, pp. 355–7; C. Alessi in Angelini 2005, pp. 288–9.

20 On Sienese tombs in the period see Munman 1993; Colucci 2003.

21 For Francesco di Giorgio in this context see Bellosi 1993, pp. 22–4, 198–9.

22 The quality of Vecchietta's ciborium has emerged after recent conservation, see A. Bagnoli in Martini 2006, pp. 91–101.

23 C. Alessi in Alessi and Martini 1994, p. 15.

24 R. Bartalini in Bellosi 1993, pp. 95–7; Bandera 1999, pp. 23–30.

25 Weller 1943, pp. 50–60; Angelini 1988, pp. 12–16; Bellosi 1993, pp. 39–47.

26 A survey of manuscript illumination in this period is given by A. Angelini in Bellosi 1993, pp. 142–5.

27 In the absence of any more up-to-date comprehensive study of Vecchietta, see Vigni 1937. On the formation of Francesco di Giorgio and Benvenuto di Giovanni in Vecchietta's shop see, among others, Pope-Hennessy 1944, p. 144; Bellosi 1993, pp. 39–47. On the formation of Matteo di Giovanni see A. Angelini in Bellosi 1993, pp. 126–35; A. De Marchi in Gasparotto and Magnani 2002, pp. 64–8; M. Boskovits in Boskovits and Brown 2003, p. 504.

28 L. Cavazzini in Bellosi 1993, p. 138; Strehlke 1993.

29 See R. Bartalini and L. Bellosi in Bellosi 1993, pp. 94–5; 110–13; cat. 1c–d.

30 For Benvenuto di Giovanni see Bandera 1999, even though the present author does not share all the conclusions reached in this very complete study. The most significant cases of works signed by Benvenuto di Giovanni but executed by Girolamo di Benvenuto are The Assumption now in the Benucci collection in Rome and The Virgin and Child with Saints Sebastian and Fabiano in the Collegiata of Sinalunga.

31 For Fungai see Bacci 1947; and in particular for the decoration of the tribune of the Cathedral, pp. 12–13; Parisi in Bellosi 1993, p. 521. For Pietro di Domenico see Folchi in Bellosi 1993, p. 527.

32 For an overall view of Matteo di Giovanni see Buricchi 1998; A. Angelini in Alessi and Bagnoli 2006, pp. 14–29.

33 For Guidoccio Cozzarelli see Paardekooper 1993, pp. 51–65; L. Kanter in Christiansen, Kanter and Strehlke 1988, p. 282. For the formation of Orioli see Angelini 1982, pp. 30–1; L. Kanter in Christiansen, Kanter and Strehlke 1988, p. 335; G. Ermini in Ceriana 2006, pp. 12–40.

34 Procacci 1960, pp. 11–13; A. Bernacchioni in Gregori, Paolucci and Acidini Luchinat 1992, pp. 26–8.

35 The question is discussed in Strehlke 1985, pp. 8–10; C.B. Strehlke in Christiansen, Kanter and Strehlke 1988, pp. 264–5; A. Angelini in Bellosi 1993, pp. 129–30; C. Alessi in Alessi and Martini 1994, pp. 52–4; Bellosi in Abbate and Sricchia Santoro 1995, pp. 81–3; P. Palladino, pp. 49–56, A. De Marchi, pp. 64–5 and L. Paardekooper pp. 77–88, in Gasparotto and Magnani 2002; Strehlke 2004, pp. 183–90.

36 Dami 1913, pp. 138–9; Weller 1943, pp. 6–7; Seidel 2003, pp. 547–53; A. Angelini in Bellosi 1993, pp. 284–9.

37 Weller pointed out the contradictions in Francesco's painted œuvre; see Weller 1943, pp. 82, 103–4.

38 For the differences between the underdrawing and the surface painting see A. Angelini in Moench-Scherer 1992, pp. 72–5; Bellosi 1993, pp. 30–9.

39 Clearly Christiansen (1990, pp. 212–3) had this kind of organisation in mind; see also the position taken by D.A. Brown in Boskovits and Brown 2003, p. 279.

40 The idea that there might have been a principal assistant, a doppelgänger of Francesco di Giorgio, formed during preparations for the exhibition held at Siena in 1993, curated by L. Bellosi: see Bellosi 1993, pp. 19–47; L. Bellosi in Fiore 2004, pp. 199–227. A similar approach had been considered by myself (Angelini 1988, pp. 10–22). However doubts have been expressed notably by C.B. Strehlke (1993, pp. 499–502), D.A. Brown (in Boskovits and Brown 2003, p. 279), and by L. Vertova (1993, pp. 325–7).

41 Fumi 1981, pp. 13–18; F. Fumi Cambi Gado in Bellosi 1993, pp. 392–5, 410–13.

42 C. Sisi in Gentilini and Sisi 1989, pp. 110–11; F. Fumi Cambi Gado in Bellosi 1993, pp. 414–19; A. Bagnoli in Bellosi 1993, p. 384.

43 F. Fumi Cambi Gado in Bellosi 1993, pp. 414–19; G. Fattorini in Angelini 2005, pp. 557–8.

44 Weller 1943, pp. 95, 232; A. Angelini in Bellosi 1993, pp. 474–81; M. Boskovits in Boskovits and Brown 2003, p. 497.

45 Seidel 1989a, pp. 31–6; Seidel 1989b, pp. 91–116; A. Angelini in Bellosi 1993, pp. 478–81.

46 Seidel 1979, pp. 3–108; Angelini 1988, pp. 20–1; Sricchia Santoro in Bellosi 1993, pp. 420–3; Christiansen, Kanter and Strehlke 1988, p. 26; Angelini 2002, pp. 131–2.

47 On Signorelli in Siena see Seidel (1984) 2003, pp. 645–707; T. Henry and L. Kanter in Henry and Kanter 2002, pp. 22–3, 167–9. On the Saint Christopher in the Louvre see A. Bagnoli in Bellosi 1993, pp. 440–3.

48 Scarpellini and Silvestrelli 2004, pp. 112–28, 160–89.

49 A. Angelini in Caciorgna, Guerrini and Lorenzoni 2006, pp. 83–99.

50 For the Piccolomini commission as a whole see R. Bartalini in Bellosi 1993, pp. 463–8; Dunkerton, Christensen and Syson 2006, pp. 18–59. For my proposal on the identity of the Master of Griselda see A. Angelini in Caciorgna, Guerrini and Lorenzoni 2006, pp. 505–21. See also Henry and Kanter 2002, pp. 147–56.

51 Tátrai 1979, pp. 27–66; L. Syson in Santi and Strinati 2005, pp. 199–203; Dunkerton, Christensen and Syson 2006, pp. 4–66.

52 Scarpellini and Silvestrelli 2004, pp. 221–6, 233–41, 247.

53 T. Henry and C. Plazzotta in Chapman, Henry and Plazzotta 2004, pp. 23–6.

54 F. Sricchia Santoro in Bellosi 1993, pp. 486–7; A. Angelini in Caciorgna, Guerrini and Lorenzoni 2006, pp. 531–2.

55 Ibid., pp. 533–5; for a differing opinion regarding the frescoes at Sant' Onofrio, see Faietti and Oberhuber 1988, pp. 52–72.

56 Serlio 2001, IV, p. lxix.

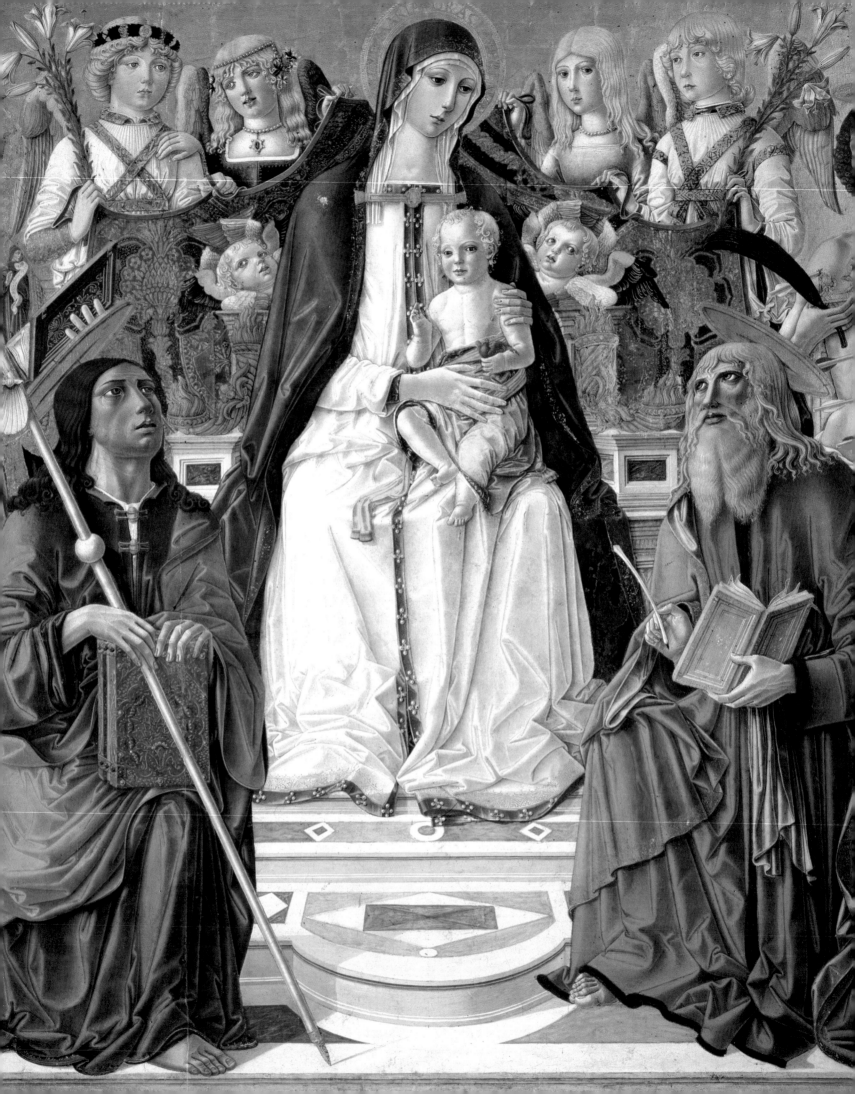

STYLISTIC CHOICES

LUKE SYSON

The Sienese Renaissance was the real thing. By the first decade of the sixteenth century, as Alessandro Angelini has explained in the previous essay, most of the works of art produced in Siena obeyed creative conventions that were already the norm elsewhere in Italy. By this period, Siena shared the widespread aim to produce paintings and sculptures that combined descriptive naturalism with an apposite range of references to ancient art. But until then – and sometimes afterwards – Siena was also noteworthy for its continuing regard for the art of its medieval past. These two stylistic strands have usually been treated as separate phenomena. Some scholars, unembarrassed by Siena's persistent medievalism, have viewed the city as a place where the religious 'mysticism' of the Middle Ages was marvellously preserved – and celebrated in art.[1] Others, by concentrating on what was novel or up-to-date, have sought to counter what had become a pervasive (but wrong-headed) idea of fifteenth- and early sixteenth-century Siena as a stagnant backwater, left behind by the rapid stream of the humanist-led Renaissance.[2] Actually, both these approaches have the real merit of linking the art of Siena to its broader cultures. Even so, what is perhaps the most remarkable characteristic of Siena in this period is the co-existence of these two cultures, and the styles associated with them – sometimes running in parallel, sometimes combined in a way that is astonishingly sophisticated.

Artists and patrons in the late Quattrocento were only gradually converted to the artistic ideals we associate with the Renaissance, naturalistic and *all'antica* styles were embraced more ardently in some quarters than in others; Siena's art was for a time essentially polyglot. It is therefore important to understand when and why different stylistic choices were made, and by whom – and to ask indeed why Renaissance styles ultimately prevailed. The overtly medievalist aspect of fifteenth-century Sienese art has recently been linked to the city's politics: 'Perhaps nowhere more vividly than in Siena does art operate as a powerful form of cultural self-definition; in fact, long after the heyday of its territorial expansion, we find Sienese art operating as an ongoing assertion of autonomy, cultural hegemony and resistance . . . '.[3] And Sienese pictorial style is defined by what it is not, by its not being Florentine: 'The Sienese artists of the Quattrocento looked to the Trecento origins of their tradition rather than the "new" art of Florence not because the conservatism of their patrons constrained them to be provincial, as is so often stated, but because of a resolve to maintain an alternative to the artistic language of Florence.'[4]

The suggestion that any analysis of the arts of Siena should take account of the city's long-standing loathing of its intimidatingly powerful neighbour is shrewd.[5] Evidence of this mistrust is found, for instance, in the account by Pius II of his employment of the Florentine sculptor and architect Bernardo Rossellino. When in 1462 Pius visited the town of his birth, newly re-christened Pienza, to inspect Rossellino's Renaissance buildings, he found the architect accused of cheating, incompetence and extravagance. There may have been some truth in these claims, but Pius added, 'He was a Florentine named Bernardo, hateful to the Sienese by his mere nationality'. Sienese anxiety about a politically and culturally domineering

Fig. 21
Detail of fig. 53

Florence is therefore part of the story, and visual references to Siena's artistic past can sometimes be interpreted as a symptom of cultural unease, mirroring bigger political anxieties. Its medievalism was consciously nurtured to buttress its civic identity when that distinctiveness was under threat.

However, Pius, though Sienese, had nonetheless chosen to employ Rossellino – to do something different. As Angelini has explained, the introduction to Siena of styles that can legitimately be termed 'Renaissance' was linked in great measure to the interests of the pope. Thus political readings of Sienese art cannot be avoided, but they need to account for both continuity and change. Of course, artists' own creative impulses and influences were absolutely essential for the appearance of their works, and no style in Siena (or anywhere else) was ever straightforwardly the product of ideology. It was surely the case, however, that the particular visual style of a city was perceived as akin to its dialect. While this language, oral or visual, might be to some extent learned naturally (with other idioms invading almost imperceptibly), both dialects and styles could also be deliberately defended, preserved and made to stand for larger identities. It is clear that certain styles came to be associated with particular groups and creeds, and that the appearance of works of art could carry this broader significance. Further, styles or manners that had evolved in the first place without any precise message in mind could be revived, bolstered or annexed for specific ends. When one such style referred to a precise historical period, the meanings attached to that era become crucial for our understanding of the work of art. The adherence in Siena to a Trecento

aesthetic for painting could certainly be defensive, but it was also celebratory. Styles that were fresh or that referred to other, non-medieval pasts might be connected to values that repudiated or amplified the mainstream Sienese republican tradition. Languages for art – both native and non-Sienese – were evidently deliberately selected by patrons and the artists serving them, and in interpreting their choices an appreciation of the intertwined politics and religion of Siena is essential.

THE OLD

A culture of copying has long been seen as central to the perpetuation of Siena's artistic tradition. This culture of imitation involved not just artists but also patrons and, just as importantly, viewers. There are many indications in this period that citations in one work from another were spotted and that the references were seen as significant. Central, for example, to the theology of devotional image-making, all over Italy and beyond, was the belief that a new work should be recognisably derived from an especially powerful prototype.[6] Stylistic control exerted by patrons is indicated most obviously by contractual stipulations that regularly demanded the copying of other works of art.[7] What is now the most famous example of such a procedure in Siena occurred in 1448, when Sano di Pietro was instructed to base his predella for the altarpiece in the Cappella de' Signori (the main chapel of the Palazzo Pubblico) on frescoes painted more than a century earlier by Simone Martini and the Lorenzetti brothers on the façade of the Hospital of Santa Maria della Scala.[8] Contracts containing

conditions of this kind were not rare in Italy, but in Siena it appears that it was not just the general structure or composition of a pre-existing work that was to be duplicated but also elements of its style.

This maintenance of the Trecento tradition during the third quarter of the Quattrocento was more imperative in some contexts than in others. Many of the paintings that were most unswervingly faithful to the style developed by Simone Martini (fig. 22) and the Lorenzetti brothers were made for organised groups – for civic bodies and, predictably, for many religious corporations. These were groups for whom the maintenance of collective identity was far more important than making individualist statements through artistic novelty. The polyptych altarpieces painted for the churches and chapels of the preaching and penitential orders, and for the meeting places of the lay confraternities linked to them, are prime examples of these deliberately conservative commissions.[9] For the Observant Franciscans and Dominicans and the Gesuati and Umiliati, devotion to an established group aesthetic might be one method of binding devotees into communities of belief. These were the patrons who, long after Siena had seen the introduction of more innovatory styles, kept alive the careers of Sano di Pietro and Giovanni di Paolo, devout Trecentists both. Arguably, these painters were past their prime by the first years of the 1460s, but they went on receiving such commissions for another twenty years (dying in 1481 and 1482 respectively), so, even if their style – to modern eyes – had ossified, becoming wearily formulaic, their willingness to repeat themselves clearly made them desirable.

Fig. 22
Simone Martini (1284–1344) and
Lippo Memmi (active 1317–about 1347)
*Annunciation with Saints Ansanus and
Margaret(?)*, 1333
Tempera on panel, 184 × 210 cm
Galleria degli Uffizi, Florence (P1024)

A crucial component of the mission of the urban mendicant orders, especially the Franciscans and Dominicans, was their interaction with a lay public. Their insistence upon aesthetic orthodoxy should be linked with their need to speak in a language that was shared and familiar.

GOVERNMENT ART

The preaching and penitent orders were not, however, the only artistic patrons for whom the medieval tradition was essential. These visual conventions were often no less critical for works commissioned by the state itself. Just as the most important elements of Siena's civil religion were fundamentally medieval, so too the civic rhetoric, the social structure and the actual functioning of the government of the Republic were shaped by what had happened in the two centuries before.

It was not always an easy inheritance. Even by the complicated standards of other republics in Italy (like Florence, Venice or the little town of Lucca), fifteenth-century Siena was burdened with a system of government that baffled outsiders, even at the time. The republic had been established in 1186, when Holy Roman Emperor Frederick Barbarossa conceded the right of self-government to the city. It was not, of course, fully democratic in the way we understand today. The franchise was limited, enshrining an ideal of a disinterested governing class; it has been estimated that Siena had about 15,000 inhabitants but a citizenry of only around 3000 adult males eligible to serve in government. All appointments were strictly temporary. The government – the *reggimento* – was formed of a Capitano del Popolo (Captain of the people), the highest state authority, and his cabinet, the Concistoro of nine priors (or *signori*) who would each serve for two months. The Concistoro controlled a whole network of other state offices and magistracies, also occupied on a short-term basis. There was therefore no category of professional politician in Siena; politics coursed through the daily lives of all citizens eligible to serve. The Concistoro was answerable to two main houses:[10] the Consiglio generale (General council) with around 300 members ultimately approved the Concistoro's most important measures, while the Consiglio del Popolo (Council of the people) held both to account. It was ensured that all the areas of the city were equally represented in all these bodies.

This, however, was not the aspect that perplexed foreigners. The real peculiarity lay in what should probably be called the party system. From 1403 to 1480, the city was run by a tripartite alliance, with representation again divided evenly between the three ruling factions, known as *monti*. Membership of all three was determined by descent from those families who had formed three of the four regimes of the late Duecento and the Trecento – the *Nove* (who governed from 1287 to 1355), the *Popolari* and the *Riformatori* (1364–80). Since these families came from the merchant and banking classes, rather than the older nobility, their *monti* were deemed 'popular'.

They may have started life as something close to orthodox political parties, but by the fifteenth and sixteenth centuries they had evolved into something more akin to tribes. Membership of one or other was required for access to the upper echelons of government, and Siena was therefore governed by a relatively closed, though not (as in Venice) officially limited oligarchy. Only very occasionally was anyone new admitted. This was a system of government that artificially perpetuated and institution-alised old factional divisions. The members of each *monte* were united mainly by clan memory, and the tribalism of the Sienese citizenry was determined more by past events and loyalties than by present priorities. It is unsurprising that the style – including the visual style – of government frequently referred to the specific, medieval past when these families had come to power.

These considerations are important since the government had considerable scope for shaping the appearance of the city. The *reggimento* was responsible for the mainte-nance and adornment of the buildings that it occupied, above all the Palazzo Pubblico. Continuity was all-important and, instead of replacing old mural schemes with others that were more modish (as happened else-where), the Sienese government made considerable efforts to ensure their survival: Pietro Orioli's 1492 restoration of Ambrogio Lorenzetti's celebrated frescoes of *Good and Bad Government* is just one example.[11] Like that of the city's religious orders and confraternities, the government's regard for the city's visual tradition was declared through its choice of artist and through the reiteration of certain subjects. Sano di Pietro's intentionally derivative work at

the Cappella dei Priori was only one of his numerous government commissions (see cat. 1); he was responsible, for instance, for more of the commemorative panels made for the financial magistracies of the Biccherna and the Gabella (for which see cat. 2–5) than any of his more innovatory peers or successors.

Governmental influence over the artistic life of the city was extended by other means. The *reggimento* might make special payments, using public money, for building or rebuilding. The following text, of a govern-ment subsidy of 1449, includes many of the typical ingredients that linked city pride and piety to the beautification of its monuments:[12]

'Again, seeing how much it is the duty of every Christian to honour God, and that a city is honoured by nothing more than by its churches – and we see that our ancient fathers have given all their efforts for the beautiful buildings that they made, but since they were not able to carry through their churches in accordance with their great and glorious beginnings it is neces-sarily the duty and the pride of our republic to finish them ourselves. And since they have already spent a great fortune on these, with the little expense that we make we will come to receive the crown and the honour of all the expense that has been made. These temples, if they are not soon repaired, are, especially some of them, going to go to ruin, in particular the churches of San Francesco, San Domenico and Sant'Agostino. There-fore, for the satisfaction of public honour and the duty of divine worship, and so that no longer, to the displeasure of eternal God and those glorious saints to whom they are dedicated, and to the great disgrace of our

city, should they remain uncompleted, but should expediently be finished to the honour of God and glory of your praiseworthy government, I provide and order …'

Generous grants to the three churches follow. This document shows how the embellishment of the city in the mid fifteenth century was consciously modelled upon the honourable activities of its citizens centuries before – another reason why some degree of stylistic consistency might be desirable. Government appointees managed the appearance of several of the city's key sites. The building and ornamentation of the Cathedral were the responsibility of the *Operaio*, who ran the Cathedral Office of Works or *Opera del Duomo*, remaining always directly answerable to the Concistoro; he was also often given responsibility for other artistic projects sponsored by the state. The government also appointed the chief administrator of the Hospital of Santa Maria della Scala, another powerful patron.

Artistic assertions of stability became especially important precisely since the city was prone to regular shifts in the internal balance of power. The fissures built into the three-party alliance often caused tremendous difficulties for the smooth running of the *reggimento*, and in fact one or another of the *monti* generally held sway, sometimes wresting control only after considerable furore. Consequently a focus on those images that had long stood for the collective ideology of the city – the protection of its liberty by the Virgin, for example – could mask regime change or could shore up a new administration, implying that the newly dominant political grouping was better equipped to preserve these shared values than its predecessors had been. The

physical preservation or embellishment of key sites had a larger political message, and the restoration of these potent images, including Lorenzetti's *Good and Bad Government* frescoes, could be taken to signify the reassertion or rescue of the values those works embodied. Sienese *libertas* might be literally and metaphorically reframed for different regimes.

The choice of an established and officially legitimised artistic style might even be a measure of political loyalty. Some of the most traditionalist art of the later Quattrocento was to be found in the Sienese territories – in the *contado*. In the towns under Sienese control, works of art could function as expressions of fealty to the centre. Certain subjects were relentlessly repeated, most conspicuously the Assumption of the Virgin. In these milieux, works by Sano di Pietro and Giovanni di Paolo once again proved popular. Even when such paintings were commissioned from artists perfectly capable of innovation their tenor tended to be conservative. It is worth comparing, for instance, Matteo di Giovanni's gold-ground *Assumption* polyptych for an Augustinian church in the Siena-ruled town of Asciano (cat. 17) with his significantly more modern-looking altarpiece for the Placidi family chapel in San Domenico (see cat. 35) in Siena itself, commissioned by an individual.

THE NEW

The self-consciousness with which tradition was maintained by these institutions is often underlined by the stylistic contrasts between many of their commissions and those of other groups (or individuals) whose publics were different or more limited. There is a telling disparity, for example, between works commissioned by the Observant Franciscans and those executed for the Olivetan Benedictines, whose monasteries were built beyond the city walls. The Olivetan monks, speaking mainly to God and to each other (rather than to a lay public), were often more experimental, employing non-Sienese artists like Liberale da Verona, Luca Signorelli (from Cortona) and Sodoma (from the Piedmont via Rome), and setting up what were among the most astoundingly modern works of their day – like Francesco di Giorgio's *Coronation of the Virgin* (fig. 5, p. 13), for their church at Monteoliveto Maggiore or his *Nativity* for their church outside Porta Tufi (fig. 19, p. 39, both now Pinacoteca Nazionale, Siena).

The existence of a stylistic mainstream is thrown into relief by departures from it, and in particular by the identification of the figures who instigated these changes. It is crucial to realise that many of the major changes in Sienese art and architecture, especially in the 1460s and 1470s, emanated from two groups largely excluded from the machinery of power: the *Gentiluomini* (nobles) and the *Dodici* (Twelve). Quattrocento Siena had gratefully inherited the principle of the medieval 'popular' Comune, and clear lines were drawn within the city's élite between the governing class, with its roots in the medieval mercantile class, and the longer established nobility, at the top of the social tree but, from 1280, largely excluded from participation in government. While frequently active – in some cases very successfully so – as merchant bankers, the leading nobles were often also landowners, with estates in the *contado*, many of them

descendants of the counts and barons imported to Siena by the Frankish and Germanic emperors.[13] Among those denied high civic office were members (until the period of his papacy) of Pius II's own family, the Piccolomini.

The *Dodici* were thrown out of government much later. At the very beginning of the fifteenth century, Siena had been ruled by an uneasy alliance of four *monti*. The number was reduced to three when, in 1403, the *Dodici*, the party that had governed Siena between 1355 and 1385, stood accused of plotting with the *Gentiluomini* and with Florence and were expelled from the *reggimento*, their descendants permanently excluded from both main councils. Left out of the political loop, members of both groups, *Gentiluomini* and *Dodici*, were free to pursue entrepreneurial interests, unencumbered by demanding government responsibilities, and some became extremely rich in the process.[14] Being excluded, they may have felt less pressure to subscribe to a group aesthetic. Their art could proclaim other priorities, and indeed their separateness from the politically incorporated. Noble and *Dodici* patrons might therefore wish to appear glaringly modern, a modernity that might – ironically perhaps – be signalled in part by references to a different, non-medieval past – the Antique.

In the mid fifteenth century, the leading member of the *Dodici* was Pius II's banker, Ambrogio Spannocchi.[15] Called 'the Magnificent', Spannocchi broke with existing stylistic models in the architecture of both his palace (fig. 10, p. 25) and his family high altar chapel at San Domenico (fig. 23), for which he employed Giuliano and Benedetto da Maiano respectively.[16] These were edifices

Fig. 23
Spannocchi High Altar Chapel,
Church of San Domenico, Siena

that looked conspicuously un-Sienese, designed by Florentines who employed a fully committed *all'antica* vocabulary. Spannocchi was also the subject of Siena's first portrait medal, made by Francesco di Giorgio. This art form set out to revive the coin portraits of ancient Greek and Roman emperors, but Spannocchi's medal was created in the context of a republic that was understandably suspicious of commemorative (princely) portraiture.[17] The banker's portrait was also included among those of ancient Roman emperors on his palace façade. All these departures can be regarded as nose-thumbing rejections of the communal Sienese tradition.

The Antique was still more significant for the nobles. Many of these families invented genealogies that placed their familial origins in a period long before the republic was even dreamed of. The Piccolomini traced their lineage to an ancient Etruscan family.[18] The Tolomei went further, claiming descent from the Egyptian Ptolomies.[19] Ways of defining nobility were always an obsession in Renaissance Italy. Blood and ancestry were politically what counted most in Siena, but it was also believed that nobility should be proved by deeds and manners. The chivalric code remained central. Increasingly important, however, was a particular brand of a humanist culture that seems to have been associated with the nobility (and its *Dodici* allies). There were two kinds of humanism in Siena, not always easily separated out, but the different ways in which ancient texts were studied might become a way of distinguishing sheep from goats. The Sienese University (the Studio) concentrated on medicine and law;[20] it therefore provided professional training – as well as humanist education – for use in service of the state.[21] This type of civic humanism is personified by the prolific Agostino Dati (1420–1478), teacher of literature at the University, ritually condemned by modern historians for his dullness and parochialism, but a man of considerable learning (however limited his imagination).[22] Dati discussed the nobility of letters, as opposed to that of blood, but his parameters remained mostly rather narrowly practical. He knew Greek and was the writer of a popular manual of Latin grammar and a history of Siena (*Historiae Senenses*). He took on governmental responsibilities and delivered countless orations for weddings, funerals and state visits. Running counter to this approach was the increasingly respectable idea of humanism for pleasure – study for its own sake, rather than solely for utilitarian application. This is the kind of humanism associated particularly with Aeneas Silvius Piccolomini (though his scholarship also contained a strong hard-headed streak) and his circle. The celebrated jurist Mariano Sozzini (1397–1467), a good friend of the future Pius II and member of the *Dodici*, stressed the idea of humanist *otium*, the idleness required to make the study of ancient texts into an abstract philosophical enquiry: 'The more I have a good time, the more I enjoy myself, and I confess and swear to you that I have never minded enjoying myself.'[23]

This latter approach was by and large the one that patrons wished to see translated into art objects. Angelini has convincingly argued that the fully antique language of Antonio Federighi's sculpture should be associated with Pius II and the group around him, not least, we should add, because it is now established that Federighi himself was a fellow noble, a member (though perhaps by adoption) of the Tolomei family.[24] Pius's classicising tendencies and those of his heirs were fully on view in the family chapel at San Francesco, once containing Federighi's sculpture, and in the Piccolomini palaces in Pienza and Siena.

For obvious reasons, this kind of message was easier to convey in secular contexts, not only in the architecture of a family palace but also in the schemes adopted for its internal decor. It has been said of the marked increase in painted schemes for private palaces in the later fifteenth century that '... this shift from the public, civic patronage of art to private, familial

patronage reflected, to a degree, shifts in power bases and ideologies of the city's political and social élite ...'.[25] New styles were developed and new areas of subject-matter explored for the paintings and (more rarely) statuary that adorned the reception spaces, bedchambers and court-yards of the palaces constructed in this period – and once again, it appears that the Piccolomini and their closest allies were in the vanguard. From the 1460s onwards (and only very rarely before), subjects were taken from Greek and Roman history and mythology and, quite quickly, standardised devotional images of the Virgin could be seen situated near episodes from the lives of ancient heroes and – principally – heroines.[26]

Since many such images were commissioned in connection with the marriage alliances formed between the city's leading families, it was women's beauty, and the virtues that their beauty conveyed, which were chiefly celebrated. Another ingredient fed into this new category, one that had major implications for its style – poetry, composed sometimes in Latin, but especially in Italian or *volgare*. The many bucolic celebrations of love and the sonnets honouring the leading beauties of the city were often appropriately Virgilian but also found a primary model in the Trecento poems of the great poet and scholar Petrarch (1304–1374). Leading Sienese poets of the mid Quattrocento included the noblemen Niccolò Salimbeni and Jacopo Tolomei, the latter another of Pius's associates.[27] Perhaps the most successful Sienese poet of all was Bernardo Lapini, called Ilicino (1433–1476), born into a noble family from Montalcino. In 1468–9, he took the chair of medicine in

Ferrara, subsequently making himself known at the Este court; Ilicino even dedicated his commentary on Petrarch's *Trionfi* (*Triumphs*) to Duke Borso d'Este. Revealingly, there was a rash of Petrarchan subjects for paintings made in Siena at about this time, many taken from the *Trionfi*. Many of the famously beautiful women celebrated in Sienese poetry were also born into noble clans – not least Bianca Saracini (cat. 50) and her mother Onorata Orsini.

The majority of these paintings, of beautiful and exemplary women with stories of Dido or Virginia, Cloelia or Tuccia, decorated the fronts of the chests that contained the dowry of brides as they left their parental homes and entered their husbands' houses. These wedding chests, now usually called *cassoni* (though *goffani* is the word found in Sienese inventories at the time),[28] though not absolutely unknown in Siena before this time, were much more popular in both Florence and the North Italian courts. In Siena, they must have been considered modern – and *all'antica*, if, as elsewhere, their shape was thought to reflect Roman sarcophagi. Since many of these paintings are now detached from the chests they adorned it is not always known for whom they were executed. There is however evidence that several of the earliest *cassoni* were commissioned by Siena's noble families. One of the first, with a scene of *The Triumph of David*, still retaining its coats of arms, was painted by Benvenuto di Giovanni during Pius's pontificate, for one of the two weddings in 1459 of members of the Piccolomini and the Buoninsegni families (now Pinacoteca Nazionale, Siena).[29]

The desired combination of ingredients, iconographic and stylistic, courtly, poetic

and properly ancient, is best exemplified by a now rather damaged *cassone* painting by Benvenuto di Giovanni of about 1468–70 representing *Apollo and the Muses* (fig. 24), once a lyrical riot of gold, silver and gorgeous blondes. Specifically Sienese Muses had been described in two poems of the 1430s by the Sicilian poet Giovanni Marrasio (see cat. 73), and Benvenuto painted his picture at exactly the moment when Ilicino's links with Ferrara, with its famous series of *Muses* painted for the Este, were strongest.[30] Benvenuto seems to have looked at Ferrarese art to arrive at his image. The attributes of the Muses, Apollo's crown and even the ornately fluttering draperies (albeit updated) are derived from a set of Ferrarese prints, the so-called 'Tarrocchi di Mantegna'.[31] The figure of a poet in Benvenuto's painting beneath the fountain of love, dreaming the scene around him,[32] has tentatively been identified as Petrarch, though it may well be Marrasio,[33] or perhaps Ilicino himself.

It is possible that some of these pictures, currently classified as *cassone* panels, functioned in fact as autonomous works of art. If this is the case, it may be that a genre considered archetypically 'Renaissance' – the mythological *poesia* – was actually initiated in Siena. One of the most delightful is the painting by Francesco di Giorgio in the Berenson collection at Villa I Tatti (fig. 25). This picture, dateable to the late 1460s, is widely thought to be a fragment originally attached to a panel now in the Stibbert Collection in Florence depicting the *Rape of Helen*, the two parts forming a narrative.[34] Careful re-examination of these continuous works shows that they do not in fact join up: therefore there is no need to think of

the I Tatti picture as part of a larger whole, and, on its own, its proportions make it most unlikely to have been part of a *cassone* front.[35] It may be sensible to revisit the idea that the work tells the story of the punishment of Psyche by Venus (wearing a crown).[36] Whatever the subject, it incontrovertibly shows Francesco di Giorgio at his most self-consciously poetic – and classicising.

Even if it is not possible, in this instance, to prove a direct link between Francesco's pioneering *poesia* and a member of Siena's humanist nobility, there is no questioning the overall cultural context from which it came. In the case of the few portraits made in Siena during this period, the connection with the noble class is clearer still. It was Pius II who commissioned Federighi's sculpted full-face portraits of his parents on their tomb at San Francesco (see fig. 15, 16, p. 33). The only surviving painted portrait by a Quattrocento Sienese artist, Neroccio de' Landi's *Portrait of a Lady* (cat. 51), probably represents a noblewoman, one of the daughters of Bandino Bandini and his Piccolomini wife. It is the painted equivalent of the poems written by Ilicino and others praising celebrated Sienese beauties, and it was inspired by sonnets written by Petrarch lauding Simone Martini's (perhaps

mythical) portrait of his beloved Laura. One Sienese poet had dedicated a poem to his beloved: *'a ley fa' che consacri ogni mio stile'* (to her who makes holy my every style). Neroccio seems to have had the same idea, and it was less important that his portrait resembled his sitter than that his picture was entirely beautiful. It was intended to be a summation of his delicate style and it was another, secular, way of converting the artistic heritage of Simone, at whose work Neroccio looked closely.

AUGMENTING THE TRADITION

Neroccio's portrait, if that is what it really is, represents a blending of styles. It lies between the two extremes of the utterly traditional and the wholeheartedly modern, constituting an important third category – which for some has proved troubling – of works, produced above all in the 1460s, 1470s and 1480s, in which we see a modernising or enrichment, but not a complete abandonment of tradition. These are works that can be said to appear both stylistically medieval and Renaissance.

In this period certain patrons and artists seem to be performing careful balancing acts in order to create works appropriate to

different classes of commission. Pius is a case in point. Although, as with the Spannocchi, the Piccolomini family's classicising tendencies were shouted loudly in its family palaces and chapel, in other places Pius deliberately combined the old and the new. He famously stated that Giotto, a Florentine, was considered the leading painter of his day. Yet in the four celebrated altarpieces Pius commissioned in the early 1460s for Pienza Cathedral he arrived at a combination of a structure and format that were Florentine and *all'antica* (probably involving Bernardo Rossellino in their design) with gold-ground pictures by the most important Sienese artists of his day, including the two least indebted to the tradition of Giotto, Sano di Pietro and Giovanni di Paolo. It is true that these altarpieces, and certainly those by Vecchietta and Matteo di Giovanni, introduce Florentine motifs, especially at their margins, but there is no doubting that the intention, for both political and religious reasons, was to extend the possibilities of the Sienese tradition rather than to discard it.

Even for government bodies, the aims and context of a commission could sometimes become more complex and nuanced. It may be taken as read that a Trecento-inspired language for art was acknowledged as

Fig. 24
Benvenuto di Giovanni
(1436–about 1509)
Apollo and the Muses, about 1468–70
Tempera, gold and silver on panel
46.4 × 120.3 cm
The Detroit Institute of Arts, Detroit, MI
Founders Society Purchase
General Membership Fund (40.128)

Fig. 25
Francesco di Giorgio Martini (1439–1501)
Mythological Scene, about 1468–9
Tempera and gold on panel
41.6 × 53 cm
Berenson Collection, Villa I Tatti
Florence (P 39)

signifying Siena's political identity. Hence it
seems reasonable to propose that the styles
of other cities were accepted as standing for
theirs. The introduction to Siena by its
officialdom of motifs that were recognisably
'foreign' might therefore have political
meaning. Sienese policy towards its neigh-
bours was often determined by the external
power supporting the dominant internal
faction. In the first half of the Quattrocento,
the *Nove*, the oldest of the 'popular' *monti*,
largely prevailed. This grouping was stoutly
anti-Florentine, pro-Holy Roman Empire
and pro-Naples: their allegiances were seen
as broadly Ghibelline. From the defeat of
the attempted 1456 *coup d'état* by Antonio
Petrucci and his *Noveschi* allies (see cat. 1)
until the end of the 1470s the government
was dominated by the *Riformatori*. Several
leading *Noveschi* were exiled and the *reggi-
mento* adopted a cautiously pro-Florentine
policy, perceived as Guelph.[37] *Riformatori*
were given leading roles at the Cathedral
office of works, the Hospital and the
University.

It has thus been suggested that, even if
the civic iconography did not substantially
change, these swings of political allegiance
were reflected or emblazoned by the styles
of works produced during these times.

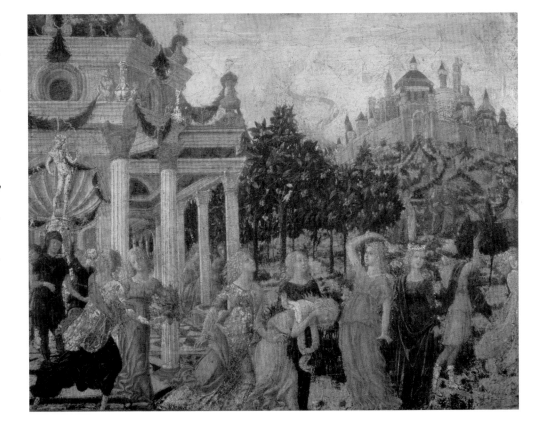

Fig. 26
Donatello (about 1386–1466)
Virgin and Child relief (known as
Madonna del Perdono), about 1457–9
Marble, 90 × 88 × 9 cm
Museo dell'Opera del Duomo, Siena (4751)

While working mainly within the stylistic parameters already described, government might subtly change tack. Although it would be wrong to say that Florentine art or artists were barred from Siena in the first half of the fifteenth century, it seems that their reception was sometimes less than rapturous. The Florentines Lorenzo Ghiberti and Donatello had been employed in the 1420s to sculpt reliefs for the Baptistery font, but Donatello was chosen only after the Sienese Jacopo della Quercia had failed to deliver and, even then, his bronze door for the font tabernacle was rejected in favour of a relief by the Sienese goldsmith and sculptor, Giovanni Turini.[38] At the beginnings of their careers painters like Sano di Pietro and Giovanni di Paolo used these and other Florentine compositions *in toto*, but challenged them by translating their separate ingredients – figures and their spatial settings – into a Sienese idiom.[39]

In the second half of the century, the stance changed and it becomes apparent that one key aspect of Sienese artistic modernity, far from being regarded as challenging a communal aesthetic, was actually legitimised by the state; 'Donatellism'. The central thesis of the extraordinary 1993 exhibition in Siena, *Francesco di Giorgio e il Rinascimento a Siena*, was that Donatello's time spent in the city between 1457 and 1461 signalled a new direction for Sienese art. On 16 September 1457, the emergency Balìa, the council ruling the city in the wake of the failed *coup d'état* by Antonio Petrucci, accepted the proposal made by the *Operaio* of the Cathedral office of works that the aged Florentine sculptor, by then the most famous Italian artist of his time, should be invited to live out what remained of his life in Siena.

The words of its decision reveal much of the reasoning behind Donatello's employment: 'Since it is the case that in your city there has arrived Donatello, most excellent master of sculpture, who desires to die and live in Your city, if it please Your Lordships, and in it, since it is the most noble city in Italy, to make some very outstanding [*singolarissimo*] work in honour of Your city and its posterity ... and therefore, so that Your city, and especially Your church [the Cathedral], may be adorned with one of his works, they have provided and ordered that the task of deciding what he should do should be placed in the charge of your *magnifico* the *Operaio* of the Cathedral, who should choose three of the present college [the Balìa], and together with these three

should provide to the effect that the said Donatello stay here for the extent of his life through those best means that seem to them most to the advantage and honour of Your city ... the which, besides what has been mentioned, shall be occasion to create in Your city some very outstanding master.'[40] The document concludes with the names of the four members of the special *commissione donatelliana* – one from each *monte* and, at its head, the newly appointed *Operaio* of the Cathedral, Cristoforo Felici, who had replaced the disgraced – and decapitated – *Novesco* conspirator Mariano Bargagli.

The government decision to employ Donatello in Siena would not have been possible if the artist himself had not wished it for a range of personal reasons. But his

arrival could take on additional meaning. Donatello's Sienese sojourn was to be absorbed into the civic tradition, linked as it was with the ornament of the city and particularly of its main religious institution, the Cathedral. It has been suggested that the choice of Donatello reflected the pro-Florentine tendencies of the new *Riformatori*-dominated regime.[41] On the evidence of the letter of 14 April 1458 to Felici from the leading *Riformatore*, Leonardo Benvoglienti, this interpretation seems reasonable: 'And give my regards to the master of the [bronze] doors [of the Cathedral], master Donatello. He is really ready to do you great honour, and if signor Mariano [Bargagli] had believed me in this, I would have brought him here from Padua four years ago, since he had a great passion to be in Siena, so as not to die among those toads of Padua, which he very nearly did.'[42] The *novesco* Bargagli had not, it appears, wanted the Florentine, and his reasons may have been political.

The Balìa's desire to obtain the services of the man who by then was far and away the most famous artist in Italy was politically as well as culturally competitive. By luring Donatello away from Florence for the glory of Siena, his style could be annexed to represent the city's success in bringing him there. Apart from the bronze Cathedral doors mentioned by Benvoglienti, Donatello was immediately put to work to adorn possibly the most important of all sites for the civic religion of Siena with a relief of *The Virgin and Child* (now, misleadingly, usually called the *Madonna del Perdono*; fig. 26). The relief was carved for the new chapel that would house the quasi-miraculous picture of the *Madonna delle Grazie* (or *del Voto*),

promoted during the early Quattrocento by the anti-Florentine *Nove* to stand for the protective Virgin of Siena, who had been instrumental in the defeat of Florence at Montaperti (fig. 27). This image was now serving the post-*coup* regime, appropriated at a moment of political crisis.

Donatello's *Madonna* relief was to be seen working in conjunction with the *Madonna delle Grazie*, the Virgin's protective powers extended to the new work by association: this was the protectress of Siena reformulated for a new age. For many, this connection effectively made Donatello's work 'Sienese', and that it was viewed in this way is indicated by its imitation in subsequent Sienese art. It was also the stated aim of the government to form Sienese masters in Donatello's image. Probably it had the art of sculpture and the craft of bronze-founding in mind, but 'Donatellisation' also affected painters, who began to look at sculptural sources in a new way. Matteo di Giovanni and Benvenuto di Giovanni in particular introduced such new, sculpturally derived elements into their works while maintaining the sovereign stylistic tradition of Siena; but instead of taking over whole compositions they made efforts to understand the thought behind Florentine art, especially that of Donatello. Now they quoted individual motifs, and they altered their stylistic approach to figures, reconsidering their anatomies, modelling with light and shade, energising their draperies (without sacrificing their elegance). This was a new vocabulary, but it was absorbed within the Sienese dialect rather than repudiating it.

Even if Sano di Pietro continued as the favourite artist of the government, this new

style became the language for art employed by the families included in Siena's tripartite ruling alliance for their own projects. A shared – communal – rhetoric continued to unite all three parties, and accordingly members of the ruling *monti* demonstrated their historical ties to the Comune by subscribing to this broad, if now embellished, visual tradition. Given, however, that the rationale for factional allegiance was increasingly hazy – based as it was on ancestry – individuals and families from all the governmental *monti* increasingly made their political choices for present circumstances independent of traditional loyalties. During this period, we begin to see a shift towards a cautious individualism, with a growing stress on the value of individual prowess (within the larger group) in both humanist writings and Franciscan and, particularly, Dominican preaching.[43] It was argued that individuals had the right to rule in concert because of their particular merits. The works of art commissioned by the ruling families have something of the same tone. Their own special projects still fitted into larger wholes, like the family chapels in those churches already regarded as the ornament of the city – San Domenico, Sant'Agostino and San Francesco; this was individuality operating within the system rather than outside it. But increasingly families keen to stress their individual status did so, from the 1470s onwards, by commissioning works of art, especially altarpieces, from artists who still worked within the existing stylistic template but whose personal styles (like Donatello's) were more distinctively their own. These patrons looked to a new generation of artists – Matteo and Benvenuto, Francesco di

Giorgio and Neroccio de' Landi. Among the best examples of works which merged old and new styles are Matteo di Giovanni's Placidi Altarpiece (see cat. 33–7) and Benvenuto di Giovanni's Borghesi Altarpiece (see cat. 32), both in San Domenico and made for families within the *reggimento*.[44] Both subtly blend inflections of Donatello with the older tradition of the *Madonna delle Grazie* (surely the source for Benvenuto's Borghesi Altarpiece Virgin, fig. 21) and Simone Martini's painting. This tendency is also evident in many works for private devotion (see cat. 13–14).

Copying remained a crucial element. It is clear that, while some contractual directives were designed to affirm tradition, other similar instructions to emulate this or that model were intended to ensure that a new building, picture or sculpture was properly up-to-date. In 1474, Giovanni di Niccolò, abbot of the Cistercian monastery of San Galgano, cited the Spannocchi palace: his own new palace was to be 'almost in the form that is the palace and mansion of Ambrogio Spannocchi' (*quasi in quella forma è il palazzo et casamento d'Ambrogio Spannocchi*).[45] In 1478, the German company of bakers in Siena told Matteo di Giovanni to model the altarpiece they had commissioned on the Borghese altarpiece, only just completed. It is significant that, although this was a project by committee, the group responsible was not Sienese.

IMITATING THE NOBLES

It is not coincidental that, as well as adopting a subtly modernised communal style, these family altarpieces – especially their overall structures – also have something in common with the works commissioned by Pius II for Pienza Cathedral. Nobility was something that non-nobles aspired to, and a key aspect of the self-aggrandising strategy of members of the 'popular' *monti* was their steadily increasing desire to demonstrate their 'nobility'. The models were there to emulate. One of the more curious features of the social life of Quattrocento Siena was the city's emblematic use of the nobles, despite the political suspicion in which they were held, as evidence of a glorious past and present chivalric values. The aristocratic mien of their men and the glamour of their women were exploited as the ornament of the whole city. In 1473, for example, Sano di Pietro painted a panel for the tax office of the Gabella commemorating the marriage of the noblewoman Lucrezia Malavolti with the foreign mercenary 'prince' Roberto di Sanseverino, one of the first official images marking a purely private occasion.[46] The nobles were officially indulged, with tax breaks granted by the state to enable them to maintain an appropriately lavish lifestyle. One noble widow thought it perfectly acceptable to plead clemency from taxes because, even though she was rather badly off, she absolutely could not survive without a slave and a maidservant to assist her in the house. Similarly, Francio Tolomei sought tax benefits to bring up his son properly, who otherwise 'does not do anything other than moon around, gamble and spend money'.[47]

The degree to which the non-aristocratic classes adopted an aristocratic way of life has proved controversial.[48] Successful merchants did not suddenly decide to put their feet up, but, since many of the nobles themselves had long become merchant bankers, it was open to these non-noble merchants similarly to mask their commercial activities with a behaviour and rhetoric learned from their 'betters'. Members of the *Nove* argued for their nobility on the grounds of the longevity of their political grouping and their greater wealth; Machiavelli actually saw the *Noveschi* as an aristocracy at war with the *Popolari*, *Riformatori* and their allies.[49] The *Riformatori*, of more recent, often non-urban origins, were rudely dubbed '*homines novi*' (new men) by the older established *Noveschi*. Pius II himself, in an unpleasant little burst of snobbery, called them '*abiecti mercatores*' (low tradesmen).[50] Officially, the anti-noble policy of *Riformatori*-dominated government held firm, accompanied by statements of conventional loathing. Benvoglienti, for example, is well known for his solemn declaration: '*Io, sapientissimi padri, ho sempre odiato i gentiluomini*' (Personally, most wise fathers, I have always hated the nobles). But even the *Riformatori* realised that links with the nobles, achieved mostly by marriage, raised their social status.

There was a scramble for titles. Men from all three governing *monti* were passionately keen to obtain knighthoods and other chivalric honours.[51] They could also demonstrate a new higher status by staging events honouring visiting aristocracy from outside the city. At the 1473 street party hosted by count Tommaso Pecci (a member of the third government *monte*, the *Popolari*) for Eleonora of Aragon, Princess of Naples, on her way to marry an Este duke, he had a wine fountain built in which the heraldic lion of the Popolo spurted red

Fig. 27
Sienese
Madonna delle Grazie (or *del Voto*)
late thirteenth century
Tempera on panel, 112 × 82 cm
Duomo, Siena

wine and the city's *lupetta* (little she-wolf)
issued white, the feast becoming a potent
blend of public and private.[52] From the
1480s onwards, ancient genealogies were
invented for families in the governing
monti, and the Roman foundation myth of
the city was reformulated and re-stressed
(not least in the face of Florentine arguments
that there was nothing Roman about
Siena).[53]

Pius II had made attempts to reintroduce
the nobles (briefly successful) and *Dodici*
(rejected out of hand) into the *reggimento* –
a project of '*concordia ordinum* (harmony
of the estates)'.[54] He also ensured that his
family's connection with Rome would
remain strong after his death by making his
nephew Francesco a cardinal. After Pius's
demise there was inevitably a return to
the political *status quo*, but the nobility kept
up its social position. During these years,
a gradual consensus emerged as to what
constituted a magnificent, aristocratic mode
of living – a noble lifestyle that was no longer
necessarily restricted to the nobility, and
which might incorporate the patronage of
art. The branch of the Piccolomini family
most closely connected with the pope,
incorporated into the *Popolari*, continued
to flourish, and these remained the men to
watch. In the 1480s, Pius's nephews pursued
an artistic policy that embraced the Antique
ever more enthusiastically. To do so, they
began to employ foreign artists. Their
family chapel in the Cathedral, constructed
between 1481 and 1485, was more completely
all'antica than anything seen hitherto in the
city. It has recently been established that it
was not only assembled, but also carved
in Siena by the Roman workshop of the
sculptor Andrea Bregno.[55]

Once again it was the Piccolomini who showed the rest of Siena how a new language for art might be merged with the old, converting an image that had become central to the Sienese tradition, Donatello's *Virgin and Child* relief, into something which was still Sienese but also self-evidently classicising. A Madonna and Child relief in the Chigi-Saracini Collection (fig. 28), with the Piccolomini arms carved into the frame, is normally attributed to a Sienese sculptor (stubbornly, and tellingly, unidentified) who was active in about 1460 and regarded as responding to or even working with Donatello.[56] In fact, a number of stylistic parallels with the Piccolomini altar are evident – the delicate carved ornament, the smoothly rounded flesh carving and the slippery, sensuously clinging draperies, so very like those of the Victory figures in the spandrels of the altar. These parallels make it much more likely that this is a work of the early 1480s, probably carved in Siena by a member of Bregno's workshop (or conceivably by a local Sienese artist who had worked on the chapel project). The sculptor had, however, evidently been asked to copy and adapt a model by Francesco di Giorgio, a terracotta *Madonna* relief of about 1470 now in Budapest, or something very like it – in other words, a work by a Sienese artist, inspired, just as the Balìa had hoped, by Donatello.[57] The impact of Donatello in this Piccolomini *Madonna* is therefore strong but mediated by another work, so that what was being copied was not a Donatello as such, but rather a *Madonna* that was already fully Sienese. There are no papal, cardinal or bishop's insignia over the Piccolomini arms, making it probable that it was executed for one of

Cardinal Francesco's brothers, most probably Iacomo, who lived in the palace where the relief remains to this day. Even after its acceptance into the political life of the city in the 1480s as members of the *Popolari*, the family's nobility singled it out, and so too did its connection with Christian Rome. A member of the family seems therefore to have chosen to translate an image that was accepted as Sienese, using an *all'antica* style, into a work that would express all the family's identities at once. This was another Piccolomini balancing act, and one that went far to establish a new common visual language for Siena that had little to do with the Trecento.

PETRUCCI STYLE

The timing was perfect. This was the decade – the 1480s – that was to transform Sienese politics, bringing the charismatic figure of the *Novesco* Pandolfo Petrucci to the fore. Pandolfo's political role and artistic patronage is discussed in more detail by Philippa Jackson but here it is enough to explain that one of the main planks of his success was his recognition that the noble aspirations of the now long-established governing *monti* could be seized upon as a political opportunity. After the attempted *coup* of 1456, and for a little time thereafter, there was, as we have seen, a period of emergency government by Balìa – a small, temporary committee, 'elected' for a strictly limited term, whose power overlaid the tradition structure. This was the group that approved the state employment of Donatello. Although various claims have been made to the contrary, this authoritarian solution to political unrest did not become

a real feature of the political landscape until the 1480s. In the late 1470s, the *Riformatori* regime was foundering; by the beginning of the next decade, political chaos was complete as the tripartite alliance within the *reggimento* broke down, one *monte* after another taking power, until finally in 1487 the exiled *Nove* rode victorious into town (see cat. 46). The Balìa device had become the standard solution to internal strife, and was not now easily abandoned. In the decade to follow, Pandolfo Petrucci forged links with leading members of the other governing *monti*, successfully pursuing a policy of unity despite the opposition of some of his separatist fellow-*Noveschi*. In 1497, he realised his ambitions, recognising, as Pius II had before him, that Siena would only attain political stability once all its leading citizens were eligible to serve. With a permanent – and dominant – place on the Balìa, Pandolfo was able to reorganise the *monti*. The *Riformatori* had essentially disappeared, and its former members, as well as the *Dodici*, were incorporated within the readmitted *Monte dei Gentiluomini*.[58] The foundations of this policy had been laid many years before, when the future Saint Bernardino had urged Siena to adopt the model provided by the city of Venice, where membership of the ruling class was closed, permanently limiting the number of families who could serve in government. Pandolfo created a similar list, finally establishing a ruling aristocracy for the city that included nobles and non-nobles. Indeed the whole governing class could now define itself as 'noble' and the documents on early sixteenth-century efforts to form a single unified *monte* to rule Siena refer to 'el *monte* de' nobili reggenti'.

Fig. 28
Attributed to the workshop of Andrea
Bregno (1418–1503)
Madonna Piccolomini, early 1480s
Marble, 66.5 × 44.5 × 8 cm
Chigi Saracini Collection
Monte dei Paschi di Siena (MPS 834)

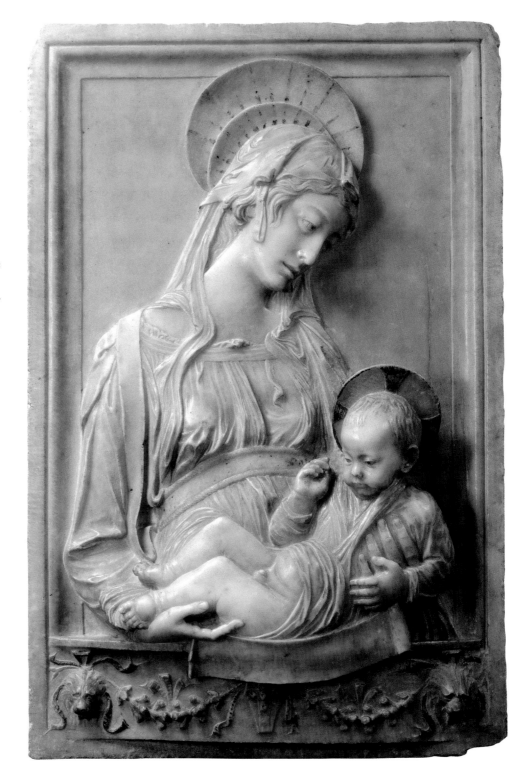

The artistic strategies of the groups previously excluded from power could therefore enter the mainstream. More than that, they could become normative. The Piccolomini remained Renaissance standard-bearers, calling upon Pintoricchio (from Perugia, via Rome) and the young Michelangelo (who, though Florentine, had also achieved great success in Rome) to perform their artistic miracles in Siena. Pintoricchio brought Raphael in his wake (cat. 74–6). The Spannocchi too carried on their family tradition, for they, seemingly, were responsible for bringing the Florentine Ghirlandaio workshop (who painted panels with stories from the lives of figures formally perceived as anti-Republican 'tyrants' Julius Caesar and Alexander the Great; fig. 12, pp. 26–7) and the Piemontese-born Sodoma to the city (cat. 61). Returning *Noveschi* exiles also continued the trends begun by the nobles and the *Dodici*, and more and more non-Sienese artists found work in the city. Luca Signorelli collaborated with Francesco di Giorgio to decorate the family chapel of Agostino Bichi, one of Pandolfo's key allies (cat. 28, 58–9). Perugino was chosen by the ever more rich and powerful Chigi family to paint its family altarpiece. Signorelli, Pintoricchio and Girolamo Genga from Urbino were employed by Pandolfo Petrucci himself for the decoration of his palace (see cat. 80–2). All this activity ensured that Renaissance style ran rife and that Pintoricchio had become the artist who best represented a 'new' Siena.[59] These were hard times for many native Sienese artists: it was a case of adapt or die. As if to underline this final rejection of the Sienese Trecento tradition, Pandolfo organised the removal of Duccio's

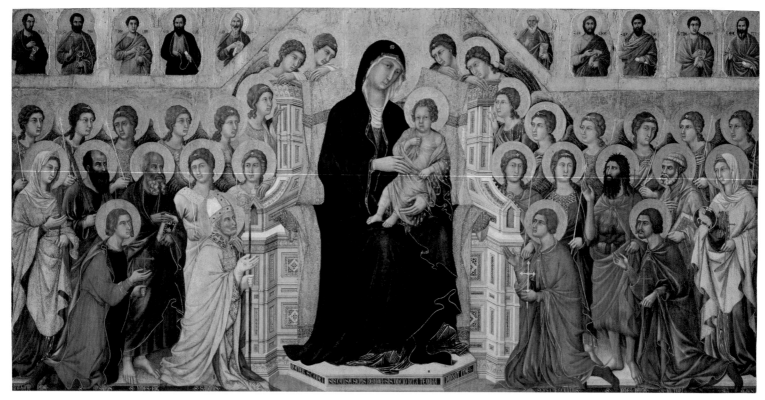

Fig. 29
Duccio (active 1278–died 1318/19)
Maestà, 1308–11
Tempera on panel, 370 × 450 cm
Museo dell'Opera del Duomo, Siena (4538)

Maestà (fig. 29) from the high altar of the Cathedral in 1506. This was an act of deliberate forgetting, a signal of a new inclusiveness that no longer contained the political divisions of the Trecento past. Pandolfo wanted to establish a modern civic tradition in his image.

A CODA

That the political connotations of this foreigner-inspired style were understood at the time is demonstrated by what happened after the regime established by Pandolfo Petrucci collapsed. After his death in 1512, and especially after the victory of the so-called *Libertini* in 1525, the cultural consensus broke down. In 1525, Mario Bandini, a fierce critic of the Petrucci-founded regime, even accused the *Noveschi* of usurping the title of *gentiluomini*.[60] The

Florentines were once again defeated at the battle of Porta Camollia in 1526, and the legend of the special protection of Siena by the Virgin was revisited for this new triumph.[61] The values of the medieval Sienese republic were rejuvenated. Among the first acts of the men who overthrew the Petrucci regime was to parade the *Maestà* and *Madonna delle Grazie* through the streets.[62] The city revived projects associated with its most politically significant civic sites – the adornment of its gates, the internal decoration of Palazzo Pubblico (including images of the city's patron saints) and the initiation of the project to paint a fresco for the Cappella della Piazza where Saint Bernardino had preached.[63] Leading artists such as Beccafumi were once again employed to paint commemorative panels for the state's financial offices (see cat. 94). Work also continued in the Cathedral

(though there it had never stopped). Now the challenge was to adapt for civic use the styles that had been developed in the three previous decades for 'private' spaces: artists like Beccafumi and Sodoma subtly reintroduced elements of Trecento style (see cat. 92). The culmination of this frenzied republicanism is witnessed in Beccafumi's ceiling for the Sala del Concistoro in the Palazzo Pubblico (see cat. 108–9), with its plethora of Roman Republican heroes (this was no place for Alexander the Great or Julius Caesar), commissioned in 1529, just before the arrival in the city of the Spanish troops of the Holy Roman Emperor Charles V.[64] The history of Siena's politics – and its arts – had shifted again.

NOTES

Stylistic Choices

1 See p. 6. For example see Pope-Hennessy 1947, p. 7: '…the place of the Sienese achievement within the complex of Italian Quattrocento painting may be compared to that of symbolist poetry in the twentieth century, in that its constituents are not unskilled or unsuccessful efforts to represent reality, but symbols of a supernatural world.'

2 Particularly in the post-war period. This approach is exemplified in Bellosi 1993, building on the observations especially of Roberto Longhi.

3 S.J. Campbell and S.J. Milner, 'Introduction: Art, Identity and Cultural Translation in Renaissance Italy' in Campbell and Milner 2004, pp. 1–13.

4 *Ibid.*

5 K. Christiansen, 'Painting in Renaissance Siena' in Christiansen, Kanter and Strehlke 1988, pp. 3–32, esp. p. 3.

6 Belting 1994, pp. 314–29, 341–8.

7 For this issue elsewhere in Italy, see O'Malley 2005, pp. 221–3, 231–46.

8 K. Christiansen in Christiansen, Kanter and Strehlke 1988, pp. 146–51, cat. 18a–c.

9 The literature on confraternities is small, but see G. Freuler, 'Sienese Quattrocento Painting in the Service of Spiritual Propaganda' in Borsook and Superbi Gioffredi 1994, pp. 81–98.

10 M. Ascheri, 'Siena del Quattrocento: una riconsiderazione' in Christiansen, Kanter and Strehlke 1989, pp. XIX–LVI.

11 Lorenzetti's frescoes were copied for tapestries in 1446. See Cecchini 1962, esp. pp. 158, 172 doc. IV.

12 Riedl and Seidel 1985, doc. 17, p. 462.

13 Hook 1979, pp. 9–10.

14 M. Ascheri, 'Siena nel Quattrocento: una riconsiderazione' in Christiansen, Kanter and Strehlke 1989, p. XXIV.

15 Ait 2005, pp. 7–44.

16 Carl 2006, pp. 309–19.

17 Hill 1930, p. 77; A. Bagnoli in Bellosi 1993, cat. 18, pp. 160–1.

18 Mucciarelli 1998; A. Angelini, 'Templi di marmo e tavole quadre. Pio II e le arti nei *Commentarii*' in Angelini 2005, p. 34.

19 The family name is spelled this way from the fifteenth century. See J. Fair Bestor, 'Marriage and Succession in the House of Este: a Literary Perspective' in Looney and Shemek 2005, pp. 49–85, esp. p. 59, note 34.

20 C.B. Strehlke, 'Art and Culture in Renaissance Siena' in Christiansen, Kanter and Strehlke 1988, pp. 33–60, esp. p. 34. For humanists and the university, see Zdekauer 1894; Fioravanti 1981; G. Fioravanti, 'Classe dirigente e cultura a Siena nel '400' in Rugiadini 1987, pp. 473–84; Denley 2006, *passim*, esp. pp. 65–8, 129–45.

21 Nardi 1982, pp. 234–53.

22 Viti 1987, pp. 15–22.

23 Nardi 1974, p. 99.

24 A. Angelini, 'Antonio Federighi e il mito di Ercole' in Angelini 2005, p. 147, note 5.

25 Norman 2003, p. 22.

26 Caciorgna and Guerrini 2003; Caciorgna 2004.

27 Medioli Masotti 1981, pp. 21–40.

28 See, for example, *'Vn paio di goffani grandi, dipenti, messi a storie, con fodare [lining] di ualescio uerde'* listed in 1483 among the goods left by the doctor and politician Bartalo di Tura Bandini (1391–1477). Mazzi 1896–1900, V, 1898, p. 270 (*'ne la camera grande disopra che fu fi bandino'* [Bartolo's son]).

29 Bandera 1999, pp. 20–2, 213, no. 1.

30 This work is now cut on the right so two of the Muses are missing. See Bandera 1999, pp. 45–6, 224, no. 24.

31 Hind 1938, pp. 221–40; L. Syson, 'Tura and the "Minor Arts" the School of Ferrara' in Campbell 2002, pp. 31–70.

32 For an analysis of this pose as that of the dreamer, see J. Röll ' "Do we affect fashion in the grave?": Italian and Spanish Tomb Sculptures and the Pose of the Dreamer' in Mann and Syson 1998, pp. 154–64.

33 I owe this suggestion to Stephen Campbell.

34 Bisogni 1976, pp. 44–6.

35 This despite the fact that it has been trimmed on all four sides. I am grateful to Joseph Connors, Fiorella Superbi Gioffredi, Roberto Bellucci and Dominique Fuchs for letting me look at both works unframed. It was shown that the architecture on the left of the I Tatti panel and on the right of the Stibbert *Rape of Helen* cannot be put together to form a single building, that the figure scale in the two works is different, that the quality is very much higher in the I Tatti picture (even taking account of the condition of the Stibbert picture)

and that, although both panels are formed from two horizontal planks, one much narrower than the other, they are not continuous. The fact that the I Tatti picture (and indeed the picture erroneously connected to it) are constructed from two planks might also contradict their usual classification as *cassone* panels (already rejected by Vertova 1979) which, to ensure the strength of the weight-bearing front of the chest were generally painted on a single plank, which was less likely to split under the weight of the chest lids. This issue merits further investigation.

36 Vertova 1979, pp. 104–21.

37 Pertici 1995, pp. 9–10; M. Ascheri and P. Pertici, 'La situazione politica senese del secondo Quattrocento (1456–1479)', Ascheri and Pertici 1996, III, pp. 995–1012.

38 Hook 1979, p. 60; G. Fattorini, 'Della "historia d'attone pel Battesimo" a "le porti di bronzo del Duomo": Donatello e gli inizi della scultura senese del Rinascimento" in Angelini 2005, pp. 45–81.

39 Campbell and Milner 2004, p. 5; Gordon 2003, pp. 94, 97.

40 Caglioti 2000, II, p. 418, doc. 9.

41 Pertici 1995, pp. 9–10.

42 Milanesi 1854–6, II, 1854, pp. 299–300; G. Fattorini in Angelini 2005, pp. 45–81, esp. p. 79, note 62.

43 Paton 1992, see esp. pp. 109–10.

44 Max Seidel has used the latter as the archetype of the modern urban altarpiece, as compared with others of more traditional format, made for sites outside the city. See M. Seidel in Seidel 2003, pp. 489–536, esp. pp. 494–500.

45 Milanesi 1854–6, II, pp. 353–4; Bruno and Pin 1981, pp. 54–70.

46 M.C. Paoluzzi in Tomei 2002, pp. 208–11. There was also a portrait medal of bride and groom cast on the occasion, possibly in Bologna where the marriage took place. See Hill 1930, ps. 296, no. 1139; F. Vannel Toderi, 'La zecca e la medaglistica' in Paolozzi Strozzi, Toderi and Vannel Toderi 1992, pp. 243, 246.

47 G. Catoni, G. Piccinni, 'Alliramento e ceto dirigente nella Siena del Quattrocento' in Rugiadini 1987, pp. 451–61.

48 G. Pinto, '"Honour" and "Profit": Landed Property and Trade in Medieval Siena'

in Dean and Wickham 1990, pp. 81–91; Ascheri 1993A, pp. 9–11.

49 Pecci 1988 edn, I, pp. 65, 79; Hicks 1960, II, pp. 412–20, esp. p. 419; D. Hicks in Ascheri 1985, p. 54.

50 Piccinni 1975–6, pp. 158–219.

51 G. Fioravanti, 'Classe dirigente e cultura a Siena nel '400' in Rugiadini 1987, pp. 473–84, esp. pp. 473–4.

52 See Fabrizio Nevola's essay in this catalogue, pp. 18–19, note 16.

53 See Nevola 2007.

54 I. Polverini Fosi, '"La comune, dolcissima patria": Siena e Pio II' in Rugiadini 1987, pp. 509–21.

55 F. Caglioti 'La Capella Piccolomini nel Duomo di Siena, da Andrea Bregno a Michelangelo' in Angelini 2005, pp. 387–481, esp. pp. 410–3.

56 G. Gentilini in Gentilini and Sisi 1989, pp. 80–98, no. 19; G. Fattorini in Angelini 2005, pp. 45–81, esp. p. 71; F. Caglioti, 'La Capella Piccolomini nel Duomo di Siena, da Andrea Bregno a Michelangelo' in Angelini 2005, pp. 387–481, esp. p. 400, 476 note 54.

57 I hope to return to the issue odf the dating and attribution of this work in the future. For the Francesco di Giorgio (or workshop) relief on which the Piccolomini Madonna is based, see Balogh 975, I, pp. 85–6, no. 88.

58 Ascheri 1985, p. 54.

59 A. Angelini, 'Pinturicchio e I pittori senesi: dalla Roma dei Borgia alla Siena di Pandolfo Petrucci' in Caciorgna, Guerrini and Lorenzoni 2006, pp. 83–99.

60 M. Mussolin, 'The Rise of the New Civic Ritual of the Immaculate Conception in Sixteenth-Century Siena' in Jackson and Nevola 2006, pp. 117–39.

61 Marrara 1976, p. 97.

62 Hook 1979, p. 131.

63 Cust 1906, pp. 192–9, 200–8.

64 Norman 2003, pp. 283–90.

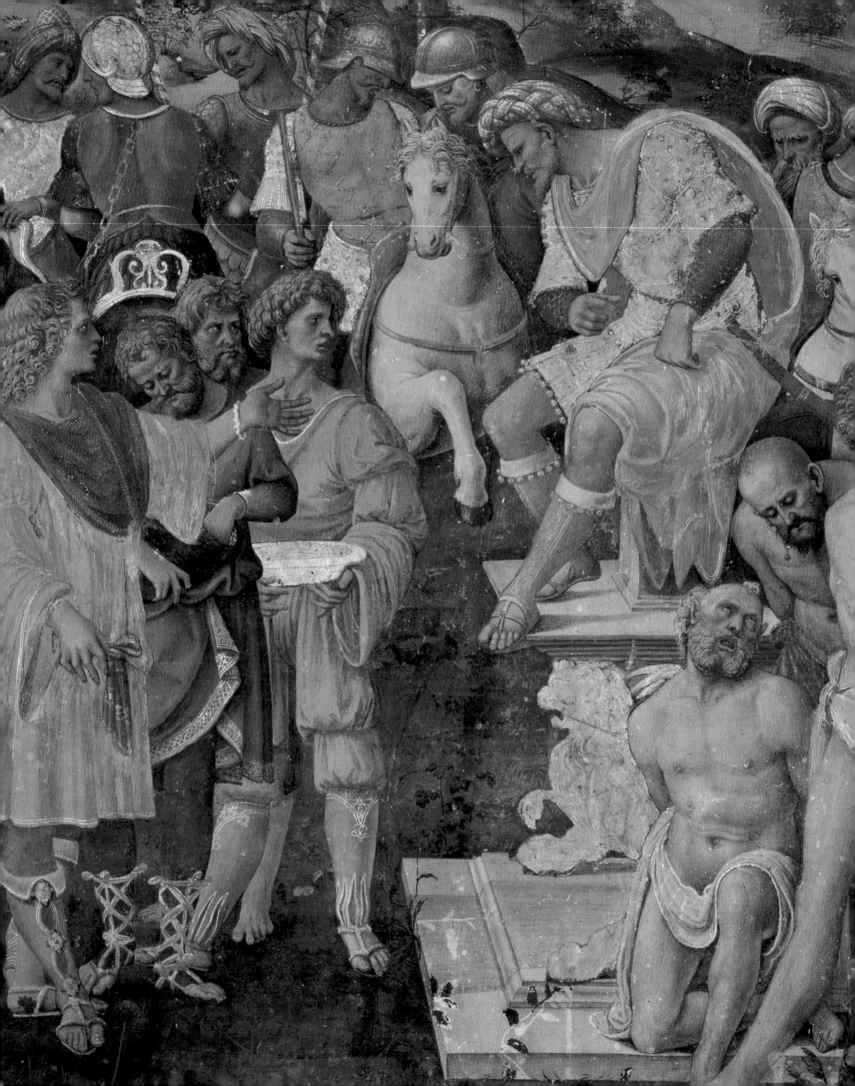

THE PATRONAGE OF PANDOLFO THE MAGNIFICENT

PHILIPPA JACKSON

On 21 July 1487, the eve of the feast of Saint Mary Magdalene, Pandolfo Petrucci (1452–1512; fig. 30) led a group of exiles who scaled Siena's walls to take control of the city the following day.[1] This was his first step on a path to dominance over the city, during which the public finances would become steadily weaker and its republican governance would be subverted, while he and his fellow oligarchs increased their own wealth through government favours and the acquisition of public property.[2] These new riches were displayed in the decoration of their private palaces and family chapels, and in the celebration of links between the city and her patricians with ancient Rome.[3]

POLITICAL BACKGROUND

The men who seized power in 1487 were *Noveschi*, or members of the *Nove*. The *Nove* were not only the richest of the five factions or *monti* who vied for control of Siena during the Renaissance period but also, during their earlier extended rule (1287–1355), had undertaken the greatest architectural projects in the city's history, including the construction of the Palazzo Pubblico.[4] The *monti*, into which a Sienese was born and bound for life, fought each other for power throughout the Renaissance period, causing social and political disruption and frequent and lengthy enforced exile; Pandolfo was brought up in Pisa after his father had been exiled following a conspiracy by the *Nove* in 1456 (see cat. 1).[5] The city's discord was famous, and led to attempts not only by political leaders but also by preachers, such as Saint Bernardino of Siena (1380–1444), to promote peace and harmonious co-existence (see cat. 6–8).[6] Yet expulsion from the city had a positive outcome in so far as it enabled excluded citizens to forge business and personal contacts abroad while maintaining contact with an eye to returning home.[7] Sienese connections were particularly strong during this period to Naples and Rome, thanks above all to the Piccolomini, Spannocchi and Chigi families.

Pandolfo Petrucci was one of ten sons of the successful merchant and landowner Bartolomeo di Giacoppo Petrucci (1408–1495). Bartolomeo's eldest son Giacoppo (1435–1497), who built a new palace next to Siena Cathedral (later absorbed into the Palazzo Governatore on the piazza del Duomo), helped pave the way for his younger half-brother's success in controlling the state, which was assured by Pandolfo's expertise in financial affairs during the 1490s. Pandolfo soon came to be known as 'il Magnifico' (the Magnificent), an epithet also earned by exceptionally wealthy Sienese such as Ambrogio Spannocchi and Agostino Chigi. The strategies of the leader of Siena's new government resembled those recommended in Machiavelli's *Prince*, for he took command of the state by using both force (controlling the palace guard within the city) and largesse, adopting duplicitous tactics to maintain his power at home and abroad. Machiavelli met Pandolfo on various diplomatic missions to Siena and in July 1505 recorded Petrucci saying: 'I govern day by day, and judge matters hour by hour, wanting to make as few mistakes as possible; because the times are more powerful than our minds.'[8] This recognition of the role of fortune impressed the Florentine, who also viewed flexibility as an essential characteristic of a Renaissance prince. Petrucci

Fig. 31
Portrait of Pandolfo Petrucci, from Paolo Giovio, *Elogies of Famous Men*, 1575

Fig. 30
Detail of fig. 37

justified his reputation for treachery by his involvement in the 1500 assassination of his father-in-law, Niccolò Borghesi, his leading political opponent. Pandolfo gradually took over the main magistracies of the city, and gained direct control of the two institutions which regularly employed many Sienese artists, the Cathedral workshop and the Hospital of Santa Maria della Scala, thus was able to dictate all public patronage decisions and urban planning, although he took care to involve others in the official process. An Italian Renaissance ruler, whether of a kingdom, a duchy or a republic, was expected to express his status and leadership through architectural and artistic patronage.[9] Pandolfo, whose ambition was to secure his own and his family's position so that his sons could inherit control of Siena, was no exception.

THE IMPORTANCE OF ROME

Rome, a centre for Sienese exiles, clerics and merchants, where the Spannocchi, and after 1503 Agostino Chigi (reputedly the richest man in Italy), became successful bankers, was the greatest cultural influence on the city during this period.[10] Chigi, however, was merely one of many Sienese merchants who accumulated wealth and property in Rome during the first two decades of the sixteenth century. This Tuscan community was aided by Pope Julius II (1503–13), who in November 1507 formally recognised that his own family had Sienese origins; he acknowledged a relationship with the Vitelli Ghianderoni family, whose head, the Balìa notary Messer Antonio, was a close ally of Pandolfo.[11] The Sienese government purchased and granted to him an extensive

estate, the Suvera (which was said to have belonged to his ancestors), which the pope in turn bestowed on his nephew, Niccolò della Rovere.[12] Julius not only used the Sienese banking network but employed artists patronised by the city's rulers, in particular Sodoma and Raphael, for his decoration of the Vatican.[13] Sienese artists who went to work in Rome included Giacomo Pacchiarotti, who decorated Basso della Rovere's chapel in Santa Maria del Popolo, the sculptor Giovanni di Stefano, the architect and painter Baldassare Peruzzi, and Domenico Beccafumi.[14] At the same time eminent foreign painters, promoted by patrons such as the Spannocchi, Chigi, Piccolomini and Petrucci, came to work in Siena; their employment was a means of displaying status, not least because only the most powerful could ignore the laws preventing foreign artists competing with native.[15] At his father's request, in 1500 Agostino Chigi recommended both Perugino – described as the best artist of all Italy – and Pintoricchio to paint the altarpiece of their family chapel in Sant'Agostino in Siena.[16] When Michelangelo agreed in 1504 to complete fifteen marble statues for the Piccolomini altar in Siena Cathedral, the contract specified that the figures had to be more perfect than modern statues to be found in Rome.[17]

Interest in ancient Rome and a search for classical antecedents, common to many Italian cities, was particularly strong in Siena in the late fifteenth century, when Francesco Patrizi, Agostino Patrizi Piccolomini and Bartolomeo Benvoglienti all wrote accounts of their city's history.[18] Francesco Patrizi asserted that the Sienese families who could claim Roman ancestry included

both his own ancestors and those of the Petrucci, who, he claimed, were descended from the Petrei, a family of senatorial rank.[19] To celebrate the connection, Pandolfo favoured classical names for his children, calling his eldest son Giulio Cesare, and later descendants often bore a second name of Romulus or Romula; other members of his oligarchy did the same, as did artists: Sodoma christened his son after the Greek painter Apelles and his daughter Faustina after the Roman empress, and Pintoricchio gave the same name to his daughter born in Siena in 1510.[20] The fashionable interest in Siena's past also found expression in the subject-matter of newly commissioned works of art. Although classical *exempla* had been common in public cycles for many centuries in Siena, the late fifteenth and early sixteenth centuries witnessed the widespread depiction of classical heroes, many of them novel, in private palaces.[21] Cycles of famous women are a particular feature of the city's culture of the time; some of these survive (see cat. 65–72), while others, such as the room of the Sibyls in the Tegliacci palace, are known from documentary sources.[22]

RELIGIOUS PATRONAGE

If Pandolfo's patronage was crucial in the promotion both of the rhetoric of magnificence and of the cult of antiquity in the city, he was also attuned to Sienese religious sentiment. He favoured the Observant movement of the mendicant orders – the Dominicans and Franciscans – who were renowned for their preaching and strict morals. His first major act of private patronage was the construction in 1497–8

Fig. 32
Giacomo Cozzarelli (1453–1515)
Lamentation, 1498
Polychrome terracotta
height approximately 100 cm
San Bernardino all'Osservanza, Siena
(Sacristy)

of his funeral chapel in the sacristy of the city's most renowned religious institution, the Osservanza, which Saint Bernardino had founded in 1404.[23] A family funeral chapel in a sacristy was particularly prestigious and in this case placed the family's mortal remains in close vicinity to the relics of the city's most popular native saint. Pandolfo was the most eminent among the wealthy patrons of the Osservanza, who included patrician friars who would make a donation on entering the order, and rich members of the laity such as Lucrezia, wife of Galgano Francesconi, who bequeathed 250 florins in her will of 1508 for a great crucifix (to be made of either terracotta or wood) to hang above the choir.[24] This large sum was exceptional, for many legacies to the Observants were notable for their simplicity – typically clothes or food. In

Pandolfo's chapel the most striking decorative feature was a large group of half life-size terracotta figures by Giacomo Cozzarelli vividly engaged in a *Lamentation* (fig. 32), the first example of its kind in the city.[25] Guido Mazzoni had created such a work for Ercole I d'Este in Ferrara and another for the royal funeral chapel in Sant'Anna ai Lombardi in Naples.[26] While the clay with which it was made respected Observant disdain for sumptuous and superfluous display, in its size, polychromy and gilding Cozzarelli's figure group proclaimed Pandolfo's standing within the city.

Pandolfo also favoured the Observant Dominicans at Santo Spirito, a break with his own family's support for the unreformed or Conventual Dominicans at San Domenico, which may have had political as well as religious motives.[27] The friars based at Santo

Spirito from September 1498 onwards were mainly foreigners (predominantly Florentine) from San Marco in Florence, where their involvement in public affairs had led to their prior, Savonarola, being burnt at the stake.[28] However, although Pandolfo paid 800 ducats for work on the dome and high altar of Santo Spirito, he brooked no opposition from them and expelled them all on Christmas Eve 1504 for refusing a government order to breach an interdict. Although the friars (save their prior) were soon allowed to return, the episode exemplifies Petrucci's determination to control all aspects of secular and religious life. Support for the Dominicans and devotion to the order's most famous female member, Saint Catherine of Siena, a patron of the city, was continued by other members of his family. Pandolfo's brother Alessandro was a

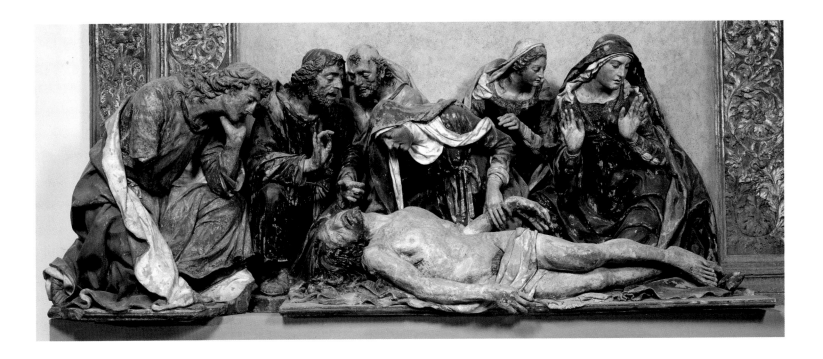

Fig. 33
After Luca Signorelli
The Festival of Pan, after 1509
Pen and ink on paper, over black chalk,
shaded with brown wash and heightened with
lead white, 29 × 37 cm
The British Museum, London (1946-7-1312)

patron of the Dominican tertiaries of Santa
Caterina del Paradiso, who passed under
the control of Santo Spirito on 2 June 1508,
and three of his sons – Cardinal Alfonso
(1492–1517), Borghese (1490–1526) and
Fabio (1505–1529) – all became members
of the confraternity of Santa Caterina in
Fontebranda, the lay centre of her cult.[29]
Although Pandolfo himself did not belong
to this confraternity, as a sign of his devo-
tion he owned a tondo of the Madonna
with Saints Catherine and Bernardino.[30]

Pandolfo had a particular affection for
Saint Mary Magdalene, whose aid he saw
in the *coup d'état* of 22 July, and who was
declared a patron saint of Siena in 1494.[31]
The government promoted her cult by
instituting a *palio* and public festivities on her
feast day, which also served as a celebration
of the *Nove* return to power in 1487.[32]
Pandolfo himself paid for a new church
for the convent of Santa Maria Maddalena,
ruled by his cousin abbess Aurelia di
Bartolomeo Petrucci, although the work
was unfinished at his death and the newly

built convent, designed by Giacomo
Cozzarelli, was destroyed in 1526. He paid
for sculptural decoration in the church
in 1511, but he also adopted a policy of
suppressing other convents with members,
property and works of art that could be
amalgamated with his favourite nunnery.[33]
As a result of Pandolfo's patronage, several
female members of his family joined the
convent; his youngest daughter Portia
and his illegitimate daughter Cassandra
(also known as Alessandra) were educated
there.[34]

THE PALAZZO DEL MAGNIFICO

Giacomo Cozzarelli, Francesco di Giorgio's
chief assistant, and not only a sculptor
of terracotta, wood and bronze but also an
architect and a designer of artillery, was
almost certainly the man who remodelled
Pandolfo's palace. The Palazzo del Magnifico,
as it is still known today, was situated in
the Petrucci family's traditional area of the
city by the square of the Baptistery; here

Pandolfo purchased various properties
piecemeal over a number of years from
which he then created his magnificent
residence.[35] The major rebuilding work
appears to have taken place around 1508,
when Pandolfo made payments to his
builder, Domenico di Bartolomeo of
Piacenza, and to his stonemason Michele
Cioli of Settignano.[36] It was also almost
certainly at this time that Cozzarelli and
his partner Carlo di Andrea Galletti were
jointly paid for the execution of the grand
bronze façade ornaments designed by
Cozzarelli. The façade was decorated not
only with these impressive bronzes but
also, very probably, with painted classical
heroes similar to those of the Borghesi
Palace (see cat. 101).

The palace interior must have been
equally grand, containing gilded leather
spalliere and elaborate beds, sculpture and
paintings with classical subject-matter. [37]
In particular in 1509 (the date on some of the
maiolica tiles), a seven-room apartment was
decorated, as the quartering of Piccolomini

Fig. 34
Detail of cat. 88

arms indicates, to celebrate the marriage of Pandolfo's eldest surviving son Borghese with Vittoria di Andrea Piccolomini, niece of Pope Pius III. The most highly decorated room, the *camera bella*, had a ceiling containing mythological and classical scenes set in a structure based on the *Volta Dorata* of the Golden House of Nero in Rome. It contained elaborate stuccowork and carved wooden decoration, a grand maiolica floor and eight large frescoes by Signorelli, Pintoricchio and Girolamo Genga of episodes drawn from Greek and Latin literature and Petrarch's *Trionfi* (*Triumphs*). The frescoes were removed or painted over in the nineteenth century: three are lost, three are today in the National Gallery (cat. 80–2), and two are in the Pinacoteca Nazionale in Siena (fig. 37–8).[38] The unusual iconography of the cycle has been interpreted as an allegory either of marital virtues or of events in the history of the Petrucci family;[39] however, the proposal that the cycle represents only 'marital' virtues ignores the fact that virtuous acts towards

the family may also stand for civic virtue, the tradition of political iconography in Siena, and the dynastic ambitions of the Petrucci family.

Two eighteenth-century commentators, Abbot Giovanni Girolamo Carli and Guglielmo Della Valle, described the paintings *in situ*.[40] It was originally possible to enter the *camera bella* from a loggia which ran along the inside courtyard of the palace, but with the room subsequently altered these viewers must have entered from one of two surviving doorways. The exact location of the fresco decoration is difficult to reconstruct but it is possible that Signorelli's paintings, now lost, of *The Calumny of Apelles* and *The Festival of Pan*, were on either side of the entrance from the loggia, which may explain why they did not survive.

The first fresco was clearly drawn from Lucian's account of Apelles's allegory of *Calumny*, painted for King Ptolemy of Egypt; according to Alberti it was the ancient painting most worthy of emulation.[41] The

Greek inscriptions on the lost fresco recorded by Carli, which closely follow Lucian's text, were almost certainly written by Severo Varini, tutor of Pandolfo Petrucci's son Alfonso, who was instructing his young pupil in Greek at this time, and had a particular interest in Lucian.[42] The virtue involved is evidently justice.

Della Valle described *The Festival of Pan* as showing Pan enthroned, holding his pipes in one hand, with two shepherds at his side and the Fates above, who were set apart from the main scene.[43] A drawing in the British Museum which may be after Signorelli, corresponding to this description, shows a static group of nude men with a youth holding a scroll which reads *DIO.PAN* (fig. 33).[44] A maiolica plate in the British Museum with Pandolfo's coat of arms also shows Pan, sitting while two shepherds kneel in obeisance before him (fig. 34). One of Signorelli's most famous paintings, *The Court of Pan*, formerly in the Kaiser Friedrich Museum in Berlin, now destroyed (fig. 35), may also be associated

Fig. 35
Luca Signorelli (about 1440/50–1523)
The Court of Pan, about 1484 (destroyed in 1945)
Oil on canvas, 194 × 247 cm
Formerly Kaiser-Friedrich-Museum, Berlin (79A)

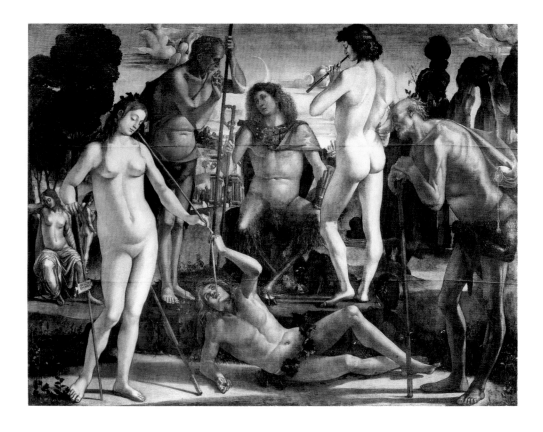

with the Palazzo del Magnifico,[45] notwithstanding its long association with a painting of gods that Vasari reported was painted for Lorenzo de' Medici.[46] It is not listed in the highly detailed inventory of Lorenzo's possessions,[47] and circumstantial evidence points to a Sienese provenance, and it is possible that the painting appears in Petrucci's posthumous inventory (which lists many fewer works of art than Lorenzo's).[48] In the extensive literature on the painting's iconography, Neoplatonic and other texts known to Florentine intellectual circles involving the Greek god Pan have been adduced (most recently Theocritus's first eclogue),[49] but the lascivious Pan of Greek myth is not recognisable in the calm

seated figure at the centre of this group of images.

A more promising line of enquiry is the nature and character of the Roman god Faunus, with whom the Greek god was identified. In the Augustan age, Faunus was variously described as king of the Latins and equivalent to Pan, Silvanus and Inuus.[50] Virgil envisaged him as an early Italian king, while according to Horace he was a tutelary deity, protecting both flocks and people.[51] Here, in his Greek form – perhaps to achieve the pun 'Pan/Pandolfo' – he presides over a bucolic setting of idealised rustic innocence. A similar figure appears in a painting by Domenico Beccafumi of the following decade representing the race

that took place during the Roman feast of Lupercalia (fig. 36, cat. 102).[52] In *The Court of Pan* there is also arguably a Sienese reference in the depiction in the background, between the shepherd and the god he is addressing, of a classical building with a couple of horsemen riding respectively white and black horses.[53] One of Siena's foundation legends related that the city was founded by Ascius and Senius, the twin sons of Remus, who fled from Rome on a similar pair of horses. The projecting half-figures on what might be a gate or triumphal arch in this background detail are also equine, a motif which may have derived from the façade of Siena Cathedral, and which can be seen on the gate in the *Funeral of the Virgin* panel of

Fig. 36
Detail of cat. 102

the Master of the Osservanza's *Nativity of the Virgin* in Asciano, and in the city scene of Benvenuto di Giovanni's *Ascension* for Sant'Eugenio. [54]

Faunus was associated with good fortune, to which the Fates who appear in the Palazzo del Magnifico fresco may refer, and with the olive-tree, upon which a votive raiment might be hung up to him (which possibly explains a feature of the British Museum plate).[55] More specifically, in the first eclogue of another Roman pastoral poet, Calpurnius Siculus, two shepherds, Ornitas and Corydon, discover a prophecy by Faunus heralding a renewal of the Golden Age under a new prince.[56] Since Borghese Petrucci, Pandolfo's eldest son and heir, was being groomed by him to govern Siena, such a theme seems appropriate to his apartment, and Signorelli's fresco may have depicted one of the two shepherds reciting Faunus's oracle. The concept of a new Golden Age of peace, morality and justice was a Renaissance topos,[57] which the Fates would aptly represent.[58] Thus the scene would not have allegorised a particular virtue but conveyed instead a more general message of peaceful rule and concord.

The third lost fresco, by Pintoricchio, probably represented by a drawing in the British Museum, depicted *The Continence of Scipio*, exemplifying temperance in the use of power. The two frescoes in Siena, attributed to Girolamo Genga (fig. 37 and 38) survive in good condition, retaining vivid colours and much of their original gilding, in contrast to the National Gallery works, which have been transferred to canvas. One of these frescoes shows Aeneas and his family fleeing Troy – the devotion of a hero to family and state, the virtue of

pietas – while the other has been identified as Fabius Maximus ransoming Roman prisoners from Hannibal.

No one theme unites all eight frescoes, although many, as we have seen, represent one or other sort of virtue; Penelope in the National Gallery fresco, for example, is an example of fidelity. The appearance of seven virtues and the Three Graces (representing concord and love; cat. 83) on the pilasters of the room reinforced the idea. At the same time the *all'antica* taste and the grandeur of the gilded decoration proclaimed the Petrucci family's pre-eminence and classical antecedents.

SIENA CATHEDRAL AND THE HOSPITAL OF SANTA MARIA DELLA SCALA

This strong interest in the Antique can also be seen in the decisions Pandolfo made after he took control of the Cathedral workshop in June 1505, particularly with his appointment, on 11 October 1505, of a new *capomaestro*, Ventura Turapilli (1451–about 1522),[59] best known today for his skilful carpentry in the oratory of San Bernardino in Siena. Turapilli was responsible for training young sculptors in the workshop and made copies of antiquities, possessing his own collection of drawings, antiquities and medals.[60] Although there is no evidence that Pandolfo proposed the new decoration for the Cathedral's interior, his support would have been crucial to the plans to remove the old choir and install a new high altar with a bronze tabernacle surrounded by candle-bearing angels and also twelve bronze Apostles placed along the nave – plans involving his friend Francesco di

Fig. 37
Girolamo Genga (1476–1551)
The Ransom of Prisoners, 1509
Fresco, Pinacoteca Nazionale, Siena (333)

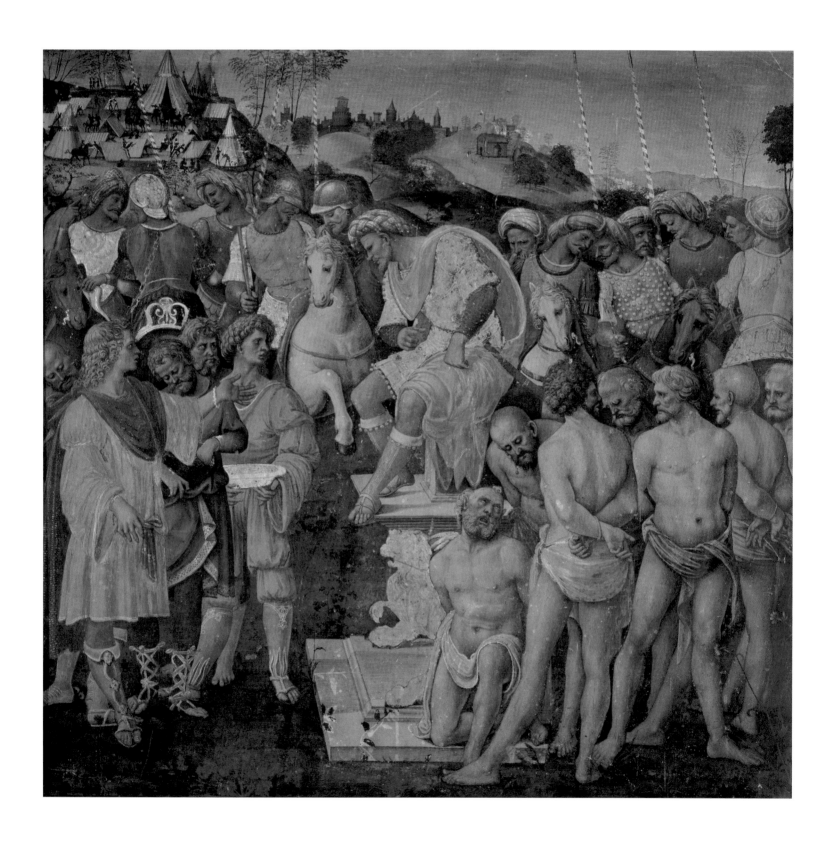

Fig. 39
The high altar, Duomo, Siena

Giorgio as well as Giovanni di Stefano, Giacomo Cozzarelli and later Sodoma and Beccafumi.[61] Both the angels and the Apostles along the nave were ideas inherited from earlier decoration of the Cathedral, and the tabernacle also had a precedent, for there had been an earlier Spannocchi commission for a marble tabernacle as the focus of the high altar of San Domenico (fig. 23, p. 48), but the choice of bronze, a material which deliberately recalled antique temples, was novel.[62] In the summer of 1506, Pandolfo removed the tabernacle made by Vecchietta for the Hospital of Santa Maria della Scala to the Cathedral – where it remains today (fig. 39) – promising that it would be paid for within three years or returned. This was a sign of his authority and increasing influence over the Scala administration, but the citizens of Siena were shocked by the removal of Duccio's famous *Maestà* (fig. 29, p. 58), which had stood on the altar for nearly 200 years. No other action by the Petrucci regime so visibly extolled its power and desire to impose a new Renaissance visual language on the city. The Scala campaigned for the return of its tabernacle for decades afterwards, only finally conceding defeat in 1583, when the Hospital ordered a new ciborium from Accurzio Baldi.[63] However, Pandolfo's grand plans for bronze sculpture in the Cathedral were delayed by the distraction of other projects, lack of cash and the necessity for extensive repairs to the building's roof, and they were eventually abandoned, although his ideas were revived by Baldassare Peruzzi in the 1530s.

It took Pandolfo longer to gain direct power over Santa Maria della Scala, but in 1508 he installed a new governor (rather than a rector), who ran the Hospital with

a council of Petrucci supporters, although particular matters were referred to Pandolfo himself.[64] Probably the delay in his obtaining control and the pressure of his many other projects held back the redecoration of the chapel of the Madonna del Manto, which was initiated only under the regime of his son Borghese (building work commenced in September 1512 and the decoration in 1513–14). The impetus for the decoration was probably the discovery of the body of the Blessed Sorore, the legendary founder of the Hospital. The new chapel was frescoed by Bartolomeo di David and a magnificent crib was made for it of large gilded terracotta figures by the Florentine sculptors Salvatore di Cornelio and Jacomo detto Borrona[65] – a work inspired by the Petrucci funeral chapel at the Osservanza and, probably, by Ambrogio della Robbia's crib for Santo Spirito.

PUBLIC PATRONAGE

Pandolfo Petrucci was particularly interested in the ornamentation of the city, creating a more pleasant environment around his palace by banning certain tradesmen, designating zones for the residence of particular craftsmen, removing overhanging balconies along the major thoroughfares of the city, and insisting on appropriate façades for palaces.[66] Pandolfo's most ambitious plan, however, was for a classical portico to run around the Campo, the main square in the centre of Siena: he employed his favourite stonemason, the Florentine Michele Cioli, and two others to create the columns of the portico in October 1508.[67] (It has often been supposed that Baldassare Peruzzi was responsible for the design, but he had already

left the city for Rome and employment by the Chigi and others.) The timing, the employment of Cioli and the personal involvement of Pandolfo in the project indicate that Giacomo Cozzarelli was probably the architect.[68] Although the plan was particularly appropriate to the commercial needs of Siena's city centre, the beauty and the effect of these structures in unifying different buildings into an architectural whole, had been a subject for discussion by both ancient and Renaissance architectural theorists.[69] The portico project failed for lack of money, the sums which the government had set aside having to be reassigned to the city's defence and other government priorities.

Pandolfo died in May 1512, leaving Siena under the control of his son, Borghese, aided by his brother Cardinal Alfonso and a trusted adviser, Antonio da Venafro.[70] These young men were less adept than Pandolfo, and political exiles plotted with their estranged cousin, Raffaele Petrucci, and Pope Leo X to overturn their regime. Raffaele, who gained control of Siena in March 1516, was made a Cardinal in 1517, and maintained his taste for grand celebrations and public magnificence to his death in December 1522. Pandolfo's youngest son Fabio returned to power briefly in 1524, but internal opposition, international interference and his early death destroyed the Petrucci cause. Pandolfo's ultimate heirs were the four daughters of Borghese Petrucci, whose complicated marital arrangements and disputes with creditors pre-empted political concerns.

The rule of the *Nove* government in Siena from 1487 until the fall of the regime in 1525 – a period dominated by members of the Petrucci family – the most important

among them Pandolfo, witnessed a flowering of artistic and architectural projects and a taste for magnificence. The city's oligarchy attracted famous foreign artists to adorn their private palaces and chapels, but the Petrucci regime's ambitions in the public sphere far outstripped the city's ability to pay for its plans.

NOTES

The Patronage of Pandolfo the Magnificent

1 Shaw 2001, p. 1.

2 This can be charted in the Lira records, the tax ratings of Sienese citizens: Pandolfo's rating increased from L6,000 in 1492 (Archivio di Stato di Siena [hereafter 'ASS'], Lira, 99, f. 28v) to L10,650 in 1498 (ASS, Lira, 106, f. 22v) and L20,000 in 1509 (ASS, Lira, 111, f. 21r).

3 On Pandolfo's 'magnificence' see C.H. Clough 'Pandolfo Petrucci e il concetto di "magnificenza"' in Esch and Frommel 1995, pp. 383–97, and more generally G. Agosti and V. Farinella, 'Interni senesi "all'antica"' in Siena 1990, pp. 578–99.

4 The classic study on the *Nove* period is Bowsky 1981; for the Palazzo Pubblico; Brandi 1983.

5 On exile and its consequences; Shaw 2000.

6 Polecritti 2000, pp. 183–221; C. Shaw, 'Peace-making Rituals in Fifteenth-Century Siena' in Jackson and Nevola 2006, pp. 89–103.

7 The wealth of the Spannocchi family increased following exile, particularly after the establishment of Giacomo di Ambrogio's bank in Ferrara. See Morandi 1978, vol. 3, p. 93.

8 '*Io mi governassi dí per dí, e giudicassi le cose ora per ora, volendo meno errare; perché questi tempi sono superiori ad e' cervelli nostri*': Machiavelli 1964 edn, vol. 2, p. 912; on its importance for Machiavelli's thinking see Skinner 1981, p. 16.

9 Jenkins 1970, pp. 162–70.

10 On the Spannocchi in Rome see Ait 2005, pp. 7–44; on Agostino Chigi see Rowland 2001 (with an extensive bibliography); and for his banking relationship with Julius: Gilbert 1980.

11 Pandolfo read the brief of Julius II dated 8 November 1507 declaring that he was '*non minus enim laetamur Senis nos oriundus, quam Saonae ortos fuisse*': Pecci 1755–60, I, pp. 228–9.

12 For Niccolò della Rovere's obtaining the estate, ASS, Notarile ante-cosimiano, 1105, 26 February 1507 (1508 modern style).

13 Bartalini 2001, pp. 544–53; Cornini 1993; Shearman 1972.

14 Scarpellini and Silvestrelli 2004, pp. 221–6; Angelini 2005, pp. 324–9; Frommel 1968, pp. 10–25; Torriti 1998, pp. 8–9.

15 Painters were subject to guild regulations which contained provisions specifically applying to foreigners: Milanesi 1854–6, vol. 1, pp. 1–56; on the close artistic links of Siena and Rome in this period: A. Angelini, 'Pinturicchio e I suoi: dalla Roma dei Borgia alla Siena dei Piccolomini e dei Petrucci' in Angelini 2005, pp. 483–553.

16 For this letter from Rome of 8 November 1500, Rowland 2001, pp. 11–13.

17 '*Di più perfectione che figure sieno hogi in Roma, moderne*': Milanesi 1854–6, vol. 3, p. 21. On the Piccolomini altar see F. Caglioti, 'La Cappella Piccolomini nel Duomo di Siena, da Andrea Bregno a Michelangelo' in Angelini 2005, pp. 387–481.

18 Francesco Patrizi, *De origine et antiquitate urbis Senae* (Biblioteca Comunale di Siena [hereafter 'BCS']), MS B.II.15, ff. 16r–36r; Agostino Patrizi, *De antiquitate civitatis senensis* (BCS, MS B.III.4, ff. 1r-6v); Bartolomeo Benvoglienti's work was published: *De urbis Senae origine et incremento opusculum*, Siena 1506.

19 BCS, MS B.II.15, ff. 23r-v; the Petroni, Ghinuzzi, Luti, Marsili, Accarigi, and others were also said to be descended from the Romans.

20 For Sodoma's children born in 1511 and 1512, see Cust 1906, p. 116; for the baptism of Pintoricchio's daughter and of his son, Camillo (whose godfather was Signorelli) baptised in January 1509, see Scarpellini and Silvestrelli 2004, p. 293.

21 One of the most elaborate was the Taddeo di Bartolo antechapel in the Palazzo Pubblico: Rubinstein 1958; Funari 2002.

22 Caciorgna and Guerrini 2003. The Tegliacci family's palace included a '*chamara dele Sibille*' (room of the Sibyls): ASS, Notarile ante-cosimiano, 1079, 22 August 1502.

23 Bertagna 1963–4.

24 ASS, Notarile ante-cosimiano, 816, 25 September 1508. It also had to portray the Virgin, Saint John the Evangelist and Saint Mary Magdalene at the foot of the cross.

25 Alessi 1984, pp. 143–7.

26 Travagli 2003; Lugli 1990.

27 This was the site of a Petrucci chapel and a favoured place of burial: Laurent 1937; BCS, MS C.III.2.

28 Mussolin 1997.

29 On Santa Caterina del Paradiso: Bisogni and Bonelli Conenna 1988; on Pandolfo's sons' membership of the confraternity in Fontebranda: BCS, MS A.I.18, f. 69v.

30 ASS, Notarile ante-cosimiano, 1268, (No. 516), f. 3v: '*1 quatretto di nostra donna San Bernardino et Santa Catherina*'.

31 On 7 February 1494: M. Ascheri, 'Verso la definizione dell'oligarchia: provvedimenti per i Monti 1493–1498', in Ascheri and Ciampoli 1986, vol. 1, pp. 351–6.

32 See P. Jackson, 'The Cult of the Magdalen: Politics and Patronage under the Petrucci' in Ascheri and Nevola forthcoming.

33 See the payments Pandolfo made to Michele Cioli and his partner Piero di Maso: ASS, Notarile ante-cosimiano, 1056, 27 September 1511, for architraves, capitals, friezes and other stonework.

34 On 9 September 1519, Vittoria Piccolomini was ordered to pay the convent of Santa Maria Maddalena 48 florins per annum to care for Pandolfo's daughters Portia and Cassandra: ASS, Balìa, 993, f. 119r.

35 On the palace see Ferrari 1985; Quinterio in Morolli 2002, pp. 145–52.

36 ASS, Santa Maria della Scala, 529, 366 left; ASS, Santa Maria della Scala, 530, 163 left; Borghesi and Banchi 1898, pp. 382–3.

37 ASS, Notarile ante-cosimiano, 1268 (No. 516).

38 See pp. 270–4, cat. 80–2.

39 On the marital virtue theme see Agosti 1982, p. 75, and on the Petrucci family thesis: Tátrai 1978, pp. 177–83.

40 On the cycle see Davies 1961, pp. 472–9 with a transcription of Abbot Carli's commentary on pp. 571–3; Della Valle 1784–6, vol. 3, pp. 319–22.

41 Massing 1990, pp. 277–83.

42 See *De Astrologia ex Luciano per Severum monachum cisterciensem*, Biblioteca Comunale Labronica, MS Spannocchi 2, ff. 250r–54v.

43 Della Valle 1784–6, vol. 3, p. 320.

44 Popham and Pouncey 1950, pp. 146–7.

45 See Henry and Kanter 2002, p. 173, for both description and bibliography.

46 Vasari 1966–87 edn, III, p. 636.

47 Spallanzani and Gaeta Bertelà 1992.

48 The painting in the Palazzo del Magnifico inventory which might possibly be associated with this painting, if the minor background figures are ignored, is '1 quatro di tela con sei figure et cornice dorata': ASS, Notarile ante-cosimiano, 1268 (No. 516), f. 2r.

49 Brummer 1964, pp. 55–67; Welliver 1961, pp. 334–45; Freedman 1985, pp. 152–9; Eisler 1948, pp. 77–92; on Pan and Daphnis see Agosti 1982.

50 For the Latin and Greek texts on Pan and Faunus: Peruzzi 1978, pp. 10–44.

51 On Horace, see Babcock 1961 pp. 13–19, 15; and on Virgil see Wiseman 1995, pp. 1–22.

52 On Faunus and the Fasti: Parker 1993, pp. 199–217; Holleman 1974.

53 Little attention has been paid to this detail described in Brummer 1964, p. 57, as 'singular and difficult to explain'.

54 On Sienese origins see Cristofani 1979.

55 Virgil, Aeneid, XII, 766–68 (trans. R. Fairclough, 2000 edn, pp. 354–5).

56 Beck 1803, pp. 1–6. The editio princeps of the Eclogues was in Rome in 1471 and further editions appeared at Daventer in 1491 and Parma in 1495.

57 For a discussion of the Golden Age in the Renaissance see 'Renaissance and the Golden Age' in Gombrich 1966, pp. 29–34; Levin 1969; Puttfarken 1980, pp. 130–49.

58 For the Fates spinning a Golden Age see Seneca, Apocolocyntosis, (ed. P.T. Eden, 1984 edn), p. 33.

59 Milanesi 1854–6, vol. 3, pp. 27–8.

60 In a petition he stated that he had passed most of his life finding and copying antiques to recover antiquity: Milanesi 1854–6, vol. 3, p. 75; G. Fattorini, 'Epilogo: Siena e la scultura "all'antica"' in Angelini 2005, pp. 555–83, esp. p. 558.

61 On the bronze angels see Martini 2006, pp. 91–103; Fumi 1981, pp. 9–25.

62 Carl 1990; on the importance of those entering a church seeing a tabernacle on the altar: Francesco di Giorgio Martini 1967 edn, 1, p. 237.

63 Gallavotti Cavallero 1985, pp. 280–3.

64 On the rectors see Banchi 1877, and more generally Morandi and Cairola 1975; Piccini and Zarrilli 2003.

65 Gallavotti Cavallero 1985, pp. 267–9; Gentilini 1996.

66 On improvements to the city's streets in this period: see Nevola 2000 and Nevola 2001.

67 ASS, Notarile ante-cosimiano, 999.

68 Francesco di Giorgio Martini 1967 edn, 2, p. 363.

69 For Vitruvius's and Alberti's views on porticos see Miller 1989, pp. 33–43.

70 For his funeral, P. Jackson, 'Pomp or Piety: the Funeral of Pandolfo Petrucci' in Jackson and Nevola 2006, pp. 104–16.

CHRONOLOGY

1450 On 24 May Saint Bernardino (1380–1444) was canonised, becoming the most popular saint in late fifteenth-century Siena.

On 23 September Pope Nicholas V nominated Aeneas Silvius Piccolomini (1405–1464) as Bishop of Siena.

1451 On 22 September the Cathedral authorities decided to create a chapel in honour of the Madonna delle Grazie, and employed the sculptors Urbano da Cortona and his brother Bartolomeo.

1452 On 7 February Emperor Frederick III arrived in Siena to meet his future bride Princess Eleonora of Portugal. Their meeting on 24 February in the presence of Aeneas Silvius Piccolomini was later recorded by the erection of a marble column and in a fresco of the Piccolomini Library (see cat. 76).

1455 On 20 April Pope Calixtus III ascended the papal throne; in June Neapolitan troops under Jacopo Piccinino, in league with the *Nove*, entered Sienese territory. Sano di Pietro's painting (cat. 1) recorded the protection of Siena by Pope Calixtus in the face of this foreign threat.

1456 Interrogations revealed a plot to take power by the *Nove* and the information was laid before the Consiglio del Popolo on 30 August. The conspirators were declared rebels and sent into exile: they included Antonio di Checco Rosso Petrucci (declared a rebel on 13 October) and Bartolomeo di Giacoppo Petrucci, who moved to Pisa with his family.

1457 Donatello arrived to work in Siena for the Cathedral, for which he was commissioned to make bronze doors (never completed). On 24 October he delivered a statue of a bronze *Saint John the Baptist* (with one arm missing) to the Cathedral authorities.

1458 Marble statues of saints were commissioned for the loggia della Mercanzia on 8 July – a *Saint Bernardino* from Donatello (never executed), a *Saint Ansanus* from Antonio Federighi, and a *Saint Paul* from Vecchietta.

Aeneas Silvius Piccolomini became Pope Pius II on 19 August, following the death of Pope Calixtus III. Sienese delight at his elevation to the papacy was expressed with public celebrations which included a *tableau vivant* of the Assumption of the Virgin (the papal coronation was later depicted in a 1460 Biccherna panel; cat. 2).

1459 Pius II employed the Florentine architect Bernardo Rossellino to create a small Renaissance city at Corsignano, the place of his birth.

In April Pius II drew up a new constitution for the Chapter of Siena Cathedral and made the see of the city an Archbishopric.

1460 On 5 March Pius II granted his nephew, Francesco Todeschini Piccolomini (later Pope Pius III), a cardinal's hat.

1461 On 29 June Pius II canonised Saint Catherine of Siena (1347–1380), which helped to popularise her cult during the late fifteenth century.

Antonio Federighi worked on the Cappella di Piazza, the open-air chapel of the Palazzo Pubblico; work continued until 1469 and the griffin frieze and decoration were probably executed after 1465.

1462 On 19 March Saint Catherine of Siena was made a patron saint of the city.

Pius II renamed Corsignano, his birthplace, Pienza and created a new bishopric of Pienza and Montalcino on 13 August; Pienza's Cathedral was consecrated on 29 August.

The Piccolomini Loggia, a portico with a gilded bronze inscription, built in Siena for Pius II by Antonio Federighi, was completed.

1464 In April the men of the district of Fontebranda requested permission to build an oratory to Saint Catherine at the house where she was born.

On 6 May Pope Pius II gave a relic of the arm of Saint John the Baptist to Siena.

Following the death of Pope Pius II on 14 August, on 19 December the *Gentiluomini*, briefly admitted to government were again expelled. Members of the Piccolomini family remained eligible for public office because they joined the *Popolari*.

1466 A relic of a rib from the body of Saint Catherine of Siena, buried in the church of Santa Maria sopra Minerva in Rome, was granted to the Sienese Republic.

1467 On 26 April Vecchietta was commissioned to make a bronze tabernacle for the Hospital of Santa Maria della Scala.

Ippolita Maria Sforza arrived in Siena on 29 June on her way to Naples to wed Alfonso, Duke of Calabria.

1469 On 28 April Francesco di Giorgio and a colleague were nominated as overseers of the *bottini*, Siena's water supply system.

The Piccolomini palace in San Martino was begun; it was still under construction in the early sixteenth century.

1470 Bishop Giovanni Cinughi requested permission on 23 May to build a small church dedicated to the Madonna della Neve (of the Snows).

1471 On 16 July Ambrogio Spannocchi was granted the choir in the church of San Domenico as his family chapel.

1472 The Opera Metropolitana or Cathedral Office of Works commissioned silver statues of the city's patron saints – Saint Catherine of Siena (ordered on 20 November from Vecchietta) and Saint Bernardino (ordered on 10 December from Francesco di Jacopo Germani).

On 29 November Vecchietta was paid 1,100 florins (and residence of a house for life) for the bronze tabernacle he had created for the Hospital of Santa Maria della Scala.

1473 Grand festivities were held to celebrate the visit of Eleonora of Aragon, daughter of the King of Naples, on her way to marry Ercole I d'Este in Ferrara.

The Spannocchi palace, designed by Giuliano da Maiano for Ambrogio Spannocchi, was begun.

1474 The palace of San Galgano was specifically modelled on the example of the Spannocchi palace.

1475 The partnership dispute between Francesco di Giorgio and Neroccio de' Landi was resolved, leaving the two men to pursue separate careers.

1476 Vecchietta created the bronze statue of the *Risen Christ* for Santissima Annunziata, the church of Santa Maria della Scala.

1477 Francesco di Giorgio started work in Urbino for Duke Federico da Montefeltro, and Vecchietta was granted a family chapel in Santissima Annunziata in which to place his *Risen Christ*.

1478 In September the Duke of Urbino stayed with the doctor and patron of Francesco di Giorgio, Alessandro Sermoneta, in Siena.

On 23 November the friars of San Domenico granted a chapel to the confraternity of Santa

Fig. 40
Detail of cat. 50

Barbara, who commissioned from Matteo di Giovanni an altarpiece of similar size to that painted for the Borghesi chapel in the same church.

1479 The Battle of Poggio Imperiale between the Florentines and Alfonso, Duke of Calabria, was followed by a visit to Siena of the Dukes of Urbino and Calabria amid great festivities on 18 December.

1480 A council was held to re-admit exiles and on 22 June the *Riformatori* were expelled from government. Bartolomeo di Giacoppo Petrucci and many others returned to Siena. Federico da Montefeltro, Duke of Urbino, negotiated the return to Siena of Francesco di Giorgio, who was admitted to the Consiglio del Popolo.

On 7 August the Duke of Calabria, who had been influential in the exiles' return, left Siena for Naples following the Turkish attack on Otranto.

1481 Matteo di Giovanni designed a marble panel for the pavement of Siena Cathedral depicting *The Massacre of the Innocents,* also the subject of three of his altarpieces. Various sculptors were employed to make pavement scenes depicting Sibyls for the Cathedral.

1482 In June leading *Noveschi*, including Giacoppo Petrucci, were exiled. Those expelled a month later included Antonio Bichi (who went to Urbino and Naples) and Leonardo Bellanti. Three *monti* were recognised – *Nove*, *Popolari* and *Riformatori*.

1483 On 1 April three *Noveschi* prisoners were defenestrated and Cardinal Cibò, who had tried to mediate amongst the Sienese factions, left the city.

On 14 June a league with Florence was concluded, and the next day the lands captured from Florence in the Pazzi War were returned.

On 24 August the city of Siena was re-dedicated to the Virgin.

1484 For the first time, books began to be printed in Siena.

1487 On 22 July the *Nove* returned to power in Siena, with members of the Petrucci family involved in government. Achille Petrucci was Captain of the People in September and October. On 19 September the government ordered that the *Noveschi*'s return should be celebrated on the feast day of Saint Mary Magdalene.

In October Francesco di Giorgio returned from Urbino to Siena.

1488 Antonio Bichi, who would be one of the most important political figures of the 1490s, and his daughter Eustochia commissioned Signorelli to create an altarpiece and Francesco di Giorgio to create a polychrome statue of *Saint Christopher* for the Bichi chapel in Sant'Agostino (see p. 224).

1489 Francesco di Giorgio Martini and Antonio Ormanni were paid for bronze angels for Siena Cathedral, the first realised part of Francesco di Giorgio's plans to remodel its interior.

1491 On 13 February Alfonso, Duke of Calabria, requested the services of Francesco di Giorgio for fortification works in Naples.

1492 The Consiglio del Popolo confirmed a Balìa (ruling council) to last for five years on 20 February.

1494 On 19 January 1494 the double marriage was celebrated of Antonio Spannocchi to Alessandra Placidi and Giulio, his brother, to the Roman Giovanna Mellini, with great ceremony and the erection of a temporary triumphal arch (see cat. 60–4).

On 7 February the oligarchy ruling Siena was clearly defined (listed in a book entitled the *Libro della Maddalena*) and it became a hereditary body. Saint Mary Magdalene was declared another patron saint of the city.

A riot occurred on 21 June following Savonarola's attempts to reform the Dominican congregation of Santo Spirito in Siena.

For the visit of Charles VIII, King of France, who arrived on 2 December, three triumphal arches were constructed, one of them displaying statues of the new king and of Charlemagne. On 31 December an accord was made between the *Nove* and the *Popolari*.

1495 Montepulciano became part of the Sienese state on 4 April and ten days later Pandolfo Petrucci became a member of the Balìa. Fortifications and artillery became a major pre-occupation of the government.

During his visit (13–17 June) Charles VIII knighted, among others, Pandolfo Petrucci's son Giulio Cesare (who would die young).

1496 On 31 January a Florentine force including Sienese exiles approached the walls of Siena but then withdrew. In April Luzio Bellanti was involved in a plot to kill Pandolfo Petrucci.

1497 On 27 April Piero de' Medici, with Sienese support, attempted to return to power in Florence.

A report to Ludovico Sforza, Duke of Milan, stated that the government was in the hands of Antonio Bichi, Niccolò Borghesi and Pandolfo Petrucci. Reforms were made by the government to equalize the power of the three *monti*.

In August three adjudicators, one of them Pandolfo Petrucci, set a price for the bronze angels which Francesco di Giorgio, made for the Cathedral of Siena.

On 21 November the Consiglio del Popolo re-confirmed the Balia for another five years.

On 16 December the inner committee known as the Tre Segreti, led by Pandolfo Petrucci, exiled a large number of Sienese families, including most of the Boninsegni and Gabrielli and the Luti, Zondadari, Binducci and other *Riformatori*.

1498 In September Observant Dominican friars from San Marco in Florence took over the convent of Santo Spirito in Siena.

1500 Niccolò Borghesi, Pandolfo's father-in-law and last major political opponent, was attacked by assassins and died in July.

1501 Cardinal Francesco Todeschini Piccolomini made a contract with Michelangelo to make fifteen marble statues for his chapel in Siena Cathedral (a contract ratified by the Cardinal's heirs in 1504).

In November Francesco di Giorgio died and was buried at the Osservanza. He was the last survivor of the leading fifteenth-century Sienese artists (Matteo di Giovanni had died in 1495 and Neroccio de' Landi in 1500).

1502 Francesco Todeschini Piccolomini employed Pintoricchio on 29 June to paint the Piccolomini library in Siena Cathedral with scenes of the life of his uncle Pope Pius II (see cat. 74–6).

On 4 August the Chigi family employed Perugino to paint the altarpiece for their family chapel in Sant'Agostino.

The first book published by a native Sienese printer, dated 28 April, entitled *La Sconficta di Monte Aperto*, was an account of the great battle of 1260 when the Florentines were vanquished by the Sienese.

On 21 November the Balìa was confirmed in power for yet another five years, consolidating Pandolfo Petrucci's hold over Siena.

1503 Pandolfo Petrucci went into exile on 28 January following threats from Cesare Borgia but he was allowed to keep his property and returned to Siena, following diplomatic pressure by the French king, on 29 March.

Cardinal Francesco Todeschini Piccolomini became Pope Pius III on 22 September but his death on 18 October, within a month of his accession, led to the bankruptcy of the

Spannocchi bank. However, Agostino Chigi benefitted commercially from the affair, and made plans to build a new palace in Siena at Piazza Postierla.

1504 On 24 December the friars of Santo Spirito were expelled by the Sienese government for following a papal interdict in refusing to celebrate religious ceremonies.

1505 Alberto Arringhieri, the *operaio* or rector of the Cathedral Office of Works, fled to Rome in late June, leaving Pandolfo and two close associates to undertake Francesco di Giorgio's plans to remodel the interior of the Cathedral. Giacomo Cozzarelli was employed to make bronze apostles to Francesco's design. The Balìa also decided to celebrate the feast of Saint Mary Magdalene in perpetuity on 11 July and to order a silver statue of her.

1506 On 8 July the old choir in the centre of Siena Cathedral was removed and, more importantly, so was Duccio's *Maestà* (which had been installed in 1311). On 4 August Vecchietta's tabernacle was taken from Santa Maria della Scala and installed on the high altar. There were particularly magnificent celebrations, including jousting, during the feast of the Assumption in mid August.

1507 On 22 July, twenty years after the return of the *Noveschi*, Pandolfo entered into a secret contract with his closest political colleagues to maintain power over the state. Members of the *Nove* far outnumbered the *Popolari* and *Gentiluomini*.

On 20 August the Balìa was confirmed in power for a further five years.

On 10 September Pandolfo embarked on an ambitious urban development scheme by creating façades for houses, destroying over-hanging balconies, and confining certain tradesmen to particular areas.

On 24 November Pope Julius II acknowledged that his ancestors had originally lived in Siena. On 14 December the Sienese Republic gave the Pope a large estate near Siena worth 12,000 florins, which the Pope promptly bestowed on his nephew Niccolò della Rovere.

1508 On 22 February Sigsimondo Chigi, brother of the banker Agostino, married Sulpitia Petrucci, eldest daughter of Pandolfo.

Many payments were made for building work on the Palazzo del Magnifico and in October the Balìa decided to construct a portico around the Campo.

Pandolfo and his associates ordered the construction of a new organ in the Cathedral. Its case was in the form of a triumphal arch, made by Antonio Barili and Giovanni il Castelnuovo in 1509, and its cover was painted with the *Transfiguration* by Girolamo Genga in 1511.

Government interference in the administration of Santa Maria della Scala led to conflict with the rector, Marco Antonio Tondi, who was removed from office. In August 1508 a governor was chosen who was not subject to the statutes applying to the rector, so Petrucci and his supporters could then control the hospital without opposition.

1509 An apartment was prepared in the Palazzo del Magnifico for Pandolfo's eldest son Borghese and his bride Vittoria Piccolomini, niece of Pope Pius III, whose marriage took place in September.

1510 On 8 June the Sienese mint struck the first coins showing the Sienese she-wolf and the twins Senius and Ascius.

1511 Alfonso Petrucci was made Cardinal by Pope Julius II on 10 March.

Siena returned Montepulciano to Florence in July 1511 and on 9 August news of a treaty of peace for twenty-five years between Siena and Florence, guaranteeing the maintenance of the Petrucci regime, was made public.

1512 Borghese Petrucci was appointed to his father's offices on 6 February (although he could not exercise these powers if his father was present).

On 21 May Pandolfo Petrucci died in the little town of San Quirico d'Orcia. Following a magnificent public funeral, he was buried in his family chapel at the Osservanza.

The oligarchy controlling the state was confirmed in another secret contract entered into by Borghese and Alfonso Petrucci on 11 July 1512.

1513 Domenico Beccafumi worked on the Chapel of the Madonna del Manto in Santa Maria della Scala and painted its altarpiece.

On 11 March Cardinal Giovanni de' Medici was elected Pope Leo X.

1516 Borghese Petrucci fled into exile on 9 March and his cousin Raffaelle Petrucci took control of the government.

1517 Cardinal Alfonso Petrucci was deprived of his honours on 22 June and executed on 4 July by Pope Leo X for his involvement in a conspiracy against him.

On 26 June Leo X appointed thirty-one cardinals, including Raffaele Petrucci and Giovanni Piccolomini.

1519 Beccafumi worked for Francesco di Camillo Petrucci on the decorative scheme for a room in his palace (cat. 102–7) and provided the design for the pavement under the dome of Siena Cathedral.

1522 On 17 December Cardinal Raffaele Petrucci, who had been the dominant political figure in Siena from March 1516, died.

1524 Fabio Petrucci, who had returned to Siena in December 1523, lost control of the state and was expelled from Siena on 18 September.

1525 On 7 April Alessandro Bichi, who had dominated Siena since the expulsion of Fabio Petrucci, was assassinated, and the new regime of the *Libertini* took over Siena.

Sodoma began the frescoes for the Turamini Chapel of Saint Catherine of Siena in San Domenico. The Accademia degli Intronati, Siena's most important literary academy, was founded.

1526 Siena was re-dedicated to the Virgin on 22 July, while threatened by the armies of Florence and the Medici Pope Clement VII.

The Battle of Camollia, on 25 July, was won by the *Libertini* regime, resulting in the exile of many who had held power under the *Nove*, including members of the Petrucci family.

1527 In July Baldassare Peruzzi, who had returned to Siena after the sack of Rome, was employed as architect to the Sienese Republic. Saints James and Christopher were declared patrons of the city.

1529 On 5 April Beccafumi was commissioned to paint the Sala del Concistoro (see cat. 108–9), and Sodoma to paint the Sienese patron saints Ansanus and Victor for the Sala del Mappamondo in the Palazzo Pubblico.

In December triumphal arches and other preparations were ordered for an expected visit by Holy Roman Emperor Charles V. He did not come to Siena, however, but remained in Bologna to be crowned Holy Roman Emperor (in February 1530) rather than proceeding to Rome.

1531 Beccafumi was paid for designs of scenes of the story of Moses for the pavement of the Cathedral on 30 August.

1532 Peruzzi was granted the right to transport Roman marble to Siena for the high altar he had designed for the Cathedral.

1536 On 24 April Holy Roman Emperor Charles V made a solemn entry into Siena. The ephemeral decorations included a large imperial eagle with a Latin inscription advocating the safeguard of liberty and an equestrian statue of Charles in Roman dress trampling three figures. This last had originally been commissioned from Beccafumi for Charles' expected visit in 1530.

THE CITY AND ITS SAINTS

Siena's self-naming as the 'City of the Virgin' can be traced back to coinage from the 1280s, but probably predates that official designation. The city was strongly devoted to the Virgin in all her roles and guises, but particularly to the Virgin of the Assumption (the Madonna Assunta), because it was after her bodily assumption to Heaven as its Queen that she could act as its intercessor. Her protective power was transferable to paintings of her and her image was everywhere. The role of Mary as protectress was spelled out by Saint Bernardino: '. . . she places herself between us and danger, she stands up to temptation, saying and commanding, "Away you evil one, get you behind me with your ill-fortune. Leave this city of mine alone, in which live so many of my devotees."'[1] His sermon is tellingly close to governmental rhetoric. In a general pardon to political opponents by the *Popolari*-dominated government of 5 August 1482, one of many similar examples, the Virgin is called 'advocate and patron of our city', associated with the defence of the city, its enrichment and its maintained liberty.[2] Thus the cult of the Virgin was the cornerstone of the 'civil' religion of Siena.[3] The Comune and Church acted in concert to relate a collection of beliefs to fixed collective rites and symbols that together gave sacred meaning to the life of the community. These were designed to create a vision of the city that accentuated its specialness and to promote a shared sense of its history and destiny, a civic ideal to which all citizens would subscribe. This civil religion worked above the ordinary (and in Siena, often extreme) internal divisions created by everyday politics, to bond the city together as a united society.

The Sienese cult of the Virgin found concrete form when construction began in the early thirteenth century on the new Cathedral, dedicated to the Madonna Assunta.[3] This dedication should be read in the context of her growing cult across Europe, but it took on particular significance in Siena. The Cathedral was the site for the annual Assumption Day ceremonies.[4] Siena is thought to have celebrated the feast of the Assumption of the Virgin as early as 1200. A document with that date (known from a copy of the late thirteenth century) apparently establishes the form of the compulsory ceremony of offerings that took place on 14 August, the eve of the feast day proper:[5] 'Each and every person, to whatsoever district [*contrata et libra*] he may belong, who dwells in the city of Siena, be held and is obliged to go on the vigil of Saint Mary the Virgin of the month of August, to the said church [the Cathedral] in company with those of the *contrada* wherein he dwells And he who shall do otherwise shall be punished with a fine of 20 *soldi* in coin; and the persons aforesaid shall go to the said church with candles and without torches, by day and not by night.' Membership of the city's *compagnie* was needed for individual citizens to take part, just as it was in the government of the city itself, a significant linkage. At least by the early Trecento, the ceremony was preceded by a procession of civic dignitaries, led from the Palazzo Pubblico by the priors of the Signoria. From about 1310 a horse-race was run (the Palio, named after the banner or bolt of cloth given to the victor) and a second ceremony occurred on the feast day itself with representatives of subject towns in the *contado* coming to the city to offer

annual affirmation of earthly, political allegiance to Siena by bringing offerings to Siena's heavenly patron. The Virgin's cult was amplified when in 1359 the Hospital of Santa Maria della Scala bought relics from the imperial chapel at Constantinople that included part of Virgin's girdle and her veil.[6]

The Assumption Day ceremonies became a key moment for popular spectacle.[7] A payment was made in 1445 from the Opera del Duomo (Cathedral workshop) to 'our master builder for the play of the Assumption made for the Feast of Saint Mary'. The most costly items were the iron 'construction for the Assumption', which had to be replaced, suggesting an earlier tradition of performance, and 'the throne of the Assumption'. Performances featured a combination of effigies and actors. Seraphim were made from old sheets, fine gesso and lacquer, but according to payments of 1448 other angels were played by young boys, wearing garlands and brass wings – one of whom, singing, was placed on top of the structure, earning himself a pair of shoes.

In the Quattrocento, the civic cult of the Virgin was further codified by the promotion of the 'myth of Montaperti', deliberately transforming a generalised form of devotion into a politically directed civic religion. It focused on the battle fought and won against the Florentines on 4 September 1260, after the formal dedication of city to the Virgin Mary. The earliest source for this narrative is an anonymous chronicle originally concluded in 1361, extended to 1392. From this brief outline it is difficult to know what had happened in the first instance and what was made up later over the course of time or for subsequent propagandist needs. It has been argued that

the whole account of the dedication was largely invented in the fifteenth century, but that some kind of ceremony took place in 1260 seems incontrovertible.[8] That the story grew in the strongly anti-Florentine first half of the fifteenth century is indicated, however, by two other much fuller narratives dating in their earliest surviving versions from that time,[9] the so-called 'Montauri' chronicle,[10] which has people crying out '*Miserichordia madre nostra reina del Cielo*' outside the Cathedral – uniting the Virgin of Mercy with the Virgin of the Assumption – and an illustrated manuscript signed in 1442/3 by Niccolò di Giovanni di Francesco Ventura.[11] These establish the canonical narrative for the later fifteenth century and the years to follow, set down as gospel by later chroniclers and in Lancilotto Politi's 1502 printed book, *La sconficta* [defeat] *di Monte Aperto.*

Immensely important for the representation of the Virgin in this period, the Montaperti narrative starts with the ceremony of dedication of the city keys to the Virgin on the eve of battle. The Sienese carried as their principal battle standard a huge, white silk banner symbolising the pure white cloak with which the Virgin shielded those seeking her protection. Her protection was demonstrated by a white cloak-like cloud that miraculously materialised over the Sienese camp. These mythic images were formed by and informed the iconography of the Assumption. There has been much scholarly discussion of the image before which the Montaperti vow was made – whether it was on the Cathedral high altar, and even whether the vow was originally associated with an image at all.[12] Whatever the truth of the matter, by the mid fifteenth century it was assumed that a certain panel, cut down from a larger original, was 'this Our Lady … who hearkened unto the people of Siena what time Florentines were routed at Montaperti', known as the *Madonna delle Grazie* or from at least from 1447 as the *Madonna del Voto* (*Virgin of the Vow*; see fig. 27, p. 55). It was this image that was housed in the newly built chapel where Donatello's important *Virgin and Child* relief erroneously now often called the *Madonna del Perdono* (fig. 26, p. 52) was also to be seen.

The Virgin was pre-eminent over a pantheon of saints, and the city also had four chief holy patrons, Ansanus, Savinus, Crescentius and Victor. The tradition continued with the creation of new prestigious patron saints, one Franciscan and one Dominican, in the fifteenth century – Bernardino and Catherine, 'advocates of order'.[13] Thus, the state established a stronger link with the religious practice of the day, finding saints from within important preaching orders.

1 Hook 1979, p. 132.
2 Hook 1979, p. 132.
3 Bowsky 1981, pp. 260–98; Webb 1996, pp. 249–316; Parsons 2004, pp. XV, 2–31 in which he cites the five characteristics of 'civil religion' identified by historians Richard Pierard and Robert Linder, summarised here.
4 Carli 1979, p. 11.
5 Heywood 1899, pp. 96–115; Cecchini and Neri 1958, pp. 15–16, 139–40.
6 'Stutuimus et ordinamus quod omnes et singuli de contrata et libra, in qua habitant in civitate Senarum, teneantur et debeant ire in vigilia Sancte Marie de mense augusti ad ecclesiam dictam solummodo cum illis de contrata in qua habitant … Qui contrafecerit, puniator in XX solidis denariorum. Et predicti debeant ire ad ecclesiam dictam cum cereis et sine doppieris, de die et non de nocte…'. Ascheri 1993b, pp. 64–6; P. Turrini, 'I fili della storia. Contrade e Palio nelle fonti documentarie' in Ceppari Ridolfi, Ciampolini and Turrini 2001; M.A. Ceppari Ridolfi and P. Turrini with

L. Vigni 'Repertorio documentario sulle contrade e sulle feste senesi' in Ceppari Ridolfi, Ciampolini and Turrini 2001, pp. 517–92, esp. pp. 261, 521, doc. 15.
7 Gallavotti Cavallero 1985, p. 80; Derenzini in Bellosi 1996, pp. 73–8, doc. II, esp. p. 75; Norman 1999, pp. 99–101, 149–51, 231.
8 Campbell 2005, pp. 435–63, esp. pp. 451–3.
9 E.B. Garrison in Garrison 1993, pp. 23–58; Webb 1996, pp. 251–75.
10 Pertici 1990, pp. 9–26; Kawsky 1995, pp. 39–52.
11 Lisini and Iacometti 1931–9, ii (*Cronaca senese conosciuta sotto il nome di Paolo di Tommaso Montauri*), esp. p. 202; Garrison 1993, p. 39.
12 Bellarmati 1844, pp. 3–98.
13 Garrison 1993, pp. 5–22; B. Kempers 'Icons, Altarpieces and Civic Ritual in Siena Cathedral, 1100–1530' in Hanawalt and Reyerson 1994, pp. 89–136; Butzek 2001, pp. 97–109; R. Argenziano, 'Le origini e lo sviluppo dell'iconografia della Madonna a Siena' in Ceppari Ridolfi, Ciampolini, Turrini 2001, pp. 91–109, esp. pp. 103–4; Parsons 2004, pp. 8–12.
14 C.B. Strehlke 'Art and Culture in Renaissance Siena' in Christiansen, Kanter and Strehlke 1988, pp. 41–2; Webb 1996, p. 276.

The Art of the State

I.

SANO DI PIETRO (1405–1481)

The Virgin recommends Siena to Pope Calixtus III, 1456

Tempera and gold on panel, 158 × 115 cm
(with original frame)
Pinacoteca Nazionale, Siena (241)

Signature inscription: · CALISTVS · III + SANVS ·
PETRI · DE · SENIS · PI[N]XIT (*Sano di Pietro of
Siena painted [this]*)
Inscribed in Italian, in Virgin's banderole: '*O pastor,
worthy of my Christian people, to you I give the care of
Siena and ask that you render her all your human sense*';
in the pope's banderole: '*Virgin mother, dear consort to
god, if your Calixtus is worthy of such valued a gift, only
death will take me from Siena*'

Sano's painting contains many of the themes to be found in Sienese civic art. The Virgin herself is depicted half-length and on a cloud, wearing the white cloak associated with her Assumption, in which role especially she was patroness of the city (see cat. 3), and her features somewhat resemble those of the *Madonna delle Grazie* (fig. 27). She entrusts the care of Siena to Pope Calixtus III (crowned 20 April 1455, died 6 August 1458), pointing with one hand decisively, even rather bossily, at the pontiff (whose expression is plausibly concerned), and gracefully indicates with the other the city under her protection. Calixtus has taken note, raising his right hand to bless Siena. This work has been rightly considered 'of outstanding historical and iconographic interest and the highest quality'.[1]

When the picture was still hanging in the Palazzo Pubblico, an inscription now lost, recorded by Gigli in 1723 and repeated by Della Valle in 1785,[2] almost certainly ran below it as a kind of predella,[3] and begins to explain its commission. 'This worthy

picture was made in 1456, the years at the time of the wise men Pietro d'Aldobrando … Pietro di Nofrio di Tura, Gentlemen of the Biado, and their Chamberlain Antonio di Giovanni Pini.' The Biado was the office of Provisions and Rations. The mule train at the pope's feet is, we can deduce, bringing in vital supplies of grain.

Sano's picture marked the survival of the Sienese republic after a moment of political crisis, having withstood the combined threat of a power- and land-hungry mercenary and an attempted *coup d'état* by leading members of one of its political factions. In 1455–6, Siena had successfully resisted the menace of Jacopo Piccinino and crushed his allies within the city walls (an episode typical of the fusion of internal factionalism with external pan-Italian power struggles). The Borgia Pope Calixtus III, albeit at long distance, had played a crucial role.

Leading members of the *monte dei Nove*, the longest-established of the ruling parties, had long pressed for a new, potentially more stable regime based on the principles of rule by a limited oligarchy, which would diminish the pernicious influence of 'new men'.[4] In the 1440s, this group had centred round the bellicose Antonio di Checco Rossi Petrucci, whom Christine Shaw has characterised as 'a prominent if anomalous figure in Sienese political life. He behaved and thought like the scion of a family of minor lords, and was inclined to the military life, although he did not try to make his fortune as a *condottiere* [mercenary]'. This generation of *Noveschi* reversed their traditional Trecento allegiance: from Guelphs, they became strongly anti-Florentine Ghibellines. The Petrucci conspiracy of 1456 brought the factional divisions in Siena to their head.[5]

Indeed in the events of the 1450s can be seen the roots of the political chaos of the 1480s (see pp. 74–9 and cat. 45–6). These *Noveschi* depended upon the external support of Alfonso V of Aragon, King of Naples, and the Naples-supported *condottiere* Jacopo Piccinino was in league with the *Nove* conspirators. Piccinino entered Sienese territory in June 1455, taking Cetona.

However, he found himself opposed – perhaps unexpectedly – by Francesco Sforza, Duke of Milan, and Pope Calixtus III, who sent troops to assist the Sienese government.[6] Piccinino retreated to Castiglione della Pescaia, which he held for Naples, and then took the Sienese coastal town of Orbetello, which enabled him to get supplies by sea. The conspirators around Petrucci hoped that Piccinino would remain there until they were ready to strike in Siena, but a peace agreement with Naples (now allied with Milan) in May 1456 meant that Neapolitan interests were less obviously served by supporting the *coup*. The plot was revealed, and Cristofano Gabrielli, the Capitano del Popolo, was able to thwart the intended *coup* (including an attempt to assassinate him). Mariano Bargagli, the Cathedral *Operaio* was one of several conspirators executed. Many fled or were exiled; Antonio Petrucci himself was officially declared a rebel on 13 October 1456, his family remaining in exile for years to come.

Sienese gratitude to Calixtus III was immense:[7] a feast day of Saint Calixtus, the first pope of that name, was introduced on 14 October 1455; the humanist Agostino Dati delivered a panegyric to the early martyr-pope, using the opportunity to laud all three popes of that name; a chapel already under

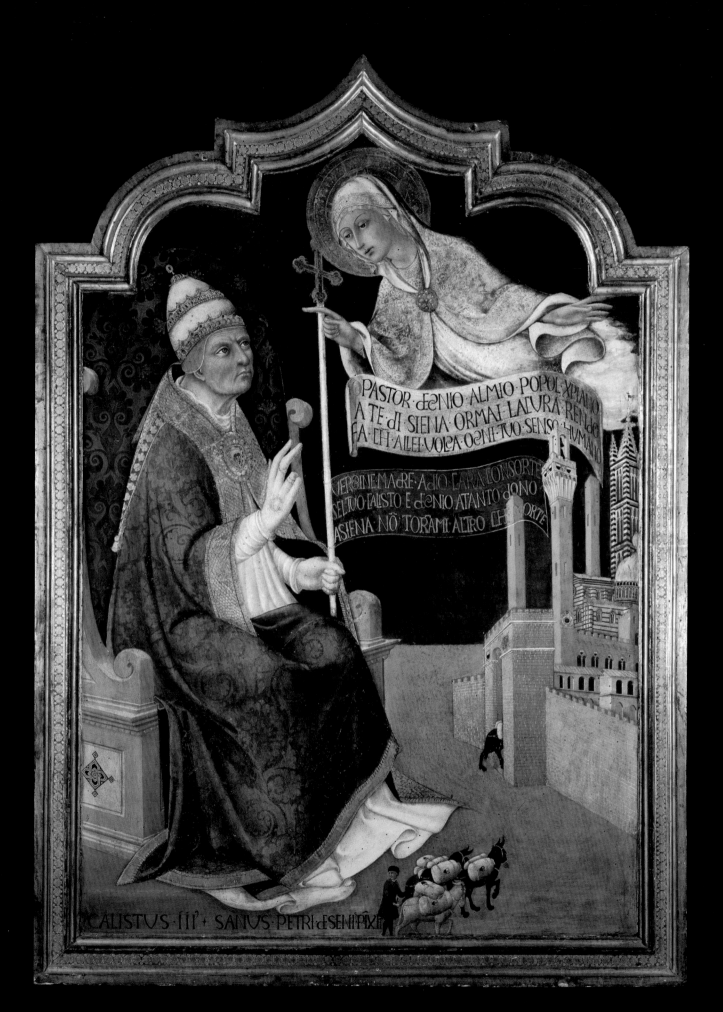

O PASTOR D·ENIO AL MIO POPOL XPIANO
A TE DI SIENA ORMAI LA CURA RENDO
FA CH·AI LEI VOLGA OGNI TUO SENSO HUMANO

VERGINE MADRE A DIO CARA CONSORTE
DEL TUO CALISTO E D·ENIO ATANTO DONO
A SIENA NÕ TORAMI ALTRO CHE MORTE

CALISTUS III · SANVS PETRI DE SENIS PIXIT

construction in the Cathedral, originally to be dedicated to Saint Boniface, was rededicated to Saint Calixtus. This newly prominent cult was probably associated, at least at its beginning, with the victorious regime of 1456. Its success and Pope Calixtus III's assistance were to be associated with the protection of the Virgin, and the power of her image. A new indulgence was granted by Calixtus III, announced on the feast day of the Annunciation 1457, with remission in Purgatory for those who should devoutly visit 'the old and holy image of the Virgin' (the *Madonna delle Grazie*) when it was exhibited 'at stated times'. The combined protection of Siena by the Virgin and her earthly representative, the head of the Church, is similarly expressed in Sano's painting, which annexes and adapts established civic imagery – representing particular political certainties and continuities – for precise political ends.

The painting, much more than a document, deliberately refers as much to a serene past as to the peaceful present. Jacobsen dismissed this picture as 'all costly naivety',[8] and modern art historians have ritually castigated Sano for his stylistic conservatism. However, Sano's stylistic evocation of the painters of the Trecento was evidently valued by Siena, and he can be seen as a kind of state painter, albeit unsalaried. Moreover, although its separate ingredients were tried and tested, Torriti was right to imply that the iconography is innovative in its amalgamation of the Assumption of the Virgin with a city view so strongly reminiscent of Ambrogio Lorenzetti's fresco of *Good Government* in the Palazzo Pubblico; this combination was to have a long currency.

The vocabulary derived from the Trecento permitted huge shifts of scale, making the picture clearly emblematic rather than realistic. The city is depicted as a group of key monuments, little more than the Palazzo Pubblico, the Cathedral and the Baptistery – brought unnaturally close to one another, in contrast to more topographically accurate later views (see cat. 2–3, 93). The picture also obeys the Trecento aesthetic of lovely craftsmanship. It is carefully planned, with the straight lines of the architecture all incised. It is also full of curious detail: we do not immediately notice the little angel on top of the striped Cathedral tower or the way the packs are tied to the mules' saddles. And it was certainly lavish. The gilded frame was carefully punched with a pattern of flowers, perhaps the roses of the Madonna. The areas of gilding stand out precisely because Sano abandoned a gold ground for the blue sky (now darkened) in which the Virgin appears. A particularly beautiful double-diamond punch containing a quatrefoil was used for the gold border of the pope's red brocade cope, which is otherwise incised freehand.[9] Sano also introduced silver, now mostly removed;[10] the centre of his crucifix was originally silvered, and silver leaf was applied in the pattern of the green brocade draped over the throne. One additional element designed to dazzle seems not to have passed beyond the planning stage. Sano scratched lines across the pope's fingers, just above the knuckles, rather casual incisions in three instances, including the forefinger, but more carefully indicated on the third and fourth fingers. These cannot be explained unless they indicate where three-dimensional papal rings were to be attached.

The work is fully autograph, with no intervention from Sano's large workshop: this government commission can be seen as summing up all his particular skills as a painter. In signing himself as Sienese (*DE SENIS*), Sano was making a point. Unlike their counterparts elsewhere in Italy, who would normally declare their origins only on works made outside their city, Sienese painters' signatures frequently emphasised their place of birth (or adopted city) to a local audience. At a moment of political crisis, this statement became all the more important. LS

1 Torriti 1980, p. 274, no. 241.
2 Gigli 1723, II, p. 306; Della Valle 1784–6, II, p. 231: 'Questa degna pittura fu fatta nel 1456 anni altempo dei savi uomini Pietro d'Aldobrando Cerretani etc. Bandolfo [Pandolfo?] di Lorenzo Picchogliuomini [Piccolomini] etc. Salvestro di Bertoccio de Marchi etc. Salimbene di Francesco Petroni, misser Gabriello di Bartolomeo Palmieri etc. Galgano di Ser Jacomo Tachalume, Giovanni di Tofano di Magio etc. Pietro di Nofrio di Tura Signori di Biado etc. Antonio di Giovanni Pini loro Kamarlengo.'
3 It is possible that the panel was originally placed within a larger structure. What seem to be sawn-off dowels are visible on the vertical edges of panel, suggesting it could have had other elements attached to it.
4 Pertici 1990, pp. 13–15; Pertici 1992, pp. 1–39; Ascheri and Pertici 1996, pp. 995–1012, esp. pp. 997–1004.
5 Shaw 2000, pp. 30–2.
6 Banchi 1879a, 4, pp. 44–58, 225–36; Banchi 1879b, pp. 177–221; Fumi 1910, pp. 525–6, 541–82.
7 Banchi 1880; Webb 1996, pp. 303, 305–6.
8 Jacobsen 1908, pp. 33–4.
9 Sano would use the same punch for description and decoration. This double diamond can be seen in other pictures at the Pinacoteca Nazionale, for example, in the halo of the Virgin in the *Coronation of the Virgin* triptych (269) and in the costume of Saint Augustine in the left hand panel of the same work (considered an early work).
10 In doing so he was perhaps influenced by Gentile da Fabriano, who had worked in Siena in 1425.

SELECT BIBLIOGRAPHY

Torriti 1981, pp. 274–5; C.B. Strehlke, 'Art and Culture in Renaissance Siena' in Christiansen, Kanter and Strehlke 1988, p. 40; Pertici 1995, pp. 29–30; Ascheri and Pertici 1996, III, pp. 995–1012, esp. p. 1007; Norman 2003, pp. 210–12.

Paintings for the Biccherna and the Gabella

The art of government does not normally stretch beyond politics or legislation, and it is rare indeed for the practical machinery of the state to engender a novel category of picture. In Siena, however, the cover decoration of the account books of its two most important financial offices gave rise to a painting type unique to the city. The Sienese Comune commissioned artists to paint the book covers for various public records, but the two magistracies that commissioned most were the Biccherna and the Gabella Generale, leading to a category of autonomous painting termed Biccherna and Gabella panels.

The institutional pluralism that was such a feature of Sienese government, designed to prevent power being concentrated in the hands of an élite few, meant that as well serving in the Concistoro, members of the city's leading families were called upon to perform other public roles, not least participating in the rotating membership of the Biccherna and the Gabella. The Biccherna was the older of the two magistracies, documented from 1168.[1] From the first half of the thirteenth century, it was run by a chamberlain (camarlengo) and four provveditori, serving six-month terms. The provveditori were, at least ostensibly, chosen by the Concistoro, the committee at the top of the government structure. They then elected the Chamberlain. Whereas for most of the fifteenth century, nobles were excluded from the heart of government, here the pool of possible candidates was wider and the nobility, many of them able merchant-bankers, were allowed to serve. The Biccherna was responsible for all state expenditure and, in its first incarnation, gathered all moneys due to the Comune.

It administered payment of all state salaries, subsidies for religious institutions (not least the Cathedral), distribution of alms and, at moments of crisis, the purchase of basic provisions. Moreover, much of the state's income flowed through this office – fines in civil or criminal cases and rents on properties owned by the city. It organised the leasing of mineral deposits in its territory in return for a portion of the profits. Perhaps most important of all, the Biccherna organised the direct taxation of Siena's inhabitants – the so-called 'Lira'.

Still more lucrative were the various forms of indirect taxation levied on citizens and visitors – the gabelle.[2] These were the state rake-offs from all forms of commercial transaction – on goods going through the city gates, on contracts drawn up by notaries and on sales of everything from wine to houses. The Gabella Generale was an office born within the Biccherna, but by the early Trecento it had become independent. By the late fifteenth century, the Gabella was commissioning paintings and had responsibility for the recording and administering of taxes on contracts. Its structure was similar to that of the Biccherna.

The series of account books containing records of revenue and expenditure starts in 1226. Bound in wood, they were initially distinguished one from another by basic symbols or letters of the alphabet. However, in June 1257 (with Siena at its commercial peak), the merchant administrators of the Biccherna decided to pay a painter, one Bartolomeo, to paint the cover of the latest account book, adding lustre to the functioning of the state, fetishising the books that stood for their actions and competence. Here begins a tradition that was to endure

for nearly four centuries, during which time the peripheral embellishments of what were after all the practical tools of fiscal management were transformed by 'civic passion'[3] into autonomous works of art. Many of these covers are significant from an art historical point of view, since they are precisely dated and some are the documented works of named artists. The 1257 cover is lost, but the first example to survive is from only a year later, showing what was to become a standardised image of the chamberlain. Once independent, the Gabella followed this precedent, and, perhaps in the spirit of competition, it was the Gabella that in 1334 and 1344 extended the range of possible subject-matter. The account-book covers could then contain larger political or historical messages. Gradually they came to be treated as a kind of pictorial chronicle.

There was firm adherence to visual tradition with little alteration of the compositional arrangement of the imagery – a figurative scene placed above the coats of arms of the officers and a commemorative inscription below naming the officers. The main image was divided from the other parts halfway down the panel by the horizontal strap of leather that bound front and back covers together. Even after 1460, when the panels commissioned by the Biccherna and the Gabella ceased altogether to function as book covers, and were instead framed and presumably exhibited on the magistracies' walls, this essential scheme was preserved.[4] LS

1 This account draws on Bowsky 1970, pp. 2–15; C. Zarilli, 'Amministrare con arte. Il lungo viaggio delle biccherne dagli uffici al museo' in Tomei 2002, pp. 22–41.
2 See Bowsky 1970, p. 114.
3 C. Zarilli in Tomei 2002, p. 31.
4 This is a change equivalent to that between cassone painting and independent so-called spalliera painting.

2.

ATTRIBUTED TO FRANCESCO DI GIORGIO MARTINI (1439–1501),
PROBABLY IN THE WORKSHOP OF VECCHIETTA (1410–1480)

The Coronation of Pope Pius II with the Virgin of the Assumption;
View of Siena between two Chimera, 1460

Biccherna panel, tempera and gold on panel, 59 × 40.5 cm (including original frame)
Archivio di Stato, Siena (32)

In 1460, both the Biccherna and the Gabella Generale chose to mark the elevation of Aeneas Silvius Piccolomini to the papacy; as Pius II, he was only the second Sienese pope.[1] Perhaps because of the importance of the event commemorated, this was the year that these account-book covers were converted into independent paintings. The Gabella commissioned a scene of Pius II's creation of cardinals.[2] The Biccherna connected his coronation and consecration with the protection of his native city by the Virgin Mary. The Virgin hovers above the pope, as the papal tiara is placed on his head by two cardinals. The enthroned Pius II, depicted frontally, is larger than his companions to left and right and the six other cardinals seated on benches to either side. The space that they occupy is indicated by their recession, particularly effective on the right, and by orthogonals scored into the gold floor. These meet – rather approximately – at the pope's hands, held in prayer, which are placed on the central axis that links his head and tiara with the Virgin above and the dome and spire of Siena Cathedral below. The dome was the only part of the panel that was originally silvered, emphasising its importance within Siena. The city is depicted in convincing perspective, its principal gateway flanked by a pair of watchful chimera, creatures with the tawny heads and front legs of lions, goat bodies and serpent tails, perhaps standing for vigilance.

Pope Pius II was crowned in Rome on 3 September 1458. He had been elected on 19 August, four days after the feast of Assumption of the Virgin. The panel thus commemorates an occasion that had taken place two years earlier; its commission in

1460 has been connected with the pope's lengthy visits to Siena in 1459 on his way to Council of Mantua and in September 1460, breaking his return journey to Rome. Unlike the Gabella panel of the same year, which has an elaborate, though invented architectural setting, here the historical event is abstracted and rendered emblematic.

It could thus be related not just to the actual coronation in Rome but also to the ceremony that was organised in Siena to mark the occasion, a performance of the Assumption of the Virgin on the Piazza del Campo on the same day.[3] An altar and stage were built in front of the Palazzo Pubblico, reaching the second storey. After a mass had been sung, and before the Elevation of the Host, huge curtains were drawn back to reveal over five hundred clergy and others of the 'religious' who represented the hierarchies of heaven. A chronicler wrote:[4] 'Once the sacrifice was celebrated, the Assumption of the glorious Virgin was represented with admirable artifice. Below, for the wonder of the observers, the man [acting the Virgin] and those who played the angels were assumed into Heaven, which was built splendidly through craft and artifice [*manu et opera*]; songs and music composed for this occasion were sung.' Another source elaborates: 'Then someone playing Pius, dressed in the pope's vestments, was accompanied at the feet of the divine Mary by two fictitious cardinals, who asked her with sweet chants that she place the crown on his head … The Virgin sang beautiful and sweet songs to move the will of her Son, and started to dress the pope with the papal gloves [*manthica*] and cope [*pluvialis*] with her hands and also to put the ring on his finger and the crown, with the

power to bind or loose souls, on his head.'[5]

The Biccherna panel was painted in 1460 or perhaps shortly thereafter (there was sometimes an interval between the end of a term of office and the execution of a commemorative panel). The officers named in the inscription, whose arms appear above, were those in place in that year. Painters were normally paid very low sums for these assignments, almost an honorarium;[6] it may be that these commissions were considered an obligation, a part of the painter-citizen's service to the state. It is not surprising that they frequently appear to have been executed rather quickly. They may also sometimes have been delegated. Though always attributed to Vecchietta, this piece has enough similarities with Francesco di Giorgio's early works to suggest that he may have executed this piece within Vecchietta's workshop. The face of the Virgin is particularly like that of Saint Dorothy (cat. 10), and the cardinals have the vigour of the protagonists in his *Saint Bernardino preaching* (cat. 8). LS

1 See Morandi 1964, pp. 94.
2 These included his nephew Francesco Todeschini Piccolomini, the future Pius III; A. Angelini in Bellosi 1993, pp. 116–17, cat. 3.
3 See Campbell 2005, pp. 445–6.
4 B.V. 40, BCS, cited by Mazzi 1882, I, pp. 36–7; Campbell 2005, p. 446.
5 Campbell 2005, p. 446.
6 Trimpi 1987, p. 19; Matteo di Giovanni was paid only 9 lire for his Biccherna painting in 1488.

SELECT BIBLIOGRAPHY

Cavazzini in Bellosi 1993, pp. 114–5, cat. 2; Becchis in Tomei 2002, pp. 196–7; La Porta in Martini 2006, pp. 38–9, cat. 2; F. Nevola 'Ritual Geography: Housing the Papal Court of Pius II Piccolomini in Siena (1459–60)' in Jackson and Nevola 2006, pp. 65–88.

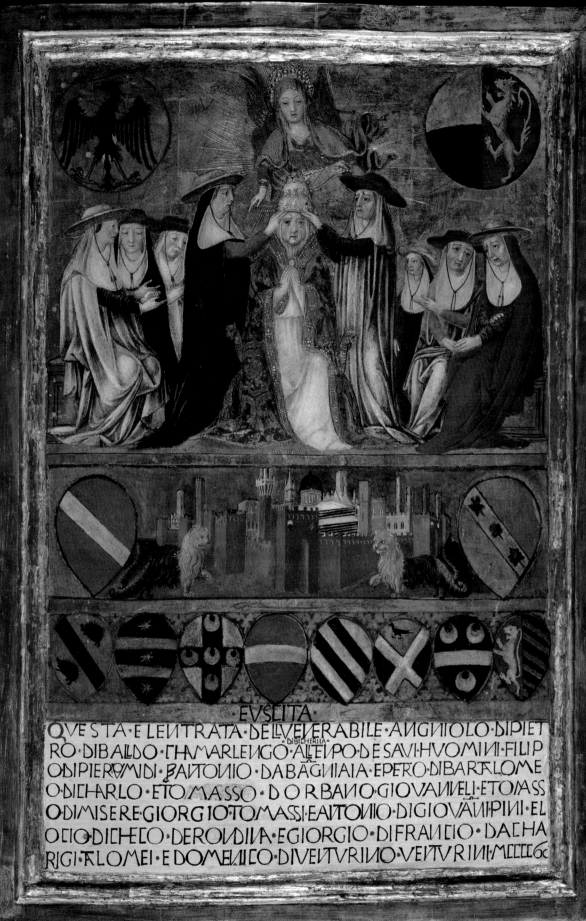

EVSCITA

QVESTA · E · LENTRATA · DELLVEVERABILE · ANGNIOLO · DIPIET
RO · DIBALDO · FHAMARLENGO · ALTEPO · DESAVI · HVOMINI · FILIP
ODIPIERAMIDI · BANTONIO · DABAGNIAIA · EPERO · DIBARTLOME
O · DICHARLO · ETOMASSO · DORBANO · GIOVANNELI · ETOMASS
ODIMISEREGIORGIOTOMASSI · EANTONIO · DIGIOVANNIPINI · EL
OTIO · DICHELO · DERONDINA · EGIORGIO · DIFRANCIO · DACHA
RIGI · TALOMEI · E · DOMENICO · DIVENTVRINO · VENTVRINI · MCCCCLX

3.

FRANCESCO DI GIORGIO MARTINI
(1439–1501)
*The Virgin Mary protects
Siena from Earthquakes*, 1467–8

Biccherna panel, tempera, gold and silver on panel
54 × 41 cm (including original frame)
Archivio di Stato, Siena (34)

4.

MATTEO DI GIOVANNI
(about 1428–1495)
*The Virgin guides the Ship of
the Sienese Republic to Calm Water*,
1487

Gabella panel, tempera and gold on panel
54 × 36.2 cm (including original frame)
Archivio di Stato, Siena (44)

5.

MATTEO DI GIOVANNI
(about 1428–1495)
*The Chamberlain and
Superintendents of the Gabella
commend the City of Siena to
the Virgin and Child*, 1489

Gabella panel, tempera and gold on panel
58.7 × 40 cm (including original frame)
Archivio di Stato, Siena (45)

Three other Biccherna and Gabella panels that place the Virgin centre stage unite with increasing sophistication the functioning and political ideology of the state, its art and civic religion. As Biccherna and Gabella panels became pictures in their own right, the city's leading artists extended the range of their subject matter still further.

The celebrated image of 'the Madonna of Earthquakes' (cat. 3), like cat. 2, is an allegorised record of a real event. The Virgin, arms outstretched, wearing the white cloak of the *Madonna Assunta*, floats above Siena, encircled by angels and cherubim. The circle of richly garbed angels also traditionally formed part of Assumption iconography and here with long blonde hair curling gracefully round their slim necks, they are depicted as ideals of ethereal beauty (see cat. 51–2). Below is the city of Siena as seen from outside Porta Pispini, with the Antiporto and Porta di Camollia on the right. According to the inscription, the Virgin was acting as protectress of the city 'in the time of earthquakes'. The panel is dated January 1466 (January 1467 in the modern calendar since the year in Siena began in March) but the chroniclers' records of earthquakes apparently contradicts the date in the inscription: they record a series of particularly ferocious quakes jolting the Sienese territory between August and September 1467. As can be seen in the panel, many citizens set up camp beyond the city walls.[1] One chronicler, Girolamo Gigli, reveals that the Virgin herself was considered a protagonist in these events.[2] This was a time in which natural disasters were widely believed to have been provoked by the sins of humanity, and therefore to be avertable or ameliorable through prayer.

Just as the first tremors struck, the Virgin was reported miraculously to have appeared in an oak tree near the city of Viterbo. The Sienese, interpreting this as a sign of the Virgin's divine protection of their city, sent a delegation of nobles to Viterbo to pay homage to their patroness. This incident has been linked directly to the iconography of the present Biccherna panel, the design of which is universally agreed to be Francesco di Giorgio's, even if the execution is sometimes given to an assistant (see cat. 23), and was apparently painted a little time after the period in office of the men named in the inscription.

The highly inventive Gabella panel (cat. 4), covering the period from 1 January 1486 (1487 new style) to 31 December 1487, like the Biccherna panel for the following year (British Library, London, a documented work by Matteo di Giovanni which is unfortunately much damaged), treats the return to power of the *Noveschi*, albeit cautiously by presenting it through political and religious allegory. Again, it makes plain that the protection of the city by the Virgin might be extended to moments of political change: here she guides a ship of state decorated with Sienese emblems – the *Lupa* (she-wolf) on a flag at the top of the mast, the flag of the Popolo (gold lion rampant on red ground) on the prow, and the black and white *balzana* flying from the poop. The passengers and crew probably represent the *Noveschi*, the exiles whose return was supposed to herald a new peace and internal order (see p. 61), safeguarded by the Virgin herself. The city in the background is less easy to identify as Siena than in others of these works, partly because of the viewpoint, but it contains what appears to be the

Cathedral façade with its rose window. The painting contains a mass of delightful detail. The Virgin appears in a cloud of seraphim (their red paint mostly lost). Matteo has painted her white cloak of the Assumption in loose swirls and folds, using *sgraffito* only in the white highlights (rather than to create a pattern). The flat gold areas convey shadow. The radiate mandorla-shaped aureole is both incised and painted but Matteo has left its right edge uncovered to emphasise the curved pose of the Virgin, and give her movement. Some highlights in the trees in the middle-ground at the centre are added with mordant gilding. There is a lovely contrast between the stormy sea – with its struggle of sailors and stylised waves – and the tranquil waters, calm enough for waterfowl. Spume breaks over the rocks in the left foreground and, on the right, the placing of the reeds is beautifully calculated. The sea is echoed in the dark clouds above, giving way to wispy cirrus clouds on the right.

Matteo's Gabella panel (cat. 5) that commemorates the two terms from 1 January 1488 (1489 new style) to 31 December 1489 introduces the five officers of the Gabella themselves (as types rather than specific portraits), dressed as penitents. They kneel before the Virgin who acts as intercessor – commending the city and its commerce (as regulated by the Gabella) to her Child. Her pose is interrogatory, as she encourages the Christ Child to enter the city, to bless it with his presence, as he already blesses its representatives. The Chamberlain and *esecutori* mostly hold their left hands to their breasts, indicating their sincere faith. One has his hands open in welcome; one gestures to the gateway

CAT. 4

90

(through which the goods taxed by the state would pass), another more broadly to the city's arms, and a fourth, upwards to the Cathedral. Finance and religion, properly paired, are represented as the lifeblood of the city.

Matteo's own talent is central to this message of civic faith. Stylistically the work is very close to cat. 4, but the technique has become, if anything, more economical and vivid, drawing and painting seamlessly blended. Matteo energises the entire scene, uniting protagonists and setting. The Virgin's terrain – a gently undulating landscape – is miraculously fresh. The sky is subtly streaked with clouds, one a glorious flourish lying low over a small town on the horizon. Even the architecture shimmers – Siena comes alive. LS

1 Fecini 1931–9 edn, p. 870.
2 A. Angelini in Bellosi 1993, p. 290, cat. 51.

SELECT BIBLIOGRAPHY

Cat 3 A. Angelini in Bellosi 1993, pp. 290–1, cat. 51; Paoluzzi in Tomei 2002, pp. 198–201; *Cat 4* Trimpi 1987, pp. 224–6, cat. A74; Buricchi 1998, pp. 70–1, no. 29. *Cat 5* Trimpi 1987, pp. 227–9, cat. A75; Buricchi 1998, pp. 70–1, no. 30.

CAT. 5

New Saints for the City:
Saint Bernardino and Saint Catherine

6.

FRANCESCO DI GIORGIO MARTINI
(1439–1501)

Saint Bernardino preaching from a Pulpit, about 1473–4

Tempera on parchment, 21 × 14.3 cm
(painted surface 20 × 14 cm)
The Metropolitan Museum of Art, New York
Robert Lehman Collection (1975.1.2474)

7.

NEROCCIO DI BARTOLOMEO
DE' LANDI (1447–1500)

The preaching of Saint Bernardino in the Campo at Siena and *The Exorcism of the Possessed Woman at his Bier*, about 1470

Tempera and gold on panel, 38 × 78 cm
Museo Civico, Siena (373)

8.

FRANCESCO DI GIORGIO MARTINI
(1439–1501)

Saint Bernardino preaching, about 1462–3

Tempera on panel, transferred to canvas
29.7 × 76 cm
Walker Art Gallery, National Museums Liverpool
(WAG 2758)

Saint Bernardino was entirely Sienese, by both birth and ideology. In this new patron saint, Siena celebrated a figure whose symbiotic blend of religion and politics could reflect and declare its own. He was born Bernardino degli Albizzeschi in Massa Maritima in the Sienese *contado* on 8 September 1380 (the feast of the Virgin's Nativity);[1] in 1402, he joined the Observant branch of the Franciscan order in Siena; in 1414, he became Vicar of the Tuscan Observant Franciscans, based at Fiesole, and between 1438 and 1442 served as the order's Vicar General. His peripatetic preaching career began in 1417 – moving through North Italy, Tuscany and Umbria – and Bernardino has been called the 'father' of the Observant revival of preaching within the Franciscan order. In Siena, two series of open-air sermons were staged in 1425 and 1427, all preceded by a mass and preached in the early morning to obtain the largest possible audience. Freed from set liturgical Gospel readings, his sermons covered a wide, carefully programmed range of subjects, and attracted a huge following.[2] As Roest has recently written, 'These preaching rallies evolved into the foundation stones of an ambitious programme of religious reform, aiming at concerting the individual towards repentance and virtue, and prescribing codes of social, economical, sexual and religious behaviour to the (gendered) individual, the household, the neighbourhood, the community and the state'.[3]

The clarity of his message was a priority. Bernardino's vividness of language and the familiarity – even homeliness – of his metaphor made his more elevated theology accessible to lay audiences.[4] He regarded imagery as a particularly effective weapon in his rhetorical armoury, establishing a dialogue between painted imagery and the pictures of the mind's eye. Images, he thought, could stamp ideas, strictures and tenets of belief on the memory. This strategy was especially important in his propagation of the Holy Name of Jesus. In 1418, Bernardino himself designed a tablet or panel – *tabulella* – with a trigram of YHS (an abbreviation of 'Jesus' in Greek and also indicating in Latin, Jesus as the saviour of mankind) in a circle of flames.[5] In typically theatrical fashion, Bernardino would lift up the *tabulella* at the end of his sermons, provoking a sometimes hysterical response.[6]

Bernardino died *en route* to Naples on 20 May 1444 at the convent of San Francesco just outside L'Aquila in the Abruzzi. Although his corpse was laid out for several days, it did not apparently decay, and the 'odour of sanctity' that hung about it was perceived as a first sign that this was the body of a saint. Healing miracles associated with his corpse were immediately reported. Although the Sienese failed in their efforts to have him brought back to Siena, they straightaway began to exert civic and confraternal pressure to have him made a saint, organising various commemorative ceremonies and calling him *beato* (blessed). They achieved their goal as early as 24 May 1450, when Bernardino was canonised by Pope Nicholas V.[7] Siena had already inaugurated his annual feast day in 1446, when Bernardino was called the '*singolarissimo avvocato del Comune e del popolo*', and the event was officially sanctioned in 1456. Practically every major institution and confraternity in the city proclaimed its allegiance to him.[8]

CAT. 6
(actual size)

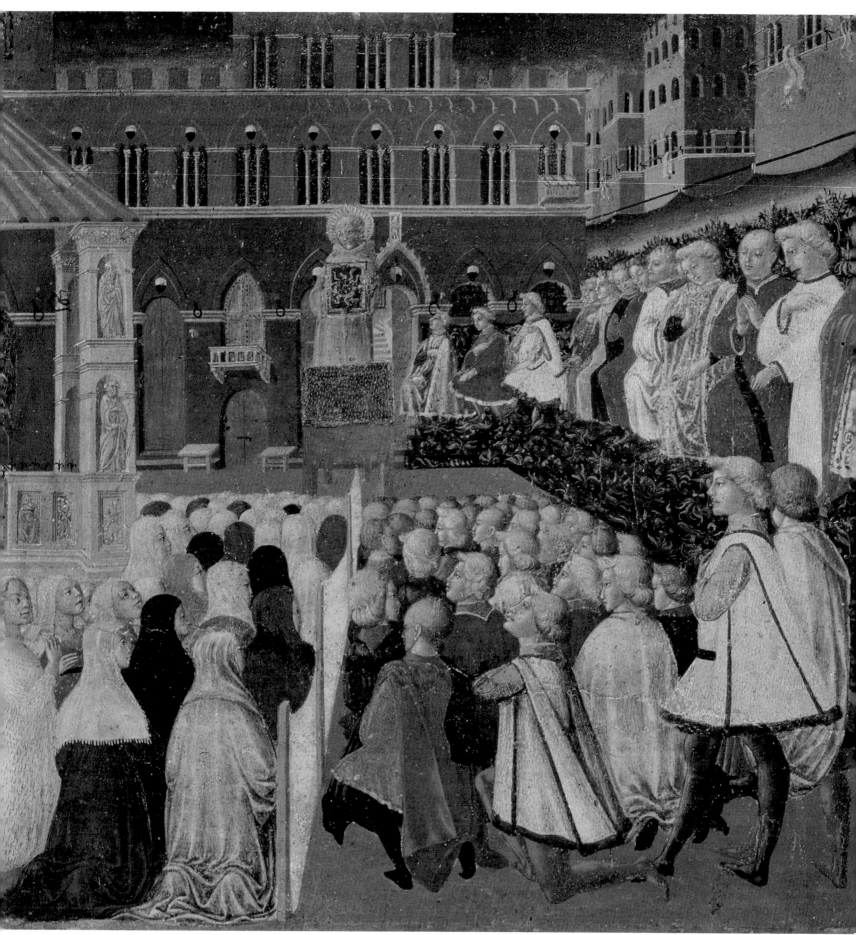

Images of Bernardino had been produced in Siena from the moment of his death. Full-length, three-quarter-view, approximately life-size likenesses were commissioned from Giovanni d'Ambrogio for the saint's own convent church, the Osservanza, signed and dated 1444 (still *in situ*), and in 1445 from Sassetta for the Hospital of Santa Maria della Scala (now lost).[9] Sassetta may already have been asked in December 1444 to paint a picture of Bernardino for the Compagnia di San Giovanni Battista della Morte, a picture that survives, albeit severely overpainted, in the Pinacoteca Nazionale, Siena (205), with a narrative strip at the bottom showing Bernardino preaching to the confraternity members – the visual record of an actual sermon. These pictures established an iconography for Bernardino. His features are recognisable, perhaps derived from his death-mask in L'Aquila – a toothless old man (he had lost all his teeth by the age of forty) with hollow cheeks, down-turned mouth and pointed chin. Bernardino's physiognomy now became a recognisable archetype: the portrait was converted into an icon. Giovanni d'Ambrogio's painting has Bernardino gesturing to the YHS trigram, with an open inscribed book in his left.[10] These were also to become his attributes. The pictures executed before 1450 were 'designed to preserve the historical memory of the preaching friar'.[11] Subsequently, by the addition of more mystical motifs, painters pursued an amplified iconography of glorification. The pictures produced in the mid 1440s became the prototypes for further images of the saint by Sano di Pietro (see cat. 11), Giovanni di Paolo, Vecchietta and Francesco di Giorgio himself.[12]

The present work (cat. 6), however, might properly be termed a speaking likeness. The viewer (or reader, if this is a page from a manuscript of his sermons) has joined Bernardino's congregation. Francesco di Giorgio's page miniature is an image of compelling restraint.[13] Bernardino stands alone against an abstracted blue ground, standing in a roughly constructed wooden pulpit of the kind set up for his open-air sermons. He dramatically raises his left arm, and stabilises both his body and the whole composition by clutching the pulpit edge with his right hand. The illumination conveys Bernardino's rhetorical command and, at the same time, his human frailty. Saint and pulpit, bathed in a strong, early morning light, are seen from below, corresponding to the view of his congregation: Bernardino is both vividly present and appropriately distant, cut off from the viewer by the large pulpit (slightly dwarfing the saint himself). This sense of genuine encounter is accentuated by the naturalistic conviction of the image. The pulpit is detailed to the point of including every nail and knothole in the planks from which it is built (the knots arranged in a diagonal to balance the saint's raised arm). And, although the saint's basic physiognomy follows the already established type, Francesco di Giorgio's greater naturalism is evident in the saint's softer features.

In Neroccio de' Landi's two scenes from the story of Saint Bernardino (cat. 7), his *Preaching in the Campo* and *The Exorcism of the Possessed Woman*, attendance at his sermons and membership of his Sienese congregation are given a very different significance. These scenes have been cut from a longer predella, original location unknown. The

greater width of the *Preaching* suggests that this was the central scene of three episodes (like cat. 8) or, just possibly, five. The two scenes may, for example, have been preceded or followed by the quite commonly represented episode showing Bernardino's Resuscitation of a Drowned Boy.[14]

The scene on the right depicts one of the earliest post-mortem miracles. The citizens of L'Aquila displayed Bernardino's sweet-smelling corpse at the church of San Francesco and here several possessed women were recorded as being freed from demons after approaching the body.[15] The woman, a little devil flying out of her mouth, is supported by several male companions, one with his hand placed over the area of her pubic mound, perhaps suggesting a link between the devil and a 'possessed', deviant sexuality. She has tentatively been identified as Genuzia, wife of Maso di Fossa Aquilana, who had been cured when she met the body on its way to the church,[16] or as Flora di Cassia.[17] Her precise identity is not crucial to the message of the scene; rather the emphasis is on Bernardino's healing powers, his curing of both soul and body. The sympathetically depicted halt and lame are therefore just as prominent in the right foreground (with friars praying behind them beside the catafalque). The predella may have been made for a hospital context, perhaps a site in the state-run Santa Maria della Scala, but, whether any clear institutional message was intended, the linking of this scene with one of Bernardino preaching directly connects his posthumous curative powers with his equally extraordinary capacity for civic healing. Just as Bernardino was able to banish evil from the soul and restore the

sick to health, so he was able to cure political and tribal division in his own city of Siena.

Bernardino is surprisingly small in Neroccio's picture.[18] Although his features and his YHS tablet are instantly recognisable, he has been relegated into the middle ground, while the focus has shifted to his congregation and the architectural setting of the city itself. A precedent for this diminished Bernardino is to be found in Sano di Pietro's paintings (before late 1448, Museo dell'Opera del Duomo, Siena, see fig. 8, p. 20) that were placed probably on either side of a polychrome statue of Bernardino and made for the altar of the chapel of the Compagnia della Vergine (to which Bernardino had belonged), next to the Hospital of Monna Agnese.[19] In these two pictures Sano distilled Bernardino's famous sermon rallies of 1425 and 1427: as Cynthia Polecritti has written, 'The pious depictions of his preaching by the Sienese artists Sano di Pietro and Neroccio di Bartolomeo would have pleased [Bernardino] since they represented the sermon as he wanted it to be – the preacher in command of an orderly and attentive [Sienese] audience'.[20] The 1425 sermon series in Siena was first held in Piazza San Francesco, outside the main Franciscan church in the city, but later moved to the Campo because of the ever-increasing size of the crowd.[21] At their peak Bernardino's sermons are said to have reached an audience of 'thirty thousand' (the Campo can hold over 50,000 people); most of the city could and must have attended.[22] On 28 May 1425, the recorder of the sermons claimed, a possessed woman was freed from her demons on sight of the *tabulella*.[23] Bernardino's preaching had

become marvellous, and the link between preaching and healing had been made.

His sermon rally in the Campo from August 15 to October 5 1427 was perhaps still more significant for the intersection of religion and politics.[24] The sermons could last for up to three hours, demanding enormous intellectual and physical commitment on the part of his listeners. This group effort therefore bound potentially warring individuals and families into a community, both spiritual and worldly, embracing the whole city.[25] As specially requested, Bernardino began his series on the feast day of the Assumption, the most important date in Siena's devotional and civic calendar, and climaxed with a glorious peace-making sermon, advocating the example of Christ's forgiveness. Along the way, he warned specifically of the dangers of factionalism. Indeed Bernardino had been invited to Siena in an attempt to avert the escalation of incipient strife between the *monti*.[26] He was careful to voice no direct criticisms of his host government, and the political divisions he mentioned were generalised as those between Guelphs and Ghibellines rather than more specifically. In general, he seems to have supported the political *status quo*, only desiring that it should function better. Indeed the physical separation of the parts of the audience reinforced conventional hierarchies.[27] Neroccio, following Sano, has depicted the white cloth modesty barrier that was set up in the Campo to separate men from women, and the political élite (all, of course, male) were seated on a raised dais decorated with *mille-fleurs* tapestries.

Bernardino's success in civic peace-making was stressed by his first biographers. Barnabò da Siena, for example, stated that

he did such a good job of pacifying Siena that 'it seemed as if all the citizens were of one mind and even soul'.[28] Party emblems on houses and walls, in churches and over portals were replaced by the YHS trigram. Bernardino's civic healing powers continued to feature in Sienese *laudi* (hymns) written after his canonisation.[29]

Neroccio's painting is most likely to refer to the sermon rally of 1427. Bernardino stands in his wooden pulpit, situated in front of the Palazzo Pubblico as it appeared before its seventeenth-century remodelling. Although it is not described with Sano's minuteness, the building's crucial details are in place. The doorways on the ground floor and the windows on the first are crowned with the city emblem, the black and white *balzana*. Just to the right of Bernardino's head can be seen the statue of another of Siena's patron saints, Ansanus. Below the tower on the far left is the Cappella di Piazza as it had appeared in Sano's picture, still with a wooden roof rather than the carved stone vault that was completed in 1468.[30] In 1427 Bernardino told his listeners that their Campo was a 'half-paradise' surrounded by invisible presences – angels from heaven eager to hear the word of God.[31] By showing the Campo as it had been in Bernardino's day Neroccio, like Bernardino himself, converted the topography of the city into a metaphor for the struggle between Christian virtue and vice.[32] Neroccio's scene promotes the idea of a city that has achieved spiritual and civic unity under Bernardino's – and God's – protection.

Even more than in Neroccio's later version of the scene, in cat. 8 by Francesco di Giorgio, Bernardino and his tablet recede into the fantastical *all'antica* architecture of

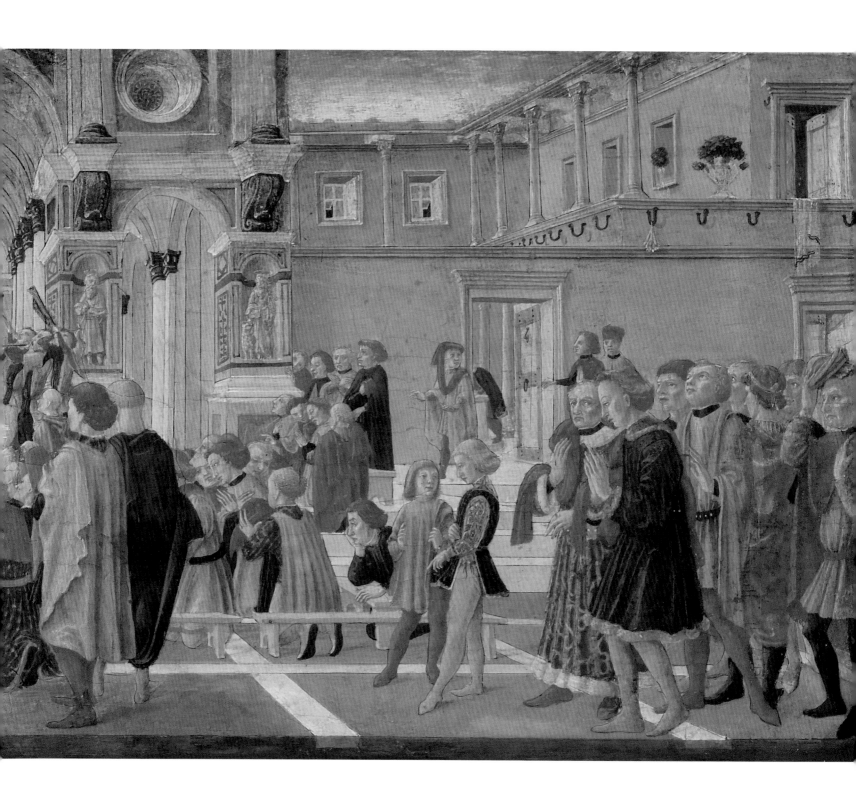

a magnificent church. The orthogonals that marshal the strongly centralised and symmetrical composition and extraordinarily ambitious perspective meet at the altar cross (see p. 30), rather than Bernardino himself, set to the left. Our eye is drawn to him therefore mainly by the elaborate Anatolian carpet draped over the front of his pulpit, and he is only a little more prominent than the sculpted Evangelists in their niches behind. Blocking out the niche where Saint Mark should be, Bernardino is presented as a modern preacher of equivalent heroic status. This link with the Evangelists may in part explain why Francesco's architecture is temporally imprecise, indeed un-Sienese. The message here is the eternal significance of Bernardino's sermons, rather than the particular relationship with a city or event. It has been thought that this panel was made as part of the predella of a larger altarpiece which was in the church of San Francesco, but this is not proven (see p. 35).

The trumpeters to the right of the opening into the church might be thought to drown out Bernardino's message with their noise, but they should perhaps be seen as sounding it with clarion notes. They are dressed in white, green and red – the colours of Faith, Hope and Charity – a colour scheme that dominates and unites the whole scene. On the banners hanging down from the trumpets are what appear to be dove motifs – but the heraldry has proved impossible to identify. Perhaps, rather than relating to a family or institution, they refer to Bernardino's post-canonisation iconography, in which he is frequently depicted with the dove of the Holy Spirit whispering into his ear, a sign of his unmediated inspiration from God.

If the church architecture is grandly classicising, Bernardino's congregation appears in contemporary dress, and once again they are the main focus of the picture. Here, however, as well as the men and woman kneeling piously on either side of the cloth barrier running out from the pulpit, there are other figures standing to left and right who seem less engaged. The group of animated youths seen in the left background – on the women's side – are perhaps more fascinated by the women than the sermon. This picture might be a truer experience of a real sermon than Neroccio's, with different members of the audience demonstrating different levels of commitment and curiosity.[33] Some commentators were sceptical about the motives of women appearing in such a public arena and suggested that their desire to show off their beauty and finery was greater than their piety. However, the inclusion of these figures may also suggest the ways in which Bernardino's message might flow out beyond his congregation, to become germane in daily life (where the architecture is more ordinary). Bernardino preached particularly successfully to women.[34] Three women are singled out to the left of the composition may represent Bernardino's three categories of woman-hood – the young unmarried girl, her head uncovered; the wife, apparently dressed in rich bridal clothes (marriage being the only time when, according to the city's sumptuary laws, such a costume might be deemed proper); and the sombrely garbed widow. LS

1 For Bernardino's biography and the preoccupations and significance of his sermons see especially: Origo 1963, *passim*; Moorman 1968, pp. 374–6 and 457–66; C. Delcorno, 'Introduzione' in Bernardino 1989 edn, I, pp. 7–51; Polecritti 2000, *passim*. What follows is especially indebted to this last, fascinating publication and to the study by Machtelt Israëls (forthcoming), which she kindly shared with me in manuscript: 'Absence and Resemblance. Early Images of Bernardino da Siena and the Issue of Portraiture (with a New Proposal for Sassetta)' to be published in *I Tatti Studies*.

2 For the texts of the Italian sermons preached in Siena in 1427 and 1429, see Bernardino 1958 edn; Bernardino 1989 edn.

3 Roest 2004, pp. 52–5 (with a good bibliography on Bernardino's preaching).

4 Origo 1963, p. 35.

5 Bernardino 1989 edn, p. 7; Arasse 1995.

6 Polecritti 2000, p. 73.

7 For an analysis of these miracles and the process of canonisation, see Liberati 1935; Liberati 1936; Bulletti 1944–50; Piana 1951; Arasse 1977.

8 See F. Nevola, 'Cerimoniali per santi e feste a Siena' in Ascheri and Ciampoli 1986–2000, pp. 171–84, esp. pp. 177–9; Israëls (forthcoming), np, n. 38.

9 For the iconography of Bernardino, see Misciattelli 1925, pp. 40–2; Rogati 1923; Pavone and Pacelli 1981, pp. 3–99; D. Arasse 'Saint Bernardino rassemblent: In figure sous la portrait' in Maffei and Nardi 1982, pp. 311–32; Israëls (forthcoming).

10 On which are written the words: QVE · SVRSV[M] · SVNT · SAPITE · NON QVE · SUPER · TERRAM ·

11 Israëls (forthcoming).

12 A tall canvas that is in the Pinacoteca at Monteoliveto Maggiore (Coor 1961). San Bernardino is depicted full length, holding the YHS *tabulella*, and as in the Lehman cutting, Saint Bernardino projects beyond the confines of his fictive frame. He also bears the standard facial iconography. The paint surface is rather worn, but its rather mechanical execution suggests that, despite the lovely sway in the body, it might have been delegated to same workshop hand responsible for the *Virgin and Child with an Angel* in the Pinacoteca Nazionale, Siena (A. De Marchi in Bellosi 1993, pp. 298–9, cat. 55), based on a cartoon, rather than Francesco di Giorgio himself.

13 Palladino (1997) states that the miniature is trimmed along the bottom and left edges. The parchment has buckled and the surface is slightly abraded. The background and border are entirely overpainted; the overpaint covers a more brilliant blue and red, visible where the paint has flaked. The lines defining the pulpit are scored with a stylus. Pricking holes on the left edge may be sewing stations, suggesting that it was originally bound into a volume, though the presence of glue residue on the verso shows that the page was subsequently attached to a panel.

14 Coor 1961, p. 25, suggested that this might be first scene of Neroccio's predella, which would have had the effect of emphasising the scene of Bernardino preaching, since chronologically the posthumous miracle of course post-dated the sermons. Even if at first sight this seems rather unlikely, it is difficult to know what from Bernardino's life might have preceded the *Preaching*. See also cat. 38 for a predella panel with the scenes out of chronological order. V. Cerutti in Santi and Strinati 2005 suggests that this fragment was paired with two scenes from the life of another saint, showing him or her with similarly paired roles. However she has not taken account of the greater width of cat. 8, which must therefore have been the central scene, the whole predella dedicated to Bernardino's story.

15 For this subject, see the predella by Sano di Pietro, now dispersed, 'the most extensive narrative cycle devoted to Saint Bernardino in fifteenth-century Sienese painting'. Dated to the early 1470s, it possibly belonged with the altarpiece, now in the Pinacoteca Nazionale, Siena, *Virgin and Child enthroned with Angels and Saints Francis and Bernardino*, of unknown provenance. See K. Christiansen in Christiansen, Kanter and Strehlke 1988, pp. 164–6, cat. 24b, in which the parallel with Neroccio's scene is drawn.

16 Niccoli in Siena 1950, pp. 82–3.

17 Cyril 1991, pp. 69–70.

18 See L. Kanter in Kanter and Palladino 2005, p. 152, cat. 29 on Fra Angelico's *Saint Peter preaching*, in which he is significantly larger than his congregation.

19 See Mallory and Freuler 1991, pp 186–92; Christiansen 1991, esp. pp. 451–2; Israëls (forthcoming).

20 Polecritti 2000, p. 20.

21 Polecritti 2000, p. 68.

22 Polecritti 2000, p. 39.

23 Bernardino 1915 edn, p. 680; Polecritti 2000, p. 74.

24 Polecritti 2000, pp. 22, 182.

25 Polecritti 2000, pp. 40–1.

26 Polecritti 2000, pp. 13, 183, 185.

27 Polecritti 2000, p. 67.

28 Polecritti 2000, p. 86.

29 Polecritti 2000, p. 186: '…*sichè l'un l'altro di carità ardente / come fratelli riamiamo / e divisione lassiamo / che a capo d'ogni mal vituperoso. Dunqua Bernardino padre diletto / e appresso al signiore nostro avvocato / del cuor ci tolga e ciachuno sia salvato / e tuo città di Siena in buon stato / in libertà mantengha*…' (so that we as brothers love one another again with ardent charity, and let us leave behind division that is the head of every vituperative evil. Therefore Bernardino, beloved father and our advocate with the Lord, take [evil] from our hearts, so that all be saved, and maintain your city of Siena in a good state and in liberty)

30 Carli in Carli and Cairolo 1963, p. 215, followed by V. Cerutti in Santi and Strinati 2005 use this fact to provide a *terminus ante quem* for Neroccio's painting, but Coor, 1961 pp. 24–6, must be correct when she argued that Neroccio, following Sano's model, had set out to depict a historical event.

31 Delcorno 1989 edn, I, pp. 128–9; Polecritti 2000, pp. 19–20.

32 Polecritti 2000, p. 190.

33 Polecritti 2000, p. 20.

34 Origo 1963, pp. 43–75.

SELECT BIBLIOGRAPHY

Cat. 6 P. Palladino in Hindman, Levi d'Ancona, Palladino and Saffiotti 1997, pp. 148–56, cat. 19; *Cat. 7* M. Maccherini in Bellosi 1993, pp. 318–21, cat. 62. V. Cerutti in Santi and Strinati 2005, pp. 80–2, cat 0.8; *Cat 8* L. Bellosi, 'Il "vero" Francesco di Giorgio e l'arte a Siena nella seconda metà del Quattrocento' in Bellosi 1993, pp. 19–89, esp. pp. 39–44 and pp. 110–11, cat. 1c (as Francesco di Giorgio).

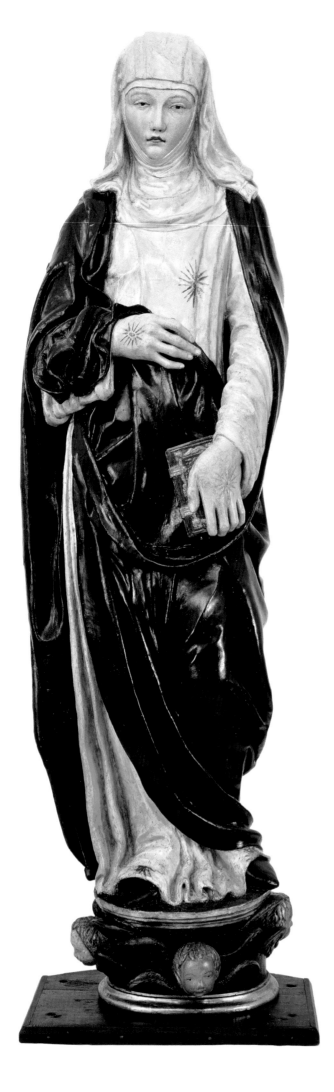

NEROCCIO DI BARTOLOMEO
DE' LANDI (1447–1500)
Saint Catherine of Siena, 1474

Polychrome wood, height 198 cm
Oratorio di Santa Caterina in Fontebranda, Siena

In the evocative words of the Italian art
historian Adolfo Venturi, 'Santa Caterina is
a poem to femininity and piety, and one of
the most exquisite images which the delicate
art of Siena can boast.'[1] The figure's tall,
slender body enclosed in the rich folds of
the Dominican habit, the delicacy of the
saint's almost pubescent face, and her
melancholy gaze cannot fail to touch the
viewer.[2] This statue was commissioned from
the painter-sculptor Neroccio de' Landi
in 1474 to be placed above the altar[3] in the
lower chapel of the Oratory of Saint
Catherine in Fontebranda, Siena.[4] This
sacred space was built between 1464–74 on
the site of the saint's family home, more
precisely in the *tintoria*, the basement work-
shop where Catherine's father practised
his wool-dying trade. In the small church,
whose design local tradition attributes to
Francesco di Giorgio, members of the
Contrada dell'Oca (the district of the *Goose*)
would gather to worship their patron.
The statue may have also been carried in
street procession on the saint's feast day,
as suggested by the fact that, although the
figure was intended to be seen from the
front, it is carved and painted on the back.
We know that Neroccio must have begun
working on the statue after 4 April 1474,
when – as attested by a surviving document
– the executors of the Gabella sent a request
to the Consiglio Generale of the Sienese
Comune for funds for the decoration of the
newly-built oratory, which would include
*'un imagine di Santa Caterina di rilievo
grande'*.[5] By May of the same year, the statue
was underway; a partial payment for
Neroccio's *Saint Catherine* is listed in the
inventory of the expenses for the oratory
drawn between February 1465 and May

Fig. 41
Lorenzo di Pietro,
known as Vecchietta (1410–1480)
Saint Catherine of Siena, 1461
Fresco
Palazzo Pubblico, Siena

1474;[6] a second payment dated 30 June indicates that Neroccio continued working on the sculpture into the summer.[7]

Like Saint Bernardino, Saint Catherine[8] was a modern Sienese saint, an influential proselytiser of the teachings of a local mendicant order, who joined the Virgin and the four ancient martyr saints of the city as Siena's official advocates in heaven.[9] Born on 25 March 1347, Caterina Benincasa was the youngest of the twenty-four surviving children of a Sienese cloth-dyer. She demonstrated from an early age a strong inclination to prayer and meditation, refusing, at the age of sixteen, to marry so as to become a Dominican tertiary. Catherine's enormous popularity among her *concittadini* can be ascribed to her life-long devotion to serving the sick, the poor and the needy. Her abandonment of a more meditative life in order to relieve the suffering of others may have been precipitated by the loss of her brothers and sisters during the plague. Attracting a large following – men and women, Dominicans and Franciscans – Catherine travelled throughout central Italy, taking her message beyond the Sienese *contado*, and acquiring a reputation for performing miracles and conversions.

Although illiterate, she dictated her *Libro di divina dottrina,*[10] today known as *Il Dialogo,*[10] and wrote over 380 letters, the largest epistolary legacy left by a woman of her era. Catherine became one of the most notable public figures of her day, famous for intervening in worldly affairs, and above all, for her intercession in the conflict between the Papacy (then exiled in Avignon) and the city of Florence. She devoted the final years of her life to making peace

between the two factions, and bringing Pope Gregory XI back to Rome. Following the Great Schism in 1378, when two rival popes were appointed in Rome and Avignon, her work in support of the Roman Papacy intensified until, on 29 April 1380, she suffered a stroke and died in Rome eight days later.[11] On 1 July 1461, three years after the election of the Sienese Pope Pius II Piccolomini, Caterina Benincasa was canonised.[12]

Catherine's canonisation did not mark the beginning of her cult; rather it gave official recognition to existing devotion. Indeed, her feast day was celebrated in many places long before she was allowed to enter the canon of saints.[13] The surviving images of the saint produced in the period between her death and her canonisation are further indication of the rapid rise of her cult.[14] As early as 1380, Andrea di Vanni painted a fresco of *Saint Catherine and a Devotee* on a wall adjacent to the church of San Domenico,[15] and in the mid Quattrocento Sano di Pietro produced many versions of this theme, such as the panel in the Pinacoteca Nazionale, Siena. While these earlier works must have informed Neroccio's iconography of the saint, it was Vecchietta's 1461 fresco for the Sala del Mappamondo in the Palazzo Pubblico (fig. 41) which appears to have served as his primary model. The fresco, on a pilaster in the Sala del Mappamondo, was commissioned by the Sienese Comune in the same year as Catherine's canonisation, and was thus presented as the officially sanctioned image of the saint. The ingenious sculptural illusion Vecchietta creates in his famous fresco, endowing the figure with the characteristics of a polychrome wood

sculpture and placing her on a pedestal in a fictive Renaissance niche, makes a compelling comparison with the Oratorio di Santa Caterina's statue. In both Vecchietta's and Neroccio's works, the saint is dressed in the Dominican habit, wearing the white veil of the tertiary, holding a book in allusion to her teaching, and showing the signs of the stigmata on her hands and feet.[16] Her wounds are depicted in the form of rays, an effective visual translation of the words from the *Legenda Maior* which describes the saint received the stigmata 'in the form of a pure goodly light'.[17] This 'softer' depiction of the stigmata – undoubtedly less fleshy than the wounds featured in Andrea di Vanni's fresco – was perhaps used in an attempt to escape the Franciscans' protests that only Francis had truly received stigmata,[18] and recalls instead the *stella maris*, the golden star featured on the Virgin's mantle in so many fourteenth and fifteenth-century Sienese paintings. This motif may be linked to a poem escribing Saint Catherine as *'la chiara stella'* (the bright star), which once appeared as an

epigraph below a fresco of her by Sano di Pietro in the Palazzo Pubblico.[19]

Interestingly, Neroccio's rendition of the theme also shows independence from that of his older master: his Saint Catherine does not hold a lily – which together with the book is the principal attribute of the saint, and the symbol of her virginal purity – but is seen instead clutching her mantle.[20] Another telling distinction is the youth of Neroccio's figure, possibly emphasised to stress the saint's early dedication to Christian life, but best understood if one considers the location for which the statue was made, that is, the site of Catherine's childhood and adolescence. Finally, Neroccio's wooden pedestal, carved with little *putti* heads, is not merely a decorative device, but a significant allusion to the saint's rise to heaven.[21]

This representation of Saint Catherine strives to marry naturalism with idealisation, to arrive at the truth of an ideal. The Dominican ideal is that of a deeply spiritual soul, and this is conveyed with a number of iconographic and stylistic devices: the downcast eyes communicating the sadness born from the knowledge of human suffering; the book reminding us of the long hours of prayer and meditation; the stigmata showing us the physical manifestation of the saint's ardent faith, and the angels carrying Catherine to the kingdom of heaven. But, very much in tune with the needs of fifteenth-century piety, Neroccio was also aware that for his Catherine to touch the soul of his contemporaries, she had to look lifelike, and most importantly, humane. SDN

1 Venturi 1923, p. 197.

2 Our appreciation of the work benefits from two restoration campaigns, carried out in 1948 and 1985. The paint on the white dress, the veil, the book and parts of the flesh are original. For a full conservation report, see Riedl and Seidel 1992, p. 149, n. 132.

3 The statue was first housed in an *ornamento di legname* (within some kind of wooden construction). Between 1676 and 1683 Austo Cini (an inhabitant of the *Contrada dell'Oca* himself) and Giuseppe Redi built a new marble niche and altar, enlarged again in 1688–9. Falassi and Catoni 1991, p. 9.

4 In 1425 an attempt by the local inhabitants to build a church dedicated to Catherine had failed because she had not yet been declared a saint. In 1464, three years after her canonisation, the *Contrada dell'Oca* purchased the premises believed to have once been the family home and started a building project to transform the house into a shrine for the saint. For a history and images of the Oratorio di Santa Caterina, see Torriti 1983, pp. 9–14; Siena 1990; Falassi and Catoni 1991; Cecchini 1995, pp. 118–27; Toti 2006.

5 This can be translated as 'a great sculpture relief of Saint Catherine'. The document also adds that the statue was '*tra le più cose le quail sarebbe honore e devotione et farle, et per mancamento di denari non si fanno*'. The original document is in the Archivio di Stato (ASS), Siena, *Consiglio Generale*, 235, c.187r. Since Domenico Toncelli first erroneously dated this letter to 31 March 1474 (Toncelli 1909, p. 1954), art historians have all followed the incorrect date. Borghesi and Bianchi (1898, pp. 239–40, no. 144) had previously published the same letter with a different date of 14 April 1473, which Philippa Jackson has also found to be incorrect.

6 '*Item 1.31 s–a Neroccio dipentore per parte d'una sancta Chaterina a fatta fare di lengniame per stare in su l'altare*'. This was most probably a first payment for the statue, which, as the word *parte* indicates, at that date had not yet been completed. ASS, *Regolatori* 9, c. 413v or ASS, *Revisioni delle Ragioni de' Camarlinghi e Uffiziali del Comune*, VIII, cc. 413; also Milanesi 1854–6, II, p. 340, no. 240.

7 We are grateful to Philippa Jackson for tracing this previously unpublished document, which, although it does not specifically mention the Santa Caterina statue, almost certainly relates to it. '*La fabricha di Santa Caterina di Fontebranda a di ultimo giugno L30 paghamo e per detto degli esechuitori a Neroccio di Bartolomeo di Benedetto dipentore chontanti.*' ASS, *Gabella*, fol. 168v, 1474.

8 The primary source for the life of Saint Catherine is the *Legenda Maior*, written by Raymond of Capua, friend of Catherine and later Master General of the Dominican Order ('*Legenda Sancti Catherine Senensis*', in Raymond of Capua 1866 edn, pp. 862–967). The

Legenda Minor was written by Tommaso Caffarini, see Caffarini 1998. See also Savi Lopez 1924; and Caratelli 1962.

9 The four traditional patron saints of Siena, whose relics are treasured in the city's Cathedral, are Crescentius, Ansanus, Savinus and Victor. See Consolino 1991.

10 For Saint Catherine's *Dialogues*, see Taurisano 1929 and Cavallini 1968. Her letters are edited and translated in Noffke 1988/2000.

11 Catherine's body is interred at Santa Maria Sopra Minerva, Rome, and her head is kept in a bust-reliquary in the Chapel of Santa Caterina in San Domenico, Siena.

12 In the bitter controversy which followed Catherine's canonisation (see cat. 97), the Dominicans made demands to the government that their saint should be honoured with the same treatment given to Bernardino (for example, with offerings from the *signori* and guilds, and the release of prisoners on her feast day). See Webb 1996, pp. 308–9.

13 On 5 June 1446 it was reported that more than 20,000 people, including the city's magistrats, attended the spectacular celebrations for her feast day at the church of San Domenico. Webb 1996, p. 301.

14 Because of the sheer amount of images depicting Saint Catherine, the focus of this entry is on full-scale representations, more directly related to Neroccio's sculpture. For an extensive survey of Saint Catherine's iconography see Bianchi and Giunta 1988 (see also Kaftal 1949, Loury and Loury 1992, and Moerer 2003)

15 The fresco was later moved to a fourteenth-century chapel situated at the west end of the church.

16 While praying in the chapel of Santa Christina in Pisa, Saint Catherine had a vision of rays descending upon her from the body of the crucified Christ.

17 See cat. 97.

18 The presence of the stigmata in images of Saint Catherine was the subject of a long and bitter dispute between the Dominicans and the Franciscans. See further cat. 97.

19 The poem is published in Jacobsen 1908, p. 34, and Bianchi and Giunta 1988, p. 249, no. 137. The fresco, heavily repainted by Francesco Mazzuoli in the nineteenth century, is now on the ground floor office area of Palazzo Pubblico.

20 The lily that appears sporadically in older publications (for example in Toncelli 1909, p. 50) is likely to have been placed in the right hand of the statue at a later stage.

21 Once again, the young artist is quoting his master, in this case imitating the pedestal made by Vecchietta for his wooden statue of Saint Bernardino, now in the Museo del Bargello, Florence.

SELECT BIBLIOGRAPHY

Riedl and Seidel 1992, pp. 147–50; A. Bagnoli in Bellosi 1993, pp. 218–21, cat. 34; Seidel 2003a, pp. 538–48.

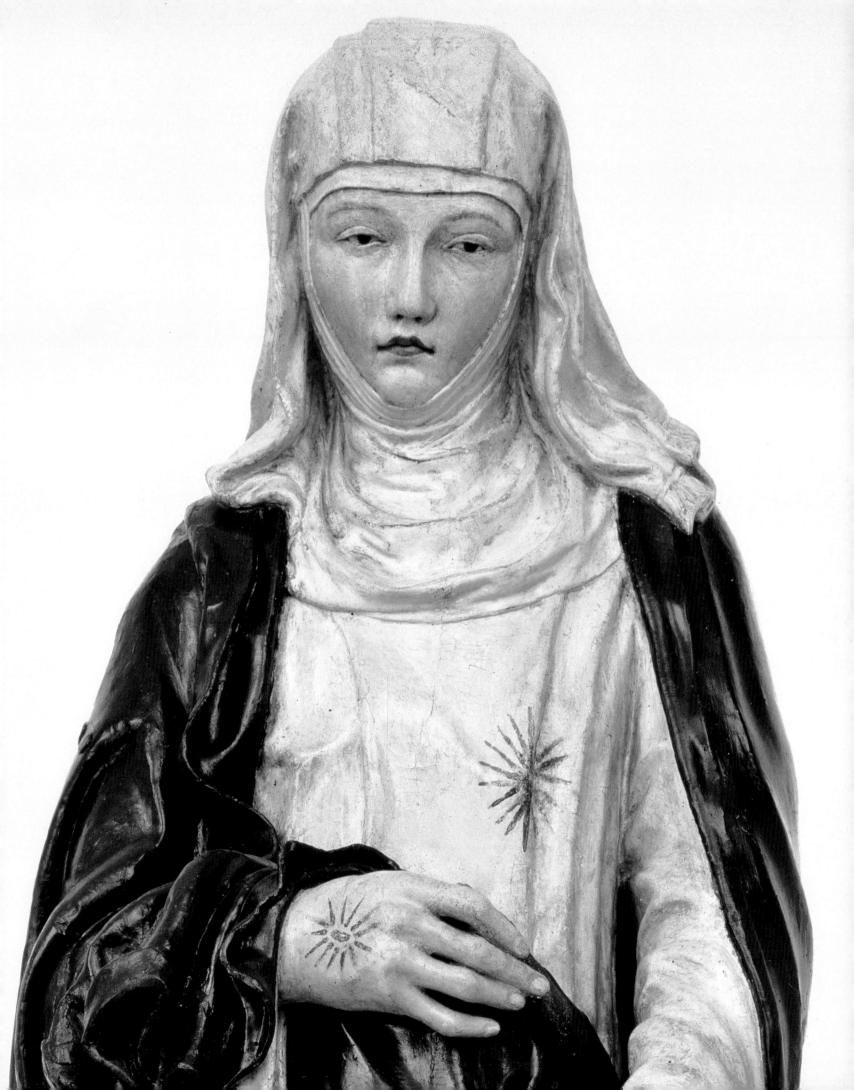

MODERNISING THE TRADITION

Marian imagery, we have already seen, abounded in late fifteenth-century Siena; significantly, however, the canonical images, even at the end of the Quattrocento, almost all dated to the first half of the Trecento and before, including the paintings in the Palazzo Pubblico by Simone Martini and others and a plethora of images in the Cathedral.[1] There Duccio's *Maestà* (fig. 29, p. 58) had been called by 'Agnolo di Tura' (possibly an anonymous fifteenth-century falsifier rather than a contemporary) 'the most beautiful painting ever seen or made' and its distinctive structure was remodelled twice in the first half of the Quattrocento to bring it up to date liturgically (and perhaps aesthetically).[2] Duccio's earlier stained-glass window, with scenes of the Assumption and Coronation that can be associated with the city's Assumption Day ceremonies (see p. 80),[3] stands at the head of a long visual tradition in Siena.[4] The four Trecento altarpieces of the life of the virgin at the Cathedral crossing were fundamental points of reference for later patrons and painters. In particular, the 1333 *Annunciation* altarpiece by Simone Martini and Lippo Memmi (fig. 22, p. 45) was among several key fourteenth-century paintings cited by Saint Bernardino in his sermons.[5] In September 1427, he famously turned the Virgin into the ideal model for well-behaved girls of marriageable age: 'Have you seen that Annunciate [Virgin] that is in the Cathedral, at the altar of Saint Ansanus, next to the sacristy? Certainly that seems to me the most beautiful, reverent and modest attitude that could ever be seen in an Annunciate. Note that she does not look at the angel, rather she has an attitude that is almost fearful.'[6]

Bernardino's attitude to art had an extraordinary impact on the style of the works made later in the century. Not surprisingly, he was actively engaged in promoting the truth of the doctrine of the Assumption,[7] and the first and most important work of art he cited was a lost fresco of the Assumption, the *Madonna dell'Antiporto di Camollia*, painted on the outer gateway leading into the city from Florence.[8] There are no surviving documents that establish the date or author of the Camollia fresco, but strong tradition asserts that this was also painted (or at least started) by Simone Martini in about 1333 (and perhaps already restored by the time Bernardino was preaching). Two sixteenth-century paintings depicting the 1526 Battle of Camollia, made shortly after the event, and Bernardino's own description, suggest that in composition it was close to a small panel attributed to Lippo Memmi, now in Munich (fig. 42).[9] Bernardino's early love for this image is attested by letter to his pious cousin Tobia.[10] In what is now his best-known description of a work of art, Bernardino alluded to the Camollia image in the first sermon of the cycle he started on 15 August 1427, on 'how our glorious mother rose up to heaven, and on the joy with which Paradise welcomed her'. From the image he conjures a fervent vision: 'All the angels are around her, all the Archangels, all the Thrones, all the Dominations, all the Virtues, all the Powers, all the Principates, all the Cherubim, all the Seraphim, all the apostles, all the Patriarchs, Prophets, virgins and martyrs; they are all of them around her, rejoicing, singing, dancing, joining hands, as you can see down there at the Camollia Gate, doing honour to Mary, and even unto the Father, the Son

and the Holy Ghost'.[11] The anonymous author of the *Compendium vitae Sancti Bernardini* says that he had a copy made as the high altarpiece for his own church of the Osservanza[12] – this must have been the picture painted by Sassetta that is recorded in the seventeenth century with the signature *Stephanus de Senis*[13] and now, despite the lack of signature, which must have been lost with the original frame, should be identified with a painting once in Berlin (destroyed in 1945).[14] In 1448–9, the Florentine goldsmith-sculptor Lorenzo Ghiberti reported that Sienese artists considered Simone their greatest painter.[15] Simone's style had taken on extra value by Bernardino's promotion of his paintings.

Franciscan individual or personal devotion was promoted through lay confraternities and by images made for their members, above all of the Virgin and Child. Saint Bernardino, according to established Franciscan tradition, emphasised the Virgin's humanity and tenderness, her happiness in caring for the infant Christ – 'how sweet she found it, caring for him, washing him, feeding him, and doing all those things'.[16] Bernardino had found a method of invigorating images in the minds of their beholders (the mental equivalent of the real animation of them in religious ceremonies). Thus the language of gesture in these works, mostly derived in the first instance from Byzantine conventions, took on a new importance, whereby subtle differences of pose and activity, including the Virgin's loving and compassionate gestures celebrated by Bernardino, had specific meanings.[17] In particular, Sienese painters of the late Quattrocento and early Cinquecento took account of a group of thirteenth-century

Fig. 42
Attributed to Lippo Memmi
(active 1317–about 1350)
Assumption of the Virgin, about 1340–50
Tempera and gold on panel, 70 × 30 cm
Alte Pinakothek, Bayerische
Staatsgemäldesammlungen, Munich (WAF671)

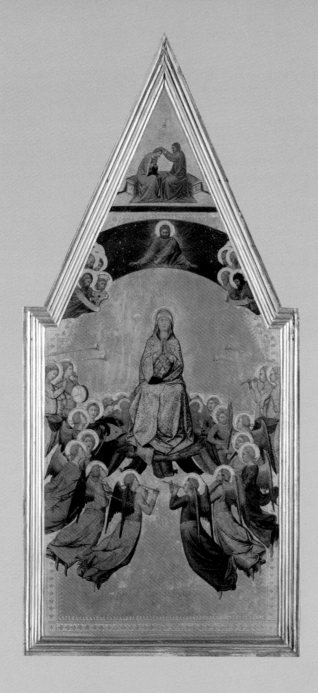

cult and miraculous images of the Virgin in the city, not least the *Madonna delle Grazie* (fig. 27, p. 55).[18] There was also continued reverence for certain Trecento paintings – half-length Madonnas by Simone's collaborators and followers and the Lorenzetti brothers – which was by no means exclusively Franciscan; Lippo Memmi's *Virgin and Child* (later called the *Madonna del Popolo*) had been acquired by the late fifteenth century by Ambrogio Luti for his family chapel in Santa Maria dei Servi, where it was set into a new fifteenth-century frame.[19] This reverence was one of the several reasons why the tradition of gold-ground painting was sustained. Even

when gold grounds finally went out of fashion, other essential elements of the old style were retained. This section examines the maintenance of this visual tradition and the impact of new works like Donatello's *Virgin and Child* relief in the Cathedral (see pp. 52–3) and the ways in which these new ingredients were blended with the old. LS

1 Norman 1999, passim.
2 Lisini 1898, pp. 20–51, esp. pp. 23–4, 37–8; Heywood 1899, p. 68.
3 L. Bellosi in Bagnoli, Bartalini, Bellosi and Laclotte 2003, pp. 166–70, no. 26.
4 A basic list of key works is given in De Marchi 1992, pp. 130–51, esp. p. 149, note 57. The theme is examined in Van Os 1969, pp. 157–85; Van Os 1990, pp. 145–51; F. Glenisson-Delaunée in Decroisette and Plaisance 1993, pp. 65–129; Fargnoli 2004, pp. 11–26; Fattorini 2006.
5 Carli 1976, pp. 155–82; Bolzoni 2002, pp. 167–80.
6 Bernardino 1989 edn, II, p. 869; K. Christiansen 'Painting in Renaissance Siena' in Christiansen, Kanter and Strehlke 1988, p. 4.
7 Jugie 1944, pp. 404–5, 607, 615; Van Os 1969, pp. 177–85.
8 Lusini 1894, pp. 3–8; Bulletti 1935, p. 151.
9 Previtali 1988; De Castris 2003, pp. 289–90.
10 Facchinetti 1933, p. 30.
11 Bernardino 1989 edn, II, p. 106.
12 Delorme 1935, p. 10.
13 Bulletti 1935, p. 151; Bacci 1939, p. 48.
14 Israëls 1994.
15 Krautheimer 1956, p. 54.
16 Hook 1979, p. 130.
17 Belting 1994, pp. 367–76.
18 Belting 1994, pp. 389–97.
19 Lusini 1908, p. 34; Hoeniger 1995, pp. 112–13.

10.

FRANCESCO DI GIORGIO MARTINI (1439–1501)
Saint Dorothy and the Infant Christ, about 1460

Tempera and gold on panel, 33.3 × 20.6 cm
The National Gallery, London (NG 1682)

When first published, this 'delicious little painting'[1] was believed to depict the Virgin Mary leading her son by the hand. In fact it represents Saint Dorothy, an early, probably legendary, Christian martyr from Caesarea in Cappadocia, whose story was told in an addition to the Golden Legend.[2] According to this fable, Dorothy was tortured for her faith, enduring her torment for love of Christ, in whose garden, she said, roses and apples flourished all year round. As she was led to martyrdom that February day,[3] a scribe called Theophilus, with legalistic literalism, hailed her as 'bride of Christ' and derisively requested some of these unseasonal blooms. As she knelt before the block on which she was to be decapitated, a little boy appeared carrying a basket (or napkin) containing three roses and three apples. Dorothy implored him to take the flowers and fruit to the cynical Theophilus, and the child – seemingly the Christ Child himself – duly presented them to the unbeliever, resulting in his conversion and eventually his own martyrdom.

This little picture omits the apples, but the child has a basket of flowers and Dorothy's identification is reinforced by the pink roses she holds. The painting has a fictive green marble or serpentine reverse, revealed only during restoration in 1993. There is no sign that it was ever hinged to form a diptych. Therefore it is likely that this was a single panel for individual devotion. That it was double-sided indicates almost certainly that it was not permanently displayed on a wall, but was instead designed as a precious and portable object for private prayer – the pictorial equivalent of a small Book of Hours.

This picture evokes paintings by Simone, his collaborators and his immediate Trecento

followers. The draperies are painted with long, fluid lines, interrupted by carefully placed triangular folds. The pleasure in sinuous, meandering line is carried through into the golden hair of both figures. Dorothy herself seems to flow rather than walk.

Each part of this painting is carefully planned,[4] and the picture has all the miniaturist detail of a work intended for close and sustained viewing. The understated tenderness of Dorothy's expression, the gentle tilt of her head on her swan neck are realised with infinite delicacy. The roses inspire the entirely appropriate colour scheme.[5] The painter delights the eye with details of the tiny flowers, the Child's fingers curled around Dorothy's thumb and the glimpse of her filmy chemise along the neckline of her overdress. This fabric's pattern was scratched into the paint while it was still tacky to reveal the gold underneath, and *sgraffito* was also employed for the pseudo-Kufic borders in the costumes of both figures. The haloes and framing border are also especially pretty. It is worth noting that one double ring-punch used in the haloes has a small break in the outer ring, which helps to determine the picture's authorship.[6] Infra-red examination reveals another, fascinating detail: it seems that Dorothy's eyes were originally drawn lower down in her face – in a rather more naturalistic relationship with her nose and forehead. By moving them up, it seems that Francesco was consciously emphasising the Trecentesque style of the work.

Dorothy's cult in Siena was not substantial (though Sano painted her several times) and her iconography was not fixed. Although it has been regularly cited as an early Italian example of the representation of Dorothy,

no one has hitherto suggested a connection between cat. 10 and the right lateral panel with the image of Saint Dorothy in Ambrogio Lorenzetti's triptych of about 1340 from the convent of Umiliati nuns, Santa Petronilla (now Pinacoteca Nazionale, Siena). Lorenzetti's Dorothy offers the infant Christ in the central panel a posy, gathered from the mass of flowers held in her cloak. Christ's belted pink costume with decorated gilded trim at the hem and neckline are similar enough to the dress of the Christ Child in cat. 10 to suggest that this altarpiece may have been used as a source. Therefore it is possible that either an Umiliati nun or rich supporter of the convent commissioned cat. 10. Dorothy was after all – like the much more popular Saint Catherine of Alexandria – declared a Bride of Christ. LS

1 L. Bellosi 'Il problema di Francesco di Giorgio pittore' in Fiore 2004, p. 212.
2 Hamer and Russell 2000, pp. 229–49.
3 Her feast day is 6 February.
4 The only small alterations visible to the naked eye are in the position of the Child's right arm – to bring him into more convincing contact with Dorothy, and in the contours of her draperies as they fall to the marble pavement on the left.
5 Although the pinks are now certainly faded, it is unlikely that they were ever especially intense. The orange tunic of the Christ probably contrasted more strongly with the rose-colour of Dorothy's cloak. The lilac shadows in her dress suggest it may once have had a more mauve tone, picked up in the colour of the Child's hose.
6 For example, it appears in the later *Virgin and Child with Saints Peter and Paul*, attributed to Francesco di Giorgio with an assistant (Pinacoteca Nazionale, Siena); see A. Angelini in Bellosi 1993, pp. 294–5, cat. 53. The significance of this punch was kindly pointed out to me by Jill Dunkerton.

SELECT BIBLIOGRAPHY

L. Bellosi in Bellosi 1993, pp. 55, 120–1, cat. 5.

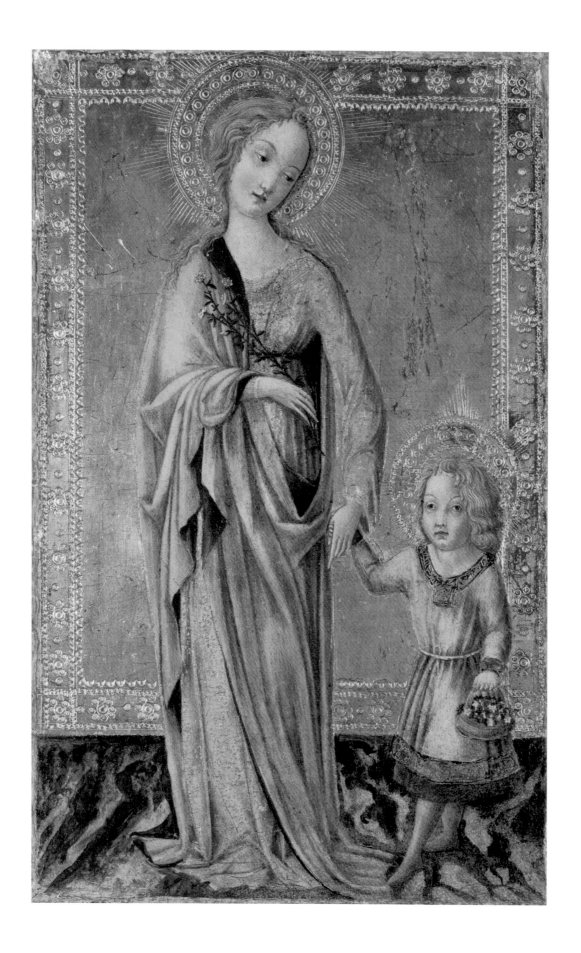

The Virgin and Child modernised

Images of the Virgin and Child were certainly the most frequently produced of all genres throughout this period. Frustratingly, there is very little information regarding the first ownership of these works: coats of arms are rare, despite the not infrequent survival of original frames, on which they might be expected. However, their ubiquity allows us to assume that a picture or sculptural relief of the Madonna was an indispensable furnishing of a bedchamber, an essential tool of private devotion – as it was throughout Italy.[1]

Sano di Pietro (with his workshop) was the most active maker of Madonnas of the 1450s–60s, but from the 1470s onwards (especially after Sano's death in 1481) their production was central to the output of several younger painters – initially Matteo di Giovanni and Neroccio de' Landi, then Pietro Orioli from the mid to late 1480s. In their different ways, these painters sought to modernise Sano's standard images, often retaining their compositional formulae but rendering them more complicated and nuanced. This they did largely by reference to Florentine sculptors and painters and, to a lesser degree, to North Italian art, mediated by prints and by the presence in Siena of Liberale da Verona and Girolamo da Cremona. Modernity was signalled most obviously by the gradual abandonment of the traditional gold ground. But such novel trends were incorporated within these painters' own distinctly Sienese visual dialect, in which they sought to preserve the mystical abstraction of Trecento prototypes. They would introduce up-to-date, naturalistic elements – details of costume and landscape, expression or anatomy – which were intended to convince viewers of the earthly and human reality of what they were seeing, while simultaneously continuing to insist that the believer, by the act of looking, should enter an unworldly, spiritual realm. Crucial for this strategy was maintaining the impression that these were images that were both manufactured and inspired, made by pious Sienese artists of God-given talent. These painters integrated the traditional methods of working gold, including punching and tooling, delicate mordant gilding, incision and *sgraffito*, which were by then particularly associated with the art of Siena, within this new naturalistic context. Their line remained not so much elegant as languid, intended to carry the eye unhurriedly across the surfaces of their pictures so as to encourage sustained devotional viewing. They also upheld certain established compositional features. We often see one or both of the Virgin's hands placed parallel with the picture surface, held lightly across the body of the Child. Sano's pairs of diminutive saints, one posted on either side of the Virgin, sometimes with angels stacked above them, were transformed into the figures that regularly appear tucked in behind her shoulders. LS

1 See Musacchio 2000.

II.

SANO DI PIETRO (1405–1481)

The Virgin and Child with Saints Jerome and Bernardino and four Angels, about 1455–60

Tempera and gold on panel, 64.6 × 44.7 cm (including original frame)
Chigi Saracini Collection, Monte dei Paschi di Siena (118 MPS)

Inscribed in Virgin's halo: AVE GRATIA PLENA d

Sano di Pietro and his workshop turned out images of the Virgin and Child in almost industrial quantities. Though Sano examined pictures by, for instance, Fra Angelico, whose compositions he adapted in at least one narrative predella, in his panels for individual devotion he largely shunned Florentine experiment. Sano was instead the most ardent (the word is deliberately chosen) proponent of a self-consciously fostered nostalgia for the unsullied beauty of Trecento gold-ground painting, a style 'suspended in time.'[1] Above all he imitated the immaculate technique and flowing line of Simone Martini and his collaborators (although the solid forms in Ambrogio Lorenzetti's paintings also inform his figures), and Sano embodies more than any other artist working in the mid fifteenth century the artistic heritage of medieval Siena. There is no doubting his popularity or commercial success.

Sano stuck to a small number of formulae for his pictures of the Virgin and Child, whether alone or in larger works in which he incorporated saints and angels, stacked up on either side of the main figures. These paintings have divided art historians. Some, apparently disheartened by the volume of his output, have seen them as arid, lazy and repetitive, others more positively have found them enchanting expressions of religious sentiment. Van Marle, writing in 1927, was among the nay-sayers: 'To Sano we owe one innovation which had considerable success in Siena; it is the type of picture showing the half-length figure of the Madonna accompanied by rather large half-figures of saints and angels for whom there is not really sufficient place on the panel, with the result that the composition

is overcharged and unbalanced, in other words the least charming type of Madonna that an artist ever invented.'[2] Offner's typically perceptive response of 1945 is more useful: he declares Sano's to have been a 'vision of perfect peace, which so completely contented his simple soul that he never altered his composition or quickened the pulses of his figures'.[3] Even if Sano repeated his basic figurative arrangements, he almost always introduced small, meaningful variations of gesture and attribute. The pictures also vary in quality. The present *Virgin and Child* stands out against the mass of workshop efforts by its combination of a finely tuned composition and exquisite technique.

The Christ Child, a baby king, is richly dressed. He draws his mother's cloak across her body – signalling her modesty. Sano fully exploits the tender possibilities of a standard iconic category, the Byzantine Glykophilousa or 'affectionate type' in which the Virgin and Child press their cheeks together.[4] Though both faces are stylised, the Virgin's heavy-lidded mournfulness contrasts with the Child's subtly animated expression, his eyes wide open and his lips slightly parted. The two heads are tightly joined by the graceful reiteration of the arcs of their almond-shaped eyes (with the same deep-brown pupils) and raised eyebrows. The play of Mary's hands with the limbs of the infant Christ is carefully calculated – for example, the Virgin, wrapping her left hand round Christ's right ankle, while his other foot rests upon her wrist, exposed, vulnerable.[5]

The gable-topped picture is still in its original frame, with flame-like acanthus climaxing into a fleur-de-lys at its point.

111

In many ways it was designed to resemble a piece of goldsmith's work, and its superb condition ensures that its craftsmanship is undimmed.[6] Sano's almost enamel-like tempera typically survives better than the paint of most other painters of the period. Like Simone Martini before him, he shows off all the varied possibilities of goldwork – *sgraffito* in Christ's costume, stippling in the gold lining of Virgin's lapis cloak, punching and incision in the filigree haloes, and delicately applied mordant gilding for the border of her mantle and the symbolic stars on her shoulder and forehead. The gold leaf is polished and textured in different places to add variety to the surface. Even the choice of conventional motifs in the haloes is carefully selected, with roses in the Madonna's and a cruciform division in the Child's.

Only the habits of the two penitential saints do not dazzle. Jerome wears the grey habit and belt of the Gesuati (see p. 168);[7] Bernardino, easily recognised by his gaunt features (see cat. 6–8), is in Franciscan brown; both are depicted praying with rosaries. These saints provide the context for this picture's commission. Sano was a member of the Confraternity of Saints Jerome, Francis and Bernardino (see p. 22), with close links to both the Observant Franciscans and the Gesuati. Sano's first independent commission in 1444 had been for the altarpiece for the Gesuati church of San Girolamo, initiating a long-standing connection. It has also been suggested that Bernardino himself may have helped formulate Sano's new kind of image for private devotion.[8] Certainly the double-sided *Virgin and Child with Saints John the Baptist and John the Evangelist* (El Paso,

Texas) has Bernardino's YHS emblem on the back.[9] The simplicity of vision evolved within a particular devotional context; it bridged the gap between the austere faith preached by Bernardino and the luxurious appearance of the pictures themselves. It may be significant that the 'affectionate type' was employed by Ambrogio Lorenzetti in his great *Maestà* at Massa Maritima, where Saint Bernardino was born. Even the repetition of these images very probably had meaning. Assuming that this and many of the other representations of the *Virgin and Child with Saints Jerome and Bernardino* were commissioned by members of the Confraternity, their similarity could symbolise a group adherence to the values promoted by the Gesuati and Franciscan Observants.

The success of Sano's new single-panel format is explained by the high quality of works like this. Yet these images' insistent repetition make it unsurprising that, from the 1470s, a new generation of patrons should prefer more innovative pictures by his younger contemporaries, who adopted his formula but significantly adapted it. LS

1 A. Angelini in Bellosi and Angelini 1986, p. 47.
2 Van Marle 1923–38, IX, p. 527.
3 R. Offner, 'The Straus Collection goes to Texas', *Art News*, vol. 44, 15–31 May 1945, p. 19; cited by M. Boskovits in Boskovits and Brown 2003, p. 619.
4 Zeri and Gardner 1980, p. 82, pl. 54.
5 This alludes to the importance of Christ's feet, into which the nails will be driven at the moment of his crucifixion, and, as Joanna Cannon has recently stressed, to the reverence paid to Christ's foot in Siena.
6 Emphasised most recently by Strehlke 2004, p. 376.
7 M. Boskovits in Boskovits and Brown 2003, p. 617.
8 Strehlke 2004, p. 378.
9 Rusk Shapley 1966, p. 145, no. K286.

SELECT BIBLIOGRAPHY

A. Angelini in Bellosi and Angelini 1986, pp. 47–8.

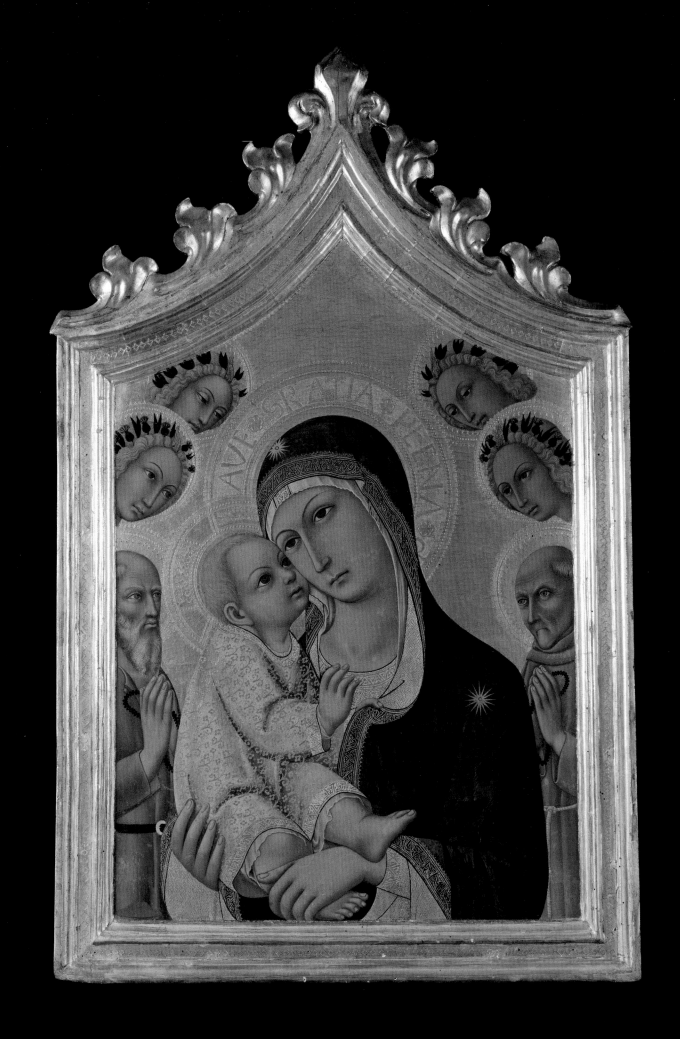

12.

NEROCCIO DI BARTOLOMEO DE' LANDI (1447–1500)
The Virgin Mary adoring the Christ Child, about 1480

Tempera and oil with gold on panel, 38.8 × 30.5 cm
The Cleveland Museum of Art, Cleveland, OH
Leonard C. Hanna, Jr. Fund (1980.101)

At a casual glance, Neroccio's *Madonna* might appear an appealing but conventional example of Sienese gold-ground painting. Actually, this picture is quietly radical in its composition and iconography, employing a new typology for the Virgin and Child seen only occasionally in Siena. Neroccio has included in this deceptively simple composition a whole web of allusion, visual and mnemonic prompts that would enrich meditation upon the mysteries of the Christ's birth and death. This sustained viewing, whereby the picture's multiple messages are only slowly revealed, is supported and encouraged by the fastidious detail with which the picture is painted.

The parapet, a Netherlandish device that Neroccio would have imitated only through earlier Florentine adaptations, encourages association with Christ's tomb. The Virgin's hands are held in prayer in what is at once the recognition of his divinity, an affirmation of her humility and a reminder of her role as intercessor. The Virgin's pose and the nudity of Christ were probably intended to remind viewers of images of Mary kneeling before the naked infant on the ground, as in Saint Bridget of Sweden's famous vision of Christ's birth, which she experienced between 1360 and 1370.[1] Copies of Saint Bridget's *Revelations* were assuredly read in Siena, since they are found in the libraries of the convent of San Francesco, of Niccolò Borghesi and of Giorgio Tolomei. They had earlier been written out the for Confraternity of Saints Francis and Jerome to which Saint Bernardino had belonged.[2]

Neroccio's picture includes other elements that were better known in Siena – not just the gold ground but Christ's gesture of blessing and his goldfinch, symbol of the Passion. The bird is not here clutched in his hand, as in so many paintings by his Trecento forebears, but perched on the parapet and tethered with the fine thread – now almost entirely worn away – that runs between Christ's fingers, explaining his gesture. The placing of the goldfinch near the foot that would be pierced during the Crucifixion, enhances its symbolic power. The benign expressions on both faces are carefully calculated: in the Child conveyed especially by his hazily focused eyes. The Virgin has very delicately painted eyelashes and her curls of blonde hair are visible under her veil, making a particular point of its transparency. Neroccio has scrupulously depicted the play of light and shade, in the dark red shadows cast by the Virgin's left arm and cloak, and in the flesh, especially in the shadow of Christ's right arm falling across his torso, which reaches precisely to his sternum and defines the form of his chest.

Neroccio combines this sophisticated naturalism with a more traditional Sienese compositional method. The spectator's eye is led smoothly but not systematically across the picture surface – along the meandering lines of the Virgin's veil and even between the lips of her sweet mouth, through the neckline of her gown and to the sleeves which, pushed up her arms, have a subtly crimped contour. The whole composition is based around an understated pattern of reiterated loops: the curve of the Virgin's cloak as it crosses her body repeats that of her left arm and Christ's left leg and, though the thread around the goldfinch's neck is abraded, it can just be seen as it crosses Christ's left thigh and the little area of gold beneath, and running under Christ's left heel; it too originally echoed the sweep of the cloak. These flowing lines justify the elongation of the neck and fingers of the Virgin and the left thigh of the Christ Child.

Perhaps in the end the most startling aspect of this picture is the very thing that seems most familiar, its gold ground. The choice seems peculiar, since the parapet was so frequently used in Netherlandish and Florentine painting to suggest the sill of the window framing a vision of another space. But here too the gilding and its ornament have a purpose within the meditative function of the painting. The fluid viewing experience is controlled by the geometry of the gold ground. The punched border is rigorously symmetrical, with the Virgin's halo at exactly the mid point of the upper edge. This border is architectural, constructing stable uprights that root the Virgin – actually slightly off-centre – in the composition, and that reinforce the significant vertical of the Virgin's face and hands, Christ's left foot and the goldfinch. Christ's halo is similarly 'fixed', allowing him to lean back as if supported by the ground itself, in a conscious play between the picture surface and the notional space the figures occupy. Elements that seem at first to be mere ornament provide a visual (and therefore contemplative) structure and boundaries. LS

1 Strehlke has related a Nativity of this kind by Vecchietta to Saint Bridget of Sweden's vision of Christ's birth. See Christiansen, Kanter and Strehlke 1988, pp. 259–60, cat. 43.
2 Chellazi Dini 1982, p. 316; Zafarana 1980, p. 292; C.B. Strehlke in Christiansen, Kanter and Strehlke 1988, p. 259.

SELECT BIBLIOGRAPHY
Seidel 1989b, pp. 71–138, esp. p. 119, n. 138.

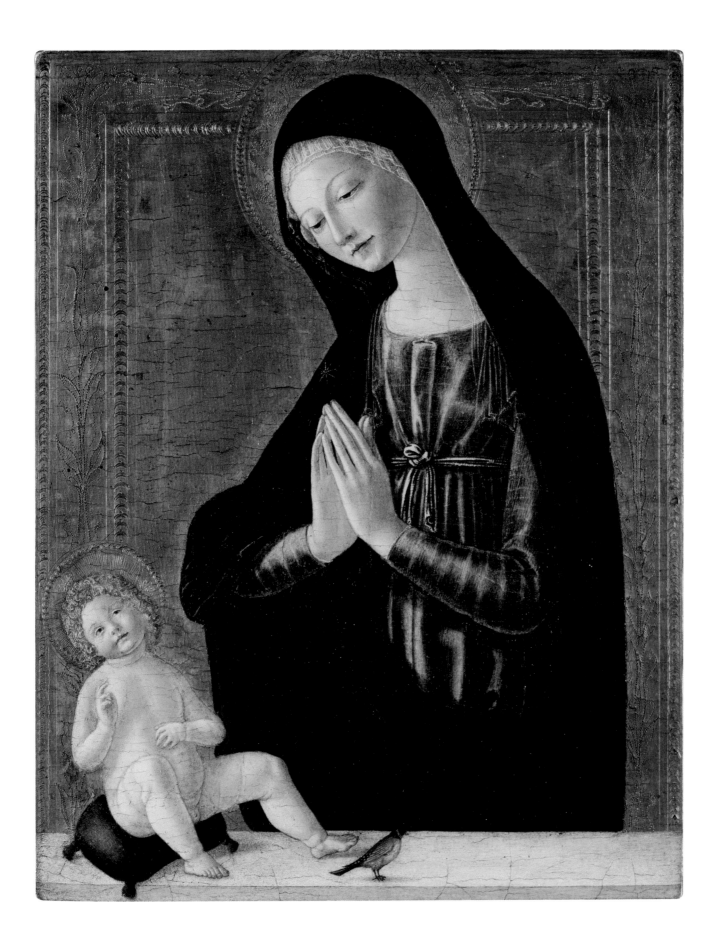

BENVENUTO DI GIOVANNI (1436–after 1509/17)

The Virgin and Child, about 1474–5

Tempera on panel, 52.1 × 34.3 cm
The National Gallery, London. Salting Bequest, 1910 (NG 2482)

Inscribed in the Virgin's halo:
AVE MARIA PLENA GRASIA DOMINUS TECUM

Benvenuto di Giovanni's Virgin represents simultaneously an enduring ideal of holy motherhood – loving and grieving, tender and melancholy – and of a remote, untouched, untouchable femininity. The Christ Child in her arms seems miraculously weightless, not so much physically supported as floating within the bounds of her beautiful hands. Christ's incorporeality, however, is countered by a lovely fleshy touch, as Christ's arm reaches round the Virgin's neck. He is both human and divine. His eyes meet ours with an expression that seems almost wary of what his future holds. Indeed the tangle of the veil around Christ's loins is deliberately and uncomfortably reminiscent of the winding sheet of the Lamentation, isolated by, but also linking, the Virgin's delicate encircling hands. The complication of Christ's draperies is stressed by their contrast with the strong columnar folds of Mary's dress. She stands at a window – a window on to a visionary world. The realm they inhabit is filled with flowers of love – roses and jasmine[1] – and the harsh crags on the left contrast with the fertile, populated hills on the right.

Though he has dispensed with the gold ground, Benvenuto has not altogether rejected the lessons learned during his period of collaboration with Sano in the later 1460s. The unbroken curve of the Virgin's cloak around her rounded head is copied from him and his predecessors. The gilding is conventionally and carefully planned: except in the gold and pearled neckline of her red dress, Benvenuto has laid down the gold leaf – of the cloak lining and the tasselled cushion – before painting the rest of the scene. His insistence on contour is traditionally Sienese but also shows awareness of North Italian modes, especially of Ferrarese painting. Here it effects an archaic, very slight flattening of the figures, and the Virgin's features in particular are arranged more with an eye for their abstract beauty than for anatomical accuracy. Nonetheless, we can see that Benvenuto has carefully studied Donatello's *Virgin and Child* relief (fig. 43). The pose and type of the Christ Child with high rounded forehead, little dimpled chin and chubby feet are strongly dependent upon Donatello's model. The accentuated musculature of his torso, with its strong pale highlights, is perhaps more reminiscent of the painters trained by Squarcione in Padua, above all Mantegna. Just as was demanded, this painting is ancient – eternal – and modern. LS

Fig. 43
Detail of fig. 26

1 Jasmine and roses are a consistent feature in Benvenuto's pictures of the Virgin: see for example *Virgin and Child* triptych (about 1480, National Gallery, London) and the Borghesi Altarpiece, worn in wreaths by angels in the latter case (see cat. 32).

SELECT BIBLIOGRAPHY
Bandera 1999, pp. 120, 233, no. 56.

14.

MATTEO DI GIOVANNI (about 1428–1495)

The Virgin and Child with Saints John the Baptist and Jerome and two Angels, about 1475–6

Tempera grassa (?) on panel, 64 × 44.3 cm
(painted surface 64.5 × 41.5 cm)
Galleria degli Uffizi, Florence (P1037)

Here, Matteo has adapted Sano di Pietro's prototype (see cat. 11), including a pair of saints smaller than Mary and the Christ Child, as well as two angels. The penitent Jerome had been included in many of Sano's paintings, usually paired with Saint Bernardino. Saint John the Baptist was also a model of penitence – and his cult grew in Siena after the 1464 gift by Pius II of the relic of his right arm to the Cathedral. Here, John blesses the infant Christ while holding a cross, his attribute, but also the only explicit warning of Christ's sacrifice.

Jerome, John the Baptist and Bernardino were overwhelmingly the most popular male saints to be included in Sienese paintings for private devotion. Interestingly, the number of saints appearing in these types of pictures is more limited than those in contemporary altarpieces. A survey of images of the Virgin and Child produced by leading Sienese painters from about 1450–1500 shows certain saints recurring with great regularity, others hardly at all.[1] Sebastian, for example, was represented frequently as the Protector against plague and dedicatee of one of the city's confraternities. Apart from Bernardino, these pictures express devotion to other Franciscans – Francis himself and Anthony of Padua. The Franciscan order was evidently especially important in promoting private devotion in this period. Dominican saints are rare – the exception being Catherine of Siena, included as a patron saint of the city. Occasional appearances are made by other Sienese patron saints – Ansanus and Victor, and Peter and Paul (sometimes paired) are also depicted. The female saints that turn up most frequently are Catherine of Alexandria, and, usually in later works, Mary Magdalene (cat. 58–9).

Others (Evangelists, Apostles, Doctors, early Christian martyrs, founders of other monastic orders and so on) were painted less often, if at all. This evidence suggests that inclusion refers to group loyalties – a sense of civic or political allegiance, or membership of one of the leading confraternities – and perhaps less to a personal devotion to one saint or another, based, for example, on the name of the patron.

Matteo has here radically rethought Sano's model. Though the saints are still smaller than the Virgin and Child, their scale reflecting their relative importance, the figures kept distinct by Sano are now complicatedly intertwined, linked by expressive gesture and sinuous line. Disentangling the composition can be seen as pictorially paralleling the mental process whereby its multiple meanings were extricated. This picture encourages sustained meditation on the Incarnation of Christ – the Word made Flesh – on his combined humanity and divinity, and on the need for penitence to achieve salvation. The most important gesture is Christ placing the ring on the Virgin's finger – she is clearly represented as his bride. The main source for this imagery is found in the Canticles (the Song of Songs), with their central characters of the bride and groom, a focus for biblical exegesis. Commentators interpreted this difficult text in various ways: the groom was taken to stand for Christ, the bride for his Church (Ecclesia); others thought of the bridegroom as God and the bride as the human soul; while a third tradition linked the poems to the mystery of the Incarnation, positing the bride as mystically representing the Virgin, while the groom stood for Christ. These approaches fed one another

and could overlap. Here the eyes of all the figures are directed at the Child, with the exception of the angel on the top right, who looks instead at the Virgin, his praying hands evoking the shape of the Church.

The Child is the still, pale centre of the composition, standing out against the assertive red costumes of the Virgin and the Baptist. He is animated only by the flutter of fingers on his left hand. Matteo's sparkling, liquid highlights, particularly in the draperies, are of the kind used by North Italian artists.[2] They are especially delicately applied in the filmy veils that cover the Virgin's blonde hair and flow around Christ, and the particular care with which they are painted draws attention to these features. The Virgin's veil emphasises her role as bride, and a relic of the veil was preserved in Siena. The taking of the veil by virgins marrying the heavenly spouse was called the ceremony of *velatio*, and Jerome called this veil the *flammeum christi*. Christ's may be interpreted as a pictorial simile of the 'veil of flesh' that conceals his divinity as described in *The Tome of Saint Leo the Great of Rome on The Nature of Christ*, adopted by the Council of Chalcedon in 451 AD.[3] LS

1 A survey of about 100 photographs at Kunsthistoriches Institut, Florence shows works attributed to Matteo and Benvenuto di Giovanni, Neroccio and Pietro Orioli, Sano di Pietro, Francesco di Giorgio, Pietro di Domenico, Guidoccio Cozzarelli and Andrea di Niccolò. The accuracy of these attributions is not of concern here.
2 Buricchi 1998; Cecchi 1991, pp. 54–5; G. Fattorini in Alessi and Bagnoli 2006, pp. 39–43.
3 Lightbown 2004, pp. 83–4.

SELECT BIBLIOGRAPHY

Trimpi 1987, pp. 140–1, no. A30; Buricchi 1998, p. 51, no. 14; G. Fattorini in Alessi and Bagnoli 2006, pp. 39–43.

15.

PIETRO ORIOLI (1458–1496)

The Virgin and Child with Saints Jerome, Bernardino, Catherine of Alexandria and Francis, about 1487–90

Tempera and gold on panel, 74.6 × 52.7 cm
Ashmolean Museum, Oxford (WA 1959.6)

The formula of Virgin and Child placed centrally with saints positioned either side continued well into the sixteenth century. In the late Quattrocento, Matteo di Giovanni's pupil, Pietro Orioli seemingly sought to revive its earlier formality. Orioli was a member of the confraternity of Saints Jerome, Francis and Bernardino from at least 1481 (see p. 21–2) and three of the four saints shown here were patron saints of the company. This picture is very likely to have been commissioned by a fellow member, and its relatively conservative composition may well reflect the taste of a devout lay brother.

The picture's ordered composition, with its tonal unity and disciplined symmetry, seems deliberately to recall Sano's prototype (see cat. 11). The saints gathered round the touchingly youthful Virgin are still small, even the Saint Jerome who gently touches her shoulder. However, Orioli has allowed his figures greater space than Matteo (see cat. 14); the flanking saints are set back, justifying their smaller size. He has re-articulated the space on the basis of his intense study of paintings by the Florentine Domenico Ghirlandaio and in particular, of the Ghirlandaiesque painter Fra Giuliano da Firenze, whose only known work is the *Virgin and Child with Saint Jerome and the Blessed Giovanni Colombini* in the Sienese convent church of San Girolamo.[1] This link with the Gesuati may explain why Orioli chose to modernise his style in this way. The impact of Donatello also continues: the Christ Child is still more precisely quoted from the *Virgin and Child* relief (fig. 43, p. 116).

Orioli has combined a traditional Sienese preoccupation with the craft of the picture with a newer wish to show off its inspired energy of creation. With meticulous brush-work, he directs the viewer to the details which matter most – the faces, especially the Virgin's; Jerome's beard and the patch of beaten flesh on his chest; Catherine's parted lips; Francis's hands and the rays of light that emanate from the stigmata.[2] The painstaking detail with which the heads are painted extends to Francis's surprising ginger bristles and the dramatic vein on Bernardino's forehead. Elsewhere, especially in the highlights and shadows of the draperies, his tempera technique is remarkably loose and painterly, the transcendental calm of the composition subtly powered by this method of execution. This is most noticeable where he has painted a series of dark reinforcing lines around the crooked little finger of the Virgin's right hand, cutting unnaturalistically across her dress and imbuing the picture with an almost Futurist vibration. This vitality is set off by the carefully regular horizontal brush strokes of the sky.

As is not unusual, the coarse grained blue azurite of the Virgin's cloak is almost entirely lost and is now retouched.[3] However, there survive the remains of the mordant gilding on its star that denotes her as the *stella maris*. The gilded ornament on the border of her cloak has disappeared, leaving only its pattern preserved in the unaltered date painted beneath. Mordant gilding was also used for the figures' transparent dotted haloes, a method that adds to shimmering effect of the work. The *sgraffito* with which Orioli achieves the gilded pattern on the Virgin's dress is also unusually free. Some colours, especially the pink, of the Virgin's dress, are now a little faded, but the picture's pearly tonality is probably close to the original desired effect, a rather austere avoidance of gaudy colour. Like Benvenuto's *Virgin and Child* (cat. 13), this picture seems never to have been varnished, contributing to the fresco-like finish. LS

1 Angelini 1982, pp. 30–43.
2 See G. Mazzoni in Mazzoni 2004, pp. 130–1, cat. 25.
3 Cat. 13 has been affected in a similar way.

SELECT BIBLIOGRAPHY
Lloyd 1977, pp. 143–4.

16.

NEROCCIO DI BARTOLOMEO DE' LANDI (1447–1500)
The Virgin and Child with Saints Paul and Mary Magdalene, about 1492–4

Tempera and gold on panel, 60 × 40 cm
Collezione Salini, Siena (23 Pittura)

Neroccio's fragile grace and emotional appeal are certainly essential features of this painting, even if continual demand for images of the Virgin and Child with Saints led, perhaps predictably, to a certain repetitiveness. Neroccio, who probably painted more Madonnas than any other artist of his generation, did not scorn the recycling of successful motifs, sometimes using a kind of cut-and-paste method for these works. Thus, gracefully linear though they are, compositionally his images can appear somewhat disjointed. His autograph pictures, however, are unified by their particularly delicate execution.

In this work, the design of the figure of Saint Paul, curiously turned away from the Virgin, his right hand and sword squeezed in rather uncomfortably behind the Child's bottom, seems also to have been based on the Paul in a larger-scale work now in the Pinacoteca Nazionale in Siena, in which he faces her – suggesting that the altarpiece was perhaps executed slightly earlier. The Saint Paul also reappears, again facing the Virgin, in Neroccio's altarpiece painted for the church of Santissima Annunziata in the little town of Montisi, signed and dated 1496. However, while the choice of Saint Paul may, in this instance, have been dictated by the personal devotion of the work's commissioner, it is arguable that the inclusion of Saint Mary Magdalene suggests that picture may post-date attempts by the *Noveschi* to promote the cult of the Magdalene after their return from exile in 1487 on her feast day. The work may

therefore have been painted in the early 1490s for one of the *Nove*.

The standing pose of the Christ Child, while not completely unknown in earlier Sienese depictions was rare and seems to have been re-introduced to Siena in this animated form by Neroccio. This liveliness and, in particular, the motifs of the crossed ankles and the hands reaching forward, were based on Florentine models emanating primarily from the Verrocchio workshop in the late 1460s and the 1470s – for example, the *Virgin and Child* (National Gallery, London) recently proposed as by the young Filippino Lippi working to a design by Botticelli[1] or the *Dreyfus Madonna* (National Gallery of Art, Washington), which is variously attributed, most frequently to Lorenzo di Credi and also, more plausibly, to the very young Leonardo da Vinci; Domenico Ghirlandaio used a similar motif in the 1480s, as in the *Virgin and Child* (also National Gallery, London).

The particular transparency of Neroccio's paint functions as a kind of metaphor and contributes to the visionary nature of his works; the painting itself takes on the character of the veil. And his figures have a subtlety and charm of expression that is unique to him. Here the delicacy and sympathetic reading of emotions makes this one of the most delightful of Neroccio's late works. LS

1 Cecchi 2005, pp. 78–9.

SELECT BIBLIOGRAPHY
Coor 1961, pp. 61–2, 79, 84, 168, no. 18.

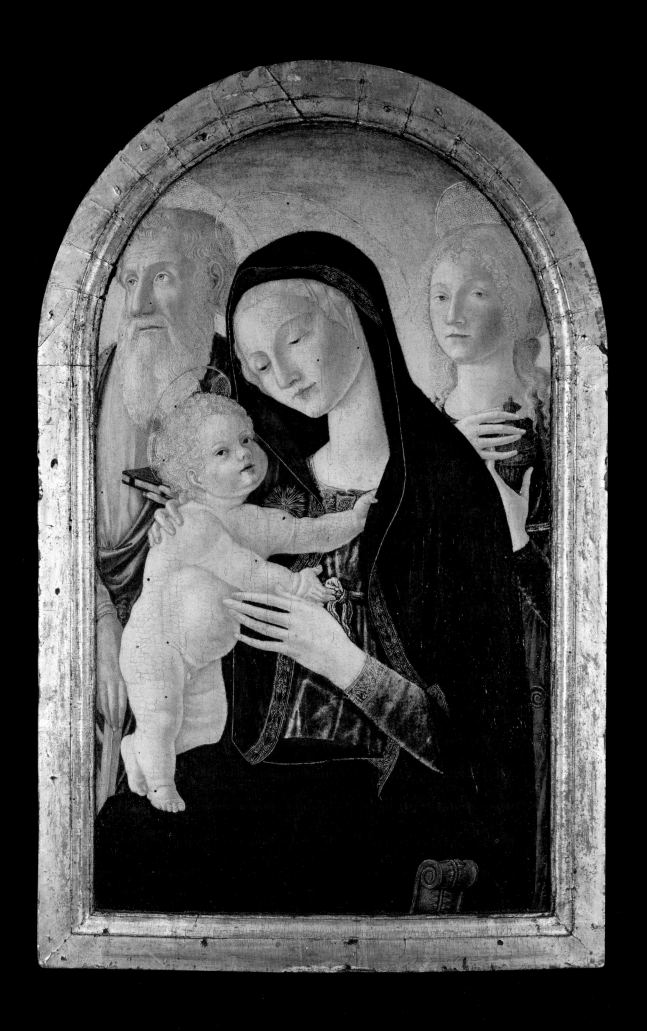

The Asciano Altarpiece, 1474

MATTEO DI GIOVANNI
(about 1428–1495)

17.

The Assumption of the Virgin

Tempera and gold on panel, 331.4 × 173.9 cm
The National Gallery, London (NG 1155)

Inscribed on the Virgin's halo:
REGINA · CELI · LETARE

18.

Saint Augustine

Tempera and gold on panel, 197 × 47 cm
(including original frame)

19.

Saint Michael the Archangel

Tempera and gold on panel, 196 × 47 cm
(including original frame)

Both in the Museo di Palazzo Corboli, Asciano (48)

20.

The Virgin Annunciate

Tempera and gold on panel, 73.3 × 42.7 cm
Museum of Art, Rhode Island School of Design,
Providence. Gift of Robert Lehman (57.301)

21.

Saint Agatha
Saint Lucy

Tempera and gold on panel
54.41 × 30.48 cm
Private collection

Matteo di Giovanni's *Assumption* is one of the great visionary works of the Quattrocento, spectacular in all senses of the word. It is hard to believe that by the end of the eighteenth century, it was kept in a wood store of the Augustinian monastery of Sant'Agostino at Asciano, approximately thirteen miles south-east of Siena, where Ettore Romagnoli rediscovered it in 1800. When he found the dismembered fragments of an altarpiece that he believed had once stood in the church, this pioneering Sienese art historian recalled: 'In the noble region of Asciano is one of the best paintings executed by Matteo on a panel. It was once located in the church of Sant'Agostino, and afterwards in the woodstore of the Augustinian fathers, where in 1800 I saw it and rescued what remained of it from complete destruction. Now there remains from the many compartments that the altarpiece contained the very beautiful *Assumption of the Virgin*, escorted by angels that look indeed as if they come from Paradise; the painting was not long ago in the possession of the Gonfaloniere of Asciano [Don Francesco Bompagini] and is now in the choir of Sant'Agostino.'[1] Thus at least the central part of the altarpiece was briefly replaced close to what was almost certainly its original location. Yet before long, cat. 17 was purchased by the Griccioli family of Siena and placed on the high altar of the restored church of Sant'Eugenio a Monistero, just outside the city walls.

The Madonna Assunta was particularly important in Siena (see p. 80) and ceremonies for Assumption Day were prominent in its civic calendar. Images of the Assumption that abound in the Sienese *contado* can be explained as much by the desire to demonstrate the political loyalty of the town under Sienese control as to express devotion to the Virgin herself: this is certainly the case for Matteo's altarpiece, made for the small town of Asciano.

His altarpiece obeys the visual conventions for this scene (see fig. 42, p. 107), but invests it with a new ardent energy. The Virgin, seated on a throne of cherubim and seraphim, rises upwards. At her feet, there is a ring of musician angels, with two tiers of angels above them, the uppermost tenderly contemplating the extraordinary event, and with a 'dense covey of saints'[2] on either side. She wears the white robes of the Queen of Heaven ('fair as the moon') and lets her girdle drop down to the doubting Thomas. He stands by the empty tomb, which is set in an enormous, panoramic landscape strewn with craggy rock formations, little trees and fields; a small town and what may be a monastery are painted left and right. Receiving Mary in heaven is a dramatically foreshortened Christ, flying out of the picture.[3] As Cole has eloquently described, 'Each of the participants – from the fervent Thomas, whose delicate hands grope for the Virgin's belt, to the ranks of hovering, ecstatic angels around the comely, sad-eyed Virgin – emits a subtle emotional vibration …'.[4]

The picture is marvellously organised, obeying a traditional hierarchy of scale, whereby the Virgin is by far the biggest figure in the picture.[5] She floats through the picture surface towards the spectator, her patterned white cloak prominent against the now faded reds, blues and darkened greens of the angels; this effect would have been stronger in the relative gloom of a church interior and before the pigments

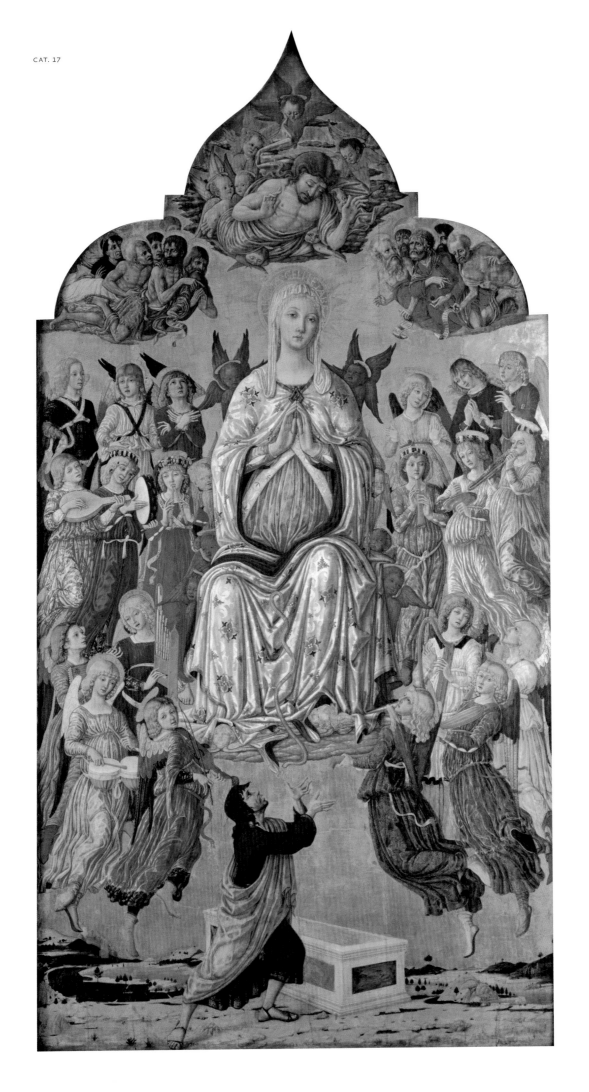

Fig. 44
Matteo di Giovanni (about 1428–1495)
Archangel Gabriel (location unknown)

Fig. 45
Matteo di Giovanni (about 1428–1495)
*Saint Monica praying for the Conversion of her
Son Augustine*, 1474
Tempera on panel, 42 × 38.9 cm
Berenson Collection, Villa I Tatti, Florence (P 26)

FIG. 44

FIG. 45

The importance of her belly – her miraculous womb – is underscored by its framing with two white bands of cloth and her praying hands above. Matteo, however, while deliberately complicating the spatial relationships between the figures, links them through the composition and especially through colour. The interplay of colours above echoes in the landscape underneath, with its green fields, and in the tomb with its blue and red panels. The gilded ground, unifying the composition, emphasises the beautiful intervals between the figures, while also allowing Matteo's visionary manipulation of space. The angels' feet in the lowest tier are carefully connected with the curve of the far horizon; it is as if they have just launched themselves off the ground, although, entirely appropriately, it is not spelled out exactly from where. Their music-making is beautifully observed.[7] Matteo lends conviction to the sense that the angels actually bear the Virgin's weight by framing her cloudy pedestal on the right with the neck of a lute; arguably she is supported by their music. Though Thomas apparently stands (in seven-league sandals) behind the Virgin, her belt and one fold of her cloak snake across the clouds towards his outstretched hands, reaching into the foreground: this effect contributes to the unusual dynamism of the figure. Thomas's dramatically arched back is echoed by the arcs of the angels nearest him.

In cat. 17, Matteo has been seen as responding to North Italian artists[8] and to the Florentine Antonio del Pollaiuolo, particularly given the wiry muscularity of Christ and Thomas, and the crisp, fluttering linearity of the draperies. The huge landscape

has been thought to result from Matteo's admiration for Piero della Francesca, the artistic hero of the town where Matteo was born. Viewed in these terms, this otherwise standard image of the Assumption has been to some small degree modernised. However, Matteo's debts to the Quattrocento 'visionaries' (Sassetta and the young Giovanni di Paolo) and all the way back to Simone Martini are just as crucial.[9] It has been pointed out that Matteo's *Assumption*

is organised along the 'spacious lines' of Sassetta's altarpiece made for the Osservanza (see p. 106),[10] itself derived from the much revered Porta Camollia fresco by, or started by, Simone Martini (both single images which are arch-topped). The three circles of angels, for example, come from these prototypes. But there are also notable variations: Sassetta's altarpiece had been commissioned by Saint Bernardino, and certain strands in the iconography might

126

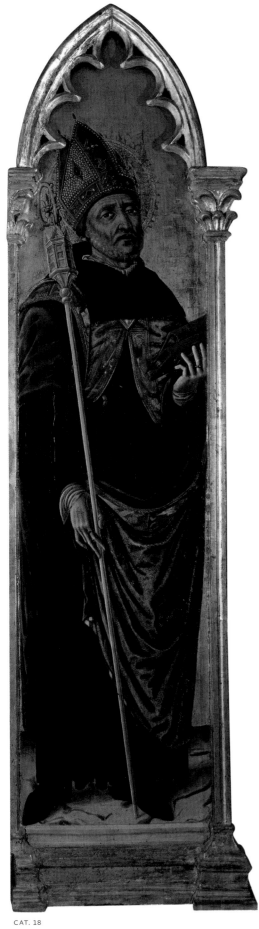

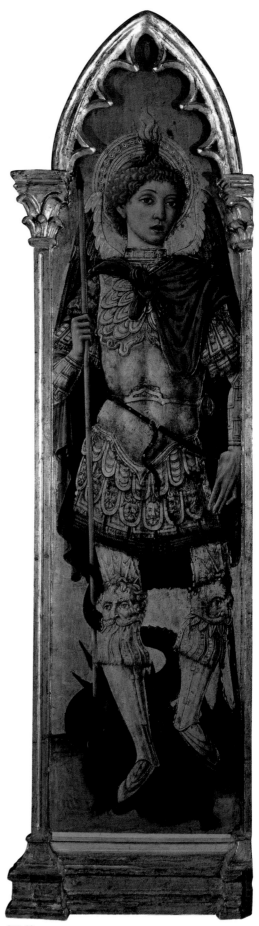

CAT. 18

CAT. 19

therefore have been associated particularly with the Franciscans. Matteo's polyptych, on the other hand, was executed for an Augustinian foundation, and had to function as a visual link to the mother city. Matteo has de-emphasised the geometric arrangement of the prototypes and he has omitted the mandorla. Sassetta's altarpiece had the panoramic landscape, as do others from the first half of the fifteenth century, but, while Sassetta has assembled the Apostles within it, Matteo has chosen to isolate Thomas with the girdle dropping into his hands. Even if his dramatic pose in profile to the left was prefigured in Sassetta's painting (in which he faces right) and was probably in Simone's model, Matteo has imbued him with a startling vigour; Thomas seems electrified.

Alternative sources associated with the wider city and the Sienese *contado* were in fact provided by the Duccio-designed stained-glass window in the Cathedral, before which the worthies of the towns under Sienese control gathered on Assumption Day. This was likely therefore to be a key point of reference for non-Franciscan images, especially in subordinate towns like Asciano. Duccio's Virgin, like all the others, faces forward, but, whereas the model pioneered by Simone and much copied presents the figure perfectly balanced (see fig. 42, p. 107), Duccio's Virgin has her right knee raised, her left lowered, and it is this more dynamic feature and the arrangement of draperies with her dress exposed that were followed by Matteo. That is not to say that Simone's model at the Porta Camollia was rejected or unimportant. But the physical structure of the altarpiece – as we will see a central narrative with a single saint on

either side – recalls Simone's *Annunciation* and the other Trecento Marian altarpieces in Siena Cathedral rather than the series associated with Bernardino. The overall message is therefore more embracing and less specifically Franciscan.

Two nineteenth-century guidebooks mention a signature and the date 1474,[11] possibly on its original frame and now lost. This makes it just possible that the central panel (or its woodwork) was cannibalised from one started for an earlier Servite project in Siena of around that date (evidently abandoned), but it is most likely that Matteo's altarpiece was in Sant'Agostino from the start.[12] The cluster of buildings in the left background of cat. 17 is possibly a schematic representation of Asciano. Like the real Asciano, Matteo's town is situated on a hillside, and includes two churches and the town hall below. It might correspond to a lateral view, seen from the west, of Sant'Agostino, with the Collegiata of Sant'Agata, the town's other main church, behind. The body of water may be the river Ombrone running through a valley near Asciano telling called the Piano (plane) di Sant'Arcangelo and the scorched terrain resembles the hills around Asciano during a Tuscan August.

An original location in Sant'Agostino in Asciano is consistent with the structure of the whole altarpiece. Although it has been argued recently that cat. 17 was intended to stand alone,[13] Romagnoli's account shows that the altarpiece must have been a polyptych containing an unspecified number of subsidiary panels ('di molti comparti che la Tavola comprendeva'). Hartlaub tentatively suggested that the Assumption could be connected with Matteo's pictures in Asciano

of Saint Augustine (the name saint of the church) and Saint Michael (a local patron saint whose name was used for the nearby valley), still in their original frames, which now are falsely married to Giovanni di Paolo's much smaller *Assumption*.[14] The saints are depicted on tall rectangular panels with spandrels at their tops creating pointed arches. The panels must have continued above these arches, but their tops were at some stage rather brutally sawn off, plausibly at the moment when the 'new' altarpiece incorporating Giovanni di Paolo's painting was constructed.

The two saints have a physical presence like that of the Virgin; Augustine is endowed with severe monumentality and Michael has a remarkable springiness. His calm expression and the shape of his head echo Mary's. The Asciano panels are, like the *Assumption* itself, pictures of great power and imagination. Matteo has dazzlingly exploited the varied possibilities of different gilding techniques for the Saint Michael. The use of dark glazes painted over the gilding for volume and incision for ornament make his fantastic *all'antica* armour truly astonishing. When Pope-Hennessy in 1950 re-elaborated Hartlaub's hypothesis, he declared that (after cleaning) there was 'no doubt' that the Saint Michael and the Saint Augustine functioned respectively as the inner and outer panels on the left side of the *Assumption* – and that two more lateral panels were once placed to the right of the central scene. Assuming four side panels in total, he suggested that the altarpiece might originally have measured 'almost four metres' in width. He added that there was a strong probability that two of the altarpiece's 'upper panels' – by which he almost

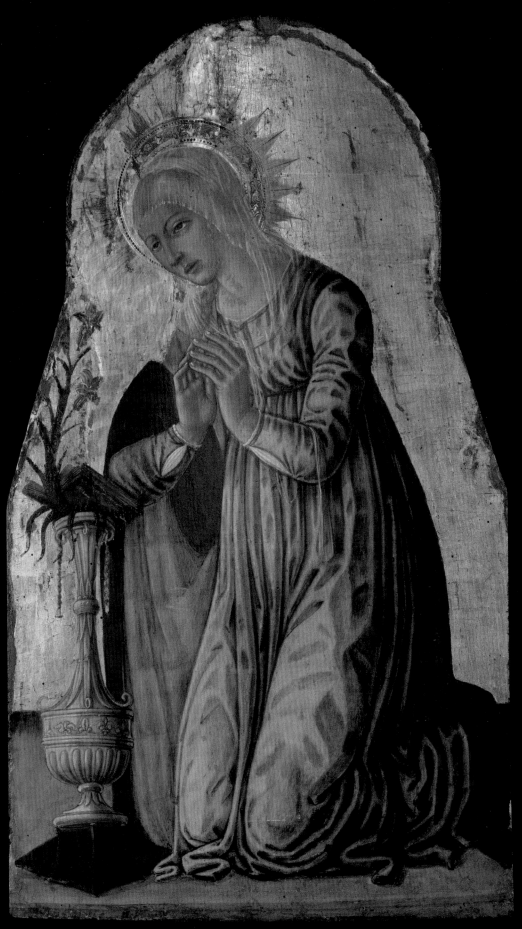

CAT. 20

certainly meant crowning pinnacles –
were the *Virgin Annunciate* (cat. 20), and a
damaged Archangel Gabriel that appeared
on the New York market in 1926, its where-
abouts now unknown. Though cut down
into its present shape, the width of cat. 20 at
its base makes it very possible that it was set
above the Saint Michael. As with the rest of
the picture, the lighting source is from the
left and Pope-Hennessy[15] rightly argued that
the *Annunciate* is a twin to the Virgin in the
cat. 17. Compelling parallels can be drawn
between the oval shape and modelling of
her head, the specific treatment of facial
features like the slightly down-turned
mouth, rosy cheeks and bruised eyelids, and
the vertical folds of her dress as it falls over
her belly. She even has the same sleeves,
revealing her underdress at the wrists, and
transparent veil covering her blonde hair.
Only her cloak has changed – necessarily,
to show her in these different roles.

However, Paardekooper corrected Pope-
Hennessy in one important respect, noting
that the Saint Michael is a right-hand
lateral panel rather than a second left-hand
one.[16] Saint Augustine would indeed more
probably, as the name-saint of the church,
have been positioned to the immediate left
of the centre panel, at Virgin's right hand
in the place of honour. On the left and right
respectively the capitals of the frames of
these side-panels are flush with the rest of
the frame, but to the right of Augustine's
head and to the left of Michael's the capitals
project beyond the frame edges and would
have overlapped the painted surface of
Giovanni di Paolo's central panel. Retouch-
ings of the *Assumption* at the points where
they were originally joined establish their
connection, confirmed by the positions of

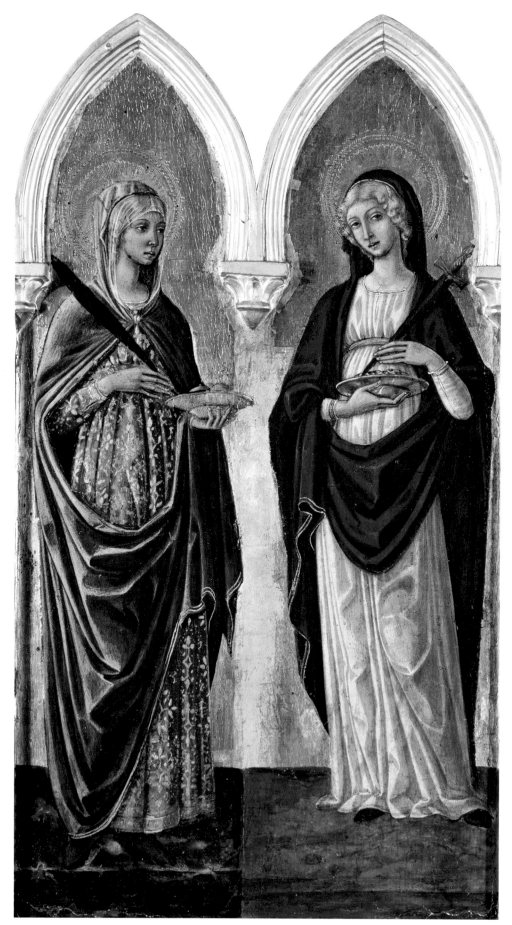

CAT. 21

130

the dowels on the edges of both the central and side panels that once pegged the parts together. The total width of the altarpiece would therefore have been approximately 3.10 m. Although the Gothic church of Sant'Agostino is now somewhat changed, the pointed entrance arch to its choir or presbytery, where the Augustinian monks would have been seated during masses, behind the high altar on which the altarpiece was surely placed, is unaltered, with a width of 4.82 m, comfortably accommodating the altarpiece.

Feasibly, further surviving pictures by Matteo may be added to this reconstruction, works that might have been painted on the side pilasters or buttresses and the predella. A gold-ground panel at Villa I Tatti of *Saint Monica praying for the Conversion of her Son Augustine* (fig. 45), may have been part of the predella. Dora Sallay has very recently (and convincingly) suggested that two panels of the same height as the I Tatti predella fragment, representing Saints Jerome and Nicholas of Bari (in Esztergom and Altenburg respectively), were once the bases of the framing pilasters of the altarpiece, details of their carpentry implying such a position.[17] The figures of *Saint Agatha and Saint Lucy* (cat. 21), of the right date and of extremely high quality, are painted on two smallish rectangular panels, now stuck together, with the gilding renewed in the areas where the two panels have been joined. The particular refinement with which the two women are painted – the lovely transparent veil over Agatha's hair, the little corkscrew of curls that touches her long neck, the elegant bounce of Lucy's hairstyle, the tapering fingers of both – link these panels to the lateral saints in Asciano.

All these pictures share a sensitive pale highlighting and the delicate dark contour line used around areas of flesh painting, especially in the hands.

It has been conjectured that these panels were once the lateral sections of a small triptych.[18] However, Trimpi had already suggested that they came from a larger altarpiece complex, this *Assumption* one of her candidates.[19] The two figures are of different heights and whereas the head and upper body of Saint Agatha are depicted as if the spectator is standing directly before her, in such a way that we view the tops of her feet, Saint Lucy, looking down, is best viewed from below; we see the underside of her dish and the back of her right hand holding it. While Lucy is mostly paint, much more gold can be seen in the figure of Agatha. This implies that the Saint Lucy was originally seen from below and further away and that the two saints were placed at different levels on the two tall side-pilasters on which small saints were typically painted above one another in series of three or more. Saint Agatha would have been in the lowest position on the left, Saint Lucy higher up on the other side. Agatha's greater prominence might be explained by the fact that Asciano's second important church is dedicated to her, and that it was quite usual to pay tribute in one church to a neighbouring foundation in this way – by placing the image in a subsidiary part of an altarpiece.
LS

1 Romagnoli Ante 1835.
2 K. Christiansen 'Painting in Renaissance Siena' in Christiansen, Kanter and Strehlke 1988, p. 23.
3 Matteo had already painted a strongly foreshortened God the Father in the much earlier altarpiece (about 1458) made for for Jacopo Scotti, also sited in the church of Sant'Agostino in Asciano.
4 Cole 1985, p. 98.
5 Not following the example of the *Coronation* (see fig. 5, p. 13) painted by Francesco di Giorgio with the help of assistants only slightly earlier for nearby Monteoliveto (A. De Marchi in Bellosi 1993, pp. 300–30, cat. 56).
6 In this respect Francesco di Giorgio's example in the painting of the *Coronation* was evidently more potent. This is also a likely model for the image size of the central panel of Matteo's polyptych.
7 Wortham 1928, pp. 323–9, esp. pp. 324–5.
8 K. Christiansen 'Painting in Renaissance Siena' in Christiansen, Kanter and Strehlke 1988, p. 23; A. Angelini, 'La seconda metà del Quattrocento' in Chelazzi Dini, Angelini and Sani 1997, pp. 293–4 (*Assumption*).
9 See Cole 1985, pp. 97–8.
10 Pope-Hennessy 1950, pp. 81–5.
11 Micheli 1863, p. 138.
12 See Syson (forthcoming).
13 Alessi 2002, pp. 142–4; L. Paardekooper, 'Matteo di Giovanni e la tavola centinata' in Gasparotto and Magnani 2002, pp. 28–9, 36 note 78.
14 Hartlaub 1910, pp. 72, 78.
15 Pope-Hennessy 1950, pp. 81–5.
16 Paardekooper in Gasparotto and Magnani 2002, p. 36, note 78.
17 Dora Sallay made this suggestion in a recent series of emails (May 2007). I am grateful to her, to Ludwin Paardekooper, to Maureen O'Brien and Gabriele Fattorini for their assistance with this entry.
18 H. Brigstocke in Weston-Lewis 2000, pp. 82–3, cat. 21.
19 Trimpi 1987, pp. 103–4, no. A7.

SELECT BIBLIOGRAPHY

Trimpi 1987, pp. 10, 100–1, no. A5, pp. 103–4, no. A7, pp. 146–8, no. A35, pp. 174, no. A52; De Marchi 1987, pp. 130–51, esp. p. 149, n. 57 (cat. 17); H. Brigstocke in Weston-Lewis 2000, pp. 25, 82–3 (cat. 21); Alessi 2002, pp. 142–4 (cat. 18–19).

22.

ATTRIBUTED TO MATTEO DI GIOVANNI (about 1428–1495)
The Virgin of the Assumption with a Franciscan Saint, about 1480–5

Tempera and gold on panel, 35 × 24 cm (with original frame)
Private collection

This little painting is self-evidently modest. However, this simplicity, which is connected with its function, should not be confused with any lack of skill. It belongs to a category of painting in which fidelity to earlier models was much more important than notions of artistic originality or flair. The miniaturisation of large-scale frescoes and altarpieces is part of a larger story of the continued repetition of particular authoritative images, and the production of such small works is a feature of the history of Assumption imagery in Siena almost from the outset. The painting in Munich, now most often attributed to Lippo Memmi (fig. 42, p. 107), copied Simone Martini's lost Porta di Camollia fresco within a few years of its execution, and is regarded as crucial evidence of the appearance of Simone's work. Small *Assumptions* based on his model were made for individual devotion well into the fifteenth century; examples survive by the Master of the Osservanza, from around 1430,[1] and by Sano di Pietro, from the 1440s. However, the present painting is rather different from these other examples. They are mostly larger than this diminutive panel – Sano's, for example, is 71.7 × 53 cm (including the elaborate frame) – and would thus make a bigger impact. Moreover they usually seek to retain the abundant drama of the original, with Christ at the top waiting to receive the Virgin, doubting Thomas receiving the girdle below and the plethora of angels who so delighted Bernardino. Here the image is stripped of all these extraneous elements, turning the narrative into an icon, so that this little picture is less the story of the Assumption of the Virgin than a *Madonna Assunta*. Sano's work has six

saints kneeling below the Virgin,[2] as well as Thomas set back reaching for the girdle, and the choice of saints suggests that the original owner was a layman, with no special loyalty to a particular order or confraternity. In this work there is just a single kneeling Franciscan saint and, in the absence of any attribute, it is not immediately clear if this is Francis himself, Anthony of Padua or – most likely – a fleshed-out Bernardino.[3]

The picture therefore falls into a special class within the category of small works made for private worship. From the mid-fourteenth century onwards single panels and, more often, small diptychs or triptychs were made for the individual devotions of members of mendicant orders, pictures in which key Christian narratives were condensed. Tiny Dominican donors were included in paintings by Barna da Siena.[4] In the later Trecento, however, the Franciscans come to the fore, represented not as donors but, as here, by Franciscan saints who act as the holy representatives of the owner friars. Saint Francis appears in this role in a picture of the Crucifixion, recently on the art market – the ex-Kaulbach picture, now in the Louvre, by Francesco di Vannuccio (1361–1389).[5] The present picture shows that this category survived into the later Quattrocento.

As we might expect in a Franciscan work, the main sources for the present work, so similar in spirit, remain the lost fresco by Simone and Sassetta's now destroyed altarpiece made for the Osservanza in which, as here, the Virgin was seated foursquare and symmetrical. Now even her figure is more simplified, constructed almost like a geometrical exercise – two principal ovals

supported by two triangles. Unusually, though entirely appropriately since the events follow one from the other, the *Assumption* is combined with a reference to the Coronation of the Virgin as Queen of Heaven. Two angels hold the crown over her head, a motif often seen in altarpieces with the Virgin and Child enthroned, such as the central panel of Matteo di Giovanni's Placidi Altarpiece (see fig. 55). Thus, once again, the Coronation is indicated as simply as possible, a reminder rather than a representation of the event. The picture functions as a tool for advanced meditation, suitable for someone in holy orders who had less need for the visually impressive cues or narrative non-essentials required by a layman.[6] LS

1 Location unknown. See K. Christiansen in Christiansen, Kanter and Strehlke 1988, pp. 124–5 (where it is wrongly identified as the pinnacle panel of a larger altarpiece).
2 Saints Nicholas of Bari, Bartholomew, John the Baptist, Peter, Luke and Jerome. See Torriti in Siena 1990, pp. 185–6.
3 His features are close to Bernardino in Matteo di Giovanni's predella scene of *Saint restoring a Child to Life* (Suida-Manning Collection, University of Austin, Texas). See L.B. Kanter in Christiansen, Kanter and Strehlke 1988, cat. 50b, pp. 280–1.
4 Now in the Gemäldegalerie, Berlin, and *Christ bearing the Cross, with a Dominican Friar*, about 1350–60, Frick Collection, New York.
5 Berenson 1968, I, pp. 145, 384; Sarti 2002, pp. 74–9.
6 A parallel can therefore be drawn with Fra Angelico's frescoes at the convent of San Marco, Florence, in which the stories of Christ's Nativity and Passion are reduced to their essentials, Dominican saints standing in for the friars. See Hood 1993, p. 220–4.

SELECT BIBLIOGRAPHY
Friedländer 1917, I, p. 64, no. 30.

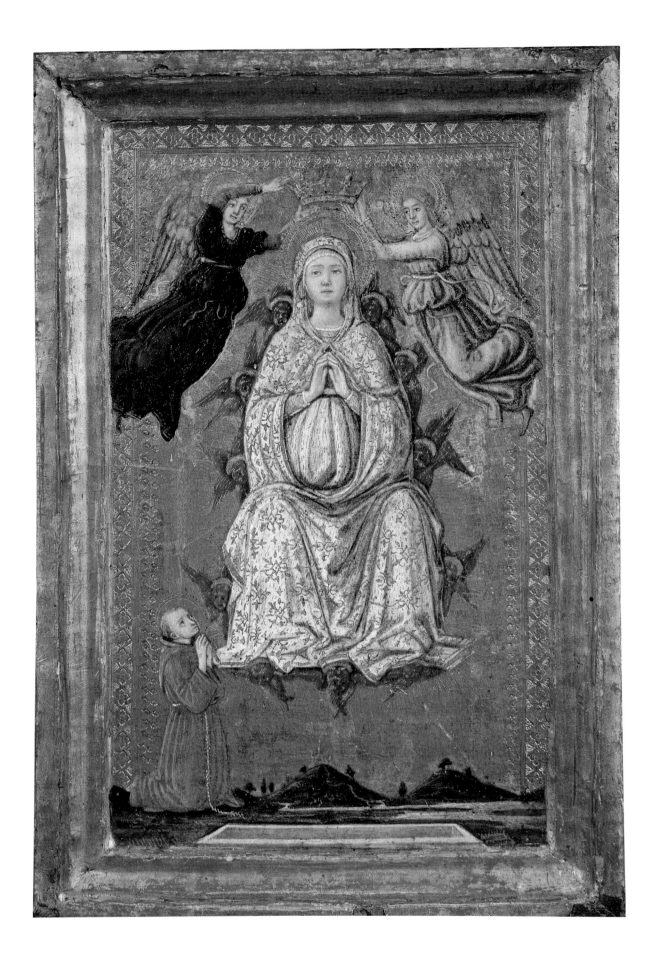

The Annunciation

23.

FRANCESCO DI GIORGIO MARTINI
(1439–1501)
The Annunciation, about 1471–2

Tempera on panel, 73.5 × 48 cm
(with original frame)
Pinacoteca Nazionale, Siena (277)

24.

NEROCCIO DI BARTOLOMEO
DE' LANDI (1447–1500)
The Annunciation, about 1478–80

Tempera on panel, 49 × 128.5 cm
Yale University Art Gallery, New Haven, NY.
University Purchase from James Jackson Jarves
(1871.63)

These two Annunciations blend the refinement and lyricism of the Trecento gold-ground tradition with a new, ostensibly naturalistic ingredient learned for the most part from the Florentines, architectural perspective, to startling, even disquieting effect. This combination of visual approaches has divided art historians, whose particular conceptions (or preconceptions) of the artistic characters – 'Gothic' or 'Renaissance' – of Francesco di Giorgio and Neroccio de' Landi have provoked considerable disagreement as to the authorship of the two works. This attributional battle brings to the fore a fundamental problem in interpreting Sienese painting from the 1460–80s. If the visionary transcendence of Sienese art and the earthbound realism of Florence are (and perhaps were) perceived as antithetical, we need to ask how modernising Sienese painters behaved when faced by Florentine innovation: did they try to put tradition behind them (in which case divergence

from Florentine norms might be seen as failure) or to find ways of welding these new elements to the old? Was Francesco di Giorgio, in particular, a committed pro-Florentine moderniser or something more complicated than that?

For painters in Quattrocento Siena making images of the Annunciation, one model continued to dominate – Simone Martini's 1333 altarpiece, then in the Cathedral (fig. 22, p. 45). Such was this painting's great beauty and its civic and religious importance that 'everywhere in Sienese painting we find the kneeling Gabriel with an olive branch and the Annunciate who withdraws in fear'.[1] Matteo di Giovanni and Giovanni di Pietro copied Simone's composition almost exactly, for example, in the centre panel of their San Pietro Ovile Altarpiece of about 1452 (and had probably been asked to do so). Benvenuto di Giovanni re-used it only slightly less faithfully in his gold-ground altarpiece for the church of San Girolamo in Volterra (1466). The debt to Simone and the Trecento tradition in the present two pictures from the 1470s is, even if less obvious at first sight, almost as strong.

Cat. 23 has generally been ascribed to Francesco di Giorgio. Made probably for individual devotion, it demonstrates its adherence to the style of its forebears by the 'hieratic scale'[2] of the Virgin, larger than Gabriel though apparently set further back in the picture, and by the gestures and attributes of the angel (the olive branch) and the Virgin (her little red book). Though their attitudes are different from Simone's, Gabriel and Mary are painted with his delicacy of touch and emotional tremor. The angel, 'curved into a graceful scimitar',[3] is truly ethereal – with costume and wings of

cerulean blue, hair like sunshine; and he is weightless, just landed on the stone pavement (marble and porphyry) but as if still poised, hovering, above it. The Annunciate's more nervous, angular pose conveys her astonishment, though without sacrificing her elegance. Her head is painted with particular delicacy and her swirls of blonde hair, exquisitely twisted with gossamer veils, are probably imitated from paintings of the late 1460s by Verrocchio and his pupils. Her heart-shaped face appears to derive from a painting by Sandro Botticelli – possibly his personification of *Fortitude* (1470, Uffizi, Florence),[4] suggesting Francesco's immediate reaction to artistic developments in Florence.

One essential aspect of the Trecento tradition is now abandoned: the protagonists are given an architectural, 'perspectival', setting, rather than a gold ground. Though far from unambitious, this perspective is not at all Florentine, and decidedly odd from an Albertian point of view (see pp. 31 and 140–1). The setting is positively vertiginous, with a bizarrely foreshortened lectern and the pale lilac columns of the 'fascinatingly flimsy portico'[5] sprout upwards to a narrow vault, Corinthian capitals balanced uneasily upon them. The perspectival orthogonals meet approximately at the far left side of picture at about the height of the Virgin's eyes, rather than at a single point at the centre, as might be expected in a Florentine painting of this date. It has been suggested that the painting was originally intended to be seen from a low viewpoint.[6] However, more than that, this painter is playing a profoundly complicated game with the concepts of space and viewpoint. The orthogonals are imagined as if laid across on the picture surface, rather

than pushing into it to establish depth – like the spokes of a wheel with the curve of the Virgin's body forming the circumference. Their splayed-out arrangement echoes the gold rays of light falling from higher up on the left. Therefore this is not an orthodox representation of a three-dimensional space and the combination of three dimensions with the insistence on two is extremely 'un-Florentine'.

Should this peculiar pictorial perspective be read as the result of inexperience with a new mode of representation? Fredericksen thought the *Annunciation* had 'problems' in this respect,[7] which Angelini and Bellosi have found a way to explain (see pp. 37–8). Bellosi noted ruefully that the *Annunciation* has always been considered a masterpiece of the Sienese mystical, lyrical and anti-scientific spirit, and later called it 'Neo-Trecentesque'.[8] For him these aspects make it difficult to attribute to the rational, 'Renaissance' Francesco di Giorgio. The perceived lack of success in describing the space becomes especially problematic because he accepts that this work must have been painted in the years around 1470,[9] several years after Francesco's hugely ambitious perspectival experiments in his *Saint Bernardino preaching* (cat. 8) and *Mythological Scene* (fig. 25, p. 51). Thus he champions the proposal made by Angelini that this *Annunciation* should be re-attributed to another artist, one without any great concern for perspectival construction; that Francesco di Giorgio, busy with architectural and engineering projects, delegated the execution of this and other painted works to an assistant.[10] Angelini viewed the picture as a crucial indication of this unknown helper's own particular 'taste fantastical and enchanted', very different

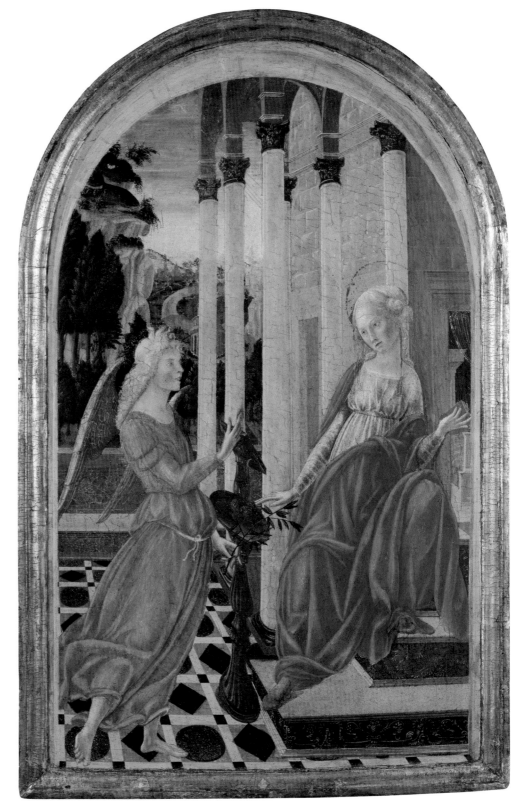

CAT. 23

135

from Francesco's 1475 *Nativity* (fig. 19, p. 39), in which the logical space is so much more consistent with his autograph works of the 1460s. For Angelini 'this collaborator, it is true, follows the style of Francesco di Giorgio very closely, but interprets the lessons of the master through a sensibility that in many ways recalls the approach of Neroccio de' Landi, and he suggests that the relationship with this assistant was formed at time of Francesco's partnership with Neroccio.[11]

Bellosi christened this shadowy figure the 'Fiduciario di Francesco' (Francesco's right-hand man), who, he now argued, collaborated with Francesco di Giorgio from as early as cat. 10, until the very end of the master's life. He claimed that Francesco di Giorgio's *bottega* was not a typical medieval or Quattrocento workshop, where the master followed all stages of every work, his degree of direct involvement depending on the importance of the commission. According to this theory, Francesco made initial designs on the panels, but distanced himself from the actual execution of his paintings, and this explains their essentially Sienese quality, absent from Francesco's fully autograph works (especially those in other media). The fact that the architecture resembles Francesco's later built works – in the use of a double string-course above the capitals, for example – would be no argument for his full participation. Bellosi claims the results of infra-red examination of the painting's underdrawing as supporting evidence. No underdrawing is seen, for example, in the lectern, explaining for Bellosi its 'anti-perspectival' appearance (but in point of fact its pigment hampers infra-red penetration). But it is thrillingly revealed beneath the Virgin's cloak, a

detailed but energetic brush-drawing seemingly typical for Francesco di Giorgio – a tangle of complex folds that are elaborately designed and densely modelled, like his sculptural reliefs. In the final painting, Bellosi states, this extraordinary design is impoverished by the blue paint layer, diminishing the richness of planes and folds. The loggia, too, he says, was originally drawn less 'simperingly' than it was painted, with a more convincing perspective.

This argument has, however, been stoutly resisted.[12] Certainly, as Strehlke states, Francesco used assistants, but 'the enormous role given to a single helper is hard to accept'.[13] Moreover, Strehlke was right to point out that, in this case, the rather poor state of the picture should be taken into account: 'For several late Quattrocento Sienese painters – Francesco di Giorgio and Neroccio de' Landi in particular – the state of their works is crucial. These artists build pictorial effects with subtle glazes and highlights so that even the slightest surface abrasion distorts appearance.'[14] Although the beauty of the conception remains, the surface of the *Annunciation* is indeed somewhat compromised. Not only is it abraded, losing much of what must have been very delicate detail, but the cracks in the paint have been eroded by insensitive cleaning in the past, exposing the gesso preparatory layer in places. The very precisely painted highlights in the trees and foliage survive quite well – a tantalising suggestion of how the whole surface must have looked originally, but the *all'antica* ornament of the bench behind the figures is now difficult to read and only traces of the mordant gilding remain on the Virgin's cuffs, in her veil, in the dotted haloes and rays of light. The

stronger red in the sleeves, where the gold has been rubbed off, hints at the original colour of her dress and shows that the picture is faded in some areas: some reds (containing vermilion) have remained intense, while others (lakes) are now much paler. This is one of the reasons for the colonnade's curiously top-heavy appearance.[15]

Angelini's explanation was also rejected as too simple by Arasse, in his sustained analysis of the meaning of the picture's perspective. Arasse found it impossible to believe in an inept '*fiduciario*', unable to follow his master's rigorous architectural plan, and he asked why indeed Francesco would have delegated this task to an assistant incapable of carrying it out. He pointed out that the essential arrangement of the scene, including most of the 'problems', was already in place at the underdrawing stage, although some changes were made to the capitals and some other details.[16] Brown saw no contradiction between a meticulously executed surface and the looseness of the preliminary drawing. He wrote: '…underdrawings are typically bolder and more spontaneous than finished paintings', an assertion that requires some qualification but is often correct.[17] It would certainly be odd if any *pentimenti*, especially in the architecture, were decisions on the part of the assistant; how much easier it would have been for him to follow the design precisely than to make his own alterations. It is very hard to imagine even Bellosi's remote and phlegmatic Francesco allowing his assistant making changes to his rational design without his say-so. These alterations, in fact, indicate that Francesco both designed and executed the painting, altering it as he went along to emphasise the immateriality of

Fig. 46
Lorenzo Monaco (about 1370–1424)
Annunciation and Saints Catherine, Anthony, Proculus and Francis (detail), 1410–15
Tempera on panel, 210 × 229 cm
Galleria dell'Accademia, Florence (8458)

the scene. The lectern is thus completely consistent with the rest. Francesco appears to have given himself the freedom to improvise, since the architecture is not first incised, as was his earlier practice.[18]

Arasse chose instead to revive an alternative interpretation of the architectural perspective, previously offered by Weller, Pope-Hennessy, Maltese and several others. Weller had drawn parallels with Simone's *Annunciation* (fig. 22, p. 45) in the picture's combination of 'mystic and fashionable elements', restated 'in the language of the later fifteenth century, so misunderstood by an older generation of critics, who found it merely exaggerated and eccentric because it did not conform to Florentine ideals ...'.[19] Francesco, he believed, was in no way naïve. 'The work is consistent in its own artistic purpose and shows a deliberate turning-away from so-called "scientific" spatial construction to an older Sienese tradition of expressionism and decoration for their own sakes.' Pope-Hennessy saw the 'perspective treated in a spirit of irrational fantasy';[20] Maltese understood it as an example of the way in which Francesco at the beginning of his career treated 'space as vision'.[21] Arasse therefore rejected the notion of 'maladresses perspectives' or 'gaucheries', preferring a 'marvellous perspective' of revelation, indifferent to mathematical legitimisation, with systematic distortions that were intended to lead the pious viewer to otherworldly contemplation.[22] Most recently, the picture has been called 'a picture-poem bordering on the unreal'.[23] Further features support this reading. The miraculous angel casts no shadow, indeed there no evidence that he ever had one – unlike the properly human Virgin, whose

shadow is seen under her right foot. The fictive arch has been much commented upon, Arasse calling it 'the way into another world of sight, to a spiritual vision'; this device allows us to distinguish between our world and the holy realm. Fascinatingly, the painter underlines this distinction by lighting the inside of the fictive 'window' from the right, while the scene it contains is lit by the rays falling from the left. Francesco di Giorgio has found a radical solution to representing a vision of the Annunciation, without Simone Martini's gold ground, but finding its modern equivalent.

The picture is said to have a provenance from the church of San Domenico but since Francesco's picture is unlikely to have been made for an ecclesiastical context, it may have been a pious donation to the church by one of the families with chapels there, the most important of whom were the Spannocchi in the high altar chapel. Francesco appears to have modelled his composition on, and sought to evoke the mood of Lorenzo Monaco's *Annunciation*, now in the Galleria dell'Academia, Florence (fig. 46). Since such citations were rarely meaningless in Siena, it is worth asking why Francesco di Giorgio chose this Florentine painting as his model, or was directed to it by the commissioner of this picture. Lorenzo painted his *Annunciation* as the central panel of his San Procolo Triptych. In 1575, this painting was to be found on an altar in San Procolo then owned by the Spannocchi family.[24] It has not yet been established how or if this family was related to the two branches of the family with that surname in Siena at the end of the fifteenth century. Though these still tenuous links require further investigation, it might at

this stage be possible to suggest that Francesco di Giorgio was asked to paint a kind of Lorenzo Monaco *redux* by a member of the Spannocchi family.

Arasse's argument that Francesco di Giorgio's fashioning of a dreamlike atmosphere for cat. 23 was entirely deliberate was supported by the supposition that, at much the same moment, he worked with Neroccio de' Landi on the *Annunciation* (cat. 24), the lunette of an unidentified altarpiece with perfectly realised linear perspective.[25] However, Francesco's direct participation in cat. 24 is also hotly debated. If he did provide Neroccio with a design for the architectural setting, or even paint it himself, as is often claimed, then it was no less to provide an otherworldly, rather than a realistic setting for the scene. In fact the architecture is just as fantastic as the cloud formation it frames, and much less logical than in cat. 23. It seems unlikely that he was

involved, and the work should probably be dated to some time after the partnership between the two painters, to the later 1470s.

The inspiration of Simone's *Annunciation* is still more evident here. From it comes the languid curve of the Virgin's body and the long clean lines of her cloak. Simone's vase of symbolic lilies is again positioned at the centre of the scene; the Virgin holds her red book; the arrangement of Gabriel's hands is also very close and, although he holds a banderole with his address to Mary (AVE GRATIA [PL]ENA, as reported by Saint Luke) inscribed upon it,[26] the feathery tree to the right of his head recalls the olive branch in Simone's altarpiece. However, Neroccio made one important change: the Annunciate is no longer frightened and unsettled. Now the angel's vital pose – his 'impetuousness' – contrasts with the quiet

and composed introspection of Mary.[27] This shift of mood, from active to passive, between the two figures is one of the factors that have caused many critics to see this as a collaborative work. Certainly the calmness of contour in the Virgin – her Trecento aspect – was undoubtedly always intended, but again the picture's condition distorts the effect. Her pictorial flatness, and therefore the internal contrast, is exaggerated by the darkening of what remains of the blue pigment in her cloak. Even if the treatment of the two figures – one so gracious and serene, the other so energetic – seems so different, the painting techniques used for both are identical.

Richard Offner's 1927 description of the Yale picture has never been bettered: 'In Neroccio's *Annunciation*, the Jarves Collection possesses one of the most harmonious

pictures by one of the most musical of masters. It is like a song overheard, like its soft echo. The Holy Ghost rides on the irradiating breath of God towards the Virgin, and she is so deeply overcome that all the forces seem gone from her body, leaving barely enough to sustain it. She submits so gracefully to the grace descended upon her, and with her senses still faint from the shock of the angel's announcement, she is so lovely that one could weep over her. The blonde and blue tonality, the delicate cool sky, give the picture the wonderful look of a world reflected in water. Certainly nothing can be expected to happen here to alter the complexion of things. They will remain as they are, wrapped in this timeless tranquillity, in which the frozen vehemence on the sculptured walls seems like a remote memory. Although Neroccio is here and in these very

reliefs borrowing, possibly at second hand, from Pollaiuolo and Signorelli, though he is fascinated by their concentrated and intensified movement, his temper commits him to the production of a total effect altogether different. He transforms everything to a gentler order, and the objects in his world are of a more precious material, more caressing and sparing of the senses than those of ours.'[28] LS

1 H.W. van Os 1990, pp. 99–106 for a summary of such images.
2 D.A. Brown in Boskovits and Brown 2003, p. 280.
3 Weller 1943, p. 280.
4 Weller (1943, p. 81) suggested that Francesco di Giorgio may have been responding to Botticeli's Mercanzia Fortitude, now in the Uffizi.
5 Weller 1943, p. 81.
6 Pope-Hennessey 1947, p. 31.
7 Fredericksen 1969, p. 16.
8 L. Bellosi, 'Il "vero" Francesco di Giorgio e l'arte a Siena nella seconda meta'del" Quattrocento' in Bellosi 1993, pp. 30–1; L. Bellosi in Fiore 2004, pp. 206, 208.

9 Schubring (1907B) at first thought it a late work, then (1915) more convincingly suggested 1475. Most other historians have given it a date in 1470, or just before or immediately after: Torriti 1980, about 1472; Arasse 1999, 1472–5; Fredericksen 1969, p. 16 and A. De Marchi in Bellosi 1993, late 1460s. Weller (1943, pp. 80–2) gave it the same date as the '1471' *Coronation of the Virgin* (now known to have been a couple of years later). Pope-Hennessy (1947), Angelini (in Bellosi 1993) and Palladino (1997) all dated it about 1470; Toledano (1987) 1470 at the latest.
10 Angelini 1988, p. 17.
11 For other works attributed to Fiduciario, see Syson (forthcoming).
12 Belief in this single assistant is reaffirmed in Chelazzi Dini, Angelini and Sani 1997 and its translation 1998, pp. 300–1, and in Alessandro Angelini's essay, p. 38. Apart from Strehlke (1993), the proposal is also rejected by Torriti (1993, p. 23); Palladino (1996, pp. 86–7); D.A. Brown in Boskovits and Brown (2003, pp. 278–82; and most recently Fahy 2006, pp. 537–40.
13 There appear to be three hands in *The Coronation of the Virgin* (fig. 5), Francesco di Giorgio himself for main figures (and two angels behind Christ), possibly Neroccio (certainly someone more delicate) for angels and figures to left of Virgin on raised platform, and another heavier hand, much disliked by Bellosi (1993),

for many of the saints below. This last hand is possibly responsible for the *Virgin and Child with an Angel* (Pinacoteca Nazionale, Siena), mechanically executed and probably a work produced speculatively by the workshop. This is confirmed by the comparatively simplified underdrawing, made probably following a cartoon.
14 The issue of the picture's condition is reiterated by Brown in Boskovits and Brown 2003, p. 280, and Höfler, 2003, p. 97.
15 The damage is revealed since the picture is now mostly un-retouched, except in the sky at the horizon, slightly obscuring the pale mountain range in the far distance – so like the *Mythological Scene* (see fig. 25, p. 51).
16 Arasse 1999, p. 215.
17 D.A. Brown in Boskovits and Brown 2003, p. 280. In addition, it has even been suggested that in Francesco's paintings the underdrawing may play some part in the finished appearance of the work, its brushiness incorporated in the underlayers and even the surface of the picture: see Panders, 'Some Examples of Fifteenth-Century Sienese Underdrawing' in Van den Brink and Helmus 1997, pp. 163–9, esp. p. 168.
18 See Dunkerton, Christensen and Syson 2006, pp. 66, n. 103. This is also the case with the 1475 *Nativity*, which, like the Annunciation, has double highlights running down the columns to establish their curve (admittedly the background of this altarpiece is also attributed to an assistant by Bellosi, though not by Angelini). This double highlight is, however, also seen in *The Chess-players* (cat. 55), here attributed to a painter close to Liberale.
19 Weller 1943, p. 81.
20 Pope-Henessey 1947, p. 8.
21 Maltese 1969, p. 441.
22 Arasse 1999, pp. 215–18.
23 Höfler 2003, p. 97. He adds that 'some participation by a collaborator seems really undeniable' (even if none of it is incompatible with the artist's own style).
24 D. Parenti and A. Lenza in Tartuferi and Parenti 2006, pp. 179–85, cat. 27, esp. p. 184.
25 Arasse 1977, p. 216.
26 Coor (1961, p. 43, note 119) notes that, in a contemporary *Rappresentazione dell'Annunziazione di Nostra Donna* by Feo Belcari, these proper Latin words are used, though the rest of play is in Italian.
27 Coor 1961, p. 42.
28 Offner 1927, pp. 40–1.

SELECT BIBLIOGRAPHY

Cat 23 A. Angelini in Bellosi 1993, pp. 296–7, cat. 54; Arasse 1999, pp. 215–8; Höfler 2003, pp. 97–102.
Cat. 24 Toledano 1987, pp. 90–1, no. 33; Seidel 1991, pp. 55–73, esp. 57–9; Sherwin Garland 2003, pp. 54–70, esp. pp. 66, 68.

SCULPTURE, DRAWING AND NARRATIVE

In discussing changing styles for religious painting in later Quattrocento Siena, it is essential to make proper distinction between the treatment of iconic images and the approach to narrative. The renovation in the 1470s and 1480s of the Sienese icon – in the main tiers of altarpieces and in private devotional panels depicting the Virgin and Child (with or without accompanying saints) – was, as we have seen in the preceding section, deliberately restrained and cautious, maintaining reverential links with the medieval past. These images retain the sense that the figures they depict inhabit a heavenly realm, emphasising their difference from the purely human viewer (and too much naturalism might heighten the danger that the paintings themselves should be idolatrously worshipped). In the same decades, however, there was a signally different approach to the representation of events that were believed really to have occurred, and the concern for naturalism in narrative scenes became more pressing. Narrative paintings were now given a temporal and human specificity by the use of naturalistic detail; though this was not new in Siena, where painters had long been concerned, for example, to record the effects of weather or time of day, now the construction of architectural spaces and the volumetric description of figures within them was ever more rigorous. This was especially the case with the predella panels placed below images of the Virgin and Child and saints, their histories explaining the status of the figures above, creating dialogues between the real and the visionary. The advent of this new naturalism coincided with the new cultural priorities of a part of the Sienese patrician élite, especially those

close to Pope Pius II, and perhaps also those who were members of the Sienese *reggimento* while it was dominated by the pro-Florentine *Riformatori*.

This change was brought about, ironically, by the continued pursuit of a traditional procedure – the imitation of existing works, and in this case especially of sculptural relief. But Sienese painters were now thinking of both this process and their sources in a new way. Up to this time, the languages for painting and sculpture developed in Siena had been largely distinct.[1] Even when the same artist produced works in both media, they obeyed different stylistic conventions for each. There are even subtle differences in the anatomical and physiognomic proportions of the figures in Vecchietta's painted design on canvas for the Hospital tabernacle and his final sculpted work. David Alan Brown has remarked in relation to Francesco di Giorgio: 'It is also important, when searching for unity in Francesco's work in different fields, to bear in mind that each medium … has its own tradition.'[2] Thus, although the use of sculptural relief as a source for painted narrative compositions goes back a long way, perhaps even as far as Duccio's exploitation of marble bas-reliefs by Nicola Pisano and Arnolfo di Cambio, there had hitherto been little attempt to reproduce the peculiar qualities of sculpture.

The heroic status of Donatello was recognised throughout mid-Quattrocento Italy, and his works were copied everywhere by painters as well as sculptors. But what painters made of his sculptural models varied in different places and at different times. The change of approach in Siena is best exemplified by responses to Donatello's

1425 gilt-bronze relief of *The Feast of Herod* (fig. 47) on the Baptistery font, of a pioneering naturalism, first by Giovanni di Paolo in 1454 and then by Liberale da Verona in the late 1460s. While Giovanni di Paolo adapted Donatello's composition for his predella scene of the same subject (fig. 48) his figures remain linear and even rather spindly, and his space is sublimely odd.[3] Giovanni di Paolo's dependence on Donatello's invention was almost entirely restricted to the iconographic and the compositional, and he treated the relief no differently from the paintings by Gentile da Fabriano and others that he cited elsewhere.

Quite another attitude was promoted by the Florentine Leon Battista Alberti when he advocated drawing after sculpture.[4] 'If it is a help to imitate the work of others, because they have the greater stability of appearance than living things, I prefer you to take as your model a mediocre sculpture rather than an excellent painting, for from painted objects we train our hand only to make a likeness, whereas from sculptures we learn to represent both likeness and the correct incidence of light.' It is not clear if he is talking about ancient or modern sculpture – and his vagueness suggests that he may have considered both as suitable models. He did not invent this idea; his words reflect current practice, not just in Florence, but also in North Italy. Certainly Donatello was the key source for those painters trained, like Andrea Mantegna, in the Squarcione 'studio' in Padua in the 1440s or those younger painters in the Veneto influenced by them. Painting was now supposed to contain the volumetric effects of sculpture, with light falling on bodies.

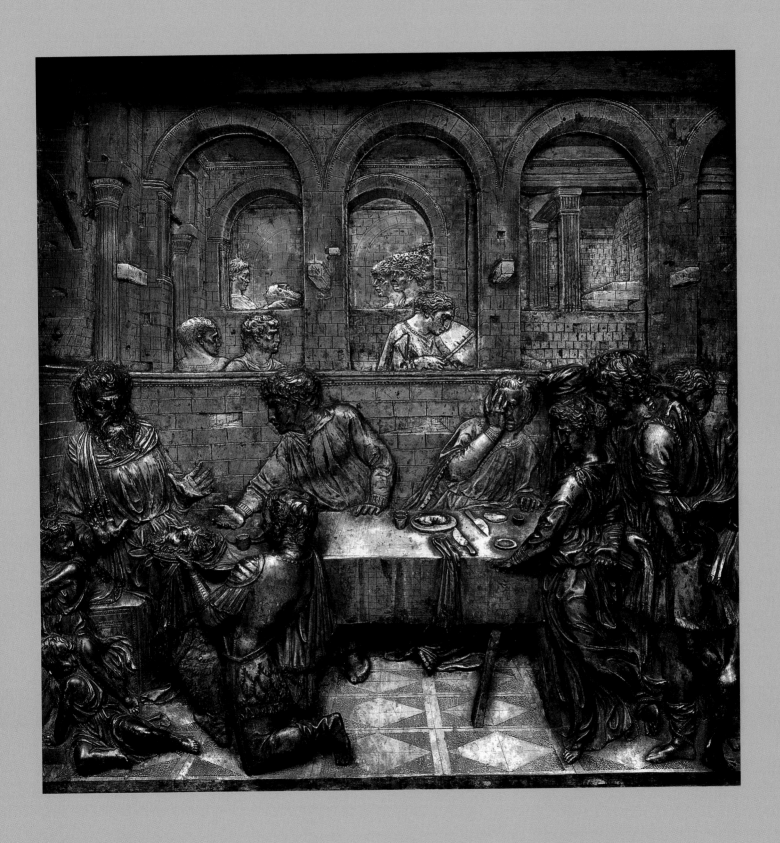

Alberti had a direct connection with Pius II, who called him an '*uomo dotto e curiosissimo ricercatore di antichità*' (a learned man and most studious researcher of antiquity).[5] A generally Albertian approach to art, promoted by Pius, may have been a contributory factor, but it is usually thought that the path for 'sculptural' narrative was explored in Siena above all by the painters and manuscript illuminators Liberale da Verona, who arrived there in 1466, and Girolamo da Cremona, journeying from Ferrara in 1469.[6] Liberale had been exposed in his native Verona to Mantegna's paintings and, more broadly, to the older painter's method. In Siena, Liberale cited sculpted relief in exactly the way recommended by Alberti, and introduced the narrative ploys he evolved for his manuscript illuminations – Liberale was a champion storyteller – into his predella panels. In his Berlin panel of *Saint Peter healing a Lame Beggar* (cat. 29) he not only refers to Donatello's *Herod* relief, he has also been looking at other sculptures outside Siena, not just by Donatello, but also by Lorenzo Ghiberti: the figure of the beggar surely derives in Ghiberti's Adam from the *Creation* scene on the Florentine Baptistery 'Gates of Paradise'. Liberale's narrative scenes include figures that are more anatomically and volumetrically compelling than their Sienese predecessors, with architectural settings that have perspectively convincing spatial recession. The gamut of extreme emotion explored by Donatello could also be appropriated, imbuing these pictures with greater expressionistic pathos. This became the tendency especially after Donatello's four-year stint in Siena at the end of the 1450s. Donatello's series of wax models of narratives intended for the Cathedral doors, of which his *Lamentation* is probably the only surviving example (cast into bronze, cat. 25), seem to have been especially important in this respect.

There can be no question that Liberale's move to Siena played a major part in the shift of approach that occurred subsequently. But the Veronese painter was a stripling when he migrated there and, whatever he contributed stylistically, he also formed his mature style in response to Sienese painters, and in particular to the stylistic experiments of Francesco di Giorgio. This local Sienese input to a change of style that is often seen as largely imported has been underestimated. Francesco was an artist who, like his master Vecchietta, worked as both painter and sculptor. It is noticeable, however, that his relief sculptures (cat. 26, 27) are indebted less to his teacher than to Donatello, both in their composition and in their treatment of bronze surfaces. Moreover, he was more audacious than Vecchietta in his attempts (where appropriate) to find a unified language for the two media – giving paintings the qualities of sculpture, but also making sculptures that have the luminous delicacy of painting. Revealingly, this journey starts with his predella panels, as early as the years immediately after 1460 with his *Saint Bernardino preaching* (cat. 8) – extraordinary for its organisation of space and the modelling of the figures – depicting events that some of his Sienese spectators might remember. This exchange of ideas between Liberale and Francesco was unusually fertile, with both artists at their innovative best, not least in their depiction of architecture. Since these were pictures intended to convince viewers of their historical truth, it is perhaps not surprising that these 'real' *all'antica* designs, closely studying antique sources, moved from painted and sculpted scenarios into constructed architecture. One of the several issues contributing to the uncertainty regarding the relative priority of these two artists' inventions is the fact that the architecture in Liberale's paintings is so close to later designs for buildings by Francesco di Giorgio.[7] Was Liberale utilising Francesco's ideas, or was he providing them?

Matteo di Giovanni also needs to be taken into account in this discussion. In mid career he looked hard at Liberale (and indeed at Francesco di Giorgio), but from the beginning of his working life he can be found quoting elements from Donatello's Baptistery sculptures.[8] He and Francesco di Giorgio were equally interested in the classicising sculptures of Antonio Federighi, and even much earlier works such as Nicola Pisano's sculpted marble relief of *The Massacre of the Innocents* on the Cathedral pulpit, a key source for Matteo's 1468 *Massacre* altarpiece painted for the Neapolitan church of Santa Caterina a Formiello.[9] This picture is also indebted to Donatello, for the contorted expressions of grief and anger on the faces of the protagonists, and it quotes Federighi in the *all'antica* pseudo-sculpture adorning the judgement hall. Indeed painters' consciousness of sculptural sources extended to the calculated representation of sculpture in their pictures.

As the aims of the two media became more convergent, and the means to their achievement became more widely perceived as the making of drawings after sculpture, drawing itself became more valued, and

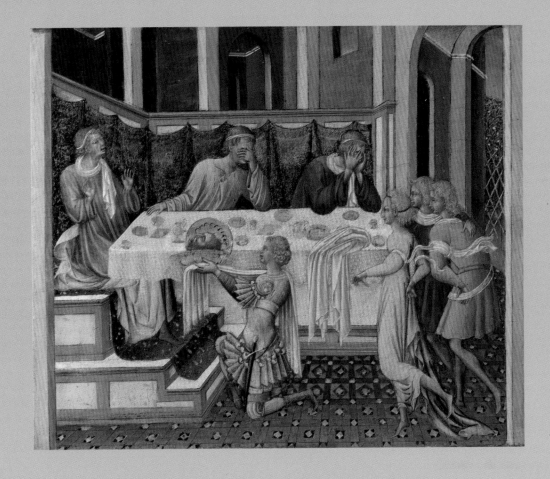

Fig. 48
Giovanni di Paolo (active by 1417–died 1482)
The Head of John the Baptist brought to Herod,
probably about 1454
Tempera on panel, 30.7 × 37 cm
The National Gallery, London
Bought with a contribution from
The Art Fund, 1944 (NG 5452)

the signs of inspired and inventive
disegno became an increasingly important
constituent in finished works, both painted
and sculptural. *Disegno*, it was believed,
underpinned both. Sadly, there is a dearth
of Sienese drawings from the Quattrocento.
No surviving works on paper by Matteo di
Giovanni, for example, have been identified,
even though the detailed underdrawings
discovered in his paintings show that *disegno*
was as much part of his repertoire as it was
of Francesco di Giorgio's. Their drawing
was not just a matter of recording, but one
also of creative energy – which, when the
greatest of draughtsmen were making
designs for religious images, was seen as
divinely inspired. This attitude is brilliantly
demonstrated in the only extant working
drawing by Francesco di Giorgio (cat. 28).
Although, in fact, it repeats well-tested
compositional formulae, the effect is one of
artistic originality rather than repetition.
The quick sketchiness of Francesco's
drawing style is reflected in the painting

techniques of Matteo di Giovanni and his
pupil, Pietro Orioli (for example, cat. 4–5).
They were all making a point of their
imaginative creativity by their technique. LS

1 For this division, see Zeri 1983, pp. 559–60.
2 D.A. Brown in Boskovits and Brown 2003, p. 280.
3 Gordon 2003, pp. 94, 97.
4 Alberti 1972 edn, pp. 100–1.
5 Piccolomini 1984 edn, p. 223; A. Angelini 'Templi di
 marmo e tavola quadre. Pio II e le arti nei *Commentarii*'
 in Angelini 2005, p. 21.
6 It has been argued somewhat inconclusively that
 Liberale was trained by a Hungarian painter working in
 Ferrara, Michele Pannonio. His first style is therefore
 characterised as 'mannered' in a somewhat Ferrarese mode,
 before he moved onto a second style characterised by
 more structured and 'Renaissance' forms. For the possible
 connection with Pannonio and for Liberale's early career,
 see Zeri 1951; Longhi 1955; Volpe 1961; L. Bellosi in
 Bellosi 1993, pp. 59–61.
7 I am grateful to Caroline Elam for this observation.
8 G. Fattorini 'Dalla "historia d'attone pel Battisimo" a
 "le porti di bronzo del Duomo": Donatello e gli inizi
 della scultura senese del Rinascimento' in Angelini
 2005, pp. 45–81, esp. p. 53.
9 C. Alessi, 'Le Stragi degli Innocenti di Matteo di
 Giovanni; quattro Frammenti ricomposti' in Alessi
 and Bagnoli 2006, pp. 99–107.

25.

DONATELLO (about 1386–1466)

The Lamentation over the Dead Christ, about 1457–9

Cast bronze relief, 32.6 × 40 cm
Victoria and Albert Museum, London (8552-1863)

Donatello's working period in Siena in the late 1450s (in the 1420s he had contributed his now celebrated sculptures for the Siena Baptistery font) has been rightly seen as a moment that marked a new direction for Sienese art.[1] By then the most famous Italian artist of his time, Donatello arrived in Siena from Florence in autumn 1457, only recently returned to Tuscany after many years in Padua. On 16 September 1457, the Balìa accepted his offer to make for Siena 'some very remarkable work'. The special commission set up to decide what Donatello's work should be was chaired by the *Operaio* of the Cathedral, Cristoforo Felici, who was instrumental in bringing Donatello to Siena (see p. 52).

At first all went well. There was money available and considerable official will to see Donatello happily at work. He immediately contributed a Virgin and Child relief to the chapel of Santa Maria delle Grazie in the Cathedral, a project already underway (see fig. 26, p. 52). But a letter of 14 April 1458 to Felici from the leading Sienese citizen Leonardo Benvoglienti, a key supporter of the new regime, makes it clear what his main project in Siena was to be – bronze doors for the Cathedral, a project surely intended to rival Lorenzo Ghiberti's doors already adorning the Florentine Baptistery. On 10 December 1457, Donatello received twenty pounds of wax 'to make the narrative of the door'. Further deliveries of wax were made over the next three months, and on 20 March 1458, Donatello obtained wire and iron for armatures, suggesting that the construction of the model had reached quite an advanced stage. He could still be found working on the doors in the following year, and his labours continued presumably right up until his departure for Florence in late 1461. Why he left and what went wrong is not known.

A key work for gauging for the impact of Donatello's sculpture upon Sienese art is this *Lamentation* in the Victoria and Albert Museum, which has been widely acclaimed as one of the great passionate masterpieces of Donatello's later career. Christ's dead body is the still centre of the composition, polished and beautiful, unmarked by the wounds suffered during the crucifixion, but heavy in death, his head collapsed forward, his arms hanging limp. The Virgin's veil pours like tears over the corpse cradled in her lap. Around them, Christ's mourners are frozen in their intense grief. The Marys are like Maenads, their churning emotions expressed by the wild swirl of their draperies. But Donatello, remarkably, conveys the helplessness of their grief by arresting their movement, so that they appear to perform actions they cannot complete. The Magdalen, in particular, reaches forward in a pose that has become fumbling and uncertain. Their grief seems to flow from the Virgin herself and their open mouths repeat her rictus wail. The whole sculpture utters a soundless scream.

That this relief was modelled during Donatello's stay in Siena is now scarcely doubted. It has several similarities to Donatello's last sculptures in Florence, made just before and after his time in Siena – his celebrated *Judith and Holofernes*, his reliefs for the pulpits at San Lorenzo and his Saint John the Baptist, started probably with a Florentine site in mind and eventually set up in Siena Cathedral. However, although the date of the work is now agreed, there is less accord as to whether it can be connected with this unrealised project for the bronze doors of Siena Cathedral. It is certainly possible, even likely, although the problem is unlikely ever to be fully resolved. LS

1 Studies of Donatello in Siena include Carli 1967; Herzner 1971; A. Bagnoli 'Donatello a Siena' in Bellosi 1993, pp. 162–9; G. Gentilini in Bellosi 1993, pp. 170–1, cat. 19–22; Caglioti 2000, pp. 23–56; G. Fattorini 'Dalla "historia d'attone pel Battisimo" a "le porti di bronzo del Duomo": Donatello e gli inizi della scultura senese del Rinascimento' in Angelini 2005, pp. 45–81.

SELECT BIBLIOGRAPHY

A. Radcliffe in Darr 1987, pp. 138–9, cat. 32; G. Gentilini in Bellosi 1993, pp. 182–5, cat. 21; G. Fattorini 'Dalla "historia d'attone pel Battisimo" a "le porti di bronzo del Duomo": Donatello e gli inizi della scultura senese del Rinascimento' in Angelini 2005, pp. 45–8.

26.

FRANCESCO DI GIORGIO MARTINI (1439–1501)
Saint Jerome in Penitence, about 1472–3

Cast bronze, 55 × 37.3 cm
National Gallery of Art, Washington, DC
Samuel H. Kress Collection (1957.14.12)

We can only guess what works by Donatello in wax or bronze may have been available to Francesco di Giorgio for study. It is possible that Francesco saw wax models connected with Donatello's project for the doors of the Cathedral, which might have included a scene of the *Lamentation* (see cat. 25). It also appears that in around 1470 he closely studied art in Florence, paying particular attention to Donatello's last works, the pulpits in the church of San Lorenzo. His *Saint Jerome in Penitence*, one of the earliest surviving examples of Francesco di Giorgio's bronze reliefs, can be read as a sculptural response to the pulpits. As long ago as 1878 Piot stated that the relief looked so Donatellesque it might as well have been detached from one of them.[1] Piot may have been thinking of the scene of the Resurrection on the North pulpit. Though Saint Jerome is normally shown kneeling in the wilderness, Francesco has given him an unusually heroic standing pose, with one foot raised, that might well be taken from (or at least inspired by) Donatello's risen Christ.

Francesco di Giorgio's depiction of 'the rugged anchorite'[2] seeks visually to evoke Jerome's own description of his life in the desert after he had fled Rome, condemned for his classical studies (see cat. 33): 'How often, when I was living in the desert, in the vast solitude which gives to hermits a savage dwelling-place, parched by the burning sun, how often did I fancy myself among the pleasures of Rome! I used to sit alone because I was filled with bitterness ... I had no companions but scorpions and wild beasts ... the fires of lust kept bubbling up before me when my flesh was good as dead. Helpless, I cast myself at the feet of Jesus ...

I remember how often I cried aloud all night till the break of day and ceased not from beating my breast till tranquillity returned at the chiding of the Lord.'[3] Francesco's Jerome may be standing rather than prone, but this single change only emphasises his spiritual isolation within the 'savage dwelling place' and the terrible grandeur of his struggle. Almost every other aspect agrees with Jerome's account very precisely: Francesco even captures the passing of time, for high in the sky are both moon and burning sun. Here it is both night and day, with the associated presence of different animals: Jerome prays through the night and, as well as the scorpions and other wild beasts of the desert, below the moon there is an owl, perched on a little corbel projecting from the classical ruin. Deer drink from the stream, as they do at dusk and daybreak. While the tree in the foreground is bare, others, further away, are in full leaf; this is also both winter and summer. Francesco has rendered his image timeless and eternal. His only departures from the texts are the typically minuscule lion and cardinal's hat, Jerome's two standard identifying attributes, and the distant view of a monastery, reachable only after an arduous climb up a high mountain.

The power of Jerome's words is fully matched by the emotional, Donatellesque force of Francesco's image, and by the techniques of modelling, casting and chasing he has marshalled to achieve this impact. The phantasmagorical ambition of the relief in turn inspired one of the great passages of art-historical tribute. In 1923 Adolfo Venturi was the first to attribute the work to Francesco di Giorgio: '...the bronze assumes the appearance of a work in crystal,

and the tiny knots on the arms of the wooden cross acquire the transparency of pearls That splendid, desolate landscape ... The artist's powers ... are evident ... in the modelling of the saint's shoulder, in his heaving, stertorian chest, in the bony skeleton of the face ... as in his quivering thigh ... The knotted limbs of this groaning figure, the complications of its drapery, the wiry hair and beard, sparkle and scintillate ... Everything is a source of light, like the torn drapery of the figure, the points of the rocks, the animals of the desert ... the birds that cross the winter sky, vivifying its dead expanse with the flash of their feathers, the ribbons of cloud in the dull air, the splinters of rock broken from those polar mountains. This great artist suggests the vibration of objects in the light as if they were a rich vision of jewels – not seeking the fugitive shadowy mysteries of Leonardo's dusks but a spry, fleeting effect, the glittering facets of a gem.'[4]

Or again, 'Against the wintry sky a ruined temple raises a sharp and slender outline, the bold forms of its broken arches, frieze and cornice hinting at the courtly and exquisite architecture practised by Francesco. The bleak climate of cold and snow presses on the keen figure of the saint and on the vegetation, which nevertheless against the ruin, the rocks and the empty sky spreads out branches as elegant as volutes, as minutely etched in their scintillating and precise ramification as anything by Leonardo. This fantastical poetic landscape inhabited by swans, ducks, deer, serpents and lizards ... is background to the image of the saint, constructed with unparalleled anatomical precision, making visible the profile of the bones beneath the emaciated

flesh – marvellously painterly in the infinite variety of their relief, from the etched wedges of the shoulder and of the impassioned face to the intricate courses of the drapery and the impressionist, crumbling articulation of the arm and right hand.'[5]

Bellosi has acutely analysed Francesco's method, not just the modelling of the piece, but also the treatment of the bronze surface after it was cast.[6] He points to the deliberate contrasts of its surface, some parts left more or less as they came out of the mould, others chased to achieve a high level of finish. The landscape, for example, is more defined on the right, full of 'horrid rocks', while the rest has a dusty distance, obtained by leaving the surface largely untouched. Francesco di Giorgio thus ensures that the eye moves forward and back through the scene. He similarly juxtaposes the polished muscles of the semi-nude saint – this is truly an athlete of the Lord – with the mess of rough draperies that hangs around his haunches. For the artist it was crucial to convey that this was a made piece, that he, like Jerome, had chosen an arduous road. He therefore stresses the notion that this is a scene with three dimensions, but also a modelled relief pushing forward from a flat ground, by making the two dragon-like cranes that fly across the sky into two little lumps sitting on the surface, in the background but also the foreground. The bare branches of the tree have a similar ambiguity, in the first plane, but also trailing across the flat ground of the bronze like veins.

This difficult image was certainly designed to appeal to one of the many members of penitent confraternities in Siena (see cat. 33). Another of the rare representations – a Florentine example – of a standing Saint Jerome can be associated by the costume he wears with the Hieronymites – a little gold-ground picture now in Princeton which might have been known to Francesco di Giorgio.[7] But this work is known to have been made for, or at least later owned by, a layman. So it is possible that Francesco's relief was also made to assist the sustained meditations of a private individual in Siena, displayed perhaps in his study.[8] This point was made by Friedmann.[9] For him the relief is 'unusually enlivened with animals', eleven of nine kinds, though the dark patina covering the surface makes them rather difficult to see: 'This leaves us with the thought that the relief was probably designed to be looked at very closely, that on close inspection its contents would emerge and reward the viewer for his effort.' In fact the patina may not be original, but the internal complications of the relief itself show that his point is sensible. The need for sustained looking might lend credence to Friedmann's theory that each of the animals is included as a symbol relating to Jerome's spiritual battle, or better, that each would act as a prompt for further meditation, amplifying the meaning and possibilities of the subject. That they are modelled with a 'curious disregard'[10] for any naturalistic relative scale enhances the sense that this is both a real and a spiritual landscape, an anomaly which might invite the viewer to read them emblematically. The lizard, snake, scorpion and tortoise are all to be found in the Princeton *Penitent Saint Jerome*. They may be simply the beasts of the wilderness, 'all essentially evil in their implications'. But the tortoise, to the right of Jerome's left foot, was considered by the saint himself to be an image of heresy – 'a heretical creature of the gravest errors, one that preferred to live in scum and filth like that of a pigsty'.[11] The lizard, on the other hand, is argued by Friedmann to be a salvation-seeking creature. The legend of the sun-seeking lizard states that when the beast becomes old its eyesight is impaired, and it seeks out a place in the rocks or on a wall facing east, stretching its head towards the morning sun, whose bright rays give new strength to its sight. The story was moralised: 'In like manner, O man, thou who hast on the old garment, and the eyes of whose heart are obscured, seek the wall of help, and watch there until the sun of righteousness, which the Prophet calls the dayspring, rises with healing power, and removes thy spiritual blindness'.[12] Thus the lizard can stand for Jerome himself, the tortoise for everything he was fighting against. LS

1 Piot 1878, p. 88.
2 Migeon 1908, pp. 16–32
3 To Eustochium, Letter XXII; translation from Wace and Schaff 1893, VI, p. 24ff; Meiss 1974, pp. 134–40, esp. p. 134.
4 Venturi 1923, pp. 213–14.
5 Venturi 1924, pp. 168–9.
6 Bellosi 1993, p. 20.
7 This has been variously attributed; to Masolino, Toscani, to the Master of the Griggs Crucifixion and (influentially, by Longhi) to Fra Angelico. See Strehlke 2003.
8 The great scholar Saint Jerome was a popular subject for the study interior throughout Italy. See Thornton 1997.
9 Friedmann 1980, p. 164.
10 Friedmann 1980, p. 172.
11 Friedmann 1980, pp. 168, 268, 300. This interpretation is based on a story in the much read *Physiologus*. In Leviticus the tortoise is one of the unclean beasts.
12 Friedmann 1980, pp. 140–1. See Payson Evans 2003 edn, p. 94.

SELECT BIBLIOGRAPHY

Toledano 1987, pp. 134–5, cat. 53; F. Fumi Cambi Gado in Bellosi 1993 pp. 202–3, cat. 28.

27.

FRANCESCO DI GIORGIO MARTINI (1439–1501)
The Flagellation of Christ, about 1474–5

Cast bronze, 56.3 × 40.4 cm
Galleria Nazionale dell'Umbria, Perugia (746)

Two steps lead up to a platform – a stage – on which Christ, already condemned by Pilate to die on the cross, is scourged. The main action takes place before, rather than within, Pilate's monumental praetorium or judgement hall, which becomes a kind of backdrop. The composition is arranged to suggest that this is a performance, a mystery play, with Christ and his judge placed in the middle ground. Looming much larger in the foreground are more figures sitting on the ground, the Virgin Mary and two hulking male nudes, witnesses, like us, to the events unfolding.

Before Schubring, in 1907, clarified the authorship of this relief (and sometimes thereafter), it was almost always ascribed to Florentine sculptors. These assessments, erroneous though they were, reveal Francesco di Giorgio's debt to Donatello and to his older Florentine contemporary Lorenzo Ghiberti. Like Donatello, in his extraordinary pulpit reliefs in the Florentine church of San Lorenzo, Francesco di Giorgio challenges himself by including a great mêlée of figures. Certainly Francesco's sculpture is more ordered than Donatello's, calming the sometimes terrifying cacophony, the carefully calculated dissonances, of the San Lorenzo reliefs. But it is from Donatello that he has derived the vitality and the pathos of the figures.[1]

Perhaps more important even than the formal relationships between the reliefs is the way Donatello's bronze sculptures inspired a new treatment of the surface. The bronze of the *Flagellation* has a granular quality, similar to that seen in Donatello's *Martyrdom of Saint Lawrence* on the north San Lorenzo pulpit.[2] Though darkly patinated, the bronze surface is very little chased, and almost entirely unpolished. This lack of finish creates very particular effects. Light defines just the edges of the elements making up the buildings (columns, windows, pilasters), modelled in exceptionally low relief, rendered both solid and ethereal. Even more than in the earlier relief of *Saint Jerome* (cat. 26), this surface gives a softness to the figures, their flesh and draperies; the light flickers over them, catching on the grain of the bronze; Francesco here begins to explore the possibilities of a kind of non-finito. This approach was seen as a defining characteristic of Francesco di Giorgio's autograph reliefs by Adolfo Venturi: 'The relief, in the gamut between low and high, takes on different effects: it breaks out with violent energy in the modelling of the magnificent torsos of the men seated in the foreground, or of the shining nude figure of Christ as he struggles athletically against his bonds … Francesco di Giorgio renders rough, irregular and tumultuous the curved back and the brutish face of the foreground figure, anticipating Impressionist effects.'[3]

If the figurative and surface energy of the *Flagellation* depend upon the example of Donatello, the order that Francesco has brought to what might otherwise be emotional chaos – through the more balanced disposition of the protagonists and, in particular, their scale against the rigorously organised architectural background – owes more to Lorenzo Ghiberti. In Ghiberti's *Flagellation* for the first set of bronze doors for the Florence Baptistery (1417–24), the praetorium is, as here, represented as a colonnade. For the much greater ambition of the cityscape, Francesco di Giorgio looked to Ghiberti's second set of

doors, to the Joseph and Solomon scenes from the *Gates of Paradise*,[4] models that encouraged him to pursue his growing interest in ancient architecture. Later, Francesco was to adapt the design of the praetorium's back wall for the exterior and interior of the nave of Santa Maria delle Grazie al Calcinaio in Cortona.[5] The idea of including a circular building partly seen behind another edifice possibly comes from the paintings of Liberale da Verona (see cat. 29–30). But Francesco has here re-envisaged the motif so that the building becomes a persuasively Roman amphi-theatre (or, as Francesco di Giorgio initially understood it, a theatre).[6]

It is likely that well before his documented journeys south, Francesco di Giorgio had travelled in Italy to view sculptural antiq-uities and ruins. The stylistic shifts in his work in the early 1470s suggest that, as well as visiting Florence at this time, he might have journeyed as far as Rome. Behind Christ, the heads of the bystanders are lined up as in a Trajanic relief, and he may have seen other antiquities. The hunched pose of the Virgin in the foreground may be taken from a coin of the Emperor Tiberius, with a reverse image of Germania Capta.[7] The way in which he combines his sources is highly imaginative, and the work contains many moments of great invention. The screaming open mouth of the flagellator, for example, is apparently a new idea. Francesco has carefully engineered contrasts between the male nudes, Christ, his tormentor and the three men in the foreground – two on the ground, one standing elegantly aloof. His command of anatomy is harnessed to the expressive needs of the work and the male body is used to articulate alternately pain,

aggression, resignation and graceful disregard.

Christ's trial for blasphemy became a focus of Christian attention in the second half of the fifteenth century, but from even before then Sienese pictorial tradition provided Francesco di Giorgio with icono-graphic models for his relief. Pilate wears his laurel wreath in Duccio's *Maestà* narra-tives, and this became the standard way of identifying him as Roman. More ingredients can be found in two key works by Sienese painters.[8] The first of these is the frescoed *Flagellation* of about 1325 by Pietro Lorenzetti, part of the Passion cycle in the Lower Church of San Francesco, Assisi.[9] Closer to home, chronologically and topographically, was the fresco by Francesco di Giorgio's own master, Vecchietta (with assistants), painted in the 1450s in Siena Baptistery. Vecchietta's painting especially exemplifies the Sienese tradition of showing the priests and elders debating with Pilate, who was otherwise reluctant to punish Christ. Clough suggested that the turbaned figure with his back to the viewer in Piero della Francesca's famous *Flagellation* at Urbino is the high priest Caiaphas,[10] an idea that works even better for the similarly turbaned figure in Francesco's relief, sitting at Pilate's feet, also turned away from the spectator.

The armed soldier attending Pilate is again a feature of Lorenzetti's and Vecchietta's frescoes. Francesco's contribution is to strip him, increase his languor and turn him into a piece of classical statuary. In Lorenzetti's painting the soldier, more alert, is standing on a lower level, behind Pilate, just as he is in the relief. The scooped profile of the soldier in Francesco di Giorgio's relief is facially rather like Lorenzetti's.

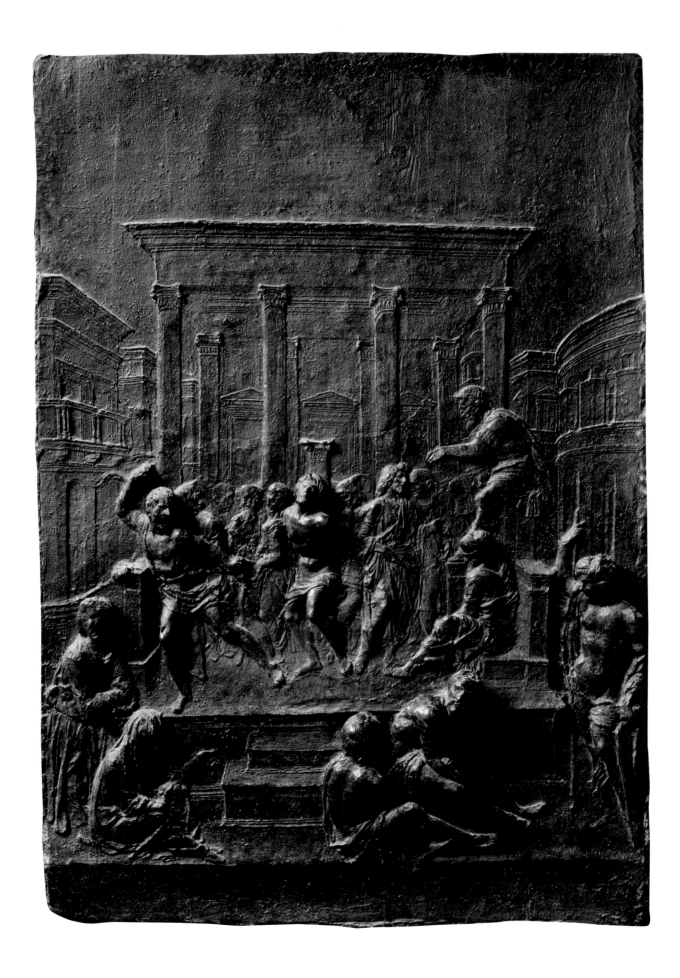

In Francesco's relief, the figure of a young bearded man is prominently placed, standing calmly before Pilate. Seemingly no-one has sought to establish his identity, or indeed the literary sources that might explain the aspects of the narrative that are not covered by the Evangelists (Matthew 27: 26; Mark 15: 15). The man's hand gesture repeats that of the Virgin; he is not therefore one of villains of the piece. An explanation for his presence can be found in the apocryphal *Gospel of Nicodemus* or *Acts of Pilate* (the titles used in medieval manuscripts). This text was widely read in the Middle Ages, when it was translated from Latin into Italian.[11] Its familiarity is demonstrated by its almost casual mention in the hugely popular *Meditations on the Life of Christ*.[12] This contains a much elaborated version of events in the praetorium than is told in the New Testament. According to the *Gospel of Nicodemus* (5: 1), 'Now Nicodemus, a Jew, stood before the governor, and said "I beseech you, pious one, to allow me a few words". Pilate said, "Speak". Nicodemus said, "I said to the elders and the priests and the Levites and to all the multitude in the synagogue, 'What do you intend to do with this man? This man does many signs and wonders, which no other has done or will do. Release him and wish no evil against him....' And now let this man go, for he does not deserve death".' His appeal fails, of course, but the dignity of the figure in the relief does justice to his sentiments. The story of the trial concludes with this passage (9: 5): 'Then Pilate commanded the curtain to be drawn before the judgment seat on which he sat, and said to Jesus, "Your nation has convicted you of being a king. Therefore I have decreed that you should

first be scourged according to the law of the pious emperors, and then hanged on the cross where you were seized".' At the same time, he specifies that Christ will be crucified with two thieves, mentioning them by name. These are surely the two men seated below the platform, one turned to Christ, the other turned away.

The inclusion of the Virgin and her youthful companion, apparently Saint John the Evangelist, is somewhat unusual. Their presence may have been justified by the description of these events in the *Meditations on the Life of Christ*, written probably by a Franciscan friar living in Tuscany in the second half of thirteenth century. In the *Meditations* (LXXVI), we read of events following Christ's arrest: 'When His mother, John and her companions – for these had gone outside the walls at dawn in order to come to Him – met Him at the crossroads and saw Him thus vituperatively and outrageously led by such a multitude, they were filled with more sorrow than can be expressed ... He is led, then, to Pilate; and those women who cannot draw near follow at a distance.'[13] In the relief, the Virgin therefore sits properly apart.

The text also contains an amplified description of the *Flagellation*: 'The Lord is therefore stripped and bound to a column and scourged in various ways. He stands naked before them all, in youthful grace and shamefulness, beautiful in form above the sons of men, and sustains the harsh and grievous scourges on His innocent, pure, and lovely flesh.'[14] This passage explains the particular beauty of his body in Francesco di Giorgio's relief; his torso the only part to have been chased and polished. LS

1 Though less complicated, the mass of overlapping protagonists recalls Donatello's relief of *Christ before Pilate* (at which the Virgin is present) and *Christ before Caiaphas* (on the north San Lorenzo pulpit). The figures seated in the foreground look not unlike those in the *Agony in the Garden* and *Entombment* (on the south pulpit). The spear-holder set to one side has something in common with the framing figures in the *Crucifixion* (also south pulpit).

2 A. Bagnoli, 'Donatello a Siena' in Bellosi 1993, pp. 163, 165. I am grateful to Irene Gunston for her advice in this area.

3 Venturi 1923, pp. 213–14.

4 Weller 1943, pp. 162–3.

5 Brinton 1934–5, p. 44.

6 See MS Laurenziana Ashburnham 361, fol.13r (Biblioteca Medicea Laurenziana, Florence).

7 See Janson 1968, p. 87, pl. IX, fig. 30 (actually Jacopo Bellini's drawing of the coin reverse).

8 For these pictures see Aronberg Lavin 1972; Clough 1980, pp. 574–7, both seeking sources for Piero and attempting to elucidate the meaning of his mysterious painting.

9 Volpe 1989 edn, no. 6, pp. 75, 77.

10 Clough 1980, p. 77.

11 A.A. Ianucci, 'The Gospel of Nicodemus in Medieval Italian Literature: a Preliminary Assessment' in Izydorczyk 1997, pp. 165–205.

12 Ragusa and Green 1961, p. 373.

13 Ragusa and Green 1961, pp. 327–8.

14 Ragusa and Green 1961, p. 328.

SELECT BIBLIOGRAPHY

F. Fumi Cambi Gado in Bellosi 1993, pp. 360–1, cat. 72; V. Garibaldi in Bon Valsassina and Garibaldi 1994, pp. 226–7, no. 50.

28.

FRANCESCO DI GIORGIO MARTINI (1439–1501)

Compositional sketches for *The Nativity of Christ* and *The Birth of the Virgin*, about 1488–90

Pen and brown ink on paper, 23.1 × 32.8 cm
Hamburger Kunsthalle, Kupferstichkabinett, Hamburg (21320)

Inscribed: *alto br. 7 ½* and *largo br. 9*

This is a drawing of swift, shimmering penmanship. The figures vibrate, made to quiver by sketchy outlining and pen hatching that reverberates through and, in the case of the kneeling Virgin, around them.[1] The work seems almost entirely improvised, drawn out of the artist's head – the lines of the architecture are not ruled and there are no traces of any underdrawing or other planning – demonstrating the draughtsman's astonishing confidence in his powers of composition. Oddly, the scenes are arranged in reverse chronological order: reading left to right, *The Birth of the Virgin* follows *The Nativity of Christ*. They are joined into a single panorama by their architectural settings: the view of a circular building in the Nativity is cut off by the

portico-like structure of Saint Anne's bedchamber, giving the two scenes a combined depth – a device Francesco had used elsewhere (see cat. 27, 44). The way that this Coliseum-shaped edifice abuts the architecture of the Birth might imply that this narrative was drawn first.

The double sheet is the only certain surviving example of a preparatory drawing made by Francesco di Giorgio as part of the design process for a work in another medium. As Weller first pointed out, this is the closest of Francesco's drawings to his bronze reliefs – in its 'vivacity of surface treatment' and in the character of classical buildings in the background of the Nativity.[2] Bellosi agreed that the rapid hatching suggests an atmospheric vibration

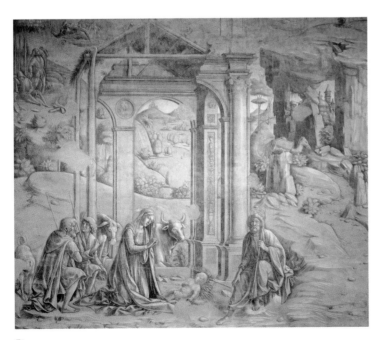

Fig. 49
Francesco di Giorgio Martini (1439–1501)
The Nativity of Christ, 1488–91
Fresco, Bichi chapel, Chiesa di Sant'Agostino, Siena

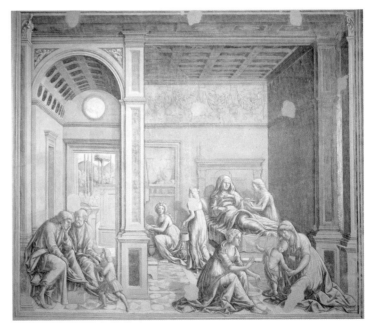

Fig. 50
Francesco di Giorgio Martini (1439–1501)
The Birth of the Virgin, 1488–91
Fresco, Bichi chapel, Chiesa di Sant'Agostino, Siena

comparable to the scintillating effects contained in the reliefs.[3] And Weller was right that the architectural forms are closely linked with the motifs seen in Francesco's *Flagellation of Christ* (cat. 27) and especially his *Scene of Conflict* (cat. 44). However, it should be stressed that the architecture and atmospheric vibrations in this drawing also show how Francesco's sculptural reliefs can be connected to his paintings, especially those from the 1470s. Not only do these links reveal the degree to which drawing – *disegno* – underpins his works in both media, it is also highly revealing of a set of artistic aims that were applied to both. The figures have a lightness and transparency that are fundamental to their energy. By looking at this compositional sketch, even though it was certainly made later, we can better appreciate the deliberate insubstantiality of a painting like *The Annunciation* (cat. 23), and of the figures, dissolving in light, in his sculptural reliefs .

The drawing is clearly linked with the recently discovered *grisaille* frescoes with the same subjects painted in 1488–91 by Francesco di Giorgio and collaborators in the Bichi Chapel at Sant'Agostino in Siena (see fig. 19–20 and cat. 58–9). Indeed, the inscriptions on the drawing, *alto br. 7 ½* (7 ½ *braccia* high; written vertically) and *largo br. 9* (9 *braccia* wide; written horizontally), correspond closely to the measurements of the frescoes. In designing these compositions, however, Francesco

was seemingly unaware of the space they were to occupy: in the fresco the two scenes are taller than they are wide. It may be that in a drawing made at great speed before Francesco knew much about the commission, and possibly with Antonio Bichi, his patron, standing at his shoulder, Francesco reverted to his most familiar mode. The composition of both scenes are, at this stage, tried and tested. They depend on a long series of paintings – especially of The Birth of the Virgin – beginning with works by the Lorenzetti brothers. Only afterwards, with the commission secured, did he make the substantial alterations that were to change his artistic direction thereafter. Certainly the final result diverged very considerably from his initial ideas. However, he continued to keep the relationship with sculpture in mind. By eliminating almost all colour from the walls of the Bichi Chapel, he turned the frescoes into enormous fictive stone reliefs.[4] LS

1 This technique was employed at much this time by Pietro Orioli in his paintings. See cat. 15.
2 Weller 1943, p. 182.
3 Bellosi 1993, pp. 27, 29.
4 It should be noted that *grisaille* frescoes, though far from common, were not unknown in Siena and its territories. See, for example, the mid-Quattrocento fresco cycle at the monastery of the Holy Saviour Lecceto, principle house of the hermit friars of Saint Augustine.

SELECT BIBLIOGRAPHY

M. Seidel 'The Frescoes by Francesco di Giorgio in Sant'Agostino in Siena' in Seidel 2003, pp. 559–644, esp. pp. 592, 594, 611–5; D. Klemm in Schaar 1997, pp. 90–1, cat. 21.

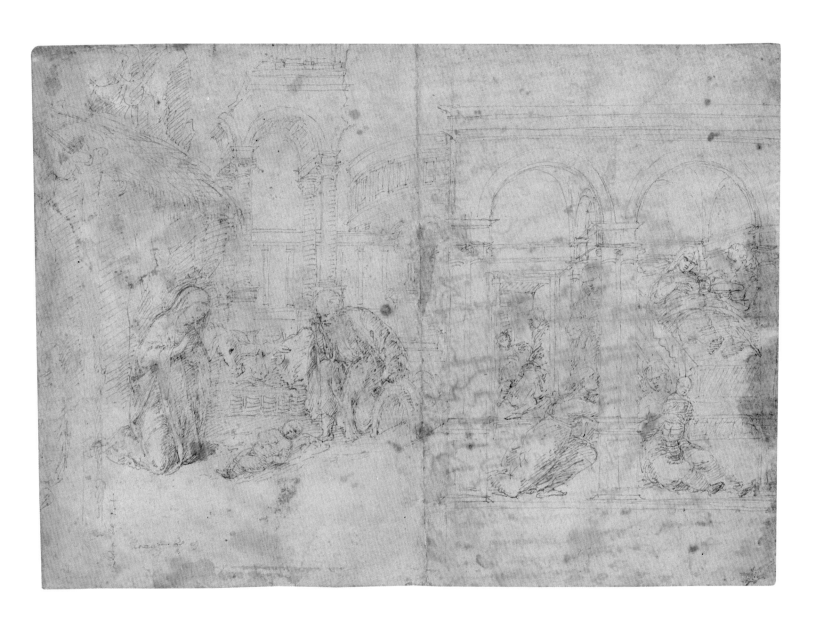

29.
Saint Peter healing a Lame Beggar, 1467–70

Tempera on panel, 31.2 × 56.4 cm
Gemäldegalerie, Staatliche Museen, Berlin (1655)

30.
Saint Peter refusing Ananias and Sapphira's Money, 1467–70

Tempera on panel, 32.1 × 56.2 cm
Fitzwilliam Museum, Cambridge (PD.21-1961)

Liberale da Verona was brought to Siena in around 1467 by the Olivetan order and he stayed there for almost ten years, when he mainly illuminated manuscripts for the Olivetans and choir books for the Cathedral of Siena.[1] But he also painted altarpieces; two can be dated to this period, *The Resurrected Christ with Saints* in the Duomo of Viterbo (dated 1472) and the *Virgin and Child with Saints Benedict and Francesca Romana* in the church of Santa Francesca Romana in Rome (from around 1475).[2] During these years he became a true master of pictorial narrative, making imaginative use of sculpted models, above all relief sculpture by Donatello. This was an approach he had learned from fellow painters in the Veneto and Emilia, and its import to Siena had a profound effect on painting in the city.

The two parts of a predella now in Berlin and Cambridge can be ascribed to this period and were probably part of a third, lost altarpiece executed by Liberale during his Sienese sojourn. Two Apostles, Peter and John, play a key role in both of these panels, and it seems likely that the two saints were prominent in the main tier of the altarpiece. Both paintings depict events from the *Acts of the Apostles*. The Berlin panel has the moment (Acts 3: 1–10), when 'Peter and John went up together into the temple at the hour of prayer, being the ninth hour. And a certain man lame from his mother's womb was carried, whom they laid daily at the gate of the temple which is called Beautiful, to ask alms of them that entered into the temple'. As the Apostles approached, 'he gave heed unto them, expecting to receive something of them. Then Peter said, Silver and gold have I none; but such as I have give I thee: In the name of Jesus Christ of

Nazareth rise up and walk. And he took him by the right hand, and lifted him up: and immediately his feet and ankle bones received strength. And he leaping up stood, and walked, and entered with them into the temple, walking, and leaping, and praising God'. As rightly proposed by Andrea De Marchi,[3] the Cambridge scene must represent another event from the Acts (5: 1–5): as people, moved by charity, were offering money to Peter and John, 'a certain man named Ananias, with Sapphira his wife, sold a possession, and kept back part of the price, his wife also being privy to it, and brought a certain part, and laid it at the Apostles' feet. But Peter said, "Ananias, why hath Satan filled thine heart to lie to the Holy Ghost, and to keep back part of the price of the land? ... Why hast thou conceived this thing in thine heart? Thou hast not lied unto men, but unto God." And Ananias hearing these words fell down, and gave up the ghost: and great fear came on all them that heard these things.' Liberale represents the moment in which Peter refuses Ananias's money and reproaches him; the presence of Sapphira on the staircase implies her knowledge of Ananias's action.

The impact of Sienese artists like Francesco di Giorgio upon Liberale's art is undeniable, but Donatello must also have been inspirational for the artist with the 'powerful dents of his draperies'.[4] Liberale's use of Donatello's *Hope* (fig. 51) from the Baptistery font as a model for his Saint John in cat. 29 is particularly striking. The figure of a youth leaning forward with his hand on his hip on the far right is a direct steal from Donatello's font relief of *The Feast of Herod* (fig. 47). Liberale's panels also powerfully demonstrate an interest in an

Fig. 51
Donatello
(about 1386–1466)
Hope, 1427
detail of the font,
Gilded cast bronze,
height 50 cm
Baptistery of
San Giovanni,
Siena (6486)

all'antica language for the architectural settings of narrative paintings. While the artist was obviously quick to appropriate Sienese stylistical traits, in these early works he also brought a specifically antiquarian Veronese culture to Tuscany.[5] XS

1 'Having been brought in by the [director] general of the monks at Monte Oliveto at Siena, for that order he illuminated many books, which turned out so well that they were the occasion that in the end he illuminated several books that had not been finished, that is, only the script had been done, in the Piccolomini Library', Vasari 1966–87 edn, IV, p. 567. For the manuscripts, see Del Bravo 1967; Eberhardt 1983; Carli 1991; A. De Marchi, 'I pittori padari e Siena' in Bellosi 1993. pp. 228–41, 248–61, cat. 37, 40–2.
2 Del Bravo 1967, pp. CVI–CIX, CXII–CXIII.
3 A. De Marchi in Bellosi 1993, p. 244, cat. 39.
4 *Ibid*. The influence of Neroccio and Vecchietta on the panels was noted by Del Bravo 1960, p. 21 and Weller 1943, p. 295.
5 For a recent discussion of Verona and antiquarian culture in the 1460s and 1470s, see Marinelli and Marini 2006.

SELECT BIBLIOGRAPHY

Eberhardt 1983, pp. 78–80, 202–3; Zeri 1987, p. 332; A. De Marchi in Bellosi 1993, pp. 244–7, cat. 39.

CAT. 29

CAT. 30

31.

FRANCESCO DI GIORGIO MARTINI (1439–1501)
Adam and Eve, about 1472–3

Pen and ink on parchment, 33.3 × 26.3 cm
Christ Church, Oxford (JBS 1976)

This remarkably detailed and highly finished drawing conflates the Old Testament story of the Temptation and Fall of Man (Genesis 3). Eve holds the forbidden fruit – here seemingly an apple or pear, though it might be a fig if it has been plucked from the tree around which the human-headed serpent is entwined. Adam, however, already has his hoe, the symbol of his labours after the Expulsion from Paradise (where there had been no need to till the soil). Moreover, the two figures, though mirroring one another to some degree in their stances, are conceived separately; Eve even stands a little forward of her husband. They are linked only by the viewer's knowledge of the text and by the landscape built up around them. The narrative elements appear to have been added after the figures were fully drawn: Eve's grip on her fruit, with forefinger elegantly extended, is unconvincing. Adam's brawniness is belied by his typically light-footed *hanchement* pose. He is beautifully balanced in terms of his silhouette, but remains curiously unweighted, partly because his anatomy is a little uncertain. His head is large for his body; his raised right arm is on the small side, lifted as if shading his eyes against the glory of God. The body is set against dark foliage so as to emphasise its contour. The same method is employed for Eve, whose lines are much softer, her body having the polished sculptural surface of an ancient Venus. Thus this work seems to have been first envisaged as an exercise in drawing the nude, then worked up into a narrative that justified the nudity and that might appeal to a collector.

The sheet is now retouched and reinforced in some parts; areas of wash may not all be original. Nevertheless, a great variety of virtuoso pen technique is still evident. There is tight and regular hatching in the gateway through which the pair will be (or have been) expelled. This shading contrasts the highly decorative swirls of Eve's long hair with the different densities of looser hatching in the foliage. The leaves on the tree between the figures are drawn with tiny flicks of the pen. The shadowing is almost stippled. The page is full of the kind of detail that anticipates German prints of the early sixteenth century, and may even indicate knowledge of earlier examples. There is much to delight the eye of a connoisseur.

The choice of subject for this early effort is revealing of Francesco di Giorgio's sources and his artistic ambitions, in particular his use of sculptural models. The gateway is taken from Jacopo della Quercia's marble relief of the *Expulsion* from the Fonte Gaia (for which see cat. 73). Other elements are inspired by Jacopo's reliefs and, in particular, by the scenes from the story of Adam and Eve on Antonio Federighi's Pozzetto del Sabato Santo.[1] It appears that these had come to be seen in Siena as subjects that served to demonstrate a sculptor's talents in the depiction of the human form. The facial type of Adam, his broad cheekbones and his mop of hair come from Federighi's scenes of God admonishing the pair and their Expulsion. Adam's upward gaze and even the shape of the Tree of Knowledge, with little stumps where branches are pruned off, also recall Federighi. Adam's anatomy may be based on the nude male captives bound to the base of one of Federighi's two holy water stoops in the Cathedral (by the first right pier, fig. 14). Eve's body is not unlike the female slave on the same work. However, her pose suggests that, even at this early stage of his career, Francesco had studied antiquities.

The modelling and 'irregular anatomy' of Adam have been called Pollaiuolesque, and this observation raises the question of the relationship of Francesco di Giorgio's sheet with a pair of equally finished drawings by the Florentine Antonio del Pollaiuolo.[2] Pollaiuolo's Eve is very different – already accompanied by her children and her distaff. But his Adam, though the pose is more relaxed, has the same upward gaze and hoe. Alison Wright places the drawings by Pollaiuolo in the late 1470s or early 1480s, though she admits their dating is difficult.[3] If they are earlier than she supposes, then Francesco's drawing, stylistically slightly earlier than cat. 41–1, becomes a quite early example of the impact of Florentine art. If her dating is correct, we might deduce that there was a more balanced mutual dialogue between the two artists than is often supposed. At any rate, Francesco, perhaps taking his cue from Polliaiuolo, already a celebrated *maestro di disegno*, was here pioneering an art form new in Siena, the presentation drawing, raising his own status as he did so. He was now less a craftsman, more what we would now term an artist. And, by taking his cue from carved reliefs, he showed the way to other painters who used sculptural sources to arrive at more dramatic narrative solutions. LS

1 A. Angelini, 'Antonio Federighi e il mito di Ercole' in Angelini 2005, pp. 123–5.
2 A. De Marchi in Bellosi 1993, p. 306.
3 Wright 2005, p. 188.

SELECT BIBLIOGRAPHY
Weller 1943, pp. 255–6; A. De Marchi in Bellosi 1993, p. 306.

BENVENUTO DI GIOVANNI (1436–about 1509)
The Expulsion of Adam and Eve from Earthly Paradise, about 1476–8

Tempera on panel, 25.7 × 34.6 cm
Museum of Fine Arts, Boston, MA
Charles Potter Kling Fund (56.512)

The small size and oblong horizontal format of this profoundly unsettling picture suggest that it was once part of a longer predella, though none of its accompanying narrative scenes has yet been traced. It shows the moment (Genesis 3: 24) when Adam and Eve were expelled from the Garden of Eden, represented by the stable, serried ranks of trees behind them. The angel stands foursquare at the centre of the composition forcibly pushing the couple into the harsh, swirling landscape outside, and into the space of the spectator. The contorted poses of Adam and Eve, all large feet and hands, elbows and twisted ankles, shout their distress; their legs are arranged as an irregular series of triangles around the strong vertical of the Angel's right leg, their arms laced into a raw-boned chain. Eve, helplessly shrugging, has the large belly that, here with special point, reflects the Quattrocento child-bearing feminine ideal. Adam's importunate vulnerability is conveyed through his open pose, his genitals protected only by a flimsy length of drapery. The heroic nudity of the angel is contrasted with the nakedness of human folly.

The picture is associated stylistically with three other small-scale works by Benvenuto, also fragments from larger, now unidentified altarpiece complexes: *Saint John Gualberto kneeling before a Crucifix* (Raleigh, North Carolina); the Berenson *Pietà* (Villa I Tatti, Florence); and *Saint Jerome with the Lion*, the saint depicted as if standing in a niche (fig. 52).[1] These pictures share a sharp lighting and tensile, incisive line, a razor dynamism that is combined with physically powerful gesture to transmit extreme emotion. In their line and colour they are usually considered to be indebted

to the several North Italian painters who had trained in the studio of Squarcione, especially Mantegna, a style acquired by Benvenuto through Liberale da Verona (see cat. 29–30) and through prints; there is no record of Benvenuto making any journey north. Benvenuto's anatomies suggest that he also learned from the Florentine Antonio Pollaiuolo's *Battle of Nude Men* engraving of about 1468–70.[2] However, what was important above all for Benvenuto was to see how all these artists had benefited from the sculptural innovations of Donatello, working

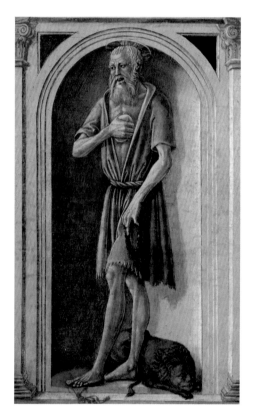

Fig. 52
Benvenuto di Giovanni (1436–about 1509)
Saint Jerome with the Lion, about 1476–8
Tempera on panel, 31 × 19.7 cm
The Wallace Collection, London (P543)

in Padua and Florence. In these four works, apparently executed at the same moment in Benvenuto's career, the impact of Donatello's sculpture is particularly apparent.

It has long been recognised that Adam and Eve's nervous, sinewy vigour is also a characteristic of Benvenuto's Borghesi Altarpiece in the Sienese church of San Domenico, with *The Virgin and Child with Saints Fabian, James, John the Evangelist and Sebastian* on the main panel and a *Pietà* lunette above (see fig. 53). This is dateable shortly before 1478, and the group including the *Expulsion* should also be dated towards the end of the 1470s, for the *Saint Jerome* (fig. 52) and the *Expulsion* share a motif with the panels from the Borghesi Altarpiece seen nowhere else in Benvenuto's œuvre – angled reflective haloes. Although other suggestions have been made in the past, their shape, date and dimensions make it also probable that cat. 32 and fig. 52 were parts of the Borghesi predella, the latter at the base of the right framing pilaster. It is possible that the *Expulsion* was considered a Dominican subject. The only other predella found with this subject, by Giovanni di Paolo (Metropolitan Museum of Art, New York), was also painted for San Domenico. The ambition of the predella may have been to make a competitive response to the Placidi Altarpiece (cat. 33–7).

In the original, complete altarpiece Adam would have looked up to the Christ Child holding a goldfinch (Adam's pose suggesting that Benvenuto may have seen Francesco di Giorgio's drawing, cat. 31), symbolising his sacrifice for mankind, and beyond him to the naked dead Christ, face turned to both Adam and the spectator. The connections between the predella, the central panel and

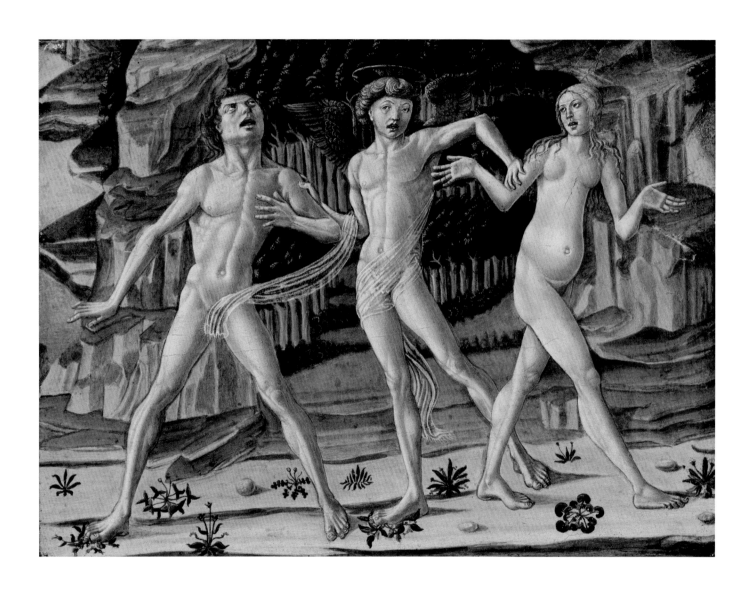

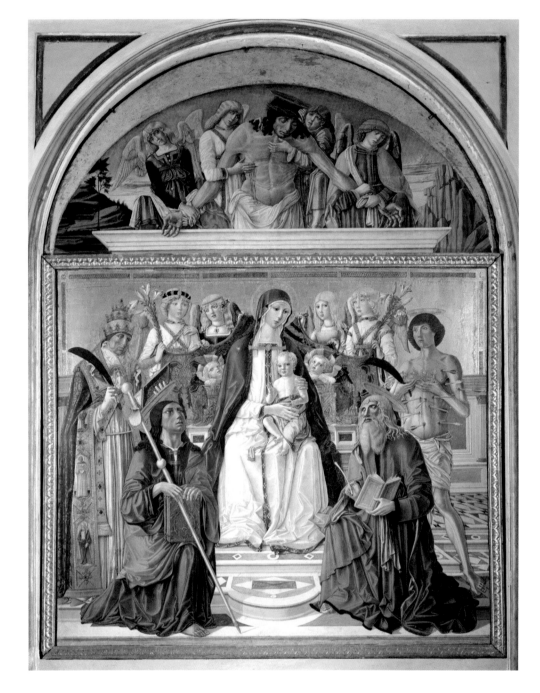

Fig. 53
Benvenuto di Giovanni (1436–about 1509)
*Borghesi Altarpiece: The Virgin and Child with
Saints Fabian, James, John the Evangelist and Sebastian,
with a lunette of the Pieta,* about 1476–8
Tempera on panel, 161 × 189 cm and 75 × 195 cm
Church of San Domenico, Siena

the lunette reinforced the message of the altarpiece, inviting worshippers to contemplate the mysteries of the Fall and the Redemption, with the Virgin Mary as the second Eve, 'whose cooperation with the divine will by consenting to Christ's Incarnation in her womb inaugurated the work of redeeming man from the Fall which Eve had brought about', and Christ as the second Adam.[3] Two well-known passages from Patristic commentaries would have been evoked as the picture was being viewed. Saint Augustine wrote, as 'Eve is born from the side of the sleeping spouse, the Church is born of the Dead Christ by the sacrament of the blood that flowed from his side'. Saint Jerome in his commentary on verse 3 of Psalm 88 explained: 'We have seen what was of the first Adam, let us now come to the second [i.e. Christ] and see how the Church has been built from his side. The Lord's side was pierced by the lance, and from it issued water and blood. Would you like to know how the Church has been built from water and blood? First by the water of baptism, which washed away sins, and then by the blood of martyrdom, with which martyrs are crowned.' LS

1 See Bandera 1999, pp. 114–15.
2 Bologna 1954, p. 19, note 3.
3 Lightbown 2004, pp. 21, 99, 113.

SELECT BIBLIOGRAPHY

Kanter 1994, I, pp. 201–3, no. 61; Bandera 1999,
pp. 114–15, 117, 142, 229–30, no. 43; Rossi 1999, p. 138.

The Placidi Altarpiece Predella, 1476

MATTEO DI GIOVANNI
(about 1428–1495)

33.
The Dream of Saint Jerome

Tempera and gold on panel, 37.4 × 65.7 cm
(painted surface 35.8 × 64.4 cm)
The Art Institute of Chicago, IL
Mr and Mrs Martin A. Ryerson
Collection (1933.1018)

34.
Saint Augustine

Tempera on panel, 36.5 × 17.3 cm
Lindenau-Museum, Altenburg (82)

35.
The Crucifixion

Tempera and gold on panel, 37 × 70 cm
Private collection

36.
Saint Vincent Ferrer

Tempera on panel, 36.5 × 17 cm
Lindenau-Museum, Altenburg (83)

37.
Saint Augustine's Vision of Saints Jerome and John the Baptist

Tempera and gold on panel, 37.6 × 66.1 cm
(painted surface 36 × 64.4 cm)
The Art Institute of Chicago, IL
Mr and Mrs Martin A. Ryerson
Collection (1933.1019)

These five panels, making up the predella of one of Matteo di Giovanni's most innovative altarpieces, are reunited in this exhibition for the first time in more than 180 years.[1] Seen together, the way in which their unusually intricate and rich iconography is supported by their inventive style becomes very evident – the five paintings making a point of their relationship with sculptured models. Removed, in about 1800, from the main panel, which is still in the church of San Domenico in Siena, the panels were originally part of the altarpiece commissioned for their private chapel by members of the Placidi family, rich *Noveschi*. On 15 June 1471, the rights to the chapel dedicated to Saint Jerome, third to the left of the high altar in San Domenico, were conceded to the six sons of Angelo and of Aldello Placidi. One of Aldello Placidi's sons was christened Girolamo, suggesting an existing devotion to the saint within the clan.[2] A codicil to the will of Gabriella, the wife of Giovanni di Angelo Placidi, of November 1472 requests her burial in the new chapel of Saint Jerome. This decision represents a change of mind; she had earlier made bequests to Observant foundations – to the penitent Confraternity of Saints Francis, Jerome and Bernardino and to the reformed Dominicans at Santo Spirito. The altarpiece itself (see fig. 54–5) was commissioned after the death of Giovanni di Angelo in 1473. Giovanni's will of 24 October 1473 shows that Saint Jerome was of particular significance to him. He recommended his soul to God and the Virgin and also to Jerome and all the saints. He too wanted to be buried in the chapel where his mother was already interred. He instructed his heir, his younger brother Placido, to go or send someone to Rome

to visit the body of Saint Jerome, whose relics were at Santa Maria Maggiore, and to make an oblation on his behalf. He died the day after.

We can assume that the altarpiece's complex iconography was minutely worked out between patrons, painter and the Dominican friars, to suit all their needs. The main tier shows the Virgin and Child, as if they have been miraculously envisaged by the two penitent saints on either side. She is depicted on the central panel as the supreme intercessor for mankind, crowned Queen of Heaven and surrounded by angels bearing flaming cornucopiae and braziers, symbols of her *caritas divina*.[3] The repentant Saints Jerome and John the Baptist are shown on either side kneeling in the wilderness; their emaciated muscularity affirms their intense, transported spirituality. Saint Jerome, the dedicatee of the chapel, is given the position of honour on the Virgin's right. His gaze is directed through the crucifix he holds towards the Virgin, underlining the notion that his vision of the Virgin's charity is granted by his imitation of Christ's sufferings. John gestures towards the Christ Child. The humanist Laudivio Zacchia (about 1435 – after 1478) in his *Life of Saint Jerome* places Jerome in the same desert where the Baptist had lived as an anchorite,[4] and the landscape behind them in Matteo's appears intended to extend continuously behind their vision of the Virgin. Its severity contrasts with the sumptuousness of the textiles in the centre.

At the centre (literal and metaphorical) of the predella, Christ on the Cross is painted with the same corporeal realism as in Jerome's crucifix, deliberately isolated from the other figures in the scene and, by virtue of his scale, floating forward of

Fig. 54
Matteo di Giovanni (about 1428–1495)
Adoration of the Shepherds, about 1476
Tempera on panel, 79.8 × 202 cm
Pinacoteca Nazionale, Siena (414 b)

Fig. 55
Matteo di Giovanni (about 1428–1495)
Placidi Altarpiece: *Virgin and Child with Angels* (centre);
Saint Jerome (left); *Saint John the Baptist* (right); 1476
Tempera on panel, 201.9 × 90 cm; 200.8 × 83 cm;
201.1 × 83 cm
Church of San Domenico, Siena

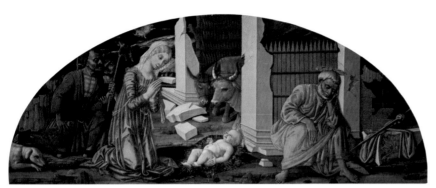

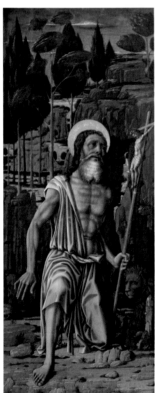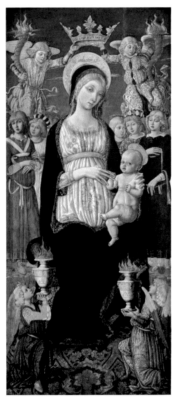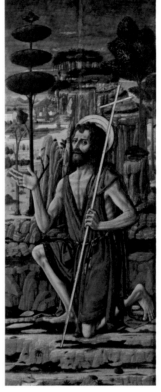

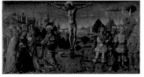

CAT. 33 CAT. 34 CAT. 35 CAT. 36 CAT. 37

them. The scene is thus at once iconic and descriptive. Saint John the Evangelist turns towards the group of women on the left in which the fainting Virgin is supported by the Marys, 'beholding far off' (Matthew 27: 55). One raises her hands in awe, while another, dressed in yellow, and Saint Mary Magdalene, dressed according to tradition in red with her hair flowing loose, place their hands on the Virgin's belly – across her womb. On the right of the cross, pointing up to it, stands the centurion, wearing *all'antica* armour and a Phrygian cap, amazed by the events which followed Christ's death: 'And, behold, the veil of the temple was rent in twain from the top to the bottom; and the earth did quake, and the rocks rent; and the graves were opened; and the many bodies of the saints which slept arose, and came out of their graves after his resurrection, and went into the holy city, and appeared unto many. Now when the centurion, and they that were with him, watching Jesus, saw the earthquake, and those things that were done, they feared greatly, saying, "Truly this was the Son of God".' (Matthew 27: 51–4).

To the left of this scene Matteo painted *The Dream of Saint Jerome*. The narrative comes from Jerome's letter to Eustochium (Letter xxii), in which he describes his penitence in the wilderness (see cat. 26) as the direct result of a dream that he had in his youth, probably in the year 374.[5] While in poor health, Jerome had dreamt that he was brought before a celestial judge and his court, who castigated him for having preferred ancient authors to the stylistically less refined writings of the Bible. 'Many years ago, when for the kingdom of heaven's sake I had cut myself off from home, parents,

sister, relations, and – harder still – from the dainty food to which I had become accustomed; and when I was on my way to Jerusalem to wage my warfare, I still could not bring myself to forego the library which I had formed for myself in Rome with great care and toil. And so, miserable man that I was, I would fast only that I might afterwards read Cicero. After many nights spent in vigil, after floods of tears called from my inmost heart, after the recollection of past sins, I would once more take up Plautus. And when at times I returned to my right mind, and began to read the Prophets, their style seemed rude and repellent. I failed to see the light with my blinded eyes; but I attributed the fault not to them, but to the sun. While the old serpent [Satan] was thus making me his plaything, about the middle of Lent, a deep-seated fever fell upon my weakened body, and, while it destroyed my rest completely – the story seems hardly credible – it so wasted away my unhappy frame that scarcely anything was left of me but skin and bone Suddenly I was caught up in the spirit and dragged before the judgement seat of the judge; and here the light was so bright, and those who stood around were so radiant, that I cast myself on the ground and did not dare to look up. Asked who and what I was I replied, "I am a Christian". But he who presided said: "Thou liest, thou art a follower of Cicero and not of Christ…". Instantly I became dumb, and amid the strokes of the lash – for he had ordered me to be scourged – I was tortured more severely still by the fire of conscience…'. At repeated cries for mercy – 'miserere mei, Domini, miserere mei. Haec vox inter flagella resonabat' – a member of court interceded on his behalf

with the judge. Jerome was pardoned on the understanding that if he again turned to the pagans he would have denied God, despite the grace of Baptism. The story was well known to a wide audience (which did not necessarily need to read Latin), retold in the hugely popular *Golden Legend*, the book of saints' lives written by Jacobus de Voragine.[6] Jacobus quotes Jerome as saying, 'Oh Lord, if I ever possess or read worldly books again, I will be denying you!' Matteo shows the moment when the judge's hand is raised in a gesture of pardon. On the right, two figures in contemporary dress are placed as witnesses to the miracle.

This narrative was complemented on the right of the Crucifixion scene by *Saint Augustine's Vision of Saints Jerome and John the Baptist*.[7] This story is taken from a letter purporting to have been written by Augustine to Cyril of Jerusalem, one of three such late thirteenth-century forgeries widely circulated from the early Trecento.[8] It contains an account of the second vision to Augustine, four nights after a first when Jerome, recently deceased, had appeared to answer a series of Augustine's questions. The setting is his study. In the second vision, Augustine, attempting to compose an encomium in honour of Jerome, falls asleep over his work and has a vision of two figures in the midst of a multitude of angels. Both look and are dressed alike, except that one has a triple diadem of gold and precious stones on his head, the other a double crown. The figure wearing three crowns introduces himself as Saint John the Baptist and says that his companion, Jerome, is wearing only two crowns because he was not martyred for his faith. In the purity of his life and his glory after death,

however, as John instructs Augustine, he and Jerome were equal. John was a hermit in the desert; so too was Jerome; John mortified his flesh, so did Jerome; John was a virgin 'clean and pure', and so was Jerome. 'What I can do, he can do; what I will, he wills; and in the same way that I see God, he too sees, knows and understands God, and in this consists all our glory and happiness and that of the saints.' Augustine therefore understood that Jerome's name should be magnified and published among the people, that he must be feared, revered and venerated; and that God will punish all his detractors and protect all those who call on him. This story was again made widely available – used, for instance, by Pietro de' Natali in his *Catalogus sanctorum* (1372), second only to the *Golden Legend* in the size of its readership.[9]

Augustine is here presented chiefly as the agent for the narrative rather than its protagonist, and the scene should be interpreted as the clarification of the holy status of Saint Jerome. In the fifteenth century, both narratives were promoted especially by the Hieronymite and Gesuati orders.[10] The Hieronymites, it has been stated, 'found in Jerome's Ciceronian dream a message meant especially for them'. Rice has written, 'The ideal of the early Hieronymites was *sancta rusticitas*, an unlettered holiness, a phrase they found in Jerome, tacitly overlooking his scholarship and eloquence'. This ideal of an unlettered Jerome was central to their promotion of Saint Jerome as martyr. In the anonymous *Hieronymi Vita et Transitus*, Jerome is said to have been raised, as John the Baptist had explained to Augustine, to the rank of martyr by the penitence he had undertaken after his dream, thus to equality

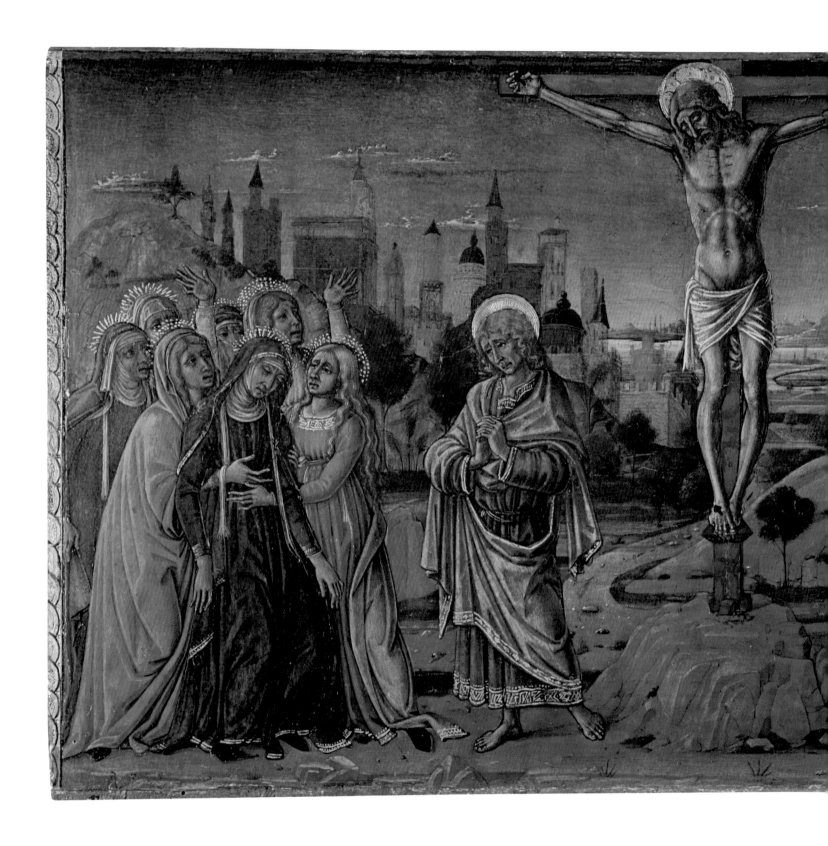

to John in the heavenly hierarchy. The narratives depicted by Matteo di Giovanni had earlier been deployed to make precisely these points in the predella of an altarpiece, now attributed to the Florentine Zanobi Strozzi, for the Hieronymite convent at Fiesole probably dateable to about 1460 (now in Avignon).[11] There Jerome's Dream is followed by his Funeral; a Pietà is at the centre; we then see Jerome's appearance with the Baptist to Saint Augustine, and lastly the chastisement of the heretic Sabinianus.[12]

Much the same message was promulgated, especially in Siena, by the Gesuati; in 1355 the wealthy Sienese merchant Giovanni Colombini had founded what was to become the Frati Gesuati di San Girolamo – named for Jerome and devoted to the imitation of his penitential behaviour.[13] Their devotional practices, seeking salvation through penitence, remained extremely popular in the fifteenth century.[14] Giovanni dalle Celle in a letter to Colombini's 'poverelli' listed the physical acts of penitence they should undergo and also advocated the avoidance of pagan books ('*fuga de' libri de' pagani*'). Colombini himself had fervently rejected ancient authors, taking literally Jerome's claim that he had not read any secular author for fifteen years after his dream. The particular stress on extreme forms of asceticism continued as the central feature of Gesuato spirituality in the fifteenth century, profoundly affecting the imagery of Jerome.[15] Thus the scene of Jerome's dream was included in the predella of the altarpiece commissioned in about 1430 from Francesco d'Antonio for the Gesuati in Florence (now also in Avignon).[16] The same subjects as in the Placidi Altarpiece had earlier been included in the predella set below Sano di Pietro's altarpiece formerly in the Gesuati convent of San Girolamo in Siena (now Louvre). In Sano's version of the dream, Jerome holds his hands in prayer, beaten by two angel flagellators. The judge wears a halo to signal his divinity.

The theme of martyrdom through penitence is further developed in the Placidi Altarpiece, where the equality of Jerome and the Baptist as martyrs is underscored. Matteo's account is, however, rather different from Francesco d'Antonio's or Sano's versions. Whereas, in both these altarpieces, Jerome is dressed in the main tier as a cardinal rather than as a penitent, here both Jerome and John are stripped almost naked, stressing the penitent roles of each and raising the former to the status of the latter.[17] Moreover, in a significant departure from the source text of Augustine's vision, both have the same number of crowns.[18] Trimpi has

written: 'The underlying meaning of Matteo di Giovanni's *Placidi Altarpiece* is man's desire for repentance, conversion and baptism in order to be reborn into a more perfect life after death.' Thus the central predella scene of the Crucifixion is well-chosen, indicating triumph over death through imitation of the sufferings of Christ. Russo argues for the importance of its setting in a funerary chapel.[19] 'The cycles of the second half of the fifteenth century emphasised . . . this aspect of this deliberately private cult, which was used as a guaranteed safe-conduct to the other life. By its location, usually in a family chapel, the predella conveyed the votive nature of the commission, the act by which the devotee entrusted his soul to the hands of his holy patron: it was the last step, perhaps the most important step; there was also the hope of remaining present in the memory of the living.'

Other more surprising variations on the theme are particularly clearly expressed in the predella. Matteo has depicted both Jerome's Dream and Augustine's Vision with a new naturalism. The flagellators, for example, have lost their angelic wings,[20] making their heavenly identity less clear; the judge is now lacking his halo. It is not surprising that the scene was at some point misunderstood as the Flagellation of Christ, and the flagellators, seen as villains, had their faces scratched out. Matteo's rigorous anatomical description of the lean but muscular body of Jerome emphasises his real physical suffering. Above all, the scenes have remarkable *all'antica* settings, seemingly directly at odds with the fundamental message of the Dream.

Matteo appears to have found two principal sources for his architecture, different for each; and each model had, seemingly,

some impact upon Matteo's method of execution. The *all'antica* architectural setting of the *Dream of Saint Jerome* has been described as 'a Renaissance fantasy world'.[21] The architecture allows for the introduction of extra elements. Above the portal at the centre of the composition is a lunette relief depicting the rite of Baptism, and visible through the doorway is a font (rather like that in the Siena Baptistery) or a ciborium (tabernacle for the Sacrament), perhaps based on Vecchietta's bronze ciborium completed in 1472 for the Hospital of Santa Maria della Scala or upon the High Altar in the Spannocchi chapel of San Domenico itself (see fig. 23). The concept of a second baptism – through the renunciation of worldly things – is explored in Jerome's writings.[22] The roundels above the entablature of the colonnade under which the judge sits were probably also related to the

theme. The subject of one, with two figures kneeling and praying before a third, is unclear, but Wilczynski has suggested that the rearing nude horseman represents Jerome's previously unbridled passion for the ancients.[23]

Jerome is positioned so that the left column of the doorway reminds the viewer of Christ's column. Not only the architectural setting but also individual figures recall Francesco di Giorgio's bronze *Flagellation of Christ* (cat. 27): the body of Jerome reverses Francesco's Christ, now with raised hands, but otherwise very similar – head thrown back, chest thrust forward, belly clenched and knees bent. The flagellator on the left, too, has a right arm curving around his head, angled to follow the direction of the left arm, just as in the relief. Matteo's underdrawing shows through this figure's pink costume, now rather transparent – the only major *pentimento* in the composition visible to the naked eye – showing that his tunic was first intended to be shorter, closer to the loincloth of his counterpart in Francesco di Giorgio's relief. The sketchiness with which the paint is applied may have been due to pressure of time, but also shows Matteo beginning to emulate the atmospheric shimmer of the surfaces of Francesco's bronze reliefs. Francesco di Giorgio must have been regarded by his contemporaries as the Sienese artist with the most profound knowledge of the Antique.

Matteo has beautifully calculated the internal colour scheme – purple-grey, strong scarlet reds, offset by small areas of white or very pale grey. Coloured marbles are inset into the buildings, climaxing in the ciborium and framing portal. It has

been argued that the composition of *Jerome's Dream* is reminiscent of Piero della Francesca's famous Urbino *Flagellation* from the mid-1450s, leading Pope-Hennessy to propose that the two works depict the same subject; Matteo was born and worked in Borgo Sansepolcro, Piero's home town, so he may have gained some knowledge of Piero's painting. However, it is doubtful that Matteo ever set out to achieve a perspective plan of such sophistication. Disjunctions are seen throughout, and are particularly noticeable in the capitals and bases of the central portal and the column bases in the pavilion on the left, which do not follow the steps or floor. The architecture does not appear to be incised, instead simply drawn, and there are *pentimenti* in the pink palazzo on the right, where the windows are suppressed. This seeming casualness may have been to ensure that the scene was perceived as visionary (see cat. 23), but remains surprising given that the style of architecture, especially the triangular pediments above the windows, appears to be based on motifs found in the architecture of that accomplished perspectivist Francesco di Giorgio, and in particular on Francesco's *Flagellation* relief.[24] In general, *Jerome's Dream* was painted more thinly and quickly than *Augustine's Vision* – an effect now accentuated because it is also more abraded, and the flesh paint more transparent. But in any case *Jerome's Dream* is more hastily highlighted, for example, with less sense of where the light hits the individual elements in the capitals; the drawing is looser and the structures less carefully established and finished. One telling signal of Matteo's speed is the dagger handle grasped by one of

the bystanders on the right, lacking either blade or scabbard.

Augustine's Vision is rather differently painted. The contrast between the two Chicago panels was noted by Lionello Venturi in 1929, but has not been discussed since.[25] Here the flesh painting appears almost chiselled. The whole is for the most part very carefully planned and meticulously painted, with only a small *pentimento* in the proper left foot of the witness. (This man is apparently a friar or monk, but his habit is unidentified. He is surely included to point up the 'reality' of the vision.) The folds within the black of his cloak or habit, and in Saint Augustine's more gaudy costume, are energetically incised, with some parallel hatching to indicate the areas of shadow, and in general these lines are scrupulously followed in the paint. The level of detail is high and is particularly striking in the pearls on Augustine's mitre and the highlights of his painted gold brocade. The colour scheme of the architecture was chosen to complement and contrast with *Jerome's Dream* – green, dark pink and warm grey. The curves of the pink moulding of the series of apse-like niches in the basement storey of the building suggest that the vanishing point for the perspective is towards the left (directed towards the central *Crucifixion* scene), but it is a little illogical. The scene is nonetheless brilliantly unified through its lighting (from the left, as in all the other panels), with sharp, strong and logical highlights throughout: these glitter on the gloves of Saint Augustine, on the still-life elements, on the capitals and other details of architecture.

The architecture is painstakingly incised throughout. The three buildings derive

directly or indirectly from the *Codex Santarelli* in the Uffizi, containing a series of fantasy drawings recreating the architecture of ancient Rome, executed probably during the 1460s.[26] The green church or chapel on the left, apparently centrally planned, is identified in the manuscript as the 'tenplum Vespasiani' (f. 164v) and the structure on the right copies the 'temple of all gods'. Augustine's study, with its basement niches, arched portal surmounted by a segmental tympanum, and paired columns on the side façade, imitate another temple, not identified (f. 163v). The *Vision of Saint Augustine* is seemingly the earliest painting to depend directly upon the *Codex*, versions of which must have circulated quite widely. The Sienese Baldassare Peruzzi certainly knew them, suggesting that they had achieved some currency in Siena and that Matteo may even have owned them.[27] Their inclusion implies a Roman setting for the scene, emphasised by what appears to be an imperial eagle above the head of a witness.

In both *Jerome's Dream* and *Saint Augustine's Vision* Matteo can be seen to cite sources that, if not properly 'ancient', might have been considered so, introducing antique motifs into the Christian story. These innovations are probably best explained by the Dominican context of the altarpiece. The story of Jerome's Dream had long presented a challenge both for devout humanists and for the Dominicans – primarily a scholarly rather than a penitent order – namely, how to negotiate the fundamental problem of combining stylistic models drawn from Greco-Roman or 'pagan' literature with the telling of the Christian story.[28] Although Jerome repudiated the ancients, his continued quotation of

poets and the imitative style of his writings show that he actually continued to use Cicero and other classical authors even after his vow – a point made by Petrarch, who saw the story as a possible model for a double allegiance.[29] Even Jerome's account of his dream, it has been argued, borrows phrases and imagery from Virgil.[30] Petrarch wrote: 'I think I can retain my love both for the Christian writers and for the ancients so long as I keep in mind which is preferable for style and which for content' (*Rerum familiarium libri,* XXII, 10).[31] Petrarch was himself a model for Quattrocento humanists, and this strand was also found in Siena. The humanist Agostino Dati (died 1478) delivered a Latin oration for Saint Jerome's feast day on 30 September 1447.[32] 'Jerome', he claimed, 'was more eloquent than Isocrates, Cicero or Quintilian, and more prudent than Cato, Solon or Socrates. We learn that Aristotle wrote 400 books, Epicurus 300, Chrysippus 700, and Democritus and Zeno very many, too, but Jerome wrote more than any of them, and what Averroës said of Aristotle should be said of him: "not the smallest error is to be found in any of his works".' The spirit here is competitive, Jerome outdoing the ancients, but, it is implied, only because of his study of them.

How then were the Dominicans to reclaim the penitent Jerome and how should they deal with the message of the Dream as it was understood by the Gesuati? How in particular should the Conventual Dominicans at San Domenico, who had rejected take-over from the Observant branch, take account of the undoubted enthusiasm that was evinced everywhere for the Gesuato Jerome? (And Gabriella Placidi had at first intended to

make bequests to reformed and penitent institutions.) It was the scholarly Jerome who traditionally had been emphasised in Dominican iconography and hagiography, even if his role as a penitent martyr was far from ignored.[33] The two aspects might appear contradictory, and the stress on just one by the Gesuati was certainly easier than combining both. A solution for the Dominicans could be found in the writings of the humanist Pierpaolo Vergerio the Elder (about 1369–1444/5), who wrote ten sermons about Jerome – essentially panegyrics – again presenting him as a model to be imitated.[34] Vergerio's Jerome was more complicated and nuanced than the unlettered penitent of the Gesuati or Hieronymites. He promoted Jerome as an example of how to be both humanist and Christian, achieving, as McManamon has put it, a 'path to sanctity through humanism'. His arguments were known in Siena; in September 1408, Vergerio had spoken about Jerome before the papal court, then temporarily in the city.[35] Moreover, his sermons began to circulate in printed form in precisely the period running up to altarpiece commission: although they were never collected together in a single volume, the *editio princeps* of one sermon was published in 1468 and printed editions of others followed thereafter.[36]

Vergerio praised Jerome not only as a martyr of the first order but also for his knowledge of letters, his '*peritia litterarum*', repeatedly citing the Dream.[37] Vergerio interpreted the Dream as a message that he should change but not that he should abandon his scholarly activities; humanist learning was to be placed at the service of the profound study of the sacred literature. Jerome, he says, never stopped studying

pagan literature. 'Amidst the cracking blows of the whip, Jerome steadfastly repeated a single phrase, "Lord, if ever again I read worldly books, I have denied you". . . . Afterwards, however, as he himself asserted, he continued to read the books of the pagans, but he treated divine matters with greater enthusiasm than he had ever shown for pagan literature in the past. For that reason, I infer that he published the entire corpus of his writings or certainly the vast majority of them after that event. In those writings, nevertheless, there is so much from the history of other peoples, so much from pagan poetry and foreign practice, and all of it accommodated to the utility of faith, that it could actually appear that he did nothing else day and night but delve into such matters.'[38]

Vergerio states that Jerome's bruises after the flagellation show the experience was real and not 'merely a dream'. That his ideas may have influenced Matteo di Giovanni and his advisers is suggested by the 'real' body that he paints. Matteo's quotation from the Antique was fully justified by Petrarch (and Vergerio) – a matter of style rather than content. In this complicated interplay of images, made for sustained meditation, Matteo has inserted a theme that was close to the hearts of the Dominicans, exploring the possibility of combining classical learning with the visionary revelation of the Trinity and the Virgin.

Thus in the predella the inclusion of the figure of the scholarly, visionary Saint Augustine (cat. 34), standing like a living statue in a niche, made a point. Saint Vincent Ferrer (cat. 36) arguably is seen as his modern counterpart. A Spanish Dominican preacher of religious reform, Vincent had

been canonised by his compatriot Pope Calixtus III in 1455.[39] He had travelled throughout Europe delivering sermons urging repentance in view of the imminence of the Last Judgement. His presence therefore seems a nod to the Observants and, of course, is profoundly relevant to the theme of salvation through penitence: he points to a vision of Christ as Judge – obviously related to scene of the judgement of Jerome to the left. But in general the message that full Christian understanding could be achieved through a combination of study (including the study of pagan authors), penitence and revelation was suggested rather subtly – through the predella scenes' 'antique' architectural settings; by the way in which in *Augustine's Vision*, Saints John and Jerome hover above piles of books and papers manuscripts, as if emerging from them; and by the unusually prominent role of the converted centurion – Roman and Christian – in the *Crucifixion* scene. LS

1 The predella was convincingly reconstructed by Trimpi (1983, 1985) and Sallay (2003, in Alessi and Bagnoli 2006, pp. 44–7). Although *The Crucifixion* appears in Christiansen, Kanter and Strelke 1988, the catalogue of the exhibition at the Metropolitan Museum of Art, New York, for conservation reasons the picture did not travel. See Christiansen 1990.

2 Trimpi 1983, p. 464 and note 39.

3 As on the pulpit in Siena Cathedral. D. Sallay in Alessi and Bagnoli 2006, p. 44.

4 Rice 1985, p. 104.

5 Migne 1844–64, XXII, *Epistula XXII*, esp. cols. 416–17; translation from Wace and Schaff 1893, p. 24.

6 Voragine 1993 edn, p. 212. The circulation of this text was wider than ever before, after the publication of the *Editio princeps* in 1470. See Seybolt 1946, pp. 327–38; Manucci 1980, pp. 30–50.

7 For which subject, see Rice 1985, pp. 52–5.

8 Pseudo-Augustine, *Epistula XVIII, ad Cyrillum*; Migne 1844–64, XXXIII, esp. col. 1125 BCH 5805: Roberts 1959; Hall and Uhr 1985.

9 Rice 1985, p. 49.

10 See especially Meiss 1974.

11 Meiss 1974, p. 135; Laclotte and Mognetti 1987, np., no. 139; Russo 1987, pp. 177–8; A. De Marchi in Di Lorenzo 2001, p. 49, note 20; L.B. Kanter in Kanter and Palladino 2005, p. 264, note 1.

12 The iconography continued to be promoted by the Hieronymites: see the Signorelli predella of 1519 in the National Gallery, London made for the church of the Compagnia di San Gerolamo in Arezzo. The main panel is now in the Museo Civico, Arezzo.

13 Rice 1985, pp. 68–76.

14 Antonio Bettini da Siena in his *Tractatus sive alligationes pro ordine Iesuatorum* wrote: 'We have dedicated all our churches and oratories to Saint Jerome because it is his teaching we imitate and follow.' See Dufner 1975, p. 183. Bettini became bishop of Foligno in 1461.

15 Campbell 1997, p. 86, has analysed for example the impact of the *Life of Giovanni Colombini* by Giovanni Tavelli (1386–1446), the Gesuato bishop of Ferrara. Tavelli's work was assuredly known in Siena – and he wrote his tract *De perfectione religionis* for a community of Benedictine nuns there.

16 Russo 1987, pp. 156–7. Matteo or his advisers may have seen this altarpiece, which is somewhat similarly structured. The pose of the Child is also rather alike.

17 Trimpi 1983, p. 458.

18 Russo 1987, pp. 184–5.

19 Russo 1987, pp. 185–6.

20 Trimpi 1983, p. 458.

21 Trimpi 1983, p. 458.

22 Migne 1845–64, XXII, *Epistula XXXIX*, col. 468; Trimpi 1983, p. 458.

23 Wilczynski 1956, pp. 74–6.

24 L.B. Kanter in Christiansen, Kanter and Strehlke 1988, p. 275.

25 This letter (2.6.1929) is in the picture's dossier at the Art Institute of Chicago.

26 Scaglia 1970, pp. 17–18.

27 See Frommel 2005, p. 6.

28 Knowles Frazier 2005, p. 48, writes '…the widespread devotional practices most attuned to the martyrological *imaginaire*, the ones that re-created both in imagination and ritual the suffering of Christ, that encouraged the *imitatio Christi*, are part of an affective and somatic piety that is not often associated with men, much less with Quattrocento humanists'.

29 Vergerio 1999 edn, p. 14.

30 See Thierry 1963, pp. 32–5.

31 See Maugeri 1920, pp. 27–9, 80–8.

32 Rice 1985, p. 95; first printed in *Augustini Dati Senensis opera*, ed. Hieronymus Dathus, Siena 1503, fols. 56v–58v.

33 Russo 1987, pp. 38, 44–51.

34 Vergerio 1999 edn, *passim*.

35 Vergerio 1999 edn, p. 23.

36 Vergerio 1999 edn, pp. 31, 85–7, 109.

37 Vergerio 1999 edn, p. 17.

38 Vergerio 1999 edn, pp. 157, 159.

39 Francesco Catellini da Castiglione used the occasion of the canonisation proceedings to write an account of Saint Vincent Ferrer (Knowles Frazier 2005, p. 24, note 77, pp. 392–3. See Smoller 1997; See also Smoller 1998).

SELECT BIBLIOGRAPHY

Trimpi 1983; Trimpi 1985; Lloyd 1993, pp. 151–8; Sallay 2003, pp. 76–81; D. Sallay in Alessi and Bagnoli 2006, pp. 44–7.

38.

NEROCCIO DI BARTOLOMEO DE' LANDI (1447–1500)
Three Scenes from the Life of Saint Benedict, about 1481

Tempera on panel, 28 × 193 cm
Galleria degli Uffizi, Florence (P835)

These three predella scenes – arranged on a single long plank, with gilded pilasters dividing them – were almost certainly placed below a large painted altarpiece, very probably made for a Benedictine Abbey near Lucca, the independent city-state in eastern Tuscany, and commissioned by its abbot, Fra Giannino de'Bernardi. They show Neroccio at his most sophisticated, fluidly blending sculptural sources with a traditional Sienese concern for delicate craftsmanship and elements taken from the most up-to-date painting of Florence. Starting on the left, they illustrate three stories from the life of Saint Benedict, *Benedict in the Wilderness*, *The Miracle of the Broken Sieve* and *Benedict receiving the Gothic King Totila at Montecassino*.

Following the chronological account of Benedict's life in *The Dialogues of Saint Gregory the Great*,[1] the source almost certainly used here by Neroccio, the earliest episode of his life to be depicted is, curiously, the one at the centre of the panel, *The Miracle of the Broken Sieve*. The young Benedict, who

had left school to dwell in the wilderness, set off on his journey with Cyrilla, his devoted nurse. They arrived at the church of San Pietro in the city of Enside, where a community of devout men lived and prayed. When Cyrilla, borrowing a sieve from a neighbour, found it broken in two pieces, Benedict fell to the ground in tears and miraculously mended the sieve with his fervent prayers. Neroccio depicts the different moments of this story simultaneously: on the right Cyrilla kneels in desperation over the broken sieve, her arms outstretched. Just behind her, the young Benedict approaches, holding his prayer book. Immediately to the left he is shown again, this time on his knees, his hands held in prayer, and the sieve miraculously mended before him. At the centre of the composition, the mended sieve is seen hanging from a classical frieze decorating a small church. Although several figures – men, women, children and even dogs – populate the scene, many looking upwards to the proof of Benedict's powers, it is

arguable that, just as in Liberale da Verona's *Saint Peter healing a Lame Beggar* (cat. 29) and Matteo di Giovanni's *Vision of Saint Augustine* (cat. 37), the real protagonist of this scene is the architecture. The event takes place in an idealised, fantastical cityscape, filled with buildings of different types and styles, and adorned with precious marbles, like the porphyry of the Corinthian columns of the church and the serpentine of the marble-inlaid pavement (widely used in contemporary Sienese painting), the whole evoking late antique and early Christian sacred architecture. The buildings are arranged so as to lead the eye towards the centre of the composition, occupied by a small hexagonal temple with an altar and cross within. In line with the burgeoning taste for the Antique in Siena, this structure is decorated with classical motifs, such as the frieze with dancing *putti*.[2] The types and disposition of the architecture – with a portico on the right, the hexagonal structure in the centre and a Roman amphitheatre on the left – appears to depend on Francesco di

Giorgio's stucco *Scene of Conflict* (cat. 44), a fact that may assist with the dating of that relief.[3]

The scene on the left represents a later episode in the life of the saint, Benedict's retreat within the cave of Subiaco, where he remained secluded in prayer and meditation for three years. Only Romanus, the charitable monk he had met during his travels, knew his whereabouts. Unable to reach the cave from his cell, Romanus would deliver a loaf of bread to Benedict by tying a basket to a rope, attaching a little bell to announce its arrival. One day the 'old enemy of mankind', furious at this act of kindness, threw a stone at the rope and broke the bell. But, in Saint Gregory's reassuring words, 'for all that, Romanus gave not over to serve him by all the possible means he could'.[4] Neroccio depicts Benedict kneeling at the entrance of his cave, whilst Romanus lowers his basket and a wonderful, red-winged demon rushes through the air, ready to strike his blow.[5] Two other earlier moments are included in the scene: on the

far left, Romanus dresses Benedict in the black monastic habit he wears in the cave; further to the right, Romanus reappears once more carrying his basket. On the horizon, we can make out a town with Gothic architecture,[6] its walls punctuated by round towers and spires, houses with stepped gables, and a tall bell tower. Both behind and in front of the town is the cool blue water of the lake and river in Saint Gregory's text. The craggy cave of the saint dominates the composition, while its massive, barren rocks and the way the foreground falls away convey a sense of the saint's isolation, cut off from the world around, and the viewer.

The town and landscape in this scene have been thought Netherlandish in style – likened, for example, to paintings by the Netherlandish artist Justus of Ghent, active in Urbino in the 1460s and 1470s.[7] Strehlke suggests that the spire at the centre of the town 'seems to reflect' the bell tower of Bruges after its octagonal belfry was added in 1483. Neroccio, he argues, may therefore

have seen a Netherlandish painting with this particular detail; interestingly an altarpiece by the Master of the Saint Lucy Legend from San Domenico in Pisa (now Museo Nazionale di San Matteo) contains a view of Bruges after this date.[8] While this relationship maybe generic rather than exact, the point is well made that Neroccio was the first artist in Siena to introduce Netherlandish landscape elements into his works – including his *cassone* panels with the story of Antony and Cleopatra (see cat. 57) – and not just architectural motifs but also its construction and saturated colours, here with the bright clarity of a Tuscan spring. However, there do not appear to have been Netherlandish models to follow in Siena itself; there are no inventory records of Netherlandish paintings, and none surviving with Sienese provenances. Thus Neroccio's exposure to Netherlandish art must have come about through travels elsewhere, probably through trips to Florence and certainly to the area around Lucca and Pisa. It may be that some of his citations are

second-hand, copied from Florentine painters (see also cat. 12, 51). Neroccio's landscapes are also indebted to local models, such as Matteo di Giovanni's Placidi *Crucifixion* (cat. 35). Moreover, it is arguable that, although the palette is more fresh and delicate, the rocky landscape also evokes Mantegnesque models, which Neroccio may have known through or prints, or more probably through the paintings of his older contemporary Benvenuto di Giovanni (see cat. 13, 32).

The third scene, on the right, recounts the visit of King Totila to Saint Benedict at the monastery of Montecassino. According to the *Dialogues*, the godless king of the Goths had decided to test Benedict's gift for divination by sending in his place Riggo, one of his guards, dressed in his regal clothes and with three courtiers to attend upon him. But after Riggo returned to the king, fearfully telling how quickly he had been unmasked, Totila himself went to the holy man and repented of his wicked ways. Neroccio depicts the very moment when Benedict, now old, calls upon the kneeling king to rise and utters his prophetic words: 'Much wickedness you daily commit, and many great sins you have done: now give over your sinful life. You shall enter the city of Rome, and you shall pass over the sea: you shall reign nine years, and in the tenth shall you leave this mortal life.'[9] The saint's allusion to Rome is taken up by Neroccio in the pastiche of monuments visible in the background, where we recognise the columns of Trajan and Marcus Aurelius, the pyramid of Cestus, and a Roman amphitheatre not unlike the Coliseum. Not far from the ancient city are the tents of the king's large convoy, which has descended from the hills to

Montecassino to witness the solemn event. Neroccio's depiction of the soldiers demonstrates his skills as a colourist, delighting in the contrasts within the figures' bright costumes, particularly in the dazzling reds, yellows and purples. It is in some of the soldiers' angelic faces and golden hair (recalling the crowd gathered in cat. 7) that Neroccio's hand is most recognisable.

On the right of the composition, Benedict's companions stand by the entrance of what must be the monastery of Montecassino. Its marble façade is so precisely rendered that one wonders if the artist was referring to a specific monument. As Toledano pointed out, the building has an interesting combination of Gothic and Renaissance features, reminiscent of the Cappella di Piazza in the Campo.[10] This key civic building, with its statuary set in niches, also seems to have inspired the architecture in Liberale's predella (cat. 29–30). In the sculpted reliefs of the upper register of Neroccio's building we detect echoes of the sculptures of Donatello and Jacopo della Quercia. In particular, the over-door lunette with *The Dead Christ supported by Angels* brings to mind Donatello's bronze relief from Sant'Antonio, Padua (perhaps known in Siena from a reproductive squeeze) while the statues of the Prophets or Evangelists placed in niches recall Jacopo della Quercia's five marble Prophets on the baptismal font of Siena Baptistery.

As in the San Bernardino predella (cat. 7), this commission gave Neroccio the opportunity to demonstrate his talent as a storyteller. So unlike the gold-ground, ethereal Madonnas for which the artist is best known, or the 'aristocratic' style which has earned him the epithet 'the new Simone Martini',

these delightful scenes emerge as one of the artist's most inventive, original and 'modern' works. It was perhaps this mode, rather than his more self-consciously Sienese style, that made his painting desirable in centres outside the city of Siena such as Lucca. SDN

1 Gregory 1911 edn; Gregory 1975 edn, pp. 165, 167, 193–5.
2 A similar 'sculpted' frieze also features in Neroccio's *Annunciation* (cat. 24).
3 The slight incisions visible above the central hexagonal building in the Victoria and Albert Museum stucco suggest the presence of a dome, part of which is also visible at the top of Neroccio's *Miracle of the Sieve*.
4 Gregory 1911 edn, p. 53.
5 According to both Weller (1943, p. 77) and Toledano (1987, p. 86), the inventiveness of the devil's image can only be the fruit of Francesco's audacious imagination. This is to underestimate Neroccio's own creativity.
6 This cannot be Subiaco, as Saint Gregory calls it 'a deserted place distant almost forty miles from Rome'. See Gregory 1911 edn, pp. 52–3.
7 Weinberger 1927, p. 37. As pointed out by Maccherini, Neroccio painted a similar landscape in the unfinished lunette of the *Crucified Christ*, in the Sergardi collection, Siena (Maccherini in Bellosi 1993, cat. 65, pp. 328–30).
8 Strehlke 1993, p. 502. If Strehlke is correct, the predella would not simply have to post-date 1483 – just possible – but have been painted even later than that. On reasonable grounds, the Saint Catherine Altarpiece from Pisa is dated to about 1490 in Nuttall 2004, pp. 85, 153. See also Roberts 1987, pp. 187–206, esp. pp. 188–91, 206. Stylistically a date of after 1490 is highly unlikely for this predella.
9 Gregory 1911 edn, pp. 73–5.
10 Toledano 1987, p. 86. The Cappella di Piazza was erected in 1352 as an *ex-voto* to the Holy Virgin by Sienese survivors of the plague of 1348. The pilasters were remodelled in their current form in 1378, the sculptures decorating them being executed in 1378–82 by Mariano d'Angelo Romanelli and Bartolommeo di Tommé. The simple wooden ceiling once covering the loggia was replaced by the current Renaissance marble vault by Antonio Federighi in 1461–8.

SELECT BIBLIOGRAPHY

Toledano 1987, pp. 86–9, cat. 32; M. Maccherini in Bellosi 1993, pp. 328–30, cat. 66.

Fig. 56
Detail of *The Miracle of the Broken Sieve*, cat. 38

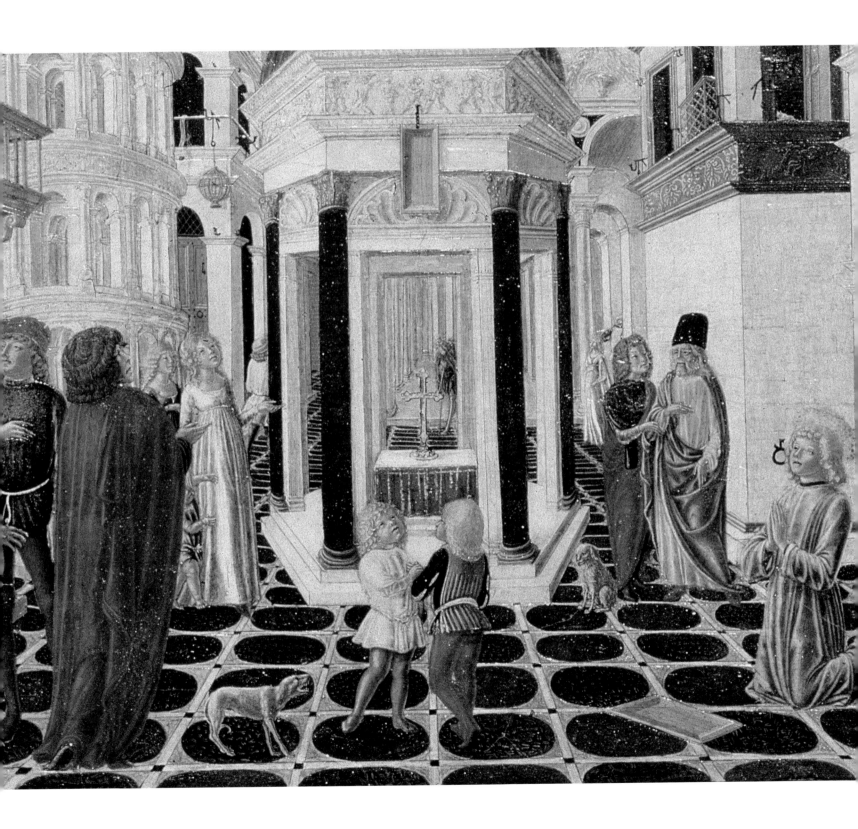

RENAISSANCE ART

It is a truism that, as well as denoting a period, the term 'Renaissance' implies a particular way of thinking (and not just about art) – the self-conscious return to the values of antiquity as they were understood through the study of ancient texts and, generally to a lesser extent, of artefacts. In the visual arts, these values could be expressed through classicising styles, the transformed standing of the 'artist' (now to be compared with Apelles or Lysippus) and, naturally enough, by the choice of classical subject-matter. All these factors were fully visible in Siena by the second half of the Quattrocento. *All'antica* styles for paintings, relief sculptures and especially the architecture depicted within both, by Francesco di Giorgio, and his contemporaries, are crucial features of many of the works included in the preceding section – a stylistic current coursing in parallel with Donatellism.[1] We have also already encountered the polymath artist. Even before Francesco di Giorgio there were Sienese precedents for working in more than one medium, but by adding further strings to his bow – architectural design and engineering – Francesco converted what might otherwise have been viewed as commercial expediency into the declaration of a new status. This was an assertion that he could make best of all through drawing: Francesco was deeply sensible of the fact that his social and artistic pre-eminence sprang from his mastery of *disegno* (see cat. 40–3).

His position and (sometimes) his style were symptoms of the growing sense Siena had of itself as an ancient Roman city, a view much encouraged by the humanist Pope Pius II and his family. The legend was played out on the city streets, and can be easily understood by the reinterpretation in this period of the Sienese she-wolf. Images of the *Lupa*, already omnipresent in and on the Palazzo Pubblico, had long been tied to Siena's foundation myth.[2] The story of Siena's Roman origins can be traced back to at least the early fourteenth century. In her first incarnation, the she-wolf was viewed simply as the feral wet-nurse of Romulus and Remus, founders of Rome, her presence signalling Siena's Roman beginnings. That there was no contradiction felt between the notion of Siena's pagan foundation and that of Siena as the city of the Virgin is demonstrated by the fact that the gilded bronze *Lupa* commissioned from Giovanni and Lorenzo di Turino in 1429 to be set up outside the Palazzo Pubblico was to be dedicated on Assumption Day, 15 August 1430. In 1459, the year after Pius's coronation, the sculpture's original column was replaced by one that was authentically ancient, reinforcing its potency as an image signalling Siena's antique past.[3] This was almost exactly the time when the legend was reformulated – not least in the face of manifest Florentine scepticism about Siena's ancient origins. Rather than representing Romulus and Remus, the suckling babies were re-identified as Ascius and Senius, the sons of Remus, now claimed as the founders of the city. The story is spurious, first appearing in written form only in latter part of the Quattrocento. It builds on the foundation myth of Rome itself – the murder of Remus by Romulus, and the flight of Remus's sons, taking with them the statue of the she-wolf from the temple of Apollo. It could even provide an explanation for the black and white Sienese *balzana*. The two boys left town riding horses, one of them black, the other white. This new 'history' was included in a chronicle written in 1477–9 by an author with the pseudonym Domenico Aldobrandini.[4] The evidence adduced became ever more fanciful and profuse in a whole series of humanist histories of the city. Agostino Patrizi Piccolomini, Bishop of Pienza and Montalcino (1435–1495; his surnames probably denoting his adoption by the two families concerned) wrote his 1488 *De antiquitate civitatis Senensis* in the form of a letter to Cardinal Francesco Todeschini Piccolomini.[5] Cardinal Francesco had already commissioned the *De origine et antiquitate urbis Senae* from Agostino's teacher Francesco Patrizi (1413–1494).[6] The noble Bartolomeo Benvoglienti

Fig. 57–8
The Stratonice Master (active about 1470–90)
Story of Antiochus and Stratonice, about 1470
Tempera on panel, both 43.2 × 109.2 cm
The Huntington Library, San Marino, CA
(26.121, 26.120)

(d. 1486) had composed the oration for the Sienese public solemnisation of Pius II's coronation: his *De urbis Senae origine et incremento*, written in 1484–6, is particularly imaginative in its forced etymologies and fictive genealogies.[7] Pius II himself was indirectly responsible for the lovely idea that the Roman Republican hero Furius Camillus gave his name to the area of the city called Camollia.[8] She-wolves proliferated in both Siena and its territories.

This gloss given to the *Lupa* suggests how existing images and styles could be reappropriated. The Antique in Siena was always open to new readings. A fairly typical blending is found in the Ventura version of events at Montaperti, in which every Sienese is called 'a new Hector' (*un Ettore novello*).[9] This was a society that admitted little contradiction between the chivalric and the Antique. Roman-ness itself could be either Republican or Imperial. In 1446, the Florentine Bernardo Rossellino had been employed by the Comune to carve the marble portal of the Sala del Concistoro, replete with *balzana* and lions of the Popolo.[10] The result was a fully-fledged *all'antica* doorway, perhaps intended as an expression of Roman Republican values. On the other hand the

later *all'antica* palaces of the Piccolomini and Spannocchi families had, as we have seen, rather different connotations.

The expression of its inhabitants' sense that they lived in a city that combined medieval tradition with an increasingly emphasised and much older past was not restricted to the architectural exteriors or internal detailing of these palaces. Their interior décor as a whole was intended to convey the idea that the modern Sienese were the direct heirs of the Romans. A plethora of images – narrative *istorie*, moralised mythologies and single exemplary figures – now jostled for space with more standard devotional subjects. They were also installed in such a way as suggest the appearance of ancient rooms. The two paintings by the Stratonice Master (fig. 57–8), painted for the fronts of *cassoni*, are excellent examples of the exploration of this new artistic terrain. They tell the story of the sick Antiochus and his love for Stratonice, a tale that comes from Plutarch's *Life* of Demetrius (ch. 38), probably as translated and embellished by the Florentine Donato Acciaiuoli, whose translations were much appreciated in the humanist circles of Cardinal Francesco Piccolomini.[11] They can

also be taken as a kind of manifesto for the appearance of the ideal Renaissance palace interior, filled with paintings and sculptures – a *David* in the courtyard, pictures and reliefs in *all'antica* frames on the walls, and images of beautiful women set into bed-heads, one, rather like Girolamo di Benvenuto's *Delphic Sibyl* (cat. 49) brandishing a flaming cornucopia. LS

1 See A. Angelini's introduction in Angelini 2005, p. 14.
2 Banchi 1882; C.B. Strehlke, 'Art and Culture in Renaissance Siena' in Christiansen, Kanter and Strehlke 1988, pp. 38–9; M. Caciorgna and R. Guerrini 'Imago Urbis. La Lupa e l'immagine di Roma dell'arte e nella cultura senese come identità storica e morale' in Santi and Strinati 2005, pp. 99–118; A. Angelini, 'Templi di marmo e Tavole quadre. Pio II e le arti nei *Commentarii*' in Angelini 2005, pp. 33–4.
3 Santi and Strinati 2005, pp. 136–7, no. 1.12.
4 Biblioteca Comunale degli Intronati, Siena, ms. A.VI. 8–9; Garrison 1993, pp. 23–58; K. Cestelli in Santi and Strinati 2005, p. 119, no. 1.1.
5 Avesani 1964, pp. 1–87; K. Cestelli in Santi and Strinati 2005, pp. 120–1, no. 1.2.
6 Caciorgna 2004, pp. 29–33; K. Cestelli in Santi and Strinati 2005, p. 135, no. 1.11.
7 K. Cestelli in Santi and Strinati 2005, p. 128, no. 1.7.
8 A. Angelini, 'Antonio Federighi e il mito di Ercole' in Angelini 2005, p. 144.
9 Webb 1996, p. 253.
10 Milanesi 1854–6, II, pp. 235–6; G. Borghini in Brandi 1983, pp. 145–349.
11 M. Caciorgna, '"Mortalis aemulator arte deos". Umanisti e arti figurative a Siena tra Pio II e Pio III' in Angelini 2005, esp. pp. 168–9.

Francesco di Giorgio Martini and Antiquity

39.

FRANCESCO DI GIORGIO MARTINI
(1439–1501)

Incipit illuminations for the
De animalibus by Albertus Magnus
with a scene of a unicorn tamed by
a virgin and, in the right border,
roundels with Hercules and the
Nemean Lion, Hercules and the
Lernean Hydra, and Hercules and
the Centaur Nessus, about 1463 or
about 1470

Tempera and gold on parchment, 39 × 28 cm
Museo Aurelio Castelli, Basilica dell'Osservanza,
Siena (3, f. 1r)

The illuminations on the first page of this manuscript, first ascribed to Francesco di Giorgio by Perkins, have come in recent years to be regarded as blazoning a new, properly Renaissance taste for the Antique in Siena and epitomising a desire there during the years of Pius II's pontificate to emulate classicising trends in Florentine art. They ornament a copy of the Aristotelian compilation of zoological knowledge by the Dominican saint Albertus Magnus (about 1193–1280), an extraordinary compendium of received knowledge of the natural world, full of information on its medicinal utility to man. It was one of several Albertus Magnus manuscripts commissioned, presumably as working tools, by the doctor and professor of medicine Alessandro Sermoneta. Sermoneta taught at the university of Siena in the 1450s and later had teaching positions in Perugia, Pisa and Padua, though without ever losing contact with his native city.[1] His fame was very great – enough to place him on good

terms with both Lorenzo de' Medici in Florence and Federico da Montefeltro, Duke of Urbino, who was his guest in Siena in 1478. Sermoneta had the bulk of his manuscripts copied between 1445 and 1470, when he began to buy printed books.

Since a note at the end of the manuscript announces its completion by Conrad, the German or Netherlandish scribe, in 1463, Francesco di Giorgio's illuminations are almost always dated to about the same year. The dating is supported by the dependence of Francesco's dynamic Hercules roundels upon three lost canvases by Antonio Pollaiuolo, painted in 1460 for the Palazzo Medici in Florence. These roundels have generally received more attention than the primary illumination – a unicorn tamed by a virgin, dressed in her 'plum-red gown'[2]– because they are viewed as representing the start of Francesco's concern with the nude in action. Polliaiuolo's paintings were more important at this stage in Francesco's career than any first-hand antique source. Francesco may also have studied Florentine manuscript ornament: the roundels resemble the fictive carved cameos that regularly appear in Florentine borders.[3]

His reliance on local sources was none-theless just as strong: he looked especially at two marble reliefs by Pius's favourite sculptor Antonio Federighi, representing Hercules's battles with Nessus and the Nemean Lion, on the Pozzetto del Sabato Santo in Siena Cathedral, which Angelini has convincingly argued should be dated a little before 1460.[4] The physical types are if anything closer to Federighi's than to Pollaiuolo's, and Francesco di Giorgio has sought, successfully, to emulate the way in which light falls on their developed

musculature. These are not the only examples of his use of sculptural precedents: the *putti* at the bottom of the page bearing the Sermoneta coat of arms come from Bernardo Rossellino's door frame of 1446 in the Sala del Concistoro in the Palazzo Pubblico. Francesco has animated them, crossing the legs of the little boy on the left, thus reducing the symmetry of the motif, and adding a curious naturalistic touch – their genitals dangling in the air.

However, despite these links to Federighi's and Pollaiuolo's works of the early 1460s, there are significant stylistic grounds – especially the facial type of the maiden – for dating Francesco di Giorgio's illumination of the page some years later than the scribe's contribution. It was not necessarily with this illumination that Francesco introduced these classicising elements into his repertoire. But his insertion of the Hercules roundels into this incipit may still be interpreted as a self-conscious effort in the wake of Pius II's papacy to make the manuscript 'antique'.

While Toledano has suggested that the overall theme for the page may be man's conquering of the passions, represented by animals – the virgin tames the unicorn; Hercules defeats the marauding beasts[5] – Hercules's presence is not justified by any passage in Albertus Magnus's text. The main illumination is warranted by a passage in the *De animalibus* (22, 144) in which Albertus Magnus describes the 'unicornis': 'The unicorn is an animal that has but moderate size for its great strength. It has a boxwood-like colour and the hoof part of its foot is split into two parts. [It] has a very long horn on its forehead which it sharpens on rocks and with which it pierces the

elephant. Neither does it fear the hunter....
They say, however, that this animal respects
virgin girls so much that when it sees them
it grows tame and is sometimes captured
and bound in a trance near them.'[6]

According to tradition the unicorn was
attracted to a virgin and her 'odour of
chastity' because of its keen sense of smell.[7]
The lion (22, 106–8) is also mentioned, and
Albertus (22, 126) describes the Bottom-like
Onocentaurus, with the head of an ass but
the body of a man, but adds, 'Some are said
to be found with the body of a horse and
the upper parts of a human'. However,
his hydra (25, 30) is not Hercules's seven-
headed monster but merely a small viper
that feeds, in a rather unlikely manner, on
the internal organs of the crocodile. Since
Hercules himself is never mentioned, the
roundels are gratuitous, not illustrations
but statements of a new aesthetic. Even if
the page cannot necessarily be connected
with the precise period of the Piccolomini
papacy, there is no doubting that it reflects
and proclaims the new taste of the 1460s
for the Antique. LS

1 Zdekauer 1894, pp. 91–2; Mecacci 1985, pp. 125–64,
 esp. pp. 126–30; Denley 2006, pp. 61, 132.
2 Weller 1943, p. 65.
3 See J.J.G. Alexander in Alexander 1994, pp. 97–8, cat. 35.
 This motif is not however restricted to Florentine
 manuscripts.
4 A. Angelini in Bellosi 1993, p. 144; A. Angelini, 'Antonio
 Federighi e il mito di Ercole' in Angelini 2005, pp. 114,
 117–18.
5 Toledano 1987, pp. 38–41.
6 Translation from Albertus Magnus 1999 edn, II,
 pp. 1539–40.
7 See Shepard 1930, p. 56.

SELECT BIBLIOGRAPHY

Perkins 1904, pp. 145–53; Toledano 1987, pp. 38–41;
L. Kanter in Christiansen, Kanter and Strehlke 1988, p. 322;
L. Bellosi in Bellosi 1993, pp. 29, 51; A. Angelini in Bellosi
1993, pp. 142–5, p. 316, cat. 10; Wright 2005, pp. 79, 80.

40.

Atlas, about 1472–5

Pen and brown and red ink over underdrawn
traces on parchment, 33 × 23.5 cm
Herzog Anton Ulrich–Museum Braunschweig,
Kunstmuseum des Landes (Z 292)

Inscribed: ORIENS (to the left of the raised celestial
disc); 'GIEMINI E MERCURIO / BRITANIA / ANNAVEN
… / MEDUSIA / VEL ORDUSIA (in red ink, in the first
segment of the disc below *Atlas*'s feet); VACHANIE /
AP[RO] AMA / SERIEQ[UE] / ARO OTHA / OEQUE /
SUDIO… (in red ink, in the second segment)

41.

A Youth standing in a Landscape,
about 1472–5

Pen and ink over traces of metalpoint (?)
on parchment, 34.4 × 24.9 cm
Gabinetto Disegni e Stampe degli Uffizi,
Florence (342 E)

One of the Titans, Atlas was condemned
for his part in their revolt against Jupiter to
bear perpetually the weight of the sky. His
body, less massive than might be expected
for a giant, his chest vulnerably rather than
heroically uncovered, twists painfully as
the heavens revolve above. His left arm is
forced backwards, armpit exposed, sinews
fully stretched. His right foot, toes splayed,
is planted firmly at the centre of the earth.
With his other limbs he fights to maintain
his balance; his tortured pose is further
destabilised by his flying hair, by the
illogical shadowing around his feet (there
does not seem to be a resolved, single light
source), by his inward-turning knees and
by the draperies that whip around him; this
is a man buffeted by the winds of fortune.
His expression of pathos – teeth bared,
eyes beseechingly raised – reveals his inner
suffering. One is tempted to interpret the
drawing as a parable of the suffering of
humankind at the hands of the gods, as
man struggles against astrologically
determined fate.[1]

The astrological intent of the drawing is
made clear by its inscriptions, though these
are incomplete. Taking as his starting-point
an image of Atlas in Michael Scot's *Liber
Introductorius* (a textbook of astrology),[2]
Francesco set out to represent the corre-
spondence of the stars in the sky (in the
upper, celestial disc) to the geography of
the earth (the lower, terrestrial disc). In
astrological theory the celestial 'patron'
determined the character of its earthly
counterpart most powerfully during the
period in its revolution through the sky
when it occupied its own 'house' – as indi-
cated in the drawing anti-clockwise from
oriens (rising): Luna (Moon) in Cancer,
Mars (on a horse) in Scorpio, Jupiter (as a
king) in Pisces, Venus in Taurus, and so on.
Each planet, except the Sun and the Moon,
has two houses, so Mars recurs in Aries
and Jupiter in what should be Sagittarius,
though Francesco actually has Pisces a
second time. He has also, for reasons one
can only guess, provided fifteen 'houses'
instead of the canonical twelve, providing
occupants for them (perhaps in some
confusion) in a manner for which there
is no textual authority. The earth below
is similarly divided into fifteen parts,
reflecting the sections above. Thus 'Gemini
and Mercury' are written in that part of the
earth, dotted with hills and little fortresses –
and identified as 'britania' – that is directly
below the celestial division in which these
signs appear.[3]

The drawing technique is exquisite and
the work is highly finished. The figure's
contours have a lovely, very slight waver,
while the volume of his body and his
swirling tunic, the latter more powerfully
drawn, is painstakingly established by short
and carefully directed pen-strokes, with
crossed hatching in areas of deep shadow.
The effort of the Titan is matched by the

effort of the draughtsman. Since many of
the same ingredients are used in the God the
Father seen in extraordinary foreshortening
at the top of Francesco di Giorgio's 1472–4
Coronation of the Virgin (fig. 5, p. 13), the
drawing of Atlas is argued by De Marchi to
be very close to this in date.[4] As he points
out, the image seems to have been stimulated
by the 'febrile fantasies' of Liberale da
Verona's manuscript illuminations of the
late 1460s and early 1470s.

Francesco's surviving drawings may be
divided into two categories – model-book
drawings to be kept as reference for the
shop, and what seem to be highly finished
so-called presentation drawings, created as
works of art in their own right, to be given
or bought by educated patrons – connois-
seurs – as examples of Francesco's *disegno*.[5]
It is into this category that, though it is
properly unfinished (possibly even aban-
doned), one would want to place the *Atlas*.
The existence of such drawings, including
the parchment sheet showing the heroine
Hippo (fig. 59), implies a new kind of
artistic patron in Siena, interested in the
process of drawing as it revealed the inven-
tive talent – the *ingenium* – of an individual
artist. This was a truly Renaissance idea,
and the generally *all'antica* subject-matter
for such drawings by Francesco di Giorgio
was appropriately demanding.

Francesco di Giorgio's Uffizi sheet
(cat. 41) was certainly just such a presenta-
tion drawing. The subject was perhaps
deliberately made difficult to determine, as
would befit a collector's piece that would
be subjected to prolonged examination. The
clues to its meaning may lie as much in the
way it is drawn as in its imagery. A beautiful
young man with flowing locks, positioned

CAT. 40

CAT. 41

to the right of the page, stands in elegant *contrapposto*, looking out of the composition. He holds together his voluminous draperies, like those worn by a saint (especially Saint John the Evangelist, though he lacks a halo or any other identifying attribute) with his proper left hand. With the forefinger of his right hand, he points towards the landscape on the left of the scene. His expression is pensive, the whole figure imbued with a gentle pathos. A river flows through the centre of composition, with a little bridge crossing it. This bridge marks the start of a gravelly road, the focus of the figure's pointing gesture, winding up a mountain studded with rocky crags and outcrops and leading to a simple church or chapel with an oculus in the façade and a *campanile* behind it, surrounded by cypresses. Behind the

figure on the right is another, easier road, running across a plane, past a farmhouse, towards the gateway of a fortified town, with a tall tower rather like a minaret (it might be domed) or the Torre del Mangia of Siena's Palazzo Pubblico.

The hatching is immensely complicated throughout, closely comparable to the *Atlas*. In the figure's cloak, areas of deep shadow are indicated by cross-hatching, diagonal crossing lines that, like the parallel hatching seen elsewhere, follow and define the fall of the draperies. There is very fine hatching in his face, lit, like the rest of the figure, from the left, the side of the church. The face is therefore turned into shadow. Shadow is important here, as is evident in its indication by straight hatching across the face rather by an attempt to follow and define the facial contours and planes. Light becomes a protagonist, emphasising the withdrawn quality of the figure. The youth's hair is left mostly unshaded, giving an impression of idealising blondness. A similar technique to that employed in the face, but much more dense, is used for the rocks, particularly dark under the overhang.

The contours of figure are the point of departure for the whole composition. They are inked over a now very faint preliminary underdrawing, probably in metalpoint; this can be seen in breaks in the inked contour, particularly where the fold of the cloak conceals the bend in the river below the pointing hand on the left, or at the wrist of the man's left hand. Indeed there are some indications that the figure was first drawn undraped. Underdrawing is visible in the left shoulder and in the upper left arm now concealed by the cloak. There does not appear to be a similar underdrawing for

the landscape, which is therefore designed around the figure and seems to emanate from him, giving a sense of complete integration. It is as if his internal emotional or mental landscape has been externalised. It seems this is a landscape about moral choices. The youth – perhaps an everyman figure – indicates that he should choose the difficult road to a virtuous, Christian life, but that it is all too easy to turn from the light. The theme, the difficult choice between virtue and pleasure, which would reappear with some regularity in Sienese art (see cat. 78), is here tackled by Francesco di Giorgio in the most sophisticated manner. LS

1 This was a theme discussed by Francesco di Giorgio. See Francesco di Giorgio Martini 1967 edn, II, p. 294; A. De Marchi in Bellosi 1993, pp. 306–7, cat. 57.
2 See Saxl 1933. I am indebted to Kristen Lippencott for her explanations of the astrology that lies behind this drawing and comments on the drawing itself.
3 The drawing is inscribed *britania beside giemini e mercurio* and Kristen Lippencott notes that in a list by Pietro Bono Avogaro of Ferrara dated February 1475, Cesena and Britain were supposed to be governed by Gemini and Mercury.
4 A. De Marchi in Bellosi 1993, pp. 312, 448.
5 For a recent account of the genesis of presentation drawings, see Chapman 2005, pp. 204–5.

Fig. 59 Francesco di Giorgio Martini (1439–1501)
Hippo, about 1472–5
Pen and ink on parchment, 29.2 × 25.4 cm
Gabinetto Disegni e Stampe degli Uffizi,
Florence (375 E)

42.

FRANCESCO DI GIORGIO MARTINI
(1439 – 1501) and assistant
Volume of designs for machines for use in peace and war: Opusculum
de architectura, about 1475–6

Pen and brown ink, brush and brown wash on
parchment, in most cases over hard brown chalk;
ten gatherings of ten leaves each,
27.4 × 22.9 cm (covers)
The British Museum, London (1947-1-17-2)

Annotated in a later hand: *fate* ['made']

43.

FRANCESCO DI GIORGIO MARTINI
(1439 – 1501)
Self portrait (?) with female attendants, about 1475–6

Pen and brown ink, brush and brown wash,
blue gouache, on vellum, 18.4 × 18.4 cm
The Metropolitan Museum of Art, New York
Robert Lehman Collection, 1975 (1975.1.376)

Annotated in pen and brown ink on lower left:
FRANC[ESC]O FRANCIA. In black chalk on the
cartouche in what seems a seventeenth-century hand:
FRANC[ESC]O / FRANCIA BOLOGNESE

This volume of designs for a huge array of machines represents an important step towards Francesco di Giorgio's celebrated *Trattato di architettura* (*Treatise on civil and military architecture*) and thus an early stage in the transformation of an artisan painter-sculptor, albeit a highly talented one, into an 'artist' – a designer, not just of works of art but of engineering projects, machinery and military, church and palace architecture. Though painters had long been given civic honours and responsibilities in Siena, there was no precedent for this new kind of 'master of design' there, and Francesco must have realised that his ambitions would be best realised through employment at a court. The rulers of Naples, Urbino, Mantua and Ferrara traditionally employed two categories of artist – specialists in architecture and engineering (with a natural emphasis on the military) and painters or sculptors whose defined individual talents would be seen as mirroring and proclaiming those of their patrons

(following the oft-cited example of Alexander the Great and his favourite artists). From the mid fifteenth century, these two roles were increasingly united, conferring on these multi-tasked artists a status akin to those of court humanists or poets, other practitioners of the liberal arts. Francesco di Giorgio must have realised that his talents as a figurative painter and sculptor would not in themselves be enough to attract the attentions of a prince. Francesco had had some experience of practical hydraulics and mapping. On 28 April 1469, Francesco di Giorgio '*depintore*' and Paolo d'Andrea (also probably a painter) were appointed *Operai dei Bottini* (Officers of Waterworks).[1] Paid an annual salary of 3200 lire, they had the task of augmenting by a third the water supply in the Campo. They remained in post until June 1472. In 1470 Francesco was paid two lire for drawing and colouring a map of Monte Vasone, a hill in the comune of Casole d'Elsa.[2] But these activities were still some way from what he would be called upon to do by a dynastic ruler. Yet, by 17 May 1477, Francesco was working for Federico da Montefeltro, Duke of Urbino, on the construction of the Castello di Costacciaro near Gubbio, and in 1480 Federico could call Francesco, '*mio dilettissimo architetto*' ('my dearest architect').[3] This volume of drawings seems to have been an important tool in obtaining his newly elevated position. Francesco di Giorgio was a very different figure when he returned to Siena in 1487.

The book contains 81 parchment sheets, many drawn on both sides, with designs for pumps, siphons and watermills, windlasses, battering rams, *trébuchets*, pontoons and other bridges, paddleboats, ships and galleys

with weapons, cranes or armaments; devices for walking on or under water, hoists, wheeled cars, hauling mechanisms, methods of exploding mines, artillery, harbour defences, scaling ramps and ladders, gun-mounts, plans of fortresses and a labyrinth. While most of these would not today come under the category of 'architecture', Vitruvius had discussed many such devices, creating a useful classical model and reinforcing Francesco's claims to a new status. The binding is not original; nor, though old, is the current pagination.

The designs are prefaced by a dedication, at the beginning of the second gathering, making self-conscious reference to Alexander the Great and his '*architectus*' Dinocrates. The first two lines of the dedication are almost entirely erased, but they can be reconstructed by reference to an early sixteenth-century copy of almost the entire manuscript in the Biblioteca Reale, Turin (Serie Militare 383, formerly no. 14856 D.C.).[4] This shows that the modestly titled '*Opusculum* [small work] *de architectura*'[5] was dedicated to Federico da Montefeltro as Duke of Urbino. The drawings can therefore certainly be dated between 1474, when Pope Sixtus IV made Federico a Duke, and Federico's death in 1482. However, the vocabulary of the dedication suggests that it should be interpreted as a *captatio benevolentiae* – an advertisement of skills appropriate to court employment: it would therefore have been written in the period when Francesco di Giorgio was trying to join Federico's court, rather than after his arrival. It was a more elaborate equivalent of the famous early 1480s letter of self-recommendation by Leonardo da Vinci to Lodovico Sforza in Milan, emphasising

CAT. 42

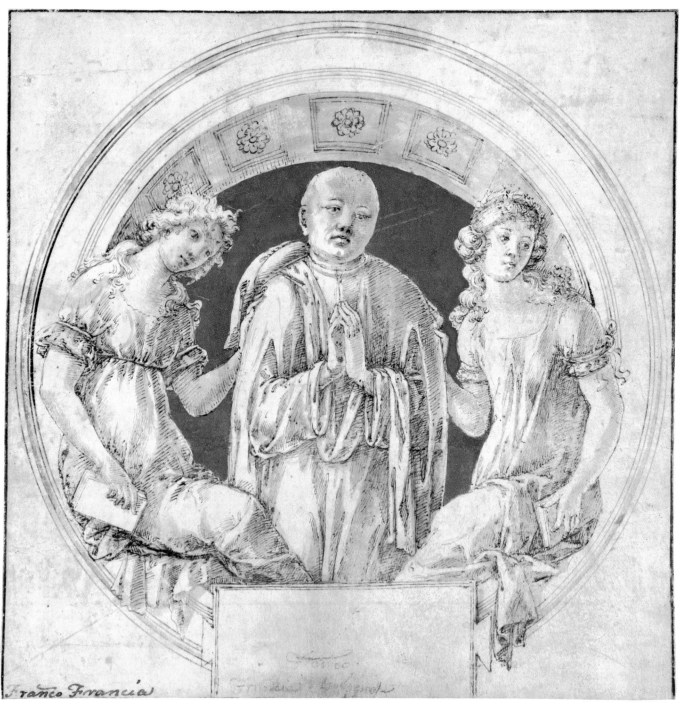

Franco Francia

engineering and architectural skills over painting and sculpture. On these grounds the *Opusculum* is datable to shortly after 1474 and not later than 1477, by which time Francesco di Giorgio was certainly living in Urbino.

Most of the drawings in the *Opusculum* are by an assistant, but in those half dozen that include animal or human figures (ff. 2, 32, 45, 49v, 55v, 77) the figures are fully autograph. If Francesco was keen to demonstrate his architectural knowledge to the Duke of Urbino, his decision to draw the figures himself shows that he also wished to indicate the source of his talent – his *disegno*. He had already made a series of presentation drawings for patrons, primarily demonstrations of his inventive talent (see cat. 40–1). His drawing of a winged male figure on a chariot in the *Opusculum* (f. 32r) seems intended to make the same point. Unlike the vast majority of the drawings in the *Opusculum*, it does not appear in subsequent versions of the *Trattato*. Indeed, since it is not a working diagram for a machine of any practical use, it would have been odd if it had. But it works brilliantly as a reminder of Francesco di Giorgio's knowledge of and debt to the ancient world, a prompt calculated to appeal to Federico da Montefeltro, famously both a warrior and a humanist scholar. The figure is beautifully drawn, using Francesco's standard method of graceful, slightly nervous contour lines and parallel hatching, crossed only in the deep shadow at his groin. He has previously been identified as Mars, but the god of war does not have wings. Its precise subject remains obscure, in line with Francesco's presentation drawings; it seems to combine motifs derived from various sources including

Petrarch's *Trionfi* not least the chariot itself. A winged male nude often represents Love and his pose is reminiscent of Love in Gherardo di Giovanni del Fora's *Combat of Love and Chastity* (National Gallery, London). But Love is normally armed with a bow and arrow, rather than a sword, which can stand for Justice or here more probably for Death. Other elements also seem to refer to Death or Time: among the attributes of Chronos (or Saturn) were a dragon with his tail in his mouth and the scythe, here moved to the wheels of the chariot. The horses race forward unbridled, as befits Time's chariot, and it seems that Francesco has created an allegory of Time out of an instrument of war.

It is proposed here that the Lehman drawing (cat. 43) of a balding man framed by an oculus and flanked by two beautiful women in classical costume, holding books, was once part of the *Opusculum*, for it is in a similar style, therefore of the same date and on a sheet of exactly the same width. While any other use or purpose that has been proposed for it seems unsatisfactory, its resemblance to Buggiano's cenotaph honouring the great architect Filippo Brunelleschi in Florence Cathedral is noteworthy; and Francesco might well have chosen to adapt such a prototype for his own self portrait. He added the attendant figures in order that they should present the two volumes, one perhaps referring to his work on machines, the other to his architectural treatise or to an explanatory text. Francesco di Giorgio may not have been primarily the 'humanist and writer' frequently suggested in the literature hitherto as the subject of this portrait, but both terms are applicable to his theoretical

work, and are just the aspects of his career he would have stressed to his potential patron, the Duke of Urbino, to whom he pays obeisance. Like the winged charioteer, the page appears in no other version of the *Opusculum*. LS

1 Weller 1943, pp. 340–1, doc. V, VI. This was almost certainly the 'Pavolo d'Andrea dipintore' who in 1466 had executed nineteen '*lettiere dipinte*' (painted beds) for the Hospital of Santa Maria della Scala; see Gallavotti Cavallero 1985, p. 430, doc. 380.
2 Weller 1943, p. 341, doc. IX. Measurements had been made by Mariano di Matteo (paid four *lire*).
3 Weller 1943, p. 349, doc. XXXV.
4 See M. Mussini in Fiore and Tafuri 1993, pp. 377–8, cat. XXI. 15.
5 This modesty is typical of such dedications.

SELECT BIBLIOGRAPHY

Cat. 42 Popham and Pouncey 1950, pp. 32–8; M. Mussini, 'La trattatistica di Francesco di Giorgio: un problema critico aperta' in Fiore and Tafuri 1993, pp. 358–9; *Cat. 43* L. Kanter in Christiansen, Kanter and Strehlke 1988, pp. 325–7, cat. 68; Forlani Tempesti 1991, pp. 202–7, cat. 70; A. De Marchi in Bellosi 1993, pp. 312–13, cat. 60.

44.

FRANCESCO DI GIORGIO MARTINI (1439–1501)
A Scene of Conflict (Lycurgus and the Maenads?), about 1474–80

Cast stucco with neutrally coloured surface coating, 50 × 60 × 5 cm
Victoria and Albert Museum, London (251-1876)

This work is an object of mystery. The subject, if any, has proved difficult to determine, and its function has remained to all intents and purposes unexplored. It is one of two surviving examples of the relief, both cast in stucco or a similar material. The other is to be found in the Chigi Saracini Collection, Siena (MPS 291). Always previously classified as Florentine, with various names suggested, it was first ascribed to Francesco di Giorgio by Schubring.[1] His opinion is now universally accepted, though a few diehard supporters of an attribution to Leonardo da Vinci have continued to state their case.

Their stucco medium makes these pieces unique within Francesco di Giorgio's oeuvre. This was not an unusual material for images of the Virgin and Child or other devotional subjects, which might be purchased even at the top of the market. These multiple casts, reproducing a single model (sometimes with slight variations), were pioneered in the workshops of the Florentines Lorenzo Ghiberti and Donatello in the first half of the century and it should not be assumed that all of them reproduce more costly bronze or marble originals. The technique was taken up in Siena, where *cartapesta* (papier-mâché) was an equally popular material for making serial replicas (see cat. 52). These works were normally coloured. Here the monochrome coating suggests a desire to evoke marble, though its primary function may be only to preserve the fragile surface. It was not therefore an expensive object, and its chief value lay in its artistry. It is therefore rather hard to imagine these pieces in the palace interiors of any but the most enlightened of Francesco's rich clients and in fact the

Petrucci owned a '*quatro di gesso*' in 1514, which might conceivably be this object.[2] Vasari mentions 'a low relief in metal' by the Florentine Antonio del Pollaiuolo, of which there could be found 'an impression with every craftsman in Florence', and Francesco may also have always intended that the present relief should be cast in a multiple edition, with the workshops of his contemporaries particularly in mind, in order to publicise his talent.

Stored and studied in artists' workshops, such casts functioned as lexicons of gesture and movement, providing a range of motifs that could be imitated and inserted into their own works. The specific meaning of such a piece was anything but paramount. Indeed its principal subject might be its own design and making, and particularly the capacity of a particular master to show the human figure in action. Francesco's relief, more than any of his other sculptures, fulfils this demand. It contains a huge number of figures, densely interlocked, in a great variety of poses. Perhaps the most impressive is the central female figure, 'a Fury with hair as of tossing serpents' who 'whirls across the foreground',[3] twisting back on herself as she runs, her draperies swirling wildly around her legs. She is sometimes interpreted as controlling events, or is seen by others as in flight. Whether victim or aggressor, she is the focus of the composition and seemingly one of its two main protagonists; the other appears to be the man on the right, whose stance is contrastingly stable, his arm extended in what may be a pleading gesture, holding – perhaps concealing[4] – his sword behind his back. This play between violence and calm is one of the oft-repeated keynotes of the piece.

In arriving at these poses, Francesco di Giorgio continued to look at works by the older Sienese sculptor Antonio Federighi: the figure reclining in the bottom right corner, pushing out beyond the frame, is loosely derived from Federighi's *Hercules* on the arm of his bench at the Mercanzia Loggia, a figure that was much admired in Siena. However, as has often been stated and as earlier attributions suggest, the relief is also strongly Florentine in flavour. The impact of Donatello has been stressed most recently.[5] The work contains the sense of arrested movement that is a defining characteristic of Donatello's narrative relief sculptures, leaving the protagonists in sometimes ungainly poses. The work has also been seen as a determined effort to compose with the *varietas* advocated in the treatise *On Painting* by Leon Battista Alberti (for whose impact in Siena see pp. 31, 140).[6] In Florence in particular, battle scenes were to become the traditional locus for experiment and the display of artistic *ingegno*. Bertoldo di Giovanni's bronze battle piece in the Medici Palace was just such a demonstration, a work with no discernible subject. So too was Antonio del Pollaiuolo's celebrated print of *The Battle of Nude Men*, engraved in about 1470. This work is often cited as a key model for Francesco.[7] Like this relief, the print was also, of course, a multiple – made for the collectors' market as well as to function as an exemplar for other artists to follow. Francesco di Giorgio, however, adds the elements of ambitious perspective and architectural design,[8] making a particular point about the nature and extent of his talents as a designer. The classical buildings – themselves particularly various – are in fact crucial for the way the

composition works. As Weller explained, the often frenetic activity is controlled by architecture, creating 'a sort of straining stability'.[9]

Apart from the central figure and an armoured man standing before the throne on the right all the protagonists are nude, an important factor if the relief was to be useful for other artists. Thus it is not difficult to spot what is an unusual feature for images of this kind – that the battle is enjoined between men and women, the women on the losing side. This element is quite specific, and, since the work also has a defined architectural setting, the scene has a sense of temporal reality that the similar works by Bertoldo and Pollaiuolo lack. There was no shortage of ancient precedent. Battles with Amazons were a common subject for Roman sarcophagus reliefs, including a celebrated example in Cortona that seems to have informed Francesco di Giorgio's work.[10] The prostrate female figure in the left foreground, arms dreadfully splayed, is derived from this relief. Francesco di Giorgio was employed in Cortona to build the church of Santa Maria del Calcinaio from 1484–90, though he may well have visited the town some time before.

The victims in cat. 44 are not, however, Amazons, since they are not armed and their resistance is so ineffectual. Their sex therefore demands another explanation. The presence of a ruler or judge figure (as in cat. 27, 33) again suggests that Francesco di Giorgio was here seeking to represent a defined subject. It is worth revisiting Panofsky's idea that he depicted the murder of the Maenads by Lycurgus (in Greek Lykurgos),[11] though it has been treated rather dubiously in most of the recent

literature. The story was mentioned by Homer (*Iliad*, VI, 130–5) and more fully related by Nonnus in the *Dionysiaca* (XX, 182–373) and by Diodorus Siculus (III, lxv, 4–6). Boccaccio also recounted the legend in his *De genealogia deorum* (XI, 22–X).

Among these texts, all known in the fifteenth century, Francesco may have used as his key source Diodorus Siculus. The text was widely available. It had been translated into Latin by Poggio Bracciolini, and published in Bologna in 1472. A copy of this book could be found in the ducal library at Urbino, but must certainly have been available in Siena too. According to Diodorus Siculus, 'When Dionysus was on the point of leading his force over from Asia into Europe, he concluded a treaty of friendship with Lycurgus, who was king of that part of Thrace which lies upon the Hellespont. Now when he had led the first of the Bacchantes over into a friendly land, as he thought, Lycurgus issued orders to his soldiers to fall upon them by night and to slay both Dionysus and all the Maenads, and Dionysus, learning of the plot from a man of the country who was called Charops, was struck with dismay, because his army was in the other side of the Hellespont and only a mere handful of friends had crossed over with him. Consequently he sailed across secretly to his army, and then Lycurgus, they say, falling upon the Maenads in the city known as Nysium, slew them all, but Dionysus, bringing his forces over, conquered the Thracians in a battle, and taking Lycurgus alive put out his eyes and inflicted upon him every kind of outrage, and then crucified him. Thereupon, out of gratitude to Charops for the aid the man had rendered him, Dionysus made over to him the kingdom

of the Thracians . . .'.[12] If this is the story told, the staff of the mysterious central figure would be the *thyrsus*, the holy wand, of the Maenads, and would be an important key to identification of the story. An educated viewer might have recognised these literary sources. But, as Alison Wright has argued, the relegation of main enthroned figure, only possibly Lycurgus, to the middle ground gives the work an 'apparently open meaning', a feature that, beyond the stylistic affinities, links the piece to Pollaiuolo.[13] In this way, the relief might appeal simultaneously to two audiences – a humanist élite, and artists who wished to quarry the piece for figurative ideas. LS

1 Schubring 1907b, p. 186.
2 I am grateful to Philippa Jackson for this information. She will shortly be publishing an inventory of the contents of Pandolfo's palace.
3 Brinton 1934–5, II, p. 96.
4 Pope-Hennessy 1964, I, p. 268.
5 G. Fattorini 'Dalla "historia d'attone pel Battesimo" a "le porti di bronzo del Duomo": Donatello e gli inizi della scultura senese del Rinascimento' in Angelini 2005, pp. 65–6.
6 See C. Cieri Via, 'Disegno e ornamento nell'opera pittorica di Francesco di Giorgio Martini' in Fiore 2004, p. 238.
7 See, most recently, Wright 2005, pp. 415–16.
8 For this see Daniele 'Francesco di Giorgio e la prospective: tra sperimentazione e percezione' in Nazzaro 2004, pp. 36, 38.
9 Weller 1943, pp. 158.
10 Pray Bober and Rubinstein 1986, pp. 180–1, no. 144.
11 Panofsky 1924, p. 189–93.
12 Diodurus (III, 65, 7) states that Lycurgus was also thought to be king of Arabia, and the attack to have been made at Nysa there.
13 Wright 2005, pp. 415–16.

SELECT BIBLIOGRAPHY

Schubring 1907b, p. 186; Brinton 1934–5, II, p. 96; Weller 1943, pp. 154–61; Pope-Hennessy 1964, I, pp. 266–8, no. 282; G. Gentilini in Gentilini and Sisi 1989, pp. 100–10, no. 20; G. Gentilini in Bellosi 1993, pp. 346–493, cat. 67; Wright 2005, pp. 415–6.

45.

Portrait medal of Borghese Borghesi (1434–1490) with a figure of Minerva on the reverse, 1479–80

Cast bronze, 6.2 cm diameter
Graham Pollard, on loan to the Fitzwilliam
Museum, Cambridge

Obverse inscription: BVRGHESIVS SENEN[SIS] ·
EQVES IVRIS VTR[IVSQVE] · CONSVLTISS[IMVS] ·
P[ATER] P[ATRIAE] ·
Reverse inscription: INGENIO MORTALI INGENIVM
PRAEBVIT IMMORTALI DEA ORTA
(The goddess born of an immortal has offered her
genius to a mortal talent)

46.

Portrait medal of Giacoppo Petrucci (1434–1497), about 1487

Cast bronze, 5.4 cm diameter
Museo Nazionale del Bargello, Florence (6116)

Obverse inscription: IACOB[VS] PETRVCCIVS
SENEN[SIS] DE RE P[VBLICA] B[ENE] M[ERITVS].
Reverse inscription: HVNC IVRE AD NOVEM COELOS
EXTOLLAM (Rightly shall I raise this man to the
nine heavens)

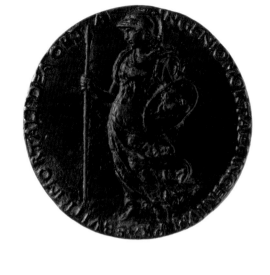

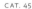
CAT. 45

These medallic records of the features of the Sienese citizens Borghese d'Agostino Borghesi and Giacoppo di Bartolomeo Petrucci are very unusual. The almost total absence of portraits of the inhabitants of fifteenth-century Siena is a defining feature of the art of the city. Whereas members of the Florentine patriciate had themselves portrayed with increasingly regularity from the late 1430s, the Sienese eschewed both autonomous panel portraits and donor or bystander portraits in altarpieces and frescoes. Indeed there were probably fewer portraits in Siena, painted or sculpted, than in any other major city-state of the Italian peninsula. Portrait medals might have been perceived by the Sienese as reviving the ancient Greek and Roman commemoration on coins of their kings and emperors – or their tyrants, to adopt a Sienese, republican perspective. Again, from the 1430s on, medal-making was primarily associated with the dynastic rulers of Naples and North Italy and their courtiers, and consequently was not regarded as an appropriate mode of representing the citizens of republics. Thus the manufacture of these two portrait medals – both correctly attributed to Francesco di Giorgio – becomes the more remarkable.[1]

The medal of Borghese Borghesi dates to the years immediately after the Pazzi

War, a period of turmoil that culminated on 7 September 1479 with the defeat of Florence by the allied forces of Pope Sixtus IV, Naples and Siena at the battle of Poggio Imperiale in the Val d'Elsa. During this period the Sienese fought alongside Federico da Montefeltro, Duke of Urbino, Francesco di Giorgio's employer and the '*generale*' of the Pope's army, and Alfonso, Duke of Calabria (eldest son of Ferrante, King of Naples), the '*capitano generale delle genti del re di Napoli*', whose political ambitions in Tuscany were to shape events in Siena in the months to follow. Although trained as a lawyer, Borghesi had been '*commissario generale*' of the Sienese army at the battle,[2] and his involvement was immediately rewarded both by a knighthood conferred by the Duke of Calabria and, seemingly, by his being named '*pater patriae*' (father of the fatherland), by the Sienese state, adapting an ancient Roman republican honorific.[3] Both new titles are commemorated by the obverse inscription of the medal. As early as 1649 Urgurgieri Azzolini stated quite explicitly: '[Borghese] was with great honour publicly knighted . . . a dignity that was conferred by public decree of the Sienese Republic . . . which struck medals in his honour'.[4]

Ostensibly these honours, medal included, celebrated Borghesi's valour at Poggio

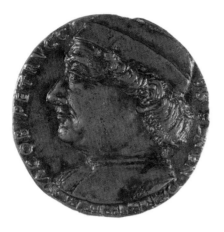
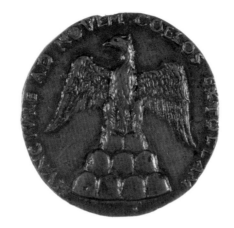

CAT. 46

Imperiale. His military proficiency is signalled by the medal's reverse, showing Minerva, the goddess of war, and also perhaps physiognomically by the stout, rock-solid portrait (though Sigismondo Tizio, writing in 1506–28, saw the medal rather differently: 'He was gross in build (*Crasso fuerat corpore*)'. Nevertheless such a proclamation, in republican Siena, of the bravery of an individual citizen on a medal should be set against the political consequences of the victory – the close alliance of the city (or factions within it) with two dynastic regimes, Urbino and especially Naples. This alliance of interests is reflected in other medals by Francesco. His medal of Borghesi was made at the same moment as pieces commemorating Federico da Montefeltro and Alfonso of Calabria. The medal of Alfonso was executed in Siena and can be connected with the recent victory; the reverse depicts him sacrificing a bull to Mars and bears the inscription 'On Poggio Imperiale, taken by force'.

Thus Borghesi's medal connected him to the two dukes – a triumvirate in war, but also in the peace to follow. (Minerva stood not just for soldierly talent, but also for wisdom.) Borghesi's public stature was to be exploited politically by the Duke of Calabria. In early 1480, he was one of the ambassadors sent to parlay with the Duke,

then at Buonconvento, and he became a leading member of the new regime that took power in the wake of the victory, dominated by pro-Neapolitan members of the *Nove* and actively sponsored by the Duke.[5] At the time of Poggio Imperiale, Siena had been ruled by the *Riformatori*, who had controlled the city since 1456. In the wake of the defeat of Florence, this government's historically pro-Florentine, 'Guelph' foreign policies became unsustainable, at odds moreover with the Duke of Calabria's political schemes for Siena. Many leading members of the *Nove* were, on the other hand, still in exile in 1479, and their readmission thus became an Aragonese priority. Borghese Borghesi's prominent membership of the *Nove* was therefore of great political significance. The Duke of Calabria, secretly conferring with *Nove* intimates, played a clever hand, presenting himself as the defender of Sienese liberty. He argued that the return of the exiles would calm the city. When this was rejected, he and his allies fostered riots, actively supported by Neapolitan troops, on the night of 20–1 June 1480. To keep the peace Borghesi came forward to urge that the *Riformatori* should be excluded from government, and the *Nove* returned. If, by this means, Alfonso hoped to make himself Siena's ruler,[6] his plans came to nothing,

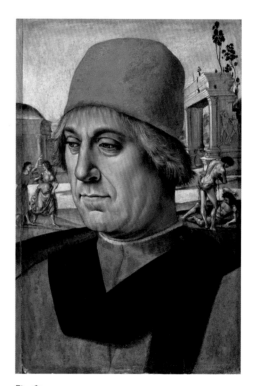

Fig. 60
Luca Signorelli (about 1440/50–1523)
Portrait of a Man (*Giacoppo Petrucci?*), about 1490
Oil on panel, 50 × 32 cm
Gemäldegalerie, Staatliche Museen, Berlin
(79 C)

because on 5 August 1480 he learnt of the fall of his city of Otranto, in Puglia, to the Turks, and left Siena in a hurry.

Giacoppo Petrucci was Borghesi's exact contemporary. His medal has a reverse showing a mountain made up of nine hummocks – the *monte dei Nove* – over which an eagle, standing for the Holy Roman Empire, spreads its protective wings. The city of Siena had a long pro-Empire – Ghibelline – tradition, one that was embraced from the early fifteenth century by the *Nove* and made manifest by its alliance with Ghibelline Naples.

The portrait seems better resolved than that of Borghesi, placed with greater conviction within the circumference of the medal, making it likely that it was executed somewhat later. The political message of the medal is explicit: it declares Giacoppo's loyalty to the *monte dei Nove*, to Naples and, more broadly, the city's and the party's Ghibelline stance. During the period of the Duke of Calabria's political machinations, in spring 1480, Giacoppo Petrucci was still exiled in Pisa with the rest of his family. However, he was said at the time to have been kept fully informed of events in Siena. Members of the Petrucci family had appar-ently re-entered Siena before the events of June 1480, but it was Giacoppo's father Bartolomeo, rather than Giacoppo himself, who was included in the new government.

Certainly Giacoppo was a prominent member of the new regime, and he continued to work in Alfonso's interests even after the Duke was forced south. Giacoppo Petrucci took on political importance when Alfonso was forced to seek Florentine support against the Turks, the price of which was the return of its territories lost after Poggio Imperiale.

After these had been handed back, the problem remained of those Florentine towns that had been given to Siena. Peace with Florence was highly desirable and Giacoppo Petrucci met Lorenzo de' Medici in September 1481,[7] informing him that some leading citizens were willing to return these towns but 'the only problem was keeping the people sweet'. His negotiations with Lorenzo and Naples continued in secret even after Siena had voted to retain these territories. The new government could not resist these internal pressures, collapsing in early 1483 to be replaced by a regime dominated by the *Popolari*. Borghese Borghesi was able to maintain his position, but in April that year Giacoppo Petrucci and the most pro-Naples *Noveschi* were once again exiled. They would return only in 1487, when this medal has most recently been dated.[8] After the return of the *Nove*, Giacoppo was one of the most important members of a new government over which his younger brother Pandolfo would eventually wrest control (see p. 61). In favour of a dating of about 1487 is the close similarity of the sitter's features to those of the subject, hitherto anonymous, of a celebrated portrait by Luca Signorelli now in Berlin (fig. 60).[9] If this, too, represents Giacoppo Petrucci, it must date to about 1490 indeed, since Signorelli arrived in Siena then, a time when he was collaborating with Francesco di Giorgio (see cat. 58–9). LS

1 These medals were first grouped together by Georg Habich. Habich 1923, pp. 65–6, 152.
2 Terziani 2002, p. 58.
3 No documentary confirmation of this latter honour has yet been traced. But in 1479 his cousin Niccolò Borghese was *Capitano del Popolo* (Captain of the People), making it possible that he was able to push

through civic honours for his relative. See Shaw 1996, pp. 9–102, esp. p. 38. The ancient title of *pater patriae* had been conferred in Florence upon Cosimo de' Medici, il Vecchio, after his death in 1464, an event also marked by the commission of a medal. See Hill 1930, I, pp. 236–7, no. 909.
4 Urgurgieri Azzolini 1649, p. 443.
5 For what follows see Prunai and De Colli 1958, p. 64; Gennaro 1970, pp. 583–4; and, most usefully, Shaw 1996, pp. 9–102, esp. pp. 13–23.
6 On 25 June 1480 in Ferrara there was a great celebration because the Duke of Calabria *'s'era fatto signore'* (had made himself lord) of Siena.
7 See Medici 1977–2004 edn, VI, pp. 86, 109, 118, 168, 233–4, 255.
8 R. Bartalini in Bellosi 1993, p. 400–1, cat. 83.
9 Dated about 1489–91 by Henry and Kanter 2002, pp. 114–5, 174, no. 20. The portrait has been variously identified in the past; the sitter is sometimes considered to be wearing legal costume.

SELECT BIBLIOGRAPHY

Cat. 45 R. Bartalini in Bellosi 1993, pp. 358–9, cat. 71;
Cat. 46 R. Bartalini in Bellosi 1993, pp. 400–1, cat. 83 (Museo Civico, Siena, 1061).

47.

FRANCESCO DI GIORGIO MARTINI (1439–1501)
Male Nude with a Snake (Aesculapius?), about 1490–5

Cast bronze, with black lacquer patination, height 113 cm
Skulpturensammlung, Staatliche Kunstsammlungen, Dresden
Acquired in 1763 from the legacy of Count Henry of Brühl (H² 21/78)

The size and medium of this bronze sculpture, combined with its dancing vibrancy, admirably convey the Sienese response to the art of the ancient world at the end of the fifteenth century.[1] The heroic nude, already variously interpreted by ancient Roman and contemporary Florentine sculptors, has been converted into something elegantly wrought and thrillingly alive. The work is thoroughly modern but still contains echoes of the twisting, stylised forms of sculptures by Vecchietta or even by Giovanni Pisano (about 1250–1314) from the façade of Siena Cathedral. Measured against its classical prototypes, the figure is off-balance, standing in a questing, enquiring pose, his head turned almost quizzically as he contemplates the snake held in his hand and loosely coiled about his arm (the serpent's head, like the man's left forefinger, is now missing).[2] Both heels are raised, reinforcing an impression of the figure's buoyancy. Some areas of the sculpture are generalised, allowing the eye to skim quickly over its surface, an eager energy of viewing paralleling the liveliness of the pose. In achieving this effect, anatomical accuracy was not a primary concern. The body is slim, the legs proportionately longer than the rest of body, and the musculature in the torso flows and ripples like water over a riverbed. The mane of hair, with knotted forelock and bands tied around the back of the head to control the mess of cascading locks, is wonderfully dynamic. Other parts are highly specific. The wrinkles in the forehead, the bushy eyebrows, the tightly curled beard and the crows' feet at the corners of his large empty eyes arrest the viewer, creating a pause to absorb the message of the man's expression. The parted lips, revealing the teeth, suggest

wonder. These naturalistic details are combined with elements that celebrate the joy of sinuous contour, seen in the piquant line of his nose and the ears curving forward like amphora handles.

Clearly intended to be seen in the round, this bronze, it has been suggested, was originally set up as a fountain figure.[3] The surface of the bronze is somewhat blemished, especially in the legs – damage that may have been caused by water as it splashed up around the feet and calves. Indeed it is possible that the idiosyncratic musculature might be explained in part by the sculptor's knowledge that light would be directed at the body both directly from above and indirectly as it reflected off the water below. It is suggestive that another work, unquestionably intended for a fountain, *Mercury taking Flight* by the Florentine Giovanni Francesco Rustici (Fitzwilliam Museum, Cambridge), though smaller and of a slightly later date, has a rather similarly modelled torso.[4]

A better clue to the figure's identity comes perhaps from its primary source. While the facial type imitates those of Antonio Pollaiuolo's various representations of Hercules, the pose of the whole upper body is derived from the famous ancient marble now known as the *Apollo Belvedere*, although Francesco has reversed the legs – the stable, stepping-forward right leg of the *Apollo* is now the figure's left – to give the bronze its airy, balletic effect. Francesco must have seen this sculpture during one of his visits to Rome in the early 1490s, the probable date of his drawings after the Antique. The location of the *Apollo* before about 1497, when it could be seen in the garden of Cardinal Giuliano della Rovere

at San Pietro in Vincoli, is not known, but there is no reason to think that it was not already visible in Rome a few years earlier.[5] Is Francesco's statue also an Apollo? The god could certainly be associated with a serpent: there is a snake on the tree stump supporting the right leg of the Apollo Belvedere. Once again, however, if this were Apollo, it should surely be a scene of conflict, showing him wrestling with the Python to take control of the oracle at Delphi. Moreover, Apollo himself is never bearded.

Nevertheless, the notion that Francesco di Giorgio's sculpture has an Apollonian paternity suggests an alternative route. Berenson and others accepted Schubring's other idea of 1907, that this is the god of medicine, Aesculapius,[6] who was actually the son of Apollo (and the nymph Coronis), just as Francesco di Giorgio's statue was the child of the *Apollo Belvedere*. Aesculapius (in Greek Asklepios) was declared by an oracle to have been born in Epidaurus in Argolis, where his most famous shrine was later built. He was taught the art of healing by the centaur Chiron and his skill in curing illness and re-awakening the dead roused the ire of Zeus, who, afraid that he might make all men immortal, killed him with a thunderbolt (Apollodorus, III, 10; Pindar, *Pythian Odes*, 3; Diodorus Siculus, IV, 71), but conferred on him another immortality by placing him in the heavens as the constellation Ophiuchus or Serpentarius, the Snake-bearer.[7] A snake makes two appearances in his myth. Aesculapius's best-known patient was Glaukes, another victim of Zeus's thunderbolt. When a snake came crawling into the room of the dead man, Aesculapius slaughtered it with his staff.

But when a second serpent slithered into the chamber and placed herbs into the mouth of its dead companion, bringing it back to life, Aesculapius used the plants to revive Glaukes. After spreading across Greece, the worship of Aescupalius was introduced to Rome on 1 Januarius, 291 BC, to ward off plague. The god was fetched by ship from Epidaurus in the form of a snake: the serpent is said to have slipped from the image of the god and followed the Romans through the streets to their ship. At the mouth of the Tiber the serpent slipped overboard and at the point where it swam ashore, on the Tiber island, the new temple was established (Livy, X, 47; Ovid, *Metamorphoses*, XV, 622).

Francesco's nude does not conform to the classical iconographical tradition, in which Aesculapius was usually represented standing, clad in a long cloak, his breast bared, brandishing a club-like staff with the serpent around it. But the telling connection with the *Apollo Belvedere* and, in particular, the reverential way in which the figure holds up the snake both support Schubring's first identification. The fact that shrines and temples of healing dedicated to Aeculapius were built near springs throughout Greece, to which the sick would come to seek cures and purification, suggests a possible context for the work in Sienese territory. The Sienese *contado* was famous for its thermal bath complexes, Bagni San Filippo being now the best known, and visited by Pius II and Lorenzo de' Medici among many others.[8] Francesco di Giorgio made designs for bath complexes, within the palace at Urbino and later for an autonomous, more Vitruvian building.[9] In his description in his *Trattato*, he nowhere mentions the inclusion

of sculpture, but he would evidently have been admirably equipped to provide a central and fitting ornament for one of these important natural resources. LS

1 I am grateful to Kristen Lippincott and Carol Plazzotta for their assistance with this entry.
2 The forefinger of his right hand was also broken off, but is now repaired.
3 Schubring 1916, p. 304.
4 Avery 2002, pp. 56–69, cat. 2.
5 Pray Bober and Rubinstein 1986, pp. 71–2, no. 28.
6 Schubring 1907b, p. 194–61;
7 The bibliography on Aesculapius is large, but see Walton 1894; Caton 1900; Rouse 1902; Harrison 1903; Edelstein 1975; Aleshire 1989.
8 Other spas included Bagno di Petriolo, Bagno di Macereto and Bagno Vignoni. For baths in the Sienese *contado*, see Rosetti and Valenti 1997; Contorni 1988; Boisseuil 2002.
9 See P. Fiore, 'Il palazzo Ducale di Urbino. Seconda metà del XV secolo e sgg.' in Fiore and Tafuri 1993, pp. 164–79, esp. pp. 169–72, which has excerpts of text and illustrations about baths from the *Trattati*, as well as a catalogue entry on Fabio Calvo's text on baths.

SELECT BIBLIOGRAPHY

L. Bellosi in Bellosi 1993, pp. 79, 84, fig. 95–6;
M. Raumschüssel in Krahn 1996, pp. 157–9, cat. 13;
A. Nesselrath in Buranelli, Liverani and Nesselrath 2006, pp. 124–5, cat. 10.

Female Virtue and Beauty

48.

ATTRIBUTED TO BENVENUTO
DI GIOVANNI (1436–about 1509)
Cimmerian Sybil ('Sibilla Cumea'),
about 1490–5

Pen and brown ink on paper with pink and
brown wash and white heightening,
23.7 × 11.4 cm
The British Museum, London (1895-9-15-1395)

Inscribed: CVMEA

49.

ATTRIBUTED TO GIROLAMO
DI BENVENUTO (1470–1524)
Delphic Sybil ('Sibilla Delfica'),
about 1490–5

Pen and brown ink over traces of black chalk with
pink and brown wash and white heightening,
22.5 × 15 cm
The British Museum, London (1895-9-15-1394)

Inscribed: DELPHICA

These two highly finished drawings belong to a sequence of ten images of the Sibyls, all now in the British Museum. There survive two further sheets from the series, with bearded men who, though unlabelled, can probably be identified as Prophets. It is not known if more Prophets were originally drawn to make pairs, as was traditional, with the Sibyls. This is the only such sequence of drawings to survive from Quattrocento Siena; indeed works on paper of any kind are astonishingly rare. Their consequent importance makes their almost complete neglect in the art historical literature all the more astonishing.

The Sibyls were believed to have been prophetesses from the pagan past (their name comes from the ancient Greek word for prophetess, *sibylla*). Their origins and identities were always profoundly obscure, but their Christian role was precise: their prophecies were interpreted as having foretold the birth, death and resurrection of the Son of God. Their predictions complemented those contained in the Old Testament. However, the Sibyls had a special significance for medieval and Renaissance theologians and believers, representing a continuum between the ancient world (of Egypt, Greece and Rome) and the Christian present. This significance affected their modes of representation, which might legitimately take elements from the imagery of women saints, of female personifications of ancient and Christian virtues, and of pagan goddesses, such as the Muses. Their representation, especially in Siena, in turn informed the depiction of other famous women of the past, such as those featuring in the sequences of Greek and Roman heroines

that were to become so popular from the last decade of the fifteenth century (see cat. 65–72).

In Siena, by far the most celebrated series of Sibyls was the ten inlaid marble pavement figures in the nave of the Cathedral, commissioned in the early 1480s.[1] These were individually designed by almost all of the city's leading artists, including Matteo di Giovanni, Neroccio de' Landi and Benvenuto di Giovanni. The same ten Sibyls are repeated in the present drawn series, for which the Cathedral sequence was the primary visual source, though it was not copied slavishly. Some of the drawn variations remain unexplained, especially since, in general, the evolution of the Renaissance iconography of the Sibyls is extremely complicated, and in parts still unsure. The literary sources for the Cathedral Sibyls have been thoroughly analysed by Roberto Guerrini.[2] He has shown that their inscriptions derive largely from a text written at the beginning of the fourth century AD, Lactantius's *Divinae institutiones*, which after its 1474 first edition was frequently reprinted. Lactantius (I, vi) reproduced the list by the Roman author Varro of ten Sibyls (from a text that is now lost), ordered chronologically, to give the group its canonical form, and the identifying inscriptions on the Cathedral pavement paraphrase this. Thus, for example, 'The third was the Delphian about whom Chrysippus speaks in the book he put together on divination. The fourth was the Cimmerian in Italy, whom Naevius names in his books on the Punic War and Piso in his Annals'.[3] Lactantius does not always indicate which Sibyl was responsible for which prophecy, though the advisor on the Cathedral iconography has

assigned them specifically. The Delphic Sibyl has multiple identities in a range of texts that provide somewhat contradictory information. She made her prophecies in the sacred precinct of Apollo at Delphi; sometimes called the 'bride of Apollo', she was also given the names Herophile and Daphne, and identified as the daughter of Lamia, or as a Phrygian named Artemis.[4] Her Christian prophecy comes from Lactantius (IV, vi, 5), transforming the celebrated instruction at Delphi, 'Know thyself', into 'Know your God himself, who is the Son of God'.

The 'Cimmerian' Sibyl seems to have been invented to overcome a chronological inconsistency thrown up by the literary sources.[5] She was probably created by Naevius so as to provide a prophetess to predict the future of the descendents of Aeneas, who had fled Troy and eventually landed in Italy. She was said to have dwelt in a cave near Cumae in Italy, but she could not be the Cumaean Sybil proper, because Cumae did not exist at the time of the Trojan War. (The Cumaean Sibyl herself also appears in Varro's list and in both these Sienese Quattrocento sequences, labelled 'Cumana'.) Naevius makes the Cimmerian Sibyl a prophetess of Campania: Aeneas consulted 'the Sibyl who prophesied the future to mortals and lived in the town of the Cimmerians', and who promptly foresaw his settlement in Latium. Virgil borrowed the consultation by Aeneas of the Sibyl in Italy, but amalgamated her with, or converted her into, the Cumaean Sibyl.[6] It is for this reason that the designers of both Sienese series have inscribed 'Cumea' next to her figure, instead of 'Cimmeria' or 'Chimica' (the other name by which she

CAT. 48

was known in the fifteenth century).[7] Her sibylline prophecy, in which she foresaw the Resurrection, is found in Lactantius (IV, xix, 10): 'After a three-days sleep he shall end death's fateful power.'[8]

In all, Lactantius provided the texts for the utterances ascribed to seven of the ten Sibyls in the Cathedral series. Two, however, derive from another source,[9] the *Opuscula* by the Dominican Filippo Barbieri, who brought the number of Sibyls up to twelve in the two editions of his book, of 1481 and 1482, both with illustrations. These extra two had already appeared in earlier painted cycles, but Barbieri was instrumental in codifying the new sequence. Although only the traditional ten were included in the two Sienese series, knowledge of Barbieri's text seems to have informed the iconography of both, and particularly the drawings. The horn, for example, which became the standard attribute of the Delphic Sibyl, is mentioned by Barbieri. In both Sienese images of her, the 'horn' emits flames, which are not a feature either of Barbieri's illustrations or of other contemporary representations, but, in what appears to be a fairly typical blending – or slippage – of iconographies, remind us of the flaming cornucopia held by the figure of Charity on Nicola Pisano's pulpit in Siena Cathedral. No explanation has been found for her bizarre animal-skin costume in the British Museum drawing, or for her extreme décolletage. The Cimmerian Sibyl is also described by Barbieri as having flowing hair, an aspect followed both in the Cathedral (where she is older than in the drawing or in Barbieri's description) and here. In both, she holds the same attribute – a book (of prophecy).

The standard attribution of all the drawings but one to Girolamo di Benvenuto, working in the last decade of the fifteenth century in close collaboration with his father, Benvenuto di Giovanni, seems secure. It has not previously been observed, however, that among them the drawing of the Cimmerian Sibyl stands out, not only in the lettering of her inscription but also in the complexity of her drapery and a greater concern for volume as opposed to decoration. Her close similarity to an angel in Benvenuto's 1491 *Ascension* altarpiece suggests that, in this case, the father, not the son, was the draughtsman.

The function of the drawings remains problematic. Popham and Pouncey, assuming they were made as working drawings for a larger project, suggested that the Sibyls were designed to occupy a raised position with their feet at the viewer's eye-level. The drawings might therefore have been made for a mural series to be painted in either a domestic or a sacred context. Philippa Jackson has found reference to a 'room of the Sibyls' in the Tegliacci Palace (see p. 62) in Siena. The paintings there may have looked something like the *grisaille* series of Old Testament figures painted by the father-and-son team in 1499 for the Confraternity of Saints Jerome, Francis and Bernardino, three of which have recently been rediscovered.[10] It is even possible, since the Sibyls were traditionally associated with the Prophets, that the British Museum drawings should be associated with that commission. Two objections to this theory might be raised. In the first place, the refined style and high quality of the drawings might suggest a date closer to the beginning of the decade. Secondly, they might be considered too finished to be classified as working designs. Their level of detail could be explained if the actual execution of the frescoes was to be delegated to an assistant, or if they were designs for works in another medium: in about 1490, Benvenuto, probably again in conjunction with Girolamo, provided designs for a stained-glass window in Grosseto Cathedral.[11] Interestingly, this was divided into twelve main compartments, matching the dozen sheets (including the Prophets) in the British Museum. However, it is also conceivable that these drawings were intended as finished works in their own right, made to be bound into an album. Certain stylistic affinities with Francesco di Giorgio's similar drawings (see cat. 40, fig. 59) would thus be explained. LS

1 Aronow 1985, pp. 236–77.
2 Guerrini 1992–3, pp. 5–50; R. Guerrini, 'Ermete e le sibille. Il primo riquadro della navata centrale e le tarsie delle navate laterali' in Caciorgna and Guerrini 2004, pp. 13–51.
3 Parke 1988, pp. 2, 30.
4 Dronke 1990, p. 3; Parke 1988, p. 111; R. Guerrini in Caciorgna and Guerrini 2004, p. 21.
5 Parke 1988, pp. 33–5, 72–3; Caciorgna and Guerrini 2004, p. 23.
6 The aged Cumaean Sibyl was celebrated by Virgil in his Bucolica, *Eclogue*, IV, vv. 4–7. Lactantius, *Divinarum istitionum* I, 6, 10, tells the story of her offer to sell her books of prophecy to the King Tarquin, burning six of her nine books before he was persuaded to buy.
7 She was called 'cimmeam' by Lactantius in another of his works, perhaps another element in this confusion. See Dronke 1990, p. 34, note 3; Lactantius, *Epitome divinarum istitionum*.
8 Dronke 1990, p. 4.
9 Dronke 1990, p. 6.
10 Alessi 2003, passim.
11 Bandera 1999, pp. 202, 249, no. XI.

SELECT BIBLIOGRAPHY

Byam Shaw 1935–6; Popham and Pouncey 1950, pp. 48–50, nos. 78, 79.

DELPHICA

CAT. 49

FRANCESCO DI GIORGIO MARTINI (1439–1501)

Bianca Saracini suspended aloft above the City of Siena
Frontispiece illumination for the *Capitolo ternario in lode di Bianca Saracini*, about 1472–4

Tempera with traces of silver on parchment, 20.7 × 13.8 cm
Biblioteca Nazionale Centrale di Firenze (Palat. 211, f. 1r)

Francesco di Giorgio's figures are often improbably weightless. This distinctive stylistic trait was never better deployed than in this enchanting illumination of a beautiful noblewoman gliding effortlessly above a town that is easily recognisable as Siena. It is rare for an image of flight, especially one as fantastical as this, to be so entirely convincing. And this is despite some sadly disfiguring 'restorations'. The lady's costume and the sky in which she floats so airily are considerably repainted.[1] Not only is the blouse and skirt combination unknown in Quattrocento, but the gaucherie of the restorer is demonstrated by the total lack of modelling in her skirts – in sharp contrast to the finesse of the highlights on her right pinkish-red shoe. As Andrea De Marchi points out, the draperies must once have fully animated the figure. The sky is almost entirely retouched to just above the cityscape – where there survives the suggestion of a rosy dawn, painted in delicate shades of blue, pink and purple (ironically the newer paint is now more discoloured – to a greenish tone – than the original). The original blue can also seen around her two hands. In her right she holds a snowball[2] and running across the palm of her left hand can be seen the remains of a veil that must once have floated free. These exquisite hands, her head and gracefully pointed feet and the city below are unscathed, and from these areas we can judge the original high quality of the work.

This is the illuminated frontispiece of a short manuscript containing a part of what has now been identified as a longer poem in *terza rima*. Only thirteen of the twenty-six pages are written upon. The second page

(f. 2r), with the incipit, has a border with the letters of the name BIANCHA scattered through it, a shield in which the arms were never painted, a bird and a number of ermine, a traditional symbol of purity. The somewhat abrupt truncation of the poem and the unpainted stemma suggests that the project was not brought to completion. The manuscript was thought in the nineteenth century to be Florentine – hence the suggestion that the woman was a member of the Medici family hovering above her native city.[3] It was attributed to Francesco di Giorgio only in 1985,[4] when the airborne maiden was misguidedly identified as Bianca, an illegitimate daughter of Ferrante, King of Naples and the ermines read as a reference to the heraldry of the house of Aragon. Only in 1993 was the text properly identified by Caterina Badini as a part (104 *terzine* or 312 lines), partly revised, of the Marchigian poet Benedetto da Cingoli's *Quando per far col bianco tore albergo*, published posthumously by his brother Gabriele in 1503 in *Sonecti, barzullecte et capitoli del claro poeta B. Cingulo*.[5] The *libello* is bilingual: in the published version this *capitolo* is preceded by a Latin elegy and a dedicatory epistle in Italian and is followed by a Latin epigram.

Benedetto da Cingoli was reader in poetry at the University of Siena from 1483 to 1495, the year he died.[6] This *capitolo* in *terza rima* exemplifies a lyrical-allegorical style that was becoming ever more popular among the writers of Italian 'eclogues' in Quattrocento Siena.[7] This was a style for Italian poetry in which the models of Dante and Petrarch remained all-important, and which combined the mythological and pastoral to beautiful effect.

In his brother's epistle prefatory to the published edition of his poems, Benedetto's '*diva*', his poetic muse, is named as the noblewoman Bianca Saracini,[8] the 'Biancha' of the incipit border and an acclaimed Sienese beauty. Bianca di Jacopo di Simone Saracini was born in 1453, and married conte Francesco di Giovanni Luti in 1470.[9] She was the child of Jacopo Saracini and Onorata Orsini (1435–1457), herself the daughter of the lord of Magnano. In the published version of the poem, but not in the manuscript, Bianca is identified through her noble mother ('The mirror of virtue and honoured by the world, through marriage become Saracina, ennobled by the ancient blood of the Orsini'). Onorata had been one of the Sienese beauties chosen to participate in the betrothal ceremony in 1452 for Emperor Frederick III and Eleonora of Portugal (see cat. 76), and she herself was the focus of poets' praise. This lineage was important. Bianca and her mother were preferred not just for their beauty but also for their nobility, which gave them a public role.

We cannot know if Francesco di Giorgio's depiction of Bianca is a true likeness. With her pale skin and blonde hair, she looks like so many of the idealised beauties depicted by Francesco and his contemporaries. It may be that this ideal was to some extent constructed in her image. Conversely, her fame may have rested on the closeness of her looks to an abstract ideal. However, there is no doubting her celebrity. A note of Bianca's loveliness was even added in her early adulthood to her baptismal record, in the 1453 Registro di Biccherna for the 18 July.[10] There she is described as 'the most beautiful there ever was in the world . . . nor

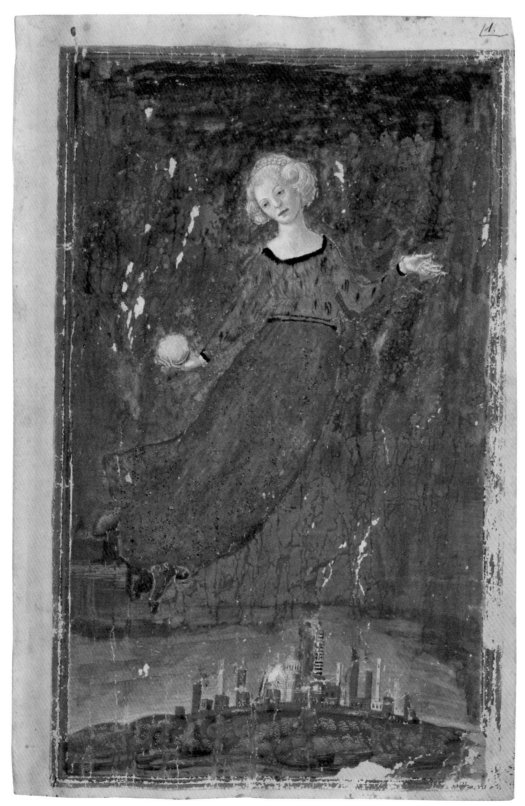

(actual size)

ever shall be found an equal to her, in whom not only does there shine the whole of beauty but also every virtue has its archetype in her, and, since Siena is in the middle of Tuscany, where the most beautiful women are to be found, and since Tuscany is the most beautiful part of the world, it follows that she is the most beautiful in the world'.[11] Like her mother, she was chosen to make appearances during official visitations to the city. The chronicler Tommaso Fecini records her being singled out during the festivities of 18–20 June 1473 during the visit to Siena of Eleonora of Aragon, daughter of the king of Naples, en route from Naples to Ferrara for her marriage to Duke Ercole I d'Este: 'They set up the installations at the house of Tomasso Pecci and in front of it they danced and celebrated and banqueted, and la Bianca and her fellow beauty Branchina danced with the duchess'.[12]

This civic pride in the beauty of Bianca was given repeated literary and poetic expression. Benedetto's *libello* is only one of several examples. Bernardo Ilicino wrote in his 1469–70 *Vita di Madonna Onorata*: 'So this is that Bianca who today not only in Italy but also among foreign nations has gained the palm of beauty, demeanour and prudence; this is the woman that is truly the image and simulacrum of her mother; this is the woman whose image, since it is not possible for several excellent lords outside Siena to know her in person, is sought after as an object in which there shines every perfection.'[13] And in one of his poems: 'A sweet, noble, chaste angelic soul in her every movement is Bianca Saracina'. These tributes may have been composed after Bianca was safely married, when the poet's praise would cease to be indecorous. All

these literary images play a part in Francesco di Giorgio's description of her.

The part of Benedetto's poem that appears here concerns Jupiter's desire to bestow on her a family and birthplace worthy of the lady's great virtue. Benedetto laments the poetic challenge presented by the subject and calls upon Apollo for assistance, who appears with all the Muses, to comfort him. Apollo begins to 'explain the heavenly origin' of the damsel. With the planets in the right position, Jupiter gathers a council of the gods. He has determined to show the world, blind and deep in mud, a new '*opera divina*'. Minerva proposes that she should have a beautiful soul; Venus a body so beautiful that it would overwhelm the 'Trojan shepherd', Paris himself. She is to have golden locks, an '*ampla fronte*' (a broad forehead), and a 'lovely whiteness surpassing snow and milk' ('*vago candore / Ad cui le nieve e 'l lacte cedaranno*'). The text is interrupted at the line: '*Et fra le dee del ciel non trovo equale*' (the goddesses in heaven have no equal I can find).

The poem contains many metaphors of whiteness throughout: 'Let white innocence cover her chaste bosom, let her soul be white, let her fine [veil or] skin be white, let white be her name and resemble its object'; 'Blessed soul, which we will enclose in a white veil'. This *leitmotif* lends credence to Andrea De Marchi's suggestion that her dress in the illumination (which shows through the rather odd orange shirt or blouse hung about with ermine tails) was originally also white. De Marchi identified powdered silver visible under the blue of the skirt, now tarnished, explaining the repaint. Moreover these similes in the poem explain her attributes – the snowball and the veil.

Benedetto makes clear that the beauty of its women signifies the excellence of the city; this is a form of *elogium urbis*. Jupiter can only choose Siena, giving it to Bianca as a kind of dowry: 'Among other outstanding and beautiful cities there is one that holds its place and always will under a clear sky and favourable stars, the city founded by two twins [Ascius and Senius] fleeing the abjection of death when fraternal blood stained the walls of Rome [Romulus killed Remus] … and so that site by particular law of virtuous, beautiful, beneficent and lovely women holds the shining palm of true excellence'. A woman of *retto* (correct) intellect both protects and embodies the well administered city, and Bianca sums up all the virtues of civic government: 'Good sense with high and provident intellect, hoary sagacity among blonde curls, sound counsel and perfect discernment, rare wisdom and choice judgement, alert sight and whole understanding, unclouded discrimination and long forethought, rapid, prescient and stately mind that always finely threads through to the centre'.

Francesco di Giorgio sought to capture this aspect in his illumination, by basing it in part on established civic imagery. He makes it clear that Bianca Saracini is not just a gift of the pagan gods, she is a kind of secular Virgin Mary. Thus she hovers above the city like the *Madonna Assunta* in so much official art (see cat. 1, 3, 4), a parallel that would have been more explicit when her dress was white. The veil was, of course, a well-known attribute of the Virgin, and the snowball, beyond its obvious play on Bianca's name and complexion and emblematising her (married) purity, suggests a connection with another group

of Madonna images. In Sassetta's *Madonna della Neve* (*Virgin of the Snows*) once in the Cathedral (now Contini Bonacossi Collection, Florence), an angel fashions a snowball from a dish of snow.[14] Sassetta appears to have invented this motif, later to reappear in Matteo di Giovanni's 1477 *Madonna della Neve* in the Cinughi Chapel, and Francesco di Giorgio cannot have been unaware of its connotation. In arriving at this image, Francesco di Giorgio found a truly ingenious means of expressing the imagery contained in a flourishing genre of secular poetry in a way that might simultaneously call upon existing civic and religious imagery to fix and amplify the meaning of the image. By citing the established iconography of the *Madonna Assunta*, he confers divine status on the woman chosen to stand for Siena.

If the manuscript had contained the complete text, it would have concluded with a Latin epigram which claimed that the ancient Greek painter Zeuxis, had he known Bianca, would not have needed so many women from which to distil his famous image of Helen of Troy, in which he combined the features of several living beauties. A parallel would thus be established between the modern painter and his celebrated classical forebear. De Marchi has argued that the face of Bianca, bathed in light, with its blonde warm tones and careful shadowing, are typical of Francesco di Giorgio's autograph works. The elegance of the pose, slightly anatomically distorted, is also characteristic. Bianca, called an angel herself, most closely resembles the angels supporting the platform in Francesco di Giorgio's *Coronation of the Virgin* (fig. 5)[15] – a part of the painting (in which there is considerable workshop intervention) that

might reasonably be attributed to the master himself. This similarity suggests a date for the illumination, fitting with Bianca's biography and the probable date of the poem. LS

1 See Gentile 1889, pp. 265–6; A. De Marchi in Bellosi 1993, p. 264. There is also some repainting in hills and trees where the original paint was damaged along the crinkles in the parchment.
2 This was first recognised as such by M. Caciorgna, '"Mortalis aemolur arte deos": Umanisti e arti figurative a Siena tra Pio II e Pio III' in Angelini 2005, p. 156.
3 Palermo 1853–68, pp. 384–8.
4 Garzelli 1985, p. 132, n. 4, first to publish this page as by Francesco di Giorgio, adds that in 1982 Carlo Volpe, on the basis of a photograph, had attributed the illumination to Francesco di Giorgio.
5 C. Badini in Bellosi 1993, pp. 262–4.
6 See also Quaglio 1986, III, pp. 273–326, esp. (for Cingoli) pp. 296–308.
7 Battera 1990, pp. 149–85.
8 M. Caciorgna in Angelini 2005, p. 154.
9 C. Badini in Bellosi 1993, p. 262.
10 M. Caciorgna in Angelini 2005, p. 154. Elsewhere her birth date is usually stated as being 1452.
11 Corso 1957, p. 9.
12 See Fecini 1931–9 edn, XV.6.iv, p. 872.
13 Ilicino 1843, p. 23.
14 Israëls 2003, pp. 128–9.
15 Garzelli 1985, p. 420.

SELECT BIBLIOGRAPHY

C. Badini and A. De Marchi in Bellosi 1993, pp. 262–5, cat. 43; M. Caciorgna, '"Mortalis aemulor arte deos": Umanisti e arti figurative a Siena tra Pio II e Pio III' in Angelini 2005, p. 156.

51.

NEROCCIO DI BARTOLOMEO
DE' LANDI (1447–1500)
A Young Woman, about 1482–90

Tempera on pine, 47 × 30.5 cm
National Gallery of Art, Washington, DC
Widener Collection (1942.9.47)

Inscribed: QVANTVM · HOMINI · FAS · EST · MIRA ·
LICET · ASSEQVAR · ARTE / NIL · AGO : MORTALIS ·
EMVLOR · ARTE · DEOS
(*Whatever a human being is permitted to do,
I attain through my prodigious art;
yet, a mortal competing with the gods, I achieve nothing*)
Signed in triangles to left and right of inscription
tablet: OP[?] · NER (*The work of Nerroccio*)

52.

NEROCCIO DI BARTOLOMEO
DE' LANDI (1447–1500) and workshop
*Mirror Frame with Head of an
ideally beautiful Young Woman and
two downward diving* amorini,
about 1480–1500

Painted and gilded papier-mâché, 45.7 × 40.6 cm
Victoria and Albert Museum, London (850-1884)

Neroccio's painting of a young – probably
very young – woman, opulently costumed
and abundantly jewelled, her pale blonde
hair cascading about her shoulders in a
radiant mass of curls, visually encapsulates
the Sienese ideal of feminine beauty in the
mid Quattrocento. Her eyes modestly
downward cast, she sits before an early
autumnal landscape,[1] touched with gold,
accentuating the poetic, even bucolic aspect
of the image. Both the landscape and the
subject's flowing hair remain in excellent
condition, enabling the modern viewer to
gauge the original superb quality of the
painting, which in other parts has suffered
by long-ago insensitive restoration.
Neroccio's always supremely delicate
flesh-painting has been severely abraded.
The lady's bodice and headdress were once
gilded; mordant gilding now survives only
in highlights on the background trees. The
present brown-red of her dress is actually
the bole to which the gold leaf was applied,
and the dark lines of this brocade were
originally green.

This lady closely resembles Neroccio's
many paintings of imagined women – his
pictures of the Virgin, of female saints such
as Catherine of Siena or Mary Magdalene,
and of ancient heroines, such as Cleopatra
and Claudia Quinta (see cat. 12, 16, 72) – an
ideal type that remained remarkably con-
sistent throughout his career. Nonetheless,
this painting has usually been treated as the
portrait of one of the celebrated beauties of
Siena. Painters and other portrait-makers
of the period, elsewhere in Italy, typically
idealised their female sitters to conform to
their particular concept of feminine loveli-
ness, in which individual likeness was not a
priority.[2] However, if this is a portrait, it is
a practically unique survival from the city of
Siena in this period. Girolamo di Benvenuto's
Portrait of a Woman of about 1500 (National
Gallery of Art, Washington) remains the
only point of comparison. All the evidence
suggests that portraits were always extremely
rare in fifteenth-century Siena, especially in
comparison with the dynastic city-states of
Naples and Northern Italy, from about 1435,
or to Florence from slightly later. Secular
patrons were very rarely depicted as donors
in altarpieces, and only a handful of medals
of private citizens were made by Francesco
di Giorgio (see cat. 45–6), including just
one woman.[3] Indeed it seems that in the
Sienese republic portraiture may have had
negative associations, being primarily
reserved for the admonitory images of
criminals or those considered otherwise
treacherous to the state.[4]

This picture may be the exception that
proves the rule: it appears that there was
a brand of painted portraiture that was
acceptable, within a strictly limited context
– images that pertained to poetry rather

than to power. The evidence of its frame
suggests that a real person was at least the
starting point of this image. Although the
frame moulding is recognised as belonging
to the Quattrocento, its authenticity has
recently been doubted, since it is not
engaged (glued or nailed to the panel).
Indeed its construction is very unusual,
even unique, and it is made from a different
wood from the portrait itself, which is
painted on pine. It has therefore been
suggested that it was cannibalised from
a piece of pine furniture on to which the
image had been painted. But this is not a
furniture painting; and it has now been
realised that the repeated motif of eagles'
heads with a golden ball takes proper
account of the frame corners and almost
certainly always belonged with the picture.

This fact is important, because, as Coor
was the first to observe, the eagle-and-ball
device alludes to the arms of the Bandini
family.[5] It seems likely that the work belonged
to one of this clan and commemorated the
beauty of one of its members. The Bandini
commissioned another portrait: the image
of Tommaso di Bartolo Bandini, now lost,
is recorded in 1483 among the belongings
of his late father, the eminent physician
and politician, Bartolo di Tura (1391–1477).[6]
This branch of the Bandini family (originally
from Massa Maritima) had settled in Siena
in the early fifteenth century. Bartolo di
Tura Bandini held various high civic offices
in his time, but the non-Sienese origins of
the family may explain its apparent disregard
for the traditional Sienese misgivings about
portraiture. Thus it has reasonably been
suggested that the subject here is one of
the three daughters of Bartolo's other son,
Bandino Bandini and his daughter-in-law

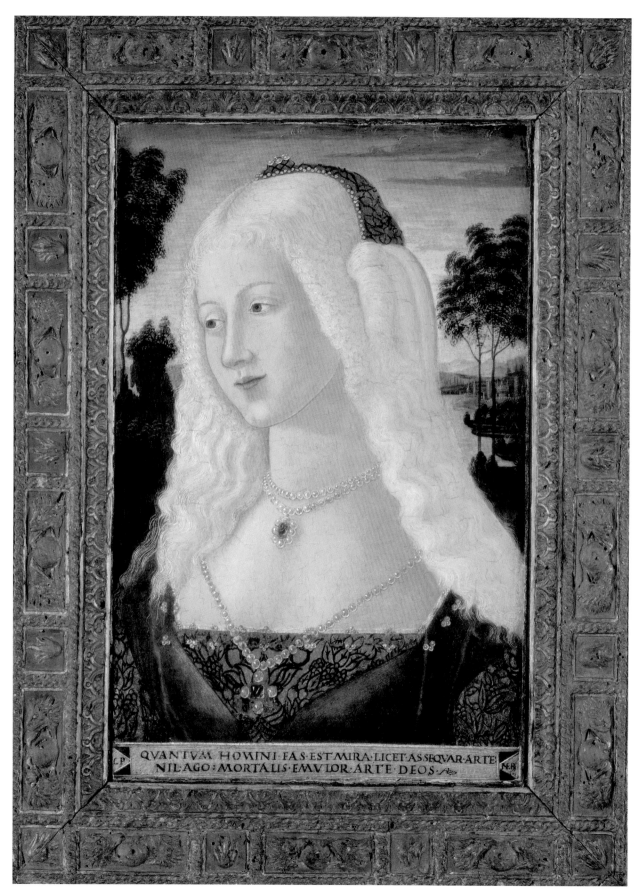

QVANTVM·HOMINI·FAS·EST·MIRA·LICET·ASSEQVAR·ARTE
NIL·AGO·MORTALIS·EMVLOR·ARTE·DEOS·

CAT. 51

Camilla Piccolomini: Eufrasia, Elisabetta or Alessandra, all of marriageable age in the mid 1480s, to which period this work belongs stylistically.[7] The high social status of the sitter – one of these Bandini girls, who may not have been much older than fourteen years when the picture was executed – is expressed by her very expensive jewellery and costume. Although Sienese sumptuary legislation placed restrictions on how expensively women could dress themselves in daily life and at times of marriage, members of the richest families, who preferred to pay the fines imposed for breaking the rules, regularly flouted these laws.[8] And the rules were officially relaxed when patrician women appeared at the balls and feasts honouring visiting dignitaries to Siena, such as the party thrown in December 1479 by the state for Alfonso, Duke of Calabria (with Federico da Montefeltro, Duke of Urbino, also present), soon after they had combined to win the battle of Poggio Imperiale.[9] The portrait is in some ways an equivalent parading of wealth and position, central to the allure of a wife or potential bride.

But if marriage was then mostly a matter of money and diplomacy, Neroccio adds the elements of love and poetry. And, even if this is a representation of a real lady of Siena, Neroccio has idealised her to make a statement about the facility of art to record or create beauty, one that was very much in line with debates then current in Florence and which might be particularly pertinent in Siena. The inscription placed below the image refers to an epigram in the well-known 'Greek Anthology': 'I who painted the form would gladly have painted also the character, but the limits of Art checked my

ambition.' It implies that Neroccio, or more likely a humanist scholar advising him, saw Art as in some ways limited.[10] However the poetic beauty of this 'sitter' is also key to the meaning of the work. The portrait is self-consciously Petrarchan, tackling issues that arose from two celebrated sonnets by Petrarch on a portrait of his beloved, Laura, by Simone Martini.[11] These poems ask if the loveliness of the soul could be represented. And they pose the question: was Nature – 'the gods' in Neroccio's inscription – always superior to Art? The first of Petrarch's poems contains the Platonic conceit that Simone had painted the picture in Paradise because, on earth, the soul is hidden by the body, implying in this case the success of artist in representing both. The second, however, does the opposite, lamenting the picture's inability to show Laura's whole beauty – internal as well as external. The fame of these sonnets stimulated the desire by Renaissance painters to 'recreate' Simone's lost or imagined picture.

This was a trend that seemingly starts in Florence in the 1470s and was to be hugely important for the subsequent portraiture of women. Painters sought to explore what Elizabeth Cropper has described as a 'fertile paradox', whereby painters trying to portray beautiful women, personifying the beauty of Nature, were doing so on the basis that their portraits would be taken to stand for the beauty of their Art – of painting itself – while at same time they were ritually restating the very impossibility of portraying everything that went to make up female beauty. It was not unimportant in this context that it was a Sienese painter who had painted the portrait of Laura, and Neroccio is often singled out as the artist

of his generation who was most inspired by Simone's blonde palette, delicate technique and curving line. He must also have had some reputation as a portraitist, since he evidently executed a papier-mâché portrait of the Duke of Calabria, presumably around 1479.[12] But here he was trying to do something more complex than simply recording a likeness; this is an early attempt to penetrate this inherent paradox of female portraiture. In Florence, Petrarchan portraiture was epitomised by Leonardo da Vinci's portrait of *Ginevra de' Benci* (about 1475, National Gallery of Art, Washington), which is another portrait of a poet's beloved. Neroccio appears to have known this painting: the pastoral beauty of the landscape background looks to Leonardo's. In Siena, this may have been one of several portraits that created links between celebrated local beauties (of high if not always noble caste), the poets who loved them and the painted portraits that extolled their beloveds' physical charm and inner virtue. Petrarchan sonnets of the 1470s by Ilicino (see cat. 50) in praise of Matteo di Giovanni's portrait of Ginevra Luti[13] and by Niccolò Angeli da Bucine lauding Liberale da Verona's picture of Francesca Benassai may be responses to portraits that once existed, or that were invented for the purpose of the poems. Whether real or imaginary, they give a sense of how Neroccio's image of one of the Bandini daughters should be read.

This then is a picture that was intended to provoke debate on the idealising capacity of artistic skill and imagination as opposed to the perfection of Nature. While the inscription makes Neroccio appear conventionally modest (like the lady herself), it simultaneously makes claims for his own

CAT. 52

'prodigious' abilities. The portrait is undeniable extremely lovely and its evident beauty thus deliberately contradicts its own inscription.

Neroccio appears to have been unusually concerned to enter this debate. At about the same time as he painted the Bandini portrait, he created a second object that similarly connects the self-conscious comparison or competition (*paragone*) between Art and Nature with the more mundane domestic world of marriage, the coloured *cartapesta* relief now in the Victoria and Albert Museum (cat. 52). Here is another beautiful woman with flowing blonde locks and elaborate jewellery, modelled by Neroccio and cast (perhaps as a multiple 'edition' of which this is the only survivor) and painted probably by his workshop. Two *amorini* (cousins to Cupid) plunge downwards on either side of her head, with a circular space between them, under the lady's neck. This would have once contained a little convex mirror of glass or polished steel. The looking-glass comes, like *cassone* paintings (see cat. 53–5), into the category of art objects commissioned in connection with marriage. But once again, the artist used this piece to make a more serious point about his own talent, since Neroccio's ideal beauty would have been seen in conjunction with the reflection, small and perhaps a little distorted, of a real woman. The presumably female owner would certainly have been able to see enough of herself to make the mirror functional, but by its smaller size the mirror was a lesser ingredient than the three-dimensional image, and thus in some ways more life-like head above it. This is very unlikely to be a portrait of a real woman – and its similarity both to Neroccio's many images of female

saints and the Virgin, as well as to cat. 51, underscores the point that cat. 51, too, is more of a poetic ideal than a convincing likeness. Neroccio now makes less diffident claims for his art – here literally and metaphorically placed above the reflected image of the real woman looking into the mirror and seemingly posited as a truer reflection of her beauty and virtue. Both Neroccio's images of beautiful women contain double messages; one is straightforward, connected with the social practices of late Quattrocento Siena, the other highly elevated and elaborate. LS

1 The foliage may originally have been a little greener but pigment analysis shows that it has always had a brownish caste.

2 Simons 1995, pp. 263–311; L. Syson, 'Consorts, Mistresses and Exemplary Women: The Female Medallic Portrait in Fifteenth-Century Italy' in Currie and Motture 1997, pp. 43–64; A. Wright in Ciappelli and Rubin 2000, pp. 86–113.

3 Of Francesca Borghesi, see R. Bartalini in Bellosi 1993, pp. 160–1.

4 A.M. 1893, pp. 23–4. It was the tradition to display portraits of traitors or those thought to have shown lack of respect to the state upside down in public places, such as the 'portrait' painted in 1445 of the Sicilian public lector Andrea di Bartolomeo, who accepted and then refused a place at Siena University.

5 Coor 1961, p. 59.

6 '*Vno quadretto dipento con la figura di tomasso figlolo di maestro bartolo*'. Mazzi 1896–1900. 4, 1897, p. 395: '*Vno quadretto dipento con la figura di tomasso figlolo di maestro bartolo*'. G. Agosti in Bellosi 1993, p. 490.

7 M. Seidel, 'The "Societas in arte pictorum' of Francesco di Giorgio and Neroccio de' Landi' in Seidel 2003A, pp. 555. Bandino's son, Sallustio di Bandino, married Montanina Todeschini Piccolomini in 1495. See Seidel 2003, p. 557, note 56.

8 Casanova 1901, pp. 17, 42, 89–93, doc. IX. In 1473 a string of 180 pearls was bought by Cione di Ravi, Conte di Lattaia for his married daughter Cassandra, only two years after he had bought a pearl-studded pendant of precisely the kinds that were banned. See Zdekauer 1904, pp. 140–50, esp. pp. 141, 146.

9 Bandini Piccolomini 1896A, p. 131.

10 The *Greek Anthologia Hellenike*, also called the *Palatine Anthology* was a much-read collection of Greek epigrams, songs, epitaphs, and rhetorical exercises that includes about 3,700 short poems, mostly written in elegiac couplets. See Shearman 1992, pp. 113–14.

11 For discussion of these themes see especially Cropper 1976; Cropper, 'The Beauty of Women: Problems in the Rhetoric of Renaissance Portraiture' in Ferguson, Quilligan and Vickers 1985, pp. 175–90. Shearman 1992, pp. 117, 121 also discusses the impact of these sonnets.

12 The inventory of the contents of Neroccio's workshop made at his death in 1500 includes '*una testa di don Federico di carta*'. See Milanesi 1854–6, III, pp. 7–8; Coor 1961, p. 157, no. 188.

13 See G. Agosti, 'Siena nell'Italia artistica del secondo Quattrocento (desiderata scherzi cartoline)' in Bellosi 1993, p. 504, note 19.

SELECT BIBLIOGRAPHY

Cat. 51 G. Agosti, 'Siena nell'Italia artistica del secondo Quattrocento (desiderata scherzi cartoline)' in Bellosi 1993, p. 490; M. Seidel, 'The "Societas in arte pictorum' of Francesco di Giorgio and Neroccio de' Landi' in Seidel 2003, pp. 552–6. M. Boskovits in Boskovits and Brown 2003, pp. 531–5; M. Caciorgna, '"Mortalis aemolur arte deos": Umanisti e arti figurative a Siena tra Pio II e Pio III' in Angelini 2005, p. 153; *Cat. 52* Pope-Hennessy 1964, I, pp. 270–1, no. 284

Cassone Paintings

53.

SIENESE PAINTER, close to
LIBERALE DA VERONA and
FRANCESCO DI GIORGIO MARTINI

*The Triumphal Procession of
a Royal Conqueror (Aurelian and
Zenobia, Queen of Palmyra?),*
about 1475–80

Tempera, gold and silver on panel,
61 × 180 cm (picture surface 35.5 × 109.5 cm)
The Marquess of Northampton

54.

SIENESE PAINTER, close to
LIBERALE DA VERONA and
FRANCESCO DI GIORGIO MARTINI

An Encounter at a Window,
about 1475

Tempera on panel, 33.4 × 41.8 cm
The Metropolitan Museum of Art, New York
Gwynne Andrews Fund, 1986 (1986.147)

55.

SIENESE PAINTER, close to
LIBERALE DA VERONA and
FRANCESCO DI GIORGIO MARTINI

The Game of Chess, about 1475

Tempera and gold on panel, 34.9 × 41.3 cm
The Metropolitan Museum of Art, New York
Maitland F. Griggs Collection
Bequest of Maitland F. Griggs, 1943 (43.98.8)

Several workshops specialising in the production of furniture painting, especially the embellishment of the fronts of *cassoni* or wedding chests, were apparently operating in Siena in the 1470s and early 1480s. The partnership set up between Francesco di Giorgio and Neroccio de' Landi was probably established, at least in part, to feed this market, which was evidently burgeoning very rapidly in Siena in this period.[1] No surviving examples of *cassone* panels are signed (and a signature would be unexpected for this sort of painting), and therefore attributions of these pictures remain hazardous. Some distinct, but anonymous personalities, responsible for such works have, however, been identified, and include the so-called Stratonice Master, emerging from Matteo di Giovanni's shop (see fig. 57–8); the Griselda Master might also have started his career in a *bottega* of this kind.

In particular, there is the group of generally very ambitious *cassone* panels that have most commonly been associated in recent years with Liberale da Verona during his time in Siena. This view seems to be mistaken. Liberale was not a native Sienese artist and should have required partnership with a local artist to get around the prohibitions of Sienese painters' guild against foreigners simply setting up shop in Siena.[2] He may therefore have decided to collaborate with a local, the author of these panels. That this was a painter who clearly looked very closely at Liberale – and may have been provided with designs by him – is demonstrated by his constant reiteration of the Veronese painter's architectural motifs and figure types. This anonymous master remained, however, notably eclectic, and

his sources were not restricted to drawings or miniatures by Liberale. It is clear that he also carefully studied works by Francesco di Giorgio. Identifying this artist may not be feasible, but various candidates emerge from the documents of the time, including Francesco di Bartolomeo Alfei and Paolo d'Andrea, the latter a known collaborator of Francesco di Giorgio; these artists both received commissions for sequences of domestic painting in the 1470s.[3] Since *cassoni* were placed low down on the floor, paintings on them have typically suffered damage – scratching and abrasion – often making their attribution difficult to judge.[4]

These chests were generally commissioned to mark marriages between the city's leading families, and the themes for their adornment were chosen to illustrate the proper (or sometimes, designed as warnings, the improper) relationship between the sexes. Many such subjects were taken from classical antiquity. The *Triumphal Procession,* not previously published, seemingly falls into this category.[5] It depicts a ruler – a languidly reclining young king or emperor, wearing a crown and holding a sceptre – drawn in triumphal procession towards a city gate. He is probably Roman, since Trajan's Column and the Pyramid of Caius Cestius are seemingly included in the background. That he is the hero of the narrative is indicated by the fact that his curiously negligent pose actually adapts that of the female personification of Peace in Ambrogio Lorenzetti's celebrated *Allegory of Good Government* fresco.[6] He is preceded by a group of female captives in exotic dress – a queen and her handmaids. The story is likely to be that of the Emperor Aurelian and his capture and parading in 272 AD of the

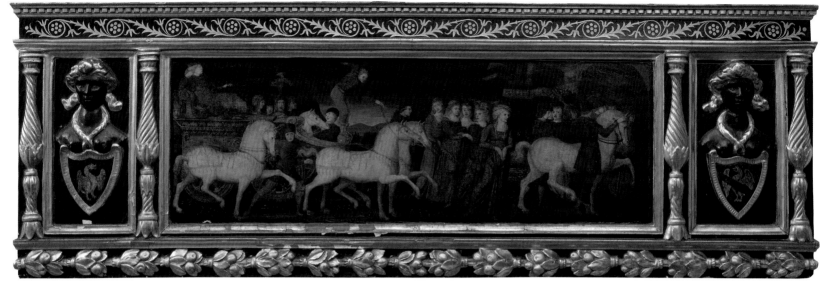

CAT. 53

brave Zenobia, Queen of Palmyra, whose
life he had spared on grounds of her sex,
even though she had waged war against him
(*Historiae Augustae Scriptores*, xxv–xxxiv).[7]
This history had already been popularised
by both Petrarch and Boccaccio. Though
now darkened by time, the picture must
once have gleamed with gold and silver
leaf; the silver is now tarnished to black
or rubbed away, revealing the red bole
beneath, but it must have glittered in the
costumes of the first four women and the
armour of the soldiers accompanying them.
It is also copious in its detail. The landscape
and the garland around the gateway are
beautifully described and the horses are
particularly elegant – beetle-browed and
looking aristocratically down their long
noses.

The *Triumphal Procession* is painted on a
single thick plank of poplar. It retains some
of its original framing elements, though
these are mostly repainted and regilded.
Nonetheless, they give a sense of how such
pictures were originally set on to the front
of very rich and elaborate wooden chests,
which were mostly extremely heavy pieces
of furniture, thanks not least to their
substantial lids. Projecting on either side

of the central narrative is a relief sculpture
of the head and torso of a bare-breasted
woman (completely repainted), with,
hanging around their necks, the shields
of the two families whose children were
getting married. The coat of arms on left is
that of the Borghesi family (see cat. 32, 45),
while the other, also completed retouched,
is seemingly spurious.

This newly rediscovered picture is clearly
by the same hand as the others now usually
given to Liberale and, like them, it contains
several references to his work, especially
in the anatomy of the brilliantly energetic
charioteer. However, the impact of Liberale
is here less striking, while that of Francesco
di Giorgio has become more perceptible,
especially in the physiognomies of the long-
chinned women. The painter has also cited
paintings by other artists working outside
Siena, including Piero della Francesca
(whose frescoes could be seen at Arezzo,
not very far from Siena), for the heads of
the soldiers seen full-face near the emperor.
Perhaps again through Liberale, who is
known to have made an altarpiece for a
church in Rome (Santa Francesca Romana,
still *in situ*, a work of about 1475), this
painter also knew the famous ancient

statues of the *Dioscuri* (or Horse-tamers) in
Rome, which he used for the dynamic poses
of the grooms. In painting classical themes,
like this one, *The Rape of Europa* (Musée
du Louvre, Paris), *The Abduction of Helen*
(Musée du Petit Palais, Avignon) and *The
Murder of the Son of Tomyris, Queen of Scythia,
by the Persian Cyrus* (private collection, New
York),[8] he was usually careful to include
such *all'antica* citations, not least in the field
of architecture, in which he, like Liberale
himself (see cat. 29–30), may have used
designs formulated by Francesco di Giorgio.

The pronounced classicising flavour of
these works is more muted in the artist's
only treatment of a subject taken probably
from a French chivalric romance or refer-
ring to an Italian novella. As well as treating
these self-consciously classical themes,
painters were sometimes called upon to
create chivalric confections, designed to
appeal to nobles and would-be nobles in a
Siena obsessed with obtaining knighthoods
and other titles. The fact that these stories
of knightly love were regarded as suitable
subjects for *cassone* painting reveals the way
in which the ancient and the chivalric
might intersect and merge in Quattrocento
Siena. Such a blending was precisely the

point of the narrative written – in Latin – by Aeneas Silvius Piccolomini (later Pope Pius II), his *Story of Two Lovers*, set during the period of the Emperor Sigismund's visit to Siena in the early 1430s.[9] Factional Siena was also the setting for the tragic story by Masuccio Salernitano (active about 1450–74) of Mariotto Mignanelli and Giannozza Saracini, one of the fifty *novelle* in Italian published posthumously in 1476 (later reset in Verona by Luigi da Porto and eventually becoming Shakespeare's *Romeo and Juliet*). It is intriguing that Salernitano had been in the service of the *condottiere* Roberto Sanseverino, who in 1473 had taken a noble Sienese bride, Lucrezia Malavolti.[10]

Fig. 61
Sienese painter close to Liberale da Verona and Francesco di Giorgio Martini
Fragment from a Cassone, about 1475
Tempera on panel, 34.7 × 27.9 cm
Berenson Collection, Villa I Tatti, Florence (P 40)

It is into this category – of an Italian work that looked to French literature – that the two parts of a *cassone* front now in the Metropolitan Museum (cat. 54–5; a third fragment, fig. 61, was painted originally between them) should be placed.[11] The precise literary source for this work, filled with comely youths and lovely women, both remarkable for their fluffy wig-like blonde hairstyles, has not yet been identified – but the picture contains ingredients from many of these tales. The woman seen in a window by a handsome young man (cat. 54) is an episode in Piccolomini's much-read tale – though he saw her by day, rather than, as here, by night or twilight; stars, now much abraded, in fact appear in the sky. The amorous chess game (cat. 55), featuring the same two principal protagonists, is a feature of several medieval French romances – like those of Tristan and Iseult and especially the story of Huon de Bordeaux and the daughter of King Ivoryn, in which Huon wins the right to sleep with the princess when she (purposely) loses a game of chess. Since, in this work, the painter derives his motifs principally from Liberale da Verona, the work may therefore be a little earlier than the *Procession*, perhaps made at the time of the notional partnership between the Liberale and the anonymous painter of this group of *cassone* panels.
XS/LS

1 This might have been a partnership like that set up in Florence in the 1450s between Apollonio di Giovanni and Marco del Buono, who are described as '*dipintori compagni*' in the *bottega* book recording the orders placed with them between 1446 and 1463. In a tax return of 1457, Marco states '*e più mi truovo in chonpagn[i]a di apolonio di Giovanni*' (and moreover I am in company with Apollonio di Giovanni): see Callmann 1974, pp. 2, 4–6, 76.

2 Liberale's two main altarpieces in these years were made for other cities, Rome and Viterbo. See cat. 29–30.
3 See X.F. Salomon in Syson (forthcoming) for further discussion.
4 The areas of damage are usually most acute where the keys dangling from the keyhole at the centre of the chest have knocked against the paint surface.
5 We are very grateful to Francis Russell for drawing this work to our attention.
6 This is an important indication of how Trecento sources were cited even in a secular context. We are grateful to Jennifer Sliwka for this observation.
7 Again, we are extremely grateful to Elizabeth McGrath for her suggestion as to the possible subject matter of this piece. For this subject and its sources, see Knox 1979, p. 409.
8 For this group, and especially the last, see K. Christiansen in Christiansen, Kanter and Strehlke 1988, pp. 297–8, cat. 58. The subject of the New York panel was subsequently identified by Elizabeth McGrath. See Christiansen 1990, p. 212. Its dimensions are 36 × 115 cm, making it just possible that the *Tomyris* subject, representing another Queen, was the pair to the present panel.
9 Piccolomini 1973 edn.
10 M.C. Paoluzzi in Tomei 2002, pp. 208–11.
11 K. Christiansen in Christiansen, Kanter and Strehlke, 1988, pp. 294–6, cat. 57a–b.

SELECT BIBLIOGRAPHY

Cat. 54–5 Eberhardt 1983, p. 219, n. 253; Christiansen, Kanter and Strehlke 1988, pp. 294–6, cat. 57a–b.

CAT. 54

CAT. 55

CAT. 56

NEROCCIO DI BARTOLOMEO
DE' LANDI (1447–1500)

56.
The Battle of Actium, about 1476

Tempera and gold on panel,
36.5 × 112.1 cm
North Carolina Museum of Art, Raleigh
Gift of the Samuel H. Kress Foundation
(GL.60.17.30)

57.
The Meeting of Antony and Cleopatra, about 1476

Tempera, gold and silver on panel,
36.8 × 113 cm
North Carolina Museum of Art, Raleigh
Gift of the Samuel H. Kress Foundation
(GL.60.17.29)

A profound moral lesson, perhaps aimed mainly at men, on the perils of love and unscrupulous women, disguised as frothy entertainment; a warning against excessive extravagance made into luxury goods; images from ancient history designed to display, not just the learning, but also the historically derived nobility and concomitant cultural values of their owner – Neroccio de' Landi, in creating these pictures, was called upon to bridge chasms. While paintings of the suicide of Cleopatra, Queen of Egypt, abound from the beginning of the sixteenth century, other episodes from her life are very rare indeed. In Siena, Cleopatra regularly appeared as a member of one of the trios of exemplary heroines that were introduced into domestic spaces from the 1490s onwards (such as the picture by the Master of the Chigi-Saracini Heroines from about 1505).[1] She could, almost, be regarded as an exemplar of conjugal loyalty; she was after all (according to Boccaccio) Mark Antony's third wife, and her suicide could be interpreted as an act of courageous devotion to her dead husband.[2] But the increasing eroticisation of these images – asp held lasciviously to nipple, dress ever more scanty – also signalled her widely held unsuitability as a role model.[3] She was almost always roundly condemned by writers, ancient and modern – who regularly accused her of pride, and called by Propertius and Pliny a *regina meretrix* – a courtesan queen;[4] and damned by Plutarch, whose *Life of Antony* in his *Parallel Lives* contains her most detailed biography. Boccaccio, who wrote of her in his *De mulieribus claris* (*On Famous Women*) between 1361 and 1375, dubbed Cleopatra 'the whore of the Eastern kings' (LXXXVIII, 9).[5] He also stated (LXXXVIII, 1), unequivocally, that 'Cleopatra had no true marks of glory except her ancestry and her attractive appearance; on the other hand, she acquired a universal reputation for her greed, cruelty and lust'. Antony, perceived as her victim, fared not much better in the literature.

Cat. 56 illustrates Plutarch's description of the journey of Cleopatra's barge up the River Cydnus: 'Although she received many letters of summons from Antony himself and from his friends, she so despised and laughed the man to scorn as to sail up the river Cydnus in a barge with a gilded poop, its sails spread purple, its rowers urging it on with silver oars to the sound of the flute blended with pipes and lutes. She herself reclined beneath a canopy spangled with gold, adorned like Venus in a painting, while boys like Cupids in paintings, stood on either side and fanned her. Her maids were attired like Nereïds and Graces, some steering at the rudder, some working the ropes. The

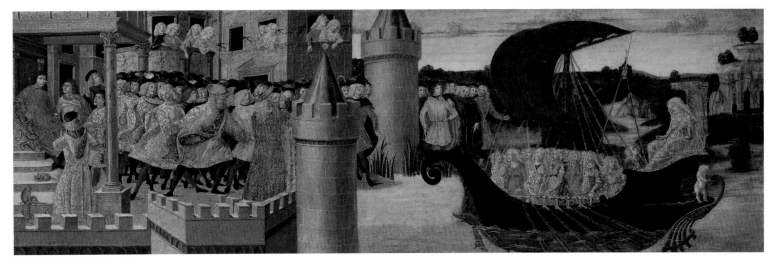

CAT. 57

perfumes diffused themselves from the vessel to the shore, which was covered with multitudes, part following the galley on either bank, part running out of the city to see the sight, while the word went through all the crowd that Venus was come to feast with Bacchus, for the common good of all Asia.' Many of the elements included by Plutarch are present in the painting, though the barge's purple sail is now discoloured, and Neroccio has only added a mischievous cupid on the rudder.

Neroccio's second picture depicts the disastrous consequences of Antony's worship of the Egyptian queen: the Battle of Actium in the Gulf of Arta on 2 September, 31 BC, one of most celebrated naval battles in history. Cleopatra had provided some of Antony's ships, and she was to be his downfall. Plutarch wrote: '… to such an extent was Antony now an appendage of the woman that, although he was far superior on land, he wished the resolution to rest with his navy, to please Cleopatra, even though he saw that … their ships were not fully manned, but most were deficient and sailed wretchedly.'[6]

Pope-Hennessy discussed Neroccio's 'playful and essentially literary attitude to the antique' and others have compared *The Battle of Actium* to a 'pageant'.[7] These comments do not deny the essential

seriousness of the pictures, but illuminate Neroccio's main tactic – to seduce his viewers by delighting them, to instruct by stealth. This approach was particularly appropriate for the pictures' function. They were painted, it is generally assumed, on the fronts of a pair of *cassoni*, commissioned at the time of a marriage.[8] They were therefore expected to be celebratory but still to contain a useful lesson for bride and groom. A raised paint edge or *barbe* visible on all sides suggests that they were indeed painted once the raised mouldings framing the images had been attached to the chest, and their dimensions are consistent with other panels of this kind. Their condition is exceptionally good for such works.[9] This fact suggests that they were early on converted into autonomous gallery paintings, at which date new frames were constructed for them.

The panels may be given to Neroccio on good stylistic grounds, though one, if not both, has been wrongly attributed to Francesco di Giorgio. They have been associated with the period of their early 1470s partnership (see pp. 354–5), though they were probably made by Neroccio shortly after the pairing broke up.[10] It may therefore be possible to connect the Raleigh pictures with the 'pair of chests with stories worked in fine gold' commissioned by the

noble Bernardino Nini, appraised in 1476 by Francesco di Giorgio (for Nini) and Sano di Pietro (for Neroccio) and part of a larger bedchamber suite of furniture paintings.[11] The chests were valued at 25 florins. LS

1 A. De Marchi in Sricchia Santoro 1988, pp. 83–90, no. 14c.
2 See, for example, the moralising vision of Cleopatra's suicide in the *Amorosa visione* by Giovanni Boccaccio (10, 55–69). See M. Caciorgna in Caciorgna and Guerrini 2003, p. 131.
3 C. Richard-Jamet, 'Cléopâtre: femme forte ou femme fatale? Une place equivoque dans les galleries de femme fortes aux XVIe et XVIIe siècles' in Ritschard and Morehead 2004, pp. 37–52.
4 Pliny the Elder, *Naturalis historia*, IX, lviii, 119; Propertius, *Elegies*, III, 11.
5 See Boccaccio 2002 edn, pp. 361, 365 for translations.
6 *Antony*, LXII, 1–2.
7 Pope-Hennessy 1947, p. 22; Coor 1961 p. 30 and Rusk Shapley 1966, pp. 154–5, no. K438–9.
8 For Sienese *cassoni*, see Misciattelli 1929, pp. 117–26.
9 Noted by Martin Davies when the painting was being considered for possible purchase by the National Gallery.
10 See further the discussion in Syson (forthcoming).
11 28 May 1476 (Milanesi 1854–6, II, pp. 356–7, doc. 245; Coor 1961, pp. 141–2, doc. VIII). This connection was floated by Shapley, but rejected because of what she thought were the earlier date of the pictures. One Bernardino di Aldobrandino Nini was born in 1447, making him the age to marry in 1476. I am indebted to Philippa Jackson for this information.

SELECT BIBLIOGRAPHY

M. Caciorgna, 'Immagini di eroi ed eroine nell'arte del Rinascimento. Moduli Plutarchei in fronti di cassone e spalliere' in Guerrini 2001, pp. 211–344, esp. pp. 237–43, no. I.1 (for cat. 56), pp. 243–7, no. I.2 (for cat. 57); M. Caciorgna in Caciorgna and Guerrini 2003, pp. 127–30.

HEROES AND HEROINES

No single project undertaken in the Siena of the 1490s is more representative of the change in taste that occurred in those years than the series of eight panels of 'Virtuous Men and Women of Antiquity' made for the *sala* (reception room) or more likely *camera* (bedchamber) of a Sienese patrician palace (cat. 65–72). This was one of the most ambitious schemes for palace decoration of the Quattrocento, not merely in Siena but in the whole of the Italian peninsula; the pictures are here reunited for the first time since their dispersal, probably at the beginning of the nineteenth century. They may have been painted for the same palace that contained the three National Gallery panels with *The Story of Griselda* (cat. 62–4) and two pictures by the Ghirlandaio workshop with stories of Alexander the Great (fig. 12, pp. 26–7) and Julius Caesar.

The functions of these works were to a large extent novel, belonging with, rather than painted on, pieces of furniture. It is probable that the Griselda narratives were preceded in Siena by other so-called *spalliere* (autonomous panels displayed at or above shoulder-height, usually made in sets, see fig. 25, p. 51). But the full-length images of ancient heroes and heroines in this sequence may have been the first of their kind, providing the model for the trios of exemplary women regularly made for Sienese palace interiors from the end of the decade (see cat. 104–6). The choice of subjects, as well as their palace context, represents the domestication – even the privatisation – of a civic tradition. Visitors would have recalled two series of Roman Republican heroes made for prominent civic sites in Siena – the frescoes in the *anticapella* of the Palazzo Pubblico by Taddeo di

Bartolo of 1413-14,[1] and the reliefs carved in marble by Antonio Federighi for the bench constructed in the 1460s for the Loggia di Mercanzia.[2] Now, however, the heroes were chosen for their connubial rather than political virtues, paired with women whose histories of chastity and exemplary devotion made the same point. They too had a kind of public visual precedent in the full-length pavement figures of the *Sibyls* at the Cathedral (see cat. 48–9). To some degree, however, they were also indebted to longer-standing types of painting for palaces. *Cassoni* sometimes include full-length female figures, in approximately antique dress, placed on either side of main narrative scene to hold the coats of arms of the families whose marriages were being marked.[3] Finally, they contained what was probably a nod to the taste of the North Italian courts. The earliest surviving sequence of ancient heroines (like those made later in Siena, a trio) was made in the mid 1480s for Eleonora of Aragon, Duchess of Ferrara, by the Este court artist Ercole de' Roberti.[4]

Part of the point of the *Sibyls* project seems to have been to show off the designing skills of the leading artists of Siena – Federighi again, but also three of the painters involved in this series of panels, Matteo di Giovanni, Neroccio de' Landi and Francesco di Giorgio. It is plausible that these secular works were commissioned with the same idea in mind, adding Pietro Orioli, a rising star, to the mix. The series was brought to completion, however, by an anonymous artist, who had initially taken a subsidiary role as a background painter. There seems therefore to have been a change of direction midway through the project.

This painter, the so-called Master of the

Story of Griselda, remains a mysterious figure in the history of Sienese art. A *corpus* for this anonymous painter was established by Bernard Berenson in 1931,[5] building upon the research of others, especially Giacomo De Nicola in 1917.[6] While a consensus has been reached that he was active in the period about 1490–1500, the problem whether his career was cut short prematurely by death or whether his pictures represent the juvenile (or possibly mature) phase of one or another better understood painter is not resolved. A small group of panels is now unanimously assigned to him. Apart from four of this series of 'Virtuous Men and Women' (cat. 65–8, 72), first and foremost are the three London pictures that give him his 'name'. A Bacchic tondo, once in the Zoubaleff collection, is probably the Griselda Master's earliest surviving independent work.[7] Other pictures that have been added to group are not so far widely accepted.[8] The identity of his patrons, the dates of his paintings, their relative chronology and his methods of collaboration with other masters, and even the master's precise artistic and geographical origin (quite apart from his name), all remain matters of dispute.[9]

This worry about the painter's origins is in itself indicative of a new direction in Sienese art. It is not even clear if he was Sienese or Umbrian.[10] Indeed, the seamless blending of these two styles has led to the Griselda Master's ambiguous classification as 'Umbro-Sienese'. He has most recently been identified as one Pietro d'Andrea da Volterra,[11] thought to have been a member of Pintoricchio's huge *équipe* in Rome.[12] Pintoricchio certainly provided a model for the Griselda Master's decidedly decorative

landscape style. The Griselda Master also seems to have had some contact with Perugino's *bottega*, perhaps in Florence; the dashes of paint that give texture and distance to his landscapes come from Perugino. However, his closest stylistic connection is with Luca Signorelli. Boskovits has argued: 'For the moment Signorelli remains the central point of reference for the anonymous master. Not only does the latter imitate Luca's free and easy brushwork, he also re-proposes the gravity of gesture and elegance of pose seen in Signorelli's work along with his dark, gloomy shadows. The fact, too, that the Master of Griselda, while borrowing Signorelli's compositional formulas with such easy confidence, modifies and over-emphasises them seems to point to a long acquaintance with the master's style. It is very likely that, in the years around 1490, the Master of Griselda was in Signorelli's workshop and received his training there.'[13]

A superimposition of Signorelli's style can indeed be detected, but the Griselda Master's citations can almost all be explained by the presence of Signorelli's 1488 Bichi Altarpiece in the church of Sant'Agostino in Siena (see cat. 58–9).[14] He need not have been Signorelli's pupil and, in his early paintings, the elongated figures have more in common with works by Francesco di Giorgio from the latter part of his career. He may have worked in Francesco's work-shop at that time. The motif of a 'dancing' statue, a typically lively feature of two of the Griselda narratives (cat. 62, 64) is also found in the painted background behind an early 1490s polychrome terracotta

Virgin and Child (Museo Diocesano, Pienza), a product of Francesco di Giorgio's *bottega*.[15] In both instances, the Griselda Master seems to have derived the motif from Francesco di Giorgio's *Conflict* relief (cat. 44). It is therefore possible that, after a first training in Siena, and possibly a spell in Pintoricchio's workshop, the Griselda Master started as a specialist in landscape and architectural backgrounds, working for Francesco. It should also be remembered that Francesco di Giorgio also had a key role in the decoration of the Bichi Chapel. The Griselda Master may therefore have encountered Francesco di Giorgio and Signorelli simultaneously.

The Griselda Master's precise origins are relatively unimportant in this context. Whether he was born in Siena or Umbria, he was certainly responsible for introducing novel Umbrian and Signorelli-inspired styles and techniques to the painted orna-mentation of palaces, while continuing to refer to models by that most internationally celebrated of native artists, Francesco di Giorgio. This must have been his primary appeal for the Spannocchi family, who (it is now firmly established) were the patrons of the Griselda panels. The Spannocchi had a long-established connection with Francesco di Giorgio (see cat. 60), but in general, as we have seen, they looked beyond the walls of Siena to find their artists. If the 'Virtuous Men and Women' were also Spannocchi commissions, the change from a scheme that grouped the talents of Siena's finest painters to one that highlighted only one, working in a 'foreign' idiom, is surely significant. LS

1 Rubinstein 1958, pp. 179–207.
2 A. Angelini, 'Antonio Federighi e il mito di Ercole' in Angelini 2005, pp. 142–4.
3 See, for example, the *cassoni* made for for Urgurgieri and Nini families produced by Francesco di Giorgio's workshop (now J. Paul Getty Museum, Los Angeles). Fredericksen 1969, pp. 33–4.
4 L. Syson in Allen and Syson 1999, pp. xxxii–xxxiii, no. VI–VIII.
5 Berenson 1930–1, pp. 735–67, esp. pp. 750–3.
6 De Nicola 1917, pp. 224–8.
7 De Carli 1997, pp. 178–9. This work was recently sold by Galerie Canesso in Paris. It was first attributed to the anonymous master by De Nicola (1917), p. 227.
8 The attribution of another group, the female personi fications of the three theological virtues, to the Griselda Master does not appear to be correct. See L. Vertova in Natale 1984, pp. 200–12, esp. pp. 205–12, supported in part by L.B. Kanter in Christiansen, Kanter and Strehlke 1988, pp. 344–51, no. 75 a–c; Kanter 2000, pp. 153–4, n. 5. Rejected by M. Boskovits in Boskovits and Brown 2003, pp. 496–504, esp. p. 496 n. 5.
9 The Griselda Master has been identified as the mature Bartolomeo della Gatta by Marini 1960, p. 141; as the young Baldassare Peruzzi by L.B Kanter and M. Miller, see Miller 1993, pp. 10–13, 15, note 42; as Rocco Zoppo by C.E. Gilbert 1996, p. 684; and as possibly the same painter as the one now called the *Maestro dei putti bizzari* by Angelini 1989; cautiously identified with Girolamo di Domenico by A. Angelini in Bellosi 1993, pp. 424–7. Resolving the differences between the figure styles of the *Maestro dei putti bizzari* and the first paintings attributed to the Griselda Master is difficult, even assuming that he had spent time in the interim in Pintoricchio's shop.
10 Longhi 1964.
11 A. Angelini, 'Pinturicchio e i pittori sensei: dalla Roma dei Borgia alla Siena di Pandolfo Petrucci' in Caciorgna, Guerrini and Lorenzoni 2006, pp. 83–99; A. Angelini, 'Pinturicchio e i suoi: dalla Roma dei Borgia alla Siena di Pandolfo Petrucci' in Angelini 2005, pp. 483–553, esp. pp. 497–9.
12 A. Angelini in Caciorgna, Guerrini and Lorenzoni 2006, p. 91.
13 M. Boskovits in Boskovits and Brown 2003, pp. 496–504, esp. p. 496.
14 The *Annunciation* in Volterra (Henry and Kanter 2002, pp. 16–17, 177, no. 23), appears to be the only certainly non-Sienese painting that may have influenced the Griselda Master, who probably used the arcade in which the Virgin stands as the model for his architecture in cat. 64.
15 A. Bagnoli in Bellosi 1993, pp. 410–13, cat. 87.

58.

Figures in a Landscape: Two Nude Youths, about 1490

Oil on panel, 69.2 × 41.2 cm
Toledo Museum of Art, Toledo, OH
Purchased with funds from the Libbey Endowment
Gift of Edward Drummond Libbey (1955.222A)

59.

Figures in a Landscape: Man, Woman and Child, about 1490

Oil on panel, 67.9 × 41.9 cm
Toledo Museum of Art, Toledo, OH
Purchased with funds from the Libbey Endowment
Gift of Edward Drummond Libbey (1955.222B)

Just as Donatello's *Virgin and Child* relief of the late 1450s had a profound effect on the pictures and sculptures that were executed in Siena thereafter (see p. 52), so the impact upon Sienese painters of Luca Signorelli's Bichi Altarpiece cannot be underestimated. It introduced to Siena a rich, saturated palette and a dazzlingly energetic oil technique. The component parts of the altarpiece are now scattered across Europe and America (fig. 62–7). Among these, though they were the least visible in their original setting (and are now the most damaged), the Toledo fragments appear to have been studied by local Sienese with particular care. Here was a method for modelling the human form with sharp contrasts of light and shade and with a new anatomical accuracy. What is more, it was a mode that could be related directly to ancient statuary. One of the nudes in cat. 58 is in the pose of a famous ancient Roman sculpture, the *Spinario* (*Boy pulling a thorn from his foot*).

The political context for Signorelli's work was very different from that of Donatello's. The altarpiece was in the Bichi Chapel in the right transept of the church of Sant'Agostino. Documents published by Max Seidel show that in 1487 Eustochia Bichi, widow of Cristoforo Bellanti (d. 1482), acquired responsibility for the chapel, which she dedicated to Saint Christopher in her husband's memory.[1] This was the year of the return of the *Nove*, in which *monte* Eustochia's father, Antonio Bichi (d. 1506), acting as Eustochia's representative, was a leading member. Bichi had spent most of the period of his exile in Naples and, significantly, in Urbino and Rome.[2] It is therefore likely that he had encountered the painting of Signorelli during his travels.

Sigismondo Tizio (1458–1528) claimed in 1513 that Signorelli had painted the 'excellent' altarpiece for Antonio Bichi in the church of Sant'Agostino fifteen years before, and until quite recently the date 1498 was universally accepted for Signorelli's panels. It is now known, however, that the commission dated from some ten years earlier. In June 1488, two potters – the brothers Pietro and Niccolò di Lorenzo Mazzaburroni – were contracted to execute a tiled pavement for the Bichi chapel. The contract for this work was transcribed in a manuscript history of about 1720, an account of the Bichi family by one of its members, Abbot Galgano Bichi (1663–1728).[3] It transpires that a month earlier the leading Sienese wood-worker Ventura di Ser Giuliano Tura had been commissioned to cut the panels on which Signorelli would paint and the frame for the altarpiece.[4] Ventura had to deliver these panels within twenty days, and the remaining parts of the frame, later described as a gilded triptych, within four months.

No surviving documents refer to Signorelli by name, but it is likely that his involvement with the chapel decoration and its altarpiece was foreseen from early on. His existing commitments in Cortona may have caused him to start work a couple of years after the project was underway. His contribution also included two *grisaille* frescoes of the *Erythraean* and *Tiburtine Sibyls*, above further monochrome frescoes designed and partly executed by Francesco di Giorgio, *The Nativity of Christ* and *The Birth of the Virgin* (see fig. 49–50, p. 153). The major redecoration of the chapel was complete by 1494. Signorelli and Francesco di Giorgio had already met in Gubbio (in the territory

 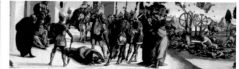

Main row, left to right

Fig. 62
Luca Signorelli (about 1440/50–1523)
*Saints Catherine of Siena, Mary Magdalene
and Jerome*, about 1490
Oil on panel, 145.5 × 76 cm
Gemäldegalerie, Staatliche Museen, Berlin (79)

Fig. 63
Francesco di Giorgio Martini (1439–1501)
Saint Christopher, 1488–90
Polychrome wood, 163 cm tall
Musée du Louvre, Paris (RF 2384)

Cat. 58

Fig. 64
Luca Signorelli (about 1440/50–1523)
*Saints Augustine, Catherine of Alexandria,
and Anthony of Padua*, about 1490
Oil on panel, 145.5 × 76 cm
Gemäldegalerie, Staatliche Museen, Berlin (79)

Cat. 59

Predella, left to right:

Fig. 65
Luca Signorelli (about 1440/50–1523)
Christ in the House of Simon the Pharisee, about 1490
Oil on panel, 26 × 90 cm
The National Gallery of Ireland, Dublin
(NGI 266)

Fig. 66
Luca Signorelli (about 1440/50–1523)
Lamentation over the Dead Christ, about 1490
Oil on panel, 29.8 × 119.1 cm
The Stirling Maxwell Collection,
Pollock House, Glasgow (PC.25)

Fig. 67
Luca Signorelli (about 1440/50–1523)
Martyrdom of Saint Catherine of Alexandria, about 1490
Oil on panel, 29.6 × 92.4 cm
Sterling and Francine Clark Art Institute,
Williamstown, MA (952)

belonging to the Duke of Urbino) in 1484. Francesco was the older and possibly the senior master in this new partnership, and it is not known if the idea to include Signorelli came from him or from Antonio Bichi.

Abbot Galgano Bichi's manuscript also contains a detailed – almost stream-of-consciousness – description of the altarpiece *in situ*, referring to his own drawings, now lost.[5] The complex was made up of three arched sections, a larger main panel and two lateral panels with figures of saints (described but somewhat vaguely identified; their arched tops have been removed. See fig. 62, 64).[6] Pilasters were attached which supported the arches of the frame. The central arch was both taller and wider and on the painted panel that it contained, set further back than the laterals, a number of figures were depicted. This functioned as the backdrop to a carved wood, polychrome statue by Francesco di Giorgio of *Saint Christopher* (fig. 63). This was thus a very large altarpiece, which, if pedimented, would have resembled a triumphal arch.

These fragments from the central section (cat. 58, 59), which were removed from the altarpiece earlier than the other elements, have suffered worse than the others from abrasion and paint losses. But the figures, generally the best preserved parts, give an idea of their original striking quality. They were more broadly and quickly painted than the laterals or predella, seemingly taking account of their more distant viewing point (and perhaps the fact that a statue would stand in front of them). The general effect is of a rather brilliant sketchiness. The figures and rocks were painted first and major *pentimenti* are now visible under the sky and water painted afterwards.

The raised arm of the woman in *Man, Woman and Child* was originally placed higher, and the size of the island to her left and the profile of her hair, once knotted behind, have been reduced. There is also a change to the rocks above the child's head. Minimal details were then added, like the tree growing out of the little promontory or the island painted over the water, cut through on the left. The picture seems to some degree improvised. Nonetheless Signorelli made use of cartoons for the some at least of the figures. *Spolveri* – dots made by pushing ink or paint through little holes in a pricked drawing – can be seen in the woman's raised hand, especially clearly in her thumb. Galgano Bichi suggested that the figures represented people dressing and undressing in order to swim across the river over which Saint Christopher ferried the infant Christ, as described in the *Golden Legend*.

These works introduced a new language for painting in Siena and they were closely studied by native Sienese painters. Pietro Orioli, for example, seems to have imitated Signorelli's loosely hatched shadowing. Neroccio in his last works changed his system for modelling form with light and shade. Above all, Signorelli was crucially important for the development of the Griselda Master. LS

1 Bandini Piccolomini 1896b, p. 123; M. Seidel, 'The Frescoes by Francesco di Giorgio in Sant Agostino in Siena' in Seidel 2003A, pp. 570–3, 577, 636–40, note 30.
2 Shaw 2000, pp. 91, 107, 130.
3 'Storia della Famiglia Bichi': see Bandini Piccolomini 1896b, p. 124.
4 Toledano 1987, p. 113.
5 Published by Vischer 1879, pp. 243–4. See Syson (forthcoming) for the original.
6 Ingendaay 1979, p. 120.

SELECT BIBLIOGRAPHY

M. Seidel, 'Luca Signorelli Around the Year 1490', in Seidel 2003A, pp. 645–707, esp. pp. 656, 664–6, 699, 702, n. 79, 80; Henry 1998, pp. 8–9; Henry and Kanter 2002, pp. 21, 171–2, no. 16.

60.

FRANCESCO DI GIORGIO MARTINI (1439–1501)

Portrait medal of Antonio di Ambrogio Spannocchi (1474–1503), about 1494

Cast bronze, 5.2 cm diameter
Museo Civico, Siena (1064)

Inscribed on obverse: · ANTONIVS · SPANN OCHIVS: (*Antonio Spannocchi*)
Inscribed on reverse: IGNIS IPSAM RECREAT ET ME CRVCIAT ·
(*The flame refreshes her/it and tortures me*)

This is apparently the portrait of a young man tortured by the flames of love. Or so the inscription on the reverse of this medal implies. It accompanies the image of a dragon-headed salamander, nestling in the middle of a bonfire and, just as authorities from Aristotle and Pliny onwards had claimed, impervious to its heat. The salamander can symbolise both chastity and passion, being able at will to extinguish or stoke up a fire. The message of device and inscription is thus not absolutely clear, an element of mystery that was probably deliberate and is typical of many Quattrocento medals. The relative obscurity of the reverse suggests that the medal had a rather limited audience – probably including the object of the lover's affections. (The medal survives in only three specimens.)[1]

The reverse was quickly modelled in wax, the sculptor scoring into the ground to indicate the more distant flames and to strengthen the contours – particularly above the lizard's tail. A simple double-ring punch, of the kind used on gold-ground paintings, was used for the stop at the end of the inscription. The obverse portrait was modelled in much the same way, though with more care, and it is clear that the portraitist has sought to emphasise the youth and beauty of the sitter – appropriately for the portrait of a young lover. His shoulder-length, wavy hair is cut shorter as it falls over his cheekbone; he has a rather large, slightly aquiline nose and generous mouth, but the lines of the whole profile are supremely elegant.

If the medal depicts a lover, it also represents an exceedingly rich and powerful young man who in 1494 had entered into a marital alliance with a member of one of

Siena's great families, surely more for political reasons than because he had fallen passionately in love. In January 1494, Antonio Spannocchi married the daughter, Alessandra (d. 1497), of Neri Placidi, who was not only a leading member of the *Nove* (for the family see cat. 33), but also a councillor of Alfonso II, King of Naples.[2] At the same time Antonio's younger brother Giulio (born 1475?) took the Roman noblewoman Giovanna Mellini as his bride (see p. 25). This double marriage broadcast the Spannocchi brothers' network of mercantile and diplomatic activity between Siena, Rome and Naples, and beyond, to Valencia in Spain. Antonio had been baptised on 27 May 1474, when his sponsors were Cardinal Francesco Gonzaga and Cardinal Rodrigo Borgia – the future Pope Alexander IV. The Spannocchi had established strong links with the Borgia during the papacy of Calixtus III. After the death of his father Ambrogio in 1478 the hugely profitable family business continued under the rubric '*eredi di Ambrogio Spannocchi e socii*' (heirs of Ambrogio Spannocchi and associates), administered on the brothers' behalf by their widowed mother, Cassandra Trecerchi. The merchant bank went on turning a large annual profit and its branches remained open in Siena, Rome, Naples and Valencia.[3] Its commercial interests included silk, wool and especially allum, and Cassandra continued to acquire properties in the city and the Sienese *contado*.[4]

The brothers came of age in 1488 and, by the early 1490s, they were at the peak of their political power. Members of the disenfranchised *monte dei Dodici*, they were re-admitted to government as *Gentilhuomini* – Antonio serving as a prior in the Concistoro

in March–April 1493 and Giulio in November–December the next year. On 11 September 1495, Antonio was dispatched by the Concistoro to the court of Pope Alexander IV (along with jurist and fellow Dodici member Bartolomeo Sozzini the Younger); the point of their mission was to ensure that the Sienese should be included in the league formed between the Pope, the Holy Roman Emperor Maximilian I, Ferdinand and Isabella of Castile (rulers, by then, of Valencia) and Lodovico Sforza, Duke of Milan ('il Moro'), to thwart the territorial ambitions in Italy of the King of France, Charles VIII. Antonio was to remain in Rome as the Sienese *oratore* (envoy). He found himself, however, increasingly stressed by the difficulty of simultaneously representing Sienese interests and remaining on good terms with his godfather, Alexander. The bank was acting as the pope's *depositario generale*. In February 1496, he wrote, touchingly: 'I do not refuse any burden whatever in the service of Your Lordships and would like to be able to do much for your benefit: but, as I said at the beginning, I am hardly old enough and my experience is not such that I can perform vigorously in the handling of these things, to a degree that I would suppose that anyone else would be more adequate to this office than I am'.[5] Shortly afterwards, Antonio returned to Siena, though his public role there was significantly curtailed. His worries proved prescient and, by the beginning of the sixteenth century, the family fortunes were beginning to founder, not least because Antonio and his brother found themselves caught up in the savage dispute between Pandolfo Petrucci and Cesare Borgia. The Spannocchi brothers thought it prudent to sell their Sienese

properties and to transfer their activities to Rome. In April 1502 they apparently sold (or perhaps mortgaged) their palace in Siena for 14,000 gold florins to Giordano da Venafro, who was working on behalf of Pandolfo Petrucci. Antonio died in Rome on 20 August 1503, just two days after Pope Alexander, and was buried at Santa Maria sopra Minerva (where Saint Catherine of Siena, minus her head, was interred). The Spannocchi bank was declared bankrupt in the same year.

In their prime, the artistic patronage of the Spannocchi brothers was focused mainly on non-Sienese artists. These included the Master of the Story of Griselda, who, even if he was in fact Sienese by birth, fashioned his style chiefly upon non-Sienese artists – of whom Pintoricchio was most tightly linked with Borgia Rome. The Spannocchi are also said to have been responsible for bringing Sodoma from Rome to Siena (see cat. 61). Francesco di Giorgio, first identified as the sculptor of this medal by Habich, was, however, thoroughly Sienese. Antonio's choice of artist was natural: Francesco had made a medal of his father Ambrogio Spannocchi, probably in the early 1470s. And of all Sienese artists working in the 1490s, Francesco di Giorgio was the only one who had become a truly international figure – one moreover who also encapsulated connections between Siena and Naples. The medal of Antonio Spannocchi is in fact most closely linked stylistically to Francesco's medallic portrait of the protonotary Juan de Mendoza, made during his trips in the mid 1490s to Naples.[6] While it is likely that Antonio's medal was made in connection with his wedding, it is possible that it was executed in Naples where Francesco di

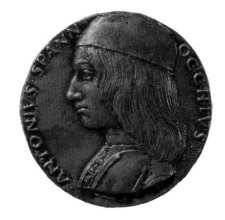

Giorgio had gone to serve King Alfonso in early 1494, having been granted permission to leave Siena only days after the Spannocchi wedding. It is, in fact, from Antonio Spannocchi that we learn of Francesco's activities in the service of the alliance formed against the French king Charles VIII. On 7 December 1495, he wrote to Siena in his role as *oratore* with an account of the imminent defeat of French troops at the Castelnuovo in Naples: 'The Castello has remained all alone [*tutto solo*], around which our maestro Francesco di Giorgio, both with underground approaches [*cave*] and other materials, only waits to constrain it in such a manner that in a very few days, either by love or force, it is thought that it will be in the hands of the King [of Naples], who beneath with underground attack, and without by bombards, has done it enough injury.'[7]

In the eyes of the world, the connection between Antonio Spannocchi and Francesco di Giorgio remained close. By March 1497, Frederick IV had succeeded to the Neapolitan throne, but Francesco di Giorgio had returned to Siena. The king was desperate to get him back and, as well as contacting the

artist himself, he wrote letters to Antonio Spannocchi and his father-in-law, Neri Placidi, as well as to Pandolfo Petrucci and Antonio Bichi.[8] This correspondence makes it clear that by then Francesco di Giorgio's services could only be obtained through diplomatic negotiations, in which the artist's Sienese patrons were key. These relationships meant that the employment of artist by patron added to the status of both. Francesco's medal of Antonio Spannocchi could therefore be taken as a sign of their intimate connection. LS

1 The other two are in the Münzkabinett, Berlin (55 mm), and one last recorded in the Von Lochner collection in Lindau.
2 This biographical information is derived chiefly from Lisini 1908; Morandi 1978; Ait 2005.
3 For the Valencia bank see Cruselles Gómez and Igual Luis 2003.
4 Morandi 1978, pp. 108–9.
5 Lisini 1908, p. 7.
6 Hill 1930, no. 313, p. 78.
7 Brinton 1934–5, II, pp. 73–4.
8 Weller 1943, p. 37.

SELECT BIBLIOGRAPHY

Lisini 1908; Habich 1923, pp. 65, 152, pl. 35.3; Hill 1930, p. 78, no. 314; Weller 1943, pp. 181–2; G. Agosti in Bellosi 1993, p. 493, fig. 5–6.

61.

GIOVANNI ANTONIO BAZZI, KNOWN AS SODOMA (1477–1549)
Portrait of a Youth (Antonio Spannocchi?), about 1500–3

Black chalk with bodycolour, washed over, 40.4 × 28.8 cm
Christ Church, Oxford (JBS 313)

Inscribed on remains of old border (by Giorgio Vasari?):
DI LEONARDO DA VINCI;
also inscribed on mat in seventeenth- or eighteenth-century hand:
RITRATO DI RAFFAEL D'URBINO

The Spannocchi family were often adventurous in their choice of artists (see p. 47). Vasari tells us that Sodoma was 'brought to Siena by some merchants who were agents of the Spannocchi'.[1] He also claims that Sodoma was particularly acclaimed at the beginning of his time in Siena for his portraits: 'producing many portraits from life with his manner for bright colours which he had brought from Lombardy, he made many friends in Siena.' Vasari further states that Sodoma was 'a very skilled young man . . . and particularly in making portraits from life'.[2] Evidence for Sodoma's particular ability in this area is provided by the many figures in his fresco cycles – especially at Monteoliveto Maggiore (see fig. 68) – which are likely to be depictions of specific individuals.[3]

This highly finished drawing, probably preparatory for a lost painted portrait, is therefore fundamental for our understanding of his contribution to Sienese art at the moment he arrived in the city and in gauging the appearance of his painted portraits, none of which survive. Sodoma presents a youth dreamily gazing out of the sheet, his long hair flowing from beneath his cap, his hands resting on a parapet. There is no basis for its traditional identification as Raphael, and rather it seems that the portrait drawing almost certainly represents Antonio di Ambrogio Spannocchi.[4] The similarity between the Christ Church youth and the image of Antonio Spannocchi in Francesco di Giorgio's medal (cat. 60) is certainly strong.[5] The long hair, cut shorter as it falls over his cheek-bone, the strong nose with its high bridge, full lips and heavy eyelids are common to both images. As we have seen, Antonio Spannocchi lived

intermittently in Rome from 1495 and died there in 1503.[6] He might have sat to Sodoma in Rome, while the painter was at work on his fresco cycle at the chuch of San Francesco in nearby Subiaco (in about 1500). Sodoma was at work near Siena by July 1503 (see p. 358), a month before Spannocchi's death.

The hands of the sitter, at the bottom left corner of the drawing, have been reworked several times, so that it is now very difficult to understand Sodoma's intention in this part of the composition. It seems that the sitter's left hand is resting on the parapet, its position slightly shifted. The right hand behind is now a confusing jumble of lines. It is possible to discern, however, an object held between the youth's right thumb and index finger, which might be a ring. This could perhaps be associated with a wedding, but might transmit another, more general message.[7] Sodoma also sketched a different, oblong attribute in the sitter's right hand, running diagonally from the hand to the left edge of the sheet. Its faint outlines only suggest its shape and it is difficult to identify this object exactly; it might, just possibly, be an ear of corn (*pannocchia*).

This format for portraiture, a three-quarter view of the sitter slightly more than bust-length, was previously unknown in Siena. In fact this drawing was long attributed to Leonardo da Vinci. Vasari himself, who might have included the drawing in his *Libro de' disegni*, was probably responsible for inscribing its border with Leonardo's name.[8] It was only in 1904 that Frizzoni correctly assigned the drawing to Sodoma, an attribution that has not since been disputed.[9]

The old attribution to Leonardo is understandable given the character of the

Fig. 68
Giovanni Antonio Bazzi, known as Sodoma (1477–1549)
Portraits of Youths; detail from *The Life of Saint Benedict; the Saint excommunicates two Nuns*, about 1503
Fresco, Abbazia di Monte Oliveto Maggiore, Siena

drawing, which, as Bartalini rightly argues, depends upon 'Leonardo's new type of portraiture'.[10] The subtle psychology and the softness and delicacy of the drawn lines can be viewed as particularly Lombard features, aspects that Sodoma introduced to Siena. It seems likely that the young Giovanni Antonio Bazzi (called Sodoma only later), received a large part of his early training before 1500 in Sforza Milan, making him aware of the art of Leonardo and his collaborators and pupils.[11] Sodoma's poetic, acute and sympathetic rendering of the sitter's features would be inconceivable without the example of Leonardo's Milanese portraits. Bartalini's reading of the drawing centres upon its relationship with Milanese prototypes, especially with the work of Boltraffio.[12] He characterises the portrait as 'more than just a resemblance, but sentimental, psychological'.[13]

Notwithstanding this lack of comparable works by Sodoma, and the general difficulty

in dating his drawings, Bartalini's date of about 1500 for the portrait is reasonable.[14] The similarities in treatment between the face of this youth and the heads in the *Marriage of the Virgin* at Subiaco are undeniable.[15] It seems probable therefore that the drawing was executed early in the first decade of the sixteenth century, a date compatible with Antonio Spannocchi's biography. XS

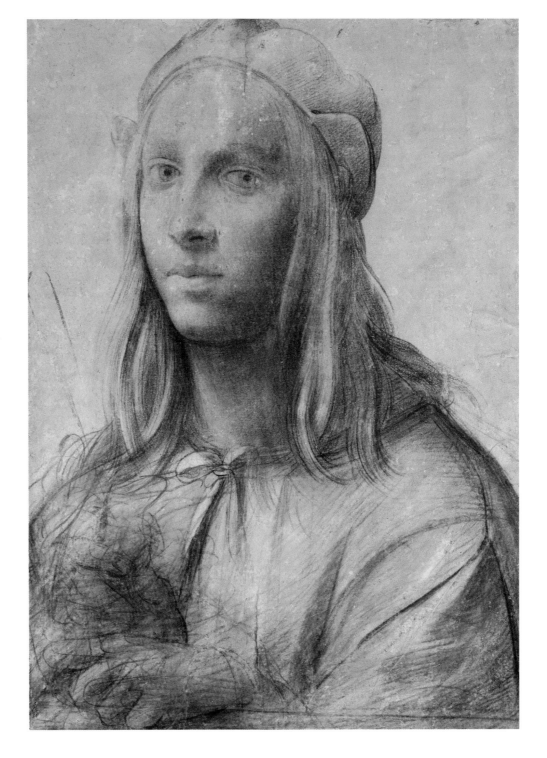

1 Vasari 1966–87 edn, V, p. 381. See also p. 166: *'condotto a Siena, come si dirà a suo luogo, da uno degli Spannocchi mercante'*.
2 Vasari 1966–87 edn, V, p. 381, p. 166.
3 Vasari confirms this, referring to a series of heads in tondi at Monteoliveto, now lost: 'and since he did not have portraits from life, Sodoma made his heads for the most part as the mood took him, and in some portrayed from the life some of the older monks who were in the convent at the time.' Vasari 1966–87 edn, V, p. 383.
4 See further X.F. Salomon in Syson (forthcoming).
5 This connection was first made verbally by Luke Syson.
6 For Spannocchi's appointment, see ASS, Balìa, 40, fol. 31r. Reference to this document was kindly provided by Philippa Jackson.
7 Spannocchi was married in 1494, which is too early for the Christ Church drawing; see cat. 60.
8 Kurz 1937, p. 32; Ragghianti Collobi 1974, p. 93; Bartalini 1996, p. 99 n. 1.
9 Frizzoni 1904, p. 98; followed by Colvin 1904, I, no. 9.
10 Bartalini 1996, p. 100.
11 For the most recent discussion of Sodoma's development, see Bartalini 1996, especially pp. 87–99.
12 Bartalini 1996, pp. 99–101.
13 Bartalini 1996, p. 100.
14 Bartalini 1996, pp. 99–101.
15 For the chapel at Subiaco, see Schmarsow 1901; Schmarsow 1928; Bartalini 1996, pp. 102–6. Hayum (1976, p. 275) rejects the attribution. However, even taking into account the poor state of the frescoes, it seems that Schmarsow and Bartalini's arguments are correct.

SELECT BIBLIOGRAPHY

Colvin 1904, 1, no. 9; Cust 1906, pp. 113–14, 369; Byam Shaw 1976, pp. 106–7, no. 313; Bartalini 1996, pp. 99–101.

The Story of Griselda

The still anonymous 'Master of the Story of Griselda' derives his designation from these three gloriously entertaining panels,[1] retelling Boccaccio's tale from the *Decameron* (1348–51) of the marriage of the Marchese Gualtieri di Saluzzo to the peasant girl Griselda.[2] In *Marriage*, the first of the three (the first, that is, of the narrative sequence but probably not the earliest painted), the Marchese, out hunting, encounters the beautiful peasant girl Griselda and announces that he will wed her on condition of her absolute obedience. Obtaining her father's consent (right background), he publicly humiliates her, stripping her bare to dress her again in her wedding finery (right). The wedding takes place at the centre of the picture, framed by a triumphal arch. In the second picture, *Exile*, which reads left to right, the now married Gualtieri tests his wife further by removing her newborn daughter and son and pretending he has had them killed (left background). Underneath the loggia at the centre, he then stages a bogus annulment of their marriage. Griselda returns her wedding ring and is once again forced to strip, though this time she is permitted to keep her *camicia*, in which she returns disconsolately to her father's house (right). In the final painting of the cycle, *Reunion*, the Marchese seeks out Griselda, who now believes her children murdered and herself divorced, and orders her to prepare his home for the arrival of a new bride (right background). Griselda – inevitably – obeys (left background) and meanwhile, in the far background, the wedding procession of this new bride arrives in Saluzzo; the Marchese's supposed wife-to-be is in fact Griselda's long-lost, grown-up daughter,

accompanied by her younger brother. Griselda is reunited with her children (right) and the Marchese reveals that her long ordeals have all been tests of her obedience, and that she has indeed proved herself a perfect wife. At the end of this troubling little tale, they embrace, an ideal couple at long last (left).

The pictures, of the type now generally classified as *spalliere*,[3] may have been installed in a row, since they are all lit from the left. It is more certain that they were intended to furnish a principal *camera* of a patrician *palazzo*, perhaps placed above three *cassoni* – or, given that the perspective angle of the architectural settings suggests that the viewpoint was intended to be reasonably low, installed higher up. A bedchamber location may be deduced not only by their size and shape, but also by their subject-matter, which makes them particularly (and typically) appropriate for a nuptial chamber.

The painter's style and technique evolved during the painting of these three works, but some aspects are consistent and distinctive. His works are characterised above all by a delicacy and lightness of touch. The pictures are populated by notably elongated men with long, well-formed legs and barrel-like thoraxes and women with tiny waists and flowing hair. The protagonists flounce and bounce on their toes, swaying and gesticulating with consummate elegance while high-stepping horses with frothy manes adopt almost balletic poses. Gesture is all-important. The artist could also be immensely witty, and he is highly sophisticated in his approach to episodic narrative. Throughout, moments in the story are linked by a chattering commentary of bystanders, a

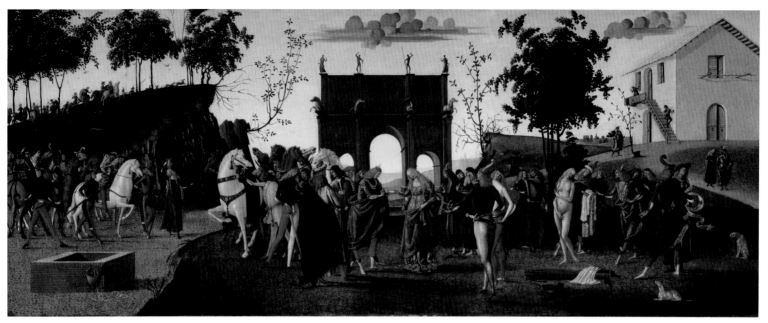

feature of Boccaccio's tale, and the animals in the foregrounds mirror or satirise the behaviour, even the extravagant costume, of the human protagonists.

It is now certain that these three pictures were commissioned by members of the Spannocchi family.[4] They should be linked with the wedding on 17–19 January 1494 of the sons of the late Ambrogio Spannocchi, Antonio and Giulio (see cat. 61). The wedding was celebrated with huge and extravagant ceremonies, by the performance of another of Boccaccio's *Decameron* stories (IX, 3) and by the erection of a temporary triumphal arch with, on top, four statues of famous men-of-arms.[5] It may be that this arch, or something very like it, is represented in *Marriage*. Two more panels at Longleat House, Wiltshire, which share a nineteenth-century provenance in the collection of Alexander Barker with the Griselda narratives, were probably made for the same event.[6] This further pair of panels depict episodes from the life of Alexander the Great (fig. 12, pp. 26–7), the story being taken from Plutarch's *Parallel Lives* (XX, 5–XXI, 5), and of his Roman parallel Julius

Caesar, crossing the Rubicon, as told by Suetonius (I, xxxi–xxxiii). The coat of arms painted on Alexander's tent is that of the Spannocchi family. The Piccolomini stemma is visible on the dexter (the family had been granted the right to incorporate Piccolomini arms with their own) and, severely abraded, the Spannocchi arms, with their three Spannocchi gold paired ears of corn (*pannocchi*), are seen on the red sinister side. These works should be attributed to the workshop of Domenico Ghirlandaio, and they seem therefore to be the pictures described by Vasari in his 1568 life of Ghirlandaio: 'Domenico [Ghirlandaio] and Bastiano [Mainardi] together painted in Siena, in a room of the palace of the Spannocchi, many stories with little figures, in tempera.'[7] One hand (there appear to be three in all) is certainly identifiable as that of Bastiano Mainardi. Ghirlandaio was active in Siena, working for the Cathedral on mosaic designs, between April 1493 and about March 1494 (or possibly a little later).[8] Davide continued to run the Ghirlandaio workshop after Domenico's death on 11 January 1494. The dates of Davide's work

for the Duomo give us a probable dating for the Longleat pictures of about 1493–4, thus probably commissioned just before Domenico's death and coinciding perfectly with the weddings of the Spannocchi brothers. The firm link between the two sets of pictures is established by the fact that servants garbed in the same liveries appear in both the Longleat *Alexander* painting and, accompanying the Marchese Gualtieri, in the first and third Griselda panels. They are clearly to be identified with the bridegroom in both instances. This is evidently a Spannocchi livery and the colours of their hose tie in precisely with those of the coat of arms – white (standing for silver), blue and a flash of gold on one leg (the Piccolomini dexter), red for the Spannocchi on the other. Since Palazzo Spannocchi was an important focus for the wedding ceremonies, we can assume that the Griselda panels, like the Longleat pictures, were commissioned for the marriage and therefore begun in late 1493.

All three have detailed underdrawings and the design of the panels, and especially the distribution of the many episodes of

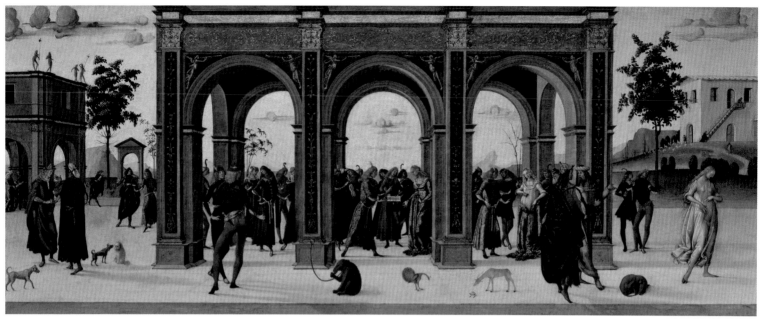

CAT. 63

Boccaccio's narrative, must have been worked out to a considerable extent in advance. The paintings were probably executed one at a time and seemingly out of narrative sequence. Sets of painted furnishings commissioned for marriages were not necessarily finished in time for the ceremonies themselves,[9] but, in the context of such a commission, it would have made sense in this instance for the painter to try to complete the third in the set first, the one that depicts the feast celebrating the marriage (albeit a staged one) of the Marchese to his supposed new bride, and the happy ending brought about by female obedience. There are also stylistic reasons for proposing that *Reunion* was the first to be executed. The figures are exceptionally tall and slender, even by the Griselda Master's standards, and their heads and feet are proportionally very small – indeed a figure's feet can be smaller than its ex-pressively gesturing hands. Although the standing figures are usually posed with their weight on one leg, in a way that suggests knowledge of works by Perugino and Signorelli, their legs are often stiff and their

backs remain straight. The Griselda Master's contact with Perugino's *bottega* was perhaps via Pintoricchio. One of the male servants in *Reunion* (in the foreground, centre left) adopts, rather wonderfully, the attitude of the attenuated Annunciate Virgin in the *Annunciation* (Ranieri Collection, Perugia), almost certainly a product of Perugino's workshop, rather than an autograph painting by the master himself.[10]

Marriage was probably the second panel to be painted. Here, bulkier and more heavily draped figures in the manner of Signorelli have been introduced, notably those of the Marchese and Griselda at the centre and the bystander with his back turned to the viewer. The poses of the figures in *Exile* have become noticeably more varied and flexible. Although some still have the stiff-legged gait of the other panels, waists now bend and hips jut and sway to give the impression of dance that is so much a feature of this anonymous master. His method of representing fluttering draperies has, however, become a little less extreme,[11] with the spirals replaced by slightly more credible zigzag folds. It can be

seen in infrared that he eliminated a flutter of drapery that he drew on the right side of the figure of Griselda in her shift. This alteration marks the beginning of a tendency for the painter to curb some of his decorative flourishes and to reduce over-complex contours, and to pursue a more naturalistic, indeed more Signorellian, impulse. Another lissom youth, serving at table in *Reunion* (foreground, centre right), derives his pose from one of the fragments from the central section of Signorelli's Bichi Altarpiece (cat. 59). Whereas he still looks a little stiff in comparison to his model, by the time the Griselda Master came to quote the altarpiece (cat. 58) again, for the bystanders seen from the back in *Exile*, he has fully understood Signorelli's take on the male anatomy and his system of lighting. The mournfully departing figure of Griselda in this scene is taken from the Bichi predella.

The Griselda Master also changed his approach to the planning of the architec-tural settings as he went along. In spite of the complex architecture of the structures that appear in *Marriage* and in *Exile*, the

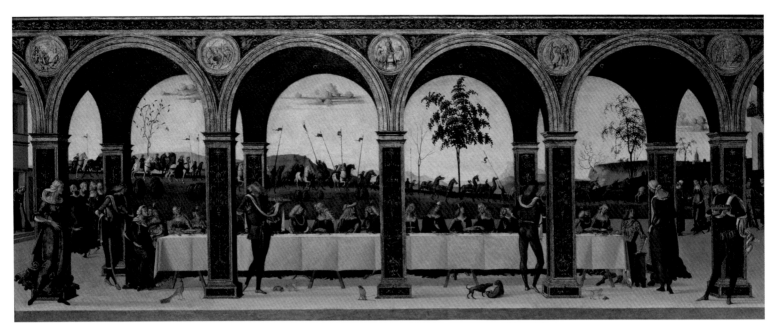

CAT. 64

painter made little use of incision, preferring to rule straight lines in ink, using a technique close to that latterly employed by Francesco di Giorgio (see cat. 23). The only incision in the architecture occurs in the arcs of the arches in all three panels and in the vaulting and roundels of *Reunion*. The positioning of the figures in *Exile*, on the other hand, is more complex and, while retaining an element of symmetry, is more subtly varied. For this more elaborate setting the painter drew a perspective grid that allowed him to establish the correct spatial location for each figure.

The three paintings owe much of their decorative effect to the use of gold leaf. This is often, but not always, used illusionistically, applied to surfaces that would be golden in reality and with careful attention to lighting effects. The figure of the Marchese, for example, is identified throughout the story (no matter how small he appears) by his cloth-of-gold tunic and gold chain. The Griselda Master was not unusual in late fifteenth-century Siena in using real gilding for cloth of gold without compromising the volume, structure and lighting of the

draperies to be depicted. Less plausibly, the rocks behind the figure of the peasant Griselda encountering the Marchese on the left of *Marriage* are lit with diagonal hatched lines of gold leaf. There are no such decorative interpolations in *Exile*. The mode here is by now thoroughly modern. LS

1 Davies 1961, pp. 365–7; L. Syson in Santi and Strinati 2005. I am very grateful to Jill Dunkerton, some of whose text in Dunkerton, Christensen and Syson 2006 is adapted for this entry.
2 Boccaccio, *Decamerone*, X, 10 (the last story in the book). Although it was very well known, it does not appear be have been an especially common subject in Italian Quattrocento painting. But see, reconstructed in the Castello Sforzesco in Milan, the late fifteenth-century detached *grisaille* frescoes originally from the so-called Sala of Griselda, Castello di Roccabianca, near Parma, and a pair of Florentine *cassoni* in Bergamo, once attributed to Pesellino (see Schubring 1923, III, pl. LXI) with a very simplified rendition of the story. For the subject see Allen 1977, pp. 1–13. We should not forget Petrarch's version, *De insigni obedientia e fide uxoria* (*Seniles*, XVII, 3).
3 Barriault 1994, cat. 9, pp. 118–19, 148–9.
4 First proposed by Tátrai 1979; confirmed by L. Syson in Santi and Strinati 2005.
5 See Ugurgieri Azzolini 1649, pp. 323–4, and A. Allegretti, *Ephemerides Seneses ab anno MCCCCL usque ad MCCCCXCVI italico sermone scriptae*, in Muratori 1733, p. 840, quoted in Syson (forthcoming).

6 See most recently L. Syson in Santi and Strinati 2005, pp. 199–203, cat. 2.18–20; Motture and Syson, 'Art in the casa' in Ajmar-Wollheim and Dennis 2006, pp. 275–7.
7 Milanesi 1854–6, III, p. 275. See Cadogan 2000, p. 288, no. 73 (under 'Lost Works').
8 Cadogan 2000, pp. 374–5, doc. 43.
9 See, for example, the paintings commissioned by his father for the marriage of Pierfrancesco Borgherini to Margherita Acciaiuoli in 1515, a series to which Pontormo is thought on stylistic grounds to have made the last contribution in about 1517–18. See Shearman 1965, II, p. 233.
10 Garibaldi and Mancini 2004, pp. 236–7, cat. i.33.
11 The source for these earlier spiralling folds, more extreme than any by Francesco di Giorgio, is possibly the draperies of Liberale da Verona.

SELECT BIBLIOGRAPHY

Tátrai 1979; A. Angelini, 'Pintoricchio e i suoi: dalla Roma dei Borgia ala Siena dei Piccolomini e dei Petrucci' in Angelini 2005, pp. 483–553; Syson in Santi and Strinati 2005, p. 199–203, cat. 2.18–20; Dunkerton, Christensen and Syson 2006, pp. 4–18

Virtuous Men and Women

65.

MASTER OF THE STORY OF
GRISELDA (active about 1490–1500)
Alexander the Great, about 1494

Oil and tempera on panel, 106 × 51.5 cm
The Barber Institute of Fine Arts
The University of Birmingham (51.4)

Inscribed: ALEXANDER / QVI PROPRIIS TOTVM
SVPERAVI VIRIBVS ORBEM /EXCVSSI FLAMMAS
CORDE CVPIDINEAS / NIL IVAT EXTERNIS BELLI
GAVDERE TRIVMPHIS / SI MENS AEGRA IACET
INTERIVS QVE FVRIT

(*[I am] Alexander, who with my own strength conquered
the whole world and banished Cupid's flames from my heart.
Rejoicing in the external triumphs of war is useless, if the
mind lies sick and rages inside*)

66.

MASTER OF THE STORY OF
GRISELDA (active about 1490–1500)
Joseph of Egypt or *Eunostos of
Tanagra*, about 1493–4

Oil and tempera on canvas
transferred from panel, 88.5 × 52.5 cm
National Gallery of Art, Washington, DC
Samuel H. Kress Collection (1952.5.2)

67.

FRANCESCO DI GIORGIO
MARTINI (1439–1501) and
MASTER OF THE STORY OF
GRISELDA (active about 1490–1500)
Scipio Africanus, about 1493

Tempera and oil on panel, 106 × 51 cm
Museo Nazionale del Bargello, Florence
(2023 Carrand)

Inscribed: VICTA MIHI CARTHAGO NOVA EST
VLTVRA PVELLAM / CVI FIEREM VICTVS PREDA
SVPERBA DEDIT / SED QVI BELLO HOSTES MEMET
RATIONESVBEGI /VT VIDEAR MERITVS BINA
TROPHAEA SIMVL

(*New Carthage, which I vanquished was about to take her
revenge. She gave me a girl so that I, vanquished in my turn,
should become her proud booty. But I who subdued the
enemy in war, have subdued myself with reason, so that I
may appear to have deserved both trophies at once*)

69.

MATTEO DI GIOVANNI
(about 1428–1495)
Judith with the Head of Holofernes,
about 1493

Tempera on panel, 56 × 46.1 cm (including 7 cm
false extension at lower edge)
Indiana University Art Museum, Bloomington, IN
Samuel H. Kress Study Collection (62.163)

70.

MASTER OF THE STORY OF
GRISELDA (active about 1490–1500)
Artemisia, about 1493–5

Oil, possibly with some tempera on panel,
87.8 × 46.3 cm
Museo Poldi Pezzoli, Milan (1126)

71.

PIETRO ORIOLI (1458–1496)
Sulpitia, about 1493

Tempera with some oil on panel, 106.7 × 46.3 cm
The Walters Art Museum, Baltimore, MD (37.616)

Inscribed: SVLPITIA / QVAE FACERE VENERI
TEMPLVM CASTAEQ[VE] P[R]OBAEQ[VE] / SVLPITIA
EX TOTA SVM MERITA VRBE LEGI / ARA PVDICITIAE
PECTVS SIBI QVODQ[VE] PVDIVM EST / CV[N]CTA
RVV[N]T FAMA DECVSQ[VE] MANE[N]T.

(*I am Sulpitia, who from the whole city deserved to be
chosen to build a temple to Venus, the chaste and virtuous
one. Whatever breast is chaste is itself an altar of chastity:
all earthly things collapse, and fame and honour remain*)

68.

MASTER OF THE STORY OF
GRISELDA (active about 1490–1500)
Tiberius Gracchus, about 1493–5

Oil and tempera on panel, 107 × 51.5 cm
Szépművészeti Múzeum, Budapest (64)

Inscribed: TIBERIVS GRACCHVS / MAS EST QVEM
PERIMIT SOSPES SED FOEMINA SERPENS /
CONIVGI SIC LAETVS SOSPITE GRACCHVS OBIT /
NEC VENIT STYGIAS VXORIVS ARDOR AD VNDAS /
CONIVNGIS AT CHARO PECTORE SEMPER ERIT.

*(It is the male snake that Tiberius Gracchus killed, and not
the female, and thus he died happy that his wife was
unharmed. Connubial love did not come to the Stygian lake,
but will be forever in his wife's dear breast)*

72.

NEROCCIO DI BARTOLOMEO
DE' LANDI (1447–1500) and
MASTER OF THE STORY OF
GRISELDA (active about 1490–1500)
Claudia Quinta, about 1493

Tempera and oil on panel, 104 × 46 cm
National Gallery of Art, Washington, DC
Andrew W. Mellon Collection (1937.1.12)

Inscribed: CLAVDIA CASTA FVI NEC VVLGVS
CREDIDIT AMEN / ET TAMEN ID QVOD ERAM
TESTIS MIHI PRORA PROBAVIT / CONSILIVM ET
VIRTVS SVPERANT MATERQVE DEORVM / ALMA
PLACET POPVLO ET PER ME HVNC ORATA TVETVR.

*(I, Claudia, was chaste and people did not believe I was,
and yet that which I was, the ship proved as my witness.
Prudence and virtue triumph, and the nourisher of the Gods
[Cybele] is gracious to the people and protects them when
invoked through me)*

The Master of the Story of Griselda was
deeply involved in a series – the most
extensive of its kind to survive, though
divided since at least 1820[1] – depicting
exemplary heroes and heroines of the
ancient world, Greek, Roman and Hebrew.
The figures are posed on pedestals, some
of which have been cut off, as if they were
polychrome statues (see cat. 9) brought to
life.[2] In the paintings that retain their fictive
plinths, inscriptions supported by paired
putti identify the subjects and give an account
of the conjugal, sexual or, more broadly,
familial virtues that lay behind their selec-
tion. Of the four men, three are identified
by inscriptions – Alexander the Great,
Scipio Africanus and Tiberius Gracchus;
the fourth, whose inscription has been cut
away, is probably Joseph of Egypt (though
he is sometimes identified as Eunostus of
Tanagra). Two women, Sulpitia and
Claudia Quinta, are clearly labelled, while
the identities of two others, Judith and
Artemisia, can be deduced. Cat. 69, the
most severely altered, has not always been
included in the series. Three of the figures
(cat. 67, 72, 71) that retain their inscriptions
have been attributed, though not always
straightforwardly, to Francesco di Giorgio,
Neroccio de' Landi and Pietro Orioli
respectively. Two of these panels, however,
were achieved in collaboration with the
Griselda Master (cat. 67 and 72). The *Judith*
(cat. 69) is by yet another artist, Matteo di
Giovanni. The other four were executed
in their entirety by the Griselda Master.

Most of the heroes and heroines, like
saints, hold attributes essential to their
stories. Their landscape backgrounds
contain episodes from the stories that had
made them famous – amplifying the iconic

figures by their exemplary narratives. This
combination of large figure and multi-
episode narrative is innovative – though
the device may derive from Signorelli's
Portrait of a Man (see fig. 60, p. 195).

Each figure was painted on a single
vertical poplar plank; the panels for the
Women are all slightly narrower. Given this
disparity in width, it is difficult to envisage
a frame design in which the Men and Women
could have alternated. The Men, therefore,
were in one group and the Women in another
(appropriately divided since they are
exemplars of sexual continence); the
panels for the Women are narrower prob-
ably because the space where they were to
be sited was slightly smaller. The arched
shapes of the panels are original, and this
laborious cutting would not have been
undertaken if the frames had been of a
tabernacle construction topped by a flat
entablature, in which case oblong panels
would have been used, with the spandrels
framed out. The upper mouldings of the
frames must have been a series of arches.
It is likely therefore that the panels were
framed together to form two secular altar-
pieces. This does not, however, mean that
they were all necessarily completed at the
same time; instead they very probably
delivered one by one, and framed and
joined together with battens only afterwards,
once all were finished.[3]

Much serious work has been undertaken
by scholars, led by Marilena Caciorgna,
on the literary sources for these panels, and
it has been shown that, while ancient texts
were certainly consulted, in particular
Valerius Maximus, later mentions and
accounts by Boccaccio and Petrarch are
likely to have been equally significant.[4]

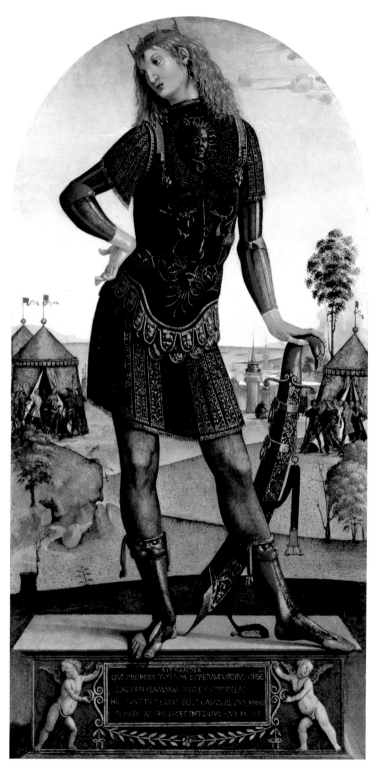

CAT. 65

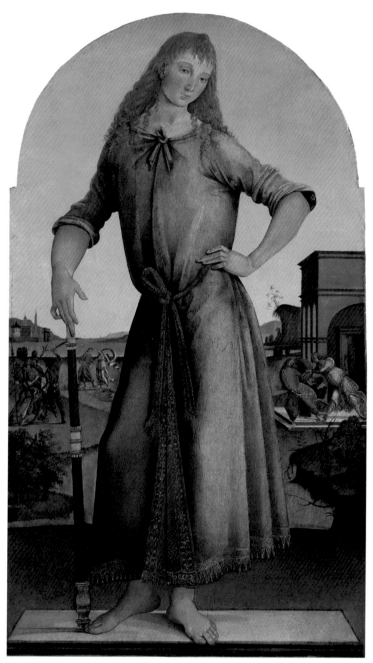

CAT. 66

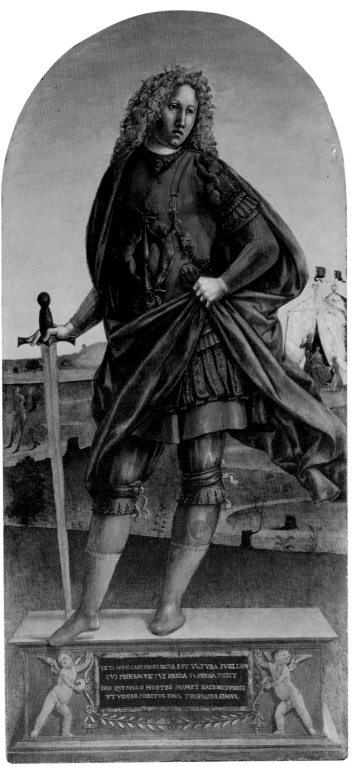

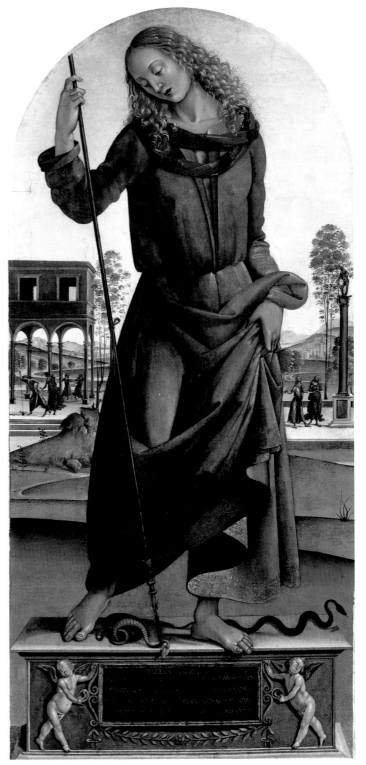

VICTA MIHI CARTHAGO NOVA EST VLTVBA PVELLAM
CVI PIEREM VICTVS PREDA SVPERBA DEDIT
SED QVI BELLO HOSTES MEMET RATIONE VBEGI
VT VIDEAR MERITVS BINA TROPHÆA SIMVL

Indications as to their probable original order have now been discovered in inscriptions ('*primo*' on the *Alexander* and so on) on the backs of some of them, painted probably in the late eighteenth or early nineteenth century, shortly before they were dispersed. These inscriptions establish that the *Alexander* was followed by *Joseph*, then *Scipio*, and finally *Tiberius Gracchus* (Scipio's son-in-law). The order of the Women is less easy to establish since, where they survive at all, the inscriptions are now illegible. But since Artemisia, Sulpitia and Claudia Quinta all appear in Boccaccio's compendium of Famous Women, *De mulieribus claris*, and in that order, it seems likely that this was also their arrangement within the frame. Details of the batten construction suggest that they were preceded by *Judith*. Other evidence supports this proposed order: the poses of the *putti* on the pedestals of both Men and Women, or at least on those that survive, which alternate between having legs open or crossed; and there is possibly also a pattern in the cutting of panels, more damaged by water as one reads left to right.

The *Scipio Africanus* (cat. 67) has a knotty attributional history. Critics are agreed that this panel derives from the workshop of Francesco di Giorgio, made around the time he was employed in the Bichi Chapel (where his *grisaille* frescoes were certainly finished by 1494, but probably somewhat earlier: fig. 49, 50, see cat. 28).[5] In recent years it has been argued that the sturdy figure of the warrior Scipio, seemingly executed almost entirely in egg tempera, is by an assistant identified as the 'Fiduciario di Francesco', rather than by Francesco di Giorgio himself.[6] Infrared reflectography

reveals, however, that the main figure was drawn on the panel with a technique of astonishing boldness, entirely typical of Francesco di Giorgio. His armour, in particular, has a freshness of invention that suggests Francesco's own hand. Many alterations and deletions were made during work on the underdrawing and at the painting stage. But the only part of the setting that may have been indicated at the same time as the principal figure is a horizon line at the left with the two broadly drawn intersecting hills, neither of which was followed in the painting.

The background tells the tale of Scipio's magnanimity – when he allowed the Carthaginian maiden Lucretia, whom he had been given as a prize of war, to marry her betrothed, the prince Aluceius (Valerius Maximus, IV, 3, 1). The technique is very different from that of the main figure, which is strongly brushmarked, indicative of the use of an oil medium, while the details, notably the plants and tree stumps, the horizontal flecks for grass and above all the style and character of the little figures, reveal that Francesco di Giorgio delegated the completion of his panel, also including the plinth with its *putti*, to the painter of the Griselda panels.[7] The little figures are underdrawn with a finer line than is used in the main figure, and the legs of Aluceius, who departs with his betrothed on the left, are shown complete beneath the folds of his tunic. His stiff-legged gait is typical of figures by the Griselda Master and the exaggerated proportions of the figures and the spiralling folds of the girl's dress are closest to those in *Reunion* (cat. 64) almost certainly the first of the Griselda panels to be painted. However, the figures are

squeezed in rather awkwardly, making it more likely that the decision to include small narratives to illustrate the acts of continence and devotion for which Scipio was celebrated was taken only after the main figure had been drawn.

That the *Scipio Africanus* was a prototype for most of the others is shown not only by the improvised underdrawing and painting of the picture. Throughout the process of design and execution *Scipio* seems to have been the test panel on which the rest of the series was to be based, and it seems that it was only after there had been considerable progress in the painting of this panel that some details of the framing were worked out. Once this prototype had been made, the other panels could be shaped to the same pattern. At the upper left edge of the *Scipio*, just below the spring of the arch, are two sets of curves, apparently scored into the wet paint of the sky rather than into the gesso and using a relatively blunt-ended tool, perhaps the end of the brush. These appear to be trial profiles to determine how much of the picture surface would be covered by projecting elements of the frame pilasters. The slightly higher profile, with a cornice and then a second projection for a moulding below, is the one that was adopted, and was scored using a similarly blunt tool into the gesso of some of the other panels. There seems initially to have been some uncertainty, however, since the other more curving profile was incised into the gesso of *Claudia Quinta*.

No uncertainty, however, is attached to the attribution of the main figure in the painting of the Roman heroine Claudia Quinta (cat. 72), or her plinth, both painted by Neroccio de' Landi 'in or about 1494'.[8]

Neroccio's underdrawing of the figure of Claudia could not be more different from the bold underdrawing to be seen in the *Scipio*. Neroccio's lines are fine and delicate, his contours are sometimes indeterminate and in places hesitant and wavery. Claudia's figure is large in scale compared to the other heroines, and Neroccio creates spatial uncertainty – further confusing the distinction between painted sculpture and living heroine – by having her step forward beyond the front edge of the plinth, almost as if he had not anticipated including it. This suggests that she had been drawn and painted before the painter had been supplied with the measurements and design for the pedestal. Probably therefore the main figure of Claudia, too, was executed at a very early stage in the whole project, perhaps even simultaneously with the *Scipio*. Neroccio had been Francesco di Giorgio's partner in the early 1470s (see cat. 23–4) and their partnership had perhaps been temporarily revived for this project. The sway of her figure is gentle, her grace relying on her flowing blonde locks and elegantly elongated fingers. Her costume seems closer to contemporary fashions than those worn by the others in the series. Claudia Quinta proved her chastity, which, given her generous application of make-up and sumptuous dress, had been doubted, by pulling to shore a heavy ship with a statue of Cybele, 'the mother of the gods', after all the strapping male youth of Rome had failed, simply by tethering it to her sash (Ovid, *Fasti*, 315–48; Boccaccio, *Famous Women*, LXXVII).

The *Sulpitia* in Baltimore was for many years attributed to Pacchiarotti, until Angelini's momentous discovery that many paintings, such as this one, traditionally considered to belong to Pacchiarotti's early career, should properly be attributed to Pietro Orioli.[9] Sulpitia, the wife of Fulvius Flaccus, was an unusual subject, but she was chosen for the series surely because she had been selected as the 'chastest of the enormous number of women abounding in Rome at that time' to dedicate a statue (according to Valerius Maximus, VIII, 15, 12; Boccaccio, *Famous Women*, LXVII) and also a temple (according to Ovid, *Fasti*, IV, 157; Petrarch, *Triumph of Chastity*, 178–80) to Venus Verticordia.[10] Orioli was one of the most celebrated painters working in Siena, and his premature death was an occasion of public mourning; his reputation would be enough to explain his participation if one of the aims of the project was to demonstrate the talents of Sienese painters. A connection with Francesco di Giorgio is established by Orioli's subsidiary role in painting the *grisaille* frescoes in the Bichi Chapel (fig. 49–50).[11] Since Neroccio was clearly brought into the project at an early stage, it seems likely that it was also at the outset of the project that Francesco di Giorgio turned to another painter with whom he had already collaborated. The many differences between Orioli's *Sulpitia* and the panels produced by Francesco di Giorgio and the Griselda Master suggest that Orioli took his panel to his own workshop, and that supervision was no more than occasional.

Matteo di Giovanni belonged to the same generation of painters as Francesco di Giorgio and Neroccio, and his fame would have made him an obvious candidate in any attempt to show off the skills of all the leading artists of Siena.[12] He, like Neroccio and Francesco, had contributed designs for the Cathedral pavement *Sibyls*. Moreover, he had been Orioli's master, providing another route for the younger painter's co-option. It is possible that Matteo, too, was involved at an early stage, but the cutting of the panel and the loss of most of the background with its narrative elements make it more difficult to estimate its place in the chronology of the series. Stylistically, Matteo's Heroine (cat. 69) belongs to the very end of his career. The panel may have been cut partly because the lower part was in poor condition, as was probably the case with its right-hand neighbour, *Artemisia*. In addition to the identifying inscription, the cutting has eliminated episodes that would have further defined the figure. Nonetheless she is almost unanimously identified as the Old Testament heroine Judith, and her putative presence is thought to support the identification of the figure in the Griselda Master's Washington picture (cat. 66) as Joseph of Egypt, assumed to be her biblical pair. The story of Judith is well known and fits the iconography of the panel: the figure brandishing her weapon and holding a severed head by the hair – the head in this case is noticeably undersized, to be understood as her attribute, rather than as a 'real' head. Judith, a rich widow, saved her native city of Bethulia when it was under siege by the Assyrian general Holofernes, by decapitating him while he lay in a drunken, amorous stupor (Judith, 8–13). Doubts have also been raised as to the kind of message the redoubtable but not primarily conjugal Judith might bear within the series. Nonetheless Judith, '*casta e forte*' (chaste and brave), is included in the procession of classical heroines in Petrarch's *Triumph of Chastity* (though none of the other women in the present series figure there).[13]

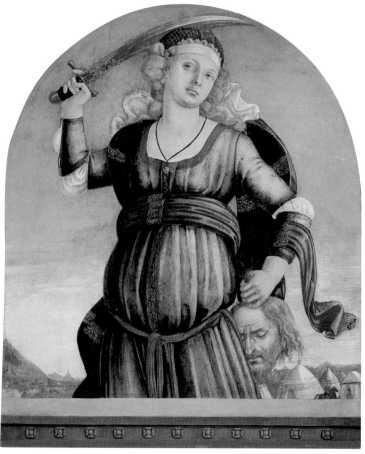

CAT. 69

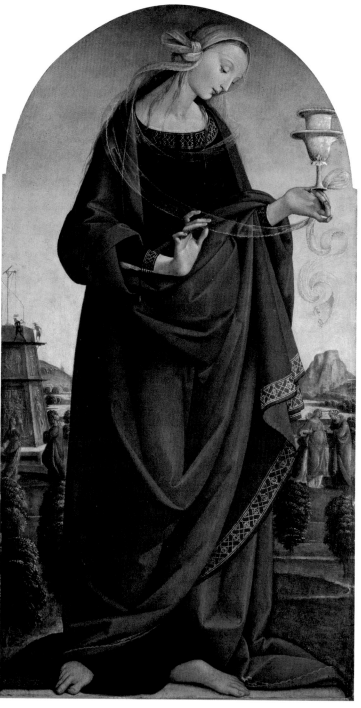

CAT. 70

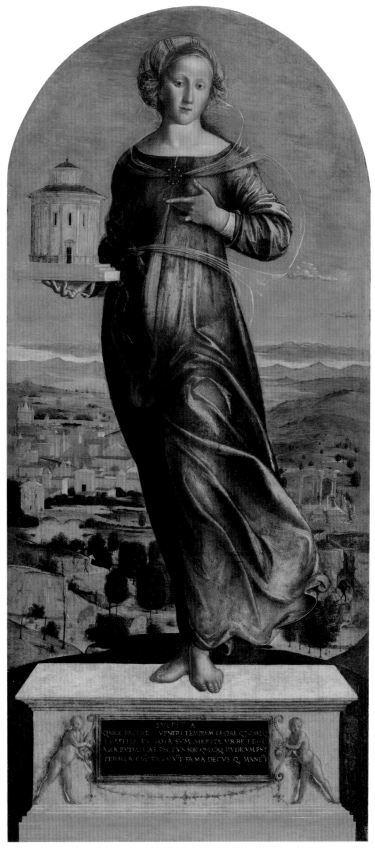

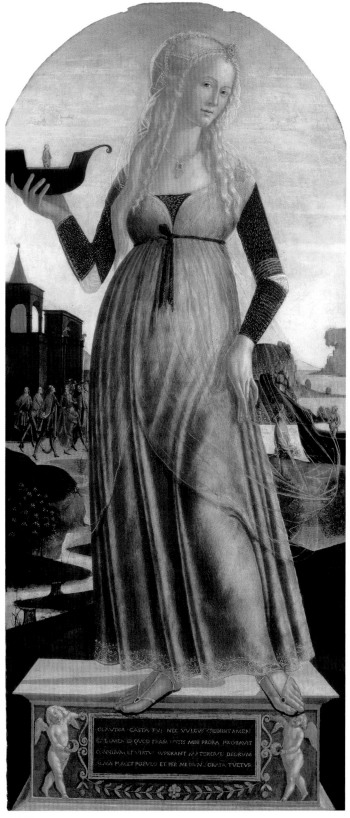

CAT. 71

CAT. 72

If, as seems likely, the four panels assigned to Francesco, Neroccio, Matteo di Giovanni and Orioli, were produced at a relatively early stage of the project, it was only once the set was half finished that the Griselda Master took control. By then, he must have proved his competence with the completion, or near completion, of the Griselda panels. Perhaps the patron had also become aware of the somewhat discordant consequences of employing four very distinctive painters, of different generations and with different techniques. To the modern eye at least, the group of men, with three figures by the Griselda Master and the fourth by the painter who was probably his master, is better balanced and visually more satisfactory than that of the Women. *Joseph* (cat. 66) seems to be the earliest of the paintings in the series for which the Griselda Master had full responsibility. The young man fleeing the embraces of the would-be seductress on the right repeats the turned-back pose employed by Francesco di Giorgio in his Uffizi drawing of *Hippo* (see fig. 59). The drapery arabesques, stiff-kneed figures and landscape are close to those in *Exile* and *Marriage*. Of all the Griselda Master's works, this picture is the most indebted to Perugino.[14]

Alexander (cat. 65) was selected for his magnanimous (and chaste) behaviour towards the women of the family of the defeated Darius (Plutarch, *Parallel Lives: Alexander*, 21; Valerius Maximus, IV, 7, Ext. 2). His figure type, radiant with youth, is close to the *Alexander* and *Julius Caesar* in the Ghirlandaio workshop paintings at Longleat (see fig. 12, p. 26–7). However, his stance is most like that (reversed) of Publius Scipio in Perugino's Collegio del

Cambio series of *Famous Men* painted in about 1498–9.[15] Perugino's painting almost certainly postdates the Griselda Master's panel, so it may be that Perugino had the chance to see this work by a lesser-known painter or that they had a common source, probably in Donatello's celebrated bronze *David*, also used by Signorelli for one of his nudes in the Bichi Altarpiece (cat. 59).

As befits his status in Greek antiquity, *Alexander the Great* is the most magnificent and ornate panel of the series. The costume of his figure was originally even more splendid than it appears today. The breastplate and cuirass are now much darkened, and the colour of Alexander's armour has to be imagined as closer originally to a pure lapis blue, appearing more purple in the shadows. The Griselda Master's use of gold leaf is notably more consistent and systematic than Francesco di Giorgio's; Scipio's very plain sword can also be compared with the elaborate gilded ornament on the black scabbard of Alexander's scimitar. Although the contrast between scabbard and armour is diminished as the result of discoloration of the blue pigments, the sword belt has retained much of its original brilliance. By this stage in the execution of the series the general design was well established. The simplicity of the underdrawing in all four of the main figures by the Griselda Master and the lack of major alterations suggests that he had made careful studies in advance and possibly even full-scale cartoons. But, if there are no evident *pentimenti* in the main figure of Alexander, the landscapes and subsidiary scenes of this panel were extensively revised to allow more space for the narrative episodes. For a painter who had been so careful to plan even the smallest

of figures in the Griselda panels this seems surprising, and suggests either hurried working or some uncertainty as to what was to be included in the Alexander stories. The painting of the figures – in oil – is rapid and direct, and the impression of haste is reinforced by the accidental omission of the arm and red sleeve of the little figure of Alexander on the left. The proportions and draperies of the background figures suggest that the stylistic trajectory – with forms increasingly simplified – started in the three Griselda panels has been continued, and that the *Alexander* panel should be dated to the same moment or slightly after *Exile*. The combination of tempera and oil techniques, and the extent of the gilded decoration, make Alexander probably the closest of all his heroes to this work.

The inclusion of the Roman Tiberius Gracchus was prompted by the story recounted by both Plutarch and Valerius Maximus (Plutarch, *Parallel Lives: Tiberius Gracchus*, 1; Valerius Maximus, IV, 6, 1). Tiberius was said to have been particularly devoted to his wife, the virtuous Cornelia (see cat. 105), daughter of Scipio Africanus. When a pair of snakes was found in their bedchamber, soothsayers advised that he should neither kill them nor let them escape, adding that if the male serpent were killed Tiberius would die, and if the female, Cornelia. Tiberius chose to dispose of the male snake, and let the female escape; and, just as predicted, he expired soon after, leaving behind his 'constant and noble-spirited' widow. In pose, he has much in common with Signorelli's *Saint Catherine of Alexandria* (reversed), once again from the Bichi Altarpiece.

The Griselda Master's increasing command of the drawing of larger-scale figures and their placing within the arch-topped format of the panels is demonstrated by the supremely elegant composition of *Tiberius Gracchus*. As in the other panels, the underdrawing of the landscapes and the small figures of Tiberius and Cornelia is more obviously improvised: the style is very like that of the underdrawings in *Marriage* and *Exile*, and an even closer association with those panels is suggested by the two sculpted figures on the roof of the loggia that appear in the underdrawing. Their dancing movement is typical, but the decision not to paint them is perhaps another indication of a tendency towards restraint by the painter – in addition, they would have been in competition with the sculpture of Apollo (representing the soothsayers, who according to Plutarch, foretold Tiberius' death) on the right, and therefore important in the telling of the story. In spite of extensive losses from the brown robe *Tiberius Gracchus* is the best preserved of the eight panels, especially in the areas of flesh paint. The head of Tiberius is in almost perfect condition, and so displays the painter's command of the structure of the head and neck. The impression is of a highly refined version of the technique used by Signorelli to achieve the strongly sculptural but smooth and polished flesh, almost like marble, which is a feature of his paintings towards the end of the fifteenth century.

In May 1857, Otto Mündler, the National Gallery's travelling agent, recorded in his Travel Diary that 'Marchese Poldi has lately purchased of Baslini a single figure of Saint Barbara, called Perugino, but decidedly by L. Signorelli, exquisit [sic]'.[16] His mis-

attribution is understandable; the pose of the figure (cat. 70) is copied from Signorelli's Magdalen in the Bichi Altarpiece (see fig. 62, p. 224). She can in fact almost certainly be identified as the queen Artemisia by the chalice she carries, containing the ashes of her dead husband Mausolus mixed with her tears, and by the unfinished mausoleum (incomplete at her death) under construction in the background (Valerius Maximus, IV, 6, Ext. 1). In the scene on the right, Artemisia leans towards a woman dressed in pink and white, with another woman in attendance. On close examination, she can be seen to be weeping into the cup containing her dead husband's ashes; the ladies with her are perhaps maidservants, one in a pose that seems to denote suffering. In the landscape on the left, the nymph-like woman in pink was painted over the mausoleum, already decorated with its relief sculptures; she plays no part in the recorded story and so, despite her apparently meaningful pointing gesture, she may have been added to supply an area of pink to balance the other side, and also to echo the large areas of that colour on the other figures in the series. As in the *Alexander* panel, the narrative content seems to have been less clearly defined in advance than was the case with *Joseph* and *Tiberius*. This may have been in part the result of pressure to finish the series, and further evidence of haste is suggested by the painting of details such as the tools of the mausoleum's builders while the paint of the sky was still soft.

If the trajectory of the career of the Griselda Master is taken into account, the field or range of possible patrons is narrowed. Given that the Griselda panels themselves can now be dated with some

security to early 1494 and if, as seems to be the case, the Master's first contributions to Francesco di Giorgio's *Scipio* and Neroccio's *Claudia Quinta* were painted before the Griselda panels, then it can be argued that the project of the Virtuous Men and Women was initiated before the end of 1493. This date would fit with their now widely accepted association with the marriage of Silvio Piccolomini and Battista Placidi in January 1493, a link suggested by the presence of what appear to be Piccolomini crescents on some of the plinths. However it cannot be entirely excluded that this series too was linked to the celebrations of the double Spannocchi wedding, since the two projects appear to have been chronologically intertwined. It is significant that the banners included in this series were at some point defaced in the same way as the Griselda panels, suggesting that they could have once been in the same place. Moreover, it is surprising that the artists chose to dress all but Artemisia, the grieving widow, in red. All the men also have costumes with red elements. The other dominant colour is a gold or golden-brown (particularly with the men), an effect that would have been heightened if the original frames were gilded. The colours may therefore refer to the red and gold of the Spannocchi arms (see cat. 62–4).

In sum, it seems that halfway through the painting of the Virtuous Men and Women the Griselda Master was assigned the panels from which he takes his 'name', a commission that may well have come to him via Francesco di Giorgio. In the course of the execution of the Griselda panels he developed rapidly as a painter, gaining in confidence as he designed the figures, their

anatomies and their architectural and land-scape settings, and becoming ever more sophisticated in his approach to narrative. At the same time he gradually shifted his technique away from the tempera-based tradition of the older generation of Sienese painters towards a more modern oil method, derived in part from his study of works in Siena by Signorelli (and perhaps also through looking hard at the achieve-ments of Perugino). On completion of the Griselda narratives, and perhaps as the result of their undoubted accomplishment, he was promoted within the Virtuous Men and Woman project and given sole responsi-bility for the four remaining panels.

Even within this sequence, the stylistic and technical evolution of this young painter was still very fast. He continued to exploit iconographic and figurative motifs taken from Signorelli and Perugino, but, whereas in the *Joseph* he continued to make reference to older Sienese masters, by the time he painted *Artemisia* he had fully absorbed the lessons of these two most admired painters and combined them in a way that was stylistically more thoroughly unified. The face of Tiberius, for example, is modelled in a manner closely akin to that of Signorelli, but his features are actually more refined than those by the older painter. The background figures in this picture, though they retain their characteristic elegance and bounce, display the increasing naturalism associated with *Exile*, while the architecture is more restrained and the trees and foliage have a new feathery freshness, which is also more true to nature. There is evidence, especially in the *Artemisia*, of some haste in finishing the series – perhaps at the behest of an impatient patron – but

the Griselda Master's confidence in under-taking the project is remarkable. By its end he had achieved a blend of styles that had become uniquely his, and were now very modern. We can only wonder what he might have accomplished next. LS

1 When the *Tiberius Gracchus* is first recorded in the Esterházy collection.
2 Much of this material is synthesised from Dunkerton, Christensen and Syson 2006. I am grateful to my co-authors for their permission to remodel this piece. Conclusions regarding the subject-matter of the *Judith* have been revised. This should be read with the magisterial account of these pictures by R. Bartalini in Bellosi 1993, cat. 103, pp. 462–9.
3 A parallel case might be the piecemeal execution and delivery of the Florentine Mercanzia panels (also arch-topped) painted by Piero del Pollaiuolo and Botticelli, although these panels (much larger than the *Virtuous Men and Women*) were almost certainly at least at first framed individually; see Wright 2005, pp. 228–30 and 241.
4 See Boccaccio 2003 edn; Coor (1961, p. 95, note 331) points out that Artemisia, Sulpitia, Tiberius Gracchus, Scipio Africanus, Alexander – and Judith – all appear in Petrarch's *Trionfi*.
5 See Toledano 1987, cat. 40, pp. 106–8, for full attributional history.
6 See Angelini 1988, p. 21; R. Bartalini in Bellosi 1993, p. 468.
7 This collaboration was first proposed by De Nicola 1917, p. 227, and has been almost uniformly accepted since.
8 Coor 1961, p. 95; M. Boskovits in Boskovits and Brown 2003, p. 538.
9 Angelini 1982, pp. 72–8; Angelini 1982, pp. 30–43.
10 M. Caciorgna in Caciorgna and Guerrini 2003, pp. 333–5.
11 F. Sricchia Santoro in Bellosi 1993, pp. 444–7.
12 Oddly, when purchased by the Kress Foundation, critical opinion, as represented by a series of letters, was almost unanimous in assigning the picture to Matteo. Only Longhi demurred, suggesting Neroccio de' Landi.
13 See also R. Bartalini in Bellosi 1993, p. 462.
14 Although the stress on contour is alien to Perugino, Joseph's facial type, with his rounded, rosy cheeks, is close, for example, to the kneeling Saint John the Evangelist in Perugino's *Pietà* (Galleria degli Uffizi, Florence); see Scarpellini 1984, no. 43, p. 82.
15 P. Scarpellini, 'Pietro Perugino e la decorazione della sala dell'Udienza' in Scarpellini 1994, pp. 67–106, esp. pp. 97–105.
16 Togneri Dowd 1985, p. 154. Mündler clearly mistook the mausoleum for Saint Barbara's tower.

SELECT BIBLIOGRAPHY

Tátrai 1979; Kanter 2000, pp. 145–52; A. Angelini, 'Pintoricchio e i suoi: dalla Roma dei Borgia ala Siena dei Piccolomini e dei Petrucci' in Angelini 2005, pp. 483–553; M. Caciorgna, '"Mortalis aeulor arte deos": Umanisti e arti figurative a Siena tra Pio II e Pio III' in Angelini 2005, pp. 151–81, esp. pp 157–9; Dunkerton, Christensen and Syson 2006, pp. 18–58

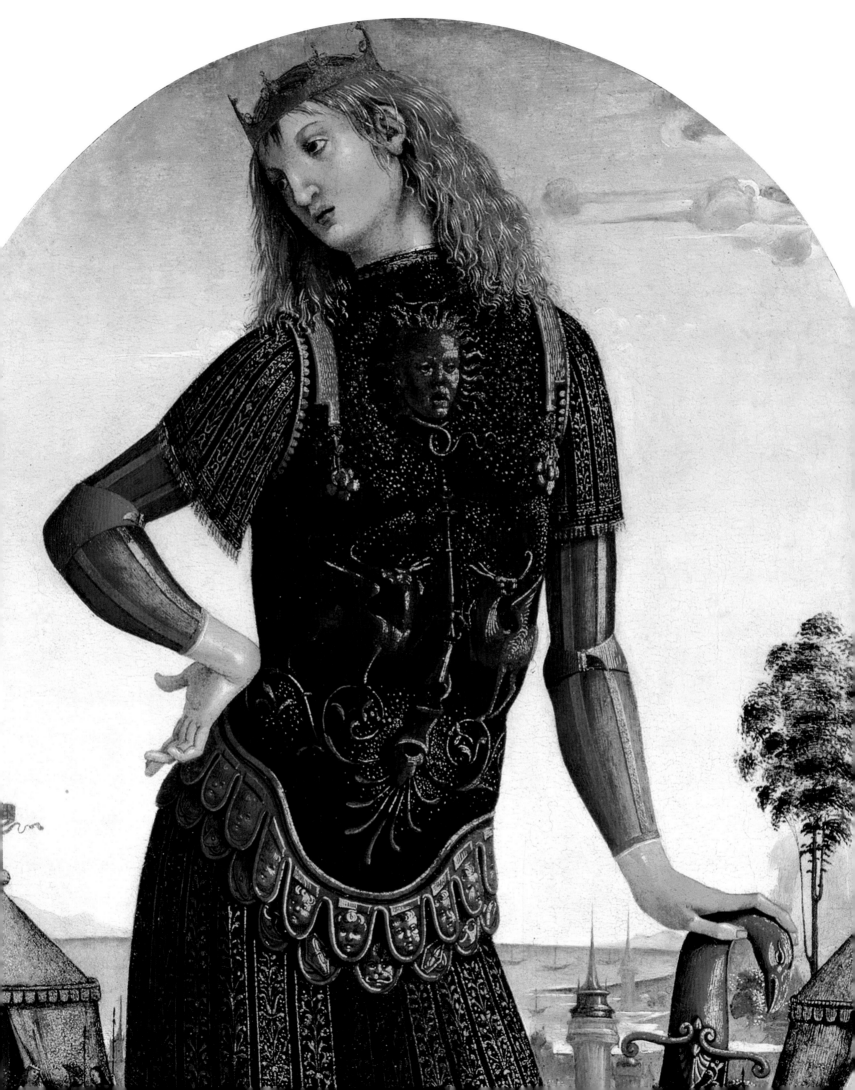

DISTINGUISHED VISITORS

The city of Siena is often presented as an unusually closed society, an attitude reflected in its artists' hostile suspicion of outsiders and their unwillingness to travel to other centres (where anyway other painters and sculptors from more go-ahead cities were preferred).[1] While it may be true that a core artistic tradition was maintained throughout most of the Quattrocento, and that aesthetic decision-making was supported by guild restrictions upon incomers' capacity to work in Siena, it is arguable that these factors were to a great extent replicated elsewhere in Italy. In fact, what is much more remarkable is the influx of non-Sienese artists and their works in the first decade of the Cinquecento. In this same ten years, in Florence, local hero Leonardo da Vinci and his young rival Michelangelo were set to decorate the principal meeting chamber of the Palazzo Vecchio, the seat of government, with battle scenes. In Venice, Giovanni Bellini (d. 1516) had an official role as painter to the Republic. In Siena, on the other hand, almost every major commission, public, private and semi-private, went to artists born outside the city. The degree to which the native Sienese were suddenly demoted in their own state is almost shocking.

The rules of the Sienese painters' guild do not survive for this period. But in the 1356 regulations of the guild (*Breve dell'Arte dei Pittori*) it was decreed 'that any foreign [non-Sienese] painter who will wish to practise his art in Siena, before he may begin to work, will have to pay the painters' guild … the [not insignificant] sum of a gold florin. He must also lay down good and sufficient security up to the sum of 25 *lire*. No painter will be allowed to hire a foreigner unless the fee owed to the guild has been paid and the security provided'.[2] It is unlikely that this statute was substantially revised in the later Quattrocento, or very different from the rules of those other guilds of Siena for which we have records.[3] Most of the painters working in fifteenth-century Siena (as in the previous century) were indeed Sienese. Until about 1487, and in particular until the first decade of the sixteenth century, there was never more than a meagre trickle of foreign artists coming to the city. Specialists were occasionally brought in to cover areas where there was little or no local expertise – for cannon, tapestries, mosaic- or clock-making and, above all, for building (always the great exception to this general rule). There was a large community of stonemasons from Milan and Como who in 1473 arrived at an accord with their local counterparts. In this instance, the payments to the guild were considerably smaller, seemingly in recognition of the need for Lombard skills in this arena – ten *soldi* for the right to work, followed by five *soldi* per annum, while *garzoni* – professional assistants – obtained free admission.[4]

Still, there were various means by which non-Sienese artists might come to Siena, several of which might bypass guild stipulations. Some came of their own accord as economic migrants – spotting commercial opportunities. The stated approval of Sienese peers (if this was a requirement for painters, as it was for woodworkers) might have made it slightly easier for 'foreigners' to insert themselves by setting up joint ventures with locals in one of the various forms of partnership, 'society' and company that were regulated by the Mercanzia (the merchants' guild that oversaw the activities of all the others).[5] The early 1490s partnership of Cortona-born Luca Signorelli with Francesco di Giorgio (see cat. 58–9) was probably not dissimilar to the business relationship of the potters Benedetto da Faenza and Sienese Galgano di Matteo (see cat. 79). But a greater number of 'foreign' artists seem to have been specifically invited. Their arrival might be state-sponsored – like that of Donatello, lured to Siena in something of a propaganda *coup* (see pp. 52–3). It is suggested that Michele di Matteo da Bologna (1410–1469) was asked to paint a *Crucifixion* fresco in the Baptistery in 1447 as a consequence of the Bolognese connections of the then bishop of Siena, Neri di Montegargulo.[6] Other painters exploited networks set up by the religious orders. This was the case with Liberale da Verona and his employment by the Olivetan Benedictines and with the mysterious Fra Giuliano da Firenze's work for the Gesuati in 1487. At the turn of the century, the Observant Dominicans at Santo Spirito, with their connections to their mother-house in Florence, brought in Florentines who had already made works for San Marco (see cat. 73).

In Pandolfo Petrucci's Siena, this trickle turned into, if not a flood, then at least a steady stream. Siena was not so much opening up, as demolishing the walls of its artistic tradition. Artists were invited to undertake commissions or even to move lock, stock and barrel to Siena by Petrucci, the nephews of Pius II (including the future Pius III) and many of their peers. The Roman connection became all-important: most of the leading artists selected – Signorelli, Perugino and Pintoricchio – had already

been highly successful in Rome and the Papal States (such as Perugia or Orvieto). The *Virgin and Child in Glory with Saints* by Raffaellino del Garbo (1502), the high altarpiece of the church of Santa Maria degli Angeli, seems to have been an exceptional example of a commission going to a Florentine.[7] Some traditional enmities, it appears, did not lie down and die.

The extent to which tastes had changed can be gauged by the concerted programme of renewal of the family chapels at San Francesco in the early 1500s. A whole new set of painted altarpieces was commissioned, but seemingly not a single one from a local artist. Tragically, all but one was lost in the fire that swept through the church in 1655.[8] Two were by Pintoricchio – a *Birth of the Virgin*, with a predella by Raphael, made for Filippo Sergardi,[9] and the altarpiece of the Sant'Andrea chapel, for which Andrea Piccolomini had the *ius patronatus*. The valuation of Perugino's altarpiece for the Vieri family chapel survives from September 1510 (though there tradition was maintained to some extent by the gold ground against which the figures were painted).[10] The painters making the assessment included, not just three Sienese (Girolamo di Benvenuto, Pacchiarotti and Pacchia), but also the Urbino-born Girolamo Genga, who arrived in Siena in the wake of Signorelli (see p. 65). A second picture by Perugino – a *Virgin and Child enthroned with Saints* – was ordered by the Tondi family. The Piedmontese painter known as Sodoma contributed two works, a *Finding of the True Cross* (a typical Franciscan subject) for the Buoninsegni and – the only altarpiece of any of these to survive – his *Deposition* commissioned by the Cinuzzi family (now Pinacoteca Nazionale, Siena).[11] The young Sodoma had also kick-started his career in Rome before he arrived in Siena. Once there, he quickly evolved his new vocabulary, based not upon native artists but on Raphael, Signorelli and Genga. LS

1 Sienese artists were not geographically more confined in the later fifteenth century than previously, as stated by K. Christiansen, 'Painting in Renaissance Siena' in Christiansen, Kanter and Strehlke 1988, p. 22. In this period, they worked or sent works all over Italy (except, revealingly, Florence). Vecchietta and Neroccio de' Landi executed altarpieces in Siena's sister republic, Lucca (see cat. 38). Matteo di Giovanni's first version of the *Massacre of the Innocents* (1468) was made for a church in Naples, at a time when the kingdom's links with Siena were strongest. The services of Francesco di Giorgio were, of course, sought by cities and rulers everywhere. Sienese painters travelled quite as much or even more than their celebrated contemporaries like Giovanni Bellini in Venice or Sandro Botticelli in Florence, and adapted their styles accordingly.
2 Milanesi 1854–6, I, pp. 5–6; Maginnis 2001, pp. 204–5.
3 See for example, the woodworkers' guild: Lusini 1904, pp. 229–30.
4 Milanesi 1854–6, I, pp. 126–9.
5 Senigaglia 1908, p. 114 (which details what should happen when disagreements within companies arose and may therefore be useful in assessing the breakdown of the partnership between Francesco di Giorgio and Neroccio de' Landi).
6 C.B. Strehlke, 'Art and Culture in Renaissance Siena' in Christiansen, Kanter and Strehlke 1988, pp. 44–5.
7 Buschmann aus Bottrop 1993, pp. 161–2, no. 26. The work is signed RAPHAEL DE FLORENTIA PINXIT MCCCCCII and was (and is) presented in a frame carved by Antonio Barili. Even he, however, had got his start painting an antechamber of the Carafa Chapel at the church of Santa Maria sopra Minerva in Rome.
8 C. Alessi, 'San Francesco a Siena, mausoleo dei Piccolomini' in Angelini 2005, p. 285.
9 Shearman 2003, I, pp. 77–9. The original document recording payment and its date is lost, but the existence of Pintoricchio's altarpiece and Raphael's involvement are confirmed by early sources. Thus the collaboration of the two painters furnishes further proof that Raphael came to Siena to work with Pintoricchio on the Piccolomini Library frescoes (cat. 74), rather than sending drawings from afar.
10 Milanesi 1954–6, III, pp. 47–8, doc. 18.
11 Torriti in Siena 1990, pp. 359–61, no. 413.

73.

ANONYMOUS FLORENTINE DRAUGHTSMAN
(probably from the workshop of San Marco, Florence)
*Study after figures of 'Rhea Silvia' and 'Acca Laurentia'
by Jacopo della Quercia on the Fonte Gaia*, about 1497–1512

Pen and brown ink and wash over traces of black chalk on paper
17 × 14.3 cm (maximum measurements, top corners diagonally cut)
Gabinetto Disegni e Stampe degli Uffizi, Florence (43 E)

In 1408, Siena's leading sculptor, Jacopo della Quercia, was called upon to execute sculptures for a water fountain, the Fonte Gaia in the Campo, probably his most celebrated public commission. Between 1414 and 1419 he carved nine reliefs of the *Virgin* and the *Virtues*, scenes of *The Creation of Adam* and *The Expulsion from Paradise* and two fully three-dimensional standing female figures, each with a pair of baby boys (fig. 69 and 70).[1] Ever since it was realised that this vigorous drawing was 'so evidently a reproduction of an already existing work'[2] rather than a study by Jacopo della Quercia for these figures, it has been largely disregarded. But the sheet is a fascinating indication, one among several, of the very high regard in which these sculptures were held, both for political and for aesthetic reasons, many decades after they were sculpted. Their sensuous sway, accomplished internal balance and alluring curvaceousness, the luxurious flow of their draperies and their softly feminine facial types were regularly imitated by the generation of painters active in Siena after 1500, especially in the many depictions of exemplary women found in palaces all over the city,[3] and not least, apparently, by artists from outside the city. Indeed painters from other centres may well have treated their study as part of a process of cultural familiarisation. Vasari's always unenthusiastic assessment of Sodoma's career in Siena is prefaced by a revealing anecdote: faced with a lack of local competition, Sodoma, he claims, was lazy in establishing his artistic credentials, 'and if he did work a little, it was only in drawing some of the works of Jacopo della Fonte [Quercia], which were considered of value'.[4] Seen

Fig. 69
Jacopo della Quercia (about 1367–1438)
Acca Laurentia, 1414–19
Marble, 165 cm tall
Complesso Museale di Santa Maria della Scala, Siena

in a less cynical light, the passage suggests that Sodoma deliberately chose models that embodied a Sienese aesthetic ideal.

The sculptures were already celebrated beyond Siena, which would have made them, once met, an obvious choice of artistic model. The Florentine Luigi Pulci, for example, in one of a series of sonnets, written probably in the 1480s, parodying the various dialects and accents found in Italy, evokes the city by reference to the Fonte Gaia.[5] Earlier, in the 1430s, the Sicilian poet Giovanni Marrasio, resident in Siena, wrote several Latin poems that employ the Fonte

Fig. 70
Jacopo della Quercia (about 1367–1438)
Rhea Silvia, 1414–19
Marble, 169 cm tall
Complesso Museale di Santa Maria della Scala, Siena

Gaia as their central motif.[6] Marrasio turned the Virgin and Virtues into the nine Muses, a conversion that would endure, and the images on the Fonte Gaia were evidently long interpreted with a certain license. In fact the original identities of the two statues depicted in the drawing remain uncertain. By the turn of the fifteenth century, they could be grafted into the myth of Siena's foundation: one was mentioned by Francesco Patrizi as Rhea Silvia, and Sigismondo Tizio, slightly later, called them both the double image of Acca Laurentia – respectively the mother and foster mother of the twins

Romulus and Remus.[7] The draughtsman, however, seems to have treated them as Charities (as in modern times it has been argued they were intended to be), who traditionally were represented nurturing several children, since he has accentuated the disparity of age between each two boys. This lack of iconographical specificity, coupled with a strong sense of the statues' broader cultural consequence, may have made them additionally attractive to artists wishing to build them into works of another subject or kind.

Confirming the thrust of Vasari's story, the special esteem Jacopo's sculptures enjoyed in the first decade of the sixteenth century is indicated by two revealing instances. A stucco copy of *The Expulsion from Paradise* was set above the doorway of the Piccolomini Library.[8] And on 7 January 1501 [new style 1502] a notably severe sentence was handed down to vandals who had attacked the reliefs.[9]

The attribution of the drawing to Sodoma, made by Cust in 1906 on the basis of Vasari's story cannot be sustained. A more recent attribution to Fra Bartolomeo is on the right lines, but also presents difficulties, and Fra Bartolomeo's associate, Mariotto Albertinelli, may be a better candidate (see Syson forthcoming). Certainly authorship from within their workshop at San Marco in Florence deserves further investigation, opening up the possibility of an artistic connection between Florence and Siena promoted by the Observant Dominicans at Santo Spirito, rather than by any private patron. LS

1 Beck 1991, pp. 161–6, no. 10.
2 Cust 1906, p. 67.
3 Such as the three heroines by the so-called Master of the Chigi-Saracini heroines. See A. De Marchi in Sricchia Santoro 1988, p. See also cat. 102–7.
4 Cust 1906, p. 58. See Vasari 1966–87 edn, V, p. 381.
5 Volpi 1898, pp. 510–12; Volpi 1907, pp. 558–60.
6 Campbell 1997, pp. 47–50.
7 Smith 1968, p. 100, 118; F. Bisogni, 'Sull'iconografia della Fonte Gaia', in Chelazzi Dini 1977, pp. 109–18; Campbell 1997, p. 174, note 101; Caciorgna 2001–2, pp. 71–142.
8 Shepherd 1993, p. 217.
9 Ls. 'Conservazione dei Monumenti', *Miscellanea storica senese*, I, 1893, p. 32.

SELECT BIBLIOGRAPHY

Petrioli Tofani 1987, p. 21.

The Design of the Piccolomini Library Frescoes

74.

BERNARDINO DI BETTO, KNOWN
AS PINTORICCHIO (1456/60–1513)
A Group of Soldiers, about 1495–1503

Brush and brown ink and wash with white
heightening over metalpoint underdrawing,
on greyish–brown prepared paper with later incisions,
25.7 × 16.4 cm
Gabinetto Disegni e Stampe degli Uffizi, Florence
(280 E)

75.

RAPHAEL (1483–1520)
A Group of Four Standing Youths,
about 1503

Silverpoint on bluish-grey prepared paper (recto),
21.3 × 22.3 cm
Ashmolean Museum, Oxford (WA 1846.154)

76.

RAPHAEL (1483–1520)
*Cardinal Aeneas Silvius Piccolomini
presents Eleonora of Portugal to
Emperor Frederick III*, about 1503–4

Pen and brown ink on paper, with brown wash
and white heightening (largely retouched)
over traces of black chalk and stylus incisions,
53.1 × 39.2 cm
The Pierpont Morgan Library, New York
Bequest of Miss Alice Tully (1996.9)

Inscribed near upper edge on left:
QUESTA E LA QUINTA [ST]ORIA DE PAPA
(*This is the fifth story of the Pope . . .*)

During the spring of 1502, Cardinal
Francesco Todeschini Piccolomini, Arch-
bishop of Siena (1439–1503),[1] at this juncture
mainly resident in Rome, was pondering the
final stages of the project he had already
initiated to commemorate his eminent
maternal uncle, Aeneas Silvius Piccolomini,
Pope Pius II, in their native city. Aeneas
Silvius had been crowned pope in 1458 (see
cat. 2), and had bestowed the cardinal's hat
on his nephew Francesco in 1460. Since, of
necessity, his uncle's body was interred at
Old St Peter's in Rome (the tomb is now in
Sant'Andrea della Valle), Francesco devised
for Siena a kind of intellectual mausoleum
– a room attached to the Cathedral that
would house both his uncle's and his own
libraries. The Library itself had been
finished by 1496, replacing the sacristy that
originally opened off the north aisle. Now the
cardinal was planning its internal decoration,
with elaborate paintings on the vault and
frescoes on three of the walls representing
ten episodes in the life of Aeneas Silvius.
The source for the imagery was the pope's
own autobiographical *Commentarii* and the
biography by Johannes Antonius Campanus,
published in 1495, from which derive the
explanatory Latin inscriptions that were
included under each scene.[2]

The attachment of a library to a religious
space had manifold and meaningful prece-
dents. Cardinal Francesco was emulating his
own '*familiare et secretario*' Canon Antonio
Albèri, who in 1499 had sited his library
abutting the Cathedral at Orvieto, but espe-
cially Cardinal Giuliano della Rovere, who
earlier had joined the library of his uncle
Pope Sixtus IV to the church of San Pietro
in Vincoli in Rome. The ancient model for
all these projects was itself potent – the
emperor Augustus's library within the
temple of Apollo on the Palatine.[3] Cardinal
Francesco chose to emphasise this antique
pedigree when, in late spring 1502 (on the
occasion of what would be his last visit to
Siena), he arranged the consignment from
his Roman palace of his marble group of
The Three Graces, a third-century copy of
a Hellenistic sculpture, to be set up in the
middle of the room on a column carved by
a follower of the Sienese sculptor Giovanni
di Stefano. The Library thus served to
emphasise the Piccolomini's much-vaunted
origins in antiquity and its present temporal
and spiritual power deriving from the
Church: a new, Christian Rome was thus
exported to the heart of Siena.

Not only was the building type Roman
(ancient and modern), so too was its adorn-
ment. The ceiling was to have up-to-date
grotesque decoration based on the ancient
wall-paintings recently rediscovered at
the Golden House of Nero (see cat. 83–6),
already employed at the Vatican and in two
cardinals' palaces in Rome; and, by selecting
a biographical subject for the walls, Cardinal
Francesco was imitating the then pope,
Alexander VI, who had commissioned fres-
coes (destroyed) for the Castel Sant'Angelo
marking his January 1495 meeting with the
French king Charles VIII. The author of
the Alexander VI frescoes was Bernardino
Pintoricchio, Perugian by birth but Roman
by association, who had also become the
main specialist in grotesque ornament.
He was therefore the obvious painter for
Cardinal Francesco's new scheme.

The chronology of the Piccolomini
frescoes' execution is far from clear. Key
stipulations were made in the unusually
detailed contract of 29 June 1502:[4] 'Namely

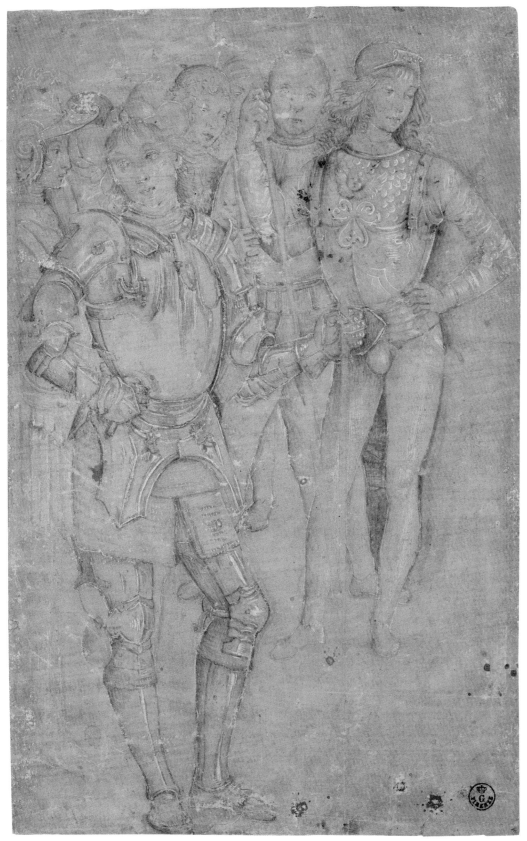

CAT. 74

that during the time it is being painted he will not take other work to paint or to do on panel or on the wall in Siena or elsewhere, by which the painting of this library would have to be postponed or delayed ... [that] he is obliged, besides the vault, to do ten histories in fresco, in which, according to what will be given to him in a memorial and note, he must paint the life of Pope Pius [II] of Holy Memory, with those suitable persons, deeds and apparel that are necessary ... Also he is obliged to render these pictures as above ["in good, fine and fast colours"], to retouch them *a secco* and to finish them with good colours, nudes, dress, draperies, trees, landscapes, cities, skies and borders and ornaments ... Also he is obliged to do all the designs of the histories in his own hand, in cartoons and on the wall, to do the heads all in fresco in his own hand and to retouch them *a secco* and to finish [them] until [they are] to his perfection.' Thereafter the frescoes were executed piecemeal, a circumstance foreseen in the contract, in which arrangements were made to pay 50 ducats for each section completed.

After signing the contract in Siena, Pintoricchio seems to have returned immediately to Perugia, where he is documented continuously until April 1503. It is likely that little substantial progress had been made by then, since this is the same month that the Cardinal, in Rome and recovering from a bout of fever, made a will that indicates his anxiety about getting the project finished.[5] Work may have begun on the painting of the ceiling – a huge project in itself – which was executed largely by Pintoricchio's workshop assistants (he received payment for their relocation and had always employed a large shop) and locally subcontracted

Sienese painters, following his designs;[6] it might therefore have been possible to direct this part of the project from a distance (there are no stipulations in the contract that it should be all Pintoricchio's own work). Thus there may have been three main stages to the job. The first, before April 1503, probably constituted the vault. The four frescoes on the north-east wall, which are of the highest quality and appear largely autograph, are more likely to have been painted between April 1503 and 18 October when Francesco Piccolomini died, only 26 days after he had been elected pope, taking the name Pius III. Although he had made provision for the commission to be taken over by his brother Andrea di Nanni

Fig. 71
Bernardino di Betto, known as Pintoricchio (1456/60–1513)
Coronation of Aeneas Silvius Piccolomini as a Poet (detail), about 1502–8
Fresco, Piccolomini Library, Duomo, Siena

Piccolomini, new works for Andrea and other demands made by the Cathedral and its *Operaio* may have diverted Pintoricchio in the years following the pope's demise. Work on the other walls is likely to have proceeded in fits and starts thereafter. They were seemingly finished in a rush some time around 1507–8. A last payment was made on 18 January 1509 by Agnese Piccolomini, Andrea's widow.[7]

The quality of the first four frescoes depends not just on their consummate technique but also on their extremely sophisticated design. The many protagonists are intricately arranged within ambitious and convincing spaces; the figures in the foregrounds are set back from the pictures' bottom edges to emphasise a sense of the separate staging of each episode in a different place at a different time. Subsequently there occurred a stylistic shift, which has been brilliantly analysed by Konrad Oberhuber. The figures drop down, moving closer to the spectator and filling the foregrounds (Pintoricchio's tendency was always to pack a picture full of incident) and the compositions become more vertical with less spatial depth; thus increasingly the scenes take on the character of wall coverings rather than vast windows. This tendency starts with the fifth scene, *Cardinal Aeneas Silvius Piccolomini presents Eleonora of Portugal to Emperor Frederick III* (fig. 72), to the left of the entrance, and becomes more marked as Pintoricchio moved to the south-west wall. At the same time, though some of the heads and figures in these sections – particularly those of the main protagonists – retain their quality, the hatching in others becomes broader, their contours cruder; some faces begin to approach caricature

CAT. 75

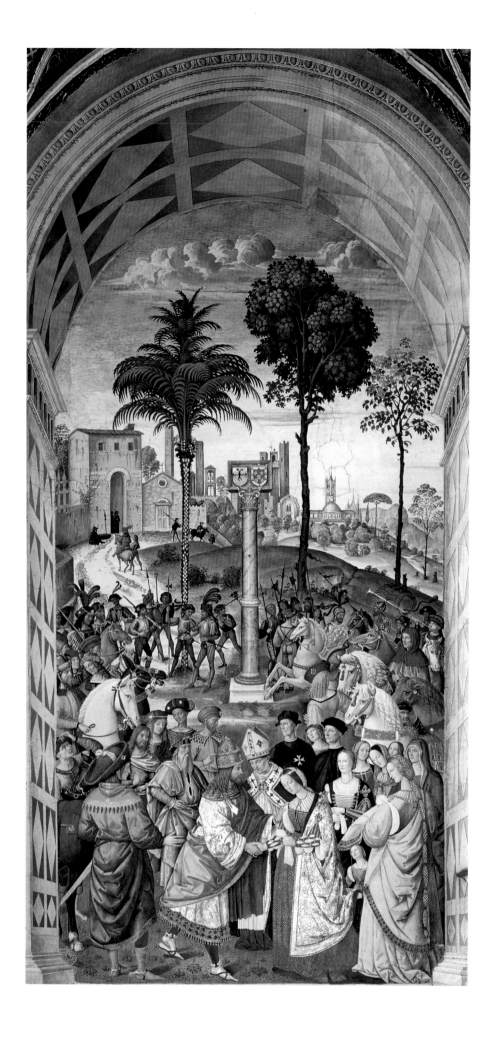

Fig. 72
Bernardino di Betto, known as Pintoricchio
(active 1456/60–1513)
Cardinal Aeneas Silvius Piccolomini presents Eleonora
of Portugal to Emperor Frederick III, about 1504–5
Fresco, Piccolomini Library, Duomo, Siena

while others are notably more feeble in their expressions and anatomies. Crucially, the protagonists also become less varied in their pose, positioning and syncopation.

This qualitative slump and change of emphasis can be explained partly by the speed with which, almost certainly, the project was finished and by the larger participation of assistants. Stylistic unity was retained by recourse to a repertoire of standard models, Pintoricchio's own inventions as well as motifs derived from Perugino, his teacher – fluid *hanchement* stances; hands placed elegantly on hips; regular faces with eyes turned dreamily upwards; and flowing, ringletted hair. The reiteration of such formulae signalled Pintoricchio's overall responsibility but also his training by Perugino – the younger painter's reputation in Siena derived not just from his works in Rome but also from his link with Perugino, the most famous and successful Italian painter of the 1490s.[8] This 'model-book mentality' prevailing in Perugino's and Pintoricchio's workshops has hampered the precise attribution of individual drawings used as sources for the finished paintings, both preparatory drawings and paintings being constantly copied and re-copied.

Among the surviving drawings that may be associated with the Library, one (cat. 74) can be reasonably be attributed to Pintoricchio (see further Syson forthcoming). It seems with little doubt an attempt to work out how two stock figures, designed separately and apart in their mirrored *contrapposto* poses, might be joined together and supported by others in a larger group. While these two elements are beautifully considered, their combination and the

insertion of their companions is not particularly happy, which is again a feature of Pintoricchio's finished paintings.

Despite the terms of the contract, the design of the frescoes was certainly not Pintoricchio's alone, and the compositional weaknesses of cat. 74 may indicate why he called upon another younger artist, Raphael, whose fame as a designer was fast growing.[9] In his *Life* of Pintoricchio, Giorgio Vasari wrote: 'But indeed it is true that the sketches and cartoons for all the subjects that he made were by Raphael'.[10] In his *Life* of Raphael he qualified this statement: '[Raphael] having acquired very great fame in following that manner [Perugino's], and Pintoricchio being allocated by Pope Pius II [*sic* for III] the Library of Siena Cathedral, Pintoricchio, knowing his friend Raphael to be an excellent draughtsman, brought him to Siena, where Raphael made him several drawings and cartoons for that work.'[11] Vasari further stated that he had seen a surviving 'cartoon' in Siena and that he himself owned several related drawings.

Vasari's assertion has been debated since the late nineteenth century, the band of Vasari-doubters headed influentially by Giovanni Morelli, who thought it 'absurd' that the older, well-established master would have turned to a twenty-year-old whippersnapper like Raphael. At least five drawings are generally related to the Piccolomini project. Critics unwilling to accept Raphael's involvement have attributed them to Pintoricchio, or else resorted to complicated explanations as to how and why Raphael may have had access to Pintoricchio's studio or to the finished frescoes to make sketches that depend upon Pintoricchio's motifs. Now, however, all

these sheets (including cat. 75, 76) are rightly given to Raphael himself, and a quick glance is all that is needed to see that they have nothing of the mothwing sensibility of Pintoricchio's cat. 74. As a result, but not least because of their spatial complication, the design of the first three, or more correctly, the first five of the frescoes is attributed to Raphael, explaining the distinct appearance of these first episodes in Aeneas Silvius's story.

Like Pintoricchio's cat. 74, not all of Raphael's drawings are precisely matched in the finished frescoes. As with this sheet, however, Raphael's cat. 75 has been related to the six soldiers in the middle ground of the *Coronation as Poet Laureate* (fig. 71) scene. There is no doubt at all that this drawing, executed with astonishing confidence and vigour, was made when the Piccolomini frescoes were being planned; on its verso there is a sketch for a shield-bearing *putto* that can only have been intended for one of the *putti* with Piccolomini arms who appear between each scene in the Library. Moreover, even if their final ordering is different, several of these youths are included in the frescoed group (albeit now dressed to the nines), painted by Pintoricchio with the assurance that is such a feature of the drawing but is so alien to Pintoricchio himself. Though they have also been connected with types used by Signorelli, the poses themselves are mostly familiar from the Perugino-Pintoricchio repertoire. Raphael, however, has precociously realised the advantages of '*pentimento* drawing' – a rapid style, imitated perhaps from Leonardo da Vinci, that could contain changes of mind to explore different compositional groupings, to show these figures from new

angles, to imbue them with greater movement, and to create charged spaces between them. The right arm of the second soldier from the left was, for example, drawn in three positions – first shown held out at waist level grasping a staff, but punching through the outline of his companion on the left (as in Pintoricchio's drawing), then lightly sketched above his shoulder, and finally established resting on the thigh, its shape now echoing the line of his neighbour's body. As Raphael arrived at his solutions, he reinforced his chosen contours, giving his figures a springy, vibrating energy. The rapid diagonal hatching was added last to give the youths volume and relative depth. Whether these youths were drawn from life, as their workaday costume suggests, or from memory, as might be indicated by the short-hands he employs, for instance for their heads, Raphael's improvisational flair allowed him to re-explore standard models to achieve novel and dynamic solutions.

Since Raphael had almost certainly worked in Perugino's studio in the late 1490s the new designs fell within the stylistic boundaries set by Perugino, thus avoiding jarring clashes with Pintoricchio's own style. These revitalised motifs might then be adopted together or singly by Pintoricchio or by Raphael himself in other works, thus extending the permitted repertoire. The figure leaning on his lance on the right of cat. 75, for instance, is seen from different viewpoints in Pintoricchio's fresco on the exterior wall of the Piccolomini Library, *The Coronation of Pius III*, and in Raphael's own predella panel of *The Adoration of the Magi* executed probably in 1503 to go under the *Coronation of the Virgin* altarpiece

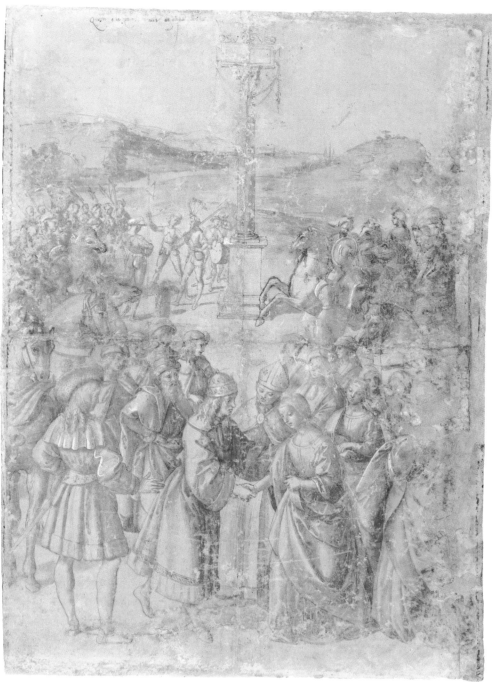

CAT. 76

commissioned by the Oddi family for their chapel in the church of San Francesco al Prato, Perugia.[12]

Raphael may have made several drawings of this type, honing his compositional and narrative skills under Pintoricchio's watchful eye, drawings that, like cat. 75, were more about animating and refreshing pre-existing stock types than about arriving at exact solutions for the Piccolomini frescoes themselves. A well-known pen-and-ink sketch (Uffizi 537 Er) of horses and riders, regularly associated with the first Piccolomini narrative, *The Journey of Aeneas Silvius to the Council of Basle*, comes into this category.[13] However, Pintoricchio also seems to have asked Raphael for worked-up *modelli* or *cartonetti*, finished compositional drawings of entire scenes which could be enlarged to make cartoons for painting on the wall. The pen-and-ink *modello* for *The Journey of Aeneas Silvius to the Council of Basle* survives at the Uffizi (520 E), squared-up for transfer and with detailed annotations in Raphael's hand.[14] A copy of another finished *modello* by Raphael (now lost) for the scene of *Aeneas Silvius making Obeisance to Pope Eugenius IV* is at Chatsworth.[15] Pintoricchio, in transferring the designs to the walls presumably using the cartoons his contract demanded, added extra detail and ornament, obscuring Raphael's great clarity of design but converting them into works that were more obviously and, from his point of view, desirably Pintoricchiesque.

Another drawing by Raphael for the fifth fresco, *Cardinal Aeneas Silvius Piccolomini presents Eleonora of Portugal to Emperor Frederick III* (cat. 76), is also usually classified as a *modello*. The subject, like several in the Library, was chosen to link the biography

of Aeneas Silvius with the wider history of Siena. The first meeting in February 1452 of Frederick III and his betrothed Eleonora of Portugal outside the Porta Camollia was probably the most significant ceremonial event in the history of fifteenth-century Siena. Raphael and, in the fresco, Pintoricchio depict Frederick and Eleonora, with Aeneas Silvius standing protectively behind them, in front of a marble column and inscription (still standing), not present on the day but erected later to commemorate the occasion.[16] Glorious and cripplingly expensive, the episode had already entered civic myth and had been described in an exceedingly long poem in *terza rima* by Mariano di Matteo di Cecco Dati, apparently written to while away a prison sentence.[17] Dati evokes the great crowd 'Of cardinals, kings, dukes and barons, around these two [the emperor and his bride] was made a circle, more beautiful even than a peacock's spread tail', very much the effect intended in the fresco. Here is an annexing of civic history for familial glory.

Like Uffizi 520E, this drawing was inscribed by Raphael himself, though more laconically. In both drawings, Raphael worked up the figures in the foreground over traces of black chalk and stylus underdrawing; this area in cat. 76 was carefully pre-planned. However, this preparatory underdrawing is absent in the upper part of the sheet, so it appears essentially improvised around the column at the centre (the only part to be incised, so as to establish its straight lines). Conceivably, Raphael was here working faster, or it is just possible, as Panofsky first suggested, that this was not his final drawing (at any rate, it was not squared up to make the cartoon). Raphael

has grouped the many figures – and their horses – so that, for the first time, they rather than any architecture or indeterminate middle ground establish the spatial recession; here, too, Raphael seems to have learned from Leonardo, especially from his unfinished Uffizi *Adoration of the Magi*, and the technique depends upon spontaneous and Leonardesque invention rather than careful preparation.

Like the chronology of the frescoes, the date (or dates) of Raphael's involvement in the project has been much debated, but the balance of the evidence (see Syson forthcoming) inclines towards 1503, the last year of Cardinal Francesco's life. He may though have returned briefly the following year (see cat. 78). The design and execution of the first five Piccolomini frescoes should be seen as a dialogue between the two artists, one that was to affect their subsequent works. Pintoricchio's additional collaboration with local painters was to have equal impact upon the later art of Siena. LS

1 For whom, see most recently Richardson 2007.
2 Schmarsow 1880, pp. 10–11; Oberhuber 1986, p. 171, note 19 (for a useful summary); M. Caciorgna, '"Mortalis aeulor arte deos": Umanisti e arti figurative a Siena tra Pio II e Pio III' in Angelini 2005, pp. 163–4, esp. pp 170–7.
3 See Green 1991, p. 123; Shepherd 1993, p. 250; D. Toracca in Settis and Toracca 1998, p. 240; C. Gilbert in Testa 1996, pp. 307–19; M.R. Silvestrelli, '"Pictor egregius" a Siena' in Scarpellini and Silvestrelli 2004, p. 233.
4 See Shepherd 1993, p. 412.
5 M.R. Silvestrelli in Scarpellini and Silvestrelli 2004, pp. 234, 244, note 19.
6 Sricchia Santoro 1982, pp. 43–58
7 M.R. Silvestrelli in Scarpellini and Silvestrelli 2004, pp. 241, 293, doc. 192.
8 See Rowland 2001, p. 12.
9 Raphael made earlier designs for Evangelista di Pian di Meleto, and the still-to-be-identified author of the São Paulo *Resurrection*. See T. Henry and C. Plazzotta in Chapman, Henry and Plazzotta 2004, pp. 98–103,

108–115, cat. 15–17, 21–4 (where the São Paulo *Resurrection* is attributed to Raphael).
10 Vasari 1966–87 edn, III, pp. 571–2.
11 Vasari 1966–87 edn, IV, p. 59.
12 Meyer zur Capellen, 2001–5, I, pp. 134, 136, no. 8c.
13 Joannides 1983, p. 146, no. 57r.
14 Joannides 1983, pp. 48–9, no. 56, pl. 8.
15 See further Syson (forthcoming).
16 The inscription on the column reads: CAESAREM FEDERICUM III IMP · ET / LIONORAM SPONSAM PORTUGAL / REGIS FILIAM HIC SE PRIMUM / SALUTAVISSE LOCO LAETISQUE / INTER SE CONSULTASSE AU- / SPICIIS MARMOREUM POSTERIS / INDICAT MONUMENTUM / A.D. MCCCCLI · VII · KL · MARTIAS.
17 Fumi and Lisini 1878; Parducci 1906–7; 14, pp. 38–40.

SELECT BIBLIOGRAPHY

Cat. 74 Ferino Pagden 1984, pp. 144 (cat. 55), 198; Forlani Tempesti 1991, pp. 214–6, no. 73; P. Scarpellini, 'Gli ultimi dieci anni (1503–1513)' in Scarpellini and Silvestrelli 2004, p. 265; *Cat. 75, 76* Joannides 1983, pp. 50–1, 147, no. 58–9; Knab, Mitsch, Oberhuber with Ferino Pagden 1983, pp. 558, 561–2, nos 28, 62; K. Oberhuber, 'Raphael and Pintoricchio' in Oberhuber 1986, pp. 163–5; T. Henry and C. Plazzotta, 'Raphael: From Urbino to Rome' in Chapman, Henry and Plazzotta 2004, pp. 25–6; A. Angelini, 'Pinturicchio e i suoi: dalla Roma dei Borgia alla Siena dei Piccolomini e dei Petrucci' in Angelini 2005, pp. 526–9; R. Eitel-Porter in Eitel-Porter 2006, pp. 26–7, no. 11.

77.

BERNARDINO DI BETTO, KNOWN AS PINTORICCHIO (1456/60–1513)
The Holy Family with the Infant Saint John the Baptist, about 1504–8

Oil and tempera on panel, 83 cm diameter
(with original papier-mâché gilded frame, 123 cm diameter)
Pinacoteca Nazionale, Siena (495)

When this picture for private devotion came to be painted, no painter was more fashionable in Siena than Pintoricchio. He had already achieved immense popularity throughout Central Italy, but by the middle of the first decade of the sixteenth century he had come to be seen as Siena's leading painter – and her adopted son.[1] On 7 March 1507 he wrote to the Balìa asking to be let off taxes, and citing ancient Roman parallels in Cicero for the state's protection of artists, thus making a strong connection between ancient and modern culture. His supplication was largely successful, agreed on the basis that the painter had '*eletto la patria senese per sua*' (chosen Siena as his fatherland). Granted these rights by the Balìa, he became a kind of new civic artist in an *all'antica* mould, as was stressed by Sigismondo Tizio in his 1513 funeral oration for Pintoricchio. His chief patrons were members of the Piccolomini family, and latterly Pandolfo Petrucci himself. He proclaimed his new allegiance in works made outside the city.[2] Also in March 1507, he was constrained to delegate the execution of an altarpiece of *The Virgin and Child with Saints* for the church of Sant'Andrea at Spello in Umbria to the Perugian painter Eusebio da San Giorgio (all except the heads of the principle figures). In the elaborate still life in the foreground of this work, Pintoricchio included two letters, one addressed to him, the other unfolded, which seemingly is a copy of the letter which records his summons back to Siena by Pandolfo Petrucci in April 1508 – an excuse for his failure to complete the painting in his own hand. In Siena, he concentrated on large-scale mural projects and a few prestigious altarpieces, his practice involving

collaboration with many other painters (see pp. 39, 356). This was not of course very different in nature from his main activity in Rome. What is different about his work in Siena is that he and his workshop seem to have produced only a very small number of devotional panels for domestic use. The present work is almost the only one accepted by most critics as dateable to this period, suggesting that it was made for one of the ruling Sienese families or their closest allies.[3] It represents an early example in Siena of the use of the tondo format (see cat. 98) made fashionable in Florence in the three decades before – an assertion of the picture's modernity.

After recent cleaning, the tondo has been revealed as a work of the highest quality, in beautiful condition and with a particularly well balanced composition.[4] Stylistically, it is of the moment when Pintoricchio was to be found working most intensively on the Piccolomini Library frescoes, probably during the second phase of work there, which was initiated by the scene of Frederick III's meeting with Eleonora of Portugal (whose head and long neck are like Mary's: see fig. 72, p. 254). This was a period of close collaboration between Pintoricchio and local artists and it has been argued that, though this picture was designed by Pintoricchio, it was executed by his frequent Sienese collaborator Pacchiarotti.[5] The quality and imagination of the work imply that Pintoricchio's participation was more active than this judgement implies, though some tiny discrepancies of technique within the picture – the tempera hatching in the Virgin's face, not seen elsewhere, and the highlights which are perhaps more delicately painted in her hair than in, for example,

Saint John's, suggest he may have received some assistance in certain areas.

Its surface is lavish, realised using gold and expensive pigments, worthy of any patrician patron. The landscape type is again close to those developed for the Piccolomini Library. The figures, all with transparent gold haloes, are posed on a carpet of flowers, including plants quite possibly with some symbolic meaning. The many trees in the background, with their gilded highlights, include palms and cypresses, and far off there is a distant view of a city in silhouette, probably by now a standard shorthand for Siena. The Virgin Mary is the largest and most imposing figure, wearing a monumental blue cloak (now darkened almost to black, showing that it was painted with azurite). Its folds are indicated by hatching and stippling, again using mordant gilding. The lakes in her red dress are now somewhat faded – and its original colour can be judged by the areas where mordant gilding, previously protecting the paint, has fallen off. Her right hand, unusually, is raised in blessing (this is usually Christ's gesture), seemingly of the book, with its bright vermilion cover, held in her left hand and also of the holy children beyond. (The text of book is not legible – nor was it intended to be so.)

Though set behind her, the melancholy Saint Joseph pushes forward of the Virgin, thanks not just to the better preservation of the colours with which he was painted but also to his position at the centre of composition. This is a relatively unusual arrangement for the Holy Family, suggesting a shift of emphasis from Mary to her husband. Joseph's prominence is further stressed by colour – by his sparkling yellow cloak, with its orange-red lining that is covered in mordant gilded stippling and hatching, and by the brighter blue of his tunic, which was always a stronger colour than that of the Virgin's mantle. Pintoricchio used lapis lazuli for this passage, a pigment that was more expensive than the azurite of the Virgin's cloak. Joseph holds in his right hand what appears to be a loaf of bread, though it is rather amorphously shaped and lacks defining shadows. He uses his left hand to prevent a small barrel – very likely of wine – rolling off his lap. Together these attributes must be the eucharistic elements associated with the Sacrament of Communion, instituted at the Last Supper – the flesh and blood of Christ.

The Infant Saint John the Baptist begins making appearances in Sienese works in this period. Here he carries a little lustred blue-and-white maiolica flask with a volute handles and a mordant-gilded crucifix-topped staff with the words *ECCE. AGN*[*VS.*] *DEI* (Behold the lamb of God) twined around. The cross is studded with rubies, perhaps a reference to the wounds of Christ. He walks arm-in-arm with the Christ Child. Christ is fully dressed and of the same age as John – a toddler rather than a baby. He too has a book – linking him to the Virgin and the notion of the Word made Flesh. In accordance with traditional iconography, Christ's is the only halo marked with a red cross. His costume is a dalmatic or other priestly vestment; he has apparently taken Holy Orders – another of the Sacraments. He points with his right hand to a spring flowing into a trough and out again through a lion-headed spout into the little brook below. Since the young Saint John is apparently taking his flask to that stream to fill it, this combination of elements refers to a third Sacrament – that of Baptism. A fourth – Marriage – is perhaps signalled by the presence of both Mary and Joseph, presented as a loving couple. This group contains not only the whole of Christ's story in essence, but also the basis for sustained contemplation of the Sacraments.

The presence of the diminutive Saint Jerome in the landscape on the far right may symbolise a fifth Sacrament – Penitence or Confession – since he is shown, kneeling and beating his breast, identified by his lion and his cardinal's hat hung on a piece of brushwood. It is possible that the idea for the inclusion of a second saint in the land-scape – Saint Anthony of Padua on the far left – came only after the painting of the landscape had begun. The disturbed paint surface in the area containing him and in particular the ridge below, crossing a rock in the middle ground, suggests a possible *pentimento*. The inclusion of Jerome might confirm the tondo's original ownership by a nun in the Franciscan convent of San Girolamo in Campansi (whence it reached the Istituto di Belle Arti probably after the Napoleonic suppression of convents in 1810). Anthony of Padua was, of course, a Franciscan, and it is worth noting that Saint Joseph was held particularly dear by the order.[6] His feast day had been embraced by them in 1399 and the argument for his incomparable power as an intercessor presented by Saint Bernardino himself in a sermon delivered in Siena. In 1479, his feast was officially admitted into the Roman calendar by the Franciscan Pope Sixtus IV.

The convent of San Girolamo in Campansi was founded in the early Quattrocento. A group of Franciscan tertiaries had met at

the church of San Francesco to pray. They had a superior called a *ministra*. Two of their number, Bartolomea da Pisa and Margherita da Siena, voiced their desire for a stricter order and in about 1430 they obtained certain houses in Campansi, near Porta Camollia, to build a convent. In 1435, Pope Eugenius IV issued a bull regulating the new order and calling it the 'Povere di Campansi'. The nuns were put under the supervision of the third order of Observant Franciscans (the Minori Osservanti). This was not a closed convent, and thus was a particularly suitable dwelling for unmarried patrician women, who might still wish to maintain links with the outside world. So it may be that Anthony of Padua's presence stands for more than the nature of the order, suggesting in addition a connection with the family of Antonio Bichi.[7] It appears that his daughter Laura Bichi had first entered the convent of Santa Maria Maddalena, but by 1497 she is recorded among the nuns of Campansi.[8] It is possible that she asked for the image of Anthony as a act of filial homage to Antonio Bichi. The family connection continued. Her sister Eustochia, the wealthy widow who was the patron of the family chapel at Sant'Agostino (see cat. 58–9), seems to have lived next door to the Campansi convent. An inventory of 14 May 1542 survives, listing the '*robbe e massaritie*' (stuffs and furniture) left by her to the convent. Several devotional pictures are included, though none whose description matches Pintoricchio's tondo.[9]

1 The best recent analysis of Pintoricchio's status in Siena in the first decade of the Cinquecento is A. Angelini in Caciorgna, Guerrini and Lorenzoni 2006, pp. 83–99.
2 Borghesi and Banchi 1898.
3 First by Brandi 1933, pp. 350–10.
4 A.M. Guiducci in Proto Pisani 2005.
5 P. Scarpellini, "'Nemo propheta in patria'" in Scarpellini and Silvestrelli 2004, p. 225.
6 Wilson 2001, pp. 6–8.
7 This was suggested to me by Philippa Jackson, from whom comes the following information.
8 Siena, Archivio Bichi Ruspoli Forteguerri, 315 (74): 'Notizie, e memorie spettanti a persone della famiglia de SS-i Bichi. Una tal diligenza è stata fatta con pensiero, et a Spesa dell'Illustrissimo Signore Abbate Galgano Bichi Patrizio Sanese, che ne commese l'Esecuzione, all'accuratezza del R. Signori Andrea Falorsi Prete sacerdote Sanese', III, p. 2.
9 ASS, Conventi, 2021.

SELECT BIBLIOGRAPHY

P. Torriti in Siena 1990, pp. 323–4, no. 495; Olson 2000, pp. 261–2, no. A75; P. Scarpellini, "'Nemo propheta in patria'" in Scarpellini and Silvestrelli 2004, p. 225; A.M. Guiducci in Proto Pisani 2005, pp. 88–9, cat. 3.

78.

RAPHAEL (1483–1520)

The Dream of a Knight, about 1504

Oil on panel, 17.5 × 17.5 cm
(painted surface 17.1 × 17.3 cm)
The National Gallery, London (NG 213)

Raphael established a connection with Siena in around 1503, working with Pintoricchio on the Piccolomini Library frescoes (see cat. 74–6). Though he may never have returned to the city, his ties with Sienese patrons continued; his lost, but much-copied *Madonna del Silenzio* tondo was seemingly made for a member of the Piccolomini family.[1] Thus the suggestion that the *Dream of a Knight* and its companion picture, the very slightly smaller *Three Graces* (fig. 73), were commissioned by a member of the Borghesi family, a theory based in large measure on their shared early seventeenth-century provenance in the Roman collection of the Cardinal Scipione Borghese (whose ancestry was Sienese), is not implausible.[2] Certainly, both works are not only informed by a knowledge of the works of art that could be seen in Siena, but they seem to allude to subject-matter particularly dear to Sienese patrons in the years around 1500.

That is not to say that the subject of the *Dream of a Knight* can – or should – be defined precisely. Efforts to associate it with one or another specific literary text have generally proved flawed – this is no mere illustration – and are probably misguided. the *Dream of a Knight* is an intentionally mysterious image, a web of references and visual prompts. Just like the most sophisticated works made in this period for private devotion, it is a picture intended to support sustained meditation, not in this case on religion, but upon love and virtue, poetry and painting itself. Its function is declared by its small scale and the jewel-like precision of its execution; this was a picture to be examined, repeatedly, at very close quarters, like a manuscript illumination or an engraved ancient gem, picking

out new details with each viewing and making new connections between its component parts. The picture was very carefully planned and was realised using a pricked cartoon now in the British Museum (1994-5-14-57).[3]

In the centre foreground, a handsome youth dressed in *all'antica* armour lies asleep propped up against his shield, beneath a laurel (or bay) tree, which provides a strong vertical accent within the composition and divides the space into two distinct zones. The first – on the left – is occupied by a woman with bare feet, soberly garbed; her overdress is purple, '*di nobilissimo colore, umile e onesto*' ('in the most noble colour, humble and honest', Dante, *Vita nuova*, II, 3). Her head is modestly covered, and her expression supremely tender. She brandishes a sword, and immediately above the knight's head, a book. On the right is another bare-footed woman, with a contrastingly bright red dress and sky-blue overdress. Her draperies are more animated than those of her opposite, with her overdress 'hitched up becomingly at her hip'.[4] Her golden hair is uncovered, knotted loosely behind her neck and entwined with a veil that twists under her left arm. Her pose mirrors that of the lady opposite and, in place of the book, she holds a sprig of flowers – with another tucked into her hair. This is often thought to be her only attribute, but in fact the coral beads that are twisted through her hair and criss-cross her torso are looped through her left hand. They therefore become the equivalent of the other lady's sword. The two women clearly stand for different things: Passavant long ago thought they represented 'noble inspiration' and 'the pleasures of life' respectively.

Though not in any sense an illustration of either tale, the imagery of this work is chiefly informed by two well-known classical texts. Underlying the whole iconography is the celebrated parable invented by Prodicus of Ceos, a Greek philosopher of the fifth century BC, as reported by Xenophon (*Memorabilia*, II.1, 21–34). This tells of Hercules's encounter, at the brink of manhood, with two women – female personifications – at a crossroads, at which the hero has to decide how to live his life, to climb Virtue's rocky road or to follow Pleasure's easier path. It has been suggested that Raphael found a visual source for his composition in a woodcut – like the painting, square – of *Hercules at the Crossroads* published in the 1497 Latin version of Sebastian Brant's *Stultifera navis* (*Ship of Fools*).[5] Hercules, an armed figure, is shown asleep. Virtue and Pleasure stand on little hummocks on either side, appearing to him in a dream. The parallels are not close, but supporting the connection with Prodicus's story is the division in the landscape in Raphael's panel. This divide is rendered more subtly than in what was to become the standardised iconography of this subject (it is worth remembering that it had not yet achieved the popularity it would later). Unquestionably, however, one road leads from the crossroads below the arm of 'Virtue' on the left towards to an imposing crag and castle. To the right are gently undulating blue hills, framing the view of a lake or inlet into which juts what might be a causeway but is more probably a covered pier – an embarking point. The landscape is loosely derived from Netherlandish pictures and perhaps, for the cluster of houses in the middle ground, from German prints.[6]

(actual size)

Raphael's knight is not, however, a conventional Hercules; he has none of the demi-god's usual identifying attributes. Panofsky introduced a further connection with the story of the vision of Scipio Africanus. He demonstrated that the dialogue between Virtue (*Virtus*) and Pleasure (*Voluptas*) inserted by Jacob Locher in the Latin version of the *Stultifera navis* had incorporated phrases from Silius Italicus's *Punica* (xv). This text had been rediscovered by Florentine humanist Poggio Bracciolini in 1417 and was first published in 1471; it would have been immediately recognisable to an educated audience. It told of the choice of Scipio in a narrative obviously informed by the tale of the Hercules's quandary: 'These anxious thoughts filled the young man's mind as he sat beneath the green shadow of a bay-tree that grew behind the dwelling; and suddenly two figures, far exceeding mortal stature, flew down from the sky and stood to right and left of him: Virtue was on one side and Pleasure, the enemy of Virtue, on the other. Pleasure's head breathed Persian odours, and her ambrosial tresses flowed free; in her shining robe Tyrian purple was embroidered with ruddy gold; the pin in her hair gave studied beauty to her brow; and her roving, wanton eyes shot forth flame upon flame. The appearance of the other was far different: her hair, seeking no borrowed charm from ordered locks, grew freely above the forehead; her eyes were steady; in face and gait she was more like a man; she showed cheerful modesty; and her tall stature was set off by the snow-white robe she wore.' Virtue promises Scipio honour, fame and glory through

victory in war – but cautions that the road to her chaste mountain dwelling is steep and stony. Pleasure counters with the offer of a life of peaceful serenity. Scipio, like Hercules, chose the more arduous path, strengthened in his resolution as a result of this experience to become leader of the Roman forces in Spain.

One key detail in the picture fits Silius's narrative precisely – the bay-tree. It should be noted, however, that as well as reinforcing a connection with this particular text, laurel was a valuable insertion for its range of associations with both valour and poetry. Other details in the poem accord less well, especially the relative scales of the central human protagonist and the visionary beings, the dress and manly physique of Virtue, and the fact that her ostensible counterpart, Pleasure, is less modestly attired than in the painting. Silius Italicus, moreover, describes a vision. The idea that Scipio is dreaming may derive from another distinguished source, Cicero's *Somnium Scipionis* and Macrobius's commentary upon it, the latter printed no fewer than four times before 1501. There the dream is different, however.

Even if this not a straightforward visual rendition of the passage in Silius Italicus's poem, Raphael's dreaming knight is undeniably characterised to resemble so many of the young Greek and Roman historical heroes depicted in Central Italy in these years. There is nothing to contradict his identification as Scipio, even if he can represent (as Scipio himself could in literature) a more general ideal of youthful male nobility. Cecil Gould compared him to the Scipio in Perugino's fresco in the Collegio del Cambio, Perugia (1499–1500). He also

has much in common with the exemplary ancients, including Scipio (cat. 67), painted for a Sienese palace in the early 1490s. Scipio had been celebrated as an archetypal poetic hero in the Middle Ages, as the saviour of Rome and a model of chastity, by Dante and, after him, at considerable length, by Petrarch, who made him the hero of his epic Latin poem *Africa*, started in 1338. This was first printed in Venice in 1501, and it too probably informed (though less directly) the iconography of Raphael's painting. Aldo Bernardo has discussed Petrarch's conversion of two historical figures, his beloved Laura and the Roman general, into figures of high poetry.[7] If Raphael's knight is indeed Scipio (or a version of him), he too has been 'poetically' transformed.

One key part of Raphael's translation is the elimination of the idea that the knight should make a choice. Cecil Gould considered that the women stand for complementary attributes rather than antagonistic ones and Carol Plazzotta sees Raphael as 'representing the double visitation not in terms of a moral dilemma, but rather as a convergence of all the qualities to which an ideal knight or soldier should aspire'.[8] The figure of 'Pleasure' is evidently not the immoral temptress of these stories, and it may be that we should rethink both ladies' identifications. The women were alternatively, though still somewhat abstractly, identified as Pallas Athena and Venus by André Chastel. Still arguing that the picture's iconography assumed a moral decision, he wrote: 'the knight Scipio has to choose, not so much between Good and Evil, as between two principles of conduct, Venus and Pallas,

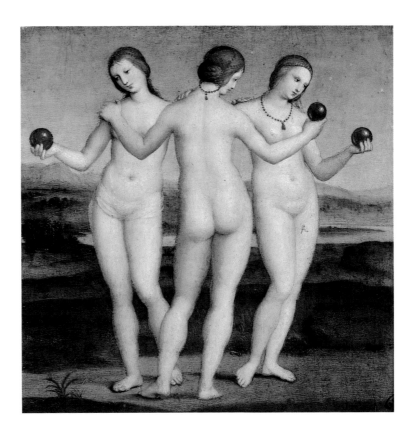

the way of worldly satisfaction and the way of a higher order'.[9] Once again, these would not be conventional depictions of the two goddesses. The book and sword held by the woman on the left are, however, perfectly acceptable (though not standard) attributes for Pallas or Minerva, the goddess of wisdom and warfare. This was a now established pairing to signal the double virtues of the righteous, educated warrior-prince, whose tutelary goddess was Minerva.[10] On the other hand, the flower held out by the woman on the right seems to be myrtle, a plant sacred to Venus – and to marriage.

The issue of the identity of the woman on the right may be somewhat clarified by considering the relationship of the *Dream of a Knight* to the Chantilly *Three Graces* (fig. 73). Though the two pictures are often thought to have formed a diptych, the marginally smaller size and larger figures of the *Three Graces* make it more likely that the Chantilly panel was the cover for the London picture.[11] The smaller panel is slightly more loosely painted and the land-scape simpler. These factors suggest that it was intended to be seen from further off, perhaps displayed on a wall. Thus the *Dream of a Knight* could only have been inspected at the distance demanded by its detailed painting once the cover had been removed. Sometimes individuated in the Renaissance as Chastity, Beauty and Love, here the identities of the Graces merge. It may be significant that all three wear coral in their hair and in two cases round their necks. It has already been noted that coral beads constitute the second attribute of the 'other woman' in *The Dream of a Knight*. This motif links her explicitly to the Graces,

who were thought of as the companions of Venus, and were so described in Petrarch's *Africa* (iii, 265–8): '. . . mark [Venus's] company / three naked girls: the first averts her eyes, / and all have snowy arms entwined in sweet / reciprocal embrace. . .'.[12] Coral may have been chosen since it, like Venus, emerged from the sea (though there is seemingly no contemporary source that confirms this association); and there is a body of water behind this figure in Raphael's picture. No matter what its precise connotations, by wearing coral, Raphael's Venus (or, better perhaps, what Paul Holberton has termed a 'Venereal personification') is seen by the juxtaposition of the two pictures to embody all three qualities associated with the Graces.[13]

For if virtue (represented by Pallas or a 'Palladian personification') constituted a knight's chief weapon, female beauty was his prize and inspiration. Together they represented aspects of love. The point was made explicitly in one of Dante's most beautiful and evocative sonnets, here given in a pleasing translation by Dante Gabriel Rossetti ('Of Beauty and Duty'):

Two ladies to the summit of my mind
Have clomb, to hold an argument of love.
The one has wisdom with her from above,
For every noblest virtue well design'd:
The other, beauty's tempting power refined
And the high charm of perfect grace approve:
And I, as my sweet Master's will doth move,
At feet of both their favours am reclined.
Beauty and Duty in my soul keep strife,
At question if the heart such course can take
And 'twixt two ladies hold its love complete.
The fount of gentle speech yields answer meet,
That Beauty may be loved for gladness' sake,
And duty in the lofty ends of life.[14]

In many ways, this poem seems as important a literary source for the picture as any identified previously.

Other poetry in the *volgare* was important for Raphael and he must have been especially inspired by his own father's example. Giovanni Santi had written a long poem celebrating the life and deeds of his patron the Duke of Urbino, Federigo da Monte-feltro, and the prologue, '*una visione in somno*' (a vision in sleep), is a version of the Choice of Hercules or Scipio. In it, the poet falls asleep under the shade of a beech tree

265

Fig. 74
Benvenuto di Giovanni (1436–about 1509) probably
with Girolamo di Benvenuto (1470–1524)
Hercules at the Crossroads, 1500
Tempera on panel, 87 cm diameter (with original frame)
Galleria Franchetti, Ca' d'Oro, Venezia (87)

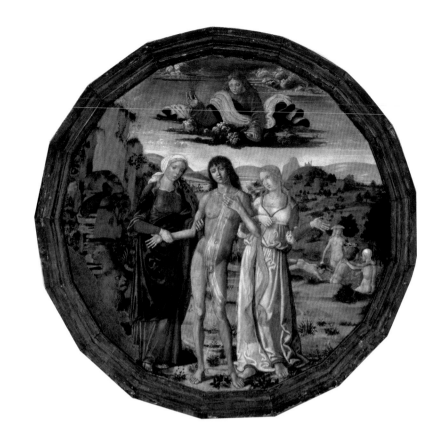

and is exhorted to abandon a life of pleasure and to pursue instead a new harsh road leading up a bare cliff to the temple of Apollo and the Muses. Giovanni Santi's poem was used as evidence by Baudissin to establish a link between the present work and the court at Urbino, suggesting that Raphael's patron should be found there.[15] His theory is not impossible, but Panofsky's earlier suggestion that the picture should be connected with an event in the life of Scipione di Tommaso Borghesi (b. 1493) remains perhaps more plausible. It is certainly the case that Scipio (or in Italian, Scipione) was a much-used name in Siena in these circles. Apart from this young Borghesi, another member of the clan was baptised Scipione Africano Vittorio (the son of Alessandro di Ambrogio Borghesi) a year later, and one Scipione Chigi was born in 1507.[16] But this fact shows only that the hero had a particular status in the city, rather than that the picture was necessarily painted for someone with that name. If it was made for a member of the Borghesi family or for another Sienese patrician, it was probably sent to Siena from Perugia, since the panel is correctly dated on stylistic grounds to around 1504 (though it is just possible that Raphael made a return trip to Siena in 1504).

Santi's prologue is a good example of a contemporary poem that exploited its readers' assumed familiarity with ancient literary precedent to arrive at a variation on the theme. Raphael's *Dream of a Knight* is its pictorial equivalent and one that employed a similar tactic. The visual strands that fed into this image and its cover were, with only one crucial exception, modern. However, it is striking how many of them

can be associated with Siena, showing that the web of allusion contained in the two works would best be understood there. Tellingly, for example, the *Three Graces* copies the sculptural group set up in the Piccolomini Library (which is believed, on the basis of a copy drawing, to have been studied by Raphael).[17] They recur often in the art produced in the Siena in the first decade of the fifteenth century, quoted by artists rather in the way that they had cited Simone Martini's Porta Camollia *Assumption* fresco (see pp. 106–7). They can represent Concord, but also Love, featuring twice in the Petrucci *camera bella*, once on the ceiling and once in a carved wooden pilaster (cat. 83).

The particularly high status accorded to Scipio Africanus in Siena is further demonstrated by the unusually large number of scenes from his life painted in the years around 1500. The youthful Scipio makes frequent appearances in Sienese domestic paintings. He is to be found not only in the series of virtuous men and women mentioned above (cat. 67), but also in two *spalliera* sequences by Bernardino Fungai. In particular, the pair of *spalliera* panels

in Saint Petersburg (Hermitage)[18] and Moscow (Pushkin Museum),[19] painted probably just before the turn of the century, in which Scipio's dress is rather like that of Raphael's knight, also have their textual sources in Silius Italicus and Petrarch. The Continence of Scipio, the episode in which he proved his chastity, remained a particularly popular subject; this was the story for the lost fresco by Pintoricchio for the Petrucci *camera bella* (see cat. 102–7), used again a decade or so later for a *spalliera* painting by Beccafumi (Pinacoteca, Lucca).

These visual sources are combined with images of Hercules at the Crossroads, and it is again revealing that one of the earliest paintings to survive with this subject is also Sienese. A properly youthful Hercules is depicted torn between Virtue and Pleasure in the *desco da parto* (birth tray) made in 1500 in connection with the marriage between Girolamo de' Vieri and Caterina Tancredi by Benvenuto di Giovanni, probably with the assistance of his son (fig. 74).[20] As in the *Dream of a Knight*, the landscape is divided. Virtue's road is not just rocky, it is also populated by (rather docile-looking) lions;

Pleasure's acolytes – or victims – can be seen frolicking behind her in a river, where the dress code seemingly only allows the wearing of a straw hat. The women's contrasting costumes in this work also anticipate Raphael's picture. Again, this theme recurred in Siena, found in the charming panel of about 1510 attributed to Pacchiarotti in the Szépmüvészeti Múzeum, Budapest in which the young Hercules is clearly asleep, and in frescoes and panels by Beccafumi – the roundel in the Palazzo Venturi (now Bindi-Sergardi), where the Three Graces also appear; and a *spalliera* in the Museo Bardini, Florence. There were even equivalents in Siena for the poetic reworking of the motif of the mountainous road to virtue, and the human capacity to choose it: this seems to be the message behind Francesco di Giorgio's mysterious drawing of a young man in a landscape (cat. 41). One of the inlaid marble pavements in Siena Cathedral, designed by Pintoricchio, contains an elaborate allegory of the Mountain of Wisdom, in which the female personification of Sapienza holds a book (and a victor's palm).[21] Even the poet-knight presented as a dreamer has a precedent in Benvenuto's Detroit *cassone* panel in which the central protagonist adopts what had already become the standard dreaming pose (pp. 50–1, fig. 24).

This deliberate conflation of sources – textual and pictorial – shows that the mysteries of a certain rare category of picture, including this one, were deliberately obscure. There is no code to be cracked – nor any single literary source that would provide a complete explanation. All its parts are potentially multivalent, and can be linked together in an almost unlimited number of ways. The book, for example,

could be an emblem of wisdom, but it could also represent poetry. The coral may be associated not only with Venus but also with Pallas; coral was considered her gift to the world, described by Ovid as seaweed transformed by the blood flowing from the head of the decapitated Medusa.[22] Pictures, by their nature, may perhaps uniquely be made subject to these kinds of associative readings. If, in Santi's poem, the dreaming hero was turned into the poet, one of the points of Raphael's picture is that the knight can also be taken to stand for the painter himself. Johannes Röll has written: 'The depiction of the dream is the subject of the painting …'. The dream therefore represents Raphael's own ability to depict the imaginary, the visionary, himself inspired by both Beauty and Duty – indeed by Love itself. LS

1 Henry 2004.
2 Panofsky 1930b; Van Lohuizen-Mulder 1977.
3 See C. Plazzotta in Chapman, Henry and Plazzotta 2004, pp. 142–3, cat. 36.
4 C. Plazzotta in Chapman, Henry and Plazzotta 2004, p. 138.
5 First suggested by de Maulde da Clavière 1897; elaborated by Panofsky (1930b).
6 Some of these elements were changed, added or particularised after the cartoon was drawn – the crossroads under the arm of the woman on the right, the species of flower held by her opposite, her coral beads, and even the specific tree type under which the knight reclines.
7 Bernardo 1962, p. ix.
8 Gould 1975; C. Plazzotta in Chapman, Henry and Plazzotta 2004, p. 138.
9 Chastel 1959, p. 252.
10 Associated with both Francesco Sforza, Duke of Milan (in his medal by Pisanello), and, especially, Federigo da Montefeltro, Duke of Urbino. The theme is explored in Brink 2000.
11 Jones and Penny 1983, p. 8; Dülberg 1990, pp. 137–43.
12 Bergin and Wilson 1977, p. 49.
13 Holberton 1984, pp. 149–82, esp. p. 152.
14 Rossetti 1861, pp. 249–50. The connection with this sonnet was first pointed out by Andrew Unger after the display of the picture in the 2004 exhibition, *Raphael: From Urbino to Rome*, email correspondence

to the author, 19 June 2006. For the original text see Dante 1967, pp. 146–9, no. 71 (B.LXXXVI):

Due donne in cima de la mente mia
venute sono a ragionar d'amore:
l'una ha in sé cortesia e valore,
prudenza e onestà in compagnia;
l'altra ha bellezza e vaga leggiadra,
adorna gentilezza le fa onore:
e io, merzé del dolce mio signore,
mi sto a piè de la lor signoria.

Parlan Bellezza e Virtù a l'intelletto,
e fan quistion come un cor puote stare
intra due donne con amor perfetto.

Risponde il fonte del gentil parlare
ch'amar si può bellezza per diletto,
e puossi amar virtù per operare.

15 Baudissin 1936.
16 It has been thought that a set of panels with episodes from the life of Scipio by Bernardino Fungai was executed for his birth: see A. Labriola in Boskovits 1991, p. 40. More recently it has been pointed out that the probable 1490s date for the pictures makes this unlikely: see M. Caciorgna in Santi and Strinati 2005, pp. 189–92, cat. 2, 11–13, esp. p. 192. For Scipione Africano Vittorio see M. Caciorgna, '"Salebrosum scandite montem" Contributo all'esegesi iconografica del Monte della Sapienza na; Pavimento del Duomo di Siena: tonti letterarie classiche ed umanistiche' in Caciorgna, Guerrini and Lorenzoni 2006, p. 113, note 71.
17 This drawing in the Venice Sketchbook of the Piccolomini *Graces* is discussed in Syson (forthcoming).
18 Kustodieva 1994, p. 175, no. 90.
19 Markova 2002, pp. 251–3, no. 151. For a definition of *spalliera* paintings see cat. 62–4.
20 Bandera 1999, pp. 196, 198, 199, 244, no. 86.
21 See M. Caciorgna, 'La navata centrale' in Caciorgna and Guerrini 2003, pp. 64–82.
22 Geronimus 2006, p. 115. Albertus Magnus thought that coral promoted wisdom.

SELECT BIBLIOGRAPHY

Panofsky 1930, pp. 37–82, 142–50; J. Röll, '"Do we affect fashion in the grave?": Italian and Spanish Tomb Sculptures and the Pose of the Dreamer' in Mann and Syson 1998, pp. 154–64, esp. p. 158; C. Plazzotta in Chapman, Henry and Plazzotta 2004, pp. 138–41, cat. 35; J. Meyer zur Capellen in Coliva 2006, pp. 114–5, cat. 4.

79.

MAESTRO BENEDETTO DI GIORGIO DA FAENZA (active about 1504–22)

Plate with a scene of an old man (Saint Jerome?) holding a skull and interlaced strapwork and arabesque borders, about 1503–10

Tin-glazed earthenware, painted in blue, blue-black and opaque white
24.5 cm diameter
Victoria and Albert Museum, London (4487-1858)

Signed on reverse: FATA Î SIENA DA Mᴼ BENEDETTO (*made in Siena by Maestro Benedetto*)

As probably the only surviving piece by one of its leading potters, this signed plate has a particularly important place in the history of Sienese ceramic production. It contains the quickly and boldly painted image of an elderly man in a cave or grotto, dolefully contemplating a human skull. He is usually identified as Saint Jerome, a key figure for the art of Siena, who does indeed appear on other plates and dishes made there,[1] but here he lacks a halo or any of his usual identifying attributes. The skull became essential to his iconography only after the issue of Albrecht Dürer's famous 1514 engraving of *Saint Jerome in his Study*. This figure therefore may be Job or more probably a personification of Time, Vanity or Death. The plate itself is astonishingly delicate and light in both its fabric and its ornament, which is restricted to blue and white. This '*alla porcelana*' decoration suggests some knowledge of ceramics imported to Italy from the Far East.

Benedetto di Giorgio came from Faenza. In the first decade of the sixteenth century, there was a transformation of Sienese ceramics, thanks not least to the arrival in the city of craftsmen from what was then the most important pottery centre in Italy. Sienese vessels had previously been rather heavy, with a decoration that can charitably be described as naïve (see, for example, the very large *Diana and Actaeon* bowl at the Holburne Museum of Art, Bath, with the arms of the Borghesi). After 1500, however, potters in Siena were trail-blazing both in their refined technique and in the ambition of the ornament and figurative elements they applied to dishes, plates, pharmacy jars and other pieces. In January 1477, potters had succeeded in erecting trade barriers

against imports from other Italian centres, and indeed from further afield.[2] They stated that there were then sixteen potteries in the city, all well-managed and producing more wares of good quality than the citizenry needed. They therefore asked for heavy taxes on foreign wares, and the city made exceptions only for highly desirable Hispano-Moresque lustreware ('*maiorica*') exported from Malaga and Valencia and purchased by the élite. This taste is exemplified by a piece with the Spannocchi arms recently acquired by the Ashmolean Museum (a commission that is not surprising since the Spannocchi company operated in Valencia). There was thus a thriving community of local potters. Kilns outside Porta Camollia and elsewhere could be rented from landlords, who were sometimes religious institutions like the nuns at Santa Petronilla. The workshops themselves were mostly sited in and around Piazza San Marco, near the church of Santa Lucia. In 1483, a whole street was even renamed 'degli Orciolai' (of the potters).[3] The Compagnia di Santa Lucia, which like others provided charity and made funeral arrangements after the deaths of its members, seemingly also functioned as a kind of trade association for potters.

However, even if their products when made elsewhere were prohibitively taxed, potters from outside Siena – from Naples, Viterbo and Pisa – succeeded in establishing workshops within the city. Above all, however, Siena welcomed craftsmen from Faenza. The flow started as a trickle in the late fifteenth century. Tommaso di Michele da Faenza, working at Asciano, is documented in 1498, when he was called a '*pictor vasorum*'.[4] His brother Evangelista was based at Siena.[5] More came in the early

years of the next century, feeding the Sienese market for pieces with exotic overtones – of the Orient or the ancient world – and reflecting a new internationalism of taste. Maestro Benedetto was probably the most successful of these new arrivals, recorded in 1509 as having lived in Siena for about six years. In March 1505, he had acquired half of a house and cellar at San Marco for 180 florins with Galgano di Matteo da Belforte (active from 1488).[6] This was probably a business arrangement enabling him to gain his *entrée* to the city, but such partnerships encouraged exchange, the pooling of technical and financial resources and the adoption of new techniques by Sienese potters. In 1509, Benedetto was still working in a *società* with Galgano, renting from the nuns of San Paolo; by this time the connection had been reinforced by his marriage to Galgano's niece in July 1506 (his new bride coming with a dowry of 52 florins provided by Galgano). His partnership with Galgano must have been useful for other reasons. Galgano was certainly the most enterprising Sienese potter of his generation. In 1513, with the support of the Sienese merchant Battista Bulgarini, he set off for Valencia to learn the secrets of lustreware, finding work in disguise ('*vestito poveramente*') in a workshop there. In his will, drawn up on the eve of his trip, he made the sons of Maestro Benedetto his universal heirs,[7] and, when he returned to Siena in March 1514, the event was thought worthy of note by the historian Sigismondo Tizio.[8] In October 1510, Benedetto became a member of the Compagnia di Santa Lucia, and became its head in the years 1521–2. He had formed a particular connection with the Hospital of

Santa Maria della Scala, which commissioned objects for dining on a huge scale, becoming essentially its official *vasaio*.

It has been suggested that blue-and-white was Maestro Benedetto's speciality.[9] A fragment published by Langton Douglas (location now unknown) with a figure, female this time, in a landscape on one side and the letters *ede* (from the middle of Benedetto's name) on the other, also used the technique[10] – one of several fragments with blue-and-white ornament allegedly excavated from the garden of the Hospital. Benedetto's output was astounding. In 1518, he produced nearly 2000 wares for the Hospital.[11] It is unlikely, of course, that all these pieces were historiated (or figured),

but it is nonetheless possible that Benedetto was responsible for throwing and firing as well as decorating a very large number of pieces every year. The form or facture of this piece is uncomplicated, and its technique is economical. That Benedetto was the painter in this instance is demonstrated by the leafy scrollwork around the signature tablet on the reverse, which is similar in style and technique to the painting on the front. His figure style seems indebted to Pietro Orioli, in whose paintings from the early 1490s can be found a similar bald-headed type with a ring of curly hair and a beard parted down the middle. The routes of mutual influence between the Sienese and non-Sienese ran in both directions. LS

1 Rackham 1940, p. 127, no. 373.
2 Borghesi and Bianchi 1898, pp. 248, 249. These restrictions on imports were reaffirmed in 1491 and 1509. See Lisini 1895, pp. 149–52, esp. p. 150.
3 Lisini 1895, pp. 149–52, p. 150.
4 *Ibid*. Langton Douglas misleadingly gives the date 1455 (Langton Douglas 1903, p. 9).
5 Luccarelli 1983, pp. 255–306, 368–400.
6 *Ibid.*, esp. pp. 282–3.
7 *Ibid.,* esp. p. 375.
8 Langton Douglas 1903, pp. 3–23, esp. pp. 18–19.
9 Luccarelli 1984, pp. 302–4.
10 Langton Douglas 1937, pp. 88–90.
11 Sutton 1979, pp. 334–41.

SELECT BIBLIOGRAPHY
Langton Douglas 1937; Wilson 1987, p. 87, cat. 133.

The *camera bella* of the Palazzo del Magnifico

80.

LUCA SIGNORELLI (about 1440/50–1523)

The Triumph of Chastity: Love Disarmed and Bound, about 1509

Fresco, detached and mounted on canvas
125.7 × 133.4 cm
The National Gallery, London (NG 910)

81.

LUCA SIGNORELLI (about 1440/50–1523)

Coriolanus persuaded by his Family to spare Rome, about 1509

Fresco, detached and mounted on canvas
125.7 × 125.7 cm
The National Gallery, London.
Mond Bequest, 1924 (NG 3929)

82.

BERNARDINO DI BETTO, KNOWN AS PINTORICCHIO (about 1456/60–1513)

Penelope with the Suitors, about 1509

Fresco, detached and mounted on canvas
125.5 × 152 cm
The National Gallery, London (NG 911)

These three frescoes, together with five others, all formed part of the decoration of a room, the *camera bella* of the Palazzo del Magnifico in Siena, commissioned by Pandolfo Petrucci as part of the apartment prepared for his son Borghese's marriage on 22 September 1509 to Vittoria Piccolomini, niece of Pope Pius III.[1] The room ('all gilded with its fittings covered in walnut and chests all round it'), roughly square in plan (6.74 × 6.29 m), had a window overlooking the street and doors in each of its three

other walls, and was situated on the second floor of the Palazzo del Magnifico within an ancient medieval tower which had been incorporated into the palace.[2] It formed part of a seven-room apartment;[3] the wooden chests and seating around the *camera bella,* and the fact that it contained only a table in an inventory of 1514, implies that it was a reception room for display.[4] The room was noted by the member of his household who drew up the document as the *camera bella del Magnifico*, emphasising that it belonged specifically to Borghese Petrucci, who inherited his father's title as well as his political position in 1512. Pandolfo Petrucci was not alone in commissioning such a suite of rooms for his heir, since grand decorative apartments were commonly created for Renaissance rulers during the early sixteenth century, most famously for the Gonzaga in Mantua and the Este in Ferrara.[5] The Sienese frescoes, displaying both Latin and Greek inscriptions and extensive gilding, as well as predominant colours of blue and gold (relating to the Petrucci arms), were a clear symbol of the family's status.

The scheme of the elaborate stucco ceiling, now in the Metropolitan Museum of Art in New York, was based on the *Volta Dorata* of Nero's Domus Aurea (Golden House). It contained paintings of mythological scenes and figures, twenty in all,[6] and in the centre the Petrucci coat of arms supported by four *putti*. Pintoricchio, who had created a taste for the use of grotesque in the decoration of vaults in Siena with the Piccolomini Library (see cat. 74–6), probably directed this project, although his personal involvement in the ceiling's execution remains debatable.[7] Red-painted and gilded stucco framed the frescoes in the

vault and the upper part of the room which contained eight medallions (of which only one subject is known, that of *Brennus placing his Sword upon the Scales*), and in the spandrels rectangular images (twelve in all) of the nine Muses and three unknown subjects.[8] The eight pendentives were filled with gilded candelabra against a blue background, dotted with gold, which supported eight tablets containing inscriptions surmounted by gilded eagles from whose wings hung bunches of grapes. The Latin inscriptions in the tablets – virtuous exhortations – were loosely based on the maxims of Publilius Syrus, which at the time were considered to be the work of Seneca.[9] Their choice may have been due to Pintoricchio's prior use of similar maxims as a source for the inscriptions in his Castel Sant'Angelo cycle recording Charles VIII's meeting in 1495 with Pope Alexander VI.[10]

There were originally eight frescoes, two per wall, by Signorelli, Pintoricchio and Girolamo Genga, all of which were removed or painted over in the nineteenth century. Three are now lost, three are in the National Gallery, London (cat. 80–2), and two are in the Pinacoteca Nazionale in Siena (fig. 37–8).[11] There has been some debate over their attribution: although *Penelope with the Suitors* (cat. 82) is universally accepted as being by Pintoricchio, who was probably also responsible for the lost *Continence of Scipio* known from a compositional drawing (The British Museum), certain scholars have argued that Girolamo Genga was responsible for all or part of *The Triumph of Chastity* (cat. 80) and *Coriolanus persuaded by his Family to spare Rome* (cat. 81), which are otherwise correctly given to Signorelli.[12] The evidence of inscriptions on

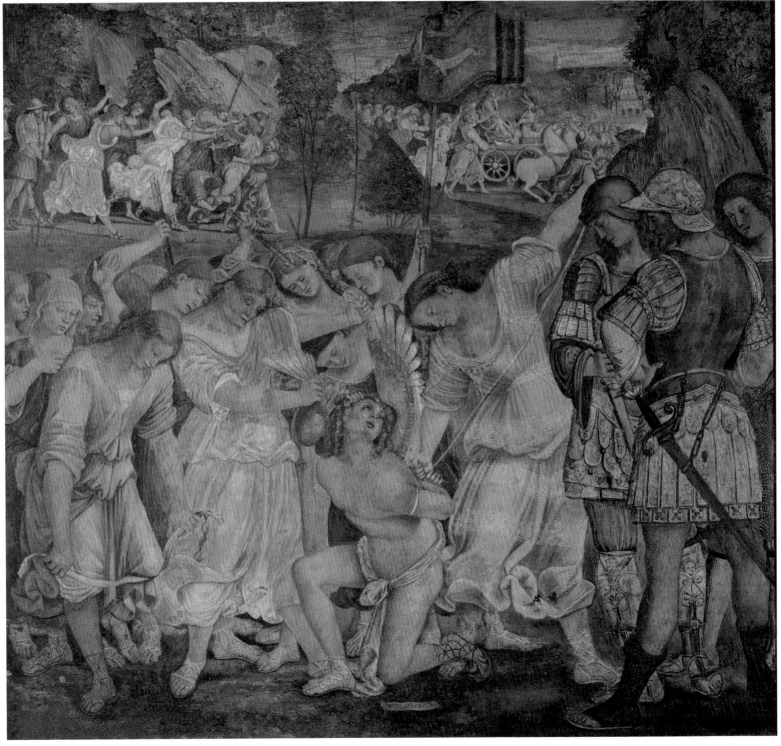

the lost frescoes, the quality of their composition, and the association of Pandolfo Petrucci with Signorelli suggest that he also undertook the lost *Calumny of Apelles* and *Festival of Pan* (see pp. 66–7). The choice of foreign artists, and in particular two painters renowned for their work for the popes in Rome, Signorelli and Pintoricchio, would have given the room high status within the city. Apart from the evidence of the surviving frescoes themselves, knowledge of the *camera bella* comes from two eighteenth-century commentators, Giovanni Girolamo Carli and Guglielmo Della Valle.[13]

The *Triumph of Chastity*, following Petrarch's famous allegorical poem, shows the god of Love being bound by Laura (personifying Chastity) while two other women from antiquity similarly renowned, Lucretia and Penelope, break his bow and arrows and pull out their feathers.[14] The two soldiers in gilded armour to the right, calmly surveying this scene, are perhaps the Roman heroes Virginius and Scipio Africanus.[15] In the left background, the women chase the god, waving a standard displaying an ermine, another symbol of chastity, while on the right the traditional Triumph with a gilded chariot containing the captured and bound god of Love can be seen. A *cartellino* in the foreground under the god of Love's feet has an inscription referring to Luca Signorelli, who was a native of Cortona (*Coritius* meaning 'Cortonian'). The subject was commonly found on *cassoni* and birth salvers,[16] in an established iconographic tradition from which, however, the fresco differs in several important respects: it not only depicts the final scene in which Chastity (Laura), triumphs over Love but also combines two related scenes in a continuous narrative, while its inclusion of Roman soldiers (chaste heroes?) to the right appears to have no precedent.

Coriolanus persuaded by his Family to spare Rome is a rare subject, but it also appears on a maiolica plaque based on this fresco and on a *cassone* attributed to Francesco di Giorgio (private collection, Milan).[17] The main scene shows a group of women in which Coriolanus's mother, Volumnia (or Veturia in some sources), the palm of her hand held upwards, appeals to her son, general of the Volscian army, to spare Rome. She stands amid a group of women; one holding a child is presumably the general's wife, and her pose recalls Jacopo della Quercia's Rhea Silvia for the Fonte Gaia (see fig. 70). On the right appears Coriolanus, attired in elaborately decorated golden armour with the laurel wreath of victory around his head, surrounded by his soldiers, a group of figures markedly larger than the women to the left. His arms are expanded in greeting while a young boy, probably his son, stretches his hands out towards him. In the background to the left appear a group of elderly men in discussion, and stretching into the distance the Volscian army's camp and the city of Rome on the banks of the Tiber. The group of three horsemen to the upper right of the main scene, who also appear in a pricked drawing in the British Museum, is based on a similar group of figures in Signorelli's fresco of *The Reception of Totila* for the abbey of Monteoliveto Maggiore.[18] The scene was described in detail by Livy, Plutarch and Valerius Maximus, and taken as exemplifying the Roman hero's love of both his family and his city.[19]

Pintoricchio's fresco (cat. 82) clearly shows Penelope, the faithful wife of Ulysses (Odysseus), dressed in the Petrucci colours of blue and gold, seated at her loom, her husband's bow and quiver hanging behind her. A maid sits on the ground working while a large cat in the foreground plays with a ball of wool. Rather oddly, Penelope was described by Herodotus as the mother of Pan (by Mercury) and was the subject of a famous painting by Zeuxis in which Pliny wrote, 'morality itself seems to be painted'.[20] The central male figure is richly dressed, with a gold chain around his neck, addressing Penelope while she sits with her eyes discreetly lowered; he may be identified either her son Telemachus or one of the many suitors who plagued her during her husband's ten-year absence.[21] Behind him to the right stands a man of oriental appearance with highly decorated footwear, on whose glove stands a bird of prey, nonchalantly waiting with two others, of whom one seems to be glancing skywards in disgust at being at the back of the queue. The man entering the room in the middle ground could be Ulysses, Penelope's husband, who returned after his long voyage disguised as a beggar. In the distance, two earlier episodes from the *Odyssey* appear: of the Sirens, whose beguiling song would lead mariners to wreck their ship, Ulysses stopped the ears of his crew and had himself tied immobile to the mast as they rowed past; and of Circe, who would turn the men she enchanted to swine – witness the pigs with a white stripe along their backs a specifically Sienese breed, the *cinta senese*. The two male figures standing next to these are probably Ulysses and Mercury, since Mercury gave a magic herb to Ulysses for

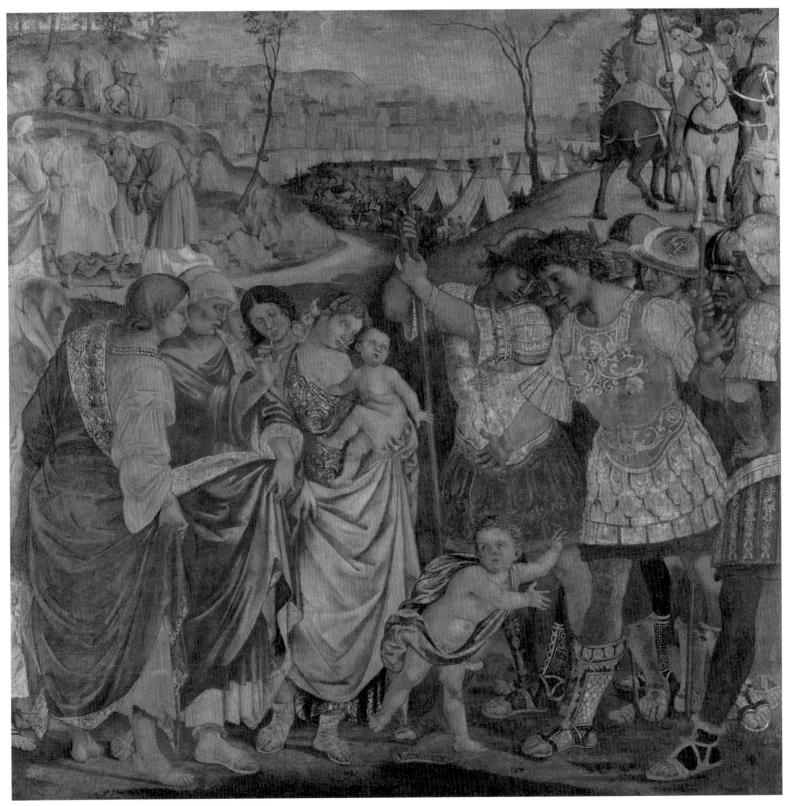

his protection.[22] The epitome of wifely fidelity, Penelope fended off her many suitors by declaring she would choose among them only after she had finished weaving a shroud for her father-in-law, which she unpicked each night. Although Homer's *Odyssey* is the ultimate source for this scene, the story of Penelope also appears elsewhere, particularly in Ovid's *Heroides* and Boccaccio's *De mulieribus claris*. There was no known visual precedent however for so many stories from the *Odyssey* appearing together in one painting, nor for the focus on the gesticulating young man in the foreground.[23]

The theme of Virtue in the fresco cycle, for which Petrucci drew on famous authors (Greek and Roman, save for Petrarch) for its otherwise unusual scenes, was emphasised again in the ceiling inscriptions, on the wooden pilasters and in the maiolica pavement. It is difficult to establish where each fresco was placed in the room, although the position from which the coat of arms in the centre of the ceiling is ideally viewed, the order of the eighteenth-century descriptions and the lighting in the surviving frescoes themselves suggest that *The Calumny of Apelles* and *The Festival of Pan* were on either side of the door leading to the loggia, facing the frescoes of *Penelope with her Suitors* and *The Continence of Scipio* on the opposite wall on either side of the window. PJ

1 'Tutta messa a oro con li soi fornimenti recinta de noce e casse intorno intorno': ASS, Notarile ante-cosimiano 1268 (512), 31 January 1513 (1514 modern style). The apartment was collectively called the *camere belle* in later documents; see too the description of rooms in Pierfrancesco de' Medici's palace called the *camere belle* in 1516: Saalman and Mattox 1985, p. 343.

2 Castelli and Bonucci 2005, pp. 128–30. On the development of the apartment during the Renaissance see Thornton 1991, pp. 300–12.

3 It has often been described as the '*camera della torre*' (see for example, Quinterio in Morolli 2002, pp. 145–52), but the *camera della torre* was the name for a room under the *camera bella* within the tower.

4 Scarpellini and Silvestrelli 2004, p. 275; Holmquist 1984, p. 50.

5 On Alfonso d'Este's rooms see Hope 1971, pp. 641–50; 712–21.

6 Such as *The Calydonian Boar Hunt*, *The Judgement of Paris* and eight *Triumphs*. On the ceiling frescoes see the detailed study of Holmquist 1984; also Ricci 1901, pp. 61–4; Burroughs 1921; Zeri and Gardner 1980, pp. 67–9; Mazzoni 2001, pp. 61–2, 210, 219–21. On grotesques see Dacos 1969; Acidini Luchinat 1979–83, pp. 159–200.

7 Schulz 1962, pp. 35–55; A. Angelini, 'Pintoricchio e i suoi: dalla Roma dei Borgia alla Siena dei Piccolomini e dei Petrucci' in Angelini 2005, p. 545 (who argues for the involvement of Jacopo Ripanda).

8 Holmquist 1984, p. 64; Ricci 1901, p. 62.

9 Holmquist 1984, p. 67, who compared the inscriptions to the *Proverbia Senecae*.

10 Schmarsow 1880, pp. 63–5; Cavallaro 2001, pp. 781–801.

11 On Genga in the Palazzo del Magnifico see Kanter 2003, pp. 68–83: for the drawing by Pintoricchio for *The Continence of Scipio*, see Kanter 1989, p. 194, note 93.

12 Berenson 1897, p. 145; Berenson 1909, p. 193 (but in Berenson 1932 and 1968 these are given to Signorelli); Siena 1990, p. 260.

13 See Davies 1961, pp. 472–9, with a transcription of Carli's commentary in appendix, pp. 571–3; Della Valle 1784–6, 3, pp. 319–22.

14 Davies 1961, pp. 436–9.

15 Holmquist 1984, p. 55; Wilson 1991, p. 158.

16 On the importance of Petrarch's poem see Trapp 2003; on the *Trionfi* in Sienese *cassoni* see B. David in Jenkens 2005, pp. 109–37.

17 Verlet 1937, pp. 183–4; Rackham, 1940, pp. 81–2; Davies 1961, pp. 485–6; J.-M. Massing, 'Nicola da Urbino and Signorelli's Lost Col11umny of Apelles' in Wilson 1991, pp. 150–6. The plaque in the Victoria and Albert Museum (4277–1857) is attributed to the Master C.I.: see Hess 2002, pp. 138–9; for the *cassone* see Caciorgna and Guerrini 2003, pp. 139–41.

18 British Museum (1860-6-16-93); Popham and Pouncey 1950, pp. 147–8; Henry 1998, p. 29, cat. 25 (with bibliography).

19 Plutarch *Lives* 1, 2, Livy, 2.32–40, Dionisius of Halicarnassus 6.92-4, Valerius Maximus 5.4.1, Boccaccio, *De muliberius claris*, 55.3.

20 Herodotus, *Histories*, 2.153.1; Pliny, *Natural History*, XXXV, 63, 1.

21 Kanter (1989, p. 195) proposes Telemachus.

22 Homer, *Odyssey*, XII, 165; X, 156–86; Caciorgna and Guerrini 2003, pp. 269–70.

23 See the *cassone* of *The Departure of Ulysses* generally attributed to Guidoccio Cozzarelli with the figure of Penelope at her loom (Ecouen; see Erlande-Brandenburg 2004, pp. 36–41) and of *The Return of Ulysses* in the Victoria and Albert Museum (5792-1860).

SELECT BIBLIOGRAPHY

Henry 1998, pp. 26–8, cat. 22–4; Henry and Kanter 2002, pp. 72–3, 224–5, no. 90–1; P. Scarpellini, 'Gli ultimi dieci anni (1503–1513)' in Scarpellini and Silvestrelli 2004, pp. 274–6; M. Caciorgna in Caciorgna and Guerrini 2003, pp. 139–43; A. Angelini, 'Pintoricchio e i suoi: dalla Roma dei Borgia alla Siena dei Piccolomini e dei Petrucci' in Angelini 2005, pp. 544–8; Caciorgna 2006, pp. 269–94.

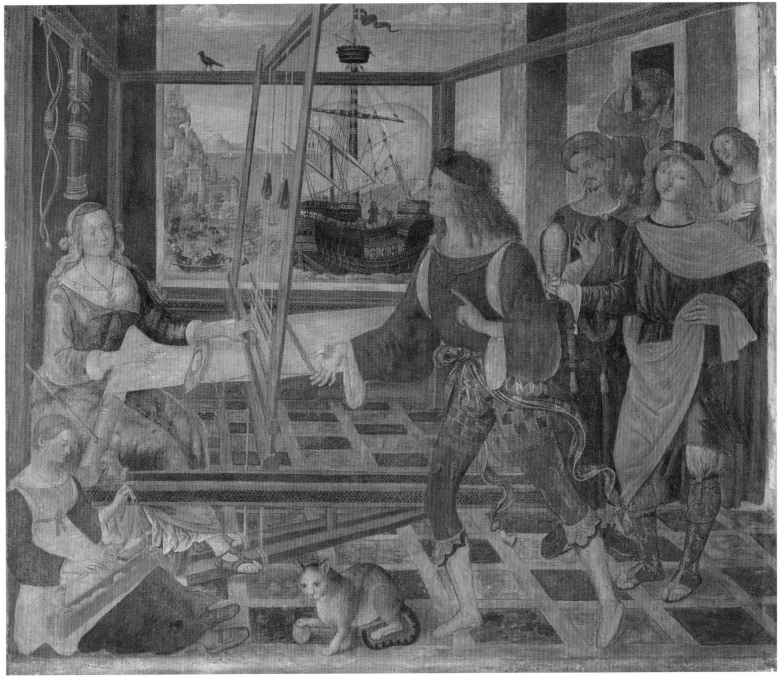

CAT. 82

83, 84.

ANTONIO BARILI (1453–1516)

Two wooden pilasters, about 1509

180 × 30 cm
Pinacoteca Nazionale, Siena

85.

SIENESE

Tiles from the Petrucci pavement,
1509

Glazed earthenware
19.6 × 19.6 × 2.6 cm
19.9 × 19.5 × 2.3 cm
Victoria and Albert Museum, London
(4915 to 5386-1857)

86.

SIENESE

Octagon of tiles with central tile of
female saint in a landscape, 1509

Glazed earthenware, 110 × 110 cm
Victoria and Albert Museum, London
(4915 to 5386-1857)

Antonio Barili carved a series of eight
pilasters of varying depths which, together
with four semi-pilasters for the corners
of the room, adorned the Petrucci *camera
bella*.[1] All the pilasters and three of the semi-
pilasters survive. Barili's carpentry skills
were particularly sought for choir-stalls,
including those for the chapel of Saint John
the Baptist in the Cathedral, and for carved
picture frames by both religious and secular
patrons.[2] Leading Sienese patricians of
the period commissioned grand rooms of
elaborate wooden furniture (including
beds, seating, cornices and chests, often
with classical details such as columns and
trophies) from both native and foreign
craftsmen.[3] If commissioned at the time of
a marriage, they were also decorated with
the coats of arms of the two families being
united. The chests lining the Petrucci
camera bella, which were adorned with
putti, foliage and birds, and served as both
storage and seating, no longer survive.[4]

CAT. 83, 84

CAT. 85

All the Barili pilasters are carved with vases, delicate tracery, elegant candelabra, zoomorphic figures and elaborate foliage – ornament generally called *grottesche*. This is a term encountered for the first time (in Siena) in 1502 in the contract for the decoration of the Piccolomini Library; it referred to the caves (*grotte*) in Rome yet to be identified as the chambers of the Domus Aurea (Golden House) of Nero, where painted and stucco decoration had been found in the 1480s. Originally highlighted by gilding, the pilasters were positioned between the frescoes (see cat. 80–2) and rose up to eight pendentives containing virtuous mottoes.

A notable feature of these pilasters is their use of allegorical figures: seven display a personification of a virtue (three theological – *Faith*, *Hope* and *Charity* – and four cardinal – *Justice*, *Prudence*, *Temperance* (cat. 84) and *Fortitude*), while the eighth (cat. 83) shows the *Three Graces*, representing concord and love. Although the Petrucci arms appear on some of the semi-pilasters, only two pilasters display recognisable coats of arms, the *Faith* pilaster showing the Piccolomini arms and the *Three Graces* with the Petrucci stemma. The pilaster depicting *Temperance* has an eagle on the capital perching on a vase of fruit and flowers, and an acanthus design in the main body leading down to an elaborate vase flanked by *putti* holding torches; the elegant winged horses near

the top of the pilaster must depend on the classical notion of Pegasus. The *Three Graces* pilaster has a design of straight-leafed acanthus surmounted with *putti*, while under the vase from which the plant grows more seated *putti* play musical instruments. The group of the *Three Graces*, who also appear in the ceiling frescoes, derives from the Piccolomini Library (see p. 250). It is not known if these pilasters also once had bases displaying coats of arms (Petrucci crossed with Piccolomini), as do those with the figures of Faith and Hope.

These coats of arms, the theme of virtue and the elaborate trophy and grotesque details were also echoed in the pavement floor of the room, composed of elaborate maiolica tiles. This type of floor decoration, the specialist product probably of only a few craftsmen, was found in certain prestigious religious and private settings in Siena, and can be seen *in situ* in the Bichi Chapel in Sant'Agostino (see cat. 87) and the Oratory of Santa Caterina in Fontebranda.[5]

Tiles from the Palazzo del Magnifico are to be found in the Victoria and Albert Museum in London and a number of other collections.[6] Some of these tiles have the date 1509, which associates them with the *camera bella* (although one now at Sèvres is dated 1513, which may indicate that other rooms in the palace apartment were adorned in the same way). The tiles have different coloured grounds. Their decorative repertoire

is wide – including masks, chimerae, trophies, *putti*, cornucopiae and ornate foliage – while the borders consistently have an egg-and-dart ornament with, on occasion, a narrow row of oval and circular beads similar to the detailing on the Palazzo del Magnifico doorframes carved by Michele Cioli. They take various shapes as well: there are two sizes of pentagonal tiles (one wide, approximately 19.5 × 19.2 cm, and one tall, approximately 20.5 × 13.8 cm), square tiles (about 19 cm square) and rectangular border tiles. These last (cat. 85) have black grounds and show *putti*, sphinxes and other monsters, and sometimes the coats of arms of the Petrucci and Piccolomini. The square orange tiles (about 13.8 × 13.3 cm) are of simpler design and execution. Orange was a colour long associated with Sienese maiolica.[7] In the centre of the group from the Victoria and Albert Museum (cat. 86) can be seen a seated figure of a female saint, loosely based on Jacopo della Quercia's figure of *Hope* on the Fonte Gaia.[8] This tile, and another, also with the figure of a saint now in Hamburg – a demure seated female with her feet crossed and her arms across her chest – lack attributes making it hard to identify them, but both they and the tile depicting *Hercules and the Hydra* in the Louvre appear to be by a particularly refined hand, seemingly that of the master responsible for a plate with the god Pan, also a Petrucci piece (cat. 88).[9] The overall

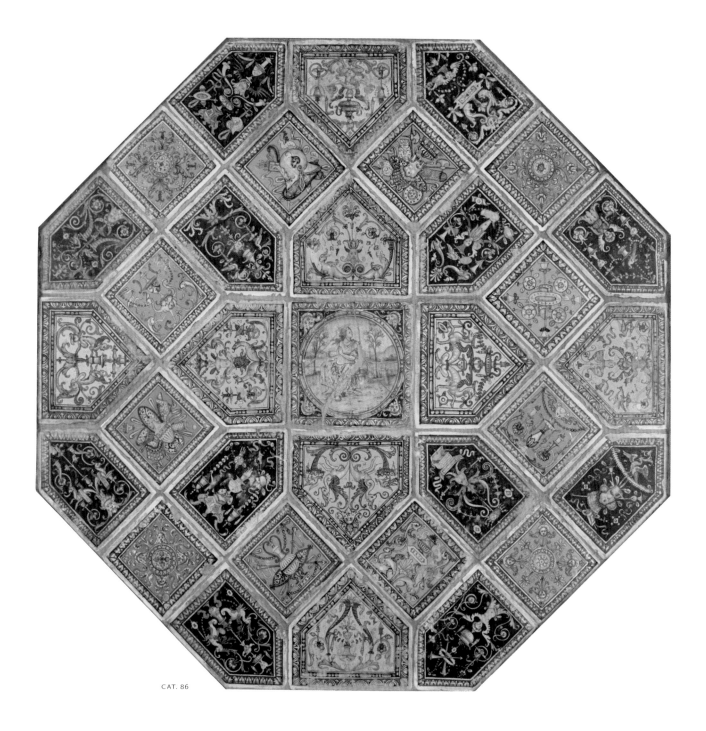

CAT. 86

design of the pavement may have been by Pintoricchio or a member of his workshop, particularly if one compares these tiles with the grotesques for the vaults of the Piccolomini Library or of the Della Rovere Chapel in Santa Maria del Popolo in Rome, and one of the artists involved with the frescoed decoration of the room may have provided specific drawings relating to the human figures.[10] PJ

1 Two pilasters depicting *Faith* and *Hope* respectively are in the Pinacoteca in Siena (see S. Frachetti in Siena 1990, pp. 552–3, cat. 190); the others are in the Palazzo Piccolomini alla Postierla.

2 On Barili's work see Milanesi 1854–6, II, pp. 389–99; S. Frachetti, 'Antonio di Neri Barilli' in Siena 1990, pp. 548–51; A. Angelini, 'Il lungo percorso della decorazione all'antica tra Siena e Urbino' in Angelini 2005, pp. 307–85, 341–59; for the cornice of Raffaellino del Garbo's altarpiece for Santa Maria degli Angeli, Borghesi and Banchi 1898, p. 386; and for his work on the Chigi Palace, Milanesi 1854–6, II, pp. 29–30.

3 See Corti 1985, pp. 105–12, for the detailed contract drawn up by Girolamo Guglielmi for work commissioned from the Florentine carpenter Bastiano di Salvadore Bindi; G. Agosti and V. Farinella, 'Interni senesi "all'antica"' in Siena 1990, pp. 578–97.

3 Della Valle 1784–6, III, p. 339; Romagnoli Ante 1835, V, pp. 469, 478; Davies 1961, p. 571.

5 Luccarelli 1983, pp. 197–8; Sutton 1979, p. 339.

6 The Fitzwilliam Museum in Cambridge, the Musée Cluny and the Louvre in Paris, and the Museum für Kunst und Gewerbe in Hamburg. Giacomotti 1974, pp. 105–9; Rackham 1977, I, pp. 132–3; Rasmussen 1984, pp. 116–27; Poole 1995, pp. 138–9.

7 On the importance of this dark orange ochre colour for Sienese maiolica, see Luccarelli 2002A, p. 34.

8 I would like to thank Jennifer Sliwka for this idea.

9 For the Hamburg tile depicting a female saint: Rasmussen 1984, pp. 117–18; for *Hercules and the Hydra*, see Giacomotti 1974, p. 105.

10 Scarpellini and Silvestrelli 2004, pp. 241–3; Genga has been associated with maiolica designs by Wilson 1991, pp. 157–65.

87.

LUCA SIGNORELLI (about 1440/50–1523)

Seated male nude playing the lira da braccio (*probably Apollo or Orpheus*) and *study for The Suicide of Lucretia*, about 1505–10

Black chalk on cream paper, 19.9 × 14.2 cm
Gabinetto Disegni e Stampe degli Uffizi, Florence (130 FV)

Inscribed on recto in nineteenth-century hand: SIGNORELLI

For all its consummate economy, Signorelli's rapid sketch of a young musician has a harmony, an energy and a flow that suggest the sound of the music performed. Complicated internal rhythms and intervals are created in the pose through contrasting weights of line and the manipulation of light and shade. The act of playing is poetically described: the youth's eyes are raised to the heavens in self-contained reverie, as if listening, inspired and enchanted by the music.[1] His body is an exercise in ideal classical proportion; the pose and anatomy are clearly inspired by antique statuary, perhaps by the celebrated Belvedere *Torso*, albeit slimmed down, to render it less heroic and more lissom.[2] Signorelli positions the figure with a subtle *contrapposto*: his head follows the direction of the bow in a movement to the right, and, though the upper contour of his right thigh continues the line of the bow, his legs and chest are turned to the left. Moreover, he creates a counter-rhythm, imparting to the figure through the lighting an alternative and opposite diagonal. The youth is lit as if by a shaft of sunlight, which falls directly upon his cheek and pectorals and casts the strong shadows of his legs upon the hummock on which he sits, which is otherwise barely delineated. The use of voids in conjunction with the sometimes broken contours is particularly effective, seen for example in the break in the hatching of the proper right leg to establish the bulge of the calf muscle. Berenson called the drawing 'luminous', the play of light and shade achieved through the particularly soft black chalk, and likened it to works on paper by Correggio and later Venetian drawings. Possibly this particular and (for Signorelli) somewhat uncharacteristic

attention paid to chiaroscuro might support the traditional identification of the musician as Apollo, the sun god, energised by the source of his power. Signorelli has reinforced some contours to make them darker, generally following his lighting scheme, but he has also emphasised his second diagonal by strengthening the lines around the fully lit right forearm and bow-hand, endowing the figure with extra movement in that crucial area. It is typical of Signorelli that here, and elsewhere on the sheet, he has concentrated on the figures rather than their setting.[3]

Signorelli turned the leaf and executed a still more quick and summary sketch of a woman collapsing into the arms of another. A third figure on the left is cut away, showing that the sheet was once bigger. This design is developed on the recto and is clearly a sketch for *The Suicide of Lucretia* (not shown in the exhibition for conservation reasons). The narrative derives from the well-known account in Livy (*Ab urbe condita*, I, 58): the Etruscan Lucretia was raped by Sextus, the son of Tarquin, and subsequently stabbed herself as a sacrifice for the honour of her husband and family. The subject became popular in Siena during the early sixteenth century and was the subject of paintings by Sodoma, Beccafumi and Brescianino, among others.[4] Signorelli stresses the tragedy of the event, instead of presenting Lucretia as a placid exemplar.[5] He has increased the instability of the central figure, making her appear close to death; he has practically broken her neck and chosen to emphasise the heaviness of her left thigh, unsupported by her twisted lower leg. The composition is clearly informed by numerous scenes of the Virgin Mary collapsing at the Crucifixion

CAT. 87 VERSO
(actual size)

CAT. 87 RECTO
(actual size)

(see cat. 35). The shifts of scale between the figures and the arrangement of the draperies suggest that Signorelli may have been looking at something like Donatello's *Lamentation* (cat. 25), or indeed possibly the relief itself: Lucretia's lower limbs and the woman supporting her, in forward-bending pose, may be derived (turned 45 degrees) from the Mary on the far left. The dead weight of Lucretia's left arm is like Christ's. That Signorelli had earlier studied Donatello in Siena is demonstrated by his citation of Donatello's Baptistry figure of Faith in the Bichi Altarpiece Magdalen (see cat. 58–9, fig. 62).

Claire Van Cleave has suggested that the *Suicide of Lucretia* may be an abandoned design for the Petrucci Palace frescoes: as she points out, the heroine, in a different guise but with similar diaphanous draperies, is included among the figures of the *Triumph of Chastity* (cat. 80).[6] Her pose in the drawing may even have been radically reworked to arrive at the figure of Penelope in the same fresco. However, there is no Apollo or Orpheus in any of the surviving frescoes, nor in the descriptions of those that are lost (see cat. 80–2). It is not impossible, however, that an Apolline subject was at first envisaged. Such a theme would not have been incompatible with the rest. Moreover it may be significant that the seated pose of this Apollo has something in common with the *Pan* in the tragically destroyed Berlin canvas, painted some twenty years earlier, possibly for Pandolfo Petrucci (see p. 66). Thus the connection noted for the first time by Capretti[7] – identifying the musician as Orpheus – between this drawing and the British Museum maiolica plate with the figure

of Pan and the Petrucci arms (cat. 88) becomes particularly telling. Both Signorelli and Pintoricchio seem to have supplied the maiolica painters who executed both this plate and the tiles for the Petrucci apartment with figurative designs. It might very well have occurred to Signorelli that the conversion of this Apollo back into a Petrucci Pan would be entirely appropriate. That the drawing may even have circulated more widely in Siena is suggested by links between the composition of *The Death of Lucretia* and Sodoma's designs for *Saint Catherine swooning* and *The Miracle of the Possessed Woman* (see cat. 90–1). As Ferino Pagden has noted, the 'soft vibrations' of the verso sketches point towards Sodoma's drawing style.[8] This may be no coincidence.

LS

1 Signorelli's sensitivity to and knowledge of music is further demonstrated by his image of a slightly pot-bellied angel tuning his lute in his mid-1480s altarpiece for the chapel of Sant'Onofrio in the Cathedral at Perugia (now Museo Diocesano) and another tuning in his Orvieto fresco of the *Crowning of the Elect*. See Henry and Kanter 2002, pp. 104–5, 141, pl. III, XIII/3.
2 Pray Bober and Rubinstein 1986, pp. 166–8, no. 132.
3 See Van Cleave 1995.
4 See for example, the Lucretias painted by Guidoccio Cozzarelli; M. Maccherini and M. Caciorgna in Santi and Strinati 2005, pp. 170–1, 194–5, cat. 2.2, 2.15. This was not of course by any means an exclusively Sienese subject before or after.
5 Van Cleave 1995, pp. 116–18.
6 Van Cleave 1995, p. 117.
7 E. Capretti in Gregori 2003, pp. 316–17, cat VI, 9a–b.
8 Ferino Pagden 1982, p. 114.

SELECT BIBLIOGRAPHY

Ferino Pagden 1982, pp. 112–14, cat. 64; Van Cleave 1995, I, pp. 116–18, no. 9.

88.

SIENESE (PERHAPS MAZZABURRONI WORKSHOP)

Dish with Pan and two shepherds and all'antica *borders*, about 1510

Tin-glazed earthenware, 42.2 cm diameter
The British Museum, London (P&E MLA 1855-12-1-114)

The central scene of this dish is adapted from Signorelli's drawing (cat. 87), enhancing its status as a masterpiece of the maiolica technique. It is a remarkable instance, notably in its *all'antica* subject-matter, of the 'new wave' of Sienese pottery in the early sixteenth century (see further cat. 79). It may have been intended primarily for display: the Sienese not only showed lustred vases on shelves set into their indoor water fountains (the *acquaio*), but also had special pieces of furniture for presenting ceramic vessels – in the Della Magione house there was '*una credenzia di legniame con più fornimenti di terra*' (a wooden buffet with several ceramic pieces).[1] But a dish such as this one was also ostensibly utilitarian, something on which to serve food or from which to eat. Its first owner could use it as an indication to his guests that he had the money and artistic discrimination to dine off the most technologically advanced and aesthetically ambitious tableware of his day.

That owner was almost certainly Pandolfo Petrucci. Above the figure of Pan, perched on a tree stump and playing his sirynx, are the Petrucci arms, suggesting that, as in frescoes and possibly easel paintings that he commissioned, the choice of deity was intended as a play on the first syllable of Pandolfo's Christian name. Kneeling in obeisance, on either side of Pan (so that he becomes a kind of host), are two idealised shepherds holding shields with other coats of arms. These remain frustratingly unidentified, though they do not seem to belong to Sienese families (and indeed, since Pandolfo, whatever his ambitions in that direction, was not Siena's lord, even an allegorical act of homage by one of the

city's other patrician families would surely have been inappropriate). A part of the message of this roundel is therefore lost, but since all three coats of arms reappear in the grotesque border they must have been an important element. Standing for Pandolfo, it is not surprising that Pan, normally characterised as sexually voracious, is here somewhat sanitised – shorn of the goaty libidinous features of his standard depictions in Roman statuary and Italian Renaissance bronze sculpture. His has lost his satyr's phallus, haunches and hoofs, though his thighs remain satisfactorily hairy and little horns still grow from his forehead. It is as if this Pan has been merged with one of chief objects of his desire, the beautiful youth Daphnis, with whom he is seen in several (one now in the Uffizi) Roman copies known to Renaissance artists of a celebrated Hellenistic sculptural group. Above all however, his defined musculature and strong contour, derived from Signorelli, give him a heroic presence, unlike the effete Daphnis.

Not only was this piece associated with one of the leading artists of the day – almost the portable equivalent of the frescoes, one showing Pan, in the Petrucci *camera bella* (see p. 66, cat. 80–2) – but in its *alla grottesca* borders, as in those of that room, it celebrated the one language for painting deriving from antiquity that was known to be authentic, rather than surmised. Pintoricchio had made the grotesque popular in Siena, though this kind of ornament was employed even more exuberantly by Sodoma, also recently arrived from Rome, in his frescoes at Monteoliveto. In the inner border is a regular, even rather sober pattern of little masks and anthemion ornament. The outer

border contains a wonderful arrangement of the fantastic and phantasmagorical, where paired griffin-like beasts, with a mass of scrolling limbs, prance to either side of volute-handled urns, while acanthus fronds transmogrify into curly-tongued dolphins. Although such motifs had been pioneered in Siena by Pintoricchio and Sodoma (just as the central figure had already been designed by Signorelli), the maiolica painter has put them together with a signal elegance and imagination that is his alone. The work demonstrates that the introduction of imported styles was not restricted to mere copying, but obeyed the principle of *imitatio*: in Petrarch's formulation, 'He who imitates must have a care that what he writes be similar not identical [with his model] ... we should therefore make use of another man's inner quality and tone, but avoid his words. For the one kind of similarity is hidden and the other protrudes; the one creates poets, the other apes.'[2]

This is important because it appears quite likely that the painter of this dish (possibly the potter) was a native of Siena.[3] This is a not a work by Maestro Benedetto from Faenza, to whom the dish was often given in the past; it has little in common, bar its medium, with the signed plate in the Victoria and Albert Museum (cat. 79). But it does bear strong similarities in both ornament and figure style with some of the floor tiles from the Petrucci *camera bella* (cat. 85–6). Examination of these tiles has shown that several hands were at work on them. However, the velvety black against which the grotesques are set is a signature note of the workshop responsible for the *Pan* dish and that the same talented painter executed both the historiated (figured) tiles and the

present dish is suggested especially by their landscapes.

This same painter seems to have been chiefly responsible for the figurative elements in the first tiles, produced in 1504–5, for the Oratorio della Cucina at the Santuario di Santa Caterina, a Borghesi commission.[4] On one of them, a winged sea-creature with a fish tail and horse's front legs, but a youth's head, arms and torso is depicted with his body similarly defined and the same strong but subtly modulated contour. All these works may have been by a single, particularly skilled ceramic painter who plied his trade on a freelance basis in different workshops – who may or may not have come from Siena. But it is notable that the very high quality of the painting on this dish is matched only by these tiles and nowhere else on a plate or vessel for dining. It therefore seems probable that it was made in a *bottega* that otherwise specialised in tile production. In Siena, the principal experts in this field appear to have been the Mazzaburroni family. In 1488, Pietro di Lorenzo Mazzaburroni and his brother Niccolò (documented from 1465, died 1495) had received the prestigious commission for the tiled floor of the Bichi Chapel (see cat. 58–9), and they are likely to have passed on their skills to their several sons, nephews and great-nephews. Their nephew Bernardino di Mattia (documented from 1481) became one of the leading ceramic manufacturers of the next generation (and *consigliere* of the guild of potters in 1508).[5] The floor of the Oratorio della Cucina has therefore been attributed to the family, though without documentary support.

It appears that at least one of the potters in this family was also a painter. Niccolò found himself in dispute with another nephew, Agnolo di Pietro, over the proper reward for many '*lavori fatti e dipenti*' (works made and painted) made by him over a period of years.[6] It is unlikely that he was the only member of the family with both skills. It is also known that in May 1507 Bernardino had some kind of association (or more properly dispute) with the painter Giacomo Pacchiarotti, thought to have assisted Pintoricchio with the Piccolomini Library ceiling, and who may therefore have provided the family with designs.[7] Pacchiarotti's small-scale paintings are actually less refined than the Pan dish roundel but they are linked by some stylistic features.[8] It seems plausible that the master of the Pan dish was a member of the Mazzaburroni family. His approach exemplifies that of other Sienese painters, of maiolica but also of panels and murals (such as Pacchiarotti himself), in the way he sought to incorporate a new vocabulary.

LS

1 Luccarelli 1983, pp. 269–70.
2 See Gombrich 1966, pp. 122–8, esp. p. 122.
3 See further Syson forthcoming.
4 Sutton 1979, pp. 334–41, esp. p. 339; Luccarelli 1995, pp. 54–5.
5 See further Syson (forthcoming).
6 Luccarelli 1983, p. 391.
7 Luccarelli 1983, pp. 284–5.
8 See, for example, Pacchiarotti's predella (Pinacoteca Nazionale, Siena) from an altarpiece in Santo Spirito, and in particular the forms of the trees and the body of the dead Christ: Torriti in Siena 1990, pp. 337–8, no. 406.

SELECT BIBLIOGRAPHY

Wilson 1991, pp. 175–65; Syson and Thornton 2001, pp. 78–9; Thornton and Wilson no. 114.

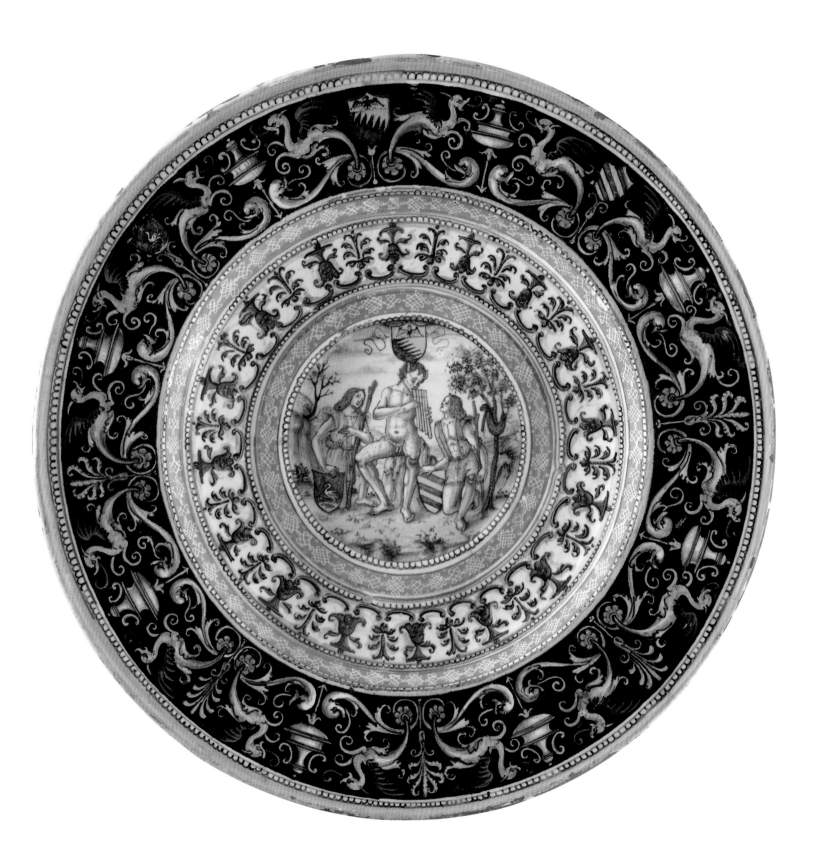

The Chapel of Saint Catherine in San Domenico and its design

GIOVANNI ANTONIO BAZZI,
KNOWN AS SODOMA (1477–1549)

89.

The Swooning Saint Catherine supported by three Angels, 1525–6

Black chalk, heightened with white
on prepared blue–grey paper, 41.7 × 26.6 cm
The British Museum, London (1895-9-15-764)

90.

The Swooning Saint Catherine supported by a Nun, 1525–6

Black chalk, heightened with white
on tan paper, 31 × 35 cm
Gabinetto Disegni e Stampe degli Uffizi,
Florence (268 s)

91.

Study for the Miracle of the Possessed Woman, 1526–36

Ink on paper, 18.1 × 13.5 cm
Gabinetto Disegni e Stampe degli Uffizi,
Florence (565 E)

Though many painters came to Siena in the early Cinquecento to undertake specific commissions, only Pintoricchio and Sodoma set up permanently in the city. After Pintoricchio's death, Sodoma became effectively the city's leading painter, to be both emulated and challenged by local artists (see cat. 101). His style in the mid 1520s was rather different, however, from his mode when he first arrived (see cat. 61), and his chameleon qualities are exemplified by the surprisingly various drawings he made for one of his most prestigious commissions, the frescoes for the Saint Catherine chapel in the church of San

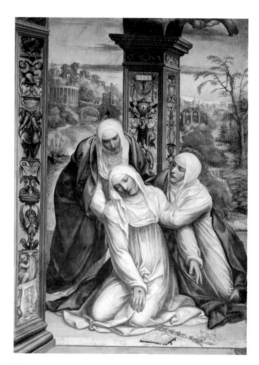

Fig. 75
Giovanni Antonio Bazzi, known as
Sodoma (1477–1549)
Scene from the *Life of Saint Catherine:
Swooning of the Saint* (detail), 1526
Fresco
Church of San Domenico, Siena

Domenico (fig. 75, 76). With the relic of the head of Saint Catherine as its focus, this was and is one of the most significant religious sites in Siena. Surprisingly little, however, has been written about the history of the chapel or the iconography of Sodoma's frescoes that decorate it.[1] After Catherine's death in Rome in 1380, her body was buried in the Dominican church of Santa Maria sopra Minerva; in 1384, however, Catherine's confessor and biographer, Raymond of Capua (1330?–1399), sent her head to the Dominicans' main church in Siena.[2] The relic was kept in the sacristy of the church until Niccolò di Buonsignore Benzi had part of the sacristy torn down to build, between 1466 and 1475, a family chapel.[3] Niccolò and his family were all buried there. The relic was thus housed in what was probably simultaneously a private burial chapel and a place of worship for the people of Siena. Between 1466 and 1470, a sculpted marble tabernacle was commissioned from Giovanni di Stefano; a silver reliquary was also designed by Giovanni but executed by Francesco d'Antonio. These projects seem to have been financed jointly by the Sienese Comune, the Dominican friars and the Benzi family.

Although the date 1526 was written on the altar wall, in one of the pilasters painted with *grottesche*, little was known until recently about the precise date and the circumstances of the commissioning of Sodoma's frescoes for the chapel. However, Philippa Jackson has now discovered a document (for the text, see Salomon in Syson forthcoming), in which, on 14 February 1525, Ventura di Giovanni Turamini is recorded as intending to have the Chapel of Saint Catherine decorated with paintings.

CAT. 89

Fig. 76
Giovanni Antonio Bazzi, known as Sodoma
(1477–1549)
Scene from the *Life of Saint Catherine:
Saint Catherine's Vision of Holy Communion*, 1526
Fresco
Church of San Domenico, Siena

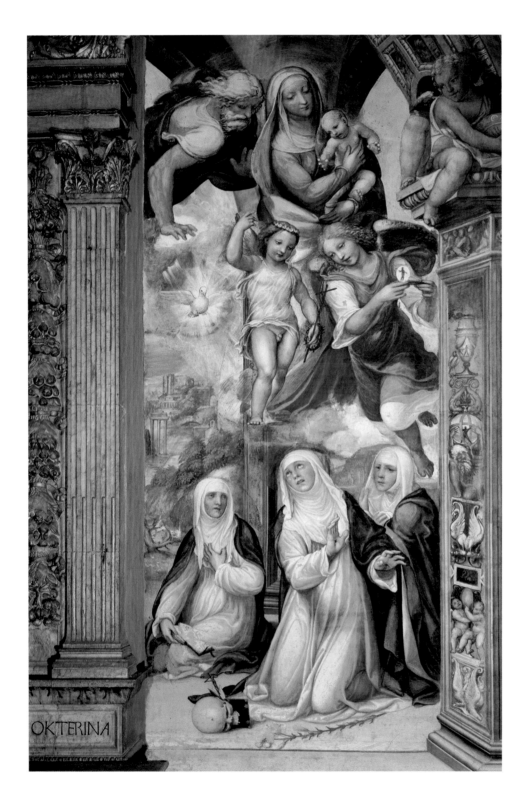

That Turamini was indeed the patron of the frescoes is confirmed by a second document, of 3 January 1536, showing that the painter Giovanni di Paolo d'Ambrogio had been called upon by the officers of the Mercanzia to 'give a *stima* of a work of Ventura Turamini, done and painted by the hand of Cavalier Sodoma in the church of San Domenico, in the Chapel of Saint Catherine'.

It transpires that a long-running dispute about payment for the chapel had followed the completion of some of the frescoes. Turamini had called on the painter Bartolomeo di David to provide a *stima* of the paintings; Sodoma, for his part, had called in Bartolomeo Neroni, known as Il Riccio, his pupil and son-in-law. These two painters 'having met many times together and not being able ever to come together to a solution with regards to the value of the said work', the third man, Giovanni di Paolo d'Ambrogio, became involved. Giovanni agreed with Bartolomeo di David (and Ventura Turamini) upon a value of 110 *scudi*.

The Turamini were a wealthy mercantile family with business interests in Rome, and had formed a partnership with the heirs of Mariano Chigi.[4] Ventura was active in the silk trade with his brothers Crescenzio and Leonardo. Crescenzio acquired the castle of Belcaro in 1525, which he later had remodelled by Peruzzi. As in his work for the Spannocchi family (see cat. 61), Sodoma was here working for a specific network of Sienese-Roman families; the painter's understanding of Roman art (especially Raphael) would therefore have been something highly appreciated by these Sienese patrons.

Since the frescoes were commissioned in 1525, it is likely that the date of 1526 painted

in the chapel accurately records their execution. However, after having painted three scenes (of four), Sodoma stopped work. Why he did so is not known. A fire in San Domenico in December 1531 has been considered one possible cause; however the extent of the destruction is not clear, or even if the chapel was directly affected. In the light of the 1536 document, it seems reasonable to suppose that Sodoma, having completed three of the frescoes by 1526 or soon after, fell into dispute with Turamini over the payment. The fire of 1531 probably slowed the process, and when in 1536 Giovanni di Paolo d'Ambrogio sided with the patron, Sodoma abandoned the project altogether. Vasari's statement that 'the other stories of the said chapel were not finished by him, partly because of his fault, as he did not want to work if not in a capricious way, and partly as he was not paid by the person that commissioned the chapel' seems to indicate a disagreement.[5]

It is not known who devised the iconography of the four episodes planned for the cycle. On the altar wall are two scenes on either side of the tabernacle – on the left, the so-called *Svenimento*, the *Swooning of the* Saint (fig. 75) and on the right, *Saint Catherine's Vision of Holy Communion* (fig. 76).[6] The *Svenimento*, its composition dependant on the many scenes of the Virgin's collapse at the Crucifixion (see, for example, cat. 35), is usually thought to depict the moment after the stigmatisation of the saint, as recounted by Raymond of Capua: 'We saw her little body, which had been lying prostrate, gradually rise up until it was upright on its knees, her arms and hands stretched themselves out, and light beamed from her face; she remained in this

position for a long time, perfectly stiff, with her eyes closed, and then we saw her suddenly fall, as though mortally wounded. A little later, her soul recovered its senses.'[7] The scene on the right of the *Vision*, is supposed to depict an event described by Tommaso d'Antonio Nacci, called Il Caffarini, in his *Libellus de supplemento prolixe virginis beate Catherine de Senis*, when Catherine was offered Holy Communion by an angel descended from Heaven.[8]

However, it is arguable that neither scene represents an individual episode, but shows recurrent themes in the life of Saint Catherine. The *Svenimento* (fig. 75) depicts Catherine in the ecstasy often described by Raymond of Capua: 'She was almost always in a state of contemplation, and her spirit was so absorbed in the Creator that she spent most of her time in a region beyond sense. This ... I experienced personally time and time again, and so did others, who saw and touched, as I did, her arms and hands, which remained so numb while she was in a state of contemplation that it would have been easier to break them than to get them to move. Her eyes remained tightly shut, her ears could not hear the loudest noise, and none of her bodily senses performed its accustomed functions.'[9] Catherine seems to have experienced this ecstasy most often after Communion: 'Her companions ... knew that after she communicated she went into ecstasy for three or four hours and that it would then be impossible to move her from wherever she was'.[10] This led to specific episodes: 'She received communion with such devotion that her spirit was rapt out of her senses and her body remained without feeling for several hours Sometimes those who were led

astray by the nuns were so incensed with her that when they came upon her in an ecstasy they would lift her up by force, insensible as she was, and throw her out of the church as though she were dirt; where her companions, with the midday sun beating down upon them, would stay watching over her with tears in their eyes until she returned to her senses.'[11] On other occasions after Communion, 'many remarkable visions were being revealed to her from Heaven' and 'in point of fact she never approached the sacred altar without being shown many things beyond the range of the senses, especially when she received Holy Communion'.[12]

It seems clear that Sodoma – and his patron – here conflated different elements of Catherine's life to arrive at two iconic images. The two scenes are particularly appropriate in conjunction with the altar: worshippers receiving the Eucharist would be encouraged to contemplate the effects the Sacrament had had on their saintly protector. The priest would have elevated the host in front of Giovanni di Stefano's tabernacle, and therefore in front of Catherine's head; thus the Saint still metaphorically received Communion every day, with the effects on her body in life painted there for everyone to see.

The two scenes on the side walls of the chapel are more specific. On the left, Sodoma painted *The Execution of Niccolò di Tuldo*.[13] The event, omitted by Raymond of Capua, but recorded by Catherine herself in one of her letters, took place in Siena in 1375.[14] Niccolò, a young Perugian accused of having defamed a senator at the time of the *Riformatori* regime, was condemned to death; Catherine visited him in prison,

comforted him and accompanied him to his execution. The episode ends with Niccolò's gruesome death, and, as Catherine wrote, 'Now that he was hidden away where he belonged, my soul rested in peace and quiet in such a fragrance of blood that I could not bear to wash away his blood that had splashed on me'.[15] Sodoma depicts the moment when Niccolò's newly decapitated body falls to the ground; as a man lifts his head in the air, his soul is carried to heaven by angels, while Catherine prays. Notwithstanding the fame of the episode, the execution of Niccolò was not often painted, and Sodoma's fresco may have been the first representation of it.[16] On the opposite wall Sodoma planned to represent *The Miracle of the Possessed Woman*; the painting was eventually executed by Francesco Vanni in 1593.[17] According to Raymond of Capua, when Catherine went to visit Monna Bianchina Trinci, the widow of Giovanni di Agnolino Salimbeni, at the Rocca di Tentennano in Val d'Orcia, she cured a possessed woman.[18] While this episode was depicted occasionally, it is relatively rare. Traditionally, the stigmatisation of Saint Catherine – the Dominican response to the most famous event of Saint Francis's life – had formed the central episode in Saint Catherine cycles (see cat. 97). Here it seems that the altar wall and the two side walls were intended to operate in different ways. While the main wall centred on the relationship between Catherine and the Eucharist, the side walls focused on Catherine's role as an intercessor, protector and patron of the Sienese people. Catherine's powers of salvation were seen to apply to both body (the possessed woman) and soul (Niccolò di Tuldo).

A good number of preparatory drawings survive for Sodoma's frescoes in San Domenico, allowing us to follow the cycle's development. The iconography of the altar wall went through several changes: there is a pen and ink sketch on blue paper (Uffizi 1943 F) that presents a rough idea of the original project for the wall. Two individual figures are placed at each side of the tabernacle: the one on the left is probably Catherine; the one on the right a nun. Soon, however, Sodoma turned to the idea of the two groups, the *Svenimento* and the *Vision*. The British Museum compositional drawing (cat. 89) is a first idea for the *Svenimento*, drawn on a sheet of prepared blue-grey paper similar in size and material to the plan in the Uffizi, and possibly from the same batch. In this exquisitely finished black-chalk drawing, Sodoma depicts Saint Catherine in ecstasy supported by three angels. By the time he had made this drawing Sodoma seems to have worked out the position of the figures: only a few *pentimenti* are present, most visible in the head of the angel to the left, which has been moved. The painter might have first drawn the figures naked, since Catherine's body (especially her navel) is clearly visible beneath her clothes. The figure of Christ appears above, in a position very different from the final composition. The drawing is most concerned with the effects of supernatural light – achieved through the masterly use of white highlighting. Sodoma also explores the tender relationship between the angels and Catherine, especially in the detail of the two angels supporting Catherine's proper left arm as she falls to the ground. The drawing was evidently copied within Sodoma's workshop: a painting by one of his followers, now in the Chigi Saracini collec-

tion in Siena, depends upon it. As the drawing in the Uffizi (cat. 90) shows, Sodoma then decided to substitute the three angels with companion nuns (possibly Alessia and Francesca, Catherine's faithful followers; only one is included in cat. 90). Again Sodoma has sympathetically delineated the gesture of the saint's companion. He has also depicted the women's draperies in accurate detail. Catherine's head, seen from below, is contrasted with her companion's, viewed from above, a shift in perspective that creates an unsettling effect.

Sodoma's depiction of the swooning Saint Catherine proved to be immensely popular. Vasari, in his otherwise rather critical biography of the artist, praises the fresco: 'The Sienese painter Baldassarre Peruzzi, considering the work, said that he had never seen anyone express the emotions of unconscious and fainting people in a better way, or more life-like, than what Giovan Antonio had been able to do. And in truth it is so, as it can be seen as well as in the work itself in the drawing for it that I own, by Sodoma's own hand, in our *Libro de' disegni*'.[19]

Although Sodoma never painted the episode of Catherine curing a possessed woman, four of his compositional drawings survive in the Uffizi. These drawings, in pen and brown ink, are different in technique from the finished *Svenimento* drawings; they are rapid sketches intended to capture grouped figures in action with assertive pen strokes. It is difficult to establish their relative chronology. The smallest of them (562 E) focuses on the figure of the blessing Saint Catherine, while the other three depict the possessed woman and her relationship with the figures around her. In one of them,

4.

CAT. 90

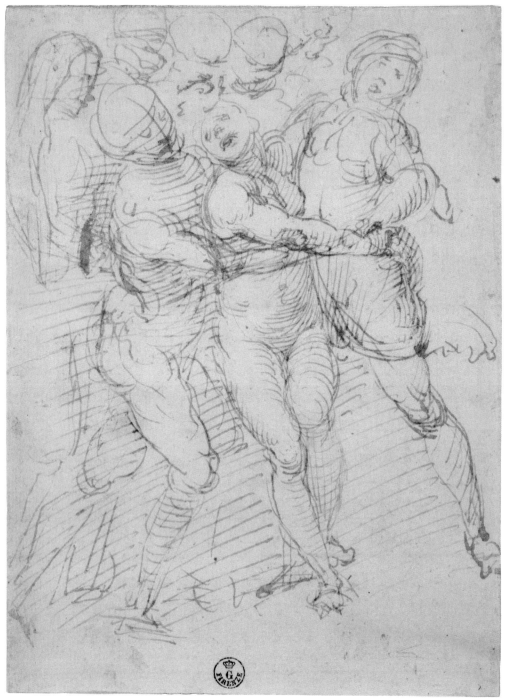

CAT. 91

the woman is supported by a man and the scene has an architectural setting; in another, there are three figures holding her up, with Catherine appearing on the right.

In the fourth of the drawings (cat. 91), the figure of Catherine has been shifted to the left, where she is barely discernible: Sodoma has directed his attention once again to the possessed woman. She stands (in Vanni's fresco she is prostrate on the ground) held up by two almost naked figures, showing, once again, that Sodoma first drew his protagonists nude, only clothing them once the composition had been established. The drawing, with its sloping central figure tightly embraced by two others is comparable to Luca Signorelli's drawing for *The Death of Lucretia* (see cat. 87). Like Signorelli, Sodoma has created a dramatically charged composition, fascinated by the tense rhythms between the figures' interlocking arms and legs bent at the knee. Three heads are barely discernible behind the main group. Sodoma employs his standard method of curved parallel hatching to give volume to the bodies – a method that also owes something to Signorelli. xs

1 Cust 1906, p. 175: 'little or no record remains concerning its [the chapel's] origins.'
2 Raymond of Capua 1960 edn, pp. 273–4; Norman (forthcoming).
3 Riedl and Seidel 1992, p. 562; Norman (forthcoming).
4 For the documents mentioned see Syson (forthcoming). Information on the Turamini family was also provided by Philippa Jackson.
5 '*L'altre storie della detta cappella non furono da lui finite, parte per suo difetto, che non voleva lavorare se non a capricci, e parte per non essere stato pagato da chi faceva fare quella cappella*', Vasari 1878–85 edn,V, p. 388.
6 The scene of the *Vision*, on the right, is often wrongly described as the *Ecstasy of Saint Catherine*; see, for example, Torriti 1982, p. 48.
7 Raymond of Capua 1960 edn, p. 175.

8 Carli 1979, p. 62.
9 Raymond of Capua 1960 edn, p. 164.
10 Raymond of Capua 1960 edn, p. 287.
11 Raymond of Capua 1960 edn, p. 365.
12 Raymond of Capua 1960 edn, pp. 166–7.
13 For Niccolò di Tuldo and the fame of the episode, see Galletti 1982; Luongo 2006, pp. 96–102; Loseries (forthcoming).
14 Letter 273; Noffke 1988/2000, I, pp. 85–9.
15 Noffke 1998/2000, I, p. 89.
16 Loseries in Mazzoni and Nevola forthcoming.
17 Cust 1904, p. 257; Cust 1906, p. 182; Hayum 1976, p. 198; Riedl and Seidel 1992, pp. 562–3.
18 Raymond of Capua 1960, pp. 246–9.
19 '*La quale opera considerando Baldassarre Petrucci pittore sanese, disse che non aveva mai veduto niuno esprimer meglio gl'affetti di persone tramortite e svenute, ne' più simili al vero di quello che avea saputo fare Giovan Antonio. E nel vero è così, come, oltre all'opera stessa, si può vedere nel disegno che n'ho io, di mano del Soddoma proprio, nel nostro Libro de' disegni*', Vasari 1878–85 edn, V, p. 387.

SELECT BIBLIOGRAPHY

Cat. 89, 90: Forlani Tempesti 1967, pp. 37–8, cat. 21; Hayum 1976, pp. 201–2; Riedl and Seidel 1992, p. 584; *Cat. 91*: Petrioli Tofani and Smith 1995, pp. 42–3, cat. 15; Norman (forthcoming).

92.

GIOVANNI ANTONIO BAZZI, KNOWN AS SODOMA (1477–1549)

The Virgin and Child with Saints Peter, Catherine of Siena and an Olivetan Monk, about 1525–35

Oil on panel, 48.9 × 37.8 cm
The National Gallery, London (NG 1144)

This little painting, made for private devotion, compares well to works executed by Sodoma in the years immediately after he had completed his frescoes for the Chapel of Saint Catherine in San Domenico (see cat. 89–91).[1] Specially cleaned and restored for the present exhibition, it is now revealed as a work with a particular delicacy of touch and freshness of colour. At the sides of the enthroned Virgin and Child is Saint Catherine of Siena (on her proper left), and Saint Peter (on her right, in the position of honour), who presents a kneeling donor, an Olivetan monk. Sodoma received a series of commissions from the Olivetans of Monteoliveto Maggiore, which suggests a long-term and strong relationship between the painter and the order for whom he had worked when he first travelled to Tuscany. His panel was almost certainly painted for the monk depicted; the presence of Saint Peter in the picture might be explained by the monk's name, or maybe by his links to Rome. Sodoma's clever play between the two little keys hanging just below donor's elbow and Saint Peter's own, more massive keys held in the same hand with which he touches the monk's shoulder, is also likely to be significant. Traditionally, Olivetan monks carry keys to the monastery with them at all times, but in this case their double presence might indicate something of the commissioner's specific role within a monastery.[2]

In the years after 1525, Sodoma seems to have become more interested in an 'archaic' style of painting. This new direction may in part have been inspired by the function of the picture, in part by the revived republi-canism in the city in that period, which celebrated the traditional civic sites for art in the city. The Virgin and Child, larger in their hieratic pose than the saints on either side, suggest that Sodoma was deliberately seeking to evoke Trecento Sienese devotional painting. The Virgin's long fingers, smoothly oval head and mournful expression (particularly marked since the removal of a syrupy nineteenth-century smile in a recent restoration) with her features large in her face, look back to Duccio and Simone. The hairline, receding at the temples, of the Christ Child recalls the type employed by Duccio and his shop.[3] His stiff little arms are also quoted from earlier works. In the late 1520s Sodoma painted a picture for the church of San Domenico, stylistically close to this, serving as a kind of frame around Francesco di Vannuccio's *Virgin and Child*, demonstrating his direct relationship with Sienese works of the past. But this picture is no mere pastiche, and perfectly epitomises what made the artist so popular in the city – his intelligent and skilful blending of a modern Leonardesque mode and his own free handling of paint (which is here especially feathery in the background), with Siena's own pictorial tradition. XS

1 Previously the painting had been supposed to have been painted in Pisa and misdated and even denied to Sodoma. See X.F. Salomon in Syson (forthcoming).
2 I am grateful to the monks of Monteoliveto Maggiore for confirming this and other aspects of the donor's costume.
3 See the two *Virgins* in the National Gallery, London, by Duccio and a close follower, probably employed in his workshop (NG 566 and NG 6356).

SELECT BIBLIOGRAPHY

Gould 1975, p. 250; Bartalini 1996, p. 16, note 10.

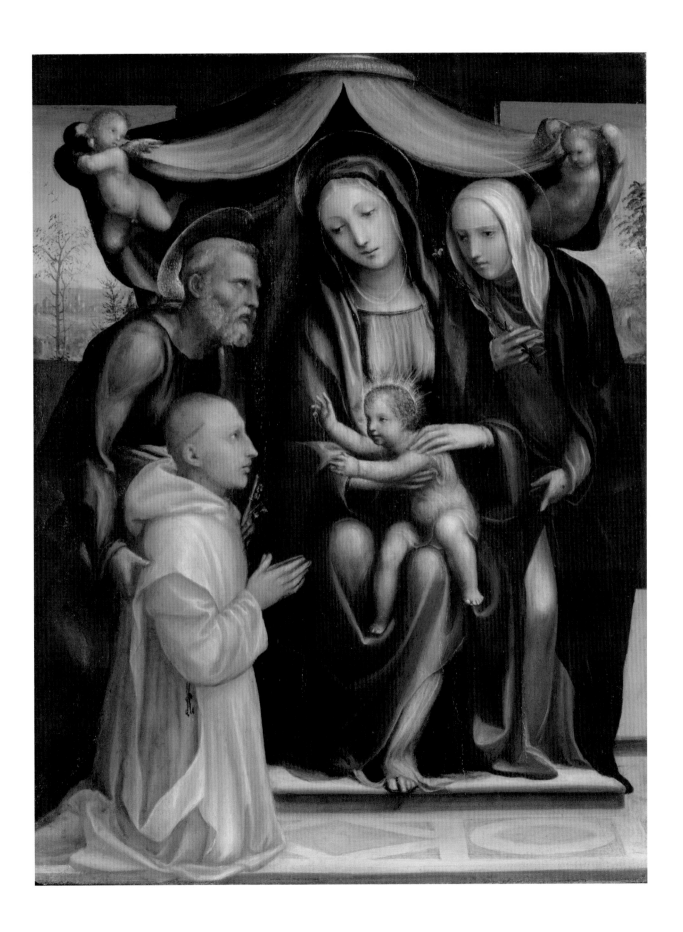

DOMENICO BECCAFUMI AND THE SIENESE TRADITION

'Virtuous and righteous man, God-fearing and dedicated to his art, but solitary beyond measure'; thus Giorgio Vasari, in his *Lives of the Most Excellent Painters, Sculptors and Architects* (1568) praised Domenico Beccafumi (also known as Mecarino, 1484–1551) as the foremost painter of the Sienese Cinquecento. Vasari parallelled the Florentine Cimabue's discovery of Giotto, some two hundred years earlier, which marks the beginning of Vasari's history of art, with Domenico's artistic beginnings. The young Domenico, the biographer claims, drew in the sand and on stones in the Sienese countryside to pass the time while minding his father's flock of sheep. Domenico's talent was noticed by a Sienese citizen, Lorenzo Beccafumi, who took the boy to the city to become an apprentice in a painter's workshop, and later bestowed his surname upon the young artist. Although Vasari had known Domenico Beccafumi personally, it is not known if this story has any truth. Nonetheless, this account places the Sienese painter at the head of a new artistic tradition; he becomes for Vasari the Sienese Giotto, introducing a new style to the city. The details of Beccafumi's early life remain, however, largely speculative, and despite his prolific career as a painter of altarpieces, frescoes and furniture, as the designer of marble inlay, as a sculptor in various media and as a printmaker, he remains a somewhat enigmatic figure.

Beccafumi's biography provides a background for a greater understanding of his artistic development. The earliest documented references to the artist are a property transaction of 1507 and a payment in 1512 for work in the Chapel of the *Madonna del Manto* in the Hospital of Santa Maria della Scala. Vasari describes Beccafumi shortly thereafter working on the *all'antica* decoration of the façade of Palazzo Borghesi in Siena (cat. 101), a design which suggests a familiarity with contemporary Roman models. Beccafumi also continued working at the Hospital, this time frescoing part of the vault of the Cappella del Manto with grotesques, and in 1513 he completed a triptych of *The Trinity* flanked by pairs of saints for the chapel. The long horizontal format of this altarpiece and classicising architectural frame mark a departure from the tradition of 'Gothic' pointed arched polyptychs, while the frame, with its grotesque and candelabrum motifs, reproduces his decoration of the vault of the same chapel. Beccafumi's *Stigmatisation of Saint Catherine of Siena with Saints Benedict and Jerome*, for the Olivetan monastery of San Benedetto fuori Porta Tufi (now Pinacoteca Nazionale, Siena) demonstrates the impact the Florentine style of Fra Bartolomeo had on the artist.

Vasari described Domenico's first sojourn in Rome as a period in which he developed his skills as a draughtsman and became a prolific inventor, implying that it was in Rome that he absorbed the qualities of *buon disegno*, or good design, and 'invention' in the Roman manner.[1] Indeed, while Francesco di Giorgio had established the importance of *disegno* in Siena (see cat. 40–3), Beccafumi took this practice to new heights. For example, it is likely that during his first trip to Rome that Beccafumi tried his hand at a form of the *sgraffito* technique, which probably played a part in his subsequent decoration of the Borghesi façade in Siena (see cat. 101).[2] In essence, the technique, incising throuh a plaster layer to another below, was not very different from the type of *sgraffito* used by painters of the Trecento and Quattrocento in their panel painting – scratching through paint to reveal a gilded layer underneath. Beccafumi was perhaps exceptional in employing this traditional technique in a decidedly modern work, such as his *Stigmatisation of Saint Catherine of Siena* (cat. 97).

From about 1515 onwards, Beccafumi began using a more highly keyed palette, exemplified in such works as the *Saint Paul* painted around 1516–17 for the church of San Paolo (now Museo dell'Opera del Duomo, Siena), the fresco of *The Meeting by the Golden Gate*, again for the Chapel of the *Madonna del Manto* in the Hospital, and his frescoes for the Oratory of San Bernardino, completed around 1518. Working alongside Girolamo del Pacchia and Sodoma to decorate this Oratory, Beccafumi painted frescoes of *The Marriage of the Virgin* and *The Assumption* as well as the altarpiece. That Domenico's collaborators were two of the most popular artists in the city at the time is indicative of his ability to secure some of the most sought-after commissions in Siena. It was the success of these works that gained him the commission for the designs of the inlaid marble pavements in the Cathedral. This project, which would come to occupy him for almost thirty years, comprised a series of Old Testament narratives.

At about the same time that he began working on these designs, Beccafumi also received the prestigious commission to decorate a chamber for Francesco Petrucci (see cat. 102–7). It is widely believed that following this commission Beccafumi made a second trip to Rome, a sojourn that would

explain the 'Romanising' artistic language of the scenes from Valerius Maximus that he painted on the vault of a room in the Palazzo Venturi (now Palazzo Agostini Bindi-Sergardi, Siena). These scenes demonstrate a familiarity with Raphael's recent decoration of the Vatican Logge and the frescoes by Raphael, Sebastiano del Piombo, Sodoma and others in the Roman villa of the Sienese banker Agostino Chigi (now Villa Farnesina).

Following this project, Beccafumi painted a series of great altarpieces, the Marsili Nativity in the church of San Martino and the two versions of *Saint Michael casting out the Rebel Angels* for the church of San Niccolò al Carmine. The first version (now Pinacoteca Nazionale, Siena) was rejected by the friars who commissioned it, possibly on account of its indecorous tangle of naked bodies. Beccafumi's second version, still in the church today, has a considerably more restrained composition and was a favourite painting of the Sienese architect Baldassare Peruzzi, who, according to Vasari, never tired of praising it. This work shows off Beccafumi's sophisticated light effects, in which deep shadows are penetrated only by the burning glow of the Inferno. Beccafumi subsequently employed this marvellous effect for *The Birth of the Virgin* of about 1530 for the church of San Paolo (now Pinacoteca Nazionale, Siena), a scene of a domestic interior in which the nurse's face is brilliantly illuminated by the fire before which she kneels. Shortly after executing the panel painting showing *The Offering of the Keys of the City to the Virgin* (cat. 94) in 1526–7,

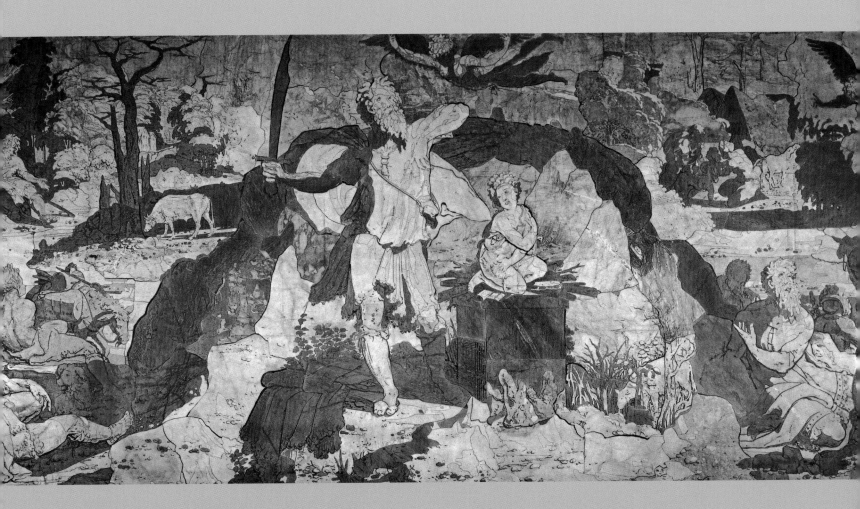

possibly for the office of the Biccherna, Beccafumi was called upon by the Sienese government to decorate the vault of the Sala del Concistoro in the Palazzo Pubblico, completed in 1535 (see cat. 108). For the Concistoro programme, Beccafumi returned to some of the same textual sources employed in his frescoes for Palazzo Venturi, now re-appropriated and adapted for a civic space in order to promote Sienese republican virtues. The project was interrupted and, in around 1532–3, Beccafumi travelled to Genoa to decorate the façade of the palace belonging to the admiral Andrea Doria.

Throughout this period Beccafumi was creating designs for the marble pavements in the Cathedral – narratives of Elijah, Moses, Abel, Abraham, Isaac and Melchisedech (fig. 77). In these designs, which Vasari described as 'a school and pastime for Domenico which he never fully gave up in favour of other work', Beccafumi truly justified his status as a *maestro di disegno*.[3] This status is also conspicuous in his highly finished drawings (for example, cat. 113), many of which are probably works of art in their own right rather than simply prepara-tory studies. The sequence of pavement designs may be used to trace the changes in the artist's graphic style over the course of his career, from the forms of his earliest marble pavements, which are defined by strong contours and outlines, to the softer, more ambiguous lines in the later pave-ments (of about 1525–47), in which greater interest is given to subtle gradations of light and shadow. Beccafumi also produced monochrome oil sketches on paper (cat. 108-11) with dramatic chiaroscuro effects. In the final decade of his life Domenico translated these into another medium,

chiaroscuro woodblock prints, for which he carved multiple (generally three) blocks, each loaded with a different shade of ink and pressed on a sheet of paper.

Beccafumi's experimentation with light effects was not restricted to his monochrome works. At the beginning of his career he was remarkable for his *colorito*, or the applica-tion of colour, in works such as the *Venus and Cupid* (cat. 107) and the tondo of the *Virgin and Child with Saint Jerome and Infant Saint John the Baptist* (cat. 98). Through the introduction of these extraordinary colours his figures acquire a fantastical air, emanating an almost phosphorescent glow. This palette is foreign to Siena, and these vibrating hues, often applied using a notably sketchy technique, bring to mind the works of Andrea del Sarto, although his Florentine works have an earthly naturalism that Beccafumi's do not possess. In contrast, Beccafumi's works often appear other-worldly, even visionary – a new formulation of a long-standing aim of Sienese art. Yet gradually, and especially towards the end of his life, Beccafumi appears to have preferred a deliberately more muted palette and transferred techniques to his oil paninitings previously used for works in other media (see his adaptation of façade *sgraffito* for cat. 97). *Disegno* becomes more important than *colore* and a discernibly 'stripped-down' aesthetic becomes manifest. The increasing economy of his painting and drawing technique, its sketchiness ever more accentuated, gives his figures a new kind of visionary quality. He had arrived at a new 'pious' style, and in many ways the personal had at last overtaken the traditional, so that he indeed became Vasari's 'virtuous and righteous man ... solitary beyond measure'.

It was perhaps the works for the Siena Cathedral pavement that inspired the Pisa Cathedral authorities to commission six panel paintings (1537–8) depicting the *Punishment of Korah*, *Moses breaking the Tablets of the Law* and the *Four Evangelists*. Beccafumi also played an important role in the transformation of the east end of Siena Cathedral, where, aided by the young Marco Pino, he painted frescoes of *The Ascension with Adoring Prophets, Angels and Saint*s and *The Virgin with Saints Peter and Paul* (1535–44). At the very end of his life Beccafumi modelled and cast a series of eight bronze candle-bearing angels for the piers of the nave. The liveliness and grace-fulness of these figures, and the sensual juxtaposition of the smooth sheen of their skin with the elaborate folds in their fine draperies, recall earlier bronzes by Francesco di Giorgio and Vecchietta. These sculptures take elements from forebears' works of the previous century and intepret them in what may be described as a 'Mannerist' idiom. Significantly, Beccafumi was the first Sienese painter to absorb the lessons of non-Sienese artists working in early Cinquecento Siena, and, profiting from his trips to Rome, Genoa and (it is assumed) Florence, he formed an individual 'modern' style. He arrived at a highly personal interpretation of the Italian *maniera*. His work is notable for a strong element of *fantasia*, or artistic imagination. Indeed a whimsical approach, described by Vasari as '*capricciosissimo*', is discernible throughout his œuvre.

The term *maniera*, literally 'manner,' is used chiefly to describe the style for painting prevailing in mid-sixteenth-century Italy, from the death of Raphael in 1520 until about 1585 (taking in the paintings of Vasari

himself). The artists of the *maniera* gave increasing weight to artistic and intellectual conceits, and their style embraced a set of formal characteristics, such as elongated forms, exaggerated or contorted poses and unnatural space and lighting.[4] Although Beccafumi is now often classified with better-known *maniera* artists such as Andrea del Sarto, Jacopo da Pontormo and Rosso Fiorentino, he differs from these Florentine masters in that, despite his adoption of this new aesthetic, he remained rooted in the Sienese artistic tradition. Indeed Vasari reports that Beccafumi, unsatisfied with a panel of *The Virgin and Child with Saints* he had painted in Pisa, made apologies for this work to his friends, including Vasari himself, and declared that when he was, 'away from the air of Siena, without certain of his comforts, it seemed he did not know how to do anything'.[5] This anecdote may serve as a metaphor for Beccafumi's entire artistic œuvre in which his devotion to the Sienese visual tradition is recognisable in his citations of the 'Gothic' sway and rhythmic patterns of the Trecento sculptures of Prophets and Patriarchs on the façade of Siena Cathedral, the soft folds of Duccio's draperies, the sinuous lines and cadence of Simone Martini's figures and the regal elegance of Jacopo della Quercia's sculptures.

During what was a particularly tumultuous period in Sienese history, in which the city was struggling to maintain its status as an independent republic, Beccafumi therefore can be found reiterating traditional artistic models as a self-conscious means of reinforcing Sienese identity. At the same time, he was fully aware of and responsive to developments in other artistic centres such as Rome, to which Siena had long-standing connections. Consequently, Beccafumi can be seen as negotiating several artistic objectives – the cultivation of a distinct or 'signature' style, the desire to demonstrate familiarity with the new 'foreign' aesthetic of *maniera* painting, and the desire to situate his works within their larger native tradition. It is in this stylistic reconciliation that Beccafumi succeeded in creating a 'modern' Sienese language, appropriate for spiritual, civic and governmental projects alike. Though Vasari presented him as a Sienese Giotto, Beccafumi remained the heir of Simone Martini. In incorporating these two stylistic strands, Domenico's works form both a continuity with those his native Sienese forebears but also point towards the eventual dilution of a distinct Sienese style.

GF & JS

1 Vasari calls Beccafumi *'fiero nel disegnare'* and *'copioso nell'invenzioni'*. See Vasari 1966–87 edn, p. 165.
2 For an excellent summary of the scholarly debate on the term, see Elizabeth Cropper's introduction in Hugh Smyth 1992.
3 Vasari 1966–87 edn, V, pp. 172–3.
4 Friedländer 1925, [13].
5 '…come era fuori dell'aria di Siena e di certe sue commodità, non gli pareva saper far alcuna cosa'. See Vasari 1966–87 edn, V, p. 175.

The City and its Saints

93.

DOMENICO BECCAFUMI (1484–1551)
View of Siena, early 1540s

Pen, brown ink and wash on paper, 7.9 × 16.7 cm
The British Museum, London (1895-9-15-584)

Inscribed bottom left, in brown ink: VEDUTA DI
SIENA (*View of Siena*);[1] bottom right of centre,
in brown ink, in a different sixteenth-century hand:
MECARINO. D[A]. SIE^.

Fig. 78
Domenico Beccafumi (1484–1551)
View of Siena, early 1540s
Pen and ink on paper, 6.7 × 7.1 cm
Musée du Louvre, Paris (D.A.G. 270)

This view is taken from quite a high viewpoint beyond the city walls to the south-west of the Siena, looking towards the gabled façade of the Cathedral with its rose window and stout *campanile* to the right. In front of the Cathedral is the arcaded rear façade of the Hospital of Santa Maria della Scala, while to the right is the crenellated tower of the Palazzo Pubblico, the Torre del Mangia. To the left a number of tall towers, once belonging to private palaces along the Banchi di Sopra but now no longer standing, lead the eye down to the church and *campanile* of San Domenico.[2]

Sanminiatelli believed that this drawing and a fragmentary view of Siena in the Louvre (fig. 78) were once continuous on a single sheet (a connecting passage of drawing has been lost). The care with which Beccafumi selected a view that displays the city's most recognisable landmarks suggests that he may have intended to insert it into a painting, though no such work is known. The degree of detail and consistency of the fall of light nevertheless give the impression of a work made from nature.[3] In order to overcome the geographical obstacles to seeing the whole city in a single view, Beccafumi may have combined a general panorama taken from the best available vantage-point with details taken from closer to the city.[4] The date of the study is hard to determine. It has most frequently been situated early in Beccafumi's career, usually in the 1510s, and certainly its minute scale and skilful control

seem to suggest a visual acuity and manual dexterity unimpaired by old age.[5] However, as Mauro Mussolin has pointed out, the presence of the oratory church of San Sebastiano to the left of Santa Maria della Scala, with its cylindrical tower over the crossing, indicates a later date, one more in keeping with De Marchi's suggestion, on stylistic grounds, of the 1540s.[6] Construction of the church was slow, extending from 1492 to the mid sixteenth century. The sacristy, visible to the left, would probably only have been completed towards the end of this period.[7]

Sienese artists were always aware of their cityscape, partly because of the unusual number of vantage points from which the city could be viewed, and partly thanks to

(actual size)

the extraordinary panoramas of the surrounding countryside visible from the city's many towers. A love of landscape was always a hallmark of Sienese painting, and from the moment the city was recognisably portrayed in Ambrogio Lorenzetti's *Allegory of Good and Bad Government*, the topography of Siena played an important part in its political and cultural self-definition. For much of the fifteenth century, Sienese cityscapes remained locked in a more or less stylised repetition of traditional components, focusing principally on the contrast between the pink-brick city walls and the black-and-white stripes of the Cathedral (see cat. 1–4).

Beccafumi's study is a rare surviving example of a topographical drawing of comparatively early date.[8] The only other

Central Italian artist known to have consistently drawn landscapes from nature was Fra Bartolomeo, from whom Beccafumi undoubtedly learnt much. A drawing of a farm beside a river suggests he copied Fra Bartolomeo from an early age,[9] and similar studies must have preceded his painting of the misty landscape with a broken bridge in the background of his altarpiece depicting *The Stigmatisation of Saint Catherine with Saints Benedict and Jerome* for San Benedetto fuori Porta Tufi of 1514–15, also looking to Fra Bartolomeo.[10] As his art matured, Beccafumi's painted landscape backgrounds became increasingly abstract, frequently enlivened by surreal colours and meteorological effects. However, towards the end of his career he occasionally reverted to a bold

naturalism of astonishing modernity, as in his depiction in his late *Annunciation* for Sarteano (1546) of a darkened cityscape – not unlike the view studied here – silhouetted against a crepuscular sky.

A handful of sketches of buildings and streets further attest Beccafumi's interest in describing the city from within: one survives of the Palazzo Pubblico, and another of via Banchi di Sopra.[11] However, like his landscapes, such naturalistic urban scenes were rarely included in his painted works. Beccafumi preferred to invent his pictorial scenography, even when he knew the topography of a setting well: views of Rome in works such as *The Story of Papirius* (National Gallery, London) and *The Flight of Clelia* (formerly Belgrade), while full of

recognisable landmarks, are largely his own fantastical reworkings.[12] Only occasionally, when commemorating recent historical events, did Beccafumi depict real spaces more accurately (see cat. 94–6). CP

1 Sanminiatelli 1967, p. 152, notes that the same hand inscribed VIA DI SIENA on a drawing from the Rosenthal Collection, Berkeley CA, and SIENA on the Louvre view.

2 The presence of the towers (on which see Nevola 2007, ch. 7) explains the identification of the drawing in the Malcolm catalogue as a view of San Gimignano; the correct identification was first noted by Sidney Colvin in the interleaved copy of the volume in the Department of Prints and Drawings in the British Museum.

3 A. De Marchi in Siena 1990, p. 442, commented that the view is only approximate and for this reason both he and Giannattasio suggest Beccafumi was working from memory, but this does not seem plausible.

4 Fabrizio Nevola kindly established the difficulty of viewing all the features of the drawing from a single vantage point.

5 Judey 1932, pp. 129, 149, no. 219; Sanminatelli 1967, p. 152, no. 67; P. Giannattasio in Torriti 1998, p. 323, no. D147.

6 Mussolin 2005, p. 116.

7 De Marchi in Siena 1990, pp. 422, 425, note 55; Mussolin 2006, p. 116, especially note 67.

8 Giannattasio points out that a view of the city, taken from further away and still more summary, was once in the Liphart Sketchbook, though these drawings appear mostly to be copies (see Liphart Rathshoff 1935, p. 36, fig. 2; on the vexed issue of the autograph status of the drawings in the Liphart Sketchbook, see Monbeig Goguel 1995, p. 15).

9 Torriti 1998, no. D1. Fischer 1990, pp. 393–4, hypothesises that Beccafumi visited Fra Bartolommeo's workshop early in his career.

10 M. Maccherini in Siena 1990, pp. 110–13, no. 9.

11 E. Tenducci in Torriti 1998, pp. 257, 308, D33 and 118; the autograph status of these drawings is not universally accepted, but, even if they are not by Beccafumi, they almost certainly record the appearance of lost sketches by him.

12 M. Folchi in Torriti 1998, p. 111, no. P36; Plazzotta 2001.

SELECT BIBLIOGRAPHY

Sanminiatelli 1967, p. 152, no. 67; P. Giannattasio in Torriti 1998, p. 323, no. D147.

DOMENICO BECCAFUMI (1484–1551)

The Offering of the Keys of the City to the Virgin before the Battle of Porta Camollia, 1526–7

Oil on panel, 46.3 × 45.4 cm
The Devonshire Collection, Chatsworth (32)

Verso branded with a Medici coat of arms; inscribed on an old label on the back, probably by the 3rd Earl of Burlington: STORIETTA DELLA CHIAVETTA / PIERINO DEL VAGA / WROTE ON THE OLD FRAME

The subject of this panel is the offering of the Keys of City to the Virgin, a votive ceremony that took place in Siena Cathedral on 22 July 1526 as Papal and Florentine troops, concentrated at Porta Camollia, laid siege.[1] Two years previously the anti-Medici faction had toppled the *Nove* government, killing their leader, Alessandro Bichi, and establishing a new government under the name of the *Libertini*. The exiled *Noveschi* turned to the Medici Pope Clement VII for support and he and the Florentines sent a large army to Siena to restore them to power.[2] As the enemy armies amassed outside the city walls, the citizens of Siena, desperate to preserve their liberty and precious revived 'democracy', congregated at the Cathedral, as they had done twice in their history before, to invoke the Virgin to be their protectress.

The ceremony took place, apparently, on the advice of Margherita Bichi Buonsignori, a widowed noblewoman said to be gifted with prophetic powers, who told the Concistoro that the Sienese would be victorious if they celebrated a High Mass every year in honour of the Immaculate Conception and rededicated the city to the Virgin.[3] Illuminated in white robes on the altar step is the Canon of the Cathedral, Giovanni Pecci, who receives the city's keys on the Virgin's behalf from the kneeling Prior of the Concistory, Tommaso di Giovanni Rondini.[4] The ceremony, attended by all the city's officials and large crowds of citizens, was a conscious revival of the first occasion on which the Sienese had placed themselves and their city under the Virgin's protection – believed to have been on the eve of the Battle of Montaperti (4 September 1260), when Siena was similarly threatened by

Florence and her Guelph allies (see pp. 80).[5] The only other occasion on which the ceremony was performed in the years between the battles of Montaperti and Camollia was in 1483, when exiles from the *Novesco* regime, overthrown the previous year, invaded the Sienese state and threatened to capture the city.[6] This event, which took place before the same chapel as the 1526 ceremony, is commemorated in a Gabella panel attributed to Pietro Orioli of 1483 (fig. 79).[7] As in 1260, the Virgin responded to the prayers: the attack failed and the exiles were driven from Sienese territory. Four days after the third ceremony, depicted in cat. 94 an ardent band of Sienese militia, backed up by only a hundred cavalry, made a surprise sortie from the gates of Fontebranda and Camollia, frightening the 8,600-strong enemy army into 'cowardly retreat'. The Torre bell rang out to gather the citizenry, who processed with a *gonfalone* of the Virgin to the Cathedral. Countless further ceremonies of thanks ensued in the city and the countryside.

Apart from the dusky colours of the figures' draperies, Beccafumi's picture is almost monochrome, executed at speed and with the sketch-like economy of his predella panels (see cat. 96). Using dramatic lighting to convey the congregation's tense hopes of the Virgin's intercession, he sets the scene in the Cathedral's twilit interior, looking from the nave into the chapel dedicated to the *Madonna delle Grazie*.[8] This housed the famous votive image of this name, a fragment of a larger work, believed from the early fifteenth century to have been the picture in front of which the Montaperti oath was sworn (see pp. 53–4).[9] The chapel, as depicted in Beccafumi's

painting and in Orioli's Gabella panel, was the product of a major campaign of enlargement and embellishment that took place between 1447 and 1459; the picture is a rare record of the chapel's appearance before it was demolished in 1659.[10] The *Madonna delle Grazie* was ensconced in an ædicule at the rear of the vaulted chapel, the structure of which is best seen in Orioli's image. In Beccafumi's painting, this pedimented shrine is cast in deep shadow behind an iron grille, and is only dimly perceptible by the light of six votive candles that burn in the Virgin's honour (smoke swirls up atmospherically from the left-hand taper). The artist focused instead on the entrance arch at the chapel's threshold, offsetting its ornate gleaming surfaces against the distinctive black and white marble stripes of the Cathedral interior. Urbano da Cortona's bas-relief scenes of the Life of the Virgin on the pilasters are only impressionistically evoked. Set into the lunette at the top of this structure is a tondo supported by two angels, which documents now suggest was Donatello's *Virgin and Child* relief (fig. 26), though the figures in Beccafumi's painting, curiously, are reversed.

The present work is a unique example in Beccafumi's œuvre of a contemporary event depicted in a real setting. Eisler and Cecchini astutely suggested that it may originally have been a Biccherna or Gabella panel, and thus comparable in function to Pietro Orioli's *Offering of the Keys*.[11] The size of the panel and its square shape indeed fit with other sixteenth-century examples of Biccherna panels (including one of the battle of Camollia itself), which by then had grown larger and more robust than their 1460s models. Eisler and Cecchini

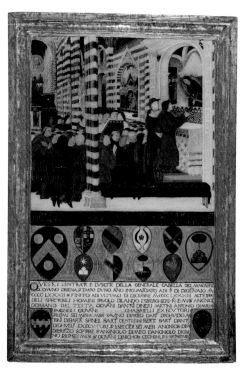

Fig. 79
Attributed to Pietro Orioli (1458–1496)
Offering of the Keys to the Virgin, 1483
Tempera on panel, 59.1 × 40 cm
Archivio di Stato, Siena (41)

surmised that the section at the bottom with the coats of arms had been cut away to make the picture more saleable, and stated that traces of these survived along the bottom edge. A recent examination of the panel out of its frame has revealed that this is not the case. The bottom of the picture is defined by an incised line and an unpainted border with no trace of any arms or inscriptions. Two hypotheses emerge from this physical evidence. Either the painting was made as we see it, with the principles of the Biccherna tradition in mind, still serving a commemorative function and perhaps destined for the wall

of a government office. Alternatively, the heraldry may indeed have been removed: traces of a raised barbe (or paint surface edge) along the left and right edges suggest that, like all post-1460 *Biccherne*, this panel once had an engaged frame, one that was attached to the panel before the painting was started; the barbe is not present at the top and bottom edges so these may have been trimmed. The usual arms and inscriptions would thus have been divided from the picture field by an unpainted border, which Beccafumi apparently intended to be seen since the drapery of the woman kneeling at the left spills over it. Comparable divisions, though more usually painted, are present in other sixteenth-century *Biccherne*. In either case, the picture is a fascinating example of the republic reinventing itself in the post-*Nove* period. Having established his reputation, ironically in the palaces of the *Noveschi* Borghesi, Petrucci and Venturi families, Beccafumi was quickly called upon by the new regime to document divine intervention in the restoration the city's liberty. The brand of (seemingly) Cosimo de' Medici on the reverse, tallying with the presence of Medici coats of arms in later sixteenth-century *biccherne*, is a poignant testament to the transience of this republican resurgence, and a reminder of the full-scale Tuscan appropriation of Siena's government offices that was to come. CP

1 The subject was first identified by R. Eisler and G. Cecchini (1948, pp. 119–21). An older record of the picture's subject is recorded in the inscription *'storietta della chiavetta'* by Lord Burlington on a label on the back (copied from the old frame). For literature on ceremony and the Battle of Camollia, see most recently Mussolin 2006, pp. 254–61 and the bibliography given in his note 22.

2 The event is recounted by the Sienese historian Pecci 1988 edn, pp. 214–15; see also Mussolin 2006, p. 255.
3 Pecci 1988 edn, pp. 211–13; Mussolin 2006, pp. 255–61.
4 Pecci 1988 edn, pp. 214–15.
5 Norman 1999, pp. 3–4
6 Toti 1870, pp. 24–32.
7 V. Ascani in Tomei 2002, pp. 218–19.
8 The artist was probably Dietisalvi di Speme, though some attribute it to Guido da Siena (Museo del Opera, Siena, after 1261, tempera on panel).
9 Norman 1999, pp. 29–33.
10 For the history and reconstruction of the chapel see M. Butzek, ' Donatello e il suo seguito a Siena. La Capella della Madonne della Grazie: una ricostruzione' in Angelini 2005, pp. 83–103.
11 Eisler and Cecchini 1948.

SELECT BIBLIOGRAPHY

Sanminiatelli 1967, p. 99; M. Folchi in Torriti 1988, pp. 128–3, no. P51; M. Butzek, 'Donatello e il suo seguito a Siena. La Capella della Madonne della Grazie: una ricostruzione' in Angelini 2005, pp. 90–1, 94, 98–9.

95.
Saint Bernardino preaching in the Campo, Siena, 1528–9

Pen and brown ink, grey and grey-blue wash on paper
15.5 × 22.3 cm
Fitzwilliam Museum, Cambridge
Accepted by H.M. Government in lieu of tax
and allocated to the Museum in memory of
Dr and Mrs Alfred Scharf (PD.39-1993)

96.
Saint Bernardino preaching in the Campo, Siena, 1528–9

Oil on panel, 31.7 × 42 cm
Fitzwilliam Museum, Cambridge
Accepted by H.M. Government in lieu of tax
and allocated to the Museum in memory of
Dr and Mrs Alfred Scharf (PD.40-1993)

Beccafumi painted Saint Bernardino more than once. This painting (cat. 96) is one of five narrative scenes that once formed the predella of an altarpiece representing *The Mystic Marriage of Saint Catherine* that Beccafumi painted for the Gambassi family chapel dedicated to the Pietà in the Dominican church of Santo Spirito in Siena, where it was installed on 20 March 1529 (fig. 80–4).[1] Vasari saw it there, and praised it for its artful effects of colour and light, as well as its judicious design, reporting that the main panel and 'several figures in the predella' won Beccafumi much honour and further commissions. Contemporary sacristy records documenting the altarpiece's installation note that it had a gilded and painted frame and was valued at the substantial sum of about 200 ducats, but little else has hitherto been discovered about the commission or patron.[2]

Vasari named five narrative scenes in the altarpiece's predella, of which three survive in the original and two in the form of sixteenth-century copies on canvas.[3] These narratives represent scenes from the lives of the principal saints in the main panel – Saint Catherine of Siena and four of the seven saints who attend them. Apart from the central *Baptism*, he describes first the sequence in which Vasari mentions them accords with the saints' positions in the altarpiece, with *Saint Bernardino preaching* furthest to the right.[4]

Beccafumi's altarpiece stands out from his other commissions of the 1520s in its

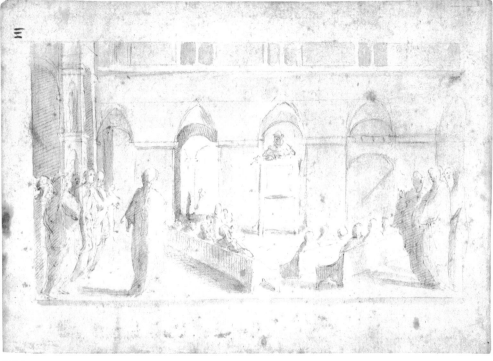

CAT. 95

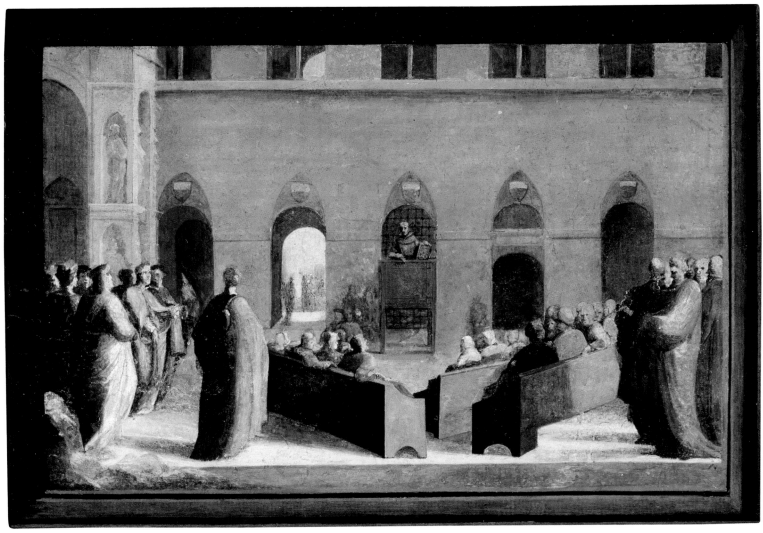

CAT. 96

orderly construction and rational symmetry, and its obvious debt to Fra Bartolomeo has frequently been noted.⁵ Its main panel, with the Virgin enthroned at the top of broad steps and flying angels supporting a canopy above her head, pays specific homage to the friar's altarpiece for the chapel dedicated to Saint Catherine in the Observant Dominican convent church of San Marco in Florence of 1512–13, of which the Sienese church was a dependant. Artistic links with San Marco were emphasised by the presence in the church of works by Albertinelli and Fra Paolino, Florentine artists closely connected with the Observant Dominican headquarters.

Beccafumi's reversion to an old-fashioned format, Virgin and Child flanked by Saints, was reinforced by his inclusion of a narrative predella, again a form outmoded in most Italian centres by the second decade

of the Cinquecento but maintained until much later in the century in Siena. Here again there may be a link with San Marco, for the ultimate inspiration of Fra Bartolomeo's, and hence Beccafumi's, altarpiece was the high altarpiece of the church of San Marco by Fra Angelico. Possibly Beccafumi further underscored Santo Spirito's links with the Florentine foundation in reviving, in the sharply defined, flame-like folds of his figures' draperies, a more 'Gothic' style, in a self-conscious attempt to recall the Observant preachers' heyday, as represented in his predella by Saints Dominic and Bernardino.

The scene of *Saint Bernardino preaching* is another, still rare instance of an accurate view of Siena in Beccafumi's paintings – though somewhat pared down in his characteristic tendency towards abstraction.

The saint is shown preaching from his pulpit set up in front of the Palazzo Pubblico, its Gothic portals surmounted by the distinctive *balzana*. At the far left is a partial view of the Cappella di Piazza. To Bernardino's right is the main doorway into the Palazzo, through which we glimpse figures in a sunlit courtyard beyond. Only in the upper storey did Beccafumi take a small liberty, replacing the triple mullioned windows of the actual façade with biforate openings. He must also have been following earlier images of San Bernardino preaching, as his positioning of the pulpit in relation to the Palazzo Pubblico and the Cappella di Piazza broadly conforms to the Quattrocento tradition (see fig. 8 and cat. 6–8). Despite such direct visual testimony, the scene of Bernardino's preaching in a recognisable setting was not much perpetuated in

FIG. 80

FIG. 81

FIG. 82

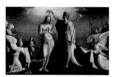

FIG. 83

FIG. 84

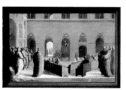

CAT. 95

the tradition of his iconography. The vast majority of independent images of him depict him either alone or in the pulpit, as in cat. 5, frequently holding his tablet with the trigram of the Holy Name of Jesus.

Notwithstanding Vasari, who describes this predella as Saint Bernardino preaching to '*un popolo grandissimo*', Beccafumi diverges from the earlier images precisely in not showing a huge congregation, with men and women segregated and kneeling in ardent prayer. Instead he shows just three benches, arranged in a rather counter-intuitive denial of centralised perspective (again perhaps intended to echo Quattro-cento solutions) around the friar's pulpit. The diminutive friar, lacking even a halo, is distinguishable principally by his habit and the *tabulella* bearing his trigram. The atmosphere, far from fervent, is somewhat languid and detached, with some of the congregation leaning back on their elbows, while behind the benches other aristocratic-looking figures, dressed in long timeless robes and turbans, elegantly drift about, casting long shadows in the early morning light. Beccafumi has transformed a scene of citizenry united by faith into what seems to be a secular gathering of oligarchs. As Pavone has pointed out, he exaggerated this sense of detachment still further when he came to paint the scene again several years later, as part of the predella of his altarpiece for the Oratorio of San Bernardino of about 1535–7 (fig. 85).[6] In that version, Saint Bernardino is cast all but unrecognisably into shadow, while a vacant chair in the 'front row' (meant for the viewer?) and a woman turning away from the pulpit to attend to her child under-score still further the audience's aloofness.[7]

The *Saint Bernardino preaching* is contained within a simple brown fictive frame, a feature that must have originally surrounded all five scenes but which has been cut away from the other surviving predella panels. Above the bottom moulding a further painted strip creates the impres-sion of a stage upon which the action is played out (a feature that recurs in the main panel and all the other predella scenes, apart from the *Baptism*). This theatrical effect is enhanced by the strong lighting of the scene from the right, emanating as if from 'the wings' behind the frame. At the left, masking the transition between fictive frame and stage, are what appear to be loosely painted rocks and vegetation, adding to the sense of illusion and artifice. Such playfulness shows how artfully Beccafumi adapted his inventive modernity to an archaic format.

Beccafumi made a drawing for this scene before painting the predella. Although Sanminiatelli was the first to relate the present drawing to cat. 96 in print, it was Alfred Scharf who first made the connection, buying first the painting (interestingly, as by Fra Bartolomeo) and then the drawing three years later. Although it has occasionally been judged a *ricordo*, this delicate sketch, about half the size of the predella panel, contains enough minor differences (the shape of the benches, the slightly alternative view) to suggest that it is preparatory.[8] In addition the figures on the left are drawn over the vertical lines of the loggia, implying that the composition had yet to be fully worked out. It is revealing that the painting, which gives the impression of having been dashed off swiftly in the manner of an oil sketch, was so carefully and painstakingly

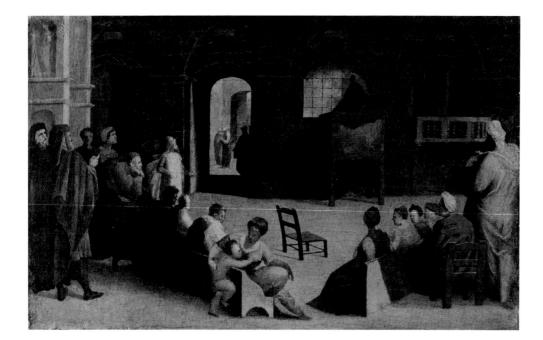

Fig. 85
Domenico Beccafumi (1484–1551)
Saint Bernardino preaching, 1535–7
Oil on panel, 32 × 51 cm
Musée du Louvre, Paris (RF 1966-1)

prepared. For all his innovative technical experiments, Beccafumi's method remained rooted in traditional Tuscan principles of compositional design. CP

1 The date in the document is 1528, Sienese style, but being in March, this translates into modern style 1529. Consequently the altarpiece has always been dated a year too early. The chapel, dedicated to Saint Dominic, was granted to the eponymous Domenico, eldest son of the goldsmith Biagio di Francesco da Gambassi, and his brothers Bernardino and Antonio on 20 April 1509 (ASS, Notarile ante-cosimiano, 981; information kindly supplied by Philippa Jackson). After his death in 1517, Domenico's heirs were obliged to fulfil his commitment to provide an altarpiece: see Mussolin 1997, pp. 117–19. At present there is no clue as to why there was such a long interval before the altarpiece was realised, though such delays were not uncommon. The presence of Saints Dominic and Bernardino in the altarpiece and the predella may reflect the names of two of the Gambassi brothers, though this does not explain the absence of the youngest brother's name saint, Anthony.
2 Romagnoli Ante 1835, VI, fol. 539.

3 These were first identified by Sanminiatelli 1967, nos 41–3.
4 Bisogni 1981 (no. 8, pp. 35–6) observed that Vasari makes no mention of further predella or framing elements relating to the three remaining saints in the altarpiece, Catherine of Alexandria, Peter and Paul, and it is an open question as to whether such narratives existed.
5 See particularly F. Sricchia Santoro in Sricchia Santoro 1988, pp. 100–2, no. 22, who also makes the link between the Observant Dominicans in the two convents.
6 The other narrative elements of the dismantled predella are also now in the Louvre, Paris. Pavone and Pacelli 1981, II, in *Iconografia*, p. 92.
7 *Ibid.*
8 Pike Gordley 1988, no. 51x, classified the drawing a weak copy but the dancing line of the black chalk, the vigour of the pen hatching and the delicacy of the wash together with all the minor variations, and indeed the greater elegance with respect to the painting, suggest that this is not the case.

SELECT BIBLIOGRAPHY

F. Sricchio Santoro in Siena 1990, p. 164; M. Folchi in Torriti 1998, pp. 130–3, no. P53c.

97.

DOMENICO BECCAFUMI (1484–1551)

The Stigmatisation of Saint Catherine of Siena, mid 1540s

Oil on panel, 55 × 37.5 cm
Museum Boijmans Van Beuningen, Rotterdam (2898)

Beccafumi's *Stigmatisation of Saint Catherine of Siena* was painted at speed and with startling economy, with the sketch-like quality of some of Beccafumi's predellas and an almost audacious disregard for refinement or polish. Yet it is too large to have functioned as a predella, and it was probably made as an image for private devotion. A well-defined gesso barbe on all four sides suggests that this robust panel (3.7–4 cm thick) once had an engaged frame, but there is no other clue to its original function as the back is smooth and the edges have been regularly sawn. The painting verges on being a *grisaille*, the only colours the deep red in the altar frontal and Catherine's book, and the blue in the flat surfaces of the architecture and the pattern on the white altarcloth. A remarkable feature of the painting is its subtle chiaroscuro effect, which Beccafumi achieved by exploiting the warm biscuit-coloured ground as the middle tone. The 'golden' lines of the stigmata and the haloes, for example, were scratched into this paint when it had dried, probably with the blunt end of his paint-brush, but were never gilded. The floral pattern of the altar frontal was made, too, by stabbing into the red paint with the end of the brush: again the spots are not paint but the underlying gesso laid bare. The candlesticks are simply reserved shapes, and other areas, such as the faces of Christ or the nuns in the doorway, are barely painted, except for rapid daubs of black and white to suggest their features.[1] The bravura with which the overall effect is achieved reveals considerable facility and experience and is reminiscent of Beccafumi's chiaroscuro experiments in other media in the 1530s or early 1540s.[2]

Saint Catherine's stigmatisation (for which see cat. 9 and 89–91) was set by Beccafumi in a classical Renaissance chapel interior. As other painters had done before him, he combined both what witnesses saw (Catherine on her knees with arms and hands raised) and what Catherine beheld with her inner eye (the stigmata descending in the form of pure light). The saint, wearing the black Dominican mantle over a cream habit and the white veil of a tertiary, kneels before an altar with her attributes of a lily and a book beside her on the steps. On the altar are two gilt candlesticks and a 'calvary' (a rock with the skull and cross-bones of Golgotha, from which emerges a large crucifix), inclined towards Catherine. The figure of Christ on the cross is lightly sketched in pure white, and hovers ethereally between darkness and light. From his wounds rays shoot down to confer equivalent stigmata on Saint Catherine's hands, feet and side (Beccafumi, perhaps incising them too fast, connected the rays to the opposite hands). She looks up in ecstasy, her face lit as if from within with that 'marvellous goodly and clear brightness' that Raymond of Capua describes in his account of her. In an inner chamber in the background, an elderly nun, one of Catherine's companions who observed her ecstasy, has cast aside her book to sleep. Her presence recalls Saint Francis's friend, Brother Leo, who was frequently shown sleeping while Francis received the stigmata – thereby aligning the Dominican miracle with the Franciscan tradition.

Beccafumi had painted this subject three times before, but not since the mid 1510s. A fresco formerly in the Palazzo Lucherini and now in the chapel of the Palazzo Chigi

Saracini in Siena is roughly contemporary with Beccafumi's great altarpiece of the *Stigmatisation of Saint Catherine with Saints Benedict and Jerome* for the Olivetan monastery of San Benedetto fuori Porta Tufi of 1514–5 (now Pinacoteca Nazionale, Siena).[3] In both these works, Beccafumi rendered the narrative iconic, in imitation of the only other large-scale treatment of the subject then known in Siena, Bernardino Fungai's altarpiece (1493–7) made for the Oratorio della Cucina, at Catherine's Santuario.[4] Beccafumi further produced a narrative predella of the scene for a now lost altarpiece, again of around the mid 1510s (this painting, along with another of *Saint Catherine receiving Holy Communion from an Angel*, is today in the Getty Museum, Los Angeles).[5] In cat. 97, Catherine's pose is very close to that in Beccafumi's own early monumental versions, although reversed, and he has adapted the iconic image for a smaller format suitable for private contemplation. In his earliest rendition of the scene, the Palazzo Lucherini fresco, Beccafumi had adhered to the rather meek and placid pose of the saint found in Fungai's altarpiece and other images associated with the saint's cult, in which the saint's hands are either passively lowered or only rather tentatively raised.[6] But in the San Benedetto altarpiece, the Getty predella and the present work, Beccafumi gave the saint a more dramatic pose, with her right arm extended. This recalls much more closely the iconography of Saint Francis receiving the stigmata – even though both Popes

Sixtus IV and Innocent VIII in the fifteenth century had firmly ruled that Catherine's stigmata, unlike Francis's, had only been visionary.[7] In Siena, Catherine had often been depicted with visible stigmata nonetheless (the wounds are discreetly shown in the saint's hands in cat. 9). Perhaps Beccafumi sought once more to re-assert the Dominican claim for physical stigmata; and in doing so he has reverted to the formula devised by Giovanni di Paolo, who superbly captured the saint's passionate mysticism in his maenad-like depiction of her stigmatisation in the predella of an altarpiece for the church of the Hospital of Santa Maria della Scala, painted shortly after her canonisation and before the controversy between the two orders had been unleashed.[8] CP

1 Many of these observations are due to Duncan Bull, who very kindly examined the painting during its conservation prior to the exhibition.
2 Sanminiatelli's late dating to the 1540s has been widely accepted (1967, pp. 117–18, no. 68).
3 M. Torriti in Torriti 1998, pp. 67–9, no. P8, and 72–4, no. P11.
4 Bacci 1947, pp. 49–59.
5 M. Torriti in Torriti 1998, pp. 74–5, nos. P12 a, b.
6 See for example Matteo di Giovanni's painting in the Musée du Petit Palais, Avignon (MI 578): Laclotte and Moench 2005, p. 153, no. 189; Pacchiarotti's bier-head is in the Oratorio di Santa Caterina della Notte: A.M. Guiducci in Loury and Loury 1992, pp. 275–6, cat. 124.
7 For the controversy see Barbara Pike Gordley's succinct summary (Pike Gordley 1992, pp. 396–8).
8 C.B. Strehlke in Christiansen, Kanter and Strehlke 1988, pp. 230–3, cat. 38e.

SELECT BIBLIOGRAPHY

Sanminiatelli 1967, pp. 117–18, no. 68; C. Alessi in Torriti 1998, pp. 182–3, no. P80.

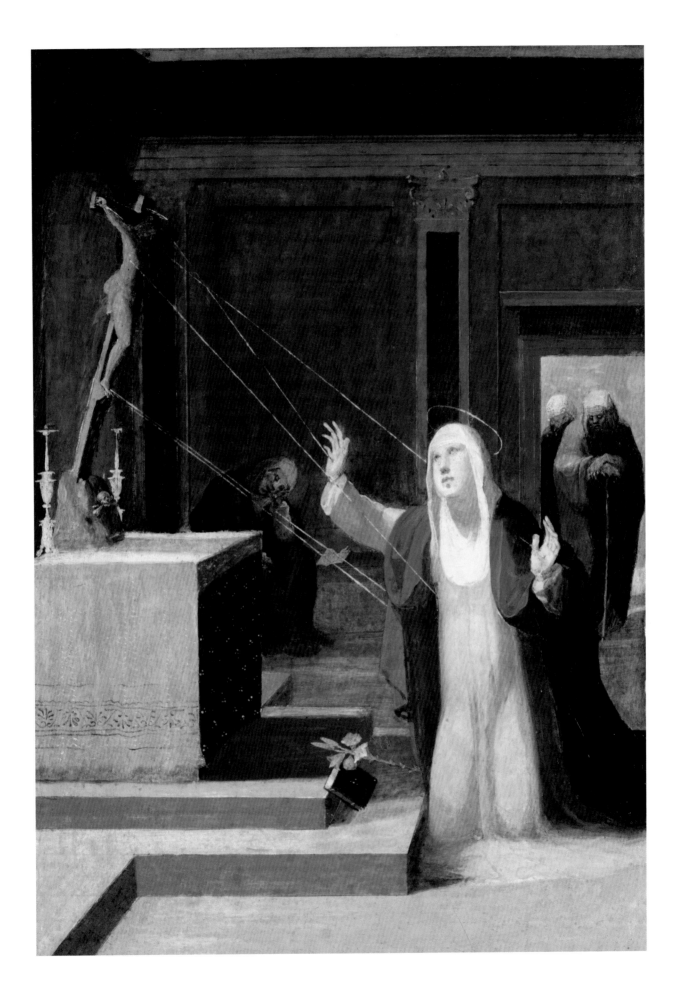

Private Devotion

DOMENICO BECCAFUMI
(1484–1551)

98.
The Virgin and Child with Saint Jerome and Infant Saint John the Baptist, about 1519

Oil on panel, 85.5 cm diameter
Museo Thyssen-Bornemisza, Madrid (33)

99.
The Virgin and Child with Saints, about 1528–9

Pen and brown ink on paper, 10.1 × 10.4 cm
Gabinetto Disegni e Stampe degli Uffizi, Florence (1267 F)

At the end of his biography of the artist, Vasari mentions that Beccafumi painted 'many other works of little importance, such as pictures of the Madonna and other similar things for private devotion [*da camera*]', singling out a 'very beautiful Virgin' in a round tondo format for the mathematician Pietro Cataneo, the artist's brother-in-law.[1] Certainly rectangular Madonnas for domestic environments were stock-in-trade for most painters of the period, including Beccafumi, but he also painted an unusual number of tondi of *The Virgin and Child with Saints*, or *The Holy Family with Saint John the Baptist*, introducing to the Florentine format his own distinctly Sienese brand of mysticism, ethereal light effects and surreal colours. No fewer than sixteen tondi are known (though many more reflect Beccafumi's influence), mostly dateable before 1530 and

almost all measuring a seemingly standard size of 70 to 90 cm in diameter. The fashion for devotional tondi peaked in Florence in the last two decades of the fifteenth century, spreading to the rest of Tuscany and beyond, before tailing off around 1520; in Siena, however, it lingered on, shored up by a strong local tradition that was perhaps partly inspired by the presence and patriotic associations of Donatello's marble tondo of the *Virgin and Child* relief in the Cathedral, which Beccafumi himself painted *in situ* (see p. 52 and cat. 94).[2] Beccafumi, Sodoma and Bartolomeo Neroni (documented in Siena 1532; died 1571) all continued to paint tondi well into the third and fourth decades of the century, and even in the early 1540s, until he left the workshop for Rome, Beccafumi's pupil Marco Pino was producing examples in his master's style.[3]

The convention of representing Christ's miraculous birth in tondo form may have evolved from the *desco da parto*, a painted tray used to carry celebratory offerings to women after they had given birth and subsequently displayed in the home.[4] The circular form was particularly appropriate for the subject because it also alluded symbolically to the perfection of the heavenly spheres, and therefore denoted a sacred space within a more secular environment.[5] Tondi were frequently embellished with ornate carved and gilded frames: fine original frames survive around several tondi by Beccafumi, two carved by the virtuosi woodcarvers Antonio and Giovanni Barili.[6] Beccafumi was particularly fond of round formats.[7] He frequently inserted roundels into other works, such as the remarkable *Virgin and*

Child tondo revealed by angels in his Saint Paul altarpiece for the Church of San Paolo (which no longer exists) – a painting within a painting. His association in his devotional works of the circle with Heaven is perhaps best exemplified by the four angels playing ring-a-roses in a perfect circle around the dove of the Holy Spirit in his Marsili altarpiece of *The Nativity* for San Martino.[8]

This early tondo by Beccafumi came to light when it was bought by Baron von Thyssen in 1981. The sweetly smiling infant Christ, seated as in many Quattrocento representations on a tasselled cushion, is distracted from his reading by the looming presence of Saint Jerome who gazes intently at Christ, his rock clasped to his breast. On the other side of the Virgin is a jovial infant Saint John the Baptist displaying a scroll announcing Christ as the Lamb of God. In contrast, the Virgin's expression is pensive in the foreknowledge of the sacrifice of her innocent child. Both her downcast gaze and the arrangement of her headdress recall Jacopo della Quercia's vision of charitable maternity personified in his sculpture of Acca Laurentia on the Fonte Gaia (fig. 69).[9] The lime-green lining of her mantle makes a fantastically shaped frame for her head and shoulders. It falls from her shoulders in a heart shape (in an exaggerated and more abstract echo of Quattrocento antecedents), converging at the symbolic heart of the painting in the pages of the devotional book with its allusion to Christ's miraculous birth from a virgin mother. The Latin inscription reads, '[God] the Father gave me this Virgin Mother'.[10] Beccafumi left his description of space intentionally vague, with an abstract green landscape on the left and a

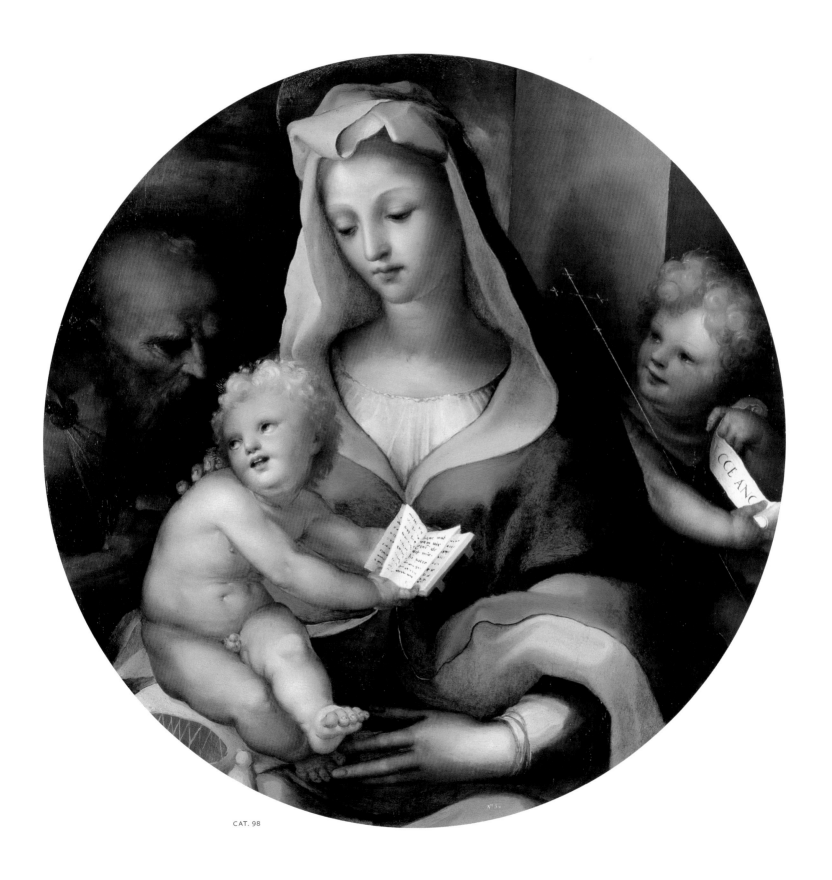

CAT. 98

CAT. 99

simple *pietra serena* pier on the right (a similar vertical element appears to the left of the Virgin's head in his drawing for a tondo, cat. 99). As if to underscore the message that Christ here represents the intersection of the divine with the human, the painting is lit both from 'our' world, the Virgin's head casting a shadow on to the pier behind her, and by an unexplained, apparently more supernatural, light glimmering from the undefined space beyond. Although the viewer is meant to perceive the figures in a sacred realm of their own, as if glimpsed through a porthole or *oculus*, Christ's foot protrudes out into the viewer's space as if it might be touched in veneration.

Apart from two early examples, painted in a more naturalistic style inspired by Fra Bartolomeo, Beccafumi invariably showed the sacred figures in his tondi in an intimate, close-up view, with no anecdotal distractions, thereby charging these images with greater devotional intensity. In the present work and in other tondi of the late 1510s, Beccafumi appears to have self-consciously returned to a traditional,

specifically Sienese idiom in which the Virgin appears in a compressed foreground space with saints tucked in tightly behind her shoulders (there are countless Quattrocento examples; see cat. 14–16). The tenderness of the Virgin, her long elegant fingers just touching Christ's toes and resting lightly on his shoulder, again keys into a much older tradition, stretching all the way back to the thirteenth-century *Madonna delle Grazie* (fig 27, p. 55). The use of brilliant colour was also a particular speciality of earlier Sienese art, but is here brought up to date with the introduction of lime greens and brilliant yellows (perhaps inspired by Michelangelo's Sistine ceiling) set against the more traditional blue and rose of the Virgin's attire. The use of contrasting colours to outline the rhythmic undulations of the mantle's border, light against dark and dark against light, is also reminiscent of Michelangelo's technique. The impishness of the children relates to Raphaelesque models, and the turn of the Christ's Child's head and his cheerful expression may owe a debt to a lost tondo by Raphael, known as the *Madonna del Silenzio*,

that was almost certainly painted for a member of the Piccolomini family and would have been one of the earliest imports of the new format from Florence.[11] Cat. 98 thus shows Beccafumi absorbing the innovations of his contemporaries while drawing on an established Sienese tradition.

There is no clue as to who commissioned this tondo, which probably dates, by comparison with cat. 104–6, to around 1519. The popularity of Saint Jerome and the Baptist in Sienese painting is discussed in cat. 14, and 33–7 though the former appears rather infrequently in Beccafumi's œuvre – as a penitent in only one independent image (cat. 100) and in three other small *Madonnas*, and as cardinal in a single altarpiece.[12] Bisogni, who rightly suggested that Saint Jerome 'ignites the visionary quality of this picture', aptly characterised his looming presence as 'a large venerable head of great moral severity created more by contrasts of light and shade than colour'. Indeed, Jerome's head, with bushy brows and beard, is executed with a freedom and sketchiness comparable to some of Beccafumi's future

experiments with the oil-sketch form, encapsulating the intensity of the saint's gaze with startling modernity (from his low position in the picture the old man is surely meant to be kneeling). The sobriety with which he is depicted, compared to the colour and light with which the sacred figures are infused, puts him at one remove from them, prompting a similarly devout attitude in the viewer. Conceivably, as may be the case for cat. 14–15, the tondo may have been commissioned by a member of a lay confraternity dedicated to penitential activities.[13] The infant Baptist, on the other hand, was represented in almost every tondo painted by Beccafumi, perhaps reflecting the derivation of the format from Florence (of which the Baptist was patron saint) as well as the importance of his cult in Siena, focused on the Baptistery and the gift to the city of the relic of his arm by Pius II.

Beccafumi's preparation for the Thyssen tondo would have included drawings similar to cat. 99, which has been associated with a later tondo representing *The Virgin and Child with Saint Sigismund and Saint Catherine*, dateable to the late 1520s (current whereabouts unknown). The saint on the left of the painting is the sixth-century Burgundian king and martyr Sigismund, who holds an orb and sceptre, the attribute of his kingship; in the drawing the corresponding figure has curlier hair, and it is hard to tell whether among the squiggles there is a circular notation anticipating his orb, but on the whole the relationship of the drawing to the lost painting, which is similar in composition and illumination, is plausible. On stylistic grounds, Sanminiatelli dated the painting close to the Santo Spirito

altarpiece of 1528–9 (see cat. 96), which interestingly also includes Saints Sigismund and Catherine. The flourishing of Saint Sigismund's cult in Siena and the *contado*, attested by many surviving fifteenth- and early sixteenth-century paintings, is yet to be explained fully. It may be connected with the sojourn in the city from July 1432 to April 1433 of King Sigismund of Hungary, Germany and Croatia, while negotiating for his coronation as Holy Roman Emperor by Pope Eugenius IV (he was accompanied to Rome by Saint Bernardino and crowned Emperor on 31 May 1433). Pro-imperial sympathies later in the century, and indeed at the time of Beccafumi's painting, may explain the revival of 'Sigismundine' imagery from the 1480s onwards.

The sheet has been cut around the circle Beccafumi first drew to mark the perimeter of his tondo composition. The drawing was clearly dashed off at considerable speed, with the artist concentrating on the relationship between the animated Christ Child and the book held by the Virgin. A welter of *pentimenti* for the child's arms and legs show Beccafumi grappling with his dynamic pose, though his frenetic exploration did little to resolve this part of the painting. A notable feature is the furious hatching-out of the parts Beccafumi wanted to push into shadow, to which the painting broadly conforms. Although he was drawing with a pen, he left the outlines of the figures as simple notations, and, as ever, it was the balance of the chiaroscuro that chiefly concerned him. Both in the free exploration of form and in his interest in tonal contrast Beccafumi was embracing Leonardo da Vinci's methods of drawing. CP

1 Vasari 1966–87, V, p. 177. In 1533 Beccafumi married his second wife, Caterina Cataneo, daughter of the bookseller Cattaneo (F. Sricchia Santoro in Siena 1990, p. 67, and Siena 1990, p. 692, doc. 155).
2 Olson 2000, passim.
3 *Ibid.*, pp. 277–80; Zezza 2003, p. 36.
4 Olson 2000, pp. 22–31; J. Musacchio, 'Conception and Birth' in Ajmar-Wollheim and Dennis 2006, pp. 125–6.
5 Olson 2000, pp. 34–57.
6 M. Folchi in Torriti 1998, pp. 132–4, nos. P54–55; a splendid original garland frame also survives around the tondo in the Doria Pamphilj collection (P56).
7 Olson 2000, p. 277.
8 M. Torriti and M. Folchi in Torriti 1998, pp. 79–80, 116–19, nos. P16, P35, P43.
9 Bisogni 1983, p. 55.
10 It may be no coincidence that the cult of the Immaculate Conception was introduced to Siena in 1526, only a few years after this picture was painted (see Mussolin 2006).
11 Henry 2004; Henry 2006.
12 M. Torriti, M. Folchi, C. Alessi in Torriti 1998, nos. P32; P77, P82, P91; and P11.
13 G. Fattorini in Alessi and Bagnoli 2006, pp. 39–43.

SELECT BIBLIOGRAPHY

Cat. 98 A. Angelini in Siena 1990, pp. 136–7, cat. 15; M. Folchi in Torriti 1998, pp. 90–2, no. P27; Pérez-Jofre 2001, pp. 202–3. *Cat. 99* A. De Marchi in Siena 1990, pp. 443–4, cat. 106; P. Giannattasio in Torriti 1998, p. 271, no. D63.

100.

DOMENICO BECCAFUMI (1484–1551)

Saint Jerome, around 1520

Oil on panel, 50 × 36 cm
Galleria Doria Pamphilj, Rome (FC 509)

Inscribed on the reverse: MECCARINO (top),
and M. 276 DI MANO DEL MACARINO (below),
with the number repeated beneath

This small panel is one of the most intense and lyrical images Beccafumi ever produced. Given the similarities with the landscapes, trees and plants in cat. 104–107, it must be almost contemporary with the Petrucci *camera* decorations and dateable to around 1520. The hermit Saint Jerome is shown kneeling outside his cave before a makeshift altar composed of a hummock with a slender tree growing out of it. From this a crucifix is suspended, while lower down hangs a brilliant red cardinal's hat, a symbol of the high office he went on to hold at the papal court.[1] In one hand the saint holds a rosary and in the other a rock with which to beat his bare chest.[2] The crucifix is shown from behind so as to afford a clear view of Jerome's face as he gazes up at it, his manifest sorrow and repentance clearly intended to inspire similar feelings of penitent devotion. Behind Jerome is his tamed lion, miniaturised to the scale of a pet dog, whose grimace seems to mimic the pained expression on the saint's face. Although the scene represents Saint Jerome's retreat to the desert of Chalcis in Syria, the bare earth touched with green, and the verdant valley with rocky mountains beyond, are more reminiscent of the Sienese *contado* in springtime.

The image of Saint Jerome in penitence had long been popular in Siena, linked above all to the Gesuati and lay followers at the beginning of the fifteenth century. He was also an important saint for several penitential confraternities that flourished in the city, many with close connections to the Franciscan order. One can surmise that this painting was executed for one of their members. One of the reasons the cult of Jerome as hermit was so attractive, both

to his devotees and to the artists they employed, was that he had not only done penance himself but had described it in vivid detail, dwelling graphically on its pains but also on its rewards. His recollection of his ascetic retreat, set down in his famous letter to Eustochium (see cat. 33), gained currency through its almost *verbatim* repetition in Jacopo da Voragine's widely read *Golden Legend* (about 1260). It was canonical among painters to reflect Jerome's account by setting the scene in harsh, rocky surroundings, but Beccafumi's version is remarkable for the atmospheric light that suffuses the scene, dispensed by the sun concealed low on the horizon beyond the rocky outcrop. This mystical dawn light is reflected in the spiky branches of the denuded trees and creates misty chromatic effects in the lovely landscape background, intimating the heavenly rewards of Jerome's abject penitence and profound identification with Christ's suffering. The brilliance of the colours and surreal, visionary effect distinguishes this painting from versions by Beccafumi's contemporaries: his image expresses more authentically than most the near hallucinatory quality of Jerome's account to Eustochium. Beccafumi's love of light and darkness, inspired here as elsewhere in his work by Leonardesque models, was an apt tool for the representation of the chiaroscuro of the soul.

Despite Saint Jerome's popularity in Siena, reflected in the frequent choice of the name Girolamo for boys, Beccafumi painted him surprisingly little. The present work is his only independent image of Jerome as a penitent, though he features with the rock with which he beat his breast in remorse in the background of cat. 98 and in three other

smaller Madonnas. This rarity of representation was probably due to the fact that the subject had distinctly Franciscan overtones in Siena, where Beccafumi was more active for the Dominicans and other orders. Admiration for Beccafumi's transcendent image is attested by the existence of several copies, mainly of the sixteenth century.[3] CP

1 Jerome was never made a cardinal as he lived three hundred years before the office was introduced. His ordination as a 'cardinal priest' is an anachronism already upheld in the *Golden Legend*, which may be one reason why he came to be portrayed in cardinal's robes.
2 Jerome spoke of beating himself but never mentioned a stone; this was an element that became popular in artistic representations of the fifteenth century.
3 Sanminiatelli 1967, pp. 87, 195, no. 25.

SELECT BIBLIOGRAPHY
Sanminiatelli 1967, pp. 87, 195, no. 25; M. Folchi in Torriti 1998, pp. 108–9, no. P32.

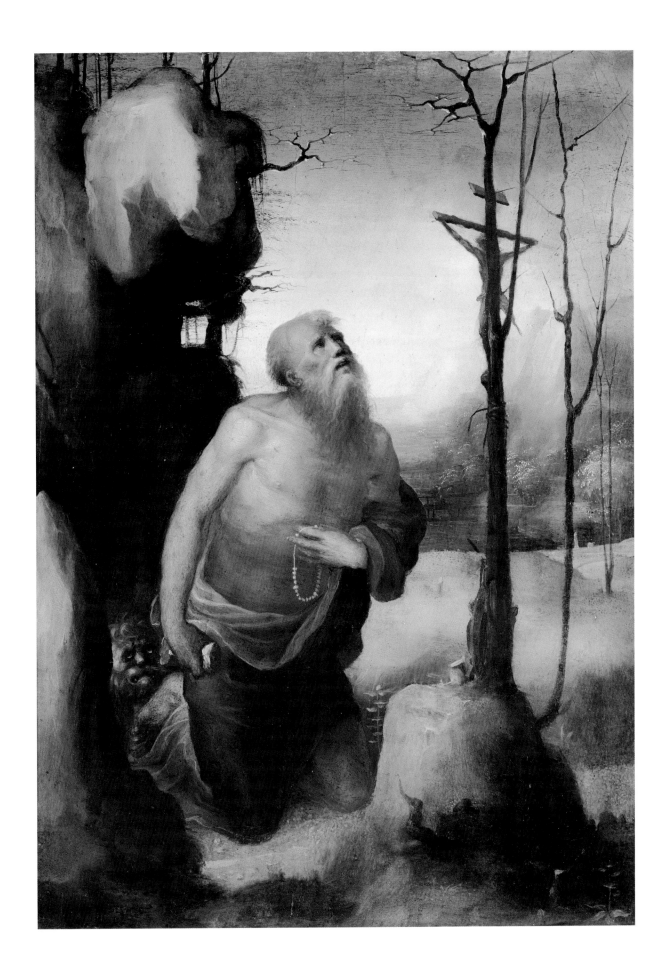

Palace Decoration

101.

DOMENICO BECCAFUMI
(1484–1551)
Design for the façade decoration of the Palazzo Borghesi, about 1514

Pen and brown ink, with brown wash, touched with red and orange watercolour, over black chalk, on paper
41.7 × 20.1 cm
The British Museum, London (1900-7-17-30)

Inscribed in brown ink by the artist below the figure in the top left-hand niche: MARCELLO; bottom right, in ink, in an old hand: MICARINO; repeated above in black chalk; in the bottom right corner, in brown ink: 160 and NO…

Throughout his career, Beccafumi worked for private and civic patrons as well as for the church.[1] This is Beccafumi's design for the lost illusionistic façade of the Palazzo Borghesi at piazza Postierla in Siena. Vasari described the façade at some length in his *Life* of the artist: 'After Sodoma had frescoed the façade of the house of Messer Agostino Bardi, Domenico [Beccafumi] in those same times painted the façade of a house of the Borghesi family by the column of the Postierla beside the Cathedral, into which he put a great deal of effort. Under the eaves he painted a frieze in chiaroscuro of several figures that were greatly praised, and in the intervals over the three storeys between the windows of travertine of the palace, he counterfeited in bronze, in chiaroscuro and in colours many classical gods and other figures which were much better than ordinary, even if those of Sodoma earned the higher praise; and both these façades were executed in the year 1512.'[2] In fact, a date fractionally later than 1512 is established by the unusual contract drawn up between Agostino Bardi and Sodoma on 9 November 1513:[3] in return for the advance payment of a horse with a black velvet saddlecloth and gilded stirrups worth 30 gold ducats, with which Sodoma would indulge his passion for racing in the Palio, the artist was given the choice of painting either the façade of Bardi's house or an altarpiece within eight months. Sodoma evidently opted for the former, and the bulk of his work must therefore have been carried out early in 1514, with Beccafumi's project not far behind.

Vasari's detailed description, corroborated by this drawing suggests he saw the Borghesi façade while it was still well preserved.

However, in Sodoma's life he notes that the 'praiseworthy things' on the Bardi façade had already been all but consumed by 'air and time'.[4] No trace of either façade survives today, though the two palaces still stand facing each other on the via di Città at piazza di Postierla. The piazza lay between the Cathedral and the Campo on the principal route into the city from the south, and, in the late fifteenth century, the final approach from Postierla to the Cathedral precinct had been developed by leading families of the new oligarchy, many of the Gothic buildings undergoing a programme of modernisation.[5] In the heart of this élite neighbourhood, the new façades were therefore extremely prestigious, and the present drawing shows how much art and ingenuity the young Beccafumi invested in this high-profile competition with his better-established foreign rival.

It is not known which member of the Borghesi family commissioned Beccafumi's palace façade. One candidate is Pietro di Onofrio Borghesi, who had strong connections with Rome and owned a house at Postierla.[6] A member of the office of the *Ornato* (responsible for the ornamentation of the city) in 1508, he would have had a particular interest in the embellishment of his neighbourhood. This hypothesis is further strengthened by the fact that Pietro Borghesi's daughter was married to Agostino Bardi, suggesting that the two palace façades might have been interrelated commissions, designed to emphasise the families' Roman links. The only known precedent for this antique style of private palace decoration in Siena was Sodoma's façade for Sigismondo Chigi's palace at the Bocca del Casato, commissioned after the

artist's return from Rome in 1510. This was painted in chiaroscuro, and covered with victories, cupids, exemplary figures from the Bible and antiquity, battles and trophies. Like the Borghesi façade, it proclaimed the sophisticated *all'antica* taste of a family whose political alliances and investments were rooted in Rome.[7]

The iconography of Beccafumi's façade has yet to be fully elucidated, but the inscription *Marcello* confirms that at least some of the figures were heroes from Roman history. 'Marcello' might be Marcus Claudius Marcellus the Younger, nephew and son-in-law of the Emperor Augustus, and one of the illustrious future Romans whom Aeneas sees in the underworld in Book VI of Virgil's *Aeneid*, where he is described as a beautiful youth in shining armour.[8] The early sixteenth-century fashion for classical subjects on domestic palace façades was partly inspired by the rich vocabulary of Sienese civic decoration with Roman themes. The exterior of the Palazzo Pubblico was formerly adorned with scenes from Roman history painted by Ambrogio Lorenzetti in 1337 (it is not known how long these remained visible), while inside in the vestibule leading to the chapel were Taddeo di Bartolo's 1413 frescoes of Roman heroes.[9]

It has been suggested that Beccafumi might have been the author not just of its pictorial decoration but also of the *all'antica* restructuring of the Gothic façade.[10] While this cannot be proved, certainly at some point in the early sixteenth century the windows were realigned, their pointed arches converted into rectangular apertures with lintels, and the whole building was topped by a monumental cornice (fig. 86).

Beccafumi's drawing, which so dramatically transforms the very plain façade, was clearly made for presentation to his patron. It shows only the left half of the façade and omits the cornice and the ground floor. The drawing demonstrates Beccafumi's impressive mastery of architectural and perspectival principles (all the more remarkable if we were to believe Vasari's curious assertion that all he had produced in his recent two-year stay in Rome was the coat of arms of Julius II on a palace façade in the Borgo). The flat brick façade, enlivened in reality only by sober window mouldings and the string-courses upon which they rest, is transformed into a three-dimensional antique fantasy. The windows

appear to be set back in bays beneath monumental cornices, decorated with grotesque friezes. The cornices seem to be supported by pairs of pilasters, the orders varying in accordance with Vitruvian principles from Doric to Ionic to Corinthian with each ascending storey. Within the pilasters are niches, containing assertively posed martial figures, nude and clothed, '*di Dii antichi e d'altri*' in Vasari's description. Above the windows are further friezes, depicting trophies, battling horsemen and fighting *putti*. Between the windows are fictive sculptures on pedestals, the gigantic nude *putti* of the first two storeys ceding to a more dignified enthroned figure in the uppermost one. The whole is seen as from below, with progressively more of the ceilings of the bays visible, with their large rosette bosses, in each ascending storey.

Beccafumi achieved his extraordinary *trompe l'œil* illusion with varying degrees and techniques of chiaroscuro, one of his particular specialities. The dark interior spaces through the windows are blocked out with dense horizontal hatching, covered with very dark brown wash. Shallower layers of relief were created with a mixture of hatching in a variety of different directions and by the application of subtly varied washes. The introduction of watercolour, to convey the colours of the finished façade (Vasari described it as a mixture of bronze, chiaroscuro and coloured paints – exactly as in the drawing), and to accentuate details of the figures' costumes is unusual. CP

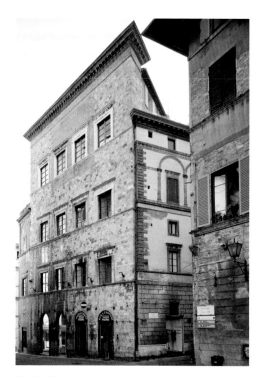

Fig. 86 The present façade of the Palazzo Borghesi at Piazza Postierla in Siena.

1 Panofsky 1930.
2 Vasari 1966–87 edn, V, p. 166.
3 Cust 1906, p. 288.
4 The comparison between the two façades might easily have been recalled by the Sienese architect and painter Baldassare Peruzzi, himself a master in the art of façade decoration, when he accompanied Vasari around Siena looking at art on one of the latter's trips to the city: Vasari 1966–87 edn, V, p. 168.
5 Nevola 2000.
6 The suggestion is Philippa Jackson's; the ensuing comments on Pietro di Onofrio are all based upon the fruits of Jackson's archival researches.
7 Like the other examples, it has long since disappeared, but some idea of its appearance can be gained from written descriptions and drawn copies; see Bartalini 2001, p. 553, note 49.
8 Plutarch devotes a long biography to Marcus Claudius Marcellus the Elder, one of the commanders of the Roman army during the Second Punic War.
9 Carter Southard 1978, pp. 117–19; Symeonides 1965, pp. 138–53.
10 Panofsky argued that the actual structure differs somewhat from that in Beccafumi's drawing, suggesting that modifications were made after his design was presented.

SELECT BIBLIOGRAPHY

Sanminiatelli 1967, pp. 35, 152, no. 69; A. De Marchi in Siena 1990, pp. 426–7, cat. 85; P. Giannattasio in Torriti 1998, pp. 240–1, no. D2.

The Petrucci *camera*

DOMENICO BECCAFUMI
(1484–1551)

102.
Lupercalia, about 1519

Oil on panel, 65.5 × 124.5 cm
Museo di Casa Martelli, Florence
(dipinti e sculture no. 52)

Inscribed: DE STERILI FIERI CVPIENS FECVNDA
LVPERCIS / HIS DET COEDENDAS NVPTA PVELLA
MANVS

(*Let the bride who wishes to transform herself from sterile
to fertile present her hands in submission to these Luperci*)[1]

103.
Cerealia, about 1519

Oil on panel, 65.5 × 124.5 cm
Museo di Casa Martelli, Florence
(dipinti e sculture no. 61)

104.
Tanaquil, about 1519

Oil on canvas and Sundeala board,
transferred from panel
92.1 × 53.3 cm
The National Gallery, London (NG 6368)

Inscribed: ·SVM TANAQVIL BINOS FECI QVE
PROVIDA REGES / PRIMA VIRVM SERVVM
[F]OEMINA [DEI]NDE M[E]VM

(*I am the prescient woman Tanaquil who made two kings,
first my husband, then my slave*)

105.
Cornelia, about 1519

Oil on panel, 91 × 53 cm
Galleria Doria-Pamphilj, Rome (FC 784)

Inscribed: ELOQUIO NATOS ALVICORNELIA
GRACCOS / QUI POENOS DOMUIT SCIPIO ME
GENUIT

(*I Cornelia nourished my sons the Gracchi in eloquence.
Scipio who vanquished the Carthaginians was my father*)

Inscribed on the reverse: N · 190 DI MECARINO DA
SIENA, repeated in a cursive hand

106.
Marcia, about 1519

Oil on panel, 92.1 × 53.3 cm
The National Gallery, London (NG 6369)

Inscribed: ·ME CATO COGNIVIT VIR MOX
HORTENSIVS ALTER· / DEINDE CATONIS EGO
MARTIA NVPTA FVI·

(*Cato knew me as my husband, soon followed by another,
Hortensius. Then I Marcia was the wife of Cato again*)

107.
Venus and Cupid, about 1519

Oil on panel, 57 × 126 cm
The Barber Institute of Fine Arts, The University of
Birmingham (62.6)

These six paintings, reassembled here for
the first time in over four centuries, most
likely formed part of the decorations
of the *camera* (bedchamber) of Francesco
di Camillo Petrucci (b. 1489), a wealthy
merchant and landowner, the nephew of
Pandolfo Petrucci. To judge from its themes
of love, fertility and wifely and maternal
virtue, the bedchamber was made in
connection with Francesco's marriage to
Caterina di Niccolò Mandoli Piccolomini
in 1512,[2] and the fact that both families
contributed to the costs of the furnishings
supports this suggestion. It seems to have
been completed around 1519, after the birth
of the couple's first son, Muzio Romulo
Maria (born 12 October 1517). Another son,
Emilio Romulo, was born on 3 August 1520
and the couple also had two daughters,
Leonora and Giulia, their birth dates
unrecorded. This was a period of prosperity
and political success for Francesco, who,
following the fall of Pandolfo's sons in 1516,
had obtained favours and lands under the
regime of his cousin Raffaelle Petrucci,
gaining a seat in the Balìa on 15 March 1516.[3]
After Raffaelle's death in December 1522,
Francesco briefly took the reins of govern-
ment, but was toppled by Pandolfo's exiled
son Fabio, who plotted with the new
Medici Pope, Clement VII, to regain power,
returning to Siena on 23 December 1523.[4]
Francesco was declared a rebel by the
succeeding *Libertini* regime, and was exiled
from the city on 17 June 1526, his possessions
confiscated by the Comune.[5] His exile led
to a series of petitions by Beccafumi and
others for outstanding payments relating
to the project of several years before.

On 26 July 1526, Beccafumi petitioned the
Comune to obtain the balance of payment

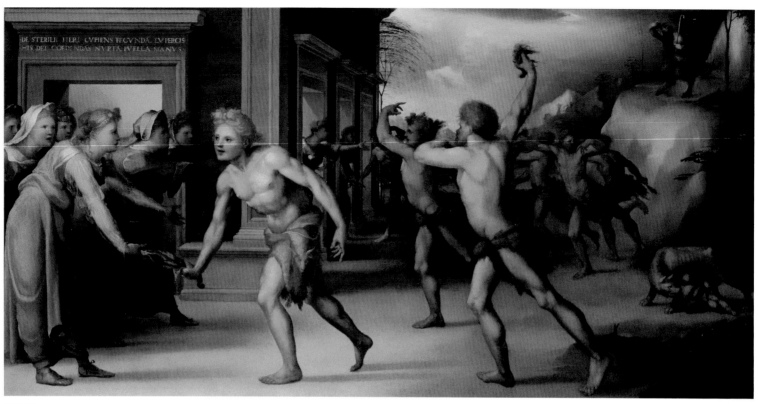

CAT. 102

for work undertaken for Francesco some time previously, which he described as 'a *lettiera* [bed] with figures and round posts, with *cornicioni* [frieze] around the whole room and a *cassapanca* [bench-chest] with pictures painted with fine colours, and all these things decorated with gold and fine blue, and an addition to the *lettiera* with figures, and all with gold and blue; for the which work, according to the judgement of a good and true master, he should have better than 180 ducats . . .'.[6] Beccafumi was seeking the outstanding balance of 60 ducats, and stated that Francesco had sold the ensemble for a good price to Scipione di Girolamo Petrucci. Scipione, the legitimised son of Girolamo di Bartolomeo Petrucci, was Francesco's first cousin. Beccafumi's renewed petition (of 4 September 1527) states that the work had been undertaken about eight years previously, thus in around 1519. In December 1527, a ruling was passed

in his favour and in February 1528 payment was made and the case closed.

A newly discovered document sheds further light on the commission. On 28 September 1526, Paolo di Lorenzo Francini, a carpenter from Montevarchi resident in Siena, also submitted a petition claiming that Francesco owed him a balance of 38 ducats for a 'seat or *cassapanca* and some other work', carried out in around 1520.[7] The *cassapanca* was valued at 70 ducats, of which Francesco had already handed over ten and the heirs of his father-in-law, Niccolò Mandoli Piccolomini, had paid thirty, leaving an outstanding debt of thirty ducats for the piece of furniture and eight ducats for unspecified work. Francini named Beccafumi, the painter Giacomo Pacchiarotti and the carpenter Giovanni il Castelnuovo as witnesses on his behalf. When called to give evidence on 11 October, Pachiarotti stated that he had seen the

cassapanca in Paolo's workshop and then in the house of Francesco Petrucci. Giovanni il Castelnuovo gave the most detailed evidence, stating that, with the help of another carpenter called Girolamo di Gabriele, he had divided up this seat and transported it from the house of the Tegliacci near San Pietro alle Scale to the palace which had once belonged to Camillo Petrucci, father of Francesco. The palace to which it was taken was one on via del Capitano which Camillo had purchased from the heirs of Antonio Bichi in 1511, and which he specifically left to Francesco in his will of February 1523, dying the following month.[8] Another carpenter, Lorenzo di Gaspare, also called as a witness, stated that he had first seen the seat in Francesco's home in the house of the Tegliacci, then in the palace of Camillo Petrucci and, finally, about three years earlier, in the house of Scipione Petrucci. It is likely that the

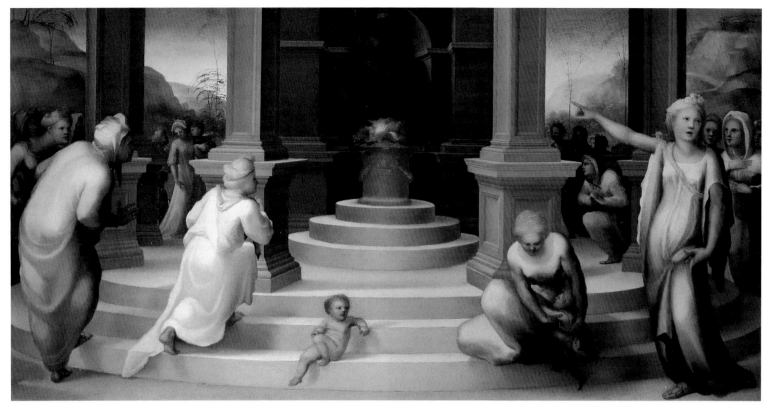

cassapanca for which Francini was seeking compensation is one and the same as the one with 'with pictures' that Beccafumi painted for Francesco.

The decorations Francesco Petrucci commissioned for the *camera* in his palace were not so much a nuptial complex, as has recently been hypothesised, as one associated with fertility, maternity, childbirth and generation.[9] The union of Francesco and Caterina did not immediately yield an heir. The date for the ensemble of 1519 suggested by Beccafumi's second petition fits much better with the birthdate of their first son and heir Muzio in 1517, and presumably expresses both their joy at his arrival and their hopes for more children, fulfilled the following year by the arrival of their second son. Francesco's marital alliance to a branch of the powerful Piccolomini family had been preceded two years earlier by his cousin Borghese's marriage to Vittoria di Andrea

Piccolomini, for which occasion Pandolfo commissioned the decorations of the apartment in the Palazzo del Magnifico that included the *camera bella* (see cat. 80–2). In commissioning his own elaborate bedchamber, with its erudite themes and allusions to antiquity, Francesco Petrucci must surely have been seeking to emulate and perhaps even to surpass the sophisticated patronage of his powerful uncle.

The association of the six pictures is based on close similarities in their luminescent style, one that fits well with the date of 1519 provided by the documents.[10] A connection between the three Heroines and the *Lupercalia* is further established by the presence in each of a Latin couplet, realised using the same elegant gilt lettering.[11] The *Cerealia*, though lacking an inscription, is identical in size and figure scale to the *Lupercalia* and has been paired with it since as early as 1632. Finally, the *Venus and Cupid*, though also

lacking any couplet, is remarkably close in style to the Heroines, sharing the same atmospheric landscape, spindly trees, similarly rendered *cangiante* drapery and notably enlarged hands and feet, typical of Beccafumi at this period. Furthermore, the *Venus* retains its original fictive frame – outer and inner brown strips outlined in white and black to give a sense of relief, enclosing an ultramarine border decorated with gold arabesques.[12] This perfectly accords with Beccafumi's repeated assertion in his petition that the furnishings were 'all in gold and fine blue'. The gold and blue colours that adorned the decorative ensemble are those of the Petrucci arms (see cat. 80–2). It is possible that more paintings adorned the *camera* than these, but none known today accord with the criteria established by this group.

It is worth reviewing the items of furniture listed in Beccafumi's petition and

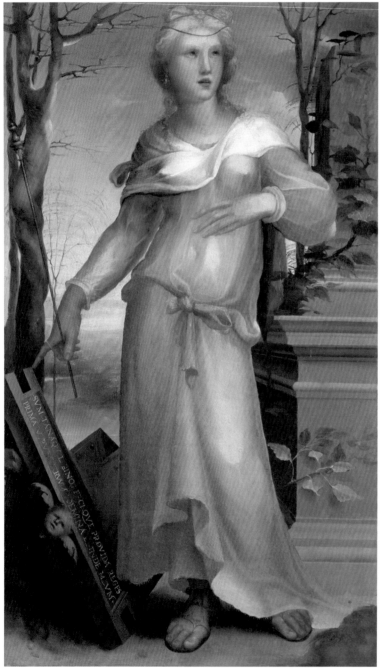

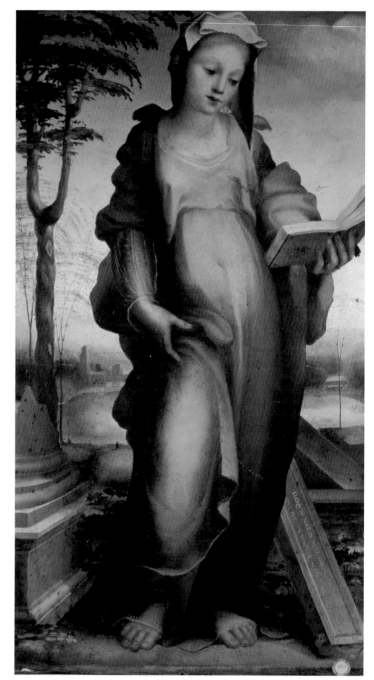

CAT. 104

CAT. 105

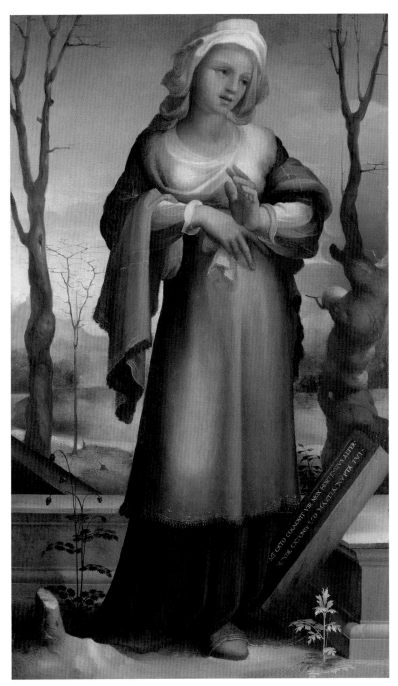

CAT. 106

speculating how the surviving paintings
might have been incorporated into the
camera.[13] The *lettiera* would have been the
main bed in the room.[14] It clearly had bed-
posts, either four, or probably two, at the
foot of the bed, the head being attached
to the wall. The 'figures' were most likely
paintings decorating the bed, but could
conceivably refer to carving in the columns.
The bed also had 'an addition … with
figures'. This was probably a structure with
a painted element that went above the
cornice of the bed, but it is impossible to be
certain about this (beds could have all sorts
of other subsidiary 'adjuncts', including
plinths, chests and seats of various types of
the kind seen in fig. 57–8). Whether it was
part of the 'addition' or an integral part of
the bed, it is very likely that the *Venus and
Cupid* (cat. 107) would have been attached
to the bedhead in some way, as this was a
conventional position for pictures of this
shape and subject. The picture has a raised
barbe at the top and bottom edges, suggesting
that it was painted in an engaged moulding,
which, presumably, formed the structure
of the bedhead.

Friezes or '*cornicioni*', such as those
described as adorning the walls of the
Petrucci *camera*, are frequently mentioned
in Florentine inventories.[15] They were plain,
intarsia or painted wooden panels framed
by cornices that formed a frieze in the upper
register of a room, well above shoulder
height. They had originated as backboards
or *spalliere* placed over painted or intarsia
cassoni, but eventually became part of the

wall decorations above. Contemporaries appear to have used the terms *spalliera* and *cornice* fairly interchangeably, but Vasari, in a famous passage on domestic furniture in his *Life* of Dello Delli, distinguished the paintings that were displayed high up as *cornici*.[16] The *Lupercalia* and *Cerealia* are good candidates for these *cornicioni*, though the fact that they surrounded the whole room implies that there may originally have been more of them (it was for others of these that Pacchiarotto might have been involved?).[17] Both panels have unpainted edges (but no barbe), suggesting they did not originally have engaged frames but were set within wooden panelling.

The seat or '*cassapanca*' would have been a bench or settle with a chest in the seat and a backboard behind. It is possible that the three Heroines were associated with this, almost certainly framed as an ensemble of three, and situated above the cornice of the *cassapanca*, high enough to be protected from the head of the person sitting down. *Tanaquil* has been transferred to canvas, but the support of *Marcia* is not the usual poplar, but a denser, smoother and heavier variety, almost certainly cherry.[18] This more expensive choice implies that the bench was an especially high-quality item in the *camera*. An excellent comparison for the arrangement is the ensemble of three exemplary heroines, *Hippo*, *Camilla* and *Lucretia*, attributed to Guidoccio Cozzarelli (about 1495–1500; private collection, Siena), the carved framework of which, with elegant fluted pilasters painted to resemble marble, constitutes a unique survival indicating how such works were originally displayed.[19] Beccafumi's Heroines are comparable in size to Cozzarelli's and were surely united

in a similar arrangement. Several other surviving groups of associated heroines, and female Virtues, must once have formed similar ensembles in Sienese domestic interiors.[20]

Although the furnishings of a Renaissance *camera* were designed for specific settings and would have been mostly fixed to the wall, they were nevertheless considered furnishings (*mobili*) rather than fixtures and, as was the case with the Petrucci *camera*, could be divided up and sold to be reinstalled elsewhere. Such items were indeed highly desirable, as we know from the Florentine carved and painted Borgherini *camera* furnishings (usually dated 1515–18) by Pontormo and others. Beccafumi may well have known this very slightly earlier ensemble, as the architectural settings of his two festival paintings seem to reflect it.

The *spalliera*-shaped panels that are likely to have formed part of the '*cornicioni*' round the room represent two ancient Roman festivals described in Ovid's *Fasti*, the Lupercalia, associated with male fertility, and the Cerealia, with female fecundity. More obscure even than the choice of heroines for the *camera*, these subjects seem to be unprecedented in pictorial art, and their inclusion in the decoration, along with the sophisticated literary allusions in the Latin couplet in *Lupercalia*, reinforces the notion that the ensemble was devised according to a scholarly programme.

Ovid's account of the Roman feast of Lupercalia, celebrated on 15 February (*Fasti*, II, 267–474), explains the derivation of its name from the cave on the Palatine where the *Lupa* had suckled Romulus and Remus – the myth so ubiquitously embraced by the

Sienese to link the city's origins to the foundation of Rome (see p. 18).[21] Beccafumi reinforced this point by including at the right of the painting the she-wolf suckling the twins, their heads beautifully reflected in the pool of water below. Her turning pose is modelled on Federighi's famous sculptural relief for the Mercanzia bench. The presence in the picture of Faunus may also be derived from Ovid's account, since he says that the Festival of Lupercalia may have been brought from Mount Lycaeus in Arcadia, a sanctuary of Pan, whom he identifies with Faunus (II, 123–4), and indeed he fuses the festival of Lupercalia with 'the rites of the two-horned Faunus' (*Fasti*, II, 267–8), another name for whom was Lupercus. Pan-Faunus was a key figure in Pandolfo Petrucci's *camera bella* (see pp. 66–7) and, in accordance with the family tradition maintained by Pandolfo's descendants, the two sons of Francesco Petrucci were given Romulus as a middle name.

Ovid does not fully describe this Lupercalian festival, which was celebrated to expiate and purify new life in the spring. From other sources, however, we know that the rites were directed by the Luperci, a corporation of priests of Faunus, who began proceedings by sacrificing two male goats and a dog, animals remarkable for their strong sexual instinct, and thus appropriate offerings to the god of fertility.[22] They then cut thongs (*februa*) from the skinned animals, clad themselves in the goatskins in imitation of Pan-Faunus (a goat's head is visible in the foremost Lupercus's pelt in the painting), and ran around the walls of the old Palatine city, striking people with the thongs. Girls and young women would

line up on their route to receive lashes from these whips. This was supposed to ensure fertility, prevent sterility in women, and ease the pains of childbirth.

The inscription over the lintel of the doorway in the painting chimes with aspects of Ovid's description of the ritual, with its emphasis on fertility, labour and childbirth:

Bride (*nupta*), why linger? No potent herb,
or prayer
Or magic spell can make you a mother:
Be patient under the blows of a fruitful hand,
And soon your husband's father will be
a grandfather . . .
 . . . the wives
Offered their backs, to be beaten by thongs
from its hide.
When the moon renewed her horns in her
tenth orbit,
The husband became a father, and the wife
a mother
Gracious Lucina, spare women heavy with
child, I beg you,
And bring the ripe burden tenderly from
the womb.[23]

However, Ovid's description of the Roman matrons offering their backs to be beaten by the goat-hide does not correspond exactly to the scene in the painting, in which, as the couplet proclaims, they proffer their hands for whipping. Indeed it has been shown that, as elsewhere in Beccafumi's rich repertoire of classical subjects, there is a cross-fertilisation of sources, so that Ovid's account was fleshed out with details from Plutarch's *Life of Caesar*, in which the women are indeed struck on their hands.[24] Cross-references to Plutarch among commentaries on the *Fasti*, in an edition like that by Antonio Costanzi and Paolo Marsi

(published in Venice in 1496), could have helped develop a more decorous iconography of this abstruse scene.

The narrative content of its pair (cat. 103) has proved hard to determine. The earliest proposal for the subject of *Cerealia* is the posthumous inventory of Cardinal Ludovico Ludovisi's possessions of 1632, where it is recorded as a 'Sacrifice of Medea'.[25] The identification of the painting as illustrating the cult of Vesta was first published, but not explained, by Mina Gregori in 1960 when the Martelli pictures were first publicly exhibited in Florence (the tradition may have been handed down in Martelli family records, since it is recorded as '*il tempio della dea Vesta con alcune vestali e altre figure*' in an inventory of 1771).[26] This identification has been perpetuated ever since. However, the goddess to whom sacrifices are being made in Beccafumi's unusual circular temple is not in fact Vesta, protectress of the domestic hearth, of whom Ovid (*Fasti*, VI, 295-98) quite explicitly states there was no effigy. This is Ceres, the goddess of growing things (particularly cereals) and motherly love, who is portrayed in the bronze statue enshrined in the niche behind the altar. With a lovely jovial face, she is clearly identifiable by the ears of corn around her head (*Fasti*, IV, 616), the sickle held aloft in her right hand and the basket over her left arm. Her altar is decorated with garlands of corn, and the women in the background wear more corn in their hair. In a passage describing the games of Ceres, the Cerealia (*Fasti*, IV, 393-416), which took place on 12 April at the beginning of the Cerealis, a seven-day festival held in her honour, Ovid associates Ceres with the labours of the ox which, he says, should be spared

from sacrifice to her; he suggests instead making an offering of the 'lazy sow', and in the painting Ceres is seated on an ox and there is a pig with a lolling tongue in the flames of the altar. He also recommends white be worn for her festival (*Fasti*, IV, 619-20), the principal colour in which the four women in the foreground are attired. The festival of Cerealia provides a far more fitting pendant to the Lupercalia, which celebrates the complimentary theme of male fertility, than the Cult of Vesta, with less appropriate connotations of virginity.[27] The cult of Ceres, with its associations of maternity, fecundity, and generation, also explains more satisfactorily the presence on the temple steps of the two small children, who would be quite out of place in a Vestal temple. The descending diagonal formed by the old woman at the left, the young woman kneeling in supplication to Ceres and the little boy reclining on the temple steps emphasises the succession of generations (the old woman's presence also acts as a visual reminder of the mother-daughter bond in the Ceres-Proserpina myth recounted by Ovid).

The three Roman heroines that adorned the bench in the *camera* are all exemplars of wifely and maternal virtue. The arrangement proposed here, with Cornelia at the centre, flanked to left and right by Tanaquil and Marcia, derives from compositional clues in the pictures themselves. There appears to be some intended continuity in the low plinth in the *Cornelia* and *Marcia* panels, which must have been adjacent to each other. There is also a symmetry in the obliquely oriented stone tablets to the left and right of Tanaquil and Marcia respectively, suggesting that they acted as

'bookends' to the trio. The glowing light in the central panel spills over into the pictures on either side. According to this scheme, the three women represent the stages through which a woman might proceed, from beautiful young bride to reflective maternity and then virtuous widowhood. This progression is reflected in the three women's costumes, and particularly in their increasingly modest headgear.

The heroines stand in ethereal dawn-lit landscapes and are surrounded by antique architectural fragments. Tanaquil is placed by a broken obelisk and Cornelia by a broken column, recalling their origins in a classical past. At the feet of each is a stone tablet inscribed with an identifying Latin couplet written in the first person. Though none of them looks directly at the viewer, Tanaquil and Marcia both appear to speak, being shown with parted lips and expressive gestures. Tanaquil motions to herself and points to the explanatory couplet; Marcia raises her left hand in greeting, and two fingers of her right hand rest on her belly, presumably signifying the two husbands whose children she bore. The erudite Cornelia, on the other hand, is appropriately more sibylline, lost in her book.[28] Like the *Lupercalia* inscription, those of the heroines do not directly quote any known source but contain allusions to multiple classical and early Renaissance texts; they must therefore have been invented by a learned advisor.

The noble Etruscan Tanaquil, gifted in the art of prophecy, was celebrated for her devotion to her husband and family, whose advancement she energetically promoted. She was the wife of Lucomo from her native Tarquinia, who, as a result of her foresight and determination, was eventually crowned as Tarquin, fifth king of Rome. On their way to the city, where Tanaquil had persuaded her husband to emigrate, an eagle flew off with Tarquin's hat, returning it afterwards to his head. Tanaquil interpreted this as a sign that the gods wanted him to become king. As queen (in the painting, she wears a simple diadem in her hair), she was one of Tarquin's most trusted advisors. She persuaded him to adopt Servius Tullius, a slave boy in their household, whose future glory she foresaw when his head was miraculously enveloped in flames. After her husband was murdered, she successfully promoted Servius, by then her son-in-law, to the monarchy, thereby protecting the interests of herself and her children.

As is the case with Marcia, Tanaquil is practically unique as a subject in art.[29] While the principal source for her story, condensed in the Latin couplet, is Livy's *History of Rome*,[30] this cannot have been the only text consulted, particularly as Livy presents Tanaquil not entirely sympathetically as a highly ambitious *femme fatale*.[31] In the painting, as Roberto Guerrini points out, she holds a spindle or distaff, an attribute celebrating a different aspect of her personality – as a gifted spinner of wool. The attribute derives from her fusion in classical and early Renaissance sources with the virtuous matron Gaia Cecilia, a central figure in the Roman marriage rite.[32] This domestic aspect of Tanaquil was admired by the Romans, who venerated her girdle (perhaps the mauve sash in the painting) and Servius's robe, both said to have been embroidered by her. The overriding themes embodied in Tanaquil are thus connected to her role as virtuous bride (Gaia) and wife (spinner), though her family-mindedness is of paramount importance as well. The two premonitions of Tanaquil, involving the eagle and flames, may be associated with the Petrucci coat of arms which combines these two elements.

Cornelia was a both paradigm of maternal dedication and a cultured and refined woman whose letters were read with interest by Cicero, explaining why Beccafumi depicts her immersed in a book. The principal source for her legend is Plutarch's *Lives* of her sons Tiberius and Gaius. She herself was the daughter of Scipio Africanus who, in an act of magnanimity and for the sake of political union, promised her in marriage to his enemy Tiberius Gracchus (for whom see cat. 68).[33] This theme of uniting families through marriage and children is shared with the *Marcia*. She had twelve children with Tiberius, but only three survived, a daughter Sempronia and her two sons, known as the Gracchi, to whom she famously referred as her 'jewels'.[34] As her inscription implies, after her husband's death, refusing other suitors, she dedicated herself to raising and educating her sons in the highest patrician traditions of service to the state.[35] She exerted considerable influence on her sons as they pushed through reform in the late Republic, and stoically bore the loss of both when they were assassinated.

Marcia personified the virtues of marital fidelity and wifely obedience, as well as fruitful maternity. The principle source for her story, employed for Beccafumi's painting, is a passage in Lucan's epic poem known as the *Pharsalia*, or 'Civil War' (II, 368–443), which embellishes an anecdote

from Plutarch's *Life* of the stoic and strictly selfless Cato the Younger (24; 52). Married as a virgin to Cato, whom she greatly loved, Marcia bore him three children. When Cato's friend Hortensius, wishing to 'join their houses in a closer tie', asked for his daughter's hand, Cato refused on the grounds that she was already married.[36] When Hortensius asked for Marcia instead, Cato magnanimously conceded his own wife 'to be a fruitful mother of his sons'.[37] Marcia then bore Hortensius several children but, once widowed, returned to Cato with the following poignant appeal:

When youth was in me and maternal power
I did thy bidding, Cato, and received
A second husband: now in years grown old
Ne'er to be parted I return to thee.
Renew our former pledges undefiled:
Give back the name of wife: upon my tomb
Let 'Marcia, spouse to Cato', be engraved.
Nor let men question in the time to come,
Did'st thou compel, or did I willing leave
My first espousals.[38]

Beccafumi's painting of Marcia appears to reflect Lucan's account of her appearance on her return to Cato, 'Wearing the garb of sorrow, while the wool / Covered the purple border of her robe'.[39] Modestly attired, and with her head covered, her expression seems to be sorrowful and she wears a coarse woollen tunic over a purple dress.

Marcia is mentioned fleetingly by Dante, poignantly divorced forever from Cato, among the virtuous heathen in Limbo (where interestingly Cornelia is also mentioned in the same line, and Tanaquil's husband Tarquin in the previous one).[40] However, Dante devotes much more space to her in the *Convivio*, turning her story into a complex allegory on the soul's progression

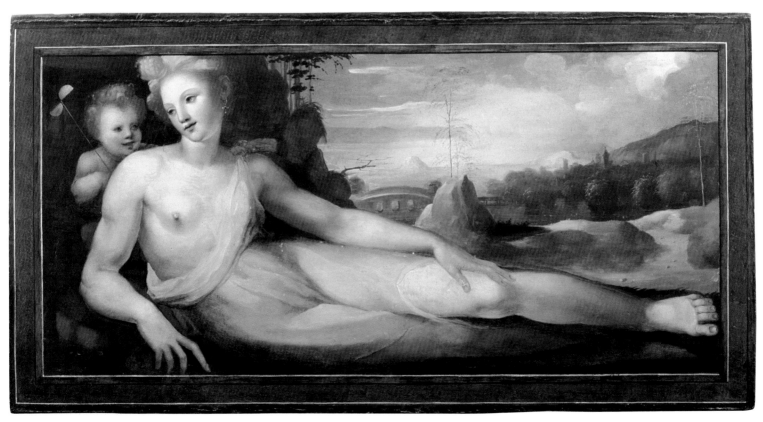

CAT. 107

331

towards God. He interprets her submission to Cato's will as 'the soul … committed to civic duties' and her return to him as 'the noble soul, perceiving that it no longer has a womb for bearing fruit … [turning] to God, who has no need of bodily members'.[41] All these complex strands explain the highly unusual choice of Marcia in the context of the Petrucci *camera*.

Venus, reclining in a landscape, resting her elbow on a grassy hummock, is a less self-evidently virtuous figure. Her bed is a mossy bank beside a spring that emerges from the mound behind her. Its waters splash into a pool, into which she sensuously dips the fingers of her right hand. Behind her, a path leads into the distance with little stones leading the way. Beyond a tumulus-like mound, a favourite motif of Beccafumi's, is a wide expanse of water with, on the far side, a bridge and a jetty, and blue mountains in the distance. The grotto-like setting has led in the past to the figure being identified simply as a nymph, calling to mind the *topos* of the guardian nymph of the spring whose sleep must not be disturbed, an appropriate theme for a bedchamber.[42] However, while languorous, this nymph is far from sleepy. Her face is flushed, and a small smile of satisfaction offers a clue to the reason for her slightly glazed look and dreamy expression. Her pink toga-like robe with lemon highlights, slit well above the knees, is loosened to reveal her right breast and clings sensuously to her belly and pudendum. Her blonde hair is done up in a classical topknot and she wears a jewelled earring like the Roman queen Tanaquil. This is surely Venus, goddess of love and fertility, and mother of the mischievous Cupid, who has come

to disturb her reverie. Her pose and in particular her curiously masculine broad shoulders and small breasts seem, once again, to derive from a sculptural relief by Federighi. A reclining female nude of just this type (another Venus?) is included in the lower frieze of his Pozzetto del Sabato Santo in the Cathedral, where she lies with a similarly naked man (Mars?).[43]

The subject of Venus and Cupid for bedheads gained popularity in the sixteenth century, growing out of the fifteenth-century tradition of reclining nudes painted inside the lids of marriage chests. One by Beccafumi, 'a Venus by Mecarino taken from a bed' is listed in an inventory as early as 1603.[44] There survive many similarly shaped Sienese panels depicting a reclining Venus with Cupid, sometimes including a second *putto* holding different varieties of revolving toy.[45] Here it is Cupid himself who holds a whirligig, signalling that he is also Folly or Jest, whose revolving plaything would remind the viewer that the world goes round and the generations turn. The picture wittily subverts the more high-minded exemplars of virtuous motherhood displayed elsewhere in the bedroom complex. Eros and his sensual mother presided at the head of the conjugal bed, both celebrating and inspiring generation.
CP

1 I am grateful to Caroline Elam for checking and improving the translations of all the Latin couplets.
2 ASS, Gabella, 335, fol. 21v: Antonio Campana 26 January 1511 (1512 new style). Record of marriage contact between '*Francesco filius Camulli Bart' de Petruccis*' and '*Caterina di Niccolo di Lorenzo Mandoli Piccolomini*' with a substantial dowry of 2,000 florins. I am grateful to Philippa Jackson for this.
3 ASS, Balìa, 64, f. 5r. Francesco was only allowed to sit when his father Camillo was absent however. Again, I am grateful to Philippa Jackson for this reference.
4 Pecci 1988 edn, I, part ii, pp. 102–4; Terziani 2002, pp. 199–209.
5 ASS Balìa, 270, fol. 24r; Pecci 1988 edn, I, part ii, p. 202.
6 Borghesi and Banchi 1898, pp. 433–4; S. Moscadelli and C. Zarilli in Siena 1990, p. 689, doc. 131.
7 This petition and the related court documents (ASS, Curia del Placito, 674) were discovered by Philippa Jackson.
8 For the will of Camillo Petrucci dated 25 February 1522 (1523 in modern dating) see ASS, Notarile ante-cosimiano, 1909 (doc. 74). On this palace, formerly owned by Antonio Bichi, see Nevola 2000, pp. 187–8; Philippa Jackson points out that it was bought from Bichi's son Firmano by Camillo Petrucci on 16 December 1511 (ASS, Notarile ante-cosimiano, 1001, doc. 3061).
9 M. Folchi in Torriti 1998, p. 93, under nos. P28A and B. R. Bartalini in Siena 1990, p. 132, under no. 14, notes that the marriage took place earlier, but still considers it a nuptial complex.
10 Sanminiatelli 1967, p. 85. Sanminiatelli was the first to associate Beccafumi's six pictures with the decorations of the Petrucci bedroom. He also included a seventh painting of Penelope (Galleria del Seminario, Venice), which can be eliminated because the style is marginally earlier, but above all because the size of the panel (84 × 46 cm) and the figure scale are smaller. M. Torriti in Torriti 1998, pp. 56–7, no. P3.
11 R. Bartalini in Siena 1990, p. 132.
12 Blue and gold mentioned in Sanminiatelli 1967, p. 84, under no. 14. G. Faluschi in Faluschi and Pecci 1815, p. 153, recorded '*una Venere di Mecherino, stupenda opera*' and '*altre pitture di questo artista*'; see also Romagnoli Ante 1835, VI, p. 627.
13 I am most grateful to Caroline Elam, who provided many helpful insights and references informing the following discussion.
14 Thornton 1991, pp. 113–20.
15 Schiaparelli 1983, I, pp. 168–74. For further discussion see Barriault 1994, pp. 42–4.
16 Barriault 1994, p. 42.
17 The Borgherini bedchamber, a comparable near contemporary project, involved the collaboration of four painters, Pontormo, Del Sarto, Bacchiacca and Granacci.
18 I am grateful to Peter Schade for the identification of the wood.
19 See M. Caciorgna, in Santi and Strinati 2005, pp. 194–5, cat. 2.15. P. Motture and L. Syson, 'Art in the Casa' in Ajmar-Wollheim and Dennis 2006, p. 271, speculate that the Cozzarelli Heroines might have surmounted an *armadio* or cupboard.
20 See cat. 69–72; other examples include works by the Master of the Chigi Saracini (Judith, Artemisia, Cleopatra), see Torriti 1998, pp. 39–41; Brescianino (Faith, Hope, Charity), see Siena 1990, cat. 61 a–c; and

Beccafumi (Sophonisba, Cleopatra, Judith), see
Torriti 1998, pp. 55–7.

21 Caciorgna, Guerrini and Lorenzoni 2006, pp. 99–118.

22 Dionysus of Halicarnassus, *Antiquitates Romanae*, I, 80,1;
Ovid, *Fasti*, II, 267–452; Plutarch, *Parallel Lives, Julius
Caesar*, 61; *Antony*, 12; *Romulus*, 21.

23 Ovid, *Fasti*, II, 425–30.

24 Barbagli 1998. See Plutarch, *Parallel Lives, Julius Caesar*,
61: 'At this time many of the noble youths and of
the magistrates run up and down through the city
naked, for sport and laughter striking those they meet
with shaggy thongs. And many women of rank also
purposely get in their way, and like children at school
present their hands to be struck, believing that the
pregnant will thus be helped to delivery, and the
barren to pregnancy.'

25 See Barbagli 1998.

26 Fiorelli Malesci 2005–6, p. 138.

27 The temple in Beccafumi's painting, while circular,
does not have the round columns typical of temples
of Vesta, including that in the Roman Forum.

28 Venturi 1901–39, IX, v, p. 450, identified Cornelia as
a Sibyl.

29 R. Guerrini in Torriti 1998, p. 97, under nos. P30 a–c,
mentions a *cassone* attributed to Sellaio depicting
Tarquinius and Tanaquil's arrival in Rome.

30 Livy, *Ab Urbe Condita*, I, 34; I: 39; 1.41, and especially
I.47,6; 1.48.

31 Guerrini 1980, p. 161, n. 18.

32 *Ibid*, pp. 162–3; M. Caciorgna in Caciorgna and
Guerrini 2003, pp. 337–9.

33 *Ibid*, p. 145, citing Valerius Maximus, IV, 2, 3.

34 *Ibid*, p. 146, citing Valerius Maximus IV, 4, preface.

35 Plutarch, *Tiberius Gracchus*, 4: 'These sons Cornelia
reared with such scrupulous care that although
confessedly no other Romans were so well endowed
by nature, they were thought to owe their virtues more
to education than to nature.'

36 Hortensius's arguments – strange even to Plutarch's
contemporaries – regarding the unconventional
deployment of female fertility outside marriage for
the greater good of the family and the common-
wealth have relevance for Marcia as an exemplum of
fecundity. 'Therefore he set himself to persuade Cato
that his daughter Portia, who was already married to
Bibulus, and had borne him two children, might never-
theless be given to him, as a fair plot of land, to bear
fruit also for him. "For," said he, "though this in the
opinion of men may seem strange, yet in nature it is
honest, and profitable for the public that a woman in
the prime of her youth should not lie useless, and lose
the fruit of her womb, nor, on the other side, should
burden and impoverish one man, by bringing him too
many children. Also by this communication of families
among worthy men, virtue would increase, and be
diffused through their posterity; and the common-
wealth would be united and cemented by their
alliances."' (Plutarch, *Parallel Lives, Cato the Younger*, 25).

37 Lucan, *Pharsalia*, II, 371–5. 'First joined in wedlock to
a greater man / Three children did she bear to grace
his home: / Then Cato to Hortensius gave the dame /
To be a fruitful mother of his sons / And join their
houses in a closer tie.'

38 Lucan, *Pharsalia*, II, 380–9.

39 *Ibid*, II, 411–12.

40 Dante, *Inferno*, IV, 127–8; *Purgatorio*, I, 79; first noted
by R. Guerrini in Torriti 1998, p. 95, no. P30, a–c; see
also M. Caciorgna, in Caciorgna and Guerrini 2003,
p. 252; Higham 2002, p. 5.

41 Dante, *Convivio*, IV, 28, vv. 16–17.

42 Liebmann 1968.

43 Illustrated in A. Angelini, 'Antonio Federighi e il mito
de Ercole' in Angelini 2005, p. 111, fig. 11.

44 Chelazzi Dini, Angelini and Sani 1998, pp. 350–1, n. 35,
with the inventory of inherited goods of Marcello
Bandinelli, living in part of the Palazzo del Magnifico,
1 May 1603. This is unlikely to be the work discussed
here, though this remains a possibility.

45 Two roughly contemporary examples are Andrea del
Brescianino, *Venus, Cupid and Folly*, Christie's, London,
13 December 2000, lot 78; Girolamo del Pacchia, *Venus
and Amorini*, Schubring 1915, I, p. 336, no. 488, also
illustrated by F. Sricchia Santoro, 'Beccafumi a Siena'
in Siena 1990, p. 35, fig. 16. Fragments from another
attributed to Riccio is in the Chigi Saracini collection
(see A. De Marchi in Sricchia Santoro 1988).

SELECT BIBLIOGRAPHY

Cat. 102 and 103 R. Bartalini in Siena 1990, pp. 132–3,
cat. 14; M. Folchi in Torriti 1998, pp. 92–4, nos. P28 a–b;
F. Fiorelli Malesci in Coppellotti 2001, pp. 29–37;
M. Caciorgna in Santi and Strinati 2005, pp. 130–3,
cat. 1.8–1.9; *Cat. 104 and 105* R. Guerrini in Torriti 1998,
pp. 95–7, no. P30a–b; M. Caciorgna in Caciorgna and
Guerrini 2003, pp. 250–3, 336–9; *Cat. 105 and 106* Torriti
1998, pp. 95–7; Caciorgna and Guerrini 2003, pp. 144–72;
Cat. 107 Spencer-Longhurst 1993, p. 27; De Castris 1997;
M. Folchi in Torriti 1998, pp. 94–5, no. P29.

108.

Amor Patriae, about 1529–31

Brush and polychrome oil on blue-grey paper
25.8 × 18 cm
Kupferstichkabinett, Staatliche Museen, Berlin
(KdZ 14704)

109.

Study for the executioner Servilius Ahala, about 1529–35

Brush and polychrome oil on ochre prepared paper,
laid down on card; varnished (with oil?).
The upper and lower left corners damaged by flaking;
the upper right corner has been cut and made up
27.4 × 17.6 cm
Rijksmuseum, Amsterdam (RP-T-1954-37)

On 5 April 1529, Beccafumi received the most prestigious commission of his career, the fresco decoration of the ceiling of the Sala del Concistoro in the Palazzo Pubblico of Siena. The meeting hall of the Concistoro, the city's highest civic magistracy and the main executive body of government (see p. 45), was also used for the reception of foreign embassies and other ceremonial events, and the redecoration has traditionally been connected with the impending arrival of Siena's protector, the Holy Roman Emperor Charles V. If so, it must have been intended to show the city's independence from the Emperor, who might be protector or, more worryingly, conqueror. It was to be 'rich and beautiful, as befits the quality of the palace', and was to be carried out within eighteen months.[1] Beccafumi's work in the Sala began promptly, but slowed after the Emperor's visit had been cancelled and came to a halt in 1532. He resumed and completed the project over a few months in 1535, in time for Charles's rescheduled arrival in Siena in April 1536.

The ceiling's programme follows the pattern established by other frescoes in the Palazzo Pubblico, many of which emphasise the primacy of justice and the need to place public interest over private concerns. It was the last great decorative scheme commissioned for the Palazzo before the fall of the Republic and the last emphatic declaration of the city's republican ideals. The author of the ceiling's programme is not known, but its ingenious iconography demonstrates considerable classical reading.[2] It is divided into three guiding themes of civic virtue based on Cicero's *De officiis* (*On Duties*): Justice, in the central tondo, is flanked in two octagons by Amor Patriae (Love of the Fatherland) and Benevolentia (Mutual Good Will). In the coving below, six large histories and ten figures taken from Valerius Maximus's *Memorabilia* exemplify the Ciceronian virtues above.[3] Both these classical sources seek to define good citizenship and promote the Roman republican virtues while abhorring tyranny and imperial autocracy. Yet, in contrast to the earlier more tranquil and decorous decorative schemes in the Palazzo Pubblico, the scenes and *exempla* chosen for the Concistoro are for the most part startlingly violent, while the dogma of republican virtue is emphasised almost to the point of hysteria. A twofold dialogue unfolds, on the one hand of selfless heroism and self-sacrifice enacted in the name of the republic and on the other of tyrants, or would-be tyrants, violently and unpityingly punished. The ceiling simultaneously articulates a vow of uncompromising patriotism and a threat of tough justice; it both exhorts ideal democracy and repudiates past and future tyranny. This dual emphasis reflects the precarious position of the *Libertini* government established, yet constantly under threat of *Novesco* reprisals, and necessarily beholden to the Emperor. Even as Beccafumi painted, power continued

Fig. 87
Domenico Beccafumi (1484–1551)
Amor Patriae, 1529–31
Fresco, Sala del Concistoro,
Palazzo Pubblico, Siena

to oscillate between the *Libertini* and the *Noveschi*, which may explain the halting nature of the project. Undoubtedly, he was chosen for this prestigious task because he had so brilliantly orchestrated another cycle of classicising frescoes inspired by Valerius Maximus, in the private context of the Venturi family palace,[4] but also for his tact: his interpretation of the tales is not always transparent and he disguises some of the more shocking aspects of the ceiling's iconography behind a façade of marvellous colour, dazzling effects of light and witty diversions. Frequently, it is only by turning to Valerius Maximus's more amplified sources that the shocking vehemence of the political parallels emerges. We know that Charles V looked long and hard at the frescoes, but one presumes that his hosts carefully weighed up how much of the ceiling's concealed propaganda to unveil.

The first of the two oil sketches exhibited here is a study for the figure of Amor Patriae (fig. 87). It is probable that Beccafumi designed and executed this part of the work in his first campaign on the ceiling, around 1529–31.[5] In his drawing, Beccafumi ignored the festive *putti* and concentrated exclusively on the figure of Amor Patriae, who is modelled on traditional figures of Virtues both within the Palazzo (those by Lorenzetti and Taddeo di Bartolo) and in other key civic locations about the city. Indeed, the graceful arrangement of the draperies and the dramatic foreshortening of the foot raised on the block are especially reminiscent of Jacopo della Quercia's sculpted *Virtues* on the Fonte Gaia in the Campo, and the bold chiaroscuro of the drawing suggests that Beccafumi may have been working from a three-dimensional model.[6] The rapid brushstrokes anticipate almost exactly the illumination in the fresco, implying that the drawing was made late in the preparatory process, after Beccafumi had resolved his complex lighting scheme. This was carefully conceived throughout the cycle, and in the Amor Patriae octagon harmonises both the natural light emanating from the window wall and the brilliant artificial light radiating from the *trompe-l'œil oculus* open to the heavens in the *Justice* tondo. Beccafumi used long sweeping strokes to form the drapery folds between the figure's knees and abbreviated daubs made with the end of the brush to show the light falling on her hands and foot.

The second sketch (cat. 109) was preparatory for the figure of the executioner Servilius Ahala in the fresco of *The Execution of Spurius Maelius* (fig. 88), one of two rectangular histories on the north-west side

CAT. 108

Fig. 88
Domenico Beccafumi (1484–1551)
The Execution of Spurius Maelius (detail), 1529–35
Fresco, Sala del Concistoro, Palazzo Pubblico, Siena

of the Concistoro ceiling. In Valerius Maximus's *Memorabilia* (VI, III, I) Spurius Maelius's execution is cited briefly as an example of 'grim severity'. In order to flesh out the narrative details of this and many other *exempla* on the ceiling, Beccafumi must have been directed to the much fuller accounts given in Valerius Maximus's sources, Livy and Plutarch, to which the edition of the *Memorabilia* used by the inventor of the Concistoro programme referred the reader.[7] From Livy, he took the scene of Servilius reporting to Cincinnatus,

the aged dictator, that he had executed the aspiring tyrant Spurius Maelius: 'Whereat the dictator exclaimed, "Well done, Gaius Servilius; you have delivered the republic".' Livy's condemnation of Maelius, which precedes and follows his account of the tyrant's execution, reflected Sienese republicans' attitudes to the city's tyrannical Petrucci era, while the scene's inclusion in the cycle reflected their determination that such despotism should never be repeated.[8]

Beccafumi's fascination with qualities of light and shade led him to develop an entirely original method for these preparatory drawings. His technique of making rapid sketches in monochrome or coloured oils on paper, exemplified by cat. 108–11, was almost unprecedented and was not fully embraced by other artists until the seventeenth century. The twenty-six studies of this type that survive all date to a period of a little over a decade, from 1527 to 1538,[9] though Beccafumi's penchant for working in this free manner is certainly adumbrated in some of his earlier paintings (for example cat. 94, 96). Some of the oil sketches, such as cat. 108 and 109, are rapid studies for whole figures; others are of heads (cat. 110–11), both young and old, often taken from life, probably from members of the artist's own entourage.[10] More than half the surviving oil sketches were made for the Concistoro ceiling, and many more must once have existed, indicating an elaborate preparatory process for this important project and reinforcing Vasari's observation that Beccafumi 'used as much diligence, study and effort as he was capable of to demonstrate his virtuosity in that famous place of his native city that thus honoured him'.[11] The fluidity of the oil technique, in which painterly effects

could be quickly and easily explored, suited the artist's impatient and experimental mentality, and facilitated his quest for dramatic chiaroscuro effects.

Cat. 109 is typical of Beccafumi's radically innovative oil sketches in its impressionistic spontaneity and dramatic exploration of light and shade. Working very rapidly and with remarkable economy, Beccafumi described the resolute figure with a few deft strokes of dark browns and touches of creamy highlights judiciously applied to the mid-tone ground, so that the figure emerges like 'a phantom violently torn from obscurity'.[12] The illumination in the fresco is certainly anticipated, but in a highly exaggerated manner, so that Servilius's face is here completely shrouded in darkness, while his brilliant swordblade, so central to theme of deliverance in the painting, where it drips with the tyrant Maelius's blood, is executed with a couple of swift strokes of pure white. Sanminiatelli was right to point out that something of the original intensity is lost in the fresco where, for the sake of clarity and decorum, everything is more evenly lit and represented in far greater detail. CP

1 S. Moscadelli and C. Zarilli in Siena 1990, p. 690, doc. 141.
2 Van Orden 1973.
3 Jenkins 1972. Cicero's *De officiis* was the source for the three virtues that govern the whole programme; Palmieri Nuti 1882, first perceived a link with Valerius Maximus's *Factorum et dictorum memorabilium libri novem* (*Nine books of memorable deeds and sayings*) See Guerrini 1981.
4 R. Guerrini in Torriti 1998, p. 97, no. 31.
5 Pike Gordley 1988, p. 353, no. 10.
6 Drawing additionally on the iconography of Charity, Amor Patriae is surrounded by festive *putti*, and holds aloft a heart. The two foreground *putti*, that on the left radiantly cheerful and that on the right lugubriously resigned, enact the inscriptions IDE[M] VELLE and

IDE[M] NOLLE (*to want the same; not to want the same*) that they bear on scrolls, symbolising the subjective positions that must be reconciled in the name of patriotism and the common good.

7 Guerrini 1981, pp. 86–90, 115, 126; R. Guerrini in Torriti 1998, p. 153; R. Guerrini in Caciorgna and Guerrini 2003, p. 385.

8 Livy, *Ab urbe condita,* IV, 13–15: Spurius Maelius, a man for those times very rich … bought up corn in Etruria with his own money … [and] set about distributing it gratis. The plebeians were captivated by his munificence; wherever he went, conspicuous and important beyond the measure of a private citizen, they followed in his train; and the devotion and hope he inspired in them gave him no uncertain assurance of the consulship. He himself, so insatiable of fortune's promises is the heart of man, began to cherish loftier and less allowable ambition; and since even the consulship would have to be wrested from unwilling nobles, considered how he might be king …. [Thus] a man who might have desired but ought scarcely to have hoped to become a plebeian tribune had flattered himself that for a couple of pounds of spelt he had purchased the liberty of his fellow citizens; he had imagined that by flinging food to them he could entice into slavery a people who had conquered all their neighbours, so that a state which could scarce have stomached him as a senator would endure him for its king, having the insignia and authority of Romulus its founder.'

9 Sanminiatelli 1955, p. 35: four sketches for the *Mystic Marriage* of 1528–9; thirteen for the Sala del Concistoro, seven of which appeared in the Reitlinger sale. In all there are three or four figure studies and seven heads (four of secondary importance); two studies of heads of *putti*; three for the *Descent into Limbo*, about 1535; two for *Evangelists* for Pisa Cathedral, 1536–8. Three new works of this kind were discovered in Brighton City Art Gallery by Hugo Chapman (see cat. 110–11). Domenico's self portrait in the Uffizi also uses this technique.

10 Pike Gordley 1988, p. 414, no. 123.

11 Vasari 1966–87 edn, V, p. 69.

12 Sanminiatelli 1955, p. 36.

SELECT BIBLIOGRAPHY

Cat. 108 Sanminiatelli 1967, p. 128, no. 19; A. De Marchi in Siena 1990, p. 452, cat. 117; E. Tenducci in Torriti 1998, p. 292, no. D94; *Cat. 109* Sanminiatelli 1967, p. 126, no. 10; A. De Marchi in Siena 1990, p. 454, cat. 119.

CAT. 109

110.

Head of a bearded man turned to the left, about 1530

Brush and polychrome oil, on paper prepared
with a light brown oil ground, the contours partly
incised, tips of the right-hand corners made up
and the surface varnished, on paper
22.5 × 16.4 cm
Brighton Museum and Art Gallery (FA 102324)

111.

Head of a young man turned to the left, about 1530

Brush and brown and white oil, on paper prepared with
a light brown oil ground, the contours partly incised,
some made up areas and the surface varnished
22.8 × 17.2 cm
Brighton Museum and Art Gallery (FA 102325)

Fig. 89
Domenico Beccafumi (1484–1551)
Head of a Girl, about 1530
Oil on paper, 24.7 × 17.6 cm
Brighton Museum and Art Gallery (102326)

These wonderfully assured and fluently
drawn sketches of heads are new additions
to Beccafumi's corpus of oil-on-paper
studies. Both drawings, as well as a third,
much less well conserved study of a girl's
head (fig. 89), were donated in 1917 to the
Brighton Museum and Art Gallery by the
widow of Leonard Lionel Bloomfield
(1858–1916).[1] These three works are part of
a small collection of Old Master drawings
and prints included in the donation of
some 9000 items. Little is known about
Bloomfield, except that he lived in Pinner,
Middlesex, and was the head of a firm of
military cap- and helmet-makers before
retiring to Brighton in 1910.[2] There is no
information about where or when he
acquired the Beccafumi studies, and they
bear no trace of previous collectors' marks
or inscriptions. Bloomfield himself inscribed
D Beccafumi 1530 on two of the mounts.
This date tallies closely to the period when
Beccafumi is known to have made such oil
studies, and the likelihood is that Bloomfield
was copying an old inscription on a lost
mount or frame.

Although neither of these drawings
can be linked directly to figures in any of
Beccafumi's paintings, a dating to around
1530 seems plausible on stylistic grounds.
The bearded man (cat. 110) is the easier of
the two to place as his prominent forehead,
strong nose and bushy beard are familiar
features in numerous figures in Beccafumi's
cycle in the Sala del Concistoro in the
Palazzo Pubblico (see cat. 108–9). This type
is similar, for example, to the head of the
man on the far left of *The Sacrifice of Codrus*
(fig. 90). It is perhaps not coincidental that
Beccafumi's own features were remarkably
similar, as can be seen from his oil-on-paper

Fig. 90
Domenico Beccafumi (1484–1551)
The Sacrifice of King Codrus of Athenas (detail),
1529–35
Fresco, Sala del Concistoro,
Palazzo Pubblico, Siena

self portrait in the Uffizi in Florence.[3] The
regular features of the beardless youth with
slightly parted lips in the other drawing
(cat. 111) are reminiscent of representations
of gods and heroes in classical marbles, such
as the *Apollo Belvedere* in the Vatican or the
Horse Tamers (*Dioscuri*) on the Quirinal.
The inspiration of such ancient models is
reinforced by the use of white paint in the
modelling, which echoes the tonality and
sheen of marble, and by the absence of the
pupils in the eyes. Such sculptural accents
are offset by the springy softness of the curls,
a detail that suggests that Beccafumi was
imaginatively combining his experience
of life drawing with his study of classical
models. The artist perhaps thought that
such a study would be appropriate for the
classically inspired cycle in the Palazzo
Pubblico, but in the event did not use it.[4]

CAT. 111

Before the emergence of the Brighton studies, fourteen oil-on-paper studies of heads were accepted unreservedly by modern authorities as by Beccafumi; a further nine drawings of full-length figures in the same medium, such as cat. 108 and 109, should be added.[5] This class of drawings by Beccafumi was first studied by Donato Sanminiatelli in 1955, an article prompted by the appearance of nine sketches on the London art market two years earlier.[6] He established that Beccafumi made such drawings between 1527 and 1538, and that the majority of them can be connected to the frescoes in the Palazzo Pubblico. In the ensuing half-century, little has been added to Sanminiatelli's findings, but major questions about these drawings still remain – not least about their technique and function.

In 1955, Sanminiatelli described the drawings' technique as that of tempera (paint made using egg yolk as the binding medium) on paper, following Agnes Mongan and Paul Sach's entry for the two Sala del Concistoro studies in the Fogg Art Museum, Cambridge MA.[7] This technical description has been accepted by American scholars including Pike Gordley and Lincoln, but in 1990 Andrea De Marchi catalogued all the drawings of this kind as oil on paper and (pending full analysis of medium samples) this looks to be correct.[8] Oil, rather than the quicker drying tempera, better fits the fluid liquidity of the brushwork. The use of a limited tonal oil palette on a dark ground was one suited to recording the play of light and shade on a figure. It is therefore perhaps not surprising that this method of drawing was explored in the first decade of the sixteenth century with the Venetian artist Giovanni Bellini, an artist whose command

340

of the oil medium brought a new subtlety to his depiction of light and atmosphere in his paintings.[9] It seems improbable that Beccafumi would have known such drawings, and it seems more likely that he came up with the technique independently. It was one that served his penchant for modelling form through light while at the same time suiting his gift for rapid, impromptu invention.

Another technical puzzle of these drawings is Beccafumi's frequent use of a stylus (a sharp pointed metal stick like a compass in a geometry set). The resulting incised lines are visible in the present drawings both around the external contours and in the modelling of such features as the nose and eyes. For Sanminiatelli, the explanation for these incised lines was that they were made to transfer the outlines of the design on to the surface of the panel or the wet plaster. If this were correct, it would signify that the drawings were cartoons – drawings made on the same scale as the heads in the painting or fresco. This conjecture seems not to have been tested. However, it is clear that Beccafumi used the stylus in oil sketches that are far smaller in scale than the finished works for which they were preparatory, such as the studies in the Metropolitan Museum, New York, for two of the life-size *Evangelist* paintings in Siena Cathedral.[10] Likewise, drawings such as the present pair, which are incised but have no painted counterparts, suggest that the stylus work was not always, if ever, related to transfer of the design. Evelyn Lincoln argued instead that the incised lines were made as a preliminary sketch, akin to the type of underdrawing found in some of Beccafumi's chalk studies such as *Mucius*

Scaevola (cat. 113).[11] While this may explain some of the stylus work, Beccafumi also used the sharp point to make marks into the wet pigment – especially noticeable in the contour of the nose and left cheek of cat. 110 – perhaps to ensure that despite the impressionistic nature of the oil medium the outlines of the salient features were clearly defined – a kind of *sgraffito* technique.

The three Brighton drawings have in common with at least two of the fourteen oil head studies the lack of a direct connection with a finished figure.[12] This opens to question the assumption that Beccafumi prepared such oil studies with specific figures in mind. In view of their similarities in scale and handling, it is possible that Beccafumi executed the majority of these sketches in a concentrated burst before he began work on the Palazzo Pubblico commission, in order to create a repertoire of types on which to draw when creating such a multitude of figures.[13] In at least one instance, Beccafumi seems to have used the same head both as an inspiration for figures in the Concistoro cycle and in a subsequent commission.[14] HC

1 I came across the drawings when I went through the collection of Bloomfield Old Master Drawings in the late 1980s. I should acknowledge that it was Alastair Laing who kindly told me that I should go down to Brighton to examine the Italian drawings.
2 I am grateful to David Beevers, who sent me the only article on Bloomfield: Wilkes 1998, pp. 8–9.
3 See E. Tenducci in Torriti 1998, p. 272, no. D64. Pike Gordley suggests that one of the oil sketches in the Rijksmuseum might be a self-portrait (Pike Gordley 1988, no. 3; E. Tenducci in Torriti 1988, p. 297, no. D102.)
4 The Palazzo Pubblico frescoes do show Beccafumi's study of classical sculpture, but his references to them are inventive, as in his adaptation of the pose of a *Marsyas* statue now in the Uffizi, Florence (Pray Bober and Rubinstein 1986, p. 75, no. 32) for the corpse in the scene of Postumius Tiburtius executing his son.

5 E. Tenducci in Torriti 1998, pp. 273–5, 293, 295–7, 299–302; nos. D68–9, D95, D98–9, D101–2, D104–9, D111 are all accepted by Pike Gordley while D103, D180–1 are rejected.
6 Sanminiatelli 1955. The drawings were sold at the H.S. Reitlinger sale at Sotheby's, London, 9 December 1953.
7 Mongan and Sachs 1940, I, pp. 53–5, nos. 66–7 (p. 53: 'generally these studies have been erroneously referred to as oil sketches. On the contrary they are tempera mixed with some kind of emulsion').
8 Pike Gordley 1988, pp. X–XI; Lincoln 2000, p. 96, describes the technique as a 'tempera-emulsion mixture, a medium also favoured by Mantegna'.
9 The three drawings by Bellini or a member of his studio are in the Fondation Custodia, Paris, the Archepiscopal Palace, Kromeríz and in a private collection; see G. Goldner 'Bellini's Drawings' in Humfrey 2004, pp. 246, 249. They can be dated around 1506 on the basis of their similarity to the Bellini and workshop painting of that year, the *Episode from the Life of Scipio* (National Gallery of Art, Washington).
10 For the two drawings see E. Tenducci in Torriti 1998, pp. 307–8, nos. D116–17.
11 Lincoln 2000, p. 96.
12 E. Tenducci in Torriti 1998, pp. 297–301, nos. D101–9; with others from the group, such as D109, a connection with a painted head is not absolutely clear-cut.
13 It is noteworthy that Beccafumi sometimes, as in the present examples, painted the head on an oval-shaped preparatory ground with the corners coloured blue. Judging from the colour illustrations in Torriti's monograph, traces of blue in the margins are detectable in examples from Berlin (E. Tenducci in Torriti 1998, pp. 295–7, no. D99) and in the Pierpont Morgan Library (*ibid.*, p. 302, no. D111). Blue is also detectable at the lower left corner of one of the British Museum drawings, *Head of an Old Woman* (*ibid.*, p. 300, no. D105). This also has the remains of a diamond-shaped framing device at the centre of the lower margin not unlike that found in a similar position in cat. 110.
14 A drawing in the British Museum (E. Tenducci in Torriti 1998, pp. 297–8, no. D101) has been connected with a figure in *The Sacrifice of Codrus* in the Sala del Concistoro and in his *Moses breaking the Tablets* of 1536–8 in Pisa Cathedral. See C. Alessi in Torriti 1998, pp. 163–6, no. P72a.

112.

DOMENICO BECCAFUMI
(1484–1551)
Initial L with grotesques,
about 1518–20

Pen and brown ink on paper, 9.5 × 10.9 cm
Gabinetto Disegni e Stampe degli Uffizi, Florence
(150 ORN)

Inscribed in black chalk, bottom centre,
in two different hands: *15* and *213*,
and top right: *150*

Beccafumi, as we have seen, was one of the
great draughtsmen of Cinquecento Italy.
He sought to demonstrate his talent by
his treatment of classical themes that had
become popular in the years around 1500,
making highly finished presentation draw-
ings and latterly prints (see cat. 113–15). His
activity as an illuminator of liturgical books
was, however, quite unknown until the
rediscovery in 1974 of a small antiphonary
in the sacristy of Santissima Annunziata
at the Hospital of Santa Maria della Scala
containing several pages with painted initials
attributable to his hand and dateable around
1520 (fig. 91). These illuminations place
Beccafumi in an active Sienese tradition of
miniature painting by painters more used
to working on a larger scale, evinced in
surviving examples by Sano di Pietro,
Giovanni di Paolo and Benvenuto di
Giovanni,¹ not to mention the astonish-
ingly inventive choirbooks painted for
Monteoliveto and Siena Cathedral by
Liberale da Verona.² However, both the
antiphonary illuminations and Beccafumi's
designs for decorative initials recast the
genre in a modern style, combining that of
the classical grotesques popularised in Siena

by Pintoricchio and Sodoma and artists
working with them (see cat. 84–6) with the
more elegant and fantastical contemporary
improvisations in which Raphael and
members of his workshop – including
Beccafumi's fellow Sienese artists Baldassare
Peruzzi and Sodoma at a later stage in his
career – specialised (notably in the Vatican
Logge).

This fantastically free and inventive
ornament drawing was first attributed to
Beccafumi by Pasquale Nerino Ferri in his
catalogue of the Uffizi drawings of 1890;
but, because the edges had been cut, it was
recognised to be a decorative initial L only
by Pike Gordley in 1989 and independently
by Cecchi in 1991. The initial provides the
framework for some elegant and witty
figurative grotesques. On the left of the
upright is a standing nude woman, her
raised arms supporting an undulating scroll
or banderole. On the right, a nude man is
seated in the bend of the initial, holding up
a fruit-filled basket out of which also emerge
a trident, a sword and a *putto* holding a spear
and a javelin. The horizontal of the letter L
terminates in ornamental foliate flourishes,
beyond which stands a sprightly *putto* from
whom a woolly-haired dog is escaping back
along the initial. Beccafumi set down his
design swiftly and intuitively, almost in
the manner of a doodle, the fertility of his
imagination matched by the calligraphic
verve of his penmanship.

It seems probable that the drawing was
made around 1518–20, soon after Beccafumi
returned from Rome: the swirling foliate
motif is very close to the classicising acanthus
scrolls in Raphael's Vatican Logge. However,
a model closer to home might have been
the unfurling vegetation in the decorative

Fig. 91
Domenico Beccafumi (1484–1551)
Initial D with the Madonna della Neve, about 1520
Illuminated mss, 34 × 24 cm (entire folio)
Complesso Museale di Santa Maria della Scala,
Siena (f. 98v)

(actual size)

carvings of the Sienese woodworker Antonio Barili (see cat. 83–4). Beccafumi's interweaving of humorous narrative amid the organic forms also recalls Pintoricchio's playful ceiling grotesques in the Piccolomini Library. In future projects, Beccafumi would embellish his frescoes with similarly diverting marginalia, and always had a particular penchant for the motif of small boys playing with dogs.

Cecchi attributed another ornament drawing in the Uffizi, with the initials DI, to Beccafumi, which, while more stilted in style, he proved to be closely associated with the present work because motifs from both are copied in a further sheet of ornamental studies, probably by a late sixteenth-century Sienese artist.[3] Amid similar scrolling acanthus, cornucopiae and muscular male nudes is another witty vignette of a cat licking something on the ground, about to be dive-bombed by a sharp-beaked bird. The DI drawing is on parchment, implying a link with book production; Cecchi has suggested it might be an illumination left unfinished after the final outline stage. The small scale of the L initial design (on paper) suggests, on the other hand, it may be preparatory sketch. CP

1 See K. Christiansen, 'Painting in Renaissance Siena' in Christiansen, Kanter and Strelke 1988, p. 23.
2 Gallavotti Cavallero 1980; see also C. Zarilli and A. Angelini in Siena 1990, pp. 140–3, cat. 17.
3 For the drawing with the initials DI (Gabinetto Disegno e Stampe, Galleria degli Uffizi, Florence) see Cecchi 1991; P. Giannattasio in Torriti 1998, pp. 245–6, no. D9; the copy drawing, once attributed to the young Beccafumi by Brandi (1933, pp. 352, 358), is in the Pinacoteca Nazionale, Siena; Cecchi 1991, p. 773, fig. 29. For illustrations see, for example, Dubus 1999, pp. 99, 106–8, 112.

SELECT BIBLIOGRAPHY

Sanminiatelli 1967, p. 140, no. 15; A. De Marchi in Siena 1990, pp. 440–1, cat. 100; Cecchi 1991; P. Giannattasio in Torriti 1998, p. 244, no. D8.

113.

DOMENICO BECCAFUMI
(1484–1551)
Mucius Scaevola, about 1540

Red chalk over traces of stylus indentation, on paper, 29.6 × 22.4 cm
The Pierpont Morgan Library, New York (1964.7)

Inscribed on the verso, bottom right, in ink(?) in
an old hand: DOMENICO BECCAFUMO DETTO MECARINO / 2.4

The story of Gaius Mucius Scaevola is told in the second book of Livy's history of Rome (*Ab urbe condita*, II, XII-XIII). One of the first threats to the newly founded Roman republic was an attack by the formidable army of the Etruscan king Lars Porsena. Porsena had been persuaded to invade by the Tarquins, supporters of the deposed tyrant king Tarquinius Superbus, whom they wished to restore to the Roman throne. With the city under siege, the brave Mucius swam across the Tiber and entered the enemy camp with a sword concealed in his robe. Seeing the King and his secretary distributing salaries to the soldiers, he mistakenly struck and killed the secretary. Captured and threatened with being burnt alive, he thrust his right hand into the fire on the altar, and held it there without flinching, saying, 'Look and learn how lightly those regard their bodies who have some great glory in view'. In the drawing, Mucius has drawn his sword from its sheath and resolutely holds his hand in the flames. He looks away, his lips parted in pain (we can see his teeth) as his flesh roasts. Smoke shoots up from the elegantly stylised fireball on the altar. Porsena was so impressed by his courage and resilience that he had him freed and made peace with Rome. Mucius was afterwards known as Scaevola (left-handed) from the loss of his right hand, and his courageous action was interpreted as the triumph of courage over brute force.

The high level of finish of this red-chalk drawing is unparalleled in the artist's graphic œuvre.[1] Bean and Stampfle considered it a study for an engraving, but De Marchi plausibly suggested that it was a presentation drawing, made to be given to a patron, rather than a preparatory work;

Beccafumi's studies for prints were typically less resolved than this, and he abandoned red chalk for print preparation after attempting to engrave cat. 115. The drawing is a demonstration of Beccafumi's superb mastery of lighting and chiaroscuro. His virtuoso handling of the red chalk, wielded with varying pressure to create subtle variations in tone and stumped with the finger to achieve softly nuanced shadows, puts this drawing on a par with those made by Michelangelo as gifts for friends.[2] Indeed, Beccafumi surely had Michelangelo in mind as the contrived pose of Mucius's left arm holding his scabbard derives from Michelangelo's sculpture of the *Duke of Urbino* in the Medici Chapel at Florence. While Beccafumi had always been fascinated by the decorative potential of Roman costume, in which several figures in his fresco cycles are elegantly garbed, here the soldier's skin-tight breast-plate and other decorative details of his armour are invigorated by the classical vocabulary of Michelangelo's San Lorenzo sculptures. Faintly delineated in the background are the tents of Porsena's camp with battling Roman and Etruscan cavalrymen.

We cannot know for whom this image of republican virtue was made, probably in the early 1540s,[3] but clearly Scaevola's high-minded patriotism was particularly relevant to the political situation in Siena, and it would have made an appropriate gift for a member of the city's ruling élite. Independent representations of Mucius Scaevola are rare before this date, but this exemplary subject was a popular choice for domestic objects such as *cassoni* and for maiolica, as well as medal reverses. The drawing perpetuates the Sienese tradition of decorative ensembles

devoted to heroes and heroines, both in private palaces and public spaces. It is consonant in form as well as in subject with Beccafumi's own fresco cycles with exemplary classical subjects, for the Palazzo Venturi and for the Sala del Consistoro: the hero's resolute wide-legged stance repeats those of heroic figures such as Scipio and Servilius (see cat. 109) in both fresco projects. Beccafumi used this identical pose, but rotated and seen from the rear, in a drawing of Hercules, raising the possibility that he may have used sculptural models.[4] The powerful vigour and classical monumentality of Beccafumi's Roman heroes updated the more static canon adopted in Quattrocento cycles of Famous Men, such as Taddeo di Bartolo's Roman heroes in the Palazzo Pubblico, and perpetuated as late as 1529 in Sodoma's *Saints Victor* and *Ansanus* painted for the Sala del Mappamondo.[5] CP

1 A. De Marchi in Siena 1990, p. 465, cat. 132.
2 Hirst 1988, ch. 10.
3 For the issue of dating see A. De Marchi in Siena 1990, pp. 465–7, n. 132.
4 P. Giannattasio in Torriti 1998, pp. 282–4, no. D78 (the drawing was once in Vasari's *Libro de' Disegni*).
5 Beccafumi and Bartolommeo di David, on behalf of the Comune and Sodoma respectively, were called in to assess the value of this work in September 1529, but their estimates seemingly failed to satisfy both parties and Baldassare Peruzzi was called in to arbitrate (see S. Moscadelli and C. Zarrilli in Siena 1990, p. 691, docs 148–50).

SELECT BIBLIOGRAPHY

Bean and Stampfle 1965, p. 48, no. 64; Vitzthum 1966, p. 109; Sanminiatelli 1967, p. 154, no. 76b; Providence 1973, p. 18, no. 14; A. De Marchi in Siena 1990, pp. 465–7, cat. 132; E. Tenducci in Torriti 1998, pp. 280–2, no. D76.

114.

DOMENICO BECCAFUMI
(1484–1551)
A Mythological or Allegorical Figure, mid 1530s

Pen and ink, on paper, 21.4 × 14.1 cm
Gabinetto Disegni e Stampe degli Uffizi, Florence (1514 E)

Inscribed in black chalk bottom right: 99

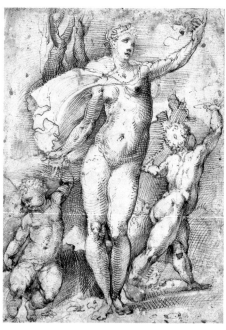

Fig. 93
Attributed to Marco Pino
(about 1525–about 1587/8)
Charity: A Standing Nude Woman flanked by Putti,
about 1537–42
Pen and brown ink, 27 × 19.5 cm
Private collection

The presence of the three children in this drawing has persuaded most recent scholars that this female figure is Charity.[1] However, unlike the many Sienese precedents for this subject, including a tondo painted by Beccafumi himself, the female figure is not involved in an intimate loving relationship with the children, nor they with her. Furthermore, the mantle billowing in the wind about her shoulders is an unusual feature for Charity, who is usually depicted semi-draped, often with one breast exposed in preparation for suckling one of her many infants, but rarely completely naked and so thoroughly *impudica* as here.[2] The drawing more plausibly represents a different mythological or allegorical subject, perhaps a Venus in both her profane and sacred

aspects, acknowledging the *amorini* on the left in her capacity as *genetrix* (mother), while turning her attention heavenwards, like the *putto* on the right. This would fit with the traditional identification of the figure as Eve, with the infants Cain and Abel (before the third *putto* was spotted by Sanminiatelli), often associated with the celestial Venus.[3] Its iconographic mystery may be deliberate and an important part of its function (see cat. 41).

In pose as well as in spirit, the figure recalls a *Lucretia* engraved in around 1510 by Marcantonio Raimondi after a design by Raphael. Other aspects of the drawing reveal a closer connection with Marcantonio's print of the *Death of Dido* (fig. 92). Although the rapid hatching of the background in the drawing appear to be largely indeterminate, serving principally to give relief to the figures by pushing them forward in space, on closer inspection some landscape details emerge. Two attempts at a tree with a branch sticking out have been cancelled in the upper left, while what appears to be a meandering river snakes off into the distance at the right. These details, all but lost amid the multi-directional penwork, as well as some pebbles by the figures' feet in the foreground, seem loosely to refer to landscape details in the *Dido* print. The figure itself is very similar to Dido except that her arms have been transposed, and she is nude (though there are vague vestiges of drapery comparable to Dido's about her right thigh and calf). Instead of a dagger she holds something soft, like a piece of cloth, or possibly flames.

The dating of the drawing has also proved controversial. Although it has recently been placed quite early in Beccafumi's drawn œuvre, around 1517, it seems worth reviving

Sanminiatelli's proposal of a date in the mid 1530s, as well as his suggestion that that it may be preparatory for a print, or at least connected with Beccafumi's printmaking activity.[4] This Beccafumi initiated only in the 1530s, conceivably as a consequence of marrying into the Cataneo family of book-sellers.[5] In support of this date is a copy of the drawing attributed to Marco Pino (fig. 93).[6] Pino was active in Beccafumi's shop from 1537 to 1542 and, though it is possible he was copying a drawing from his master's archive, it is likely that he would have been interested in more recent work. Pino's copy differs from the original in several ways, including the addition of a fourth child in the background and a pointing index finger added to the woman's raised left hand (which was clearly an afterthought as she already has four curled fingers). Pino attempted to clarify indeterminate elements of the drapery and landscape, which he understandably misinterpreted in places. The more regular hatching of his copy seems to reflect techniques of engraving, supporting the

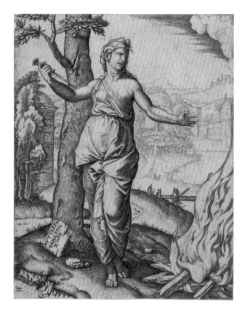

Fig. 92
Marcantonio Raimondi (about 1475–1534)
after Raphael
The Death of Dido, about 1510
Engraving, 16 × 12.8 cm
The British Museum, London (1868-8-22-37)

suggestion that cat. 114 was linked to Beccafumi's activity in this area. The fact that Beccafumi was looking to prints for inspiration again strengthens this possibility. One might add that the muscular back and curiously dislocated hips of the child lunging forward on the right appear to have been inspired by the back-turned soldier in Marcantonio's *Massacre of the Innocents* engraving after Raphael. CP

1 A. De Marchi in Siena 1990, pp. 431–2, cat. 91, P. Giannnattasio in Torriti 1998, p. 246, no. D10, and Zezza, pp. 23, 25, 43, n. 32, all identify the subject as Charity. The tondo is in the Victoria and Albert Museum (165, Torriti 1998, no. P47).
2 A rare exception is a figure of Charity in the ceiling of the Piccolomini Library by Pintoricchio and his workshop.
3 Sanminiatelli 1967, p. 146, no. 42, was the first to note the presence of the third child peeking out from behind the *putto* on the left; prior to this the female figure had been identified as Eve with Cain and Abel (Ferri 1890, p. 171; Judey 1932, p. 137, no. 65, and, later, Petrioli Tofani 1987, p. 630).
4 Sanminiatelli 1967, p. 146, no. 42; A. De Marchi, in Siena 1990, pp. 431–2, no. 91, dated the drawing to around 1517 on the grounds of its resemblance to drawings by Sodoma and was followed in this proposal by P. Giannattasio in Torriti 1998, p. 246, no. D10. Pike Gordley, who viewed the drawing as a workshop product, nevertheless felt that it was based on a Beccafumi type of around 1530. The figure's face is unlike Beccafumi's figures of the 1510s or even the 1520s. The bulging forehead and cheek are found in figures in works of the 1530s, such as the female nude on the right of *Christ's Descent into Limbo* (M. Folchi in Torriti 1998, pp. 143–5, no. P66) and the figure of the Christ Child in the altarpiece for the Oratorio of San Bernardino (*ibid.*, pp. 145, no. P67), both of which also stand in comparable *contrapposto*. The rapid, even rather messy execution of the drawing is more in keeping with later works, as is the claw-like morphology of the woman's feet.
5 This connection was suggested by Philippa Jackson.
6 Zezza 2003, pp. 23, 25, 43, note 32; the drawing was sold at Christie's, London, 10 July 2001.

SELECT BIBLIOGRAPHY

Sanminiatelli 1967, p. 146, no. 42; A. De Marchi in Siena 1990, pp. 431–2, cat. 91; P. Giannattasio in Torriti 1998, p. 246, no. D10.

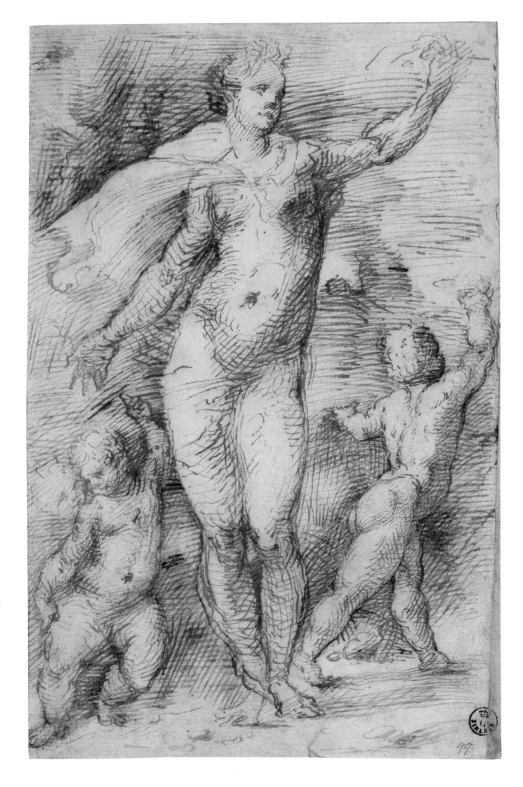

115.

DOMENICO BECCAFUMI (1484–1551)
Two Nudes in a Landscape, about 1537

Red chalk with traces of black chalk, on paper, 22.4 × 15.8 cm
The Devonshire Collection, Chatsworth (6)

Inscribed in pen and brown ink on a repair
in the bottom right corner in an old
(eighteenth-century) hand: MECCARINO

Fig. 94
Domenico Beccafumi (1484–1551)
Two Nudes in a Landscape, about 1537
Engraving and two woodblocks, 26.6 × 16.4 cm
Fitzwilliam Museum, Cambridge (31.K9-29)

This splendid red-chalk drawing of two male nudes in a landscape is related to one of Beccafumi's earliest forays into the art of printmaking. Although at first glance it gives the impression of a figure study for a larger composition, the *mise-en-page*, enigmatic subject and landscape background suggest it was made specifically with the print in mind. The print (fig. 94) follows the drawing very closely, not just in terms of composition, but also in the lighting, musculature and the curious landscape feature of a tumulus-like mound with a tree growing out of its side and a stump emerging from the top. Although the poses are carefully considered, the drawing was clearly made quickly and certainly lacks the finish of a worked-up presentation drawing such as cat. 113. This sketchy, non-*finito* quality is present in other drawings from which Beccafumi made prints, such as the related *Three Reclining Nudes*,[1] suggesting that he frequently finalised his ideas on the plate itself. There are a number of *pentimenti* in the raised arms and upper torso of the standing man, and another one for the raised left arm of the recumbent figure, barely sketched in, which Beccafumi suppressed in favour of the outstretched arm passing behind the standing man's legs. Yet in the print Beccafumi reverted to the rubbery bent arm, presumably to avoid an unseemly lunge towards the standing man's groin. This revision, made – to judge by its awkwardness – directly on the plate, is further evidence of a close relationship between the drawing and the print, which cannot have been separated by any great interval of time.[2]

The speed with which Beccafumi drew, fudging elements such as the positions of the arms and the features of the faces about which he remained indecisive, led him into difficulties when he attempted to resolve these ambiguities with the linear precision of the burin.[3] It may be no coincidence that he never again returned to red chalk preparatory to engraving, preferring black chalk or pen, frequently modulated with white heightening and wash. In this instance, he recaptured some of the chiaroscuro effects adumbrated in the smudged shading of the drawing by adding two woodblock tones to his engraving. His natural propensity for chiaroscuro and tone led to his eventual abandoning the use of intaglio plates entirely in favour of woodblocks, to which he added increasingly daring colours and innovative tonal contrasts.[4]

Attempts to discover a subject for the drawing have proved futile. Brulliot suggested that it shows Deucalion regenerating the Human Race, and Nagler that the figures are Cain and Abel, but most authors agree that this is a figure exercise without a precise subject.[5] The fact that the two figures have no real relationship to each other and are even lit from two opposing light sources, supports the idea that the drawing was made as an exercise in portraying the male nude in action. This was a type of drawing that Beccafumi, like many of his contemporaries, may have been inspired to make by looking at Michelangelo's *Battle of Cascina*; the recumbant figure in cat. 115 is similar to the reclining soldier on the right of Michelangelo's celebrated cartoon (now known only through copies).[6]

De Marchi was surely correct to date the drawing around 1537 on the grounds of the similarity between the recumbent

348

nude and one of the horrified bystanders in Beccafumi's dramatic depiction of *Moses breaking the Tablets of the Law* for Pisa Cathedral (a comparison already astutely noted by Mariette in the eighteenth century).[7] The relationship between the painted and drawn figures is extremely close, both in lighting and in the pose of the outstretched arm which Beccafumi was forced to abandon when he added the second figure. His interest in the male nude dates back to his early trips to Florence and Rome. He had painted reclining nudes before, for example in his *Fall of the Giants*, one of the roundels in the Palazzo Bindi-Sergardi in Siena, and comparisons with figures such as these persuaded Sanminiatelli to date the present drawing and the inception of Beccafumi's printmaking activity a decade earlier, to the 1520s. But the figures in those works are much more graceful and effete. In the 1530s, Beccafumi's style became more powerful and monumental, largely as a consequence of his ever-increasing appreciation of the works of Michelangelo, evident here both in the Resurrection-like poses and in the articulation of the musculature. CP

1 Cleveland Museum of Art (58.313); E. Tenducci in Torriti 1998, D157.
2 Hartley (1991) suggested that the print was made after an interval of a decade, but this is implausible.
3 Landau and Parshall 1994, p. 273.
4 *Ibid.*, p. 274.
5 Brulliot, 1832–4, II, p. 129, n. 901.
6 See Chapman 2005, pp. 78–80, fig. 21.
7 A. De Marchi in Siena 1990, pp. 478–80, cat. 145–6. Mariette 1851–60 edn.

SELECT BIBLIOGRAPHY

Sanminiatelli 1967, p. 137, no. 3; A. De Marchi in Siena 1990, pp. 478–80, cat. 144–6; Landau and Parshall 1994, pp. 273–5; E. Tenducci in Torriti 1998, p. 306, no. D113 (D155–6 for related prints).

ARTISTS' BIOGRAPHIES

Sano di Pietro
(Siena 1405 – 1481)

Lorenzo di Pietro, known as Vecchietta (Siena 1410 – 1480)

Sano di Pietro, faithful adherent to the Trecento tradition, was perhaps the most prolific Sienese painter of his day. Born in Siena in 1405 and active as a painter from 1428 at the latest, he was almost certainly apprenticed to Sassetta. Developing ideas proposed by Berenson and Brandi, some scholars have identified his early activity (before 1444) with the work of the anonymous Osservanza Master, although this theory is still disputed by a number of others.

Sano di Pietro's earliest certain works are from the 1440s – the repainting of the image of the Emperor Frederick Barbarossa in Spinello Aretino's fresco cycle in the Palazzo Pubblico, Siena (1443), and the Gesuati Altarpiece, commissioned in 1439, signed 1444 and undoubtedly the painter's masterpiece (now in Pinacoteca Nazionale, Siena; predella in the Louvre, Paris). In the following years, Sano di Pietro executed frescoes – *The Coronation of the Virgin*, painted in 1445 over an older image by Lippo Vanni – as well as panel paintings for churches in the Sienese *contado*. Fragments of such works for churches in San Gimignano and Scrofiano are in the Pinacoteca Nazionale, Siena. He painted a predella to complete Simone Martini's polyptych in the Cappella dei Signori of the Palazzo Pubblico (1448–52; now dispersed). As instructed by his patrons for this project, Sano di Pietro transcribed the Marian stories that the Lorenzetti brothers and Simone Martini had frescoed (these are now lost) on the façade of the Hospital of Santa Maria della Scala a century before, a fact that speaks volumes about Sano's closeness to Sienese Trecento tradition. Sano used his archaising style for portraits of contemporary figures as well: examples are *Saint Bernardino* (fresco in the Sala del Mappamondo, Palazzo Pubblico) and Pope Calixtus III (cat. 1). He was commissioned by Pope Pius II to paint an altarpiece for Pienza Cathedral (1462), where his Trecentesque figures sit rather uneasily within a modern frame. In fact, Sano's experimentation with new models of carpentry, for example in his altarpieces for the Collegiata of San Quirico d'Orcia and for Badia a Isola (1471), is one of the most interesting aspects of his later career. Sano di Pietro's 1479 Santa Petronilla polyptych (Pinacoteca

Nazionale, Siena) is once again anachronistic in its format, in the use of gilding and in the rigidity of its main figures, but shows a noteworthy vivacity in the predella narratives, in which Sano proved himself a meticulous illustrator. Indeed he also painted numerous manuscript illuminations, such as those in the *Breviary of Santa Chiara* (now Biblioteca Comunale, Siena). Regularly employed for public commissions as well as by confraternities and regular orders (especially the Franciscans), Sano also produced countless *Virgin and Child* panels of a simple, devout appearance (see cat. 11, for an attractive example). His style was surely directly informed by a personal, heartfelt spirituality: his obituary certifies that he was buried in the cloister of the church of San Domenico on 1 November 1481, 'a famous painter and a man devoted to God'.

Vecchietta was a versatile artist who often signed himself as 'painter' on his sculpted works and as 'sculptor' in his paintings. He registered in the *ruolo* (guild) of painters in 1428 and during the mid 1430s gained valuable experience working under the direction of the Florentine painter Masolino, who introduced him to Florentine styles of perspective and foreshortening.

Back in Siena by 1439, Vecchietta collaborated with Sano di Pietro on a sculpted *Annunciation* for the high altar in the Cathedral (now lost). For the Hospital of Santa Maria della Scala, he then painted a fresco of *The Story of the Blessed Sorore* in the Sala del Pellegrinaio, a work that contained many Renaissance elements, not least its monumental *all'antica* architectural setting. Vecchietta continued in this vein throughout the 1440s, with further commissions for the Hospital (a pantheon of Sienese saints and a *Passion* cycle for the doors of the Hospital's *arliquiera* or cupboard containing relics) and a fresco cycle in the old Sacristy of the Cathedral illustrating the articles of the Creed. He also executed frescoes for the Martinozzi Chapel in San Francesco. Only one scene from this cycle now survives, *The Lamentation over the Dead Christ*, now in the Museo Diocesano, Siena, where it may be seen alongside one of his earliest sculptures, a polychrome wooden *Pietà* carved for the church of San Donato.

In the 1450s, Vecchietta began a series of challenging mural schemes for the vaults and apse of the Baptistery (1450–3), along with a *Crucifixion*, recently rediscovered in the church of Sant'Ansano, and the panel and frame for a *Madonna of Mercy* (1458; Palazzo Pubblico). These projects built his reputation, and before long he became one of Pope Pius II's favoured artists; Pius commissioned Vecchietta to paint *The Assumption of the Virgin* for Pienza Cathedral (1460–2), adapting the Trecento iconography of Simone Martini's famous fresco in a modern unified scheme – 'sine civoriis' (without arches). He applied this new format to subsequent panel paintings, for example the altarpiece for the Grancia of Spedaletto (fig. 17, p. 34), a work emulating the luminosity of Domenico Veneziano. This style is also evident in the delightful small panel of

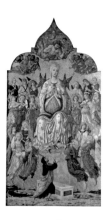

Matteo di Giovanni
(Sansepolcro, about 1428 – Siena 1495)

Benvenuto di Giovanni di Meo del Guasta
(Siena 1436 – about 1509)

The Resurrection of a Monk (Museo Diocesano, Pienza) and in his *Saint Catherine of Siena* fresco commissioned for the Palazzo Pubblico to mark her canonisation in 1461 (fig. 41, p. 103).

The impact of Donatello's Sienese sojourn (1457–61) upon Vecchietta is demonstrated in his *Saints Paul and Peter*, sculpted for niches on the loggia della Mercanzia (respectively in 1458–9 and 1460–2): these two marble statues are conceived according to Leon Battista Alberti's definition of sculpture – fully developed from every viewpoint, with strong expressions, attention to anatomical detail and remarkably executed.

As a mature sculptor, Vecchietta mostly worked in bronze. Among these last works is the *Resurrection* relief signed and dated 1472 in the Frick Collection, New York. His large schemes for the church of the Hospital continued; the monumental ciborium he made for it (1467–72) was moved to the Cathedral in 1506 by order of Pandolfo Petrucci (fig. 39, p. 70); and the extraordinary *Christ Resurrected* (1476) was executed for his own burial chapel there, together with a panel painting in which the *Madonna and Child with Four Saints* are set against a majestic *all'antica* apse (1477–8; Pinacoteca Nazionale, Siena). He was also employed for a series of works in Narni, Umbria – a *Saint Bernardino* in wood (Museo del Bargello, Florence), another polychrome wood sculpture of *Saint Anthony Abbot* (1475) and a panel of Saint Giovenale for Narni Cathedral. Vecchietta died in 1480, leaving unfinished an *Assumption of the Virgin*, an 'altarpiece in relief' destined for the church of San Frediano in Lucca; it was later completed by Neroccio de' Landi (Museo Nazionale di Villa Guinigi, Lucca). Neroccio was one of the many artists who trained in Vecchietta's workshop, a veritable hotbed of talent from which emerged some of the major Sienese painters of the late fifteenth century, from Benvenuto di Giovanni to Francesco di Giorgio Martini.

Matteo di Giovanni was one of the most successful artists in Siena of the fifteenth century. Born in Sansepolcro, he is first recorded in Siena in 1452, when he was already '*compagno*' (partner) of a certain Giovanni di Pietro. A Biccherna panel (1451–2, Rijksmuseum, Amsterdam) recently attributed to him by Luciano Bellosi is possibly his earliest commission. More certainly, he painted the altarpiece for the altar of Saint Anthony of Padua in the Baptistery (1460, now Museo dell'Opera). This sets the trend for his altarpieces throughout the 1460s such as the Graziani Triptych (Museo Civico, Sansepolcro) and the two '*tabulae quadratae sine civoriis*' (square panels without arches), in other words Renaissance *sacre conversazioni*, painted for Pienza Cathedral. In these works, Matteo demonstrates his familiarity with the vocabulary of local artists such as Pietro di Giovanni d'Ambrogio, Domenico di Bartolo and Vecchietta, but also picks up on the more naturalistic traits of the art of Donatello, Piero della Francesca and (in his first Pienza altarpiece) of Antonio del Pollaiuolo. Matteo di Giovanni worked within these stylistic parameters at least until 1470, when he signed the Della Ciaia Altarpiece for the church of the Santa Maria dei Servi (now Pinacoteca Nazionale, Siena). In 1468, he completed the *Massacre of the Innocents*, now in the Museo Capodimonte, Naples, his first version of a subject he would revisit three more times, all of them with architectural settings in classicising style. Matteo's career in the 1470s and 1480s is marked by more monumental works, such as his *Assumption* of 1474 (cat. 17) and the Placidi Altarpiece for the church of San Domenico (1476; see cat. 33–7) – which display an awareness of the styles of Liberale da Verona and Girolamo da Cremona – the Cinughi Altarpiece for Santa Maria della Neve (1477), the Santa Barbara altarpiece for San Domenico (1479) and the Celsi Altarpiece for the Cathedral (1480, now Museo dell'Opera). The painters Guidoccio Cozzarelli and Pietro Orioli trained in his workshop during this period.

Matteo's second large *Assumption*, for the church of Santa Maria dei Servi, Sansepolcro, was commissioned in 1487 and remained unfinished at the time of the artist's death. It represents one of the best examples of his later style, poised between the naturalism of Piero della Francesca and the innovation of Francesco di Giorgio. Right at the end of his career Matteo contributed *Judith* (cat. 69) to the cycle of Virtuous Men and Women and painted the lunette of the Tancredi Altarpiece in San Domenico, the centrepiece of which would be Francesco di Giorgio Martini's *Nativity*.

Cesari Brandi's description of Benvenuto di Giovanni as a 'Sienese infidel' has met with approval from many scholars: Benvenuto formed his own, stylistic vocabulary by leavening the great tradition of Sienese Trecento art with numerous non-Sienese influences – those of Girolamo da Cremona and Liberale da Verona, of painting from Umbria and the Marche, and of Netherlandish art – arriving at a style of particular sophistication. The gentle elegance of his Virgins, such as those in the Lehman Collection and the Detroit Institute of Arts, has been widely appreciated by critics from Bernard Berenson onwards.

Benvenuto trained in Vecchietta's workshop. He is recorded working as early as 1453, when he contributed to the now-lost fresco cycle of the *Passion with Saints Nicholas and Lucy*. In 1460 he is documented painting alongside Vecchietta and Francesco di Giorgio; Benvenuto assisted Vecchietta in completing the decoration of the apse of the Siena Baptistery, where the small *Works of Mercy* framing *The Way to Calvary* are attributed to him. The first certain surviving works by him are the *cassoni* panels with *The Triumph of David* (1459; Pinacoteca Nazionale, Siena), the *Miracle of the Mule* (about 1460–2; Alte Pinakothek, Munich), and the frescoed *Miracles of Saint Anthony of Padua* (about 1461) in the Chapel of Antonio di Carlo in the Siena Baptistery (fig. 18, p. 36).

In 1466, Benvenuto completed an *Annunciation* for the Observant Franciscan church of San Girolamo, Volterra (now Museo Diocesano d'Arte Sacra, Volterra), a painting in part inspired by Simone Martini's celebrated *Annunciation* (fig. 22, p. 45). However, the scenes in its predella demonstrate the impact of Vecchietta's handling of light and colour. A few years later, Benvenuto painted the magnificent *Adoration of the Magi* now in the National Gallery of Art, Washington, an overt tribute to Gentile da Fabriano's masterly treatment of this subject (1423; Uffizi, Florence). His Gabella panels of 1468 and 1474 (Archivio di Stato, Siena) are influenced by Ambrogio Lorenzetti's civic imagery.

In the 1470s, Benvenuto began a close association with Sano di Pietro, the pair collaborating on commissions for the church of San Giorgio in Bolsena; Benvenuto painted the predella to Sano's *Annunciation* and illuminated some pages of choir books for the Hospital of Santa Maria della Scala (now in the Museo dell'Opera del Duomo, Siena; Cleveland Museum of Art; Koninklijke Bibliothek, The Hague). Two other panels on which the two painters collaborated are in the Gemäldegalerie, Berlin. Meanwhile he was able to delegate the completion of a chapel ceiling in the Hospital of Santa Maria della Scala to his workshop, while concentrating on a *Nativity*

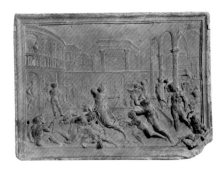

Francesco di Giorgio Martini
(Siena 1439 – 1501)

for the church of San Girolamo (now Pinacoteca, Volterra), and another *Annunciation*, this time for the Franciscans at San Bernardino, Sinalunga. These altarpieces – the former rectangular, the latter retaining a Gothic frame – reveal an emerging interest in work of Squarcione and Mantegna, transmitted to Siena by Liberale da Verona and Girolamo da Cremona. This interest is also evident in the illumination of *The Stigmatisation of Saint Francis* (probably 1470s) for Gradual no. 3 in the convent of the Osservanza in Siena. The dazzling Montepertuso altarpiece (1475; now in the parish church of Vescovado di Murlo) cites Matteo di Giovanni and shows an awareness of painting of the Marche and Urbino – especially its spacial construction. These developments, though set in a slightly archaic triptych structure, characterise the highpoint of Benvenuto di Giovanni's career. To this phase also belong the Borghesi Altarpiece in the Sienese church of San Domenico (completed during 1478), the Mantegnesque *Expulsion of Adam and Earth from Earthly Paradise* (cat. 32), the National Gallery *Virgin and Child* (cat. 13), and *Saints John the Baptist and Michael* (Musée des Beaux-Arts, Lyons), which, it has recently been proposed, may be the sole surviving fragment of the Bellanti Altarpiece, painted for San Domenico in 1483.

These masterpieces are in marked contrast to the banal legion of monochrome *Prophets* that he painted in collaboration with Guidoccio Cozzarelli in the dome of Siena Cathedral (1482). Yet Benvenuto regained his form with his designs for two marble floor panels in the Cathedral, *The Tiburtine Sibyl* (1483) and the energetic *Expulsion of Herod* (1483–5). In 1491, he completed an *Ascension* for the church of the Benedictine monastery of Sant'Eugenio, near Siena (now Pinacoteca Nazionale, Siena; its predella is in the National Gallery of Art, Washington). This was the climax of a larger commission that also included the illumination of a psalter (now Badia della Trinità, Cava dei Tirreni) and the frescoes in the chapterhouse (his *Crucifixion* and *Resurrection* remain in the church; *Saint Benedict* is in the Museo Bardini, Florence).

After the Sant'Eugenio commissions, Benvenuto di Giovanni's career merges with that of his son Girolamo (1470–1524), their workshop operating well into the sixteenth century. Despite the number of works signed by one or the other artist, distinguishing their individual hands is difficult. Commissions resulting from this father-son partnership include a *Nativity* (Museo Civico, Montepulciano) and a series of *Prophets* and *Patriarchs* in the Hospital of Santa Maria della Scala, Siena. These were rediscovered only recently in the rooms that originally housed the Confraternity of Saints Jerome, Francis and

Bernardino, of which Benvenuto was a very active member. This relationship possibly explains the numerous commissions he received from the Observant Franciscans, with whom the confraternity was associated.

Francesco di Giorgio Martini was the key artistic personality in Siena during the second half of the Quattrocento. He was a brilliant engineer as well as architect and artist (both painter and sculptor) and his services were sought by the prominent Italian *signori* of his time. His talents have long been celebrated, for example in the contemporary verse *Chronicle* written by Giovanni Santi in honour of Federico da Montefeltro, Duke of Urbino, and later in Giorgio Vasari's *Lives* (1550 and 1568). He undoubtedly relied on a large workshop and, particularly as regards his paintings, the degree of his participation has proved problematic for art historians: in the major 1993 exhibition dedicated to Francesco di Giorgio (Sant'Agostino, Siena) it was proposed that Francesco had by his side a *'fiduciario'* (right-hand man) who completed a considerable number of paintings on his behalf, but this theory is not unanimously endorsed (see p. 37).

Francesco di Giorgio almost certainly completed his apprenticeship in Vecchietta's workshop (their collaboration is discussed in the 1568 edition of Vasari's *Lives*). He is probably the 'Francesco' mentioned in a 1460 document from the Opera del Duomo together with Lorenzo di Pietro (Vecchietta) and Benvenuto di Giovanni. Several works ascribed to Francesco's early career reflect Vecchietta's influence – the *cassone* panels of *Stories of Joseph* (two surviving fragments are in the Pinacoteca Nazionale, Siena, the third in the Wellcome Institute, London); the *Saint Bernardino preaching* and small panels with Franciscan allegories, now divided among several collections (see cat. 8); a *Mythological Scene* (fig. 25, p. 51); the fragile *Saint Dorothy and the Infant Christ* (see cat. 10); and the illuminations for frontispiece of *De animalibus* (cat. 39).

Francesco was appointed as *operaio* in charge of Siena's water supply alongside the painter Paolo d'Andrea in 1469: this is the first document referring to his long, successful career as an engineer, recorded in his treatises (see cat. 42). In 1470–1, Francesco worked on the new church of the Hospital of Santa Maria della Scala, executing the decoration (in partnership with Lotto di Domenico) of the coffered ceiling and a now-lost fresco of *The Coronation of the Virgin*. This same subject appears in the large panel painted in 1472–4 for the church of the Abbey of Monteoliveto Maggiore (fig. 5, p. 13), for which Francesco adapted the composition of a niello pax and related print by the Florentine goldsmith Maso Finiguerra and painted the figure of God the Father in the flamboyant style of Liberale da Verona, with whom Francesco possibly shared a number of secular commissions. This altarpiece, and some other paintings that precede it, such as *The Virgin Mary protects Siena from Earthquakes* (cat. 3) and *Annunciation*

Liberale Bonfanti, known as Liberale da Verona

(Verona, about 1445 – about 1527/9)

(cat. 23), have been seen as showing a disparity between the design and the execution. This has been tentatively resolved by ascribing the design to Francesco and the completion to his 'fiduciario'. By this point, Francesco had probably already formed a 'societas in arte pictorum' (partnership in the art of painting) with Neroccio de' Landi, which lasted until 1475, a collaboration about which much remains to be discovered. Also in 1475 Francesco was commissioned to produce The Nativity currently in the Pinacoteca Nazionale, Siena (fig. 19, p. 39): as well as signing the painting, Francesco must have painted the main figures, which have fine light effects learned from Verrocchio and, indirectly, from Netherlandish artists. Other parts of this altarpiece were delegated to his workshop and it was delivered only in 1480 (a date once visible on the painting).

In 1477, Francesco di Giorgio moved to Urbino to serve Federico da Montefeltro at the court that had embraced Piero della Francesca, Pedro Berruguete and Fra Carnevale. He would be based there for nearly a decade. Francesco became the Duke's appointed architect and was entrusted with the direction of construction works at the Palazzo Ducale, the Cathedral and the church of San Bernardino, as well as projects in surrounding territories. His presence lured other artists from his Sienese entourage to the Marche, including Giovanni di Stefano, Giacomo Cozzarelli, the wood carver Antonio Barili and possibly Pietro Orioli. During his time in Urbino, Francesco also executed a portrait medal of the duke. Francesco was able nonetheless to maintain his links with Siena, often returning to carry out inspections on the fortifications in the Sienese contado.

In the final years of the Quattrocento, after 1487, Francesco di Giorgio returned to his native city, undertaking both works of military engineering and architecture for the government and important artistic commissions, for the cathedral. He also directed the busy work site for the decoration of the Bichi Chapel in Sant'Agostino (1488–94), where he found himself once again in the company of the painter Luca Signorelli, who had appointed him to manage the construction of the church of Santa Maria del Calcinaio in Cortona some years earlier. For the Bichi Chapel, Francesco carved a Saint Christopher (fig. 63, p. 224) as the centrepiece of a retable painted by Signorelli (see cat. 58–9). He also designed two episodes from the life of the Virgin for the side walls (see fig. 49–50, p. 153), frescoed in part by his collaborators. Concurrently, Francesco contributed to the cycle of Men and Women (cat. 67), a project of which he was probably in overall charge, at least initially. The problematic Nativity in the church of San Domenico (which features splendid

angels inspired by Botticelli and shepherds painted by Bernardino Fungai) belongs to the last phase of Francesco's career as a painter. While engaged in these numerous public commissions in Siena, he was also able to continue prestigious projects from Duke Giangaleazzo Sforza, who in 1490 summoned the artist to Milan to judge a model for the new domed crossing for the Cathedral there, and Alfonso II of Aragon, who often requested Francesco di Giorgio's presence in Naples for fortification works.

This most industrious and talented of artists died in November 1501. He was buried at the Osservanza in Siena on 29 November. Destined for this church was his large Spoliation of the Christ (Pinacoteca Nazionale, Siena, see fig. 20): it was finally completed by his workshop, possibly with the collaboration of the young Baldassarre Peruzzi.

Liberale da Verona, along with Girolamo da Cremona, also from North Italy, played an important role in the artistic life of Siena during the early 1470s. The arrival of these two masters sparked one of the finest moments in Quattrocento manuscript illumination with their pages for Siena Cathedral's great choir books. In January 1467, Liberale presented himself in Siena as 'a Lombard youth' to the Cathedral authorities, who entrusted him with the illumination of a capital letter for an antiphonal, representing Christ in Glory (Barber Institute of Fine Arts, Birmingham), his first commission. Liberale introduced emerging artistic trends from the northern cities of Padua, Ferrara and Mantua, styles informed by Donatello, Squarcione and Andrea Mantegna. This was to have a profound effect on local masters, such as Francesco di Giorgio and Benvenuto di Giovanni.

Liberale was born in Verona, where he is recorded as a ten-year-old. In 1465, he witnessed a deed at the monastery of Santa Maria in Organo, an Olivetan Benedictine foundation with which Liberale would be on friendly terms throughout his career; explaining why he was to receive many assignments from Olivetan congregations all over Italy. The Olivetans were probably responsible for persuading the young Liberale to move to Siena to undertake the decoration of the choir books for the abbey of Monteoliveto Maggiore, near Asciano. Arriving around 1466, the young artist worked on four of twenty-two choir books for the abbey (the codices A, Q, R and Y now Museo della Cattedrale, Chiusi). The lively, expressionistic charge of the Olivetan illuminations indicates that Liberale must have previously trained in Ferrara. His art in Siena combined Ferrarese invention with an occasional propensity for Sano di Pietro's more traditionally Sienese style – apparent both in the figures from the Olivetan choir books and in panel paintings such as an early Virgin and Child (Lindenau-Museum, Altenburg).

Liberale remained engaged on the Cathedral choir books until 1476. The earliest still display the unbridled fantasy of Ferrarese art – for example, his New Testament scenes, both witty and colourful, of 1467–8 (codex 24.9). This style is epitomised by his marvellous illumination of a wild-haired wind, the so-called Aeolus (1468–70; codex 20.5), in the only choir book entirely illustrated (and signed) by him. From late 1469, he was joined on the project by Girolamo da Cremona, who was then about thirty-five years of age, a faithful follower of Andrea Mantegna. Girolamo left Siena in 1474, eventually returning to his native Veneto. Liberale's style, following his contact with Girolamo da Cremona (and therefore Mantegna), became more lucid and substantial, as seen in his Crucifixion in the missal in the Biblioteca Comunale,

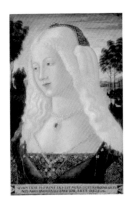

Neroccio di Bartolomeo de' Landi
(Siena 1447 – 1500)

Siena (1471), his illuminations in choir books 21.6 (1472), 23.8 (1472–3, also containing some extraordinary pages by Girolamo) and 13.0 (1475), and in two remarkable paintings, *Christ the Redeemer with Saints* in the Cathedral of Viterbo (1472) and *The Virgin and Child with Saints Benedict and Francesca Romana* (about 1474–5; Santa Maria Nuova, Rome).

A defining factor in Liberale's stylistic evolution was his interest in new developments taking place within the Sienese artistic community – Donatello's arrival in 1457, and the classicising style of Antonio Federighi and Francesco di Giorgio. Two fragments of a predella of 1469–70 with stories of Saint Peter (cat. 29, 30) closely reflect Francesco di Giorgio's idiom, and it is likely that the two had a working relationship, for example in the decoration of a short poem in praise of Bianca Saracini (1473–4; cat. 50). The other surviving works from Liberale's time in Siena are his illuminations for Pliny's *Natural History*, commissioned by Gregorio Loli Piccolomini (1476; Victoria and Albert Museum, London), and three pages in a Book of Hours which once belonged to the nun Artemisia Piccolomini (about 1475; Free Library of Philadelphia). These works confirm Vasari's report that Liberale worked for the Piccolomini family.

After completing a few small assignments for Monteoliveto Maggiore, Liberale ended his decade-long stay in Siena in 1476 and returned north, where he pursued his career as an illuminator and painter for another half-century, re-establishing himself in his native Verona and embracing new developments in Venetian and Netherlandish painting.

The dreamy lyricism of Neroccio de' Landi's paintings made him a firm favourite among Anglo-American art historians of the beginning of the twentieth century, largely influenced by Bernard Berenson, who hailed him as the heir to Simone Martini. Born in 1447, the young Neroccio is recorded as working for the Opera del Duomo, Siena, in 1461. It is plausible that by that time he was already active as an apprentice in Vecchietta's workshop, possibly responsible for some of the angels in Vecchietta's *Assumption* altarpiece for Pienza Cathedral (1460–2). At the same time, he was probably following the progress of Vecchietta's Spedaletto Altarpiece (now Museo Diocesano, Pienza), the lunette of which (fig. 17, p. 34) clearly inspired his *Annunciation* (cat. 24). He perfected his skills as a sculptor on a terracotta bust of Saint Jerome, now lost, for the Sienese *compagnia* devoted to the saint. His Bernardino predella (cat. 7) shows his debt to Vecchietta's style, and an interest in the rigorous spatial construction that so fascinated his contemporary Francesco di Giorgio, beside whom he must have worked in Vecchietta's shop. Despite their different approaches, Neroccio and Francesco formed a *'societas in arte pictorum'* (partnership in the art of painting) that was rescinded in 1475. Notwithstanding significant research by Max Siedel, this phase remains rather obscure. What is certain is that during these years Neroccio carved a number of extraordinary wooden figures – *Saint Catherine of Siena* for her Oratory in Siena (cat. 9) and the *Angel of the Annunciation*, carved from a walnut trunk that had been purchased by Francesco di Giorgio in 1474 (Salini collection, Asciano), believed to have been destined for the church of the Hospital of Santa Maria della Scala. The energetic draperies of these statues hark back to Donatello's sculpture – via Vecchietta – while their facial features closely resemble figures painted by Francesco di Giorgio at this time: these very individual traits of Neroccio as a sculptor also appear in the *Saint Albert* recently rediscovered by Laura Martini at the church of San Niccolò al Carmine in Siena.

Following the termination of his partnership with Francesco di Giorgio, Neroccio painted a triptych (1476, Pinacoteca Nazionale, Siena; original location unknown) notable for its traditional style – gold ground and exquisite, floating figures as if from another world. These features are also characteristic of Neroccio's vast number of private devotional works (cat. 12, 16) and of his few altarpieces, made mostly for subject towns outside Siena – Montepescini (1492; now Pinacoteca Nazionale, Siena), Rapolano (now National Gallery of Art, Washington) and Montisi (1496; *in situ*).

After Vecchietta's death in 1480, Neroccio purchased his old master's home and workshop situated near the

Piazza del Duomo, and completed the wooden sculpture of the *Madonna Assunta* that Vecchietta had started for San Frediano in Lucca (now in the Museo di Villa Guinigi, Lucca). In 1481, Neroccio was again in Lucca, commissioned to paint an altarpiece for the abbot of San Salvatore a Sesto. A predella with enchanting stories of Saint Benedict (cat. 38) almost certainly belonged to this painting. Back in Siena, Neroccio worked on several commissions for the Cathedral, designing the floor panel of the *Hellespontine Sibyl* (1483) and carving the marble tomb of Bishop Tommaso Piccolomini del Testa (1485), a work in an indisputably Renaissance style. The celebrated *Portrait of a Young Woman* (cat. 51) probably also dates to this period. A similar ideal of female beauty would find an expression both in *Claudia Quinta* (cat. 72) for the cycle of Virtuous Men and Women and in a marble *Saint Catherine of Alexandria* for the chapel of Saint John the Baptist in the Cathedral, commissioned in 1487 but not installed until 1501, a year after Neroccio's death.

Neroccio left behind a packed workshop, the contents painstakingly recorded in an inventory. As well as tools, marbles, paintings, sculptural models and completed sculptures, there was a plaster *Virgin* by Donatello and a collection of *'anticaglie'* – this last detail confirming Neroccio's interest in the Antique.

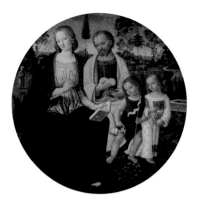

Bernardino di Betto, known as Pintoricchio

(Perugia 1456/1460 – Siena 1513)

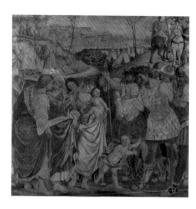

Luca Signorelli

(Cortona, about 1440/50 – 1523)

Probably the most successful painter in Rome during the Borgia papacy at the end of fifteenth century, Pintoricchio merited a number of celebratory sonnets by his poet friend Serafino Aquilano (whose portrait he painted) and later the praise of Francesco Maturanzio who, in his *Chronicles*, declared him second only to Perugino. In 1500, the Sienese banker Agostino Chigi wrote a now famous letter from Rome to his father in Siena, in which he recommended Pintoricchio as the best painter after Perugino to entrust with the altarpiece for the family chapel in Sant'Agostino. The contemporary scholar Sigismondo Tizio was sufficiently moved to write: 'Bernardino himself surpassed Pietro [Perugino] as a master of painting'. Tizio knew the works of Pintoricchio, now settled in Siena, and described his style, claiming that, in emulation of the Roman painter Ludius, Pintoricchio would embellish his images 'with luxuriant foliage and aerial perspectives of towns, and with beautiful draperies'. Ironically these same elements would be harshly condemned in Vasari's *Lives* (1550 and 1568), and Vasari's verdict, that 'his name was much more famed than his works deserved', would colour Pintoricchio's reputation for centuries.

Recent research by Maria Rita Silvestrelli suggests that Pintoricchio was probably born in Perugia between 1456 and 1460 into a family of modest means. By the time he enrolled in the painters' guild in Perugia in 1481, he had been working for some time, contributing to the cycle of *The Life of Saint Bernardino* of about 1473 (Galleria Nazionale, Perugia) with Perugino who, according to Vasari, was his master. Works such as *The Virgin and Child* (National Gallery, London) and the small *Crucifixion with the Saints Jerome and Christopher* (Galleria Borghese, Rome) exemplify his early style with its decorative quality and leafy landscapes.

Under the direction of his master Perugino, Pintoricchio worked on the decoration of the Sistine Chapel in Rome, contributing to the frescoes of *The Baptism of Christ* and *The Journey of Moses* (1481–2). Pintoricchio also obtained the commission to fresco Niccolò Bufalini's family chapel at Santa Maria all'Aracoeli (painted 1482–5). The result was a series of airy, beautifully balanced scenes from the life of Saint Bernardino of Siena, framed by *all'antica* borders and infused with a humorous narrative vein (including a tribute to one of Perugino's Sistine Chapel frescoes in the building at the centre of *The Burial of Saint Bernardino*). In Rome, Pintoricchio immersed himself in the study of the Antique, especially the ornamentation of the recently discovered Domus Aurea (Golden House of Nero). In a number of projects undertaken during these years – the best known of them the richly ornamental paintings in

the apartments in the Vatican of the newly elected Pope Alexander VI (1492–5) – he proved his ability as a director of works, managing a large group of assistants among whom Alessandro Angelini has recognised a number of Sienese painters.

In 1502 Francesco Todeschini Piccolomini (who would briefly become Pius III in 1503) summoned Pintoricchio to Siena to decorate the Piccolomini Library in the Cathedral, a task that would occupy him until 1508. He executed the *all'antica* vault (1502–3; largely delegated to Giacomo Pacchiarotti), *The Coronation of Pius III* on the façade (1503–4; possibly with the young Baldassarre Peruzzi) and the vast biographical cycle of *The History of Pius II* (1504–8). Raphael appears to have played a fundamental role in the planning of some episodes in this scheme, as stated by Vasari and confirmed by an important body of drawings (see cat. 75, 76). The 'painted biography', taken from the *Life of Pius II* by Giovanni Antonio Campano (1495), spans ten monumental scenes, in which Pintoricchio downplays the more 'picturesque' aspects of his painting in favour of more balanced Peruginesque compositions.

While in Siena, Pintoricchio received many commissions for the Cathedral, including frescoes for the Chapel of Saint John the Baptist (1504) and the design for the inlaid marble floor panel with the *Allegory of Wisdom* (installed in 1505–6), and contributed, along with Signorelli and Girolamo Genga, to the fresco cycle in Pandolfo Petrucci's palace (see cat. 80–2). He also painted a now lost *Nativity* for the Piccolomini Chapel in San Francesco (1504), the tondo of *The Virgin and Child with Saint Joseph and Infant Saint John the Baptist* (cat. 77), an *Assumption* (1512; Pinacoteca Civica, San Gimignano) and a *Way to the Calvary* (1513; Museo Borromeo, Isola Bella). These many undertakings did not prevent the ever-industrious Pintoricchio from completing an altarpiece for Sant'Andrea in Spello (begun in 1506, mainly delegated to Eusebio da San Giorgio). He also carried out the prestigious commission to decorate the vault of the presbytery of the Roman church of Santa Maria del Popolo (1509–10), at the request of Pope Julius II. Pintoricchio died in Siena in May 1513 and was buried in the church of the Santi Vincenzo e Anastasio, the seat of the same Bishop Sigismondo Tizio who had been such an admirer of his work.

'Luca Signorelli was more famous throughout Italy in his day, and his works were held in greater esteem than has ever been the case with any other master at any time whatsoever, for the reason that in the works that he executed in painting he showed the true method of making nudes, and how they can be caused, although only with art and difficulty, to appear alive.' Thus Giorgio Vasari praised Signorelli, with whose biography he concluded the second part of the 1568 edition of his *Lives*. Vasari also relates how Michelangelo had been passionately taken with Luca's powerful style of painting, and particularly by the frescoes in the San Brizio Chapel in the Cathedral of Orvieto.

Born in Cortona, Signorelli is first documented as a painter in 1470. According to his contemporary Luca Pacioli, he was a pupil of Piero della Francesca, and Berenson suggested that a series of works that recall Piero della Francesca's style (such as *The Madonna with Child and Three Angels* in Christ Church, Oxford) may belong to Signorelli's early career; this proposal is not unanimously accepted. Vasari recorded that Signorelli painted *The Testament and Death of Moses* in the Sistine Chapel (about 1482), though many now consider at least part of this to be the work of Bartolomeo della Gatta. Although Signorelli's certain early paintings – his *Flagellation* and *Madonna with Child* in the Brera, Milan, his frescoes for the Sagrestia della Cura, Basilica di Loreto, and the richly coloured Vagnucci Altarpiece (1484, Perugia Cathedral) – look strongly Florentine, no early stay in Florence is securely documented. His first contact with Sienese art dates to 1484, when he travelled to Gubbio on behalf of the city of Cortona to entrust Francesco di Giorgio with the design of the church of Santa Maria al Calcinaio. Signorelli would later collaborate with Francesco di Giorgio on the decoration of the Bichi Chapel in Sant'Agostino, Siena, painting two *Sibyls* in lunettes and the panels of the altarpiece (see cat. 58–9). Now dispersed, these panels reveal a significant stylistic affinity with three remarkable altarpieces painted by Signorelli in Volterra (*The Annunciation* and *The Virgin and Child with Saints*, both 1491; Pinacoteca Comunale, Volterra; *The Circumcision* in the National Gallery, London).

The early 1490s were auspicious for Signorelli, bringing commissions from the Medici, among which was *The Madonna and Child with Male Nudes* (Uffizi, Florence). During this busy time, Signorelli worked for patrons across central Italy – in Montepulciano (*The Madonna with Child*, Santa Lucia); in Urbino (1496; *The Crucifixion*, Galleria Nazionale delle Marche); and above all in Città di Castello (*The Adoration of the Child*, Capodimonte, Naples; *The Adoration of the Magi*, Louvre, Paris; *The Adoration*

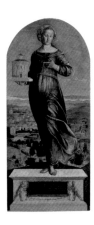

Pietro di Francesco Orioli
(Siena 1458 – 1496)

of the Shepherds, 1496; National Gallery, London; *The Martyrdom of Saint Sebastian*, 1498; Pinacoteca Comunale, Città di Castello). Two fresco cycles stand out from this period: in 1498, Signorelli frescoed the cloister of the abbey of Monteoliveto Maggiore with nine episodes from the life of Saint Benedict, part of a vast scheme that would later be completed by Sodoma; and in 1499, by virtue of his reputation as 'most famous painter in all Italy' and as author of 'many wonderful paintings in many cities and especially in Siena', Signorelli obtained the commission for the decoration of the San Brizio Chapel in the Cathedral of Orvieto. This was his greatest project, that kept him occupied until 1504. His frescoes there illustrate a tremendous *Apocalypse*, in a sequence of scenes framed by grotesque decoration and crowded with foreshortened nudes with beautifully observed anatomies.

Signorelli's stay in Orvieto (interrupted by other commissions) was followed by two further interludes in Siena and a productive stay in the city of Arcevia in the Marche (1507–8; where two altarpieces remain in the church of San Medardo). In 1506, he was asked by the Siena Cathedral authorities to design a scene for the Cathedral floor, which he never completed. He returned, however, to work in Pandolfo Petrucci's palace, together with his young assistant Girolamo Genga and the aging Pintoricchio. This project was completed in around 1509 (see cat. 80–2).

Finally settling in Cortona, Luca Signorelli lived until 1523. His pictures remained much in demand around Arezzo and the Val di Chiana. His late works, however, reveal an inability to adapt to the innovations of the 'the modern manner', and were often made in collaboration with his workshop (as is the case with the 1515 altarpiece from Montone, now in the National Gallery, London). His workshop had always been full of assistants, among the most important of whom was Luca's nephew Francesco Signorelli, a faithful follower since the period of the Orvieto project.

Pietro di Francesco Orioli was one of the most talented painters in Siena at the end of the fifteenth century, the humanist Sigismondo Tizio going so far as to declare that, had he not died prematurely in 1496, he would have been 'not at all inferior to Zeuxis or Apelles'. Despite his contemporary fame, after his death he was forgotten, and his works were confused with those by other masters (particularly Giacomo Pacchiarotti). Orioli's œuvre was rediscovered by Alessandro Angelini on the basis of the documented *Washing of the Feet*, frescoed in 1489 in the Baptistery, Siena: this is one of the most important Sienese paintings of the late Quattrocento and demonstrates the artist's great talent in its spatial rigour, brilliant clarity and skilful composition. These stylistic traits suggest that the painter was part of Francesco di Giorgio's circle, and it is possible that Orioli might have spent time at the Montefeltro court in Urbino.

Born in Siena in 1458 and recorded as a painter as early as 1474 (carrying out a minor commission for the Hospital of Santa Maria della Scala), Pietro was trained in Matteo di Giovanni's workshop, on the evidence of his earliest known works, which date to the late 1470s – the altarpiece for the Pieve di Buonconvento and *The Nativity with Saints Bernardino and Anthony of Padua* (now Museo di Arte Sacra, Massa Marittima). In the early 1480s, he painted a detailed interior of the Cathedral of Siena on a Gabella panel (fig. 79, p. 304).

Orioli's style continued to evolve in the 1480s, influenced by the naturalism of Domenico Ghirlandaio's painting, which was introduced to Siena by Fra Giuliano da Firenze (especially in the altarpiece *The Virgin and Child with Saints Onophrius and Bartholomew* in the Pinacoteca Nazionale, Siena). It is thought that his putative sojourn in Urbino belongs to this period. Back in Siena, Orioli received a series of important commissions – the decoration of the refectory of the abbey of Monteoliveto Maggiore (of which only a few fragments remain); an altarpiece commissioned by Andrea Todeschini Piccolomini for the chapel of his villa at Castel Rosi near Buonconvento, an *ex-voto* following the plague of 1486 (now Capitolo, Siena Cathedral); the aforementioned fresco for the chapel of Saint John the Evangelist in the Baptistery, Siena (commissioned by the *operaio* Alberto Aringhieri, completed in 1489); and the altarpiece for the Collegiata in San Casciano Bagni.

In 1492, Orioli restored Ambrogio Lorenzetti's famous *Allegory of Good and Bad Government* in the Palazzo Pubblico of Siena, and in the same room, on the window wall, painted a fictive classical arcade. About the same time, he contributed to a series of collective projects, including the decoration of the Bichi Chapel at

Sant'Agostino (under the direction of Francesco di Giorgio, with the participation of Luca Signorelli) and the cycle of Illustrious Men and Women (*Sulpitia*; cat. 71). His altarpieces of the *Ascension* and *Visitation* now in the Pinacoteca Nazionale, Siena, should probably be dated to the very end of his career, as should the altarpiece of *The Nativity with Saints* (National Gallery, London), painted for the church of the castello at Cerreto Ciampoli. In his many works for private devotion, Orioli alternated between a modern style (for example *The Adoration of the Shepherds*, recently purchased by the Fondazione del Monte dei Paschi di Siena) and more traditional images (see cat. 15), an expression of his deep religious faith. Orioli was a committed member of the Confraternity of Saints Jerome, Francis and Bernardino. Confraternity documents testify that he died in Siena on 9 August 1496, adding that 'at the burial there were many people; it looked as if the whole city was in mourning' and that he 'was a most excellent painter, and apt to become even better'.

Giovanni Antonio Bazzi, known as Sodoma

(Vercelli 1477 – Siena 1549)

Sodoma is one of the best-known artists 'born under Saturn', famed for his licentiousness (hence his nickname) and the eccentric behaviour described and condemned by Giorgio Vasari in the 1568 edition of his *Lives*. Paolo Giovio had earlier written of Sodoma that he was 'of preposterous and unstable state of mind, insanely affected' in his *Life of Raphael* (written in 1523–7). However, in the same work, Sodoma is noted as one of Raphael's 'heirs', an indication of the high esteem in which he was held by his contemporaries.

Sodoma was an apprentice in 1490 in Martino Spanzotti's workshop in Vercelli, where he was trained in a North Italian Renaissance style. He had left Vercelli by 1501 at the latest and, by July 1503, was working near Siena on the cycle of frescoes in the refectory of the Olivetan monastery of Sant'Anna in Camprena. As proposed by Roberto Bartalini, Sodoma's early style, which essentially follows Leonardo da Vinci with *all'antica* inflections, suggests that his arrival in Siena (according to Vasari, effected by the Spannocchi family) was preceded by a brief stay in Milan, after which he moved to Rome. It was then that he painted frescoes of the *Life of the Virgin* and *The Crucifixion* in San Francesco, Subiaco, and perhaps also a *Pietà* for the Confraternity of Santa Maria dell'Orto. Confirmation of Leonardo's influence on Sodoma – especially in his portraiture – is found in the splendid early drawing in Oxford (cat. 61).

Sodoma was summoned by the Olivetans of Monteoliveto Maggiore to complete the cycle of the *Life of Saint Benedict* in their cloister which had been started by Signorelli some years earlier, and there, between 1505 and 1508, he frescoed around thirty episodes, his unbridled imagination running free in the surrounding grotesque decorations. Meanwhile, in Siena, Sodoma came into contact with Sigismondo Chigi, who was then lavishly refurbishing his palace, for which Sodoma decorated a vault with stories from Ovid's *Metamorphoses*. His *Nativity* tondo (Pinacoteca Nazionale, Siena) was possibly also a Chigi commission. Chigi later acted as Sodoma's guarantor during negotiations with Pope Julius II for the commission to paint what became the Stanza della Segnatura in the Vatican. Sodoma began work in October 1508, but proceeded no further than planning the layout of the ceiling, painting the central foreshortened oculus and eight historical and mythological episodes. In 1509, Raphael was commissioned to decorate the remainder of these apartments.

We know that Sodoma then returned to Siena, where he painted the Raphaelesque *Deposition* for the church of San Francesco (around 1510; Pinacoteca Nazionale, Siena); two now lost *all'antica* façades for the palaces of

Sigismondo Chigi (1510) and Agostino Bardi (see cat. 101); and a *Flagellation* for San Francesco (of which only a fragment now remains, in the Pinacoteca Nazionale, Siena). Several documents record his stay in Florence in 1515 and prove a connection between Sodoma and Jacopo d'Appiano, Lord of Piombino, and with Alfonso I d'Este, Duke of Ferrara, for whom he painted a *Saint George and the Dragon* (1518; National Gallery of Art, Washington).

Sodoma went back to Rome during 1516–17, and there frescoed *Stories of Alexander the Great* in the villa of Agostino Chigi, Sigismondo's brother, now known as the Farnesina; among them a *Marriage of Alexander and Roxanne*, derived from a Raphael drawing. It was through Agostino Chigi that Sodoma presented a *Lucretia* to Pope Leo X, usually identified with *The Suicide of Lucretia* (Szépmüvészeti Múzeum, Budapest), which was celebrated in a series of epigrams by Euralio d'Ascoli and for which he was rewarded with the title of *cavaliere*.

By 1518 he had again returned to Siena, where he collaborated and competed with Beccafumi and Girolamo del Pacchia in the Oratory of San Bernardino, executing frescoes of *The Presentation of the Virgin* and *The Coronation of the Virgin*. Also in 1518, Sodoma wrote to Alfonso d'Este and Francesco Gonzaga, hoping to visit their courts, though it is unclear whether these visits ever materialised. At this point in Sodoma's career, there is something of a gap until the mid 1520s, when he is again recorded in Siena – signing a celebrated double-sided banner for the Compagnia di San Sebastiano (Galleria Palatina, Florence); painting the frescoes for the Chapel of Saint Catherine in San Domenico (1526; see cat. 90–1) and the *cataletto* (bier) for the Confraternity of San Giovanni Battista (paid for by 1527; Museo dell'Opera del Duomo, Siena). These works demonstrate an awareness of the Roman '*maniera*' and, in particular, of Polidoro da Caravaggio's landscape style.

Important public commissions continued to flood in – for paintings of *Saint Victor and Saint Ansanus* (1529) and the *Blessed Bernardo Tolomei* (1533; Sala del Mappamondo, Palazzo Pubblico), and a large *Nativity of the Virgin* lunette for Porta Pispini (now much abraded, 1530–1; San Francesco in Siena). Sodoma continued to work at important churches in Siena, painting the Spanish Chapel at Santo Spirito (1530), the magnificent *Adoration of the Magi* in the church of Sant'Agostino (by 1533), and altarpieces for the Chapel of Saint Calixtus in the Cathedral and the chapel of the Rosary in San Domenico.

In 1538, Sodoma left Siena, moving first to Piombino with Jacopo d'Appiano and later to Pisa, where he completed two paintings for the Cathedral (1541–2)

and the altarpiece for Santa Maria della Spina (1542, Museo Nazionale di San Matteo, Pisa). Little is known about his last years; though there survives an affectionate letter to him from Pietro Aretino in 1545. Following Sodoma's death, the posthumous inventory of his goods of 1549 described a substantial number of paintings in his workshop, together with 'antiquities and painter's things'.

PLAN OF SIENA

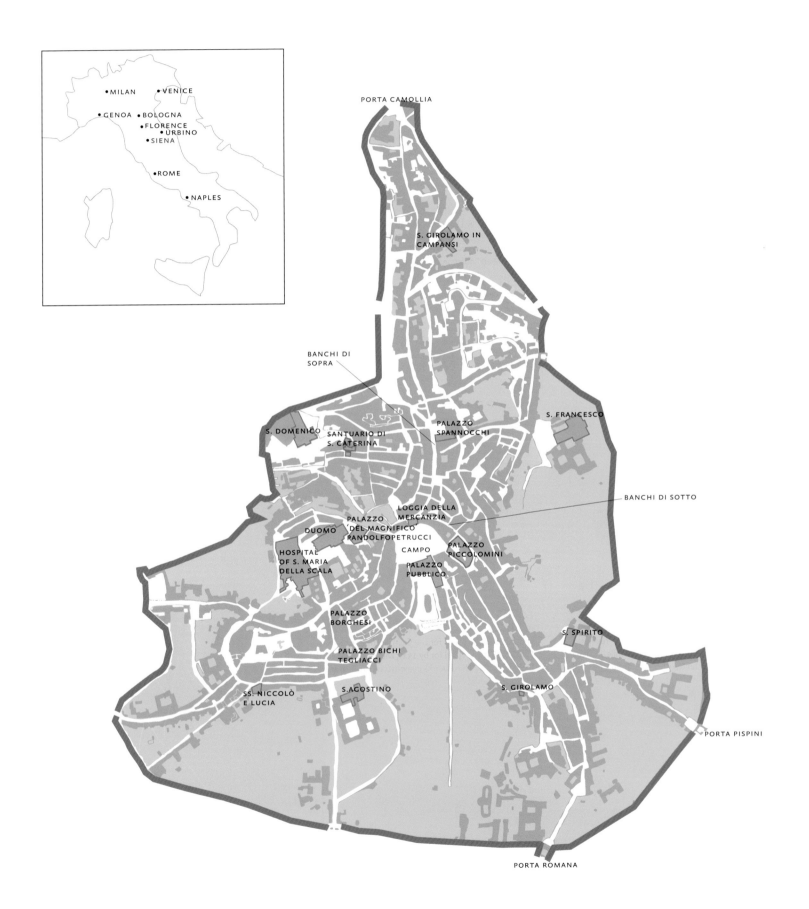

MILAN VENICE

GENOA BOLOGNA
FLORENCE URBINO
SIENA

ROME

NAPLES

PORTA CAMOLLIA

S. GIROLAMO IN
CAMPANSI

BANCHI DI
SOPRA

S. FRANCESCO

S. DOMENICO SANTUARIO DI PALAZZO
S. CATERINA SPANNOCCHI

BANCHI DI SOTTO

LOGGIA DELLA
MERCANZIA

DUOMO PALAZZO
'DEL MAGNIFICO'
RANDOLFOPETRUCCI
PALAZZO
PICCOLOMINI

HOSPITAL
OF S. MARIA CAMPO
DELLA SCALA PALAZZO
PUBBLICO

PALAZZO
BORGHESI S. SPIRITO

PALAZZO BICHI
TEGLIACCI
S. GIROLAMO

SS. NICCOLÒ S. AGOSTINO
E LUCIA
PORTA PISPINI

PORTA ROMANA

BIBLIOGRAPHY

NOTE
Renaissance Siena: Questions of Attribution, (ed. L. Syson) will be published in 2008. This title will present further research and findings on the works documented in this exhibition catalogue.

ABBATE AND SRICCHIA SANTORO 1995
F. Abbate and F. Sricchia Santoro, *Napoli, l'Europa. Ricerche di Storia dell'Arte in onore di Ferdinando Bologna*, Catanzaro 1995, pp. 79–83

ACIDINI LUCHINAT 1979–83
C. Acidini Luchinat, 'La grottesca', *Storia dell'arte italiana*, 11 vols, Turin 1979–83

AGOSTI 1982
G. Agosti, 'Precisioni su un "Baccanale" perduto del Signorelli', *Prospettiva*, 20 (1982), pp. 70–7

AGOSTI 1986
G. Agosti, 'La fama di Cristoforo Solari', *Prospettiva*, 46 (1986), pp. 57–65

AGOSTI AND ISELLA 2004
G. Agosti and D. Isella, *Antiquarie prospettiche romane*, Parma 2004

AIT 2005
I. Ait, 'Mercanti-banchieri nella città del papa: gli eredi di Ambrogio Spannocchi fra XV e XVI secolo' in *Mercanti stranieri a Roma tra '400 e '500*, Rome 2005, pp. 7–44

AJMAR-WOLLHEIM AND DENNIS 2006
At Home in Renaissance Italy, eds M. Ajmar-Wollheim and F. Dennis, exh. cat., Victoria & Albert Museum, London 2006

ALBERTI 1972 EDN
L.B. Alberti, *On Painting and on Sculpture: the Latin Texts of De Pictura and De Statua*, ed. and trans. C. Grayson, London 1972

ALBERTI 1998 EDN
L.B. Alberti, *De Statua*, ed. M. Collareta, Livorno 1998

ALBERTUS MAGNUS 1999 EDN
Albertus Magnus, *On Animals: A Medieval Summa Zoologica*, trans. K.F. Kitchell Jr. and I.M. Resnick, 2 vols, Baltimore 1999

ALESHIRE 1989
S.B. Aleshire, *The Athenian Asklepieion: the people, their dedications and the inventories*, Amsterdam 1989

ALESSI 1984
C. Alessi, 'Pandolfo Petrucci e L'Osservanza' in *Restauro di una terracotta: il "Compianto" di Giacomo Cozzarelli*, exh. cat., Opificio delle Pietre Dure, Florence and Modena 1984, pp. 143–7

ALESSI 2002
Palazzo Corboli. Museo d'Arte Sacra, ed. C. Alessi, Siena 2002

ALESSI 2003
C. Alessi, *La Confraternita ritrovata. Benvenuto di Giovanni e Girolamo di Benvenuto nello Spedale Vecchio di Siena. The Rediscovered Confraternity. Benvenuto di Giovanni and Girolamo di Benedetto in Siena's Spedale Vecchio*, Asciano 2003

ALESSI AND BAGNOLI 2006
Matteo di Giovanni. Cronaca di una strage dipinta, eds C. Alessi and A. Bagnoli, exh. cat., Santa Maria della Scala, Palazzo Squarcialupi, Siena 2006

ALESSI AND MARTINI 1994
C. Alessi and L. Martini, *Panis vivus. Arredi e testimonianze figurative del culto eucaristico dal VI al XIX secolo*, Siena 1994

ALESSI, MARIOTTI, MATTEINI, MOLES, POGGIO, ROSSI 1992
C. Alessi, P.I. Mariotti, M. Matteini, A. Moles, B. Poggio, D. Rossi, 'Le pitture murali della zona presbiteriale del Battistero di Siena: storia, studi e restauri', *OPD*, 4 (1992), pp. 9–27

ALEXANDER 1994
The Painted Page: Italian Renaissance Book Illumination, 1450–1550, ed. J.J.G. Alexander, exh. cat., Royal Academy of Arts, London and The Pierpont Morgan Library, New York 1994

ALLEGRETTI 1733
A. Allegretti, 'Ephemerides Senenses ab anno MCCCCL usque ad MCCCCXCVI italico sermone scriptae' in *Rerum Italicarum Scriptores*, ed. L. Muratori, 23, Milan 1733, pp. 772–3

ALLEGRETTI 1733
A. Allegretti, 'Ephemerides Senenses ab anno MCCCCL usque ad MCCCCXCVI italico sermone scriptae' in *Rerum Italicarum Scriptores*, ed. L. Muratori, 23, Milan 1733, pp. 772–3

ALLEN AND SYSON 1999
D. Allen and L. Syson, *Ercole de' Roberti: the Renaissance in Siena*, exh. cat., J. Paul Getty Museum, Los Angeles 1999

ALLEN 1977
S.S. Allen, 'The Griselda Tale and the Portrayal of Women in the Decameron', *Philological Quarterly*, 56, 1977, pp. 1–13

A.M 1893
A.M, 'Pene ai traditori', *Miscellanea storica senese*, I, (1893), pp. 23–4

AMMANNATI PICCOLOMINI 1997 EDN
I. Ammannati Piccolomini, *Lettere (1444–1479)*, ed. P. Cherubini, 3 vols, Rome 1997

ANGELINI 1982
A. Angelini, 'Pietro Orioli e il momento "urbinate" della pittura senese del Quattrocento', *Prospettiva*, 30 (1982), pp. 30–43

ANGELINI 1988
A. Angelini, 'Francesco di Giorgio pittore e la sua bottega. Alcune osservazioni su una recente monografia', *Prospettiva*, 52 (1988), pp. 10–24

ANGELINI 1989
A. Angelini, 'Intorno al Maestro di Griselda', *Annali (Fondazione di Studi di Storia dell'Arte Roberto Longhi, Firenze)*, 2, 1989, pp. 5–15

ANGELINI 1992
A. Angelini, 'Giovanni di Stefano e le lupe marmoree di Porta Romana a Siena', *Prospettiva*, 65 (1992), pp. 50–5

ANGELINI 2002
A. Angelini, 'Franceco di Giorgio e l'architettura dipinta a Siena alla fine del Quattrocento', *Bullettino senese di storia patria*, 109 (2002), pp. 117–183

ANGELINI 2005
Pio II e le arti. La riscoperta dell'antico da Federighi a Michelangelo, ed. A. Angelini, Siena 2005

ARASSE 1977
D. Arasse, 'Fervebat pietate populus: art, devotion et societé autour de la glorification de S. Bernardin de Sienne', *Mélanges de l'Ecole Française de Rome (Moyen-Age et Temps Modernes)*, 89, 1 (1977), pp. 189–263

ARASSE 1995
D. Arasse, 'Entre devotion et hérésie. La tablette de saint Bernardin ou le secret d'un prédicateur', *Res*, 28 (1995), pp. 118–39

ARASSE 1999
D. Arasse, *L'Annonciation italienne: une histoire de perspective*, Paris 1999

ARONBERG LAVIN 1972
L. Aronberg Lavin, *Piero della Francesca: The Flagellation*, London 1972

ARONOW 1985
G.S. Aronow, 'A Documentary History of the Pavement Decoration in Siena Cathedral, 1362 through 1506', Ph.D. diss., Columbia University, New York 1985

ASCHERI 1985
M. Ascheri, *Siena nel Rinascimanto. Istituzioni e sistema politico*, Siena 1985

ASCHERI 1993A
M. Ascheri, *Renaissance Siena (1355–1559)*, Siena 1993

ASCHERI 1993B
M. Ascheri, *Antica legislazione della Repubblica di Siena*, Siena 1993

ASCHERI 2001
Siena ed il suo territorio nel rinascimento, III, ed. M. Ascheri, Siena 2001

ASCHERI AND CIAMPOLI 1986–2000
Siena e il suo territorio nel Rinascimento, eds M. Ascheri and D. Ciampoli, 3 vols, Siena 1986–2000

ASCHERI AND NEVOLA (forthcoming)
Siena nel Rinascimento: l'ultimo secolo della repubblica, eds M. Ascheri and F. Nevola, forthcoming

ASCHERI AND PERTICI 1996
M. Ascheri and P. Pertici, 'La situazione politica senese del secondo Quattrocento (1456–1479)' in *La Toscana al tempo di Lorenzo il Magnifico. Politica Economia Cultura Arte. Convegno di Studi promosso dale Università di Firenze, Pisa e Siena, novembre 1992*, III, Pisa 1996, pp. 995–1012

ASCHERI AND TURRINI 2004
La Misericordia di Siena attraverso i secoli dalla Domus Misericordiae all'Arciconfraternita di Misericordia, eds M. Ascheri and P. Turrini, Siena 2004

AVERY 2002
V. Avery, *Renaissance and Baroque Bronzes from the Fitzwilliam Museum*, London 2002

AVESANI 1964
R. Avesani, *Per la biblioteca di Agostino Patrizi Piccolomini vescovo di Pienza*, Vatican City 1964

BABCOCK 1961
C.L. Babcock, 'The role of Faunus in Horace, Carmina 1.4', *Transactions of the American Philological Association*, 92 (1961), pp. 13–19

BACCI 1939
P. Bacci, 'L'elenco delle pitture, sculture e architetture di Siena compilato nel 1625–26 da Mons. Fabio Chigi, poi Alessandro VII', *Bullettino senese di storia patria*, 10 (1939), pp. 197–213

BACCI 1947
P. Bacci, *Bernardino Fungai pittore senese (1460–1516): appunti e documenti*, Siena 1947

BAGNOLI, BARTALINI, BELLOSI LACLOTTE 2003
Duccio. Alle origini della pittura senese, eds A. Bagnoli, R. Bartalini, L. Bellosi and M. Laclotte, exh. cat., Santa Maria della Scala and Museo dell'Opera del Duomo, Siena, Milan 2003

BALOGH 1975
J. Balogh, *Katalog der ausländischen Bildwerke des Museums der Bildenden Künste in Budapest: IV–XVIII Jahrhundert*, 2 vols, Budapest 1975

BANCHI 1877
L. Banchi, *I Rettori dello Spedale di Santa Maria della Scala*, Bologna 1877

BANCHI 1879A
L. Banchi, 'Il Piccinino nello Stato di Siena e la Lega Italica (1455–1456)', *Archivio storico italiano*, 4 (1879), pp. 44–58, 225–245

BANCHI 1879B
L. Banchi, 'La guerra de' Senesi col conte di Pitigliano (1454–1455)', *Archivio storico italiano*, 3 (1879), pp. 184–97

BANCHI 1880
L. Banchi, 'Ultime relazioni de' Senesi con papa Callisto III', *Archivio storico italiano*, 5 (1880), pp. 427–46

BANCHI 1882
L. Banchi, *Le origini favolose di Siena*, Siena 1882

BANDERA 1999
M.C. Bandera, *Benvenuto di Giovanni*, Milan 1999

BANDINI PICCOLOMINI 1896A
F. Bandini Piccolomini, 'Feste senesi per la presa di Colle d'Elsa nel 1479', *Miscellanea storica senese*, 4 (1896), pp. 129–32

BANDINI PICCOLOMINI 1896B
F. Bandini Piccolomini, 'Documenti', *Miscellanea storica senese*, 4 (1896), pp. 121–5.

BARBAGLI 1998
L. Barbagli, 'I "Lupercalia" di Domenico Beccafumi tra Ovidio e Plutarco', *Fontes*, 1, 1–2 (1998), pp. 207–19

BARNABÒ DA SIENA AND VEGIO 1866 EDN
Barnabò da Siena and Maffeo Vegio, *Acta Sanctorum*, Paris 1863–1931

BARRIAULT 1994
A.B. Barriault, *Spalliera Paintings of Renaissance Tuscany: Fables of Poets for Patrician Homes*, University Park, Pennsylvania 1994

BARTALINI 1996
R. Bartalini, *Le occasioni del Sodoma*, Rome 1996

BARTALINI 2001
R. Bartalini, 'Sodoma, the Chigi and the Vatican Stanze', *The Burlington Magazine*, 143 (2001), pp. 544–53

BATTERA 1990
F. Battera, 'L'Edizione Miscomini (1482) del Bucoliche elegantissime composte', *Studi e Problemi di Critica Testuale*, 40 (1990), pp. 149–85

BAUDISSIN 1936
K.G. von Baudissin, 'Auf der Suche nach dem Sinngehalt, I. Raffael's Junger Ritter am Scheideweg', *Jahrbuch der Königlich Preussichen Kunstsammlungen*, 57 (1936), pp. 88–97

BAXANDALL 1978
M. Baxandall, *Pittura ed esperienze sociali nell' Italia del Quattrocento*, Turin 1978

BEAN AND STAMPFLE 1965
J. Bean and F. Stampfle, *Drawings from New York Collections. I. The Italian Renaissance*, exh. cat., The Metropolitan Museum of Art and Pierpont Morgan Library, New York 1965

BECCADELLI (PANORMITA) 1538
A. Beccadelli (Panormita), *De dictis et factis Alphonsi regis Aragonum libri quatuor*, Basel 1538

BECK 1803
T. Calpurnii Siculi Eclogae XI, ed. C.D. Beck, Leipzig 1803, pp. 1–6

BECK 1991
J. Beck, *Jacopo della Quercia*, New York 1991

BELLARMATI 1844
M. Bellarmati, 'La Sconfitta di Montaperto secondo il manoscritto di Niccolò di Giovanni di Francesco Ventura', *Miscellanea storica senese*, 1844, pp. 3–98

BELLOSI 1993
Francesco di Giorgio e il Rinascimento a Siena 1450–1500, ed. L. Bellosi, exh. cat., Chiesa di Sant'Agostino, Siena, Milan 1993

BELLOSI 1996
L'Oro di Siena. Il Tesoro di Santa Maria della Scala, ed. L. Bellosi, exh. cat., Ospedale di Santa Maria della Scala, Siena, Milan 1996

BELLOSI AND ANGELINI 1986
L. Bellosi and A. Angelini, *Sassetta e i pittori toscani tra XIII e XV secolo. Monte dei Paschi di Siena*, Florence 1986

BELTING 1994
H. Belting, *Likeness and Presence: A History of the Image before the Era of Art*, trans. E. Jephcott, Chicago and London 1994

BERENSON 1897
B. Berenson, *The Central Italian Painters of the Renaissance*, New York and London 1897

BERENSON 1909
B. Berenson, *The Central Italian Painters of the Renaissance*, New York and London 1909

BERENSON 1916
B. Berenson, *Pictures in the Collection of P.A.B. Widener at Lynnewood Hall, Elkins Park, Pennsylvania, III: Early Italian and Spanish Schools*, Philadelphia 1916

BERENSON 1930–1
B. Berenson, 'Quadri senza casa: il Quattrocento senese, II', *Dedalo, anno xi, part 3* (1930–1), pp. 735–67

BERENSON 1932
B. Berenson, *Italian Pictures of the Renaissance: A List of the Principal Artists and their Works, with an Index of Places*, Oxford 1932

BERENSON 1968
B. Berenson, *Italian Pictures of the Renaissance: A List of the Principal Artists and their Works, with an Index of Places*, 3 vols, London 1968

BERGIN AND WILSON 1977
T.G. Bergin and A.S. Wilson, *Petrarch's Africa*, New Haven and London 1977

BERNARDINO 1915 EDN
S. Tosti (ed.), 'De Praedicatione S. Bernardini Senensis in patria civitate, anno 1425', *Archivum franciscanum historicum*, 8 (1915), pp. 678–80

BERNARDINO 1958 EDN
Bernardino da Siena, *Le prediche volgare*, ed. C. Cannarozzi, 3 vols, Florence 1958

BERNARDO 1962
A.S. Bernardo, *Petrarch, Scipio and the 'Africa': the Birth of Humanism's Dream*, Baltimore 1962

BERNARDINO 1989 EDN
Bernardino da Siena, *Prediche volgare sul Campo di Siena, 1427*, ed. C. Delcorno, 2 vols, Milan 1989

BERTAGNA 1963–4
M. Bertagna, *L'Osservanza di Siena. Studi storici*, Siena 1963–4

BIANCHI AND GIUNTA 1988
L. Bianchi and D. Giunta, *Iconografia di Santa Caterina da Siena*, Rome 1988

BISOGNI 1976
F. Bisogni, 'Risarcimento del "Ratto di Elena" di Francesco di Giorgio', *Prospettiva*, 7 (1976), pp. 44–6

BISOGNI 1981
F. Bisogni, 'Le Opere di Domenico Beccafumi nella Collezione di Galgano Saracini' *Prospettiva*, 26 (1981), pp. 25–47

BISOGNI 1983
F. Bisogni, 'A Madonna and Child by Domenico Beccafumi' *Apollo*, 98, n. 257 (1983), pp. 54–6

BISOGNI AND BONELLI CONENNA 1988
L'Oratorio di S. Caterina nella contrada del Drago; la storia e l'arte, eds F. Bisogni and L. Bonelli Conenna, Siena 1988

BOCCACCIO 2002 EDN
G. Boccaccio, *Famous Women*, trans. V. Brown, Harvard 2002

BOERNER 2002
C.G. Boerner, *Chefs d'œuvre du Fitzwilliam Museum de Cambridge*, exh. cat., Artemis, Paris 2002

BOISSEUIL 2002
D. Boisseuil, *Le thermalisme en Toscane à la fin du Moyen âge: les bains siennois de la fin du XIIIe siècle au début du XVIe siècle*, Rome 2002

BOLOGNA 1954
F. Bologna, 'Miniature di Benvenuto di Giovanni', *Paragone*, 51 (1954), pp. 15–19

BOLZONI 2002
L. Bolzoni, *La rete delle imagini. Predicazione in volgare dale origini a Bernardino da Siena*, Turin 2002

BON VALSASSINA AND GARIBALDI 1994
C. Bon Valsassina and V. Garibaldi, *Dipinti, sculture e ceramiche della Galleria Nazionale dell'Umbria. Studi e restauri*, Florence 1994

BORGHESI AND BANCHI 1898
S. Borghesi and L. Banchi, *Nuovi documenti per la storia dell'arte senese*, Siena 1898

BORSOOK AND SUPERBI GIOFFREDI 1994
Italian Altarpieces, 1250–1550, ed. E. Borsook and Superbi Giofredi, Oxford 1994

BOSKOVITS 1978
M. Boskovits, 'Ferrarese Painting around 1500: Some New Arguments', *The Burlington Magazine*, 120 (1978), pp. 370–85

BOSKOVITS 1991
Dipinti e sculture in una raccolta Toscana, secoli XIV–XVI, ed. M. Boskovits, Florence 1991

BOSKOVITS AND BROWN 2003
Italian Paintings of the Fifteenth Century: The Collections of the National Gallery of Art, eds M. Boskovits and D.A. Brown, Washington, DC 2003

BOWSKY 1970
W.M. Bowsky, *The Finance of the Commune of Siena: 1287–1355*, Oxford 1970

BOWSKY 1981
W.M. Bowsky, *A Medieval Italian Commune: Siena under the Nine, 1287–1355*, Berkeley, Los Angeles and London 1981

BRANDI 1933
C. Brandi, *La Regia pinacoteca di Siena*, Rome 1933

BRANDI 1934
C. Brandi, 'Disegni inediti di Francesco di Giorgio', *L'arte*, 37 (1934), pp. 45–57

BRANDI 1983
Palazzo Pubblico di Siena, Vicende costuttive e decorazione, Cinisello Balsamo, ed. C. Brandi, Milan 1983

BRINK 2000
C. Brink, *Arte et Marte: Kriegskunst und Kunstliebe im Herrscherbild des 15. und 16. Jahrhunderts in Italien*, Munich and Berlin 2000

BRINTON 1934–5
S. Brinton, *Francesco di Giorgio Martini of Siena: Painter, Sculptor, Engineer, Civil and Military Architect (1439–1502)*, London 1934–5 (2 vols)

BRULLIOT 1832–4
F. Brulliot, *Dictionnaire des Monogrammes, Marques Figurees, Lettres Initiales, Noms Abreges etc. avec lesquels les Peintres*, Munich 1832–4

BRUMMER 1964
H.H. Brummer, 'Pan Platonicus', *Konsthistorisk Tidskrift*, 33 (1964), pp. 55–67

BRUNO AND PIN 1981
A. Bruno and G. Pin, 'Il Palazzo di San Galgano in Siena', *Bullettino senese di storia patria*, 88 (1981), pp. 54–70

BULLETTI 1935
E. Bulletti, 'La Madonna di Porta Camollia', *Bullettino di studi bernardiniani*, 1, 3–4 (1935), pp. 147–56

BULLETTI 1939
E. Bulletti, 'Per la nomina di S. Bernardino a vescovo di Siena', *Bullettino di studi benardiniani*, 5 (1939), p. 185

BULLETTI 1944–50
E. Bulletti, 'Per la canonizzazione di S. Bernardino da Siena', *Bulletino di studi benardiniani*, 10 (1944–50), pp. 110–15

BURANELLI, LIVERANI AND NESSELRATH 2006
Laocoonte: alle origini dei Musei Vaticani, eds F. Buranelli, P. Liverani and A. Nesselrath, exh. cat., Monumenti, Musei e Gallerie Pontificie, Città del Vaticano, Rome 2006

BURICCHI 1998
S. Buricchi, *Matteo di Giovanni. Opere in Toscana*, Città di Castello 1998

BURROUGHS 1921
B. Burroughs, 'A Ceiling by Pinturicchio from the Palazzo del Magnifico in Siena', *The Metropolitan Museum of Art Bulletin*, 16 (1921), pp. 3–10

BUSCHMANN AUS BOTTROP 1993
H. Buschmann aus Bottrop, 'Raffaellino del Garbo. Werkmonographie und Katalog', Ph.D. diss., Albert-Ludwigs-Universität, Freiburg im Breisgau 1993

BUTZEK 2001
M. Butzek, 'Per la storia delle due "Madonne delle Grazie" nel Duomo di Siena', *Prospettiva*, 103–4 (2001), pp. 97–109

BYAM SHAW 1935–6
J. Byam Shaw, 'Girolamo di Benvenuto (1470–1524) – The Samian Sibyl, the Tiburtine Sibyl, a prophet, the Delphic Sibyl: British Museum; from the J.C. Robinson Collection', *Old Master Drawings*, 10 (1935–6), pp. 11–13

CACIORGNA 2001–2
M. Caciorgna, 'Moduli antichi e tradizione classica nel programma della Fonte Gaia di Jacopo della Quercia', *Fontes*, 4–5 (2001–2), pp. 71–142

CACIORGNA 2004
M. Caciorgna, *Il naufragio felice. Studi di filologia e storia della tradizione classica nella cultura letteraria e figurative senese*, La Spezia 2004

CACIORGNA 2006
M. Caciorgna, '"Radice atra, purpureus flos": Ulisse, Mercurio e l'erba moly nello Stanzino di Francesco I de'Medici, fonti letterarie e tradizione iconografica' in ed. P. Morel, *L'art de la Renaissance entre Science et Magic*, Paris 2006, pp. 269–94

CACIORGNA AND GUERRINI 2003
M. Caciorgna and R. Guerrini, *La virtù figurata. Eroi ed eroine dall'antichità nell'arte senese tra Medioevo e Rinascimento*, Siena 2003

CACIORGNA AND GUERRINI 2004
M. Caciorgna and R. Guerrini, *Il pavimento del Duomo di Siena. L'arte della tarsia marmorea dal XIV al XIX secolo*, Siena 2004

CACIORGNA, GUERRINI AND LORENZONI 2006
Studi interdisciplinari sul Pavimento del Duomo di Siena: iconografia, stile indagini scientifiche. Atti del Convegno internazionale di studi (Siena, Chiesa della SS. Annunziata, 27 e 28 settembre 2002), eds M. Caciorgna, R. Guerrini and M. Lorenzoni, Siena 2006

CADOGAN 2000
J.K. Cadogan, *Domenico Ghirlandaio: Artist and Artisan*, New Haven and London 2000

CAFFARINI 1998
T. Caffarini, *Santa Caterina da Siena: vita scritta da frai Tommaso da Siena detto 'il Caffarini'*, ed. and trans. B. Ancilli, Florence 1998

CAGLIOTI 1995
F. Caglioti, 'Ancora sulle traversie vaticane del giovane Mino, sulla committenza statuaria di Pio II e su Leon Battista Alberti', *Dialoghi di Storia dell'arte*, 1 (1995), pp. 126–31

CAGLIOTI 2000
F. Caglioti, *Donatello e i Medici. Storia del David e della Giuditta*, 2 vols, Florence 2000

CALLMANN 1974
E. Callmann, *Apollonio di Giovanni*, Oxford 1974

CAMPBELL 1997
S.J. Campbell, *Cosmè Tura of Ferrara: Style, Politics and the Renaissance City, 1450–1495*, New Haven and London 1997

CAMPBELL 2002
Cosmè Tura: Painting and Design in Renaissance Ferrara, ed. S.J. Campbell, exh. cat., Isabella Stewart Gardner Museum, Boston 2002

CAMPBELL 2005
A. Campbell, 'A Spectacular Celebration of the Assumption in Siena', *Renaissance Quarterly*, 58 (2005), pp. 435–63

CAMPBELL AND MILNER 2004
S.J. Campbell and S.J. Milner, *Artistic Exchange and Cultural Translation in the Italian Renaissance City*, Cambridge 2004

CARATELLI 1962
G. Caratelli, *Santa Caterina da Siena*, 1962

CARL 1990
D. Carl, 'Il Ciborio di Benedetto da Maiano nella Cappella Maggiore di S. Domenico a Siena: un contributo al problema dei cibori quattrocenteschi con un excursus per la storia architettonica della chiesa', *Rivista d'Arte*, 42 (1990), pp. 3–74

CARL 1999
D. Carl, 'Die Büsten im Kranzgesims des Palazzo Spannocchi', *Mitteilungen des Kunsthistorischen Institutes in Florenz*, 43 (1999), pp. 628–38

CARL 2006
D. Carl, *Benedetto da Maiano: ein Florentiner Bildhauer an der Schwelle zur Hochrenaissance*, Regensburg 2006

CARLI 1950
La mostra delle tavolette di Biccherna e di altri uffici dello Stato di Siena, ed. E. Carli, exh. cat., Palazzo Strozzi, Florence 1950

CARLI 1967
E. Carli, *Donatello a Siena*, Rome 1967

CARLI 1976
E. Carli, 'Luoghi ed opere d'arte senesi nelle prediche di Bernardino del 1427' in *Bernardino predicatore nella società del suo tempo, Atti del Convegno del Centro di studi sulla spiritualità medievale, 9–12 ottobre 1975*, Todi 1976, pp. 155–82

CARLI 1979
E. Carli, *Il Duomo di Siena*, Genoa 1979

CARLI 1991
E. Carli, *Miniature dei corali per il Duomo di Siena*, Florence 1991

CARLI 1993
E. Carli, *Pienza. La città di Pio II*, Roma 1993

CARLI AND CAIROLO 1963
E. Carli and A. Cairolo, *Il Palazzo Pubblico di Siena*, Rome 1963

CARTER SOUTHARD 1978
E. Carter Southard, 'The frescoes in Siena's Palazzo Pubblico, 1289–1539: Studies in Imagery and Relations to other Communal Palaces in Tuscany', Ph.D. diss., Indiana University 1978

CASANOVA 1901
E. Casanova, 'La donna senese del Quattrocento nella vita privata', *Bullettino senese di storia patria*, 8 (1901), pp. 3–93

CASTELLI AND BONUCCI 2005
V. Castelli and S. Bonucci, *Antiche Torri di Siena*, Siena 2005

CATON 1900
R. Caton, *Two Lectures on the Temples and Ritual of Asklepios at Epidaurus and Athens*, London 1900

CATONI AND LEONCINI 1993
G. Catoni and A. Leoncini, *Cacce e tatuaggi; Nuovi raguagli sulle contrade di Siena*, Siena 1993

CAVALLARO 2001
A. Cavallaro, *Pinturicchio 'Familiare' della corte Borgiana: L'Appartamento di Alessandro VI a castel Sant'Angelo*, Rome 2001

CAVALLINI 1968
G. Cavallini, *Il Dialogo della divina provvidenza ovvero Libro della divina dottrina*, Rome 1968

CECCHI 1991
A. Cecchi, 'Decorated initials by Beccafumi in the Uffizi', *The Burlington Magazine*, 133 (1991) pp. 772–3

CECCHI 2005
A. Cecchi, *Botticelli*, Milan 2005

CECCHINI 1962
G. Cecchini, 'L'arazzeria senese', *Archivio storico italiano*, 120 (1962), pp. 149–77

CECCHINI 1995
D. Cecchini, *Gli oratori delle contrade di Siena*, Siena 1995

CECCHINI AND NERI 1958
G. Cecchini and D. Neri, *The Palio of Siena*, Siena 1958

CEPPARI RIDOLFI, CIAMPOLINI, TURRINI 2001
L'immagine del Palio. Storia cultura e rappresentazione del rito di Siena, eds M.A Ceppari Ridolfi, M. Ciampolini and P. Turrini, Siena and Florence 2001

CERIANA 2006
M. Ceriana, *Brera mai vista*, Milan 2006

CHAPMAN 2005
Michelangelo Drawings: Closer to the Master, ed. H. Chapman, exh. cat., The British Museum, London 2005

CHAPMAN, HENRY AND PLAZZOTTA 2004
Raphael: From Urbino to Rome, eds H. Chapman, T. Henry and C. Plazzotta, exh. cat., The National Gallery, London 2005

CHASTEL 1959
A. Chastel, *Art et humanisme à Florence au temps de Laurent le Magnifique*, Paris 1959

CHELAZZI DINI 1977
Jacopo della Quercia fra Gotico e Rinascimento. Atti del Convegno di Studi (Siena, 2–5 ottobre 1975), ed. G. Chelazzi Dini, Florence 1977

CHELAZZI DINI 1982
G. Chelazzi Dini, *Il Gotico a Siena*, exh. cat., Palazzo Pubblico, Siena, Florence 1982

CHELAZZI DINI, ANGELINI AND SANI 1997
G. Chelazzi Dini, A. Angelini, B. Sani, *Pittura senese*, Milan 1997

CHELAZZI DINI, ANGELINI AND SANI 1998
G. Chelazzi Dini, A. Angelini and B. Sani, *Sienese Painting from Duccio to the Birth of the Baroque*, trans. C. Warr, New York 1998

CHRISTIANSEN 1990
K. Christiansen, 'Notes on Painting in Renaissance Siena', *The Burlington Magazine*, 132 (1990), pp. 205–13

CHRISTIANSEN 1991
K. Christiansen, 'Sano di Pietro's S. Bernardino Panels', *The Burlington Magazine*, 133 (1991), pp. 451–2

CHRISTIANSEN, KANTER AND STREHLKE 1988
Painting in Renaissance Siena 1420–1500, eds K. Christiansen, L.B. Kanter and C.B. Strehlke, exh. cat., The Metropolitan Museum of Art, New York 1988

CHRISTIANSEN, KANTER AND STREHLKE 1989
La pittura senese nel Rinascimento: 1420–1500, eds K. Christiansen, L.B. Kanter and C.B. Strehlke, Milan 1989

CIAPPELLI AND RUBIN 2000
G. Ciappelli and P. Rubin, *Art, Memory and Family in Renaissance Florence Art*, Cambridge 2000

CIONI AND FAUSTI 1991
Umanesimo a Siena. Letteratura, arti figurative, musica, atti del convegno Università di Siena 5–8 giugno 1989, eds E. Cioni and D. Fausti, Florence 1991

CIRFI WALTON 1996
M. Cirfi Walton, 'Antonio Federighi and Papa Pius II: the emergence of the Renaissance architecture in Siena', *Rivista di studi italiani*, 17 (1996), pp. 116–127

CLARKE 2003
G. Clarke, *Roman House – Renaissance Palaces: Inventing Antiquity in Fifteenth-century Italy*, Cambridge 2003

CLOUGH 1976
C.H. Clough, *Cultural Aspects of the Italian Renaissance: Essays in Honour of Paul Oskar Kristeller*, Manchester and New York 1976

CLOUGH 1980
C.H. Clough, 'Piero's Flagellation', *The Burlington Magazine*, 122 (1980), pp. 574–7

COLE 1985
B. Cole, *Sienese Painting in the Age of the Renaissance*, Bloomington 1985

COLIVA 2006
Raffaello da Firenze a Roma, ed. A. Coliva, exh. cat., Galleria Borghese, Rome, Milan 2006

COLLARETA 1982
M. Collareta, 'Considerazioni in margine al "De Statua" e alla sua fortuna', *Annali della Scuola Normale Superiore di Pisa. Classe di Lettere e Filosofia*, s. 3, 12 (1982), pp. 171–87

COLUCCI 2003
S. Colucci, *Sepolcri a Siena tra Medioevo e Rinascimento*, Florence 2003

COLVIN 1904
S. Colvin, *Drawings by Old Masters in the University Galleries and in the Library of Christ Church*, Oxford 1904

CONSOLINO 1991
F.E. Consolino, *I Santi Patroni Senesi*, Siena 1991

CONTORNI 1988
G. Contorni, *Bagni San Filippo: antiche terme nel Senese*, Florence 1988

COOR 1961
G.M. Coor, *Neroccio de' Landi 1447–1500*, Princeton 1961

COPPELLOTTI 2001
Casa Martelli a Firenze. Dal rilievo al museo, ed. A. Coppellotti, Florence 2001

CORNINI 1993
Raphael in the Apartments of Julius II and Leo X, eds G. Cornini et al, Milan 1993

CORSO 1957
C. Corso, 'L'Ilicino (Bernardo Lapini)', *Bullettino senese di storia patria*, ser. iii, 16 (1957), pp. 3–108

CORTI 1985
G. Corti, 'Un contratto d'allogagione di mobili e l'attività di un legnaiolo Fiorentino a Siena ai primi del Cinquecento', *Paragone*, 36 (1985), pp. 105–12

CRISTOFANI 1979
Siena: le origini. Testimonianze e miti archeologici, ed. M. Cristofani, Florence 1979

CROPPER 1976
E. Cropper, 'On Beautiful Women: Parmigianino, Petrarchismo, and the Vernacular Style', *Art Bulletin*, 58 (1976), pp. 374–94

CROWE AND CAVALCASELLE 1864–6
J.A. Crowe and G.B. Cavalcaselle, *A New History of Painting in Italy from the Second to the Sixteenth Centuries*, 3 vols, London 1864–6

CRUSELLES GÓMEZ AND IGUAL LUIS 2003
J.M. Cruselles Gómez and D. Igual Luis, *El duc de Borja a Gandia. Els comptes de la banca Spannocchi (1488–1496)*, Gandia 2003

CURRIE AND MOTTURE 1997
The Sculpted Object, 1400–1700, eds S. Currie and P. Motture, Aldershot 1997

CUST 1904
R.H. Hobart Cust, 'On Some Overlooked Masterpieces', *The Burlington Magazine*, 4 (1904), pp. 256–8

CUST 1906
R.H. Hobart Cust, *Giovanni Antonio Bazzi, hitherto usually styled 'Sodoma'. The Man and the Painter 1477–1549. A Study*, London 1906

CYRIL 1991
J.W. Cyril, 'The Imagery of San Bernardino da Siena, 1440–1500: An iconographic study', Ph.D. diss., University of Michigan 1991

D'ACCONE 1997
F.A. D'Accone, *The Civic Muse: Music and Musicians in Siena during the Middle Ages and the Renaissance*, Chicago 1997

DACOS 1969
N. Dacos, *La découverte de la Domus Aurea et la Formation des grotesques à la Renaissance*, London 1969

DALLI REGOLI AND CIARDI 2002
Dalli Regoli and Ciardi, *Storia delle arti in Toscana. Il Quattrocento*, Florence 2002

DAMI 1913
L. Dami, 'Neroccio di Bartolomeo Landi' in *Rassegna d'Arte*, 13 (1913), pp. 137–43, 160–70

DANTE 1967 edn
Dante's Lyric Poetry: The Poems, Text and Translation, eds and trans K. Foster and P. Boyde, 1, Oxford 1967

DARR 1985
Italian Renaissance Sculpture in the Time of Donatello, ed. A.P. Darr, exh. cat., Detroit Institute of Arts and Kimball Art Museum, Fort Worth, Detroit 1985

DAVIES 1961
M. Davies, *The National Gallery Catalogues: The Earlier Italian Schools*, London 1961

DE CARLI 1997
C. de Carli, *I deschi da parto e la pittura del primo rinascimento toscano*, Turin 1997, pp. 178–9

DE CASTRIS 1997
P.L. de Castris, 'Una "Venere" del giovane Beccafumi, e un "Eva" del Brescianino', *Scritti per l'Istituto Germanico di Storia dell'Arte di Firenze*, Florence 1997, pp. 282–6

DE CASTRIS 2003
P.L. de Castris, *Simone Martini*, Milan 2003

DE CLERCQ 1978–9
C. de Clercq, 'Quelques series italiennes de Sibylles', *Bulletin de l'institut historique Belge de Rome*, 48–9 (1978–9), pp. 105–27

DE MARCHI 1987
A. De Marchi, 'Review of P.A Riedl and M. Seidel, Die Kirchen von Siena, I, 1–3, Abbadia all'Arco-S. Biagio', Munich 1985, *Prospettiva*, 49, April 1987, pp. 92–6

DE MARCHI 1992
A.G. De Marchi, 'Una fonte senese per Ghiberti e per il giovane Angelico', *Artista: Critica dell'arte in Toscana*, 1992, pp. 130–51

DE MARCHI 2004
A. De Marchi, *Scrivere sui quadri. Ferrara e Roma. Agucchi e alcuni ritratti rinascimentali*, Florence 2004

DE NICOLA 1917
G. De Nicola, 'Notes on the Museo Nazionale of Florence – IV: Fragments of Two Series of Renaissance Representations of Greek and Roman Heroes', *The Burlington Magazine*, 31 (1917), pp. 224–8

DEAN AND WICKHAM 1990
City and Countryside in Late Medieval and Renaissance Italy. Essays presented to Philip Jones, eds T. Dean and C. Wickham, London 1990

DECROISETTE AND PLAISANCE 1993
Les fêtes urbaines en Italie a l'époque de la Renaissance. Verone, Florence, Sienne, Naples, eds F. Decroisette and M. Plaisance, Paris 1993

DEL BRAVO 1960
C. Del Bravo, 'Liberale a Siena', *Paragone*, 11 (1960), pp. 16–38

DEL BRAVO 1967
C. Del Bravo, *Liberale da Verona*, Florence 1967

DELCORNO 1989 EDN
C. Delcorno, *Prediche volgare sul Campo di Siena 1427*, 2 vols, Milan 1989, pp. 7–51

DELLA VALLE 1784–6
G. Della Valle, *Lettere sanesi sopra le belle arti*, 3 vols, Rome 1784–6

DELORME 1935
F.M. Delorme, 'Une esquisse primitive de la vie de S. Bernardin', *Bullettino di studi benardiniani*, 1, 1 (1935), pp. 1–22

DENLEY 2006
P. Denley, *Commune and Studio in Late Medieval and Renaissance Siena*, Bologna 2006

DI LORENZO 2001
Omaggio a Beato Angelico: un dipinto per il Museo Poldi Pezzoli, ed. A. Di Lorenzo, exh. cat., Museo Poldi Pezzoli, Milan 2001

DRONKE 1990
P. Dronke, *Hermes and the Sibyls. Continuations and Creations*, Cambridge 1990

DUBUS 1999
P. Dubus, *Domenico Beccafumi*, Paris 1999

DUFNER 1975
G. Dufner, *Geschichte der Jesuaten*, Rome 1975

DÜLBERG 1990
A. Dülberg, *Privatporträts. Geschichte und Ikonologie einer Gattung im 15. und 16. Jahrhundert*, Berlin 1990

DUNKERTON, CHRISTENSEN AND SYSON 2006
J. Dunkerton, C. Christensen and L. Syson, 'The Master of the Story of Griselda and Paintings for Sienese Palaces', *National Gallery Technical Bulletin*, 27 (2006), pp. 4–71

EBERHARDT 1983
H.J. Eberhardt, *Die Miniaturen von Liberale da Verona, Girolamo da Cremona und Venturino da Milano in den Chorbüchern des Doms von Siena. Dokumentation – Attribution – Chronologie*, Munich 1983

EDELSTEIN 1975
E.J. Edelstein, *Aesculapius: A Collection and Interpretation of Testimonies*, New York 1975

EISLER 1948
R. Eisler 'Luca Signorelli's School of Pan', *Gazette des Beaux-Arts*, 30 (1948), pp. 77–92

EISLER AND CECCHINI 1948
R. Eisler and G. Cecchini, 'Una tavoletta di Biccherna nuovamente scoperta', *Bullettino senese di storia patria*, 55 (1948), pp. 119–21

EITEL-PORTER 2006
R. Eitel-Porter et al., *From Leonardo to Pollock: Master Drawings from the Morgan Library*, New York 2006

ERLANDE-BRANDENBURG 2004
A. Erlande-Brandenburg et al., *Les cassoni peints du Musée National de la Renaissance*, Paris 2004

ESCH AND FROMMEL 1995
Arte, committenza ed economia a Roma e nelle corti del Rinascimento (1420–1530), eds A. Esch and C.L. Frommel, Turin 1995

FACCHINETTI 1933
P.V. Facchinetti, *S. Bernardino da Siena*, Milan 1933

FAHY 2006
E. Fahy, 'Early Italian Paintings in Washington and Philadelphia', *The Burlington Magazine*, 148 (2006), pp. 537–40

FAIETTI AND OBERHUBER 1988
M. Faietti and K. Oberhuber, 'Jacopo Rimanda e il suo collaboratore (il Maestro di Oxford) in alcuni cantieri romani del primo Cinquecento', *Ricerche di storia dell'arte*, 34 (1988), pp. 52–72

FALASSI AND CATONI 1991
A. Falassi and G. Catoni, *La nobile contrada dell'Oca*, Siena 1991

FALUSCHI AND PECCI 1815
G. Faluschi and G.A. Pecci, *Breve relazione delle cose notabili della città di Siena*, Siena 1815

FARGNOLI 2004
N. Fargnoli, *L'Assunta del Vecchietta a Montemerano. Restauro e nuove proposte di lettura/Vecchietta's Assumption of the Virgin at Montemerano. Restoration and New Keys for Interpretation*, Quaderni della Soprintendenza per il patrimonio storico, artistico e demoetnoantropologico di Siena e Grosseto, 3, Asciano 2004

FATTORINI 2006
G. Fattorini, 'Pio II e la vergine di Camollia,' in *Pio II Piccolomini: Il papa del rinascimento a Siena*, acts of the International Conference, Siena, in ed. F. Nevola, Siena 2006

FECINI 1931–9 EDN
Cronaca senese di Tommaso Fecini (1431–1479), Siena 1931–9.

FERGUSON, QUILLIGAN AND VICKERS 1985
Rewriting the Renaissance: The Discourses of Sexual Difference in Early Modern Europe, eds M.W. Ferguson, M. Quilligan and N.J. Vickers, Chicago and London 1985

FERINO PAGDEN 1982
S. Ferino Pagden, *Disegni umbri del Rinascimento da Perugino a Raffaello*, exh. cat., (Gabinetto Disegni e Stampe degli Uffizi), Florence 1982

FERINO PAGDEN 1984
S. Ferino Pagden, *Disegni i Umbri: Gallerie dell'Accademia di Venezia*, Milan 1984

FERRARI 1985
A. Ferrari, 'Il Palazzo del Magnifico a Siena', *Bullettino senese di storia patria*, 92 (1985), pp. 107–53

FERRI 1890
P.N. Ferri, *Catalogo riassuntivo della raccolta di disegni antichi e moderni posseduta dalla R. Galleria degli Uffizi di Firenze*, Rome 1890

FIORAVANTI 1981
G. Fioravanti in 'Universita e città. Cultura umanistica e cultura scolastico a Siena nel '400', *Quaderni di Rinascimento*, 3, Florence 1981

FIORE 2003
F.P. Fiore, 'La Loggia di Pio II per i Piccolomini a Siena' in eds A. Calzona, F.P. Fiore, A. Tenenti e C. Vasoli, *Il Sogno di Pio II e il Viaggio da Roma a Mantova: atti del convegno internazionale, aprile 2000*, Florence 2003, pp. 129–42

FIORE 2004
Francesco di Giorgio alla corte di Federico da Montefeltro. Atti del convegno internazionale di studi, Urbino, monastero di Santa Chiara, ottobre 2001, ed. F.P. Fiore, Florence 2004

FIORE AND TAFURI 1993
Francesco di Giorgio architetto, eds F.P. Fiore and M. Tafuri, exh. cat., Magazzini del Sale, Palazzo Pubblico, Siena, Milan 1993

FIORELLI MALESCI 2005–6
F. Fiorelli Malesci, 'Una collezione settecentesca: dalla casa al museo. Marco Martelli e la quadreria di famiglia fra due inventari (1771–1813)', Ph.D. diss., Università degli Studi di Firenze, Florence 2005–6.

FISCHER 1990
C. Fischer, *Fra Bartolomeo: Master Draughtsman of the High Renaissance. A Selection from the Rotterdam Albums and Landscape Drawings from Various Collections*, exh. cat, Museum Boymans van Beuningen, Rotterdam 1990

FLORENCE 2001
I mai visti. Capolavori dei depositi degli Uffizi, exh cat., Uffizi, Florence 2001.

FORLANI TEMPESTI 1967
A. Forlani Tempesti et al., *Disegni Italiani della Collezione Santarelli. Secoli XV–XVIII*, Florence 1967

FORLANI TEMPESTI 1991
A. Forlani Tempesti, *The Robert Lehman Collection*, V, *Italian Fifteenth- to Seventeenth-Century Drawings*, New York and Princeton 1991

FRANCESCHINI 1942
Leggenda minore di S. Caterina da Siena, ed. E. Franceschini, Milan 1942

FRANCESCO DI GIORGIO MARTINI 1967 EDN
Francesco di Giorgio Martini, *Trattati di architettura ingeneria e arte militare*, ed. C. Maltese, 2 vols, Milan 1967

FREDERICKSEN 1969
B.B. Fredericksen, *The Cassone Paintings of Francesco di Giorgio*, Los Angeles 1969

FREEDMAN 1985
L. Freedman, 'Once more Luca Signorelli's Pan Deus Arcadiae', *Konsthistorisk Tidskrift*, 54 (1985), pp. 152–9

FREULER 1986
G. Freuler, *Biagio di Goro Ghezzi a Paganico*, Milan 1986

FRIEDLAENDER 1925
W. Friedlaender, 'Die Entstehung des antiklassischen Stiles in der italienischen Malerei um 1520', *Repertorium für Kunstwissenschaft*, 46 (1925), p. 37

FRIEDLÄNDER 1917
M.J. Friedländer, *Die Sammlung Richard von Kaufmann Berlin*, Berlin 1917

FRIEDMANN 1980
H. Friedmann, *A Bestiary for Saint Jerome: Animal Symbolism in European Religious Art*, Washington, DC 1980

FRIZZONI 1904
G. Frizzoni, 'Disegni di antichi maestri a proposito della pubblicazione dei disegni delle collezioni di Oxford', *L'Arte*, 7 (1904), pp. 93–103

FROMMEL 1968
C.L. Frommel, *Baldassari Peruzzi als Maler und Zeichner*, Vienna 1968

FROMMEL 2005
Baldassare Peruzzi 1481–1536, eds C.L. Frommel, A. Bruschi, H. Burns, F.P. Fiore and P.N. Pagliara, Vicenza 2005

FUMI 1910
L. Fumi, 'Francesco Sforza contro Jacopo Piccinino (dalla Pace di Lodi alla morte di Callisto III)', *Bollettino della regia deputazione di storia patria*, 16 (1910), pp. 525–82

FUMI 1981
F. Fumi, 'Nuovi documenti per gli angeli dell'altar maggiore del Duomo di Siena', *Prospettiva*, 26 (1981), pp. 9–25

FUMI AND LISINI 1878
L. Fumi and A. Lisini, *L'incontro di Federigo III Imperatore con Eleonora di Portogallo*, Siena 1878

FUNARI 2002
Un ciclo di tradizione reppublicana nel Palazzo Pubblico di Siena: le iscrizioni degli affreschi di Taddeo di Bartoo (1413–14), ed. R. Funari, Siena 2002

GALLAVOTTI CAVALLERO 1980
D. Gallavotti Cavallero, 'Mecherino miniatore: precisazioni sull'esordio senese', *Storia dell'Arte* (1980), pp. 38–40

GALLAVOTTI CAVALLERO 1985
D. Gallavotti Cavallero, *Lo Spedale di Santa Maria della Scala in Siena, vicenda di una committenza artistica*, Siena and Pisa 1985

GALLETTI 1982
A.I. Galletti, '"Uno capo nelle mani mie": Niccolò di Toldo, Perugino' in eds D. Maffei and P. Nardi, *Atti del Simposio Internazionale Cateriniano-Bernardiniano*, Siena 1982, pp. 121–7

GARDNER 1987
J. Gardner, 'An Introduction to the Iconography of the Medieval Italian City Gate,' in *Studies on Art and Archeology in Honor of Ernst Kitzinger on His Seventy-Fifth Birthday*, eds W. Tronzo and I. Lavin, *Dumbarton Oaks Papers*, 41 (1987), pp. 199–213

GARIBALDI AND MANCINI 2004
Perugino, il Divin Pittore, eds V. Garibaldi and F.F. Mancini, exh. cat., Galleria Nazionale dell'Umbria 2004

GARLAND 2003
Early Italian Paintings: Approaches to Conservation, ed. P. Garland, New Haven and London 2003

GARRISON 1993
E.B. Garrison, *Studies in the History of Mediaeval Painting*, IV, London 1993, (first published Florence 1960–2)

GARZELLI 1985
A.R. Garzelli, 'Un' inedita allegoria di Francesco di Giorgio Martini', *Paragone*, 26 (1985), pp. 124–34, 419–23

GASPAROTTO AND MAGNANI 2002
Matteo di Giovanni e la pala d'altare nel senese e nell'aretino, 1450–1500, eds D. Gasparotto and S. Magnani, Montepulciano 2002

GENNARO 1970
C. Gennaro, 'Borghese, Borghese' in *Dizionario biografico degli italiani*, 12, Rome 1970, pp. 583–4

GENTILE 1889
L. Gentile, *Ministero della Pubblica Istruzione. Indici e Cataloghi. IV. I codici palatini della R. Biblioteca Nazionale Centrale di Firenze*, 2 vols, Rome 1889

GENTILINI 1996
G. Gentilini, 'Il beato Sorore di Santa Maria della Scala', *Antologia di Belle Arti*, 52–5 (1996), pp. 17–31

GENTILINI AND SISI 1989
G. Gentilini and C. Sisi, *Collezione Chigi-Saracini. La scultura. Bozzetti in terracotta, piccoli marmi e altre sculture dal XIV al XX secolo*, exh. cat., Palazzo Chigi Saracini, Siena, Florence 1989

GERONIMUS 2006
D. Geronimus, *Piero di Cosimo: Visions Beautiful and Strange*, New Haven and London 2006

GIACOMOTTI 1974
J. Giacomotti, *Catalogue des Majoliques des Musées Nationaux: Musées du Louvre et de Cluny, Musée National de Céramique a sèvres, Musée Adrien-Duboche a Limoges*, Paris 1974

GIGLI 1723
G. Gigli, *Diario Senese*, 2 vols, Lucca 1723

GILBERT 1980
F. Gilbert, *The Pope, his Banker, and Venice*, Cambridge, MA 1980

GOMBRICH 1966
E.H. Gombrich, *Norm and Form: Studies in the Art of the Renaissance*, London 1966

GORDON 2003
D. Gordon, *National Gallery Catalogues: The Fifteenth-Century Italian Paintings, Volume 1*, London 2003

GOULD 1975
C. Gould, *The National Gallery Catalogues: The Sixteenth-Century Italian Schools*, London 1975

GREEN 1991
S.D. Green, 'The Context and Function of the Piccolomini Library and its Frescoes. Aeneas Sylvius Piccolomini as a Paradigm of the 15th-Century Ideas about Rhetoric and Reform', Ph.D. diss, University of California 1991

GREGORI, PAOLUCCI, ACIDINI LUCHINAT 1992
M. Gregori, A. Paolucci and C. Acidini Luchinat, *Maestri e botteghe: Pittura a Firenze alla fine del Quattrocento*, exh. cat., Palazzo Strozzi, Florence 1992

GREGORI 2003
In the Light of Apollo: Italian Renaissance and Greece, ed. M Gregori, exh. cat., National Gallery and Alexandros Soutzos Museum, Athens, Milan 2003

GREGORY 1911 EDN
The Dialogues of Saint Gregory, eds E.G. Gardner and G.F. Hill, London 1911

GREGORY 1975 EDN
Saint Gregory, Dialoghi, ed. G. Bellardi, 2 vols, Milan 1975

GUERRINI 1980
R. Guerrini, 'La figura di Tanaquilla in un dipinto del Beccafumi con distico latino. Ricerca sulle fonti letterarie classiche', *Athenaeum*, 58 (1980), pp. 159–64

GUERRINI 1981
R. Guerrini, *Studi sul Valerio Massimo: con un capitolo sulla fortuna nell'iconografia umanistica, Perugino, Beccafumi, Pordenone*, Pisa 1981

GUERRINI 1992–3
R. Guerrini, 'Le Divinae Institutiones di Lattanzionelle Epigrafi del Rinascimento. Il Collegio di Cambio di Perugia e Il Pavimento del Duomo di Siena' in *Annuario dell' istituto storico dioesano di Siena*, Siena 1992–3, pp. 5–50

GUERRINI 2001
Biografia dipinta. Plutarco e l'arte del Rinascimento, 1400–1550, ed. R. Guerrini, La Spezia 2001

GIUSTI 1984
Restauro di una terracotta del Quattrocento: il 'Compianto' di Giacomo Cozzarelli, ed. A.M. Giusti, exh cat., Opificio delle Pietre Dure e Laboratori di Restauro, Florence, Modena 1984

HABICH 1923
G. Habich, *Die Medaillen der italienischen Renaissance*, Stuttgart and Berlin 1923

HALL AND UHR 1985
E. Hall and H. Uhr, 'Aureola super auream: Crowns and Related Symbols of Special Distinction for Saints in Late Gothic and Renaissance Iconography', *Art Bulletin*, 67 (1985), pp. 567–603

HAMER AND RUSSELL 2000
Supplementary Lives in Some Manuscripts in the Gilte Legende, eds. R. Hamer and V. Russell, Oxford 2000

HANAWALT AND REYERSON 1994
City and Spectacle in Medieval Europe (Medieval Studies at Minnesota, 6), eds B.A. Hanawalt and K.L Reyerson, Minneapolis 1994

HARRISON 1903
J.E. Harrison, *Prolegomena to the Study of Greek Religion*, Cambridge 1903

HARTLAUB 1910
G.F. Hartlaub, *Matteo di Giovanni und seine Zeit*, Strasbourg 1910

HARTLEY 1991
C. Hartley, 'Beccafumi "glum and gloomy"', *Print Quarterly*, 8 (1991), 4, pp. 418–25

HAYUM 1976
A. Hayum, *Giovanni Antonio Bazzi – 'Il Sodoma'*, New York and London 1976

HENRY 1998
T. Henry, *Signorelli in British Collections*, exh. cat., National Gallery, London 1998

HENRY 2004
T. Henry, 'Raphael and Siena', *Apollo*, 160 (2004), pp. 50–6

HENRY 2006
T. Henry, 'Nuove prospettive per Raffaello prima di Roma/New possibilities for Raphael before Rome' in *Accademia Raffaello: Atti e studi*, N.S., 1 (2006), pp. 89–110

HENRY AND KANTER 2002
T. Henry and L.B. Kanter, *The Complete Paintings of Luca Signorelli*, London 2002

HERZNER 1971
V. Herzner, 'Donatello in Siena', *Mitteilungen des Kunsthistorischen Instituts in Florenz*, 15 (1971), pp. 161–86

HESS 2002
C. Hess, *Italian Ceramics: Catalogue of the J. Paul Getty Museum Collection*, Los Angeles 2002

HEYWOOD 1899
W. Heywood, *Our Lady of August and the Palio of Siena*, Siena 1899

HICKS 1960
D.L. Hicks, 'Sienese Society in the Renaissance', *Comparative Studies in Society and History*, II (1960), pp. 412–20

HICKS 1986
D.L. Hicks, 'Sources of Wealth in Renaissance Siena: Businessmen and Landowners', *Bulletino senese di storia patria*, 93 (1986), pp. 9–42

HIGHAM 2002
H. Higham, 'Domenico Beccafumi's Venus in a Landscape', BA dissertation, University of Birmingham, 2002.

HILL 1930
G.F. Hill, *A Corpus of Italian Medals of the Renaissance before Cellini*, 2 vols, London 1930

HIND 1938
A.M. Hind, *Early Italian Engraving: a Critical Catalogue with Complete Reproduction of All the Prints Described*, I, London 1938

HINDMAN, LEVI D'ANCONA, PALLADINO, SAFFIOTTI 1997
The Robert Lehman Collection, IV, Illuminations, eds S. Hindman, M. Levi d'Ancona, P. Palladino and M.I. Saffiotti, New York and Princeton 1997

HIRST 1988
M. Hirst, *Michelangelo and his Drawings*, New Haven and London 1988

HOENIGER 1995
C. Hoeniger, *The Renovation of Paintings in Tuscany, 1250–1500*, Cambridge 1995

HÖFLER 2003
J. Höfler, 'Francesco di Giorgio e la pittura bizantina: nota sull' Annunciazione Martiniana di Siena' in *Arte in Friuli Arte in Trieste*, Trieste 2003, pp. 97–102

HOLBERTON 1984
P. Holberton, 'Botticelli's Hypnerotomachia in The National Gallery, London: A Problem of the Use of Classical Sources in Renaissance Art', *Illinois Classical Studies*, 9 (1984), pp. 149–82

HOLLEMAN 1974
A.W.J. Holleman, *Pope Gelasius I and the Lupercalia*, Amsterdam 1974

HOLMQUIST 1984
J.B. Holmquist, 'The Iconography of a Ceiling by Pinturicchio from the Palazzo del Magnifico, Siena', Ph.D. diss, University of North Carolina 1984

HOOD 1993
W. Hood, *Fra Angelico at San Marco*, New Haven and London 1993

HOOK 1979
J. Hook, *Siena: a City and its History*, London 1979

HOPE 1971
C. Hope, 'The "Camerini d'Alabastro" of Alfonso d'Este', I and II', *The Burlington Magazine*, 113 (1971), pp. 641–50, 712–21

HUGH SMYTH 1992
C. Hugh Smyth, *Mannerism and Maniera*, Vienna 1992

HUMFREY 1987
P. Humfrey, 'Il dipinto d'altare nel Quattrocento' in *La pittura in Italia. Il Quattrocento*, II, Milan 1987, pp. 538–50

HUMFREY 2004
The Cambridge Companion to Giovanni Bellini, ed. P. Humphrey, Cambridge 2004

ILICINO 1843
B. Ilicino, *Vita Madonna Onorata pubblicata per la prima volta sopra un codice del secolo XV da Giuseppe Villardi figlio*, Milan 1843

INGENDAAY 1979
M. Ingendaay, 'Rekonstruktionsversuch der "Pala Bichi" in San Agostino in Siena', *Mitteilungen des Kunsthistorischen Institutes in Florenz*, 23 (1979), pp. 109–26

ISRAËLS 1994
M. Israëls, 'De lotgevallen van Sassetta's Hemelvaart van Maria', *Kunstlicht*, 15 (1994), pp. 7–15

ISRAËLS 2003
M. Israëls, *Sassetta's Madonna della Neve. An Image of Patronage*, Leiden 2003

IZYDORCZYK 1997
A.M. Ianucci, 'The Gospel of Nicodemus in Medieval Italian Literature: a Preliminary Assessment' in Izydorczyk 1997, pp. 165–205

JACKSON AND NEVOLA 2006
Beyond the Palio: Urbanism and Ritual in Renaissance Siena, eds P. Jackson and F. Nevola, Oxford 2006

JACOBSEN 1908
E. Jacobsen, *Das Quattrocento in Siena. Studien in der Gamäldegalerie der Akademie*, Strasbourg 1908

JANSON 1968
H.W. Janson, 'Donatello and the Antique', *Donatello e il suo tempo: atti del VIII. Convegno internazionale di studi sul Rinascimento, Firenze-Padova, 25 settembre –1 ottobre 1966*, Florence 1968, pp. 77–96

JENKENS 1997
L.A. Jenkens, 'Pius II and His Loggia in Siena' in *Pratum Romanum: Richard Krautheimer zum 100 Gieburtstag*, ed. R.L. Colella, Wiesbaden 1997, pp. 199–214

JENKENS 2001
L.A. Jenkens, 'Caterina Piccolomini and the Palazzo delle Papesse in Siena' in *Beyond Isabella: Secular Women Patrons of Art in Renaissance Italy*, eds S. Reiss and D. Wilkins, Kirksville 2001, pp. 77–91

JENKENS 2005
Renaissance Siena: Art in Context, ed. L.A. Jenkens, Kirksville, Missouri 2005

JENKINS 1970
A.D.F. Jenkins, 'Cosimo de' Medici's Patronage of Architecture and the Theory of Magnificence', *Journal of the Warburg and Courtauld Institutes*, 33 (1970), pp. 162–70

JENKINS 1972
M. Jenkins, 'The Iconography of the Hall of the Concistory in the Palazzo Pubblico, Siena', *The Art Bulletin*, 54 (1972), pp. 430–51

JOANNIDES 1983
P. Joannides, *The Drawings of Raphael: with a complete catalogue*, Oxford 1983

JONES AND PENNY 1983
R. Jones and N. Penny, *Raphael*, London 1983

JUDEY 1932
J. Judey, 'Domenico Beccafumi', Ph.D. diss., Albert-Ludwigs-Universität, Freiburg 1932

JUGIE 1944
M. Jugie, *La Mort et l'Assomption de la Sainte Vierge: Etude historico-doctrinale*, Vatican City 1944

KAFTAL 1949
G. Kaftal, *Saint Catherine in Tuscan Painting*, Oxford 1949

KANTER 1989
L.B. Kanter, 'The Late Works of Luca Signorelli and His Followers, 1498–1559', Ph.D. diss., New York University 1989

KANTER 1994
L.B. Kanter, *Italian Paintings in the Museum of Fine Arts, Boston, I, Thirteenth–Fifteenth Century*, Boston 1994

KANTER 2000
L.B. Kanter, 'Rethinking the Griselda Master', *Gazette des Beaux-Arts*, 142 (2000), pp. 145–55

KANTER 2003
L. Kanter, 'Luca Signorelli and Girolamo Genga in Princeton', *Record: Princeton University Art Museum*, 62 (2003), pp. 68–83

KANTER AND PALLADINO 2005
Fra Angelico, eds L.B. Kanter and P. Palladino, exh. cat., The Metropolitan Museum of Art, New York 2005

KAWSKY 1995
D.L. Kawsky, 'The Survival, Revival and Reappraisal of Artistic Tradition: Civic Art and Civic Identity in Quattrocento Siena', Ph.D. diss., Princeton University 1995

KNAB, MITSCH, OBERHUBER, FERINO PAGDEN 1983
E. Knab, E. Mitsch, K. Oberhuber with S. Ferino Pagden, *Raphael: die Zeichnungen*, Stuttgart 1983

KNOWLES FRAZIER 2005
A. Knowles Frazier, *Possible Lives: Authors and Saints in Renaissance Italy*, New York and Chichester 2005

KNOX 1979
G. Knox, 'Giambattista Tiepolo: Queen Zenobia and Ca' Zenobio', *The Burlington Magazine*, 121 (1979), pp. 409–18

KRAHN 1996
'Von allen Seiten schön', Bronzen der Renaissance und des Barock, ed. V. Krahn, exh. cat., Skulpturensammlung, Staatlich Museen zu Berlin, Peussischer Kulturbesitz, im Alten Museum, Berlin 1996, pp. 157–9

KRAUTHEIMER 1956
R. Krautheimer, *Lorenzo Ghiberti*, Princeton 1956

KURZ 1937
O. Kurz, 'Giorgio Vasari's "Libro de' Disegni"', *Old Master Drawings*, 7 (1937), pp. 1–15, 32–44

KUSTODIEVA 1994
T.K. Kustodieva, *The Hermitage. Catalogue of Western European Painting. Italian Painting, Thirteenth to Sixteenth Centuries*, Moscow and Florence 1994

LACLOTTE AND MOENCH 2005
Peinture italienne : Musée du Petit Palais, Avignon, eds M. Laclotte and E. Moench, exh. cat., Musée du Petit Palais, Avignon, Paris 2005

LACLOTTE AND MOGNETTI 1987
M. Laclotte and E. Mognetti, *Avignon, Musée du Petit Palais: Peinture Italienne*, Paris 1987

LADIS AND ZURAW 2001
Visions of Holiness: Art and Devotion in Renaissance Italy, eds A. Ladis and S.E. Zuraw, Athens, GA 2001

LANDAU AND PARSHALL 1994
D. Landau and P. Parshall, *The Renaissance Print: 1470–1550*, New Haven and London 1994

LANGTON DOUGLAS 1903
R. Langton Douglas, 'Le maioliche di Siena', *Bullettino senese di storia patria*, 10 (1903), pp. 3–23

LANGTON DOUGLAS 1937
R. Langton Douglas, 'A Note on Maestro Benedetto and his Work at Siena', *The Burlington Magazine*, 52 (1937), pp. 88–90

LAURENT 1937
M.H. Laurent, *I Necrologi di San Domenico in Camporegio*, Milan 1937

LEVIN 1969
H. Levin, *The Myth of the Golden Age in the Renaissance*, Bloomington and London 1969

LIBERATI 1935
A. Liberati, 'Le prime manifestazioni di devozione dopo la morte di S. Bernardino', *Bulletino senese di storia patria*, 6 (1935), pp. 149–61

LIBERATI 1936
A. Liberati, 'Le vicende sulla canonizzazione di S. Bernardino', *Bulletino di studi benardiniani*, 2 (1936), pp. 91–108

363

LIEBMANN 1968
M. Liebmann, 'The Iconography of the *Nymph of the Fountain* by Lucas Cranach the Elder', *Journal of the Warburg and Courtauld Insitutes*, 31 (1968), pp. 434–7

LIGHTBOWN 2004
R. Lightbown, *Carlo Crivelli*, London and New Haven 2004

LINCOLN 2000
E. Lincoln, *The Invention of the Italian Renaissance Printmaker*, New Haven and London 2000

LIPHART RATHSHOFF 1935
R. de Liphart Rathshoff, 'Un libro di schizzi di Domenico Beccafumi', *Rivista d'Arte*, 17 (1935), pp. 33–70 [part I]; pp. 161–200 [part II]

LISINI 1895
A. Lisini, 'Notizie sull'arte dei vasai in Siena', *Miscellanea storica senese*, 3 (1895), pp. 149–52

LISINI 1898
A. Lisini, 'Notizie di Duccio pittore e della sua celebre ancona', *Bullettino senese di storia patria*, 5 (1898), pp. 20–51

LISINI 1901
A. Lisini, *Le tavolette dipinte di Biccherna e di Gabella del R. Archivio di Stato in Siena*, Siena 1901

LISINI 1908
A. Lisini, 'Medaglia d'Antonio Spannocchi', in *Circolo Numism/Rivista italiana di numismatica*, 1908

LISINI AND IACOMETTI 1931–9
Cronache senesi, eds A. Lisini and F. Iacometti, *Rerum italicarum scriptores*, XV.6, Bologna 1931–9

LLOYD 1977
C. Lloyd, *A Catalogue of the Earlier Italian Paintings in the Ashmolean Museum*, Oxford 1977

LLOYD 1993
C. Lloyd, *Italian Paintings before 1600 in the Art Institute of Chicago*, Chicago and Princeton 1993

LONGHI 1955
R. Longhi, 'Un apice espressionistico di Liberale da Verona', *Paragone*, 6 (1955), pp. 3–7

LONGHI 1964
R. Longhi, 'Un intervento Raffaellesco nella serie "eroica" di Casa Piccolomini', *Paragone*, 175 (1964), pp. 5–8

LOONEY AND SHEMEK 2005
Phaeton's Children: the Este Court and its Culture in Early Modern Ferrara, eds D. Looney and D. Shemek, Arizona 2005

LOSERIES (forthcoming)
W. Loseries, 'Un Theatrum Sacrum del Sodoma: La Cappella di Santa Caterina', forthcoming

LOURY AND LOURY 1992
Catherine de Sienne, eds M. Loury and C. Loury, exh. cat., Palais des Papes, Avignon 1992

LUCCARELLI 1983
A. Luccarelli, 'Contributo alla conoscenza della maiolica senese: il pavimento della capella Bichi in S Agostino', *Faenza*, 69 (1983), pp. 197–8

LUCCARELLI 1984
M. Luccarelli, 'Contributo alla conoscenza della maiolica senese. La "maniera di Maestro Benedetto"', *Faenza*, 70 (1984), pp. 302–4

LUCCARELLI 1995
A. Luccarelli, 'Contributo alla conoscenza della maiolica senese: il pavimento dell'oratorio di Santa Caterina', *Faenza*, 69 (1985), 1–2, pp. 54–55

LUCCARELLI 2002A
M. Luccarelli, 'Contributo alla conoscenza della maiolica senese. Il pavimento dell'Oratorio di Santa Caterina', *Faenza*, 81 (1995), pp. 54–5

LUCCARELLI 2002B
M. Luccarelli, 'Contributo alla conoscenza della maiolica senese', *Ceramic Antica*, 10 (131), anno XII (November 2002), pp. 32–61

LUGLI 1990
A. Lugli, *Guido Mazzoni e la rinascita della terracotta nel Quattrocento*, Turin 1990

LUONGO 2006
F.T. Luongo, *The Saintly Politics of Catherine of Siena*, Ithaca, NY and London 2006

LUSINI 1894
V. Lusini, 'La Madonna dell' Antiporto di Camollia detta la Madonna di San Bernardino', *Miscellanea storica senese*, 2 (1894), pp. 3–8

LUSINI 1904
V. Lusini, 'Dell'arte del legname innanzi al suo Statuto del 1426', *Bullettino senese di storia patria*, 11 (1904), pp. 183–246

LUSINI 1908
V. Lusini, *La Basilica di S. Maria dei Servi in Siena*, Siena 1908

MACHIAVELLI 1964 EDN
N. Machiavelli, *Legazioni e commissarie*, ed. S. Bertelli, 3 vols, Milan 1964

MACK 1987
C.R. Mack, *Pienza. The Creation of a Renaissance City*, Ithaca, NY 1987

MAFFEI AND NARDI 1982
Atti del simposio internazionale cateriniano-bernardiniano, Siena 1980, eds D. Maffei and P. Nardi, Siena 1982

MAGINNIS 2001
H.B.J. Maginnis, *The World of the Early Sienese Painter*, University Park, Pennsylvania 2001

MALLORY AND FREULER 1991
M. Mallory and G. Freuler, 'Sano di Pietro's Bernardino Altarpiece for the Compagnia della Vergine in Siena', *The Burlington Magazine*, 133 (1991), pp 186–92

MALTESE 1969
C. Maltese, 'Il protomanierismo di Francesco di Giorgio Martini', *Storia dell' arte*, 4 (1969), pp. 440–6

MANN AND SYSON 1998
The Image of the Individual: Portraits in the Renaissance, eds N. Mann and L. Syson, London 1998

MANUCCI 1980
V. Manucci, 'Manoscritti e stampe antiche della Legenda aurea di Jacopo da Voragine volgarizzata', *Filologia e critica*, 5 (1980), pp. 30–50

MARIETTE 1851–60 EDN
P.J. Mariette, *Abecedario de P.J. Mariette et autres notes inedites…*, Paris 1851–60

MARINELLI AND MARINI 2006
Mantegna e le arti a Verona 1450–1500, eds S. Marinelli and P. Marini, exh. cat., Palazzo della Gran Guardia, Verona 2006

MARINI 1960
A. Marini, 'The Early Work of Bartolomeo della Gatta', *Art Bulletin*, 42 (1960), pp. 133–41

MARKOVA 2002
V. Markova, *State Pushkin Museum of Fine Arts. Italy, XIII–XVI Centuries. Collection of Paintings*, Moscow 2002

MARRARA 1976
D. Marrara, *Riseduti e nobiltà: profilo storico-istituzionale di un oligarchia toscana nei secoli XVI–XVIII*, Pisa 1976

MARTINI 2006
La 'Rinascita' della scultura: ricerca e restauri, ed. L. Martini, exh. cat., Palazzo Squarcialupi, Santa Maria della Scala, Siena 2006

MASSING 1990
J.M. Massing, *Du texte à l'image: la Calomnie d'Apelle et son iconographie*, Strasbourg 1990

DE MAULDE DA CLAVIÈRE 1897
R. de Maulde da Clavière, 'Le Songe du Chevalier', *Gazette des Beaux-Arts*, 1 (1897), pp. 21–6

MAUGERI 1920
G. Maugeri, *Il Petrarca e San Girolamo*, Catania 1920

MAZZI 1882
C. Mazzi, *La Congrega dei Rozzi di Siena nel secolo XVI*, 2 vols, Florence 1882

MAZZI 1896–1900
A. Mazzi, 'La casa di Maestro Bartalo di Tura', *Bullettino senese di storia patria*, 3, 1896, pp. 142–76, 394–401; 4, 1897, pp. 107–14, 395–402; 5, 1898, pp. 81–8, 270–7, 436–51; 6, 1899, pp. 139–46, 393–400, 513–19; 1900, 7, pp. 300–21

MAZZONI 2001
G. Mazzoni, *Quadri antichi del Novecento*, Vicenza 2001

MAZZONI 2004
Falsi d'autore. Icilio Federico Joni e la cultura del falso tra Otto e Novecento, ed. G. Mazzoni, exh. cat., Palazzo Squarcialupi, Santa Maria della Scala, Siena 2004

MAZZONI AND NEVOLA (forthcoming)
Siena nel Rinascimento: l'ultimo secolo della repubblica, Acts of the International Conference, eds G. Mazzoni and F. Nevola, Florence forthcoming

MECACCI 1985
E. Mecacci, 'Contributo allo studio delle biblioteche universitarie senesi', *Studi senesi*, 97 (1985), pp. 125–64

MEDICI 1977–2004 EDN
L. de' Medici, *Lettere*, eds R. Fubini, N. Rubinstein, M. Mallett, H. Butters and M.M. Bullard, 11 vols, Florence 1977–2004

MEDIOLI MASOTTI 1981
P. Medioli Masotti, 'Componimenti bucolici e rusticali del XV secolo di Jacopo Tolomei', *Bullettino senese di storia patria*, 88 (1981), pp. 21–40

MEISS 1974
M. Meiss, 'Scholarship and Penitence in the Early Renaissance: the Image of St. Jerome', *Pantheon*, 32 (1974), pp. 134–40

MEYER ZUR CAPELLEN 2001–5
J. Meyer zur Capellen, *Raphael. The Paintings*, 2 vols, Landshut 2001–5

MICHELI 1863
E. Micheli, *Guida artistica della città e contorni di Siena*, Siena 1863

MIGEON 1908
G. Migeon, 'La collection de M. Gustave Dreyfus, III. – Petits bronzes. – Bas-reliefs', *Les arts*, 7, no. 73 (1908), pp. 16–32

MIGNE 1844–64
Patrologia Latina, ed. J.P. Migne, 217 vols and 4 index vols, Paris, 1844–64 (vol 22, Saint Jerome, *Opera omnia post monachorum ordinis S. Benedicti*)

MILANESI 1854–6
G. Milanesi, *Documenti per la storia dell'arte Senese*, 3 vols, Siena 1854–6

MILLER 1989
N. Miller, *Renaissance Bologna. A Study in Architectural Form and Content*, New York 1989

MILLER 1993
M. Miller, '"Alcune cose in Siena, non degne di memoria" – Baldassare Peruzzi's Beginnings', *Allen Memorial Art Museum Bulletin*, 46, no. 2, (1993), pp. 3–16

MISCIATTELLI 1925
P. Misciattelli, 'La maschera di S. Bernardino da Siena', *Rassegna d'arte senese*, 18 (1925), pp. 40–2

MISCIATTELLI 1929
P. Misciattelli, 'Cassoni senesi', *La Diana*, 4 (1929), pp. 117–26

MISCIATELLI 1931
P. Misciatelli, *Studi Senesi*, Siena 1931

MITCHELL 1979
B. Mitchell, *Italian Civic Pageantry in the High Renaissance. A Descriptive Biography of the Triumphal Entries and selected other Festivals for State Occasions*, Florence 1979

MOENCH-SCHERER 1992
E. Moench-Scherer, *Sienne en Avignon: peinture siennoise du moyen-age et de la Renaissance*, exh. cat., Musée du Petit Palais, Avignon 1992

MOERER 2003
E.A. Moerer, 'Catherine of Siena and the use of images in the creation of a saint', *1347–1461*, Ph.D. diss., University of Virginia 2003

MONBEIG GOGUEL 1995
The Katalan Collection of Italian drawings, ed. C. Monbeig Goguel, Poughkeepsie, New York 1995

MONGAN AND SACHS 1940
A. Mongan and P.J. Sachs, *Drawings in the Fogg Museum of Art*, Cambridge, MA 1940

MOORMAN 1968
J. Moorman, *A History of the Franciscan Order from its Origins to the Year 1517*, Oxford 1968

MORANDI 1964
U. Morandi, *Le Biccherne senesi. Le tavolette della Biccherna, della Gabella e di altre magistrature dell'antico Stato senese conservate presso l'Archivio di Stato do Siena*, Siena 1964

MORANDI 1978
U. Morandi, 'Gli Spannocchi: piccoli proprietari terrieri, artigiani, piccoli, medi e grandi mercanti-banchieri' in *Studi in onore di Federico Melis*, 5 vols, Naples 1978, III, pp. 91–120

MORANDI AND CAIROLA 1975
U. Morandi and A. Cairola, *Lo Spedale di Santa Maria della Scala*, Siena 1975

MOROLLI 2002
Le Dimore di Siena: L'arte dell'abitare nei territori dell' antica Repubblica dal Medioevo all'Unità d'Italia, ed. G. Morolli, Florence 2002

MORROGH, SUPERBI GIOFFREDI, MORSELLI, BORSOOK 1985
Renaissance Studies in Honor of Craig Hugh Smyth, eds A. Morrogh, F. Superbi Gioffredi, P. Morselli, E. Borsook, Florence 1985

MOSCADELLI 1996
S. Moscadelli, *Felici Cristoforo* in *Dizionario biografico degli Italiani*, 46, Rome 1996, pp. 63–5

MUCCIARELLI 1998
R. Mucciarelli, 'Sulle origini dei Piccolomini. Discendenze fantastiche, architetture nobilanti e celebrazioni genealogiche attraverso le carte della Consorteria', *Bullettino senese di storia patria*, 104 (1998), pp. 357–76

MUIR 2002
E. Muir, 'The Idea of Community in Renaissance Italy', *Renaissance Quarterly*, 105 (2002), pp. 1–18

MUNMAN 1993
R. Munman, *Sienese Renaissance Tomb Monuments*, Philadelphia 1993

MUSACCHIO 2000
J. Musacchio, 'The Madonna and Child, a Host of Saints and Domestic Devotion in Renaissance Florence' in *Revaluing Renaissance Art*, eds G. Neher and R. Shepherd, Aldershot 2000, pp. 147–64

MUSSOLIN 1997
M. Mussolin, 'Il convento di Santo Spirito a Siena e i regolari osservanti di San Domenico', *Bullettino senese di storia patria*, 104 (1997), pp. 7–193

MUSSOLIN 1999
M. Mussolin, 'La chiesa di San Francesco a Siena: impianto originario e fasi di cantiere', *Bullettino senese di storia patria*, 106 (1999), pp. 115–55

MUSSOLIN 2005
M. Mussolin, 'San Sebastiano in Vallepiatta' in *Baldassarre Peruzzi, 1481–1536*, ed. C. Luitpold Frommel, Venice 2005, pp. 95–122

MUSSOLIN 2006
M. Mussolin, 'The rise of the new civic ritual of the Immaculate Conception of the Virgin in sixteenth-century Siena', *Renaissance Studies*, 20 (2006), pp. 253–75

NARDI 1966–8
P. Nardi, 'I borghi di San Donato e San Pietro a Ovile. "Populi", contrade e compagnie d'armi nella società senese dei secoli XI–XIII', *Bullettino senese di storia patria*, 73–5 (1966–8), pp. 7–59

NARDI 1974
P. Nardi, *Mariano Sozzini giureconsulto senese del Quattrocento*, Milan 1974

NARDI 1982
P. Nardi, 'Umanesimo e cultura giuridica nella Siena del Quattrocento', *Bullettino senese di storia patria*, 88, 1982, pp. 234–53

NATALE 1984
Scritti di storia dell'arte in onore di Federico Zeri, ed. M. Natale, Milan 1984

NAZZARO 2004
B. Nazzaro, *Francesco di Giorgio Martini: rocche, città, paesaggi*, Rome 2004

NEVOLA 2000
F. Nevola, '"Creating a Stage for an Urban Elite: the Re-development of the Via of the via del Capitano and Piazza Postierla in Siena (1487–1520)' in *The World of Savonarola: Italian Elites in Crisis*, eds C. Shaw and S. Fletcher, London 2000, pp. 182–93

NEVOLA 2001
F. Nevola, 'Siena nel rinascimento: sistemi urbanistici e strutture istituzionali (1406 circa –1520)', *Bullettino senese di storia patria*, 106 (2001), pp. 44–67

NEVOLA 2003
F. Nevola, '"Lieto e trionphante per la città": Experiencing a mid-fifteenth-century Imperial Triumph along Siena's Strada Romana', *Renaissance Studies*, 17 (2003), pp. 581–606

NEVOLA 2005
F. Nevola, 'The Palazzo Spannocchi: Creating Site and Setting in Renaissance Sienese Architecture', in *Renaissance Siena: Art in Context*, New Haven and London 2005, pp. 141–56

NEVOLA 2007
F. Nevola, *Architecture and Government in Renaissance Siena. Fashioning Urban Experience (1400–1555)*, London and New Haven 2007

NOFFKE 1988/2000
The Letters of Catherine of Siena, ed. S. Noffke, 5 vols, Binghamton, AZ 1988–2000

NORMAN 1999
D. Norman, *Siena and the Virgin: Art and Politics in a Late Medieval City State*, New Haven and London 1999

NORMAN 2003
D. Norman, *Painting in Late Medieval and Renaissance Siena (1260–1555)*, New Haven and London 2003

NORMAN (forthcoming)
D. Norman, 'The Chapel of Saint Catherine in San Domenico. A Study of Cultural Relations between Renaissance Siena and Rome', forthcoming

NUSSDORFER 1997
L. Nussdorfer, 'The Politics of Space in Early Modern Rome', *Memoirs of the American Academy in Rome*, 42 (1997), pp. 161–86

NUTTALL 2004
P. Nuttall, *From Flanders to Florence: the Impact of Netherlandish Painting, 1400–1500*, New Haven and London 2004

OBERHUBER 1986
K. Oberhuber, 'Raphael and Pintoricchio', *Raphael before Rome, Studies in the History of Art*, 17 (1986) pp. 155–72

O'MALLEY 2005
M. O'Malley, *The Business of Art: Contracts and the Commissioning Process in Renaissance Italy*, New Haven and London 2005

OFFNER 1927
R. Offner, *Italian Primitives at Yale University: Comments and Revisions*, New Haven 1927

OLITSKY RUBINSTEIN 1957
R. Olitsky Rubinstein, 'Pius II as a Patron of Art with reference to the History of the Vatican', Ph.D. diss., Courtauld Institute of Art, University of London 1957

OLSON 2000
R. Olson, *The Florentine Tondo*, Oxford 2000

ORIGO 1963
I. Origo, *The World of San Bernardino*, London 1963

PAARDEKOOPER 1993
L. Paardekooper, 'Due famiglie rivali e due pale di Guidoccio Cozzarelli per Sinalunga', *Prospettiva*, 72 (1993), pp. 51–65

PAARDEKOOPER 1996
L. Paardekooper, 'La Pala del Vecchietta per Spedaletto. La committenza del rettore e del camerlengo dello Spedale di Santa Maria della Scala e i rapporti con Pio II', *Mededelingen ven het Nederlands Instituut te Rome*, 55 (1996), pp. 149–86

PALERMO 1853–68
F. Palermo, *I manoscritti palatini di Firenze*, 3 vols, Florence 1853–68

PALLADINO 1996
P. Palladino, 'Francesco di Giorgio', *Old Master Drawings*, 34 (1996), pp. 86–7

PALLADINO 1997
P. Palladino, *Art and Devotion in Siena after 1350: Luca di Tomme and Niccolò di Buonaccorso*, exh. cat, Timken Museum of Art, San Diego, CA 1997

PALMIERI NUTI 1882
G. Palmieri Nuti, *Discorso sulla vita e la opere di Domenico Beccafumi detto Mecarino, artista senese del secolo XVI*, Siena 1882

PANIZZA 2000
L. Panizza, *Women in Italian Renaissance Culture and Society*, Oxford 2000

PANOFSKY 1924
E. Panofsky, 'Das "Discordia"-Relief im Victoria- und Albert-Museum: ein Interpretationsversuch', *Belvedere*, 5 (1924), pp. 189–93

PANOFSKY 1930
E. Panofsky 'Das erste Blatt aus dem "Libro" Giorgio Vasaris. Eine Studie über die Beurteilung der Gotik in der italienischen Renaissance mit einem Excurs über zwei Fassaden-projekte Domenico Beccafumis', *Städel Jahrbuch*, 6 (1930), pp. 25–72

PAOLOZZI STROZZI, TODERI, VANNEL TODERI 1992
Le monete della Repubblica Senese, eds B. Paolozzi Strozzi, G. Toderi and F. Vannel Toderi, Siena 1992

PARDUCCI 1906–7
P. Parducci, 'L'incontro di Federigo III Imperatore con Eleonora di Portogallo', *Bullettino senese di storia patria*, 13 (1906), pp. 297–379; 14 (1907), pp. 35–96

PARKE 1988
H.W. Parke, *Sibyls and Sibylline Prophecy in Classical Antiquity*, London and New York 1988

PARKER 1956
K.T. Parker, *Catalogue of the Collection of Drawings in the Ashmolean Museum, II, Italian Schools*, Oxford 1956

PARKER 1993
H.C. Parker, '*Romani numen soli:* Faunus in Ovid's *Fasti*', *Transactions of the American Philological Association*, 123 (1993), pp. 199–217

PARSONS 2004
G. Parsons, *Siena, Civil Religion and the Sienese*, Aldershot 2004

PATON 1992
B. Paton, *Preaching Friars and the Civic Ethos: Siena, 1380–1480*, London 1992

PAVONE AND PACELLI 1981
Enciclopedia bernardiniana, eds M.A. Pavone and V. Pacelli, 2 vols, Salerno 1981

PAYSON EVANS 2003 EDN
E. Payson Evans, *Animal Symbolism in Ecclesiastical Architecture*, Montana 2003

PECCI 1755–60
G.A. Pecci, *Memorie storico-critiche della città di Siena*, 2 vols, Siena 1755–60

PECCI 1988 EDN
G. A. Pecci, *Memorie storico-critiche della città di Siena*, Siena 1988

PELLEGRINI 2003
M. Pellegrini, 'Pio II, il collegio cardinalizio e la Dieta di Mantova' in *Il sogno di Pio II e il viaggio da Roma a Mantova*, eds A. Calzona, F.P. Fiore, A. Tenenti, C. Vasoli, papers from the international convention in Mantua 2000, Florence 2003, pp. 129–42

PEREZ-JOFRE 2001
T. Pérez-Jofre, *Grandes obras de arte. Museo Thyssen-Bornemisza*, Cologne 2001

PERKINS 1904
F. Mason Perkins, 'La pittura alla Mostra dell'antica arte in Siena', *Rassegna d'arte*, 4 (1904), pp. 145–53

PERTICI 1990
P. Pertici, *Tra politica e cultura nel primo Quattrocento senese: le epistole di Andreoccio Petrucci (1426–1443)*, Siena 1990

PERTICI 1992
P. Pertici, 'Una "coniuratio" del reggimento di Siena nel 1450', *Bullettino senese di storia patria*, 99 (1992), pp. 1–39

PERTICI 1995
P. Pertici, *interventi edilizi a Siena nel Rinascimento. L'ufficio dell'Ornato (1428–1480)*, Siena 1995

PERTICI 1999
P. Pertici, 'Condottieri senesi e la "Rotta di San Romano" di Paolo Uccello', *Archivio storico italiano*, 157 (1999), pp. 537–50

PERUZZI 1978
E. Peruzzi, *Aspetti culturali del Lazio primitivo*, Florence 1978

PETRIOLI TOFANI 1987
A. Petrioli Tofani, *Gabinetto disegni e stampe degli Uffizi. Inventario. 1. Disegni esposti*, Florence 1987

PETRIOLI TOFANI AND SMITH 1995
A. Petrioli Tofani and G. Smith, *Renaissance Drawings from the Uffizi*, exh. cat., The Art Gallery of New South Wales, Sydney 1995

PIANA 1951
C. Piana, 'I processi di canonizzazione su la vita di S. Bernardino da Siena', *Archivum franciscanum historicum*, 44 (1951), pp. 383–435

PICCINI 1975–6
G. Piccinni, 'I "villani incittadini" nella Siena del XIV secolo', *Bullettino senese di storia patria*, 82–3 (1975–6), pp. 158–219

PICCINI AND ZARRILLI 2003
G. Piccinni and C. Zarrilli, *Arte e assistenza a Siena: le copertine dipinte dell'ospedale di Santa Maria della Scala*, exh. cat., Santa Maria della Scala, Siena, Pisa 2003

PICCOLOMINI 1972–6 EDN
Enea Silvio Piccolomini, *I Commentarii*, 5 vols, Siena 1972–6

PICCOLOMINI 1984 EDN
Enea Silvio Piccolomini, *I Commentarii*, ed. L. Totaro, Milan 1984

PIEPER 2000
I. Pieper, *Il progetto di una visione umanistica del mondo*, Stuttgart and London 2000

PIKE GORDLEY 1988
B. Pike Gordley, 'The drawings of Beccafumi', Ph.D. diss., Princeton University 1988

PIKE GORDLEY 1992
B. Pike Gordley, 'A Dominican Saint for the Benedictines: Beccafumi's "Stigmatization of St. Catherine', Zeitschrift für Kunstgeschichte, 55 (1992), pp. 394–412

PINELLI 2004
A. Pinelli, *La bellezza impura: arte e politica nell'Italia del Rinascimento*, Rome 2004

PIOT 1878
E. Piot, 'Exposition universelle. La sculpture a l'exposition retrospective du Trocadéro', *Gazette des beaux-arts*, 18 (1878), pp. 576–600

PLAZZOTTA 2001
C. Plazzotta, 'Beccafumi's Story of Papirius in the National Gallery', *The Burlington Magazine*, 143, no. 1182 (2001), pp. 562–6

POLECRITTI 2000
C. Polecritti, *Preaching Peace in Renaissance Italy: Bernardino of Siena and his Audience*, Washington, DC 2000

POOLE 1995
J. Poole, *Italian Maiolica and incised slipware in the Fitzwilliam Museum*, Cambridge 1995

POPE-HENNESSY 1944
J. Pope-Hennessy, 'The 'Development of Realistic Painting in Siena', *The Burlington Magazine*, 84 (1944), pp. 110–19, 139–44

POPE-HENNESSY 1947
J. Pope-Hennessy, *Sienese Quattrocento Painting*, Oxford and New York 1947

POPE-HENNESSY 1964
J. Pope-Hennessy, *Catalogue of the Italian Sculpture in the Victoria & Albert Museum*, 3 vols, London 1964

POPHAM AND POUNCEY 1950
A.E. Popham and P. Pouncey, *Italian Drawings in the Department of Prints and Drawings at the British Museum: The Fourteenth and Fifteenth Centuries*, 2 vols, London 1950

PRAY BOBER AND RUBINSTEIN 1986
P. Pray Bober and R. Rubinstein, *Renaissance Artists and Antique Sculpture. A Handbook of Sources*, London 1986

PREVITALI 1988
C. Previtali, 'Introduzione al problemi della bottega di Simone Martini' in *Simone Martini*, ed. L. Bellosi, Florence 1988, pp. 151–66

PROCACCI 1960
U. Procacci, 'Di Jacopo d'Antonio e delle compagnie del Corso degli Adimari nel XV secolo' in *Rivista d'arte*, 35 (1960), pp. 3–70

PRODI 1982
P. Prodi, *Il sovrano pontefice. Un corpo e due anime: la monarchia papale nella prima età moderna*, Bologna 1982

PROMIS 1841
Francesco di Giorgio, Trattato di architettura civile e militare di Francesco di Giorgio Martini architetto senese del secolo XV, ed. C. Promis, 3 vols, Turin 1841

PROTO PISANI 2005
Perugino a Firenze. Qualità e fortuna d'uno stile, ed. R.C. Proto Pisani, exh. cat., Cenacolo di Fuligno, Florence 2005

PROVIDENCE 1973
Drawings and Prints of the First Maniera 1515–1535, exh. cat., Brown University Museum of Art, Providence, RI 1973

PUTTFARKEN 1980
T. Puttfarken, 'Golden Age and Justice in Sixteenth-century Florentine Political Thought and Imagery: Observations on Three Pictures by Jacopo Zucchi', *Journal of the Warburg and Courtauld Institutes*, 43 (1980), pp. 130–49

QUAGLIO 1986
A.E. Quaglio, 'Donne di Corte e di Provincia' in G.C. Balardi, G. Chittolini and P. Floriani, *Federico da Montefeltro: lo stato, le arti, la cultura*, Rome 1986

QUINTERIO 1989
F. Quinterio, 'Verso Napoli: come Giuliano e Benedetto da Maiano divennero artisti nella corte aragonese', *Napoli Nobilissima*, 28 (1989), pp. 204–10

QUINTERIO 1996
F. Quinterio, *Giuliano da Maiano: 'Grandissimo domestico'*, Rome 1996

RACKHAM 1940
B. Rackham, *Victoria & Albert Museum: Catalogue of Italian Maiolica*, 2 vols, London 1940

RACKHAM 1977
B. Rackham, *Victoria & Albert Museum: Catalogue of Italian Maiolica*, 2 vols, with emendations and additional bibliography by J.V.G. Mallet, London 1977

RAGGHIANTI COLLOBI 1974
L. Ragghianti Collobi, *Il libro de' disegni del Vasari*, Florence 1974

RAGUSA AND GREEN 1961
Meditations on the Life of Christ, eds I. Ragusa and R.B. Green, New Jersey 1961

RASMUSSEN 1984
J. Rasmussen, *Italienische Majolika: Museum für Kunst und Gewerbe Hamburg*, Hamburg 1984

RAYMOND OF CAPUA 1866 EDN
Blessed Raymond of Capua, 'Legenda Sancti Catherine Senensis', *Acta Sanctorum*, 3 (April), pp. 862–967, Paris 1866, in *The Life of Saint Catherine of Siena by Raymond of Capua*, trans. C. Kearns, Wilmington 1980

RAYMOND OF CAPUA 1960 EDN
Blessed Raymond of Capua, *The Life of Saint Catherine of Siena*, trans. G. Lamb, London 1960

RICCI 1901
C. Ricci, 'La Sala del Pintoricchio nel Palazzo del Magnifico a Siena', *Arte italiana decorativa e industriat*, 10 (1901), pp. 61–4

RICE 1985
E.F. Rice, *Saint Jerome in the Renaissance*, Baltimore 1985

RICHARDSON 2007
C.M. Richardson, *Locating Renaissance Art*, New Haven and London 2007

RICHTER 2002
E.M. Richter, *La scultura di Antonio Federighi*, Turin 2002

RIEDL AND SEIDEL 1985
Die Kirchen von Siena, I, Abbadia all'Arco – S. Birgio, eds P.A. Riedl and M. Seidel, Munich 1985

RIEDL AND SEIDEL 1992
Die Kirchen von Siena, II, *Oratorio della Carità – S. Domenico*, eds P.A. Riedl and M. Seidel, Munich 1992

RITSCHARD AND MOREHEAD 2004
Cléopâtre dans le miroir de l'art occidental, eds C. Ritschard and A. Morehead, exh. cat., Musée Rath, Geneva 2004

ROBERTS 1959
H.I. Roberts, 'Saint Augustine in "Saint Jerome's Study": Painting and its Legendary Source', *Art Bulletin*, 41 (1959), pp. 283–97

ROBERTS 1987
A.M. Roberts, 'North meets South in the Convent: the Altarpiece of St Catherine of Alexandria in Pisa', *Zeitschrift für Kunstgeschichte*, 50 (1987), pp. 187–206

ROEST 2004
B. Roest, *Franciscan Literature of Religious Instruction before the Council of Trent*, Leiden and Boston 2004

ROGATI 1923
F. Rogati, 'L'arte e San Bernardino da Siena', *Bullettino senese di storia patria*, 30 (1923), pp. 3–22

ROMAGNOLI ANTE 1835
E. Romagnoli, *Biografia cronologica de' Bellartisti senesi (ante 1835)*, mss. L. II. 1–13 Biblioteca Communale di Siena (edn Florence 1976)

RONDONI 1895
G. Rondoni, 'Il mistero di Santa Caterina in un codice della Biblioteca Comunale Sanese', *Bullettino senese di storia patria*, 2 (1895) pp. 231–63

ROSETTI AND VALENTI 1997
E. Rosetti and L. Valenti, *Terme e sorgenti di Toscana: note, meno note, sconosciute*, Florence 1997

ROSSETTI 1861
D.G. Rossetti, *The Early Italian Poets from Ciullo d'Alcamo to Dante Alighieri*, London 1861

ROSSI 1999
A. Rossi, 'Due note sull' attività di Benvenuto di Giovanni', *Prospettiva*, 95–6 (1999), pp. 131–42

ROUSE 1902
W.H.D. Rouse, *Greek Votive Offerings*, Cambridge 1902

ROWLAND 2001
I. Rowland, *The Correspondence of Agostino Chigi (1466–1520) in cod. Chigi R.V.c.*, Vatican City 2001

RUBINSTEIN 1958
N. Rubinstein, 'Political Ideas in Sienese Art: the Frescoes by Ambrogio Lorenzetti and Taddeo di Bartolo in the Palazzo Pubblico', *Journal of the Warburg and Courtauld Institutes*, 21 (1958), pp. 179–207

RUDA 1993
J. Ruda, *Fra Filippo Lippi: Life and Work with a Complete Catalogue*, London 1993

RUGIADINI 1987
I ceti dirigenti nella Toscana del Quattrocento. Comitato di studi sulla storia dei ceti dirigenti in Toscana. Atti del V e VI Convegno: Firenze, 10–1 dicembre 1982; 2–3 dicembre 1983, ed. D. Rugiadini, Florence 1987

RUSK SHAPLEY 1966
F. Rusk Shapley, *Paintings from The Samuel H. Kress Collection, I, Italian Schools, XIV–XV Century*, London 1966

RUSSO 1987
D. Russo, *Saint Jérôme en Italie. Étude d'iconographie et de spiritualité (XIIIe–XVe siècle)*, Paris and Rome 1987

SAALMAN AND MATTOX 1985
H. Saalman and P. Mattox, 'The First Medici Palace', *Journal of the Society of Architectural Historians*, 44 (1985), pp. 329–45

SALLAY 2003
D. Sallay, 'Nuove considerazioni su due tavole d'altare di Matteo di Giovanni: la struttura della pala Placidi di San Domenico e della pala degli Innocenti di Sant'Agostino a Siena', *Prospettiva*, 112 (2003), pp. 76–93

SANMINIATELLI 1955
D. Sanminiatelli, 'The Sketches of Domenico Beccafumi', *The Burlington Magazine*, 97 (1955), pp. 35–40

SANMINIATELLI 1967
D. Sanminiatelli, *Domenico Beccafumi*, Milan 1967

SANTI AND STRINATI 2005
Siena e Roma. Raffaello, Caravaggio e i protagonisti di un legame antico, eds B. Santi and C. Strinati, exh. cat., Santa Maria della Scala, Siena 2005

SANUDO 1873
M. Sanudo, *La spedizione di Carlo VIII in Italia*, Venice 1873

SARTI 1998
G. Sarti, *Trente-Trois Primitifs Italiens de 1310 à 1500: du Sacré au Profane*, Paris 1998

SARTI 2002
A. Sarti, *Fonds d'or et fonds paints italiens (1300–1560)*, Paris 2002

SAVI LOPEZ 1924
M. Savi Lopez, *Santa Caterina da Siena*, Milan 1924

SAXL 1933
F. Saxl, 'Atlas, der Titian, im Dienst der astrologischen Erdkunde', *Imprimatur. Ein Jahrbuch für Bücherfreunde*, 4 (1933), pp. 44–53

SCAGLIA 1970
G. Scaglia, 'Fantasy Architecture of Roma antica', *Arte Lombarda*, 15 (1970), pp. 9–24

SCARPELLINI 1984
P. Scarpellini, *Perugino*, Milan 1984

SCARPELLINI 1998
P. Scarpellini, 'Pietro Perugino e la decorazione della sala dell'Udienza' in Scarpellini ed., *Il Collegio del Cambio di Perugia*, Milan 1998, pp. 67–106.

SCARPELLINI AND SILVESTRELLI 2004
P. Scarpellini and M.R. Silvestrelli, *Pintoricchio*, Milan 2004

SCHAAR 1997
Italienische Zeichnungen der Renaissance aus dem Kupferstichkabinett, ed. E. Schaar, exh. cat., Hamburger Kunsthalle, Hamburg 1997

SCHEVILL 1909
F. Schevill, *Siena: the Story of a Medieval Commune*, London 1909

SCHIAPARELLI 1983
A. Schiaparelli, *La Casa Fiorentina e i suoi arredi nei secoli XIV e XV*, 2 vols, Florence 1983

SCHMARSOW 1880
A. Schmarsow, *Raphael und Pinturicchio in Siena: eine kritische Studie*, Stuttgart 1880

SCHMARSOW 1882
A. Schmarsow, *Pinturicchio in Rom: eine kritische studie*, Stuttgart 1882

SCHMARSOW 1901
A. Schmarsow, 'Der Freskenschmuck einer Madonnen-Kapelle in Subiaco' in *Berichten der philologisch-historischen Classe der königlichen sächsischen Gesellschaft der Wissenschaften zu Leipzig*, Leipzig 1901, pp. 75–88

SCHMARSOW 1928
A. Schmarsow, 'Die Madonnen-Kapelle in S. Francesco von Subiaco', *Belvedere*, 9 (1928), pp. 99–124

SCHUBRING 1907A
P. Schubring, 'Gli acquisti del Museo Kaiser Friedrich', *L'Arte*, 10 (1907), pp. 451–5

SCHUBRING 1907B
P. Schubring, *Die Plastik Siena im Quattrocento*, Berlin 1907

SCHUBRING 1915
P. Schubring, *Die italienische Plastik des Quattrocento*, Berlin and Neubabelsberg 1915

SCHUBRING 1916
P. Schubring, 'Francesco di Giorgio Martini' in *Allgemeines Lexikon der bildenden Künstler: von der Antike bis zur Gegenwart*, ed. U. Thieme and F. Becker, 12, Leipzig 1916, pp. 303–6

SCHUBRING 1923
P. Schubring, *Cassoni*, Leipzig 1923

SCHULZ 1962
J. Schulz, 'Pinturicchio and the Revival of Antiquity', *Journal of the Warburg and Courtauld Institute*, 25 (1962), pp. 35–55

SEIDEL 1979
M. Seidel, 'Die Fresken des Francesco di Giorgio in S. Agostino in Siena', *Mitteilungen des Kunsthistorischen Institut in Florenz*, 23 (1979), 1–2, pp. 4–118

SEIDEL 1989A
M. Seidel, 'Francesco di Giorgio o Ludovico Scotti? Storia della "Pala Tancredi" in San Domenico a Siena', *OPD*, 1 (1989), pp. 31–6

SEIDEL 1989B
M. Seidel, 'Sozialgeschichte des Sieneser Renaissance-Bildes. Studien zu Francesco di Giorgio, Neroccio de'Landi, Benvenuto di Giovanni, Matteo di Giovanni e Bernardino Fungai', *Städel Jahrbuch*, n.f., 12 (1989), pp. 71–138

SEIDEL 1991
M. Seidel, 'Studien zu skulptur der Frührenaissance: Francesco di Giorgio, Giovanni Antonio Amadeo', *Pantheon*, 49 (1991), pp. 55–73

SEIDEL 1993
M. Seidel, 'Die Societas in arte pictorum von Francesco di Giorgio und Neroccio de' Landi', *Pantheon*, 51 (1993), pp. 46–61

SEIDEL 2003A
M. Seidel, *Italian Art of the Middle Ages and the Renaissance*, I, *Painting*, Venice 2003

SEIDEL 2003B
M. Seidel, 'Luca Signorelli intorno al 1490', in M. Seidel, *Arte italiana del Medioevo e del Rinascimento*, (1984), I, Venice 2003, pp. 645–707

SENIGAGLIA 1908
Q. Senigaglia, 'Statuto dell'arte della mercanzia', *Bullettino senese di storia patria*, 15 (1908), pp. 114

SERLIO 2001
S. Serlio, *L'architettura. I libri I-VII e extraordinario nelle prime edizioni*, ed. F.P. Fiore, Milan 2001

SETTIS 1985A
La fede negli astri. Dall'antichità al Rinascimento, ed. S. Settis, Turin 1985

SETTIS 1985B
Memoria dell'antico nell'arte italiano, II, *I generi e i temi ritrovati*, ed. S. Settis, Turin 1985

SETTIS AND TORACCA 1998
La Libreria Piccolomini del Duomo di Siena (The Piccolomini Library in Siena Cathedral), eds S. Settis and D. Toracca, Modena 1998

SEYBOLT 1946
R.F. Seybolt, 'Fifteenth-Century Editions of the *Legenda aurea*', *Speculum*, 21 (1946), pp. 327–38

SEYMOUR 1970
C. Seymour, Jr., *Early Italian Paintings in the Yale University Art Gallery*, New Haven and London 1970

SHAW 1996
C. Shaw, 'Politics and Institutional Innovation in Siena. 1480–1498 (I)', *Bullettino senese di storia patria*, 103 (1996), pp. 9–102

SHAW 2000
C. Shaw, *The Politics of Exile in Renaissance Italy*, Cambridge 2000

SHAW 2001
C. Shaw, *L'ascesa al potere di Pandolfo Petrucci il Magnifico, Signore di Siena (1487–1498)*, Siena 2001

SHEARMAN 1965
J. Shearman, *Andrea del Sarto*, Oxford 1965

SHEARMAN 1972
J. Shearman, *The Vatican Stanze: Functions and Decorations*, London 1972

SHEARMAN 1992
J. Shearman, *Only Connect … Art and the Spectator in the Italian Renaissance*, Washington and Princeton 1992

SHEARMAN 2003
J. Shearman, *Raphael in Early Modern Sources, 1483–1602*, 2 vols, New Haven and London 2003

SHEPARD 1930
O. Shepard, *The Lore of the Unicorn*, Boston and New York 1930

SHEPHERD 1993
G.V.G. Shepherd, 'A monument to Pope Pius II: Pintorichio and Raphael in the Piccolomini Library in Siena', Ph.D. diss., Harvard University 1993

SHERWIN GARLAND 2003
Early Italian Paintings: Approaches to Conservation, ed. P. Sherwin Garland, New Haven and London 2003

SIENA 1950
Mostra Bernardiniana nel Vº Centenario della Canonizzazione di S. Bernardino. Maggio–Ottobre 1950. Catalogo, Siena 1950

SIENA 1990
Domenico Beccafumi e il suo tempo, exh. cat., Pinocateca Nazionale, Siena, Milan 1990

SIMONS 1993
P. Simons, 'Mating the Grand Masters: The Gendered, Sexualized Politics of Chess in Renaissance Italy', *Oxford Art Journal*, 16 (1993), pp. 59–74

SIMONS 1995
P. Simons, 'Portraiture, Portrayal, and Idealization: Ambiguous Individualism in Representations of Renaissance Women', in ed. A. Brown, *Language and images of Renaissance Italy*, Oxford 1995, pp. 263–311

SKINNER 1981
Q. Skinner, *Machiavelli*, Oxford 1981

SMITH 1968
L.F. Smith, 'A Notice on the *Epigrammata* of Francesco Patrizi, Bishop of Gaeta', *Studies in the Renaissance*, 15 (1968), pp. 92–143

SMOLLER 1997
L. Smoller, 'Defining the Boundaries of the Natural in the Fifteenth Century: the Inquest into the Miracles of St Vincent Ferrer (d. 1419)', *Viator*, 48 (1997), pp. 333–59

SMOLLER 1998
L. Smoller, 'Miracle, Memory and Meaning in the Canonisation of Vincent Ferrer', *Speculum*, 73 (1998), pp. 429–54

SPALLANZANI AND GAETA BERTELA 1992
Libro d'inventario dei beni di Lorenzo il Magnifico, eds M. Spallanzani and G. Gaeta Bertelà, Florence 1992

SPENCER-LONGHURST 1993
P. Spencer-Longhurst, *The Barber Institute of Fine Arts. Handbook*, Birmingham 1993

SRICCHIA SANTORO 1991
F. Sricchia Santoro, *Collezione Chigi Saracini. Da Sodoma a Marco Pino. Addenda*, Siena 1991

SRICCHIA SANTORO 1988
Da Sodoma a Marco Pino. Pittori a Siena nella prima metà del Cinquecento, ed. F. Sricchia Santoro, exh. cat., Palazzo Chigi Saracini, Siena, Florence 1988

STEINZ-KECKS 1990
H. Steinz-Kecks, 'Santa Caterina in Fontebranda: Storia della costruzione' in *L'oratorio di Santa Caterina di Fontebranda*, ed. Contrada dell'Oca, Siena 1990, pp. 1–28

STREHLKE 1985
C.B. Strehlke, 'Sienese Paintings in the Johnson Collection', *Paragone, Arte* 36, no. 427 (1985), pp. 3–15

STREHLKE 1993
C.B. Strehlke, 'Review: Francesco di Giorgio', *The Burlington Magazine*, 135 (1993), pp. 499–502

STREHLKE 2003
C.B. Strehlke, 'The Princeton Penitent Saint Jerome, the Gaddi family, and Early Fra Angelico', *Record. Princeton University Art Museum*, 62 (2003), pp. 4–27

STREHLKE 2004
C.B. Strehlke, *Italian Paintings 1250–1450 in the John G. Johnson Collection and the Philadelphia Museum of Art*, Philadelphia 2004

SUIDA 1953
W.E. Suida, *Paintings and Sculpture of the Samuel H. Kress Collection*, Philbrook Art Center, Tulsa 1953

SUTTON 1979
D. Sutton, 'Robert Langton Douglas, Part II: VII, Maiolica in Tuscany', *Apollo*, 109 (1979), pp. 334–41

SYMEONIDES 1965
S. Symeonides, *Taddeo di Bartolo*, Siena 1965

SYSON (forthcoming)
L. Syson, *Renaissance Siena: Questions of Attribution*, forthcoming

SYSON AND THORNTON 2001
L. Syson and D. Thornton, *Objects of Virtue: Art in Renaissance Italy*, London 2001

TARTUFERI AND PARENTI 2006
Lorenzo Monaco: A Bridge from Giotto's Heritage to the Renaissance, eds A. Tartuferi and D. Parenti, exh. cat., Galleria dell'Accademia, Florence, Florence and Milan 2006

TÁTRAI 1978
V. Tátrai, 'Gli affreschi del Palazzo Petrucci a Siena: una precisazione iconografica e un'ipotesi sul programma', *Acta Historiae Artium*, 24 (1978), pp. 177–83

TÁTRAI 1979
V. Tátrai, 'Il Maestro della Storia di Griselda e una famiglia senese di mecenati dimenticata', *Acta Historiae Artium*, 25, 1–2 (1979), pp. 27–66

TAURISANO 1929
I. Taurisano, *Il Dialogo della Divina Provvidenza di Santa Caterina da Siena*, Rome 1929

TERZIANI 2002
R. Terziani, *Il governo di Siena dal Medioevo all'età moderna: la continuità repubblicana al tempo dei Petrucci, 1487–1525*, Siena 2002

TESTA 1996
La Cappella Nova o di San Brizio nel duomo di Orvieto, ed. G. Testa, Milan 1996

THIERRY 1963
J.J. Thierry, 'The Date of the Dream of Jerome', *Vigiliae Christianae*, 17 (1963), pp. 28–40

THOMAS 1995
A. Thomas, *The Painter's Practice in Renaissance Tuscany*, Cambridge 1995

THORNTON 1991
P. Thornton, *The Italian Renaissance Interior: 1400–1600*, London 1991

THORNTON 1997
D. Thornton, *A Scholar in his Study: Ownership and Experience in Renaissance Italy*, New Haven and London 1997

THORNTON AND WILSON (forthcoming)
D. Thornton and T. Wilson, *Italian Renaissance Ceramics: A Catalogue of the British Museum Collection*, London forthcoming

TOGNERI DOWD 1985
The Travel Diary of Otto Mundler, ed. C. Togneri Dowd, The Walpole Society, 51, London 1985

TOLEDANO 1987
R. Toledano, *Francesco di Giorgio Martini. Pittore e scultore*, Milan 1987

TOMEI 2002
Le Biccherne di Siena. Arte e finanza all'alba dell' economia moderna, ed. A. Tomei, exh. cat., Palazzo del Quirinale, Rome, Bergamo 2002

TONCELLI 1909
D. Toncelli, *La Casa di Santa Caterina a Siena*, Rome 1909

TORRITI 1980
P. Torriti, *La Pinacoteca Nazionale di Siena: I dipinti dal XLL al XV secolo*, Genoa 1980

TORRITI 1981
P. Torriti, *La Pinacoteca Nazionale di Siena. I dipinti dal XV al XVIII secolo*, Genoa 1981

TORRITI 1982
P. Torriti, *La casa di Santa Caterina e la Basilica di San Domenico a Siena*, Genoa 1982

TORRITI 1993
P. Torriti, 'Francesco di Giorgio Martini', *Art e Dossier* 51, no. 77 (1993), Milan 1993

TORRITI 1998
P. Torriti et al. *Beccafumi*, Milan 1998

TOTI 1870
A. Toti, *Atti di Votazione della Città di Siena e del Senese alla SS. Vergine Madre di G.C.*, Siena 1870

TRAPP 2003
J.B. Trapp, *Studies of Petrarch and his Influence*, London 2003

TRAVAGLI 2003
Guido Mazzoni. Il Compianto sul Cristo morto nella chiesa del Gesù a Ferrara. L'Opera e il restauro, ed. A.M. Visser Travagli, Florence 2003

TRIMPI 1983
E. Trimpi, '"Iohannem Baptistam Hieronymo aequalem et non maiorem": A predella for Matteo di Giovanni's Placidi altarpiece', *The Burlington Magazine*, 125 (1983), pp. 457–67

TRIMPI 1985
E. Trimpi, 'A Re-attribution and Another Possible Addition to Matteo di Giovanni's Placidi Altarpiece', *The Burlington Magazine*, 127 (1985), pp. 363–7

TRIMPI 1987
E.S. Trimpi, 'Matteo di Giovanni: Documents and a Critical Catalogue of his Panel Paintings', Ph.D. diss., University of Michigan 1987

TURRINI 1996–7 AND 2002–3
P. Turrini, 'Religiosità e spirito caritativo a Siena agli inizi della reggenza Lorenese: luoghi pii laicali, contrade e arti', *Annuari dell'Istituto Storico Diocesano*, Siena 1996–7, pp. 145–293; 2002–3, pp. 1–234

TURRINI 2003
P. Turrini, 'La chiesa dei santi Giacomo e Cristoforo in Salicotto: il profilo storico' in *L'oratorio della Contrada della Torre San Giacomo maggiore. Restauri, storia e testimonianze*, ed. D. Orsini, Siena 2003, pp. 28–39

UGURGIERI AZZOLINI 1649
I. Ugurgieri Azzolini, *Le Pompe sanesi, o´ vero, Relazione delli huomini e donne illustri di Siena, e suo stato, scritta dal padre*, Pistoia 1649

VAN CLEAVE 1995
C. van Cleave, 'Luca Signorelli as a Draughtsman', Ph.D. diss., University of Oxford 1995

VAN DEN BRINK AND HELMUS 1997
Album discipulorum: J.R.J. van Asperen de Boer, eds P. van den Brink and L.M. Helmus, Zwolle 1997

VAN LOHUIZEN-MULDER 1977
M. van Lohuizen-Mulder, *Raphael's Images of Justice, Humanity, Friendship: a Mirror of Princes for Scipione Borghese*, trans. P. Wardle, Wassenaar 1977

VAN MARLE 1923–38
R. van Marle, *The Development of the Italian Schools of Painting*, 19 vols, The Hague 1923–38

VAN ORDEN 1973
S.C. Van Orden, 'The Ceiling Frescos in the Sala Concistoro, Palazzo Pubblico, Siena by Domenico Beccfumi', Ph.D. diss., University of Syracuse, NY 1973

VAN OS 1969
H.W. van Os, *Marias Demut und Verherrlichung in der sienesischen Malerei 1300–1450*, 's Gravenhage 1969

VAN OS 1987
H.W. van Os, 'Painting in a House of Glass: The Altarpieces of Pienza', *Simiolus*, 17 (1987), pp. 25–38

VAN OS 1990
H.W. van Os, *Sienese Altarpieces 1215–1460: Form, Content, Function*, II, *1344–1460*, Groningen 1990

VASARI 1878–85 EDN
G. Vasari, *Le vite de' più eccellenti pitori, scultori ed architettori*, ed. G. Milanesi, 9 vols, Florence 1878–85

VASARI 1966–87 EDN
G. Vasari, *Le vite de' più eccellenti pittori, scultori e architettori nelle redazioni del 1550 e 1568*, eds R. Bettarini and P. Barocchi, 9 vols, Florence 1966–8

VAUCHEZ 1977
A. Vauchez, 'La Commune de Sienne, les Ordres mendiants et la culte des saints. Histoire et enseignements d'une crise', *Mélanges de l'Ecole Francaise de Rome*, 89 (1977), pp. 757–6

VENTURI 1901–39
A. Venturi, *Storia dell'arte italiana*, 11 vols, Milan 1901–39

VENTURI 1923
A. Venturi, 'Francesco di Giorgio Martini scultore', *L'arte*, 26 (1923), pp. 197–228

VENTURI 1924
A. Venturi, *L'arte a San Girolamo*, Milan 1924

VENTURI 1933
L. Venturi, *Italian Paintings in America*, trans. Countess van den Heuvel and C. Marriott, 3 vols, New York and Milan 1933

VERGERIO 1999 EDN
J.M. McManamon and S.J. Pierpaolo (eds and trans), *Vergerio the Elder and Saint Jerome: An Edition and Translation of Sermones pro Sancto Hieronymo*, Tempe, AZ 1999

VERLET 1937
P. Verlet, 'A Faenza Panel at the Victoria & Albert Museum', *The Burlington Magazine*, 71 (1937), pp. 183–4

VERTOVA 1979
L. Vertova, 'The Tale of Cupid and Psyche in Renaissance Painting before Raphael', *Journal of the Warburg and Courtauld Institutes*, 42 (1979), pp. 104–21

VERTOVA 1981
L. Vertova, *Maestri toscani del Quattro e Cinquecento : Finiguerra, Pollaiuolo, Verrochio, Ghirlandaio, Lorenzo di Credi, Francesco di Simone Ferrucci, Francesco di Giorgio, Leonardo etc.*, Florence 1981

VERTOVA 1993
L. Vertova, 'In my view … problems with exhibitions. The summer shows and their catalogues', *Apollo*, 138 (1993), pp. 325–7

VIGNI 1937
G. Vigni, *Lorenzo di Pietro detto il Vecchietta*, Florence 1937

VISCHER 1879
R. Vischer, *Luca Signorelli und die Italienische Renaissance*, Leipzig 1879

VITI 1987
P. Viti, 'Dati, Agostino' in *Dizionario biografico degli italiani*, 33, Rome 1987, pp. 15–22

VITZHUM 1966
W. Vitzthum, 'Drawings from New York Collections', *The Burlington Magazine*, 107 (1966), pp. 109–10

VOLPE 1961
C. Volpe, 'L'apice espressionistico ferrarese di Liberale da Verona', *Arte antica e moderna*, 13–16 (1961), pp. 154–7

VOLPE 1989 EDN
C. Volpe, *Pietro Lorenzetti*, ed. M. Lucco, Milan 1989

VOLPI 1898
G. Volpi, 'Un antico sonetto in dialetto senese', *Bullettino senese di storia patria*, 6 (1898), pp. 510–12

VOLPI 1907
G. Volpi, 'Un altro sonetto antico in dialetto senese', *Bullettino senese di storia patria*, 14 (1907), pp. 558–60

VORAGINE 1993 EDN
Jacobus de Voragine, *The Golden Legend: Readings on the Saints*, trans. W. Granger Ryan, 2 vols, Princeton 1993

WACE AND SCHAFF 1893
'The Principal Works of St Jerome', VI, trans. W.H. Freemantle with G. Lewis and W.G. Hartley in *A Select Library of Nicene and Post-Nicene Fathers*, eds P. Schaff and H. Wace, New York, 14 vols, Oxford 1890–1900

WALTON 1894
A. Walton, 'The Cult of Asklepios', *Cornell Studies in Classical Philology*, 3 (1894), pp. viii–136

WEBB 1996
D. Webb, *Patrons and Defenders: the Saints in the Italian City-States*, London and New York 1996

WEINBERGER 1927
M. Weinberger, 'Bemerkungen zu Francesco di Giorgio Martini', *Mitteilungen des Kunsthistorischen Institutes in Florenz*, 3 (1919–32), p. 137

WEISSMAN 1982
R. Weissman, *Ritual Brotherhood in Renaissance Florence*, New York and London 1982

WELCH 1995
E. Welch, 'Between Milan and Naples: Ippolita Maria Sforza, duchess of Calabria', in *The French Descent into Renaissance Italy, 1494–95. Antecedents and Effects*, Aldershot and Brookfield VT 1995, pp. 123–36

WELLER 1943
A.S. Weller, 'Francesco di Giorgio (1439–1501)', Ph.D. diss., University of Chicago 1943

WELLIVER 1961
W. Welliver, 'Signorelli's "Court of Pan"', *Art Quarterly*, 24 (1961), pp. 334–45

WESTON-LEWIS 2000
A Poet in Paradise. Lord Lindsay and Christian Art, ed. A. Weston-Lewis, exh. cat., National Gallery of Scotland, Edinburgh 2000

WILCZYNSKI 1956
B. Wilczynski, 'Matteo di Giovanni: Two Episodes from the Life of St Jerome', *AIC Quarterly*, 50 (1956), pp. 74–6

WILKES 1998
R. Wilkes, 'Introducing Mr Bloomfield', *Royal Pavilion Libraries and Museum Review*, April 1998, pp. 8–9

WILSON 1987
T. Wilson, *Ceramic Art of the Italian Renaissance*, exh. cat., The British Museum, London 1987

WILSON 1991
Italian Renaissance Pottery, ed. T. Wilson, London 1991, pp. 157–65

WILSON 2001
C.C. Wilson, *St. Joseph in Italian Renaissance Society and Art: New Directions and Interpretations*, Philadelphia 2001

WISEMAN 1995
T.P. Wiseman, 'The God of the Lupercal', *The Journal of Roman Studies*, 85 (1995), pp. 1–22

WORTHAM 1928
H.E. Wortham, 'Music in Early Renaissance Art', *Apollo*, 8 (1928), pp. 323–9

WRIGHT 2005
A. Wright, *The Pollaiuolo Brothers: the Arts of Florence and Rome*, New Haven and London 2005

ZAFARANA 1980
Z. Zafarana, 'Per la storia della biblioteca di San Francesco in Siena', *Bullettino senese di storia patria*, 86 (1980), pp. 284–95

ZDEKAUER 1894
L. Zdekauer, *Lo Studio di Siena nel Rinascimento*, Milan 1894

ZDEKAUER 1904
L. Zdekauer, 'Sano di Pietro e Messer Cione di Ravi, Conte di Lattaia (1470–73)', *Bullettino senese di storia patria*, 11 (1904), pp. 140–50

ZERI 1951
F. Zeri, 'The Beginnings of Liberale da Verona', *The Burlington Magazine*, 93 (1951), pp. 114–18

ZERI 1983
F. Zeri, 'Rinascimento e Pseudo-Rinascimento' in *Storia dell'arte italiana*, 5, *Dal Medioevo al Rinascimento*, Turin 1983

ZERI 1987
La pittura in Italia. Il Quattrocento, ed. F. Zeri, 2 vols, Milan 1987

ZERI AND GARDNER 1980
F. Zeri with E. Gardner, *Italian Paintings. A Catalogue of the Collection of the Metropolitan Museum of Art: Sienese and Central Italian Schools*, New York 1980

ZEZZA 2003
A. Zezza, *Marco Pino: Un protagonista della maniera moderna*, exh. cat., SS Marcellino and Festo, Gesu Vecchio, SS Severino e Sossio, S Angelo a Nilo, Duomo and S Lorenzo, Naples 2003

INDEX

PHOTOGRAPHIC CREDITS

ALTENBURG/THÜRINGEN
© Lindenau-Museum, Altenburg: cat. 34, 36.

AMSTERDAM
© Rijksmuseum, Amsterdam: cat. 109.

ASCIANO (SIENA)
Museo di Palazzo Corboli, Asciano © Museo Civico
Archeologico e d'Arte Sacra, Palazzo Corboli, Asciano.
Photo Lensini Siena: cat. 18, 19 and p. 126.

BALTIMORE (MD)
© The Walters Art Museum, Baltimore, MD: cat. 71.

BERLIN
Gemäldegalerie, Staatliche Museen, Berlin © bpk /
Gemäldegalerie, Staatliche Museen zu Berlin: fig. 60.
© bpk / Gemäldegalerie, Staatliche Museen zu Berlin /
Jörg P. Anders: cat. 29; fig. 62, 64.

Kupferstichkabinett, Staatliche Museen, Berlin © bpk
/ Kupferstichkabinett, Staatliche Museen zu Berlin /
Jörg P. Anders: cat. 108.

BIRMINGHAM
© The Barber Institute of Fine Arts, The University
of Birmingham: cat. 107. © The Barber Institute of
Fine Arts, The University of Birmingham. Photo
The National Gallery, London: cat. 65 and p. 245.

BLOOMINGTON (IN)
© Indiana University Art Museum Bloomington, IN.
Photo Michael Cavanagh, Kevin Montague: cat. 69.

BOSTON, MASSACHUSETTS (MA)
© 2007 Museum of Fine Arts, Boston, MA: cat. 32;
fig. 81, 82.

BRAUNSCHWEIG
© Herzog Anton Ulrich-Museum Braunschweig,
Kunstmuseum des Landes Niedersachsen.
Photo Bernd-Peter Keiser: cat. 40.

BRIGHTON
Brighton Museum and Art Gallery, Brighton ©
The Royal Pavilion, Libraries and Museums, Brighton
and Hove: cat. 110, 111; fig. 89.

BUDAPEST
Szépművészeti Múzeum, Budapest © Szépművészeti
Múzeum, Budapest. Photo A. Rázsó: cat. 68.

CAMBRIDGE
© Fitzwilliam Museum, Cambridge: cat. 30, 95, 96;
fig. 94.

CHANTILLY
Musée Condé, Chantilly © RMN, Paris.
Photo R.G. Ojeda: fig. 73

CHICAGO, LLINOIS (IL)
The Art Institute of Chicago, IL © The Art Institute
of Chicago, IL: cat. 33, 37, and p. 8.

CLEVELAND, OHIO (OH)
© The Cleveland Museum of Art, Cleveland, OH:
cat. 12; fig. 4.

DERBYSHIRE
The Devonshire Collection, Chatsworth
© Reproduced by permission of Chatsworth
Settlement Trustees. Devonshire Collection,
Chatsworth: cat. 94, 115.

DETROIT, MICHIGAN (MI)
© 1983, The Detroit Institute of Arts, Detroit, MI: fig. 24.

DRESDEN
© Skulpturensammlung, Staatliche Kunstsammlungen
Dresden. Photo Jürgen Karpinski, Dresden: cat. 47.

DUBLIN
The National Gallery of Ireland, Dublin © courtesy of
The National Gallery of Ireland, Dublin: fig. 65.

FLORENCE
Berenson Collection, Villa I Tatti, Florence
© reproduced by permission of the President and
Fellows of Harvard College: fig. 25, 44, 61.

Biblioteca Nazionale Centrale di Firenze © Ministero
per i Beni e le Attività Culturali / Biblioteca Nazionale
Centrale di Firenze. Photo S. Lampredi, Laboratorio
Fotografico BNCF: cat. 50; fig. 40.

Fototeca Berenson, Villa I Tatti, Florence
© reproduced by permission of the President and
Fellows of Harvard College: fig. 45.

Gabinetto Disegni e Stampe degli Uffizi, Florence
© Soprintendenza Speciale per il Polo Museale
Fiorentino, Gabinetto Fotografico, Ministero per
i Beni e le Attività Culturali: cat. 41, 73, 74, 87, 90,
91, 99, 112, 114; fig. 59.

Galleria degli Uffizi, Florence © Soprintendenza
Speciale per il Polo Museale Fiorentino, Gabinetto
Fotografico, Ministero per i Beni e le Attività
Culturali: cat. 14, 38 and p. 177; fig. 22.

Galleria dell'Accademia, Florence © Soprintendenza
Speciale per il Polo Museale Fiorentino, Gabinetto
Fotografico, Ministero per i Beni e le Attività
Culturali: fig. 46.

Museo di Casa Martelli, Florence © Soprintendenza
Speciale per il Polo Museale Fiorentino, Gabinetto
Fotografico, Ministero per i Beni e le Attività
Culturali: cat. 102, 103; fig. 36.

Museo Nazionale del Bargello, Florence
© Soprintendenza Speciale per il Polo Museale
Fiorentino, Gabinetto Fotografico, Ministero per
i Beni e le Attività Culturali: cat. 46, 67.

GLASGOW
The Stirling Maxwell Collection, Pollok House,
Glasgow © Glasgow City Council (Museums): fig. 66.

HAMBURG
Hamburger Kunsthalle, Kupferstichkabinett,
Hamburg © bpk / Hamburger Kunsthalle /
Christopher Irrgang: cat. 28.

LIVERPOOL
© Walker Art Gallery, National Museums Liverpool:
cat. 8; fig. 13.

LONDON
Conway Library, Courtauld Institute of Art, London
© Conway Library, Courtauld Institute of Art, London
(Neg. no. A63/4061). Photo J. C. Thomson: fig. 7.

The British Museum, London © The Trustees of
The British Museum: cat. 42, 48, 49, 88, 89, 93, 101;
fig. 33, 34, 92.

© The National Gallery, London: cat. 10, 13, 17,
62, 63, 64, 78, 80, 81, 82, 92, 104, 106; fig. 48 and
pp. 2, 126.

Victoria and Albert Museum, London © V&A Images /
Victoria and Albert Museum, London: cat. 25, 44, 52,
79, 85, 86; fig. 12 and p. 192.

The Wallace Collection, London © Wallace Collection,
London / The Bridgeman Art Library: fig. 52.

MADRID
© Museo Thyssen-Bornemisza, Madrid: cat. 98.

MILAN
© 2007 Museo Poldi Pezzoli, Milan: cat. 70.

MUNICH
Alte Pinakothek, Bayerische Staatsgemäldesammlungen,
Munich © ARTOTHEK; Bayerische Staatsgemälde-
sammlungen, Munich: fig. 42.

NEW HAVEN, CONNECTICUT (CT)
© Yale University Art Gallery, New Haven CT: cat. 24.

NEW YORK
The Metropolitan Museum of Art, New York
© 1997, The Metropolitan Museum of Art,
New York: cat. 6.
© 1986, The Metropolitan Museum of Art,
New York: cat. 55.
© 1988, The Metropolitan Museum of Art,
New York: cat. 43, 54 and frontispiece.

© The Pierpont Morgan Library, New York: cat. 113.
© The Pierpont Morgan Library, New York. Photo
Joseph Zehavi: cat. 76.

NORTHAMPTON
The Marquess of Northampton, Great Britain
© Photo courtesy of the owner: cat. 53.

OXFORD
© Ashmolean Museum, Oxford: cat. 75. © courtesy
of Ashmolean Museum, Oxford. Photo The National
Gallery, London: cat. 15.

Christ Church, Oxford © By permission of the
Governing Body of Christ Church, Oxford: cat. 31, 61.

PARIS
Musée du Louvre, Paris © RMN, Paris. Daniel
Arnaudet / René-Gabriel Ojéda: fig. 63. © RMN, Paris.
Photo Daniel Arnaudet: fig. 85. © RMN, Paris.
Photo Thierry Le Mage: fig. 78.

PERUGIA
Galleria Nazionale dell'Umbria, Perugia © For kind
concession of the Soprintendenza BAPPSAE dell'
Umbria – Perugia, Italy: cat. 27.

PIENZA (SIENA)
Museo Diocesano, Pienza © courtesy of Parrocchia
di Pienza. Photo Lensini Siena: fig. 17.

PRIVATE COLLECTIONS
© Courtesy of Collezione Salini, Siena: cat. 16.

Graham Pollard, on loan to the Fitzwilliam Museum,
Cambridge © Photo Fitzwilliam Museum, Cambridge:
cat. 45.

Private collection © Christie's Images Ltd. 2001:
fig. 93. © Photo courtesy of the owner: cat. 21, 22, 35.

PROVIDENCE, RHODE ISLAND (RI)
Museum of Art, Rhode Island School of Design,
Providence. © 2007, Museum of Art, Rhode Island
School of Design, Providence. Photo Erik Gould:
cat. 20 and p. 126.

RALEIGH, NORTH CAROLINA (NC)
© North Carolina Museum of Art, Raleigh: cat. 56, 57.

ROME
© Galleria Doria Pamphilj, Rome: cat. 100, 105.

ROTTERDAM
© Museum Boijmans Van Beuningen, Rotterdam: cat. 97.

SAN MARINO, CALIFORNIA (CA)
The Huntington Library, San Marino, CA © courtesy
of the Huntington Library, Art Collections, and
Botanical Gardens, San Marino, CA: fig. 57, 58.

SIENA
© Photo Lensini Siena: fig. 9, 10, 11, 23, 86.

Abbazia di Monte Oliveto Maggiore, Siena
© courtesy of Ministero per i Beni e le Attività
Culturali, Soprintendenza PSAE di Siena & Grosseto.
Photo Lensini Siena: fig. 68.

Archivio di Stato, Siena © Archivio di Stato, Siena
(aut. no. 695/2007). Photo Lensini Siena: cat. 2, 3, 4, 5;
fig. 6, 79 and cover.

Basilica di San Domenico, Siena © courtesy of
Ministero per i Beni e le Attività Culturali.
Soprintendenza PSAE di Siena & Grosseto.
Photo Lensini Siena: fig. 21, 53, 55, 75, 76.

Battistero di San Giovanni, Siena © Opera della
Metropolitana di Siena (aut. no. 918/07).
Photo Lensini Siena: fig. 18, 47, 51.

Bichi chapel, Chiesa di Sant'Agostino, Siena
© courtesy of Comune di Siena. Photo Lensini Siena:
fig. 49, 50.

Chiesa di San Francesco, Siena © Photo Lensini Siena:
fig. 15, 16.

Chigi Saracini Collection, Monte dei Paschi di Siena
© courtesy of Banca Monte dei Paschi di Siena.
Photo Lensini Siena: cat. 11; fig. 28, 80.

Complesso Museale di Santa Maria della Scala, Siena
© courtesy of Comune di Siena. Photo Lensini Siena:
fig. 69, 70, 91.

Duomo, Siena © Opera della Metropolitana di Siena
(aut. no. 918/07). Photo Lensini Siena: fig. 14, 27, 39, 77.

Museo Aurelio Castelli, Basilica dell'Osservanza,
Siena © courtesy of Convento San Bernardino
all'Osservanza, Siena. Photo Lensini Siena: cat. 39,
fig. 32.

Museo Civico, Siena © courtesy of Comune di Siena.
Photo Lensini Siena: cat. 7, 60.

Museo dell'Opera del Duomo, Siena © Opera della
Metropolitana di Siena (aut. no. 918/07). Photo
Lensini Siena: fig. 8, 26, 29, 43.

Oratorio di Santa Caterina in Fontebranda, Siena
© Photo Lensini Siena: cat. 9 and p. 105.

Piccolomini Library, Duomo, Siena © Opera della
Metropolitana di Siena (aut. no. 918/07). Photo
Lensini Siena: fig. 71, 72.

Pinacoteca Nazionale, Siena © courtesy of Ministero
per i Beni e le Attività Culturali, Soprintendenza
PSAE di Siena & Grosseto. Photo Lensini Siena:
cat. 1, 23, 77, 83, 84; fig. 5, 19, 20, 30, 37, 38, 54.

Palazzo Pubblico, Siena © courtesy of Comune di
Siena. Photo Lensini Siena: fig. 41, 87, 88, 90

TOLEDO, OHIO (OH)
© Toledo Museum of Art, Toledo, OH: cat. 58, 59.

TULSA, OKLAHOMA (OK)
© 2007. The Philbrook Museum of Art, Inc.,
Tulsa, OK: fig. 83, 84.

VENICE
Galleria Franchetti alla Ca' d'Oro, Venezia
© courtesy of Ministero per i Beni e le Attività
Culturali, Soprintendenza Speciale per il Polo
Museale Veneziano: fig. 74.

WASHINGTON, DC
National Gallery of Art, Washington, DC © 2007
Board of Trustees, National Gallery of Art,
Washington, DC: cat. 26, 51, 66, 72.

WILLIAMSTOWN, MASSACHUSETTS (MA)
© Sterling and Francine Clark Art Institute,
Williamstown, MA: fig. 67.

LIST OF LENDERS

ALTENBURG
Lindenau-Museum, Altenburg

AMSTERDAM
Rijksmuseum

ASCIANO
Museo Archeologico e d' Arte Sacra di
Palazzo Corboli di Asciano

BALTIMORE (MD)
The Walters Art Museum

BERLIN
Staatliche Museen, Gemäldegalerie
Staatliche Museen, Kupferstichkabinett

BIRMINGHAM
The Barber Institute of Fine Arts

BLOOMINGTON (ID)
Indiana University Art Museum

BOSTON (MA)
Museum of Fine Arts

BRUNSWICK
Herzog Anton Ulrich Museum

BRIGHTON
Brighton Museum and Art Gallery

BUDAPEST
Museum of Fine Arts

CAMBRIDGE
The Fitzwilliam Museum

CHATSWORTH
The Devonshire Collection

CHICAGO (IL)
The Art Institute of Chicago

CLEVELAND (OH)
The Cleveland Museum of Art

DRESDEN
Staatliche Kunstsammlungen Dresden

FLORENCE
Biblioteca Nazionale Centrale
Museo di Casa Martelli
Museo Nazionale del Bargello
Galleria degli Uffizi

HAMBURG
Kunsthalle, Hamburg

LIVERPOOL
Walker Art Gallery

LONDON
The British Museum
The National Gallery
Victoria and Albert Museum

MADRID
Museo Thyssen-Bornemisza

MILAN
Museo Poldi Pezzoli

NEW HAVEN (CT)
Yale University Art Gallery

NEW YORK
The Metropolitan Museum of Art
The Morgan Library and Museum

NORTHAMPTON
The Marquess of Northampton

OXFORD
The Ashmolean Museum
Christchurch Picture Gallery

PERUGIA
Galleria Nazionale dell'Umbria

PROVIDENCE (RI)
Museum of Art, Rhode Island
School of Design

RALEIGH (NC)
North Carolina Museum of Art

ROME
Galleria Doria Pamphilj

ROTTERDAM
Museum Boijmans Van Beuningen

SIENA
Archivio di Stato di Siena
Museo Aurelio Castelli
Museo Civico di Siena
Contrada dell'Oca
Pinacoteca Nazionale

TOLEDO (OH)
The Toledo Museum of Art

WASHINGTON, DC
National Gallery of Art

The Right Hon. The Earl of
Crawford & Balcarres

Mr Graham Pollard

The Earl of Oxford and Asquith KCMG

Salini Construttori S.p.A.

Collezione Chigi-Saraceni/Banca Monte
dei Paschi di Siena

And all lenders and private collectors who
wish to remain anonymous.

This exhibition has been made possible
with the assistance of the Government
Indemnity Scheme which is provided by
DCMS and administered by MLA.